The Life of Isamu Noguchi

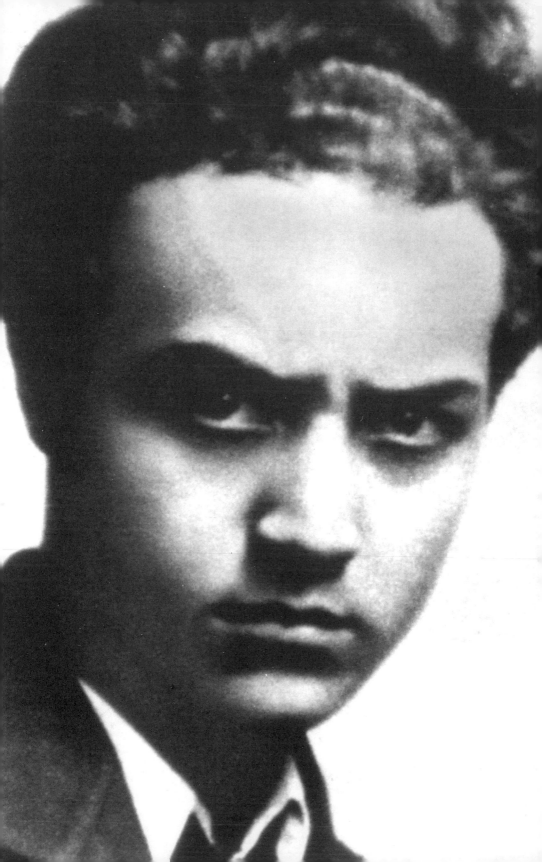

The/Life of Isamu Noguchi

Journey without Borders

Masayo Duus

Translated by Peter Duus

PRINCETON UNIVERSITY PRESS

Princeton and Oxford

To Leonie Gilmour

Front cover: Isamu Noguchi with his sculpture *"Face Dish (Me)"*, 1952. Photo: Jun Miki/Time Life Pictures/Getty Images.
Back cover: Isamu Noguchi, photographed by Andrée Ruellen, during a trip to Versailles.
Frontispiece: Isamu Noguchi, 1927. Courtesy of Isamu Noguchi Foundation, Inc.

Originally published as *Isamu Noguchi: Shukumei no ekkyōsha*, copyright © 2000 Kodansha, Otowa 2-12-21, Bunkyō-ku, Tokyo, Japan

English-language edition published by Princeton University Press, 41 William Street, Princeton, New Jersey 08540
In the United Kingdom: Princeton University Press, 3 Market Place, Woodstock, Oxfordshire OX20 1SY
pup.princeton.edu

Translated from the Japanese by Peter Duus

Designed and composed by Tina Thompson
Printed by Maple-Vail, Binghamton, New York

Printed and bound in the United States
10 9 8 7 6 5 4 3 2 1

Library of Congress Cataloging-in-Publication Data

Duus, Masayo, 1938–
 [Isamu Noguchi. English]
 The life of Isamu Noguchi : journey without borders / Masayo Duus ; translated by Peter Duus.
 p. cm.
 Translation of: Isamu Noguchi.
 Includes bibliographical references and index.
 ISBN 0-691-12096-X (cl : alk. paper)
 1. Noguchi, Isamu, 1904– 2. Japanese American sculptors—Biography. I. Title.

NB237.N6D8813 2004
709'.2—dc22
[B] 2004044532

CONTENTS

On a visit to New York's financial district more than thirty years ago, I first discovered one of Isamu Noguchi's public sculptures, *Red Cube*, a steel hexahedron, twenty-four feet high, balanced like a gigantic die on one end in front of the Marine Midland Bank Building, a fifty-five-story tower faced with glass. The sculpture puzzled many passersby hurrying along the busy street but a few paused to look. Some even peered through the hole in its center at the cold gray skyscraper behind it. The sculpture seemed to comfort them, if only for a moment. To me the breathtaking brilliance of its vermilion color recalled the special warmth of Japanese lacquerware. As I gazed at it I somehow felt at home, and from that moment I never forgot the Japanese-American artist who had created it.

"Things which are so far back are not like a part of myself, more like the life of somebody else, and should be written by another. To me it all seemed like chance; choice, if any, came much later. How I came to make decisions, I do not know. Perhaps choice, too, is chance, like the rolling of dice. With my double nationality and double upbringing, where was my home? Where were my affections? Where my identity? Japan or America, either, both—or the world?"[1]

Isamu Noguchi began his brief memoir in *A Sculptor's World* in 1968 with these words. Despite his international reputation, he always felt like an outsider. Born in the United States but brought up in Japan, he spent his whole life crossing the cultural borders between East and West, trying to understand what it meant to belong to a race, a nationality, or a country. Caught between two cultures, he yearned to find a place where he belonged.

"The problem is that I don't think I fit in. I'm not understood either way; over here [in America] I am Japanese and over there [in Japan] I am American, a peculiar sort of thing."[2] Yet, as his friend Buckminster Fuller pointed out, Isamu Noguchi was "always inherently at home—everywhere."[3] He was a cosmopolitan figure whose stage was the world.

Isamu Noguchi crossed many artistic borders, too. "He tried to go beyond sculpture," says Thomas Messer, former director of the Guggenheim Museum. "He tried to go beyond every border line he faced in art."[4] Few modern American artists have left behind such a wide-ranging body of work. There was hardly an artistic genre that he failed to explore: from his brilliantly unconventional early portrait busts to the powerful stone abstractions of his later years; from his imaginative models for children's playgrounds to the pyramid at Moerenuma Park in Japan; from his spare sets for Martha Graham's ballets to the Akari lanterns advertised in interior design magazines.

I began to think about writing a biography of Isamu Noguchi in 1985 when I came across his name again in the files of the wartime relocation camps for Japanese-American internees. My curiosity was aroused. What had this Japanese-American artist done during World War II? Why had he gone into a relocation camp? My curiosity eventually launched me on a journey that took me around the world, across many borders to places where I had never expected to go, speaking with people who had known him and visiting the many sites where he had worked.

Isamu Noguchi had shown a different face to everyone I talked with, and to each he revealed a different side of his character, but over and over again all of them said, with different voices and different words, that they had never met anyone so complicated. He was a man bursting with contradictory impulses. The more I delved into his life, the more I felt myself pulled this way and that, seeing now his dark face and now his bright. His intense ego and pride could irritate, anger, frustrate, and baffle those around him, and he often behaved toward others with an insensitivity that bordered on callousness. Andrée Ruellan, who had known him since his days in Paris, told me, "He always stepped on the accelerator and the brake at the same time."[5] But I never heard a harsh word from any of his former lovers. The beautiful women he pursued until the end of his life all remembered only his gentle thoughtfulness. Even in his old age, he still appealed to women—and men, too.

Richard Lanier, a trustee of the Isamu Noguchi Garden Museum, described Isamu to me as "mercurial."[6] As I worked on his biography I often felt that that was literally true. A drop of mercury will splatter into countless tiny droplets that divide into smaller ones, defying all attempts to knead them together again. Chasing the tiny droplets of Isamu Noguchi's life was often frustrating, but in the end they merged together into a tight round ball all by themselves.

Isamu Noguchi left a legacy of words that reflected the complexity of his personality. He did not open up to journalists easily, but he often gave interviews and wrote essays for newspaper and magazines. He was also careful to preserve correspondence with family, friends, and lovers. Like many people, intentionally or not, he did not always speak the truth inside him, and he often took words he had uttered in the past to mean the exact opposite of what he had said. But I soon began to hear his fiercely intense inner voice, and I began to understand his victories, his courage, and his arrogance as well as his disappointments, his anxieties, and his compulsions. All the words of Isamu Noguchi quoted in this book are his own, drawn from his written memoirs and reminiscences, his speeches and interviews, his essays and other writings, and a series of tape recordings made at the end of his life.

The memoir Isamu Noguchi wrote in 1968 for *A Sculptor's World*, only thirty pages long, was too brief to reveal his true face. But self-revelation was not his intention. The book was published in connection with a major retrospective exhibition at the Whitney Museum of American Art. Not until he was eighty-three years old did he think seriously about writing an autobiography. "Before my memory goes completely blank," he said, "I should put down as much as possible."[7] He felt that his time was growing short and he wanted to pass his artistic legacy on to future generations. He recorded his recollections on cassette tapes, but when he listened to them his story seemed to have no focus.

He decided to finish his autobiography by hiring a bilingual interlocutor to interview him. "It will be a book about the search for art," he told her. "Not because it's art, and art is part of life. . . . It's a kind of journey."[8] He wanted his autobiography to explore the era he had lived in, the thoughts that had come to him, the work he had accomplished. Until then he had found it difficult to talk about his birth and his childhood. As he

approached the end of his life he finally confronted that dark side of his past, too.

Isamu Noguchi was a deeply suspicious person. He wanted to find out what kind of person his interlocutor was. He spoke with her for three nights, recording their conversations on tape, but the press of other business interrupted, and the opportunity for another interview never came. He died six months later. As he roamed the landscape of his heart on those three nights, Isamu kept returning to his origins, trying to trace his "journey" from its beginnings, recalling his life as a hapless child of destiny with an uncertain future. His reminiscences, moving in circles, always returned to the story of the mother and father who had brought him into the world. I could hear the pain in his voice when he said, "Our family really had no cohesion. I should hardly say 'our family.'"[9] But as I listened, I could also hear a logic that he never concealed, a logic that always took him back to his parents' two cultures.

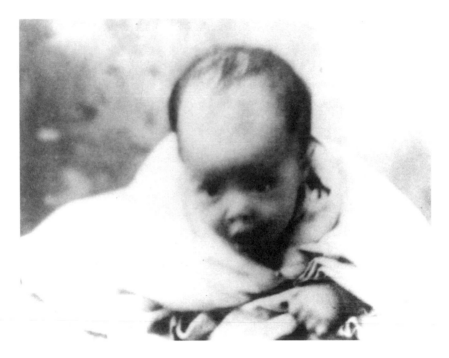

Isamu Noguchi at about six weeks

Yone and Leonie

"Yone" Noguchi

Isamu Noguchi wanted to begin his autobiography with of the story of his American mother, the person who had the greatest influence on his life. "It should be more than just a biography," he said. "I think it should be a history of our times with . . . my mother coming to Japan and trying to make a go of it. . . . I believe she was involved with my father because he needed some kind of help with his English. As a result of all this I was the product. What to do with me was her problem. Merely bringing me up in America as another kid was not her idea of progress. So in a way [going to Japan] was my mother's decision what would be best for me."[1]

His Japanese father, he said, was only a bit player in his life. He "did not quite fit into the picture too well. It was unfortunate."[2] As a child, Isamu rarely saw his father, and although he once confessed a "moral loathing" for him, he admitted that even that this unfortunate part of his life was important. Like it or not, he could never escape the influence of the parent who had abandoned him. Growing up fatherless had a profound impact on his personality, and in later life his absent father often cast a shadow across his path.

Yonejirō Noguchi, who would come to be known in the United States as "the poet Yone Noguchi," was born in the sleepy provincial town of Tsushima in central Japan on February 8, 1875. He was the youngest son of Denbee Noguchi, a shopkeeper who claimed samurai ancestry but ran a small store selling wooden sandals, paper, umbrellas, and other sundry goods. Competition, ambition, and opportunity defined the Japan of Yonejirō's childhood and youth. Just seven years before his birth, the Meiji

Restoration had launched the country on a race to catch up with the "civilized" countries of the West. Old customs, old habits of mind, and old social barriers were swept away by a barrage of reforms, and new opportunities opened up for the brightest and the best to "rise in the world." The liberation of personal ambition created a restless generation of strivers, and Yonejirō was one of them.

A fascination with language set him on his road to success. His autobiography, *The Story of Yone Noguchi*, begins with the moment that shaped his future. "My first sensation, when I got a Wilson's spelling-book, was something I cannot easily forget; I felt the same sensation when, eight years later, I first looked upon the threatening vastness of the ocean upon my embarking on an American liner, where I felt an uneasiness of mind akin to pain for the conquest of which I doubted my little power. I remember how I slept every night with that spelling-book by my pillow, hoping to repeat the lesson whenever I awoke at midnight. It was my ambition to make my study advance in the shortest time possible, so that I could understand what a foreigner spoke."[3] Whether the boy knew it or not, mastery of a foreign language, especially English, had brought wealth and renown to many young men of his day.

After graduating from the First Prefectural Middle School Yonejirō left home. His "boyish ambition" had grown too strong for him to remain content with life in a provincial city like Tsushima. With his precious English/Japanese dictionary tucked in a bundle of belongings, he set off to seek his fortune in Tokyo, the country's intellectual, cultural, and social capital, where his eldest brother, Hidenosuke, worked as a surveyor for the Japan Railway Company. He spent a year at a preparatory school for Keiō Academy, a private college founded by Yukichi Fukuzawa, the country's most prominent intellectual. The college's curriculum was heavily weighted with lectures on Western philosophy, law, and politics, and the sixteen-year-old Yonejirō was soon bored with studying somebody else's economy and history. He skipped classes but he never lost his burning desire to learn English. He desperately wanted to learn the language in a country where it was spoken every day.

"Many people imagine that I left to go abroad because from the start I wanted to become a man of letters and I once wrote that that was the case, but in fact it was not. When I went to America I was eighteen and did not understand anything about literature at all. My motive in going to

America was nothing more than a kind of curiosity. It was an idea that popped into my head from almost the same feelings that students of that age have today—I didn't like school and I was afraid of exams."[4] On November 3, 1893, Yonejirō set sail for San Francisco as a third-class passenger on the steamship *Belgic*.

By the 1890s, San Francisco, a bawdy Gold Rush town in its early days, had risen to respectability as the largest city on the West Coast. It was also the most ethnically diverse. Thousands of Chinese immigrants who came to America to work in the gold fields or on the transcontinental railroad had settled in the city's famous Chinatown. Far fewer Japanese had migrated but about a thousand or so huddled in a neighborhood later known as Japantown. Most Japanese Yonejirō saw in San Francisco were immigrant laborers who "lived like dogs and pigs." To the city's inhabitants he looked just like one of them.

"Even though I had come to America feeling like the character in some fantastic tale, there was nothing at all that I could do there and so for a while I idled away my days doing nothing."[5] Study abroad was limited to an elite few who traveled on Japanese government scholarships or private funds. Yonejirō was not nearly so fortunate. His eldest brother gave him enough money for steamship fare but once he got to San Francisco he had almost nothing left to support himself. His trip to America was a gamble. He had to find work.

The day after his arrival, Yonejirō made his way to a shabby wooden house reeking of fish and sake at the end of O'Farrell Street. It was the headquarters of the Patriotic League (*Aikoku dōmei*), an organization of radical young Japanese refugees who fled to America after being banned from political activity at home. Most local Japanese immigrants dismissed them as political toughs who brawled with rival political factions, and Yonejirō was apprehensive as he climbed the rickety steps to the front door with a letter of introduction to one of the league's leaders. Once inside, his "boyish spirit of adventure and romance" revived. He found the young occupants passionately debating how to preserve the independence of the Hawaiian kingdom. Caught up in their excitement, and anxious "not be taken for a mere boy," he donated money to the cause on the spot.[6]

Yonejirō's first job in America was delivering the league's lithographed daily newspaper, the *Soko shinbun* (*San Francisco News*). He did

not ask for wages but he was allowed to sleep on a large table in the league headquarters with a stack of newspapers as a mattress and a volume of the *Encyclopedia Britannica* as a pillow. It did not take long for him to realize that he could neither improve his English nor support himself by working for a paper with fewer than two hundred readers. Like many other poor but ambitious, educated young immigrants, he took a job as a houseboy (or what Japanese immigrants called a "schoolboy"). The duties were light and the wages were low, but the job gave him a chance to study English. After preparing the family's breakfast every morning, he set off for an American elementary school, returning at four to help with the evening meal, wash dishes, and do light cleaning.

School sparked his interest in English poetry. As he did his evening chores, he recited to himself poems he learned during the day, often so deep in his reveries that he dropped the dish he was washing. Tiring of the monotonous work as a "schoolboy," he slipped out of his employer's house through a window early one morning and made his way south to Palo Alto, where Stanford University had recently opened its doors. The university charged no tuition, and it welcomed students from Japan. Yonejirō took a job at Manzanita Hall, a preparatory school for the university, where he cleaned classrooms and waited on tables for room and board, but he felt uncomfortable and out of place in his heel-less shoes and scruffy coat. To restore his finances he went to work as a dishwasher at the nearby Menlo Park Hotel.

When Yonejirō heard news that war had broken out between Japan and China in August 1894, he hurried back to San Francisco with thirty dollars of savings in his pocket. He was flush enough to buy shoes and shirts for his friends at the *Soko shinbun*, who hired him to translate articles from the American press. He also wrote essays extolling Japan's expansion-ist policy in Asia. "To play a patriot or an exile was one of my pleasures at that time," he recalled.[7] The strain of living in a foreign country had sharp-ened his nationalist sentiments. As one of his colleagues noted in a letter to an American friend: "Yone is most queer boy among all Nipponese. . . . He is dreamer. Yes, he are [*sic*] dreaming always of his sweet dream, mostly of his native country."[8]

Yonejirō worked at the newspaper for about a year, but he wanted to continue his studies. "[I] thought that books should be read slowly but thoroughly after having a good sound rest. . . . The fine sleeping which had

hitherto been denied to me since my arrival in America, I really thought the first necessity for the good understanding of books."[9] A friend told him that Joaquin Miller, a famous poet living in the Oakland hills, was interested in Japan and sometimes let Japanese students stay with him. Yonejirō decided to pay a visit.

Joaquin Miller, a self-promoting poseur with a gift for telling tall tales, had come west from Ohio with his pioneer parents, who eventually settled in Oregon. He spent his adolescent years, he later claimed, in California, where he worked as a cook in mining camps, ran a roadhouse, lived with an Indian tribe, and was thrown in jail for horse theft. For a while he taught school in the Washington Territory, then read law in Portland. While serving as a county judge in Oregon he began to write verse. To pursue his blooming literary aspirations in 1863 he moved briefly to San Francisco, where a small circle of writers including Bret Harte, Mark Twain, Ina Coolbrith, and Charles Warren Stoddard gathered at the *Overland Monthly*. When he returned in 1870, he made his debut as a poet with *Songs of the Sierras*, a collection of poems celebrating the Western landscape. His style was reminiscent of mainstream New England poets like Longfellow but his ability to evoke the romance of the rapidly vanishing frontier and the beauty of its natural wonders won him a popular following.

When Mark Twain, battening on the success of *The Gilded Age*, his satire of the follies of postbellum America, left for the East Coast, Miller, with his tall tales and flamboyant manner, became the new center of San Francisco's literary Bohemia. Miller soon followed Twain and Harte east, then went to London where he was hailed as the "Byron of Oregon." After several years in England, Italy, and the East Coast, Miller returned to California in 1883. By then his literary following had dwindled. In 1887 Miller settled at "The Hights"—his spelling—a small estate in the hills overlooking Oakland, where he recreated the life of a simple pioneer, living in a small triangular-roofed cabin he built himself. Yonejirō remembered it as the first "hovel" he had seen in America. Close by was a house for Miller's mother, and another cottage for guests and visitors.

A man of towering height with flowing white hair and beard, Miller carefully cultivated his romantic image as a Western pioneer. He wore a cowboy hat and boots with a deerskin or bearskin draped over his shoulders. To Miller, Yonejirō must have looked as diminutive as a child, but the poet took a liking to the young man right away. When Yonejirō volunteered to

help Miller plant flowers and acacia bushes on the hillside surrounding his cabin, he immediately said yes. Yonejirō was impressed that Miller addressed him as "Mr. Noguchi," not as "Charley" or "John" as had his American employers when he worked as a "schoolboy."

During his long stay at The Hights Yonejirō took Miller as his model in everything. While Miller wrote poetry in the morning, Yonejirō devoted himself to reading, and in the afternoon the two men worked together clearing land and planting trees and shrubs. "As I watched Miller writing, I marveled at how easily he wrote. All you have to do is write down things as you think of them, he told me. So I thought, 'I'll write in English myself. Or better than that I'll write poetry. And a result I will absorb it naturally.'"[10] Freed from worry about supporting himself, Yonejirō spent his days immersed in American and English poetry, particularly the work of Edgar Allan Poe, whose elegant style captivated him. He delighted in the peace and solitude he enjoyed at The Hights, perched in its idyllic setting overlooking San Francisco Bay. As he wrote to an American friend, "The Hights of Oakland is . . . Heaven."[11]

In June 1896 five of Yonejirō's English-language poems appeared in *The Lark,* a San Francisco literary magazine to which Miller contributed. The editor, Gelett Burgess, a frequent visitor at The Hights, was a transplanted Bostonian who hoped to establish San Francisco as a literary and artistic center. (Today he is best remembered for his humorous quatrain, "I've never seen a purple cow, I hope I never see one, et cetera.") Burgess may have published Yonejirō's poetry because he found it an interesting oddity. Most Japanese immigrants in California were manual laborers, and English poetry written by one of them was bound to excite public curiosity. Whatever Burgess's motives, his decision to publish the work transformed Yonejirō into "the poet Yone Noguchi."

Three months later the Bohemian Press brought out Yonejirō's maiden work, *Seen and Unseen, or Monologues of a Homeless Snail*, a slim volume that began with a poem entitled "Prologue":[12]

> The fate-colored leaves float dumbly down unto
> the ground breast, thousands after thousands,
> matting the earth with yellow flakes,
> Whist the brushing of a golden, Autumn wind
> dreams away into the immortal stillness.
> Ah, they roam down, roam down, roam down!

The *San Francisco Chronicle* critic praised "this strange jumble of words" by a "disciple of Joaquin Miller" as a new kind of nature poetry. The American poetry world was in the doldrums at the time. Despite his half-digested English, or perhaps because of it, Yonejirō's work appeared original and novel. As Burgess noted in his introduction to the volume, "[He] has lifted the veil of convention and discovered fresh beauties and unexpected charms in our speech." Yonejirō's vaguely exotic imagery must also have charmed literary Bohemians by its "Oriental" character.

Not everyone greeted Yonejirō's debut so positively. A letter to an Oakland newspaper accused him of plagiarizing Poe almost word for word in a poem published in *Philistine*, another local literary journal. Yonejirō denied the charge, and when Miller wrote a letter to the paper defending him the affair died down. But in his English-language autobiography, Yonejirō admitted, "I read each line and all the words of Poe's poems, my first love being *Annabel Lee*; in time they grew almost chiselled in my mind."[13]

When *The Lark* folded for business reasons, Yonejirō found himself without a venue for his English poetry. Determined to make his mark on the local literary world he published *The Twilight*, a slim English-language poetry journal eight pages long. It folded after the second issue. In 1897 Yonejirō brought out a second collection of poetry, *The Voice of the Valley*, written after he visited Yosemite to commune with nature. He also did his best to ingratiate himself with Miller's friends in the San Francisco literary world.

In late 1898 Yonejirō began corresponding with Blanche Partington, an older single woman who worked as a theater and cultural reporter for the *San Francisco Call*. His first letter was hardly subtle: "I think you was beautiful last night. Mr. M said to Mrs. M that you are about thirty-five years old, and Mrs. M. insisted, however, and said that must be seventeen. Are you thirty-five? Are you seventeen? Tell me how old you are." He asked her to read and correct two poems. "I think you are so bright and full of good judgements. I am such a write without good grammar and spelling."[14]*

No one was more surprised than Yonejirō when *Seen and Unseen* met a warm critical welcome. As his letter indicates, he was aware how poor his English was. His choice of vocabulary was odd, and his expressions unnatural. Only occasionally did he marshal his words in proper order. He

* Due to the idiosyncratic nature of Yonejirō's English prose, "[*sic*]" will be used only to indicate misspellings rather than errors of syntax and grammar.

needed an amanuensis to edit his work, and he thought he had found one in Blanche Partington. Within a few months, his letters to her became more and more demanding, and in the spring of 1899, after returning from a trip to Los Angeles, he pressed her to correct a book manuscript that he planned to call *Ocho-san's Diary*.

In 1898 the monthly magazine *Century* published *Madame Butterfly*, a novella by John Long, a Philadelphia lawyer. The novella rode a rising wave of *japonisme* in the United States. At the turn of the century international exhibitions aroused public interest in Japanese culture, and so did the influx of Japanese woodblock prints, chinaware, and other objets d'art into middle-class parlors. *Madame Butterfly* was the touching tale of Cho-Cho-San, a geisha who fell in love with an American naval officer, bore him a child, and then was cast aside when he returned to the United States to marry his American fiancée. Although the novella was allegedly based on a true story that Long heard from his younger sister, the wife of a missionary in Nagasaki, the author may have been inspired by Pierre Loti's *Madame Chrysantheme*. The story became widely known when the impresario David Belasco adapted it for the stage in 1900.

Yonejirō's *Ocho-san's Diary* was clearly an attempt to capitalize on the popularity of *Madame Butterfly* and other books like it. Like many Japanese sojourners he wanted to "return home clad in brocade." The fastest way to achieve recognition as a poet in Japan was to establish a reputation abroad, and he realized that he could not do so if he remained in San Francisco. From reading Miller's memoirs he knew that his mentor had won fame only after he became well known in New York and London—and Miller had surely told him as much himself. Yonejirō was writing *Ocho-san's Diary* to make money for a trip to the East Coast, the center of the American literary world, but Blanche Partington was slow to respond to his pleas to revise his manuscript. When Joaquin Miller left on a trip to China in the summer of 1900 he decided to pull up stakes. With little prospect that Blanche would finish the revision of his story soon, Yonejirō bid farewell to his beloved Hights.

Leonie Gilmour

"I expect some money coming from Hawaii, but it has to come from Chicago from where the money will be forwarded to New York. . . . How

lonely I feel! Have you sympathy with me? Can you not let me have some money till my money will come? . . . I can not sell my writing today. What shall I do? I am so down-hearted. Help me! Will you?"[15] Shortly after his arrival in New York City a pickpocket had relieved Yonejirō of his wallet as he wandered the streets of "the Jewish colony." He turned for help to Charles Warren Stoddard, a middle-aged poet teaching American literature at Catholic University in Washington, with whom he had corresponded for several years. Joaquin Miller had introduced them.

Hardly remembered today except as a friend of Robert Louis Stevenson, and more recently as a pioneering gay poet, Stoddard was a well-known literary figure at the turn of the twentieth century. A colleague of Mark Twain, Ambrose Bierce, and Joaquin Miller, he had gotten his literary start in San Francisco, where he contributed poems to the *Golden Era*. For several years he lived a wandering life, working as a secretary for Mark Twain in London, living in Rome with Miller, and eventually finding his way to Tahiti. *South Sea Idylls*, a collection of his poems, celebrated his deep friendships with "brown-skinned youths" in the Pacific. He was surprisingly open about his feelings at a time when homosexuality was a criminal offense. Perhaps because his poems rhapsodized about life on distant tropical islands, the erotic undercurrent in his poetry escaped controversy. He was also fortunate to have literary friends who accepted his sexual preferences and shielded them from public view.

Yonejirō clearly hoped that Stoddard would be his patron on the East Coast as Miller had been in California. To his relief Stoddard sent money, and he immediately boarded a train to visit his benefactor in Washington. Stoddard was disappointed that the "dear poet who came to me out of the Orient" was not wearing a Japanese kimono when they met, but he was charmed by Yonejirō. The young poet was "sweet, serious, often sad—sometimes in tears, he know not why," Stoddard noted in his diary. "We are sympathetic to the last degree."[16] After a three-week stay with Stoddard Yonejirō sent him an effusive thank-you note: "How rare your sweet magnetism! Your breath so soft and impressive like autumn rain! Your love—thank God! . . . loveliest visit to you was my dream realized. It was a great event in my life."[17]

"Yone Noguchi" had a modest literary reputation in San Francisco but he was still completely unknown in New York. Anonymity only spurred him to pursue public recognition more doggedly. He took a room on Riverside Drive overlooking the Hudson River to finish his manuscript. The

money he had been expecting from Hawaii had arrived, sent by members of the Patriotic League who had moved their headquarters to Honolulu, where they set up a highly profitable immigration company to handle the passage of Japanese laborers hired to work in the sugar cane fields. It would not have been difficult for them to send a modest living allowance to a former colleague who dreamed of becoming a famous poet in America.

In early February 1901 Yonejirō replied to a letter from a Miss Leonie Gilmour who answered his newspaper ad for an editorial assistant: "Dear Madam; Permit me! I am a young Japanese who advertised in the Herald and received your letter. I called on your place but not finding even a person. I don't need any English teacher—Yes, I do! I want one who can correct my English composition. Can you take such a task? I suppose that you are able, with good English and literary ability. About three pages a week. How much you charge? Pray, answer me!"[18] In short order Miss Gilmour replied that she would help correct his unsteady English, and a month or so later Yonejirō sent his new assistant manuscript chapters of *Ocho-san's Diary*.

The *Diary*, written in the first-person voice of a young Japanese woman, was intended for a popular audience but Yonejirō did not want to admit that he was writing to make money. "Diary! Charming, isn't it?" he wrote Leonie. "I think that it is very clever. It has some literary art and originality. . . . I do not feel ashame such a writing, because it is art."[19] He told her to rework the manuscript as she wished, indeed, almost pleaded with her to rewrite the next three chapters. "Say, listen, can't you fix them according to your own idea? . . . This is broken English, but it got to be literature, you know, therefore I wish that you will take out some unnecessary words, and condense them nicely. Try it, please. I am in mood of writing but somehow my mind is scattered, so can not write really clever thing. Please, try best you can. . . . The broken English is not refined so well, so you might change as much as you please."[20]

Like most children, Isamu was familiar with his mother only as an adult. Of her childhood and youth he knew nothing but the memories she chose to share with him. The fragments of her life must be pieced together from those recollections and her letters. Her father, Andrew Gilmour, migrated to the United States from the village of Coleraine at the northernmost tip of Ireland. The Great Potato Famine of the 1840s sent a flood of Irish immigrants across the Atlantic, but just when Andrew arrived in America

is not clear. It appears he left home to escape a complicated family conflict. Although Leonie once told Isamu that her father was a reporter for the *Brooklyn Eagle*, a newspaper once edited by Walt Whitman, his name does not appear in the newspaper's only published history. When Leonie was enrolled at the Ethical Culture School in Manhattan, his occupation was listed as "clerk."

Leonie was born in New York City on June 17, 1874. Her mother, Albiana Smith, was four years older than her husband, and she appears to have come from a successful family. Her father, Aaron Smith, bought a plot in Cypress Hills Cemetery in Brooklyn large enough to accommodate the graves of thirty-two relatives. One of Albiana's grandmothers was the daughter of a French fur trader and a Cherokee woman, and Isamu remembered his grandmother looking "like an Indian."[21]

Albiana was already thirty-three years old when Leonie was born. Before marriage she had worked as a nurse, and she continued to do so while Leonie and her younger sister, Florence, were growing up. The two girls attended the Ethical Culture School through junior high school. Originally founded as The Workingman's School, it was open to children of all classes and religions. Children of poor laborers were given free tuition to study side by side with the offspring of their fathers' bosses.

According to school records, Leonie was an exceptional pupil, with outstanding grades, a love of books, and strong literary interests. After graduation she received a scholarship to study at Bryn Mawr. The college's curriculum, intended to promote equality between the sexes, provided young women the same kind of education that Yale and Harvard offered young men. Its graduates were prepared for independent professional careers as teachers or scholars, not as wives and mothers. Leonie entered Bryn Mawr along with thirty-seven other students in the fall of 1891, the same year that Yonejirō had entered Keiō Academy. Unlike Yonejirō, she excelled at her studies. In her sophomore year she won a scholarship to study at the Sorbonne. Already proficient in French, and fond of the French Romantics, she spent a year in Paris reading French literature. Isamu recalled that his mother had translated the works of the novelist George Sand, a liberated woman, famous for cross-dressing and love affairs with Prosper Merimée, Alfred de Musset, Frederic Chopin, and others. Her interest in Sand hints at unconventional views on relations between the sexes.

Leonie's father had sired two daughters by another woman, and since they were not very different in age from Leonie and Florence, his marriage to Albiana must have been in trouble early on. Since broken families were looked down upon, Leonie's parents never went through the legal process of divorce but Albiana was, in practice, a single mother who worked to support her daughters.

Although Isamu thought that his mother had dropped out of Bryn Mawr, college records list as her as a member of the Class of 1895. She majored in history and philosophy. Bryn Mawr graduates were much sought after as teachers by girls' schools all over the country but Leonie wanted to find work in writing or publishing, and she returned to New York to live with her mother while she looked for a job.

The 1890s were years of burgeoning feminism in the United States. "New Women," college graduates eager to use their education but blocked by gender discrimination from professions like medicine, law, and science, began to challenge the legitimacy of a male-dominated society. Some fought to secure for women the right to vote, others sought jobs only open to men. Although Leonie carried no placards and handed out no pamphlets, her sense of personal independence had been awakened at Bryn Mawr, and in her own way she, too, was one of these New Women.

Leonie found the world of work more daunting than she had imagined. Had she come from a well-to-do family with good connections, or had she been exceptionally gifted, she might have built a successful professional career as a writer or editor. But it was difficult to make a mark on the world simply by virtue of having a Bryn Mawr degree. She found no editorial work in Manhattan. Three years after graduating from college Leonie took a job teaching Latin and French at a Catholic girls' school in Jersey City. She was in her fourth year there when she answered Yonejirō's ad.

In a letter to Catherine Bunnell, a good friend from Bryn Mawr, Leonie revealed somewhat sheepishly that she was working on a short novel. During the day she taught at the school, and at night she wrote. But busy as she was, she had little money to spare, and she needed to find part-time work to cover her mother's unexpected medical expenses. "Mama has to go to the hospital about Christmas time to have her eyes operated on," she wrote Catherine.[22]

When Leonie first met Yonejirō she must have looked very much the schoolmarm. Neat and refined in manner, she was slightly built, a little

over five feet three inches tall, with thin and delicate features. Her hazel-colored eyes peered at the world through rimless glasses. In a photograph at the time she seems to be looking far beyond the camera. It is an odd gaze, unfocused, evaporating into empty space. Something about her hinted at a deep loneliness.

A reticent person who listened attentively to others, Leonie was not at all fond of talking about herself. Shy around others, she kept people at a distance. Her love of solitude bordered on unsociability. Always reluctant to take things at face value, she was also something of a skeptic. "My mother was what you call an agnostic," Isamu Noguchi later recalled.[23] When she read him Bible stories as a child she often questioned their believability. Despite her passion for French Romantic novels, Leonie kept her eyes open to the harsh realities of life. Behind her apparently fragile and reserved exterior lay a stubborn independence and a determination to guard her own inner world.

It is not too difficult to understand why this sensitive and intelligent young woman found Yonejirō, a half-educated Japanese who spoke and wrote broken English, so fascinating. In a photograph taken shortly before he left for America, Yonejirō had a boyish air, with close-cropped hair and a collarless shirt peeking through his wrinkled kimono. He was very much the image of a student up from the provinces. Three years later, in a studio portrait sent to members of the literary world with complimentary copies of *Unseen and Seen*, he appears to be an entirely different person: a handsome youth in three-piece suit and high white collar, with features unusually deep for a Japanese: a firm jaw, a high-bridged nose, deep sunken eyes, and softly feminine lips. The provincial student had become a dreamy poet. "The sweet face; the too sensitive mouth," as Charles Stoddard noted in his diary, "They also are most sensitive and artistic."[24]

Leonie had spent her youth among women, first in an all-women's college, then as a teacher in a girls' school. Into her cloistered life there suddenly appeared the seductively exotic Yonejirō, perhaps the first young man she came to know very well. What attracted Leonie more than anything else was that he was a real poet, with published work praised by literary critics. "I think her interest in him was largely literary," Isamu later surmised. "I mean, whatever the other relationship between them, I think that [her] evaluation of him as a literary person, certainly at the beginning, was very high."[25] The relationship was businesslike, with Leonie acting as a partner in Yonejirō's work.

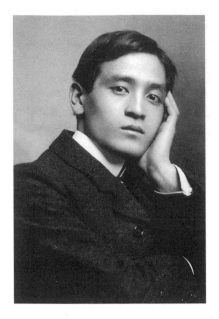

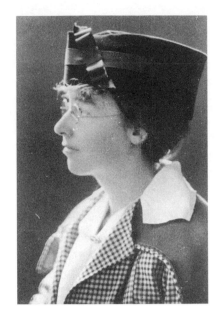

Yonejirō Noguchi, 1903

Leonie Gilmour

New York City was experiencing a "Japan boom" at the turn of the century. Art galleries held shows of Japanese prints, popular journals published stories and travel articles about the Japanese "fairyland," and middle-class families filled their parlors with Japanese bric-a-brac. Leonie, who imbibed this popular *japonisme*, must have found it fascinating to help this unusual young Japanese who was so determined to build a literary career and so confident that he could write. Yonejirō confessed his ambition to her. "Truly I believe I can write a short story as anybody does," he wrote. "Simply I am afraid my vocabulary isn't very fine, so you have liberty to make it beautiful as much as you want."[26]

Leonie, like many others, must have found Yonejirō's peculiar poetry fresh and original. The poems in *Unseen and Seen* echoed Poe's sense of mystery and Whitman's worship of the natural but they were also infused with a kind of Japanese spirituality. His poetic sensibility rather than his poetic skills may have appealed to Leonie. His English syntax was clumsy but he expressed his feelings with persuasive directness. From the start Leonie did more than correct his vocabulary or revise his unnatural phrasing. She tried to capture the sense of his original words and transform

them into literary form. Yonejirō gave her a free hand to do so. As he wrote in early April 1901, "I thought some while ago I will change the whole thing. But I don't think it is so bad. Leave the thing to your judgment. . . . I send here another revision that will come next to what I sent yesterday. I'm deadly tired. I cannot write correct and well. You will fix what you please."[27]

Leonie took care not to hurt Yonejirō's sensitive feelings as she edited his work. She doubtless found satisfaction in testing her own literary talent and her skills as an editor. She proved more capable than Yonejirō expected, and, with her support, he began to revise the manuscript of *Ocho-san's Diary* in earnest. He changed the heroine's name from Ocho-san ("Miss Butterfly") to "Miss Morning Glory," and he changed the title to *The American Diary of a Japanese Girl*. Edited and reworked by Leonie, the story was serialized in three installments in *Leslie's Monthly* beginning in November 1901. The firm of Frederick Stokes offered to publish it as a book. Acting as Yonejirō's agent, Leonie took care of the contract negotiations. In early December 1901 Yonejirō departed for Washington to relax with Charles Stoddard, leaving Leonie to prepare the final manuscript, proofread the galleys, and assure that publication went smoothly.

The American Diary of a Japanese Girl was an account of the adventures of Miss Morning Glory, a young Japanese woman on a trip to America with her uncle, a Yale graduate who had become a top executive for the Nihon Mining Company. Her observations on the strangeness of American society—"a country of women"—were written in a light and amusing tone. Miss Morning Glory, who found her own "brown sisters . . . extremely behind the time," showed more than a bit of feminist spunk. "I act as I choose," she let the reader know. "I haven't to wait for my mama's approval to laugh when I incline to." The outspoken Miss Morning Glory shattered the image of the shy Japanese woman, overshadowed by men, who "is intimate with the art of crying" and for whom "a tear is as eloquent as a kiss."[28] The book cleverly stood on its head the conventional stereotype of Japanese heroines as they appeared in stories like *Madame Butterfly*.

To arouse public interest the publisher listed the author of the book as the eponymous "Miss Morning Glory," and Genjirō Etō, a Japanese artist living in New York, provided illustrations that added a touch of the Japonesque. Reviews, all of them positive, appeared in more than seventy newspapers and magazines. Most reviewers ignored the pretense that "Miss

Morning Glory" had written the book. Everyone knew that the author was Yone Noguchi. He had finally achieved the success he sought so single-mindedly since his arrival in America nine years before. Even so, he still was not satisfied.

"Honestly I wish [the book's] great success—I mean financial success," he wrote Charles Stoddard. "But I think I cannot expect so much out of it, since it was only a girlish diary—having not much solid quality. My chief work is my poetry, although a few people incline to appreciate it."[29] He continued to write poems revised with Leonie's help, and with the *Diary* a commercial success, he set his eyes on another goal. "I wish to go to England," he wrote Stoddard, "I like to publish my book of poems over there, if I can."[30] He hoped to conquer London as his mentor Joaquin Miller had decades before. East Coast literati still looked to London for approval. He knew it was important for his poems to be published there. With the royalty money from *The American Diary of a Japanese Girl*, he bought a transatlantic ticket and sailed for England in November 1902.

In Love with a Foreigner

Today the Brixton section of London is a worn-down working-class district populated by Third World immigrants. Workingmen's families lived in the neighborhood when Yonejirō arrived at the Brixton lodgings of the artist Yoshio Makino in 1902. The two men came from the same prefecture in Japan. They had met in San Francisco, where Makino was putting himself through art school by mopping floors and doing other menial work. Makino, fleeing rising anti-Japanese sentiment in California, had left for England, and he had not seen Yonejirō in six years.

In his first letter to Leonie from London, written after he moved into Makino's boarding house, Yonejirō was already complaining about his circumstances. "My having a good time in London is beyond my reach, I fancy. Everything was opposite to my fancy. And fogs! What a nasty weather we are having here? It is suicide truly. Wet sticky disagreeable to the extreme."[31] Armed with a list provided by Charles Stoddard, he had made the rounds of several publishing houses, but found no one willing to talk with him, so he decided to publish his little book of poems privately. He ordered two hundred copies at a job printer in Kensington, planning to sell them at two shillings each.

From the Eastern Sea, a slim pamphlet sixteen pages long, contained eight poems. Yonejirō sent complimentary copies, the smell of ink still fresh on their pages, to newspapers, magazines, and every famous English person he could think of. He even sent copies to members of the royal family, including the Queen and the Prince of Wales. With the help of letters of introduction from Stoddard and others, his preposterous strategy succeeded. The novelist Iza Duffus Hardy, Thomas Hardy's daughter, who had been engaged to Joaquin Miller during his stay in London, invited him to tea, and so did other literary figures. William Michael Rossetti, a critic who had compared Miller to Walt Whitman, lauded Yonejirō's poems as "full of a rich sense of beauty and of ideal sentiment." He also thoughtfully warned him to take out a proper copyright.[32]

Despite its slender size, *From the Eastern Sea* was reviewed in several newspapers and magazines within a week of its publication. The critics were entranced by the work, and London literati were curious about this unusual Japanese who wrote poetry in their own language. Since the Anglo-Japanese Alliance had just been concluded, public interest in Japan was high. The poems—with titles like "Apparition," "Under the Moon," and "Ocho-san"—sounded quintessentially "Oriental." The critic for *The Saturday Review* noted that while the poems were "no more than rhythmical prose . . . genuine poetic feeling [is] struggling through, . . . occasionally for a few lines together, expressing itself in a new personal way, which seems to bring some actual message or fragrance to us from the East."

Nearly every review mentioned "Apparition," a mildly erotic poem likening a woman's moods to the changing hours of the day. It was the first poem that Yonejirō asked Leonie to edit. It began:[33]

'Twas morn;
I felt the whiteness of her brow
Over my face; I raise my eyes and saw
The breezes passing on dewy feet.

The Unicorn Press offered to bring out an expanded version of *From the Eastern Sea* with several new poems added to the original eight. Makino designed a cover showing Japanese boats with sails bearing the Noguchi family crest. Published in an astonishing two weeks, the new volume attracted attention across the Atlantic. Yonejirō was ecstatic when he learned it had gotten good reviews in New York. "Ah, my literary name was finally made," he

later wrote. "Just like Lord Byron, I thought to myself, I had become famous overnight. Ah, success! Was it really success? Success, I embrace you a thousand times! . . . I clearly saw the road to fame. Hurrah (Banzai)!"[34]

Before leaving for London Yonejirō told Stoddard that he had fallen in love. The older poet warned his protégé to think carefully about his future: "[N]o matter how deeply you may be in love, nor how much you may [miss] her when you are away from here, it seems to me it is not yet the time to think of marriage. . . . Six months abroad will do wonders for you. An early marriage, I fear you will live sorely to regrett [sic]; and then if Baby comes—that will ruin all Love, suffer, long for, as much as you will. These are the seeds of poesy. Marriage is the most . . . the most exasperating fate that can befall a young man."[35]

The object of Yonejirō's passion was not, however, Leonie Gilmour; it was Ethel Armes, a literary and art reporter for the *Washington Post*. He had become hopelessly—and one-sidedly—infatuated after meeting her at Stoddard's place in Washington. His obsession with Ethel was another reason that he craved recognition by the East Coast literary establishment. The twenty-five-year-old Ethel, a charming young woman with a long, slender face and bold, defiant eyes, was just a year younger than Yonejirō. Her father, a former Union Army colonel, had served as an aide to General Ulysses S. Grant during the Civil War. Yonejirō was attracted not only by Ethel's beauty, but also by her intelligence. The articles she wrote for the *Washington Post* impressed him. "It seems she is rather clever girl."[36] He was excited at the thought that she might help him with his work, and before leaving for London he had visited Washington again to become better acquainted.

Writing in late January 1903 Stoddard continued to warn Yonejirō against pursuing Ethel. "I beg you to dismiss her from your mind. She is not one to think seriously of; she will bring you only unrest and unhappiness. Write to her, by all means and tell her of your success. But go no farther—If you love me you will heed me! I know what I am saying!"[37] No doubt Stoddard's hostility to the relationship was stirred by feelings of intense jealousy, but he also understood that Yonejirō tended to lose control when fascinated by someone. Indeed, it was partly to dampen Yonejirō's ardor for Ethel that Stoddard had advised him to go to London.

After his hurried return to New York Yonejirō found it difficult to arrange a reunion. Ethel had left Washington with her family for Birming-

ham, Alabama, where she took a new job as a reporter. Although the success of *From the Eastern Sea* established Yonejirō's literary reputation, the royalties were not enough to support him, let alone buy a train ticket to Alabama. He barely managed to eke out a living selling Japanese *objets d'art* from a booth on the roof of Madison Square Garden, and he cadged free meals by preparing tempura and other Japanese dishes for wealthy families to whom Stoddard had introduced him.

Stoddard, who had moved to New York after resigning from Catholic University, tried to divert Yonejirō's interest from Ethel by introducing him to other literary young ladies. One of them was Zona Gale, a former reporter for the *New York Evening World* who later won a Pulitzer Prize for her novel *Miss Lulu Bett* in 1920. To some degree the tactic worked. "The woman poet Zona Gale is a blossom among the younger poets," he later wrote. "Not only is her verse beautiful, she herself is a rare beauty."[38] Zona had another suitor at the time but Yonejirō still visited every week to solicit her views on literature.

Strong successful career women like Ethel and Zona attracted Yonejirō. Both had made their mark in a profession dominated by men. Leonie's academic background was in no way inferior to theirs but she had not enjoyed similar success. She had failed at finding a career in publishing. The problem was not just that doors were closed to women; the problem was that Leonie herself was not forceful enough. Shy, introverted, soberly taciturn and disinclined to promote herself, she was at a disadvantage in a male-centered world.

Leonie revealed her feelings only in letters to her friend Catherine Bunnell, who shared her love of literature. The daughter of a well-to-do Connecticut family, Catherine had entered Bryn Mawr three years after Leonie but lived in the same dormitory. Though their backgrounds were very different, and their later lives as well, Catherine was the only person Leonie trusted to the end of her life. She first told her friend about Yonejirō in September 1902, just after the publication of *The American Diary of a Japanese Girl*. "Yone is five feet 3 1/2 inches tall," she wrote. "Yone grows in grace though not in height."[39] Whether Catherine sensed it or not, Leonie had fallen in love with this young Japanese despite his immaturity.

After returning from London Yonejirō asked Leonie to prepare some poems for the *National Magazine*, a Boston monthly. By then she had quit her job at the Catholic girls' school and was earning a living as a French

translator. To judge from their correspondence, the relationship was still businesslike. His letters to Leonie displayed no hint of passion or affection. All began with a casual greeting—"Dear Leonie," "Leonie," "Dear Friend"—and ended with a simple "Yone" or "Bye, bye." By contrast he always addressed his mentor Charles Stoddard as "My dear Charlie," "My dearest Charlie," or "O Dear Charlie." Yonejirō valued Leonie's help, and he depended on her as a collaborator, but there was nothing more to it than that. Indeed, he likened their relationship to that of "close male friends." Even after the relationship became physical his feelings toward her never really changed.

Yonejirō was obsessed with Ethel, and charmed by Zona Gale, an "unattainable star beyond his reach," but it was to Leonie that he turned for sex. It is impossible to say exactly how their affair began. Perhaps Yonejirō alluded to the moment in a Japanese poem several decades later:[40]

> With a young American woman,
> I took a walk in New York's Central Park.
> (It's now some twenty long years ago.)
> Let's walk in the dark, dark places," I told her,
> And we stepped in the shadow of the trees where no one passed by.
> The chill of the winter night pierced my body,
> I could not even hear the sound of the wind.
> (Oh, how ashamed I am of my irresponsible curiosity.)
> I told her of my love for her,
> And I even promised her many things.
> I squeezed her hand,
> And touched it to my mouth.

Yonejirō hid his relationship with Leonie even from Charles Stoddard, his "dear Dad," to whom he revealed more of his feelings than he did anyone else. If Stoddard found out about the affair with Leonie, he would have immediately reported it to Ethel. Neither woman knew about the other. Ethel was in far off Alabama, and the antisocial Leonie had nothing to do with Yonejirō's friends in New York. Yonejirō had a compelling reason to keep them ignorant of one another. It was summarized on a single sheet of ordinary lined notebook paper dated November 18, 1903, written in his hand and signed "Yone Noguchi." It simply read: "I declare that Leonie Gilmour is my lawful wife."

"Are you deadly tired of me?" Yonejirō had written Leonie two months earlier. "I shall say that it would be the time when I must make a

graceful exit. (Oh, if possible!) I don't know what I am going to do. I am something like a jelly fish which has no head or tail. Just I am contemplating—about what? God knows."[41]

Yonejirō was already thinking about returning to Japan when he presented Leonie with his "declaration." He had been sending essays and articles to highbrow Japanese magazines like *Teikoku bungaku* (*Japanese Literature*) and *Keiō gijuku gakuhō* (*Keiō Academy Journal*) to establish his literary credentials at home. In October 1903, a Japanese publisher brought out the book *From the Eastern Sea* in English, using the same plates and illustrations as the original edition. Its reception was more favorable than Yonejirō expected. What impressed the critics most was his "great achievement" in "winning success in England and America." He stood as an inspiration to other unknown young men struggling to write poetry, including Takuboku Ishikawa, then a student but later the leading poet of his generation, who wrote asking Yonejirō whether recognition abroad was the key to his future and begging his help in getting to America.

When war broke out between Japan and Russia in 1904, Yonejirō later claimed, he resolved to return to his homeland as it faced its "gravest crisis." To be sure, he also claimed that America, where he had lived for eleven years, was his "second homeland" but he never seems to have thought about making it his permanent home. His "success story" in America was a prelude to his return to his first homeland, and even though he told Stoddard over and over again how much he worshipped Ethel, not once did he express a wish to remain in America for her sake. His dream was to share his life with Ethel in Japan. He wanted to marry her before he left America.

Ethel was understandably reluctant to accept his proposal. Marriage meant following him to his native land, whose language and customs she did not understand. But suddenly, four days before Yonejirō was to leave New York, she finally said yes. On August 3, 1904, he boarded a train for Alabama. Putting his liaison with Leonie out of sight and out of mind, as though mesmerized, he could think only of his romantic dream of a future with Ethel. During his four-day stay in Birmingham, he affirmed his love for her. At the end of August, after a reunion with Joaquin Miller at his beloved Hights, he boarded the *Manchuria* in San Francisco for the final leg of his journey home. His sojourn in America, his "second homeland," was at an end.

Two months later, on November 17, 1904, Leonie gave birth to a baby boy in Los Angeles.

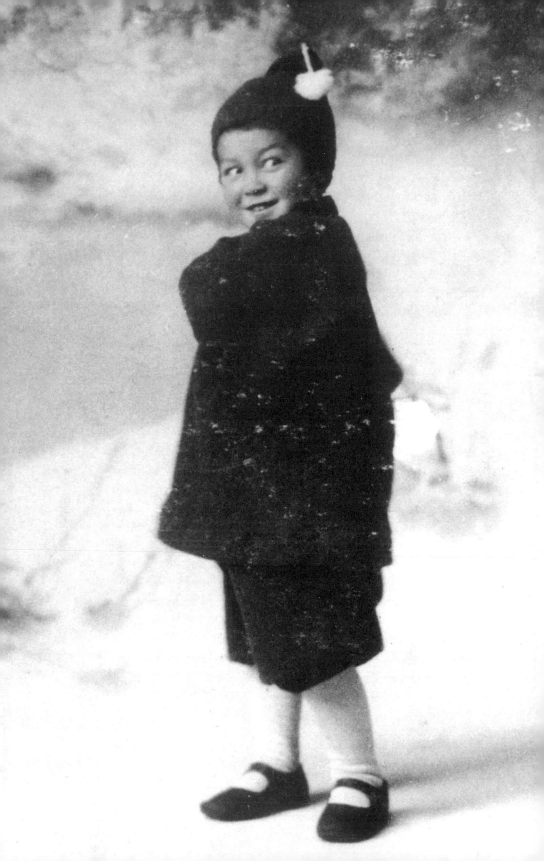

His Mother's Child

Destiny's Child

In 1904 Los Angeles was still a provincial city, not yet touched by the great migration that would transform it into a world metropolis. Its population was a little over 100,000. Projects to bring water to the city from the Sierra Nevada watershed were still on the drawing board, and work on them would not begin for another several years. But as the last stop on the American frontier, the city had already become a magnet for the hopeless and the hopeful seeking better lives.

Settlers who arrived from the Northeast and the Midwest at the turn of the century brought with them the conventional morality of the white Protestant majority, including puritanical ideas about sex and marriage. Most states had laws that criminalized extramarital sex by forbidding adultery, and in some it was illegal for a married person to take someone of the opposite sex across the state line. In 1900 when Theodore Dreiser wrote *Sister Carrie*, a novel about an inexperienced young Wisconsin girl who learned how to exploit her sexuality after being seduced by a traveling salesman, his publisher's wife was so shocked at the author's moral outlook that she urged her husband to withdraw the contract.

At the turn of the century Nathaniel Hawthorne's *The Scarlet Letter* had become an American classic. As punishment for her adultery with the minister Arthur Dimmesdale, Hester Prynne, the novel's heroine, was condemned to atone by pinning a scarlet letter, "A" for adultery, to the breast of her gown. Although Leonie's sin was fornication, not adultery, giving birth to an illegitimate child meant that she, too, wore an invisible scarlet letter—and her child, born out of wedlock, bore a badge of shame that fame could

not erase. Jack London, a frequent visitor to The Hights, was proof of that. Despite his eminence as a writer he was never able to live down the stigma of having been born a bastard and raised in poverty by an unmarried mother.

Leonie knew that the child in her womb might never know his father, and that her life as a single mother would not be easy, but she put the best face on her plight in a poignant letter to Catherine shortly before her son was born. "It may be that I shall never see him [Yonejirō] again. I have a fancy as if he were a bird that flew through my room and is vanished. And I console myself—or try to—saying that I am more fortunate than other women who must see their lovers grow old, indifferent, and perhaps even commonplace, whereas mine will be ever young, and ever a poet."[1]

Perhaps Leonie took heart from the example of her mother, Albiana, who raised her two daughters without a father. If her mother could do it, she was confident that she could, too. Albiana, now in her sixties, had moved to Los Angeles to find a place for Leonie to live. In New York family members and long-time friends might ask embarrassing questions but in Los Angeles she and Leonie were strangers. They would not have to explain why Leonie was not properly married or why the baby's father was absent. Perhaps Albiana, and Leonie, too, thought it would be easier to raise a half-American, half-Japanese child in California, where many Japanese immigrants had settled.

Yonejirō's child entered the world on Thursday, November 17, 1904, at the Los Angeles County Hospital, a charity hospital for the poor, where Leonie registered herself as "Mrs. Yone Noguchi." The name caught the eye of a *Los Angeles Herald* reporter, who wrote a story under the headline: "YONE NOGUCHI'S BABE PRIDE OF HOSPITAL: WHITE WIFE OF AUTHOR PRESENTS HUSBAND WITH SON." The story went on, "That the wife of the man who had achieved so much success in the literary world should be lying sick in the hospital, surrounded only by strangers, seems strangely sad, but Noguchi, the father, is far away in Japan and knows nothing of the little son who bears his name, and the American mother in the day of her trial and triumph waits patiently for a time when things will be better for them. The dark little bundle at her side . . . smiles his happy little smile, all unconscious of the conditions under which he was ushered into the world eight days ago."[2]

There was more to the story than the birth of a well-known writer's son. The reporter raised the unsettling specter of racial mixing. "The young man gives promise of being in every way a fine specimen of the kind that is

holding the attention of the whole civilized world. In spite of the fact that the baby was born under the flag of Uncle Sam and that his mother is an American woman, of the blue-eyed type, he has not a single trace of anything but Japanese and the hair and eyes are as black as his father's ever were."

From the moment of his birth Leonie's child faced not only the moral scrutiny of society but also its deeply embedded racial prejudice. An 1872 California state law had declared marriages between "white persons" and "negroes" or "mulattoes" illegal and void but as more and more Japanese immigrants arrived on the West Coast, the legislature amended it in 1905 to prohibit marriage between whites and "Mongolians," as well. Had Leonie come to Los Angeles just a few months later, she would not have been able to present herself as "Mrs. Yone Noguchi."

On the first page of a photo album Leonie left to her son, a small faded photograph shows him at six weeks lying on his stomach. Already he was able to lift his tiny head. The blanket wrapped around him was probably a gift from Catherine Bunnell. Leonie told her friend that she could be the baby's godmother but that he would have to have a Japanese name. The nurses at the Los Angeles County Hospital called him "Bobbie," and Leonie simply called him "Baby" in her letters. She was still waiting for his father to name him.

"Baby has tried on his shoes and he thinks that they will fit nicely about the time he gets ready to wear shoes. . . . Wish I had a decent picture to send. The newspaper picture is rank injustice. He's a sweet pretty boy. Don't know just who he looks like. At first he had a decided resemblance to his daddy, but it's wearing off." As the bluish Mongolian spot at the base of the baby's spine—common to most babies of Asian, African, or Native American descent—disappeared, so did the "Oriental" look of his face. The special smile that later charmed so many women also made an early appearance. "He has a funny little Irish-Japanese smile that would do your heart good to see. First he stretches his mouth as wide as he can, turns up one corner of it, then shuts one eye and gazes at you with the other. It would do credit to an Irish comedian."[3]

Leonie and her mother at first lived in downtown Los Angeles near the site of the present City Hall. Roses and "green kitchen stuff" grew in their garden, and the surrounding cottages were "set against the faraway hills like a picture hung on the wall before you."[4] After Leonie left the hospital, they moved to Pasadena, a town of ten thousand residents nestled at

the foot of the San Gabriel Mountains. Its dry, clear air and year-round balmy weather attracted many retired Easterners. It was also host to a bohemian artistic community, the Arroyo Seco culture, whose members celebrated the beauty of Native American and Mexican folk craft.

The little family settled in a tent village on the hilly outskirts of town where sheep grazed. Most of their neighbors were immigrants who had bought land cheaply but did not have enough money to build proper dwellings. With money from her sister Florence's savings Leonie bought a lot on the hardscrabble soil, and it was on this rugged wasteland that "Baby" took his first tottering steps. A photograph at the age of one year shows him clad in an ankle-length dress playing in his bare feet by some tomato plants in a vegetable garden.

"He has a lively temperament," Leonie wrote Catherine. "When he gets mad he jumps up and down so hard I'm afraid he'll injure his feet. He loves his mama awful much—well, as much as the ripe figs which he dotes on."[5] In October 1905 Yonejirō promised to "send some good name soon," but he never kept his word.[6] Leonie decided to call her son "Yosemite," perhaps because Yonejirō had told her about his trip there. "Yo," the first syllable of both "Yone" and "Yosemite," became his nickname.

Leonie found work as a typist at the Los Angeles Chamber of Commerce after Yo was born. When the little family moved to Pasadena, despite her weakness with numbers, she took a job as stenographer and assistant bookkeeper at an iron foundry. Albiana looked after her grandson during the day as he played happily outdoors, and Florence, who quit her job at the Encyclopedia Britannica in New York to join her mother, sister, and nephew, put up a small hut next to the one-room shanty house Leonie had built for her mother.

Isamu Noguchi took his first steps in life with neither the help nor the blessing of his father. Like Jack London, he always felt that that his birth had been "unfortunate." Toward the end of his life, he said, "I suspect that I was an accident, unexpected and inconvenient." But that was a retrospective view. His days as a toddler in Pasadena were untroubled. He was a happy child, surrounded by the natural beauty of the Pasadena hills, and doted upon by his "blue-eyed" mother and a grandmother who looked "like an Indian." His little family may have defied society's conventions but it enfolded him with love.

A warm welcome awaited Yonejirō on his return to Japan. The author Rohan Kōda, a leading light in the Japanese literary world, published a long poem in the *Yomiuri shinbun* congratulating him on the success of the Japanese edition of *From the Eastern Sea*. In February 1905 Yonejirō wrote Stoddard that he was enjoying himself at welcoming banquets nearly every evening. During his first four months home he had written about his experience in America for several publications. His essays, collected into a single volume, *Ei-Bei no jūsannen* (*Thirteen Years in England and America*), introduced Japanese readers to the Western literary world and regaled them with stories about his friendship with famous American and English authors. Indeed, for the rest of his life, Yonejirō made a career—and to some extent, a living—writing about his youthful experiences abroad.

His reception as a poet in Japan, however, was very different from his reception abroad as "Yone Noguchi," the Japanese poet writing in English. Returning home is never easy for a Japanese who has been overseas. He faces a kind of cultural hazing. Sakutarō Hagiwara, a leading poet, voiced a general assessment of Yonejirō. "His artistry is always new for us," he wrote, "always like a fresh ocean breeze blowing in from the Pacific." But, he continued, "To Japanese eyes, his poetic sentiment is typically 'un-Japanese.' The first thing we feel when reading his poems is that his handling of the subject, his expression of ideas, his use of poetic language, and more than anything else, his fundamental feelings are so unlike those of a Japanese that one seems to be reading a Westerner's poems translated directly into our language." Hagiwara added that Yonejirō even looked different. "With blue eyes and features like those of a foreigner it is hard to think of him as being a Japanese at all."[7]

Yonejirō himself expressed similar self-doubt in a Japanese poem entitled *Nijūkokusekisha* ("Dual Citizen"):[8]

When Japanese read my Japanese poetry they say,
"His Japanese poems are not so good but perhaps his English poems
 are better."
When Westerners read my English poetry, they say,
"I can't bear to read his English poems, but his Japanese poems must
 be superb."
To tell the truth,
I have no confidence in either language.
In other words, I guess I am a dual citizen.

The poem openly—and quite uncharacteristically—confessed Yonejirō's difficulty in writing poems in his native tongue.

Brought up speaking a local dialect as a child Yonejirō had not mastered the standard colloquial Japanese that developed during the late Meiji period. His efforts at writing English poetry had further distanced him from his native tongue. Despite his success in England and America he found that he could not express himself freely in Japanese. Indeed he did not publish a single poem in Japanese for seventeen years after his return from the United States. He remained an isolated outsider in the Japanese literary world, who gained acceptance only if he remained "Yone Noguchi."

To continue writing in English Yonejirō needed a collaborator. He wanted to bring Ethel to Japan as soon as he could. In late January 1905 he wrote Stoddard that he expected her arrival in a few months. "Ethel is coming to Japan, and so give some encouragement, will you? She is a girl who wants to be told of much hopes and love. I love her—you know. I like to make her happy and beautiful. I promised myself I will do everything for her own sake." She was scheduled to leave from San Francisco in March. "I will make our home here in Tokyo. . . . We—I and Ethel—will work together and hard as possible, and build an ideal home, and then you will come. What a dream! Yes, you must come here and cheer us up once in a while."[9]

But Yonejirō's dream was shattered when Ethel suddenly broke off their engagement three months later. She had discovered his relationship with Leonie. "Did Ethel write you about the Los Angel's [sic] woman?" Yonejirō wrote Stoddard in April. "It is not black with me as you may fancy. Don't trouble yourself with that matter, pray. I will settle it myself. And in fact it was all settled—a long time ago."[10] Ethel had learned about Leonie from a woman reporter for the Los Angeles Herald. She asked her to get the truth about Yonejirō directly from Leonie. "I haven't been able—literally to write a sane line since it all happened," she confided to Stoddard. "Her name is Leonie Gilmour or Gilman and I believe she goes as Mrs. Noguchi. . . . She says—you know—that Yone lived with her the year—all that year he was writing to me & we were engaged—she says he was married to her all that time. I heard from him a few weeks ago & he says he lived with her one week only & that she lies. I do not think she lies."[11]

All the evidence suggests that Ethel was right: Yonejirō had indeed lied to her. From September 1903 until August 1904, there is no extant correspondence between Yonejirō and Leonie. The only document he wrote to

her during that period was his declaration that Leonie was "his lawfully wedded wife." Since Leonie continued to edit his work, it would have been natural for them to write to one another. Neither had a telephone. But in September 1903 their correspondence stopped for a year. It seems unlikely that Leonie, who treasured Yonejirō's letters, would have destroyed a whole year's worth. The obvious conclusion is that that no letters exist because the two were so close together that they could talk to one another directly. The absence of correspondence supports Leonie's claim that Yonejirō lived with her for a year.

To judge from Yonejirō's addresses they lived together for about seven months. From the time he returned from London until April 1904, his address in New York City was 315 East 26th Street, not far from Bellevue Hospital. Leonie probably began to live at his lodgings when he wrote his "declaration" in November 1903, and when she could no longer conceal her swelling pregnancy, she left to join her mother in California. Yonejirō then moved, too. From April until August 1904 he lived at 121 West 64th Street.

What all this suggests is that Yonejirō deceived Leonie as well as Ethel. At a time when conventional middle-class women were expected to remain "pure" before marriage, he wrote his "declaration" to persuade her to have a sexual relationship with him. Leonie, believing that they would marry in the near future, had committed herself to him, and to cut living expenses, the two set up housekeeping together. Leonie probably thought this a temporary arrangement until they got married but for Yonejirō it was an easy way to satisfy his sexual desires and get on with his work. He must have been shaken when he learned that Leonie was pregnant. His decision to return to Japan had nothing to do with his country's "great crisis." The "great crisis" he faced was Leonie's pregnancy. Feeling himself cornered, he resolved the crisis by abandoning her. He had no intention of taking responsibility for the life growing inside Leonie's body or assuming the burdens of fatherhood. When he returned to Japan he intended to marry Ethel, not the mother of his child.

Ethel could not forgive Yonejirō for the way he had treated her and Leonie. "You can give me your impressions at least . . . ," she wrote Stoddard sadly. "But it makes no difference—there is the child—his treatment of that woman—& plain written that he never loved me yet & I do not think ever could love me—It is strange—I used to dream he really cared

for me & that was when I loved him so—because I thought he cared so much—but—you see—he never loved me once & never cared at all. I am not unhappy at all—Do not think I am feeling more than I do. I feel nothing whatsoever."[12] Even Stoddard, who had forgiven "Dear Yone's" selfishness before, began to see his protégé in a new light.

Although Yonejirō wrote poems in a sweet lyrical vein he often revealed his true feelings with jolting frankness. In a Japanese poem entitled *Aikyōshin* ("Love for My Native Place") written years later, he confessed how he felt about women in his youth.[13]

> Thinking back about love, it's shameful to say,
> I think I could feel nothing but the pleasures of the flesh.
> I too am nothing more than a materialist descendant of Izanagi and
> Izanami.

(In ancient Japanese myth, the female Izanagi and the male Izanami were primordial gods whose couplings spawned the Japanese archipelago and all the natural deities who inhabited them.) *Onna* ("Woman"), a poem written as a dialogue with a friend, begins with the line, "A woman is not good for much besides sex."

It is difficult to say just when Yonejirō learned about the birth of his son. The first of his letters to mention "Baby" was written in April 1905, five months after the child was born, but it had more to do with business than with his son. He was sending Leonie twenty-five copies of *The Summer Cloud*, a collection of English poems that she had polished and revised while he was still in America. "I will send you one more article," he wrote. "And take some money out, and send me the rest. I am not living extravagantly, but always money is short."[14] After Yonejirō returned to Japan he asked his American editors to send to his writer's fees to his "American agent" Ethel Armes but when she broke their engagement he persuaded Leonie to take on the job again.

In January 1906, a few months after "Baby's" first birthday, Yonejirō sent Leonie a letter about a "very important" matter: "Some time ago I suggested you of your coming to Japan," he wrote. "And again I am thinking of it. And I believe it would be better for you and our baby of course. Why? Because I can help in bringing up the baby, and he can escape from being a fatherless child. . . . I wish he will grow brightly and happily. I was wrong in past, and I repent greatly, and I wish to do for him." Leonie would also find

it easier to support herself in Japan than in California, he said. "You must be a school teacher and work at a company. School business is not hard here, and we respect a foreigner."[15]

Yonejirō had taken a position as an instructor in the Faculty of Literature at Keiō Academy, the college he had dropped out of as an adolescent. The job assured him a stable income. He was living with two servants in a middle-class Tokyo neighborhood inhabited by academics and intellectuals. Just a few months earlier, in October 1905, he even felt flush enough to invite Stoddard to Japan. "If you have enough money for the ticket, that will be sufficient," he wrote. "No money is necessary after your arrival in Japan. I make money enough for myself, and beside for somebody else. . . . If you have enough health and courage to cross the ocean, come."[16]

To Leonie, however, Yonejirō only complained about his financial difficulties. His academic post gave him social status, he told her, but his salary provided only enough to support himself. If she came to Japan, she would have to work four or five hours a day. The most important thing, he insisted, was "Baby's" future. "If you think you can bring up the baby safely in America, and educate duely [sic], and want to keep him yourself, I have nothing to say. You do what you please. But I wish I like to do something for him as his father." He urged her to come in the fall when the child would begin to talk. He also made the alternative clear: if she did not come he would no longer be able to send her any money. He did not want to write books and magazine articles to make ends meet. He wanted "to return to a poet, and to live in poetry."[17]

When his attempts at writing Japanese poetry failed, Yonejirō realized that he had no choice but to continue writing in English, and for that he needed Leonie's help. He soon wrote again. "I suggested that you must work for a few hours every day if you come . . . because I can only make money enough to keep me decently. . . . So I say you must try to make some money yourself to make our household go. Of course, till the time when everything will be on the right road. . . . So we will work together, and bring up our baby handsomely. . . . Come to Japan, will you? I will be true to you, and be a good father to our baby. I promise that, Leonie. If you come, when can you start—write me immediately."[18] His tone was impatient, as though he could not wait another day.

"I have read your letter—yes, several times," Leonie replied in late February.

Of course, you understand that I want to do the very best for Baby, and as for wanting to keep him all to myself, why that is nonsense. I am only too happy to share him with you. But whether it were wise to leave California at present and go over to Japan—that is a question—I am very doubtful about it.

Listen! America is a good country, California in particular. Baby is well. He is happy. Though we be poor, he does not suffer from it. Maybe our way of living is not quite civilized—we live in a tent, where the rain and the winds come in at will—Baby has no shoes on his feet. He runs as free as a squirrel on the hillside. Does it matter, our way of life? Roses are glowing on his cheeks. We built a little California house of one room beside the tent. There my Mother lives and I took Baby in on the day it was finished. He was like a caged bird lazily looking to door and windows for escape. He does not like house; nor shoes.

He is growing like a flower under the sky. Shall I take him out of this beautiful green country to put him in an ill-smelling city like Tokyo, where rains are incessant and winters are harsh? Wouldn't he turn into just a pale Japanese boy? . . . Education is free here. I do not think much of "school" myself: I could teach him everything he would learn in school. I dare say the schools are not much better in Japan than here. But there is an education outside of school; that I understand. As far as the aesthetic side of life is concerned, I suppose Japan may be far superior to here. For the moral training and character? I do not know. . . .

Many a time I have thought, "Some day I will go over to Japan when Baby is five or six years old." Then I will have a little money, and [be] better able to shape his life. I would like to put him in an Art school somewheres, where he will have eye and hand trained to express his ideas—No matter if he becomes an artist or not. . . . And still—all those things he could have here.[19]

Leonie's tone changed abruptly when she turned to her relationship with Yonejirō—and his future career:

And you Yone! You [want] to return to be[ing] a poet, and to live in poetry. Very well! . . . But how about your poetry? Where will you find it? In business? In the crowding cares and responsibilities! In the companionship of a wife you do not love? [Underscored in original] You shut love out of your life—human love, which is also divine. . . . Maybe you think you will make amends for the past. Past is past, you cannot amend it. Maybe you think we, Baby and I, need you. We do not. Therefore I think it better that we live apart. If I have a chance to work in Sothern [sic] Japan someday I will come. And you can see Baby all you like. And we will have a proper separation when you get ready—and you will remarry according to your better and ripened judgement. Baby and I will have each other to love. Yes, that's better.

Rebuffed by Leonie, Yonejirō in desperation turned for help to Frank Putnam, an editor at the *National Magazine* in Boston, who had become friends with Leonie through correspondence about his manuscripts. When Putnam wrote Leonie urging her to go to Japan for the sake of her child's future, she revealed to him an inner struggle that she concealed from Yonejirō. "If I believed what you say I would go right over to Japan and shake Yone good and <u>make</u> him love me," she wrote. "Honestly I do love Yone (I don't mind telling you now you have promised not to bother him any more). Simply I wish to do what is the very best thing and for once in my life I believe I have decided wisely. It is a relief to have a thing definitely decided anyway. Really I am not 'good enough' for him. Unnatural modesty? Do you say? I confess the remark springs from an ingrained pride."[20]

Leonie had fond memories of Yonejirō. "I do not remember Yone ever having been anything but charming to me, though I must have tried his patience by dissolving into tears every time he spoke to me for the last few weeks of our acquaintance—I couldn't help it and I suppose my condition had something to do with it. No, he is naturally gentle and forgiving, far more so than I, and I have no doubt he would try to be as nice as possible and to make the best of a bad bargain. But I would like to have something better in his life than that. And I am too proud. I daresay I am too much in love with him to undertake his 'reclamation.' You know it makes me feel such an idiot—and I never was clever about managing people."

Leonie had desperately wanted to marry Yonejirō for the sake of her unborn child, and when he had betrayed his declaration that she was his "lawful wife," she felt deliberately deceived. But even after he abandoned her, she loved him too much to make more demands on him. "I think you don't quite understand Yone—" she told Putnam, "he is not fickle nor weak—he is no woman's fool—never has been and never will be—His faults are not in that direction. (I believe he cares more for you than any of us.)" She did not blame Ethel for his behavior either. "I know she is a high-minded woman—She did exactly as I should have done in her place. . . . He was not true to her—it seems to me that is a thing a woman can forgive once. I know perfectly well what she could not forgive was his treatment of us. . . . You think he will eventually marry some Japanese woman—maybe that would be best—I should feel terribly for a little while, I suppose, but I guess baby can comfort me for anything." She signed her letter "Leonie G. Noguchi."

Despite his pleas that Leonie think about "our baby's" future, Yone-jirō had yet to choose a name for him. When he received Leonie's second rebuff, his reply was oddly tepid. "Of course, I cannot say 'No' to you, if that was your decision," he wrote. "Is your decision firm like a rock? I know that you are wise always. And baby is too little, and I am afraid that he will soon turn to be a little Jap boy. I really think California is a better place to educate one and raise uprightly."[21] It was as though all the arguments he made to persuade her to come to Japan had suddenly lost any meaning.

In April 1906 Yonejirō wrote to ask whether Leonie and the baby were safe and sound after the San Francisco earthquake, but he said nothing more about her coming to Japan. Quite the contrary, a few weeks later he wrote: "And about your coming over to Japan? And this matter is sure— if you can build yourself up nicely, and be happy in California, it would be useless and unwise to come over to Japan. . . . I can not ask you to come to Japan, when you are doubtful, and I am not offering you many opportunities and happiness. Wait! Only wait, when we are not sure to do things right. 'Wait,' as [Joaquin] Miller used to say. We may soon come to a better wisdom. Meanwhile, we love Baby, and try to do our best."[22] He also promised to send several essays to her for publication in the *National Magazine* and other magazines. "You will place them as I tell you, and get some money. The arrangement between you and me would be the same as before. I must tell you how I stand in Japan. I am much honored—a great deal more than I deserve. But when I come to money matter, I am still far from satisfaction."[23]

As the months passed Yonejirō's letters to Leonie showed less and less concern about her circumstances, more and more about their mutual "business." As he wrote in late June, "Leonie, did you send me some money? I expect to be pretty hard-up in this Summer vacation, since I do not get a cent from my school. I hope you will send me, if you have something to send me."[24] Leonie moved from one clerical job to another to support her little family. Working from early morning until late in the evening, she often saw Yo's face only when he was sleeping. Even so her salary was too small to support her family. To earn extra money, she sat by the roadside selling flowers and vegetables grown in their garden, and in the evenings she reworked the manuscripts that Yonejirō sent her. Often she typed until dawn. Frank Putnam ran nearly all the articles she sent him. The writer's fees helped Yo as well as Yonejirō.

By summer's end Yo had twelve "toofins." He looked quite cute to his mother. "Imagine a yellow peachy little face, with cheeks of brightest roses, crowned with curly yellow hair, and lovely limpid brown eyes."[25] In November 1906, after his second birthday, she wrote Catherine that he was "a wonderful conversationalist, singer, actor, story-teller, climber, dancer, jumper and general stirrer-up of things."[26] She delighted in reporting that her chattering Yo had a wonderfully rich imagination and that he liked to tell fortunes with tea leaves and blow kisses at the moon.

In early December 1906 Charles Stoddard received a neatly typed letter—signed "Leonie Gilmour Noguchi"—with some surprising news. "I suppose you may have heard from Yone San that we are going over to Japan pretty soon—that is, if poor Yone can ever scrape up half the price of a ticket via the way of the steerage people." Less than a year had passed since she had refused Yonejirō's invitation to go to Japan. Now, unexpectedly, she changed her mind about the one decision in her life that she thought she had made wisely. "I am going to make a little Japanese boy out of my son," she told Stoddard.[27]

Signs of growing hostility toward the Japanese in California had changed her mind. During the Russo-Japanese War, American public opinion—and Wall Street dollars—had supported the plucky little "Japs" against the Russians, but when the "Japs" began to expand their influence in China after the war was over, many American politicians and journalists, especially on the West Coast, had second thoughts. The Japanese victory fanned fears of a menacing "Yellow Peril" across the Pacific, and as more and more low-paid Japanese field workers left Hawaii for the West Coast, another kind of "Yellow Peril" loomed at home; the 1905 prohibition of marriage between whites and "Mongolians" was a straw in the wind.

After the 1906 earthquake anti-Japanese sentiment gathered momentum. San Francisco labor unions controlled by white workers, many immigrants themselves, called for an end to the influx of "cheap Oriental labor." Just a month before little Yo turned two, the San Francisco school board passed a regulation barring Japanese immigrant children from regular schools and ordering them to attend segregated schools for Chinese youngsters instead. The school board's decision quickly burgeoned into a diplomatic crisis. The Japanese government reacted by rejecting a plan for Japanese-American cooperation in building a railway system in Manchuria, and diplomatic relations between the two countries experienced a chill.

The press was filled with alarmist stories about war between the two countries, and reports of rising public hostility toward Japan and the Japanese hit the headlines. In San Francisco, Japanese immigrants who had married white spouses before the 1905 amendment of the marriage law were placed under investigation; in Mill Valley, a small town north of San Francisco, a Japanese youth was arrested for writing a love note to a white schoolmate; and in Pasadena, where Leonie and Yo were living, orange grove owners added the words "No Japanese" to signs that already read "No Chinese wanted."

All this worried Leonie. She did not want to raise Yo as a second-class citizen in his own country. "Merely bringing me up in America as another kid was not her idea of progress," Isamu recalled. She had romantic and ambitious dreams for her child's future, too. As she told Yonejirō, she hoped that Yo might study art or perhaps learn to be an actor in Japan. She felt him destined to become a bridge between Japan and America, following in the footsteps of his father, the Japanese poet who had made a name for himself in the United States. Above all, she wanted him to become an artist, to enter a world that transcended country, race, and nationality, a world where he could express his individuality.

Trusting in Yonejirō's sincerity, and hoping the best for her child, she decided to take her son back to Japan sooner than expected. "I am going to take Baby for a little trip across the Pacific Ocean about Feb. 1st," she wrote to Catherine in early 1907. "Yes, we are really going to Japan, which is a fact that I can hardly realize though the time is so near." But she could not hide her uneasiness at living with Yonejirō in a country whose language she could not speak. "The horizon is very hazy to my mind, though not without hope."[28] She expressed doubts to Frank Putnam, too: "Am I glad or sorry? Really, I don't know. Call no one happy until he is dead. I won't tell you until I get there. Yone's letters are ominous, to say the least. He warns me not to bring any 'dreams' with me."[29]

On March 9, 1907, Leonie and Yo departed from San Francisco on the *Mongolia*, a Pacific Mail Steamship Company vessel, headed for Yokohama. The ship carried 350 first-class passengers, 68 second-class passengers, and 1,400 third-class passengers. The third-class passengers occupied 438 tiny cabins on the lower decks equipped with two sets of double-bunks. Most of them were Chinese laborers returning to Hong Kong. Leonie and her child were in a cabin directly under the boiler room. Yo left

on the long journey to his father's homeland clutching "Dear Bear," a stuffed animal that Catherine had given him. On his arrival Yo became "Isamu," written with an ideograph meaning "brave" or "courageous." ("Mr. Courageous," as his father later put it into English.)

To His Father's Land

In his autobiographical writings Isamu, probably relying on his father's published chronology, noted that he arrived in Japan with his mother in 1906. At the end of his life, he was not really sure of the date. He might have arrived when he was two or three, he said, and he was not certain whether the year was 1906 or 1907.[30] In fact, the *Mongolia* pulled into its berth at Yokohama on March 26, 1907.

Yonejirō pushed his way through the crowd to board the *Mongolia*. Just as he reached the cabin where Leonie was waiting, he heard his son, still a stranger to him, crying inside. He felt himself on the edge of tears. "I was despising myself, thinking that I did not pay any attention to him at all for the last three years," he later wrote. "'Man is selfish,' I said in my heart, and again I had to despise me."[31] His son was slumped half-asleep in his baby carriage, dead tired. The seventeen-day voyage had been rough, Leonie explained, and the seasick child had hardly eaten at all. "See Papa," she said, trying to make him look at his father. Isamu turned his half-closed eyes away. It was as though he had been born "with no thought of a father," Yonejirō ruefully recalled.

The trip to "Papa's" house was upsetting. Isamu did not want to part from his baby carriage, his safe haven on the long trip from California. He had slept in it on the ship. When the conductor on the train to Tokyo insisted it be put in the luggage compartment, Isamu began to bawl. From Shinbashi station, his parents pushed him up the Ginza, where the reunited family had their first dinner together. The folded baby carriage, wrapped in a large cloth (*furoshiki*), made it as far as Iidabashi by tram but when they changed cars the driver refused to let it on board. Baggage in hand, Leonie and Yonejirō pushed Isamu under a dark starless sky, the cold night air clinging to their skin.

The spectacle of a strange-looking foreign woman in a long skirt pushing a baby carriage along the street attracted a curious crowd. Isamu, half asleep, burst into tears every time he heard the sound of *geta* (wood

clogs) clopping on the pavement. By the time they reached Yonejirō's house in Hisakata-chō it was already past eight in the evening. Even when Yonejirō presented Isamu with a stuffed puppy, his son did not stop crying, and when one of the servant girls tried to treat him with a piece of rice cake he began sobbing again. At the beginning of the day Yonejirō was on the verge of tears at the sight of his child; by its end, he was running out of patience.

Within a few days Isamu's crying stopped. He ate everything, including the unseasoned white rice that foreigners usually found too bland, but he still missed his life in Pasadena. "Where's Nanna?" he asked—his nickname for his grandmother Albiana. When Leonie told him she was "far, far" away, he turned pale and silent. Every now and then, to his mother's distress, he told her, "I want to go to Nanna's place." When Leonie encouraged him to "go see Papa," he refused with a firm "No."

Isamu became accustomed to life in his father's country much more easily than his mother. He amused himself by opening and closing the sliding *shōji* screens, and as the sun dropped low in the sky at the end of the day he delighted in making shadows on the paper. When his uncle Tōtarō Takagi, Yonejirō's second eldest brother, who had been adopted into a well-to-do Tokyo merchant family, brought him two paper flags, one Japanese and one American, Isamu learned to say his first Japanese word: "Banzai." Leonie asked him, "Are you a Japanese baby?" he immediately answered "Yes." When she asked him, "Are you an American baby?" he said "Yes" again.

Isamu enjoyed being carried about on one of the maidservant's backs. Whenever an itinerant candy peddler came by beating a drum she took Isamu out to watch him spin treacle into wonderful shapes—dogs, foxes, goblins. If he wanted the maid to carry him, he shouted, "Donko don, donko don!"—the sound of the peddler's drum. "[M]y clearest recollection is of riding on somebody's back and being fondled and enjoying myself," he later recalled. "There was a bamboo fence, I remember, and I would peer across it. . . . This was my one clear recollection of, you might say, happiness—of having finally found a situation of security."[32]

In a photograph taken at a nearby photography studio, curly locks tumble down to Isamu's shoulders, and his forelock is tied with a little ribbon. A dark dress with puffy sleeves peeks out under his white lace-edged smock. He may not have looked like a boy but to Japanese eyes it was clear at a glance that he was a "foreign child."

Isamu after his arrival in Tokyo, 1907

Yonejirō's house stood on the corner surrounded by a fence. Instead of a conventional wooden name plate at the gate written in Japanese characters Yonejirō had brushed "Yone Noguchi" on the globe of a gaslight lamp in *katakana*, the syllabary script used to transliterate foreign words. The name hinted at the exotic. Neighbors could hardly contain their curiosity about the "returnee from abroad" and his "Merikan-san" wife and child. Every day children shouted "Baby-san" over the fence as they passed by, and Isamu rarely missed a chance to run out and show himself. The neighborhood children, and adults, too, addressed Leonie as "Mama-san." Mother and child became famous local attractions. Rickshaw men from miles around could tell their customers where "Baby-san" and "Mama-san" lived.

What Isamu liked most about the Hisakata-chō house was the moonlight streaming through the translucent *shōji* screens at night. He could not fall asleep until he saw the moon rise in the sky. On evenings when there was no moon or the moonrise was late, Yonejirō brought a lamp from his

study to shine light on the *shōji*. Only when Isamu saw the lamp, made of white paper pasted on a bamboo frame, did he finally doze off peacefully.

Although Yonejirō had few interests outside his work, he often entertained literary colleagues living nearby. Some were surprised to discover that he had a mixed-blood child but they were cordial toward "Mrs. Noguchi." Indeed, some thought she was the woman Yonejirō referred to in *My Love*, a poem he had written immediately after his return from America. But beneath the placid surface of their daily lives, the relationship between Leonie and Yonejirō remained tense.

"Yone & I don't fight," Leonie wrote Frank Putnam in May 1907, "but as far as happiness with a capital H, why I fear we are both too selfish as you say. Yone changed so much I would hardly have known him, especially the shape of his nose and the acquisition of his mustache. . . . It's rather lonesome here because everybody speaks a strange language which I fear I shall never learn. [The city streets] are dirt road and all tangled up and I don't know which way is which."[33]

To make matters worse, less than two months after Leonie's arrival Yonejirō shut himself away in a Buddhist temple at Kamakura, about an hour by train south of Tokyo. The Engakuji Temple, founded in the thirteenth century, was the head temple of the Rinzai Zen sect. The chief abbot, Shakusōen, a priest with a cosmopolitan reputation who had been one of the representatives of Japanese Buddhism at the World Parliament of Religions at Chicago in 1893, arranged for Yonejirō to live in the Zōrokuan, a subtemple, where Japan's most famous novelist, Natsume Sōseki, had come to write after his return from a long sojourn in London.

"I hear only the temple bells now and then; and the stupid but glorious voice of an owl in night," Yonejirō wrote his "Dear Dad." "My friend Zen sect priest read sutra every morning and evening; and with his voice I send up my mind to combine with the thought of Nirvana. Indeed, I am here as I was tired of the city . . . , and I am perfectly satisfied with everything here which is grey in tone, and silent in atmosphere. My mind will be higher and better, and above all, I can write better."[34]

"I quite agree with you that poets—at least some of them—were not made for domestic uses," Leonie wrote Stoddard before she left for Japan. "So I shall open the door of the cage as soon as I get over there."[35] Yonejirō seemed relieved by the separation. "Yesterday, my boy Isamu and Mrs.

Noguchi were here, making some noise" he wrote Stoddard "and last night, they returned home in Tokyo, leaving me in my beloved Silence without which I cannot exist."[36]

Yonejirō was escaping not only from his family but from his frustration as a poet. "I feel a thousand times better now than before," he wrote Stoddard. "For some times I was cursing Japan; as she did not give me time to enjoy, I hated Japan. But as I left Japan spiritually, I am happy." In 1906 Yonejirō had founded an international poetry society, the *Ayamekai* (The Iris Society), which brought together twelve Japanese poets with twelve Anglo-American poets and literary figures, including Stoddard, Joaquin Miller, William Butler Yeats, and Arthur Symons. He included himself among the English-language poets as "Yone Noguchi." His evident purpose was to promote his reputation in Japan. The society's main activity was publishing *The Iris*, a quarterly poetry journal that included works by both Japanese and Anglo-American poets. The journal collapsed after the second issue. Yonejirō was criticized for not offering younger Japanese poets the opportunity to publish in the magazine, and he had trouble with the publisher over the payment of manuscript fees. His disappointment at this failure became another reason to shut himself away in Kamakura.

Leonie's life in Tokyo was busy from the start. During her first summer, since Yonejirō received no salary, she began teaching English to some well-to-do students that he had recruited: an electrical engineering professor at Tokyo Imperial University; a banker about to leave for a posting abroad; the heir to the largest kimono store in Tokyo; and several others. Her favorite was Lt. Tomoharu Iwakura, grandson of one of the founding fathers of the "New Japan." He was "brave, chivalrous, yes, and also tall and good-looking from our Western point of view, gifted in every athletic sport, and a lover of poetry," she told Catherine.[37] The lieutenant was not the most industrious of students but his son was about Isamu's age. Whenever he came for a lesson, he brought a little present to delight Isamu—singing crickets in a small cage or a goldfish in a bucket.

Isamu was upset by the arrival of winter. Brought up under the bright California sky, it was hard to live in a house where thin sliding doors and a *hibachi* (charcoal brazier) were the only defense against the winter chill. Leonie was unhappy, too. "I felt generally miserable in my innards this winter—too cold," she wrote Frank Putnam. "I'm homesick for the country—Japanese country, American country, any country where there are fields and

blossoms and breeze and unscented by city odors. And a garden. I'm just crazy to dig. But we are shut up in Tokyo, and likely to remain so for the rest of our natural lives, unless we happily die off young. . . . And poor Baby. 'What are you doing, baby?' I called out, seeing him holding his wooden geta, with trowel in hand. 'Nothing, mama, nothing,' he answers. 'Nothing to dig.'"[38]

When their landlord sold the Hisakata-chō house the family rented a two-story house nearby in Nishigoken-chō. In April 1908 Leonie wrote Catherine that they had moved again, to a "tiny house on a hill top" in Myōgadani-machi, though she did not explain why. It did not disturb Leonie that Yonejirō, always "oblivious to the cares and worries of this sordid world," was absent most of the time. "He has engaged at a temple, where he can write in peace far away from madding crowd of baby and me. Incidentally this leaves me something like your earthly ideal. A little house, a maid servant and nobody's bother. Isamu is thrown in by good measure. I'm quite enjoying it to get some work done. It's typing Yone's new book, [with] chiefly teaching and housework etc. thrown in. It's awfully busy."[39]

Yonejirō contributed some of his salary to household expenses but Leonie was footing most of the bill. As an English-language tutor, she made about ¥85 a month, enough for an ordinary Japanese middle-class family to get by, but it was not easy to keep house, pay for a maid, buy expensive American foodstuffs, provide clothes and shoes for Isamu, and still send ¥20 a month to her mother in California. Leonie worked steadily, taking on more English pupils and teaching at a small private girls' academy in the neighborhood. Instead of juggling so many jobs, she desperately wanted to find a regular position at an established school.

Before Leonie left for Japan she had told Charles Stoddard, "I will find one friend in Japan when I go there, that is Miss Tsuda, who went to the same college with me, and in whose school I shall teach when I go over."[40] Umeko Tsuda was three years ahead of Leonie at Bryn Mawr, and for about a year they lived in the same dormitory. Tsuda, sent to study in the United States at the age of seven, did not return to Japan until she was eighteen. For a time she taught at Peeress' School, an institution for daughters of aristocratic families, but with the encouragement of an American friend, Alice Bacon, she returned to America at the age of twenty-five to study biology and education at Bryn Mawr. In 1900 she founded Women's English Academy, which later became Tsuda College, one of the country's premier women's colleges.

Exhausted and ailing from overwork, Umeko Tsuda was traveling abroad when Leonie arrived in Japan. During her absence an old Bryn Mawr friend, Anna Hartshorn, also an acquaintance of Leonie, took charge of the school, whose main goal was to train English teachers. Since instructors for whom English was their native language were difficult to find or keep, a Bryn Mawr alumna with teaching experience like Leonie should have been a godsend for the school, but she was never offered a job. Miss Tsuda, always protective of the moral atmosphere of the school, told her students never to attract public attention. She wanted them untouched by scandal. Scandal, unfortunately, hovered over Leonie and her husband.

Although Yonejirō introduced Leonie socially as "Mrs. Noguchi" he did not enter her name in his household register, the normal procedure when a man got married. Several months after her arrival rumors about his personal conduct began to circulate. His name appeared on the gate of the house at Myōgadani-machi, but he maintained another household that Leonie learned about only in the spring of 1908. Pursuit of solitude was not the only thing that kept Yonejirō away from home, and the Engakuji Temple in Kamakura was not the only place he stayed. He was leading a double-life with his "other wife."

One of his Japanese poems, *Ningen no zenkatei* ("Becoming Fully Human") begins with an autobiographical revelation:[41]

I came home at the time of the Russo-Japanese War,
I was baptized with an ardent patriotism.
And then I played with love,
I became drunk with pleasures of the flesh,
I won and lost in the game of love,
And I got married.

Yonejirō's chronology notes that he married Matsuko Takeda in January 1906, a year before Leonie's arrival, and that Matsuko gave birth to his eldest daughter, Hifumi, in December 1907. (The birth was registered in January 1908.) In other words, if the chronology were correct, Matsuko was already pregnant by the time Leonie arrived. That is why Yonejirō acquiesced so quickly to Leonie's refusal to come to Japan in early 1906. He was already deeply involved with Matsuko but he had not yet formally registered her as wife. No doubt he later falsified his chronology to protect his eldest daughter by "legitimizing" the circumstances of her birth. He made

it appear that he had been married to Matsuko at least a year before his daughter's birth. That is also why he referred to Leonie as his "previous wife" in the chronology and placed her arrival with Isamu a year earlier than they had actually come.

No one is really certain how Yonejirō met Matsuko. According to his son-in-law, the art critic Usaburō Toyama, Matsuko had been a maid "who took care of Yonejirō's personal needs" at the house in Hisakata-chō. The children of Yonejirō's older brother Tōtarō Takagi heard a different story. Yonejirō lived for a time at their father's house in Nihonbashi, where Tōtarō introduced him to several artist friends. According to Nobue Saitō, Tōtarō's granddaughter, her parents told her that Matsuko was a model who posed in the nude for them. Yonejirō's son Tomiji denies both stories: "I never heard that my mother was a maid or a model."

Matsuko had just turned eighteen when her daughter was born. That means that Yonejirō began his relationship with her when she was seventeen. Tall and solidly built for a woman of her generation, Matsuko was neither charming nor particularly feminine. In a photograph taken when she was about twenty, her long face, narrow up-turned eyes, and down-turned mouth make her look much older. She bore Yonejirō nine children, and it was she, not her husband, the aspiring poet, who took care of the household.

It was not easy to support such a large family on a professor's salary. Tōtarō helped them out financially. At New Year's Matsuko always visited the Takagi family to pay her respects and offer her thanks but she was never open with the family. By contrast, the Takagis were fond of Leonie. Even though an American she seemed well bred. Since she was a college graduate herself, they thought her a more suitable wife for a university professor than Matsuko. Perhaps that is why Matsuko was so guarded in her relations with Tōtarō's family.

According to Tomiji, Matsuko first learned about Yonejirō's American wife and child the day before they arrived in Yokohama. She left the house in Hisakata-chō, taking one of the maids with her. Afterward Yonejirō spent most of the week in Kamakura, but when he came up to teach at Keiō he stayed at Matsuko's house in Yanaka Negishi, a residential district near Tokyo Imperial University. All the while he introduced Leonie to his friends as "Mrs. Noguchi," he was practicing de facto bigamy.

"[M]y father would sometimes come to visit," Isamu later recalled. "And I remember sort of bowing to him in imitation of the maids. . . . In

later years I found out that he had another household. In fact my younger sister Hifumi was two years younger than I, so that she must have already been born when we arrived in Japan. . . . I never [had] any sense of having a father around . . . as any fixture in my life. Although the earliest times in Japan must have been as close as I came to having that experience. And maybe there was a period when my mother and he were together."[42]

Yonejirō boasted about his son to his American friends. In July 1908 he wrote Stoddard, "Isamu—that's my boy's name—such a wonderful fellow; he speaks now perfect Japanese like any other Japanese boy, and handles English too. And he can make noise ten times louder than any Japanese boy; and he is such a handsome fellow, so many people flatter him."[43] But Yonejirō never entered Isamu in his household register. Even though he urged Leonie to bring their son to Japan so he would not be branded as a "fatherless child," he never took legal steps to recognize Isamu as his legal child or to establish his Japanese citizenship. To the end of his life, Isamu remained the illegitimate child of his American mother, Leonie Gilmour. When Matsuko bore a son, Haruo, in 1909, Yonejirō listed him, not Isamu, in the household register as his "eldest son."

"I have moved away from Myōgadani-machi to a little house at 71 Kobinatadai machi Sanchome," Leonie wrote Kazuo Koizumi in October 1908. "It is quite near the last car stop." She appended a little map with directions: "After getting off the streetcar at Edogawabashi, cross the river, then right, then climb a road up slope to the left, and just after the vegetable store near the top turn left on the next small alley and look for the house with the red gate." Leonie had tutored Kazuo for about a year. His father was Lafcadio Hearn, who had naturalized as a Japanese citizen and taken the Japanese name Yakumo Koizumi.

The child of a British army surgeon and a Greek mother, Lafcadio Hearn began his career as a journalist. He was attracted to the exotic, the macabre, and the romantic. After spending several years in New Orleans and Martinique, in 1889 he decided to visit Japan, where a friend had found him a position teaching English at a middle school in Matsue, an old castle town on the Japan Sea coast. There he met and married Setsu Koizumi, the daughter of a former samurai, who bore him three sons and a daughter. Enthralled by Japanese culture, Hearn became famous in Japan and abroad as the author of popular books—*Glimpses of an Unfamiliar Japan*, *Ghostly Japan*,

and *Kwaidan*—that introduced Japanese folklore, customs, and people to Western audiences. Eventually he was invited to become professor of English literature at Tokyo Imperial University, a position that he held until 1903.

Hearn, whose own childhood had been lonely and difficult, doted on his children. Worried about their future as mixed-blood children in Japan, he wanted them to be educated in America so that they could choose where to spend the rest of their lives. In 1904, just as he was arranging to take Kazuo to the United States, Hearn died suddenly. His widow, Setsu, following her husband's wishes, hired English tutors for her two older sons—fifteen-year-old Kazuo and eleven year old Iwao. One of them was Leonie.

"I remember also being taken to the house of Lafcadio Hearn," Isamu recalled. "I remember going in the 'genkan' [vestibule] there and meeting his children."[44] While Leonie tutored the two older boys Isamu played at the Koizumi house in Ōkubo with the two younger children, eight-year-old Kiyoshi and five-year-old Suzuko, in a spacious garden planted with cherry and zelkova trees and a bamboo grove in the back. Often when Kazuo was unable to answer a question, "Mrs. Noguchi" would summon Isamu, who reminded Kazuo of a kewpie doll, and have Kazuo repeat Isamu's answer over and over again. In Kazuo's photograph album is a picture of a brightly smiling four-year-old Isamu, wearing a fringed wool cap, a half coat and short pants obviously sewn by his mother, and calf-length white socks.

When Setsu learned about Yonejirō's "other wife," she no longer welcomed him as a guest, but she remained friendly toward Leonie, whom she knew was an indispensable collaborator for Yonejirō, just as she had been for her own husband. Since Hearn could not read Japanese, Setsu had read to him from old storybooks in the evening. One of his best-known works, *Kwaidan*, could not have been written without her help. Setsu felt sorry for Leonie, who worked so hard to support herself and her son in a foreign country with hardly any time to rest. She took her to see Kabuki and Noh plays, and in the summer she invited her and Isamu to Yaizu, a summer resort in Shizuoka, where Hearn had taught his children to swim.

About ten months after moving to Kobinatadai-machi, Leonie told Kazuo that they had moved to another house nearby. The haiku poet Shuchiku Suzuki, then a fourth-grader living next door, later remembered how quiet the house became after "Noguchi Leonie" moved in. The neighboring kitchens faced one another, and when the vegetable seller came by Suzuki often heard a woman's voice ordering in broken Japanese. Suzuki,

who liked the "bright look" of the new little neighbor boy, called out to "Isamu-san" whenever they met in front of the gate or on the street. "One day," he recalled, "Isamu-san covered the whole front gate of the house with gobs of mud. I didn't actually see him do that but I did see the gate was completely covered with mud when I passed by. His mother did not scold him at all. Without fussing she simply had the maid clean the gate off with water."[45]

Isamu attended a kindergarten that had recently opened in nearby Mejirodai-machi. He insisted on shaving his hair close as his fellow pupils did, and his head, Leonie wrote Catherine, was "like an egg." "I told him he should be careful about bumping his head now that he has no hair to protect it. So he promptly tried a bump then said, 'Why, it feels nice. It's much better this way.'"[46] At home Isamu played with toy locomotives, making tunnels with *zabuton* (floor cushions) and tables, and he delighted in watching caterpillars in the garden. Whenever he found a particularly interesting one he summoned his mother to look at it. His other constant companion was "Dear Bear."

Isamu pestered his mother to teach him how to read and write. "I shall put it off as long as possible," Leonie wrote Catherine. "He has the best eyes of any in his school and I don't want to spoil them. . . . Are you tired of all this chatter about a boy? In fact, he is everything to me. Now he gets on my lap, his favorite seat, . . . leaning his head on my shoulder. No, I'm not anxious to invade Yone's temple. Glad to have his cigarettes out of the way. Isamu and I can run the ranch. . . . No school tonight and as he thinks I belong to him."[47]

Even though Leonie no longer lived with Yonejirō, she continued to act her role as "Mrs. Noguchi." Her admiration for his work was the bond that kept them together. His poetry collection *The Pilgrimage*, a product of their collaboration, was published in London in 1909, and the Valley Press, organized by Leonie, brought it out in a private edition in Japan. The volume, often regarded as his representative work, was dedicated "To Leonie." It is the only one of his works that recognized her contribution.

In April 1910 "Noguchi Leonie" started work in Yokohama as an English-language teacher at the Kanagawa Prefecture Girls' Higher School. She replaced another foreign woman married to a Japanese. The job was only part-time but it afforded her more financial security. "I like to walk in our school garden at recess listening to the chorus of girlish voices, which are to me like the voices of birds chattering an unknown tongue," she wrote in a little essay for the school alumnae report. "I once read of a

man who, waking from sleep, suddenly found himself able to understand the language of birds. . . . Now I wonder if I were suddenly to awake and find myself able to understand the Japanese tongue, whether the girlish chattering around me would seem any more musical. I think not."[48]

In December 1910 Leonie and Isamu moved once again, to Iriai Sannō in Ōmori on the south side of Tokyo. The long commute to Yokohama from the northern part of the city by streetcar, then by train, had been quite tiring for Leonie so she looked for lodgings closer to her school. A well-to-do farm family rented her an inexpensive cottage, just the kind of place she had long hoped for, surrounded on all sides by greenery and fields. Best of all, close by was a new kindergarten for Isamu.

"Rich old gentleman (Mr. Morimura) . . . making an ideal school," she wrote Catherine. "Turned beautiful grounds over to the little ones and is getting the best teachers to be had for love or money. Goats, chickens, monkeys, peacocks, seesaws, swings, etc. Very small, very [?], a trifle expensive. We visited there one day, and it seems all right. Isamu says he likes [that] it is such a beautiful garden."[49] Ichizaemon Morimura, a wealthy Yokohama merchant and businessman, who had parlayed profits from his foreign trading business into the ownership of a bank and a glass manufacturing company, had turned his mansion and two-and-a-half-acre garden into a kindergarten and an elementary school. Unusual for its day, the school emphasized the importance of each student's individuality, and it even allowed pupils to wear whatever they wished in school.

The Morimura Kindergarten had opened just six months before Isamu entered as a member of its first class, along with five other boys and four girls. He was registered as "Noguchi Isamu" (written in Japanese characters). The class's graduation picture shows him standing at the left end of the rear row wearing a Little Lord Fauntleroy suit with a broad white collar, his head no longer "shaven like an egg." The other pupils grasp their diplomas carefully but Isamu appears to be blowing through his like a flute. He is the shortest of the boys.

Isamu remembered his experience at the Morimura Kindergarten with fondness. "I was finally among people who seemed to take me as one of them, or rather, as somebody of interest to them. . . . I remember the schoolyard; I remember the small zoo they had there. It was, as I understood it, a kind of experimental and new school; and a half-breed person such as myself was a welcome addition, I believe. That's why I was treated

Kindergarten graduation ceremony at Morimura Gakuen, 1911

in a way, not as a freak, you might say, but somebody like themselves, or rather you might say, somebody they'd like to know."[50] Life in Japan had made Isamu feel different from other children, not part of their world. His childhood years, he often said, were a "dark and uncertain time" but the days he spent at the Morimura Kindergarten, an oasis where he felt at peace, were among his happiest childhood memories.

"I remember that I did a sculpture of a 'wave,' which was in clay, which was then fired and had a glaze on it of blue and white." He had already surprised his teachers at his first kindergarten by drawing a picture they could not believe had been done by a child. "You had to look hard to see anything on the paper," Leonie told Catherine, "and then you perceived some faint blue lines representing the waves of the sea with a few pale yellow sails on it."[51] It was a recollection of his visit to the seashore the previous summer. He told his mother that he had decided to become an artist instead of a soldier. She recalled that when she had asked why, he had said, "Because all the soldiers got to die, and I don't want to die. Even a general had to die."

Although he later forgot his kindergarten drawing, the ceramic wave he had made at Morimura Kindergarten remained vivid in his memory. Even in

his old age, he recalled exactly how it looked. The piece seemed nothing out of the ordinary as he molded it from soft clay but when it emerged from the kiln it had been magically transformed into a wave splashing on a vast sea. It was his first work of art. "Quite nice, I thought. Anyway, it was shown around ... great pride by people. . . . Somehow or other I knew about waves. It was a kind of prophecy. . . . On a boat, coming here [to Japan], I saw waves."[52] Consciously or not he recognized the little ceramic wave was not only the starting point of his artistic career but also an intimation that it was his destiny to be tossed on the restless sea that separated Japan and America.

Dreams of a Homeland

Leonie did not return to the United States when she discovered Yonejirō was living with his other wife. Isamu later speculated that she did not have money enough for the return fare but it would have been easy enough to borrow from Uncle Tōtarō. Even when Leonie learned that her mother had died she did not return to America. She had come to Japan to make "a Japanese boy" out of her son, and she did not want to take him back to America while anti-Japanese sentiment was still strong.

"I'm now living in Chigasaki, a place so small [as] to be unnoticed in the railway timetable, but rather famous for the clean air and a fragrance of sea and pine tree which make it a resort for consumptives," she wrote Catherine in late 1911.[53] Less than a year after she had found an "ideal" living situation in Ōmori, Leonie pulled up stakes once more. It was the sixth time she had moved since coming to Japan. She had trouble finding anyone willing to rent her a place for very long. Her Ōmori landlord had apologized to the neighbors about renting his cottage to a "foreign woman," but said he thought it wasteful to leave it unoccupied. Something about Japanese society itself made Leonie so restless that she had to uproot herself and Isamu over and over again.

Leonie does not seem to have confronted Yonejirō about his other family. Leonie had not played the role of aggrieved woman when she had learned about Yonejirō's engagement to Ethel nor did she do so when she learned about Matsuko. It was a matter of pride—and determination—for her to live independent of any man. But even though she kept her feelings to herself, she could not have failed to realize that she and her son had been abandoned. Perhaps her constant moving also reflected a deep sense of hurt and uncertainty.

In Chigasaki she rented a room in a farmhouse along the old Tōkaidō highway, not far from the groves of pine trees made famous by Hiroshige's woodblock prints. But clear air and ocean breezes were not all that attracted her to this town of fishermen and farmers. It was also close to Kamakura, where Yonejirō had hidden himself away to write.

Isamu, who lived with his mother in Chigasaki for six years, later called it his hometown. "At first we lived in the house of a farmer whose wife raised silkworms on trays of mulberry leaves in the house. It was there that I attended two years of the local school. I had by then become a typical Japanese boy, knowledgeable in the ways of nature; such as how to skin the young willow twigs to make whistles, or where to find eels. There were all the festivals I delighted in, the Obon dancing in the streets, the kites in the wind, the many-colored mochi 'rice cakes' roasted on forked branches over autumn bonfires. There was a travelling Kabuki troupe. There were sunsets to which we sang, 'Yū yake ko yake.'"[54]

Whenever asked about his childhood Isamu always mentioned his idyllic years in Chigasaki. "Primarily what we carry around with us is a memory of our childhood, back when each day held the magic of discovering the world," he told the art critic Katherine Kuh. "I was very fortunate to have spent my early childhood in Japan. I don't mean to belittle other places, but one is much more aware of nature in Japan—not a vast panorama of nature but its details: an insect, a leaf, a flower. Nature is very close, a foot away."[55] By "Japan," of course, he meant Chigasaki. His happy childhood experience there had shaped his "individuality" as an artist, he told a Japanese interviewer: "I used to climb trees and go swimming with my playmates. I never thought of myself as mixed blood child. Foreigners were rare at the time, and I remember shouting 'Stinks of butter!' along with the fishermen's children whenever we saw one."[56]

Perhaps Isamu Noguchi idealized his years in Chigasaki to disguise painful memories. Shortly before his death he confessed that he suffered deep wounds while living there. "I remember incidents in Chigasaki . . . myself being treated in an odd way, to my discomfort. After all, I was something of a freak, without any doubt, and children don't hide their feelings. . . . It was in the summertime no doubt that . . . my memories are keenest. Various . . . incidents of childhood trauma, of running away, of feeling abandoned, and wanting to go away, and 'They'll feel sorry later on.'"[57] He must have realized that he, too, "stank of butter."

In September 1911 Isamu was registered at an elementary school on the north side of Chigasaki as "Noguchi Isamu." A class photograph taken when he entered second grade shows him standing amidst Japanese classmates dressed in homespun kimono. Many children came to school after rising at dawn to help their fathers take out the nets, and some worked as errand boys or nursemaids living with their employers and not their own families. It was not difficult to pick Isamu out of the group. He was wearing shirt and pants, and curly hair covered his ears. All the other boys had closely shaved heads.

Chigasaki lay in the midst of a countryside rich with the wonders of nature, but its narrow social world left deep psychological scars on Isamu. Surrounded by fishermen's and farmers' children with sunburned faces and rough ways, he was thrust into a milieu unimaginably harsher than Morimura Kindergarten, where every child's individuality was respected and nurtured. "Children are not able to hide things so well," he recalled at the end of his life. "I felt not being one of them. Whatever situation I was in, I felt not quite one of them."[58]

In this small rural community, it was easy for Isamu to understand what others really felt about him. Over and over again he was reminded that he was indeed a "freak." The other children called him *baka* (dummy) or *gaijin* (foreigner). Being an *ai no ko* (mixed-blood) made things even worse. His schoolmates let him know that he did not belong to their world, but he could not understand why. "[D]iscrimination is not something that you can perceive unless someone tells you. . . . Nobody tells his child that he is being discriminated against. He has no way of knowing. I never felt I was being discriminated against."[59]

As an adult Isamu recognized that Japan was a closed society where everyone was expected to conform. "The fact of the matter is that the Japanese do not accept foreigners as another person equal to themselves because Japanese are Japanese and everybody else is foreign," he told an American interviewer in 1973. "It's a very traditional country in a sense; and very unusually so."[60] He likened his position in Japan to that of an "irregular verb." To be "irregular" threatened those who lived in a society that demanded that everyone observe the rules. With an unmarried American mother, in every sense of the word, he was a misfit.

If Isamu had had a Japanese father to protect him from his classmates, his childhood might have been different, but in Chigasaki he was the "half-breed" son of a "red-haired foreign woman" who rented a room in

a farmhouse that reeked of silkworm cocoons. The local villagers, ignorant of Leonie's family circumstances, must have gossiped about her, and their children found her fatherless child easy to bully. On his way to and from school, the tormenting grew worse and worse. The children taunted him, pummeled him, and threw stones at him. No matter how hard he ran, he could never escape, and when he was caught his tormentors pushed him into a rice paddy or shoved his head into a stack of rice straw.

"I had nobody excepting [my mother]," he later recalled. She was . . . my total link to life. I'm not sure that was good for me, but that was the case."[61] According to Tomio Iwata, who as a teenager lived next door to Leonie's house in Ōmori, "Isamu was always too proud to admit defeat or give in, and he was greedy about food, so he was an easy target to teasing and torment." Tomio once hoisted him onto an exercise bar in his yard too high for his feet to touch the ground. "Isamu soon began to scream his lungs out. It was amusing. I just pretended I didn't hear or care. Then suddenly the gate swung open, and Mrs. Leonie came bounding into the yard as fast as a rabbit. Without a word she grabbed Isamu, hugged him to her body, and immediately fled back to her house."[62]

In Chigasaki it was not so easy for Leonie to protect her son. She commuted to her school in Yokohama by train every day. Isamu spent the end of the day alone waiting for her return. Only when he saw her making her way home from the railroad station did he feel safe and secure again. "I always worried that Mother would disappear," he recalled. "[I] always worried where my next meal was coming from."[63] But he never told his mother about his daily torment. It was a world of anguish he did not want to reveal to her. "I was surprised that Isamu never behaved like a spoiled child or acted petulantly toward his mother," Tomio Iwata said. "Rather he treated his mother like a teacher—with respect."[64]

"My mother always seemed to be calling to me," Isamu recalled. "Frail and small, with grey-blue eyes, she would come at evening to my infinite relief. How I lived in fear of losing her! My fondest recollection is of Mother reading to me. She read to me according to her taste. As a result I believed in Apollo and all the gods of Olympus before I knew of any other. . . . I became terribly confused later when I learned of God and Santa Claus."[65] The first poem he learned was "Ah, sunflower" by William Blake, his mother's favorite poet. When he started to read and write, she read to him her other favorites—Chaucer, Uncle Remus, and Lady Gregory. "I

loved listening to her more than anything," he remembered. The two of them eagerly awaited the package of books that Catherine sent every Christmas, and with his mother's help Isamu made his own "books," too. Intellectually he was far ahead of his schoolmates. When they tormented him during the day, he found solace in knowing that his mother would return to comfort him at night.

In early 1912 Isamu's "paradise with Mother" came to a sudden end. "[I]t was when I was eight," he recalled, "that my mother came back after some absence with a little sister. . . . [O]f course, then that threw my whole life . . . into another turbulence of doubt and dismay. [W]hereas I had been the total center of her attention, now it was distracted, and my whole world was not the same. My mother was away a great deal of the time so that the birth of my sister was a great surprise to me."[66]

Although her son did not realize his mother was pregnant, Leonie could not hide the fact from the adults around her. Her pregnancy may have been another reason she moved from Ōmori to Chigasaki. Even in a letter to Catherine less than two weeks before she gave birth, Leonie made no mention of her condition. She went into early labor on January 27, 1912, at the girls' school where she taught in Yokohama. Soon after the new baby came home Leonie moved to a small cottage on the grounds of a viscount's villa on the seaward side of town. The main house was used only during the summertime, and the cottage provided more privacy than the farmhouse.

In early July, when the new baby was six months old, Leonie shared news of her daughter's birth with Catherine for the first time. "Isamu is in the front garden watering the morning glories. Baby Ailes is rolling on the floor beside me. A maid is in the back yard hanging the baby's clothes. . . . Baby's name is 'Ailes Gilmour.' 'Ailes was a girl that stepped on two bare feet' in Moira O'Neill's poem. Believe it's a Celtic version of Alice. I call her Ailes but the neighbors call her as 'Mary-san.' . . . I'm rather overburdened. But I suppose it is her destiny to be born, poor thing. She is not [as] active as Isamu. Puts her energy into growing and talking. Talks incessantly, sounds loud like a grown up. Voice very high and girlish." She described her baby daughter as "an American type" with "long legs and very slim feet, . . . white skin and very short brown hair."[67]

Since Leonie still used the name "Noguchi Leonie" as a teacher many assumed that Yonejirō was the new baby's father. He had not married Matsuko in a formal wedding ceremony, and not all of his friends realized that

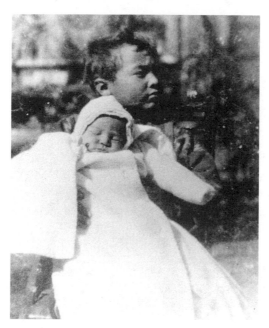

Isamu with baby Ailes at the Chigasaki house, 1912

Leonie had become his "previous wife." But the father was not Yonejirō. Indeed, Yonejirō used Ailes's birth as an excuse to distance himself even more from his American wife and child. He told his brother Tōtarō's family that Leonie-san had "betrayed" him. But Leonie never revealed who the father was. "My mother was a very, I would say, a reserved person," Isamu recalled, "She was sensitive and she was not out for display of any kind." She told no one, not even her own children, the name of her daughter's father. "I never asked my mother. She never told me. She's never told my sister, for that matter, that I know of."[68] It was a secret that she carried to the grave. Hifumi's children were told that Ailes's father was a "person of high social standing," and Isamu speculated that he was one of Leonie's English students.

In the spring of 1997, several years after Ailes's death, her son, Jody Spinden, discovered an old blue-lined notebook that his grandmother had used to teach penmanship. Inserted in its pages was a sheet of stationary folded in four and dated December 19, 1912, just a few weeks before Ailes's first birthday. "Dear Madame," it began. "I will be busy now because of school examinations. Suddenly last night I have dreamed about you and baby. I am anxious about baby as something happed [*sic*] in her fortune.

But I wonder [undecipherable] I have something that never go out of my mind [about you and baby?] in the morning and at night, especially every Sunday, and now. You understand [undecipherable]." The address in the upper right-hand corner appears to be a student boarding house near Tokyo Imperial University but the sender's signature at the bottom of the page was torn away. Perhaps Leonie did not want to compromise the future of this Japanese student, so deeply worried about her and her baby, because he was her young lover.

Even though Ailes was a healthy baby Leonie now devoted most of her attention to the infant. To Isamu it was as though his mother, whose affections he had monopolized, was suddenly snatched away from him. Competing for her affections made life all the more difficult. In March 1913 Leonie wrote Catherine, "Did I tell about the disastrous cherry tree lesson?" Isamu had told his friend Shō-chan, whose grandparents were caretakers at the viscount's villa, the story of George Washington and the cherry tree. Taking a step toward greatness Shō-chan chopped down a prized bamboo in the viscount's garden. His grandfather gave him a sound thrashing, and his grandmother scolded Isamu for having turned Shō-chan into the "worst kind of boy." "Isamu was so depressed," Leonie wrote, "he stayed at home the whole day, occasionally muttering 'Am I a bad boy?' and 'Am I a worst boy of the world?'"[69] Crushed at losing his first neighborhood playmate and at being branded as a "bad boy" by the neighbors, Isamu took his anger out on Ailes by hitting her when she rummaged through his beloved book collection. At the end of his life, he told his sister that many people did not have a very good opinion of him. "I don't think mother had a very good opinion of me, either," he added.[70]

When Isamu caught measles that spring, Yonejirō finally came from Kamakura to visit him. "I have very few recollections of him," Isamu recalled. "I was sick and he came to call on me. I felt very puzzled and very good about this."[71] It was one of his few memories of the father he rarely met during his childhood, and it was the only time Isamu saw Yonejirō during his years in Chigasaki. Leonie must have missed having a father in the house. Isamu, who was beginning to display his father's intense temperament, was becoming harder and harder for her to handle.

In September 1913 Leonie wrote Catherine, "Isamu is starting to attend English school at Yokohama St. Joseph's College upon his giving strenuous

demand of all the rights of an American, as he pronounces himself. . . . I dare say the change will be good for Isamu, quite expensive, though."[72] Leonie had wanted to educate her mixed-blood son as a "Japanese boy" but he rebelled. He refused to attend Japanese school any longer, and he insisted on his "rights as an American." Leonie still did not want to take him back to the United States, where the anti-Japanese mood was growing stronger. The California legislature, for example, had just passed a law to prevent Japanese immigrants from owning property.

When Isamu entered St. Joseph's Leonie took back her old name to "simplify family complications," and she registered him as "Isamu Gilmour." The Jesuit boys' school stood on "The Bluff," a foreigners' residential area overlooking the city. The faculty were all foreign Catholic priests, the curriculum provided a Catholic religious education, and the language of instruction was the King's English. Isamu rose every morning at 4:00 to catch the 5:52 train from Chigasaki station, and from Yokohama station he hiked two and a half miles uphill to the school. "The first times were very exciting," he recalled. "I remember very well the commuting to Yokohama: the railroad station, the run through . . . Chinatown, going to the Bluff where the school was and the experiences in school."[73] But the daily trip was long and tiring for an eight-year-old.

Isamu had hoped his life would be easier at an English-language school but once again he felt himself an outsider. His experience as "Isamu Gilmour" at St. Joseph's was not so different from his experience as "Noguchi Isamu" at his Japanese elementary school. Most of the students were English, though there was an admixture of Americans, Europeans, Indians, Filipinos and Hong Kong Chinese, as well, and even other mixed-blood children. In that sense Isamu was not as entirely exceptional as he had been in Chigasaki, but even so he felt a "certain sense of separation and unhappiness."[74]

"I don't recall any particular friends. I always felt a little bit outside the general community. It was a Catholic school; I was not a Catholic. . . . I wished I could be a Catholic; I didn't know how." He still had a chip on his shoulder. "I remember an occasion when we had gone off someplace to play outside and I felt myself being put upon. I . . . practiced a bit of what I had learned of jujitsu on one [of my playmates named Yang] and threw him over my head. I thought I had hurt him. I was terribly worried."[75]

Leonie loved Chigasaki with its "ideal climate and scenery and beautiful loneliness" but since no houses were for rent, she decided to build one

for herself. A new house was expensive, about ¥600–700, more than she could afford. Her annual income as a teacher was ¥840, just enough to meet basic expenses. "I don't know how she raised the money," recalled Isamu. "Maybe she had a boyfriend."[76] He probably meant Ailes's father. The answer was much simpler. "I feel as if I had suddenly come into a fortune when I read your magnificent offer," Leonie wrote Catherine in early November 1913.[77] Her friend offered to lend her $400. Leonie had already bought a plot of land with a loan from the bank where she deposited her salary. She used $200 of Catherine's money as an advance to the carpenter and put another $200 in the bank, promising to return it with interest a year later and to pay back the remainder over the next five years.

The tiny house lot, only one-tenth of an acre, faced Teppōdō (Musket Street), a narrow lane running parallel to the oceanfront. (The Tokugawa shogunate had established a gunnery training school in the vicinity before Commodore Perry's arrival.) The lot was located in the midst of several large villas but it sloped off so sharply in the rear that no one else was interested in buying it. "I engaged a carpenter to make a little house of three rooms downstairs and one upstairs," she wrote Catherine, "in a fashion which I commanded should be cheap but not look so."[78] He built a "three-cornered house" to fit the triangular lot.

On the side facing the street were a Western-style living room with board floors and a small Japanese-style room with a sliding glass door opening onto a narrow veranda. The entryway was to the rear on the side away from the street, where normally a Japanese house had a back entrance. The kitchen, bath, and toilet were squeezed into the narrow tip of the triangle at the rear of the ground floor. Upstairs was a large room that Leonie used as a study and bedroom. From there she could look across the trees to the ocean. The "Triangle House" (as the neighbors called it) confounded Japanese common sense by having a big glass window facing westward, an architectural feature Japanese avoided because of the strong afternoon glare of the sun.

When Matsuko gave birth to her second son that spring, Yonejirō had built a new house in Higashi-Nakano, a neighborhood known as Bunkamura (Culture Village), where many artists and writers lived. That may have prompted Leonie to build her own, but the "Triangle House" was also a project for Isamu, who helped oversee its construction. Although she had given up the idea of educating him as a "Japanese boy," she still had not

abandoned her dream of making him an artist able to draw on his dual cultural heritage. She wanted to raise him as a "crosser of borders," at home wherever he might find himself in the world. Designing the new house, she thought, was a step in that direction.

Isamu later remembered the house as a major event of his childhood. He thought that it was his mother's way of placating him after his sister's birth. She "wanted this house to be my house in the fullest sense. . . . This was a time of turbulence and a time when I actually did see my mother because she stayed there, as I remember." [79] Letting Isamu help was a bid to recapture the affections of her increasingly self-assertive and independent son. "She wanted me to watch the carpenters, who she admired." As "supervisor" of the house's construction, Isamu showed powers of concentration worthy of an adult. He surprised the carpenters by his careful attention to detail, and every day he reported to his mother exactly what progress had been made.

"The baby has fallen asleep, the maid has gone to the station to fetch Isamu home with a lantern, and here's a quiet house and a good half hour to write you," Leonie wrote Catherine after the construction was finished. "[The] house is a joy to behold and to hear the carpenters whacking away at it. You may have the best parlor . . . for your exclusive use any time you do be stopping in this country. . . . There's a grand view of Mt. Fuji to the westward, and from an upstairs window an equally grand view of the sea." [80] An elegant and uninterrupted vista of the famous mountain's slope was visible from an upstairs window that framed it like a scene from a Hiroshige print. In the late afternoon, when the setting sun bathed the western sky red, Isamu often gazed at its beauty. "[T]hat was my big experience," he recalled, "which started me off into life—and a part of my consciousness ever since." [81]

While the little house was being built Yonejirō wrote to Leonie from London, where he had been invited to lecture on Japanese culture. "I am quite all right in London, people here show so much interest to myself. You might say that I lionized. . . . Yesterday I was invited by Bernerd [sic] Shaw and tonight am going to take dinner with Yeats. And so on—you see, I am splendid in condition, but not financially. . . . So you are building your house. . . . That is fine news. I hope that you will not be cheated by carpenters and other working men." [82] It had been ten years since Yonejirō had visited England. In the interim he had not only continued writing poetry in

English, he had also published English-language articles on traditional Japanese artists like Kōrin and Sōetsu, on woodblock prints, on the Noh and Kabuki theaters, and various other aspects of Japanese culture. But these topics reflected Leonie's interests in Japanese culture more than Yonejirō's. For example, he began to write poems about "pine trees" only after Leonie moved into lodgings near a tree-lined section of the old Tōkaidō highway, and it was only when she moved into her new house with its magnificent view of Mt. Fuji that he began to write poems celebrating its beauty. Leonie earned her share of his royalties not simply as his editor but also— one could say at the very least—as a source of his creative inspiration.

The summer of 1914 was Isamu's first vacation in the new house. "To see Isamu, naked except for a pair of white tights and sitting cross legged with a piece of watermelon, his startling green eyes reflecting the watermelon, is to get a glimpse of a line of poetry of savagery."[83] That summer Isamu met children from one of the neighboring villas. Masutarō Niida, a law professor at Tokyo Imperial University, owned the closest one, and about fifty meters away was the villa of Eiichi Makino, another member of the university's law faculty. It was with the Makino children that Isamu played most often.

Makino, a well-known expert on criminal law, had two daughters and four sons, the eldest of whom was Isamu's age. Every year the Makino children spent their two-month summer vacation in Chigasaki. It was the only time of the year when the neighborhood rang with the sound of children at play. Isamu's summer friendships began when Kazuko Makino, the second daughter, became a playmate of "Ai-chan," his three-year-old half-sister Ailes. With her big round eyes and happy temperament, Ailes was a perfect companion for five-year-old Kazuko, who had no other friends her own age. Ailes spent the whole day at the Makino house, chasing cicadas and the beautiful white- and black-winged butterflies native to the region. Even in her eighties Kazuko (now Kazuko Kunieda), a retired piano teacher, remembered scenes of her summer play with "Ai-chan."

Her memories of Isamu were altogether different. "I was always frightened by Isamu's eyes," she recalled. "As a child I knew nothing about his circumstances, but I always thought that he had some kind of grudge or bitterness toward Japanese people. What I remember about Isamu now is that he never walked across the beautiful green lawn in the front of the

house but always went through the dark grove of pines at the end of the back garden."[84] In her recollections, Isamu appears very different from the boy his mother described in letters to Catherine.

To the Japanese who knew him at the time Isamu was a man-child with a forbidding expression. The discrimination he suffered at the hands of local children had hardened into feelings of suspicion and distrust. Even when someone was kind to him, he was always wary about what the person thought of him. He never left himself vulnerable. If someone tried to touch him, he stiffened like a porcupine ready to jab back. "Since Ai-chan came to play with me all the time," Kazuko recalled, "I guess Isamu-san came too. He must have played with my elder brother but somehow I remember him as always alone."

Kazuko hesitated to befriend Isamu because he was known in the neighborhood as a "child prodigy" who designed his own house. What Kazuko particularly remembered about the house was the magnificent view of Mt. Fuji from the round window, where Isamu sat waiting for his mother's return from Yokohama. He could see the train just a moment before it reached the station. "My mother always seemed to be calling me," he later wrote.[85] Indeed, Kazuko's recollections of "Ai-chan's mother" began with her memory of Leonie calling her children—"Isamu! Ailes!"—in a long, clear, strained, and drawn-out voice.

According to Kazuko, Leonie's face was always expressionless. She never smiled. "I always thought of her as being very severe, and not laughing very much and looking at life in truthful way," Isamu recalled. "I don't think she had very much joy in life."[86] He recognized that raising her children without a father's help was a "terrible burden." When she commuted other passengers on the train often stared with curious and suspicious looks. A "foreign woman" was still an unusual sight, and sometimes drunks called her insulting names. Yet when she returned home, she had to be both mother and father to her children. She turned forty in the summer of 1914. It is not surprising that her face showed signs of stress—or that Kazuko found her severe, thin face as frightening as Isamu's.

Leonie once came to the Makino villa with a jar of strawberry jam to ask a favor: Would they be kind enough to take care of Ailes for about a month? She had taken on an editorial job in Tokyo at *New East*, a magazine that introduced Japanese culture to foreign readers, and she had to be away from Chigasaki for a while. Kazuko's mother agreed. "It will make

Kazuko so happy," she said. Ailes moved into the Makino house, spreading her futon quilt beside Kazuko's, but Isamu insisted on remaining alone at home. The "Triangle House" had been burglarized three times during the first six months after Leonie moved in, and it must have been unsettling for the ten-year-old boy to stay there by himself at night. Even when the Makino family pressed him to sleep at their house he said that he preferred to stay at home. The "old lady" who took care of the Niida villa cooked his meals.

The only person Isamu recalled as a real friend in Chigasaki was "Haruhiko-san"—Haruhiko Fujii, a middle-school student six years older than he—who came down from Tokyo during the summer. Every afternoon after naptime Isamu tagged along after Haruhiko-san to the beach, along with the Makino children. What Kazuko most remembered about these trips to the beach was "Ai-chan's mother," who joined them whenever she was home. She came up behind children who could not swim, swept them up in her arms, and tossed them into water over their heads. Thanks to this peculiar habit Kazuko learned how to swim but at the time she thought she was going to drown.

Swimming is forbidden on the beach at Chigasaki today. The sea floor has eroded over the years, and the waves sometimes reach ten feet high in a storm. Even on calm days the surf is rough. Farther out in the bay, about two and a half miles offshore, the water suddenly becomes quite calm near a small rocky island. Whenever Leonie came to the beach, she swam out to the island with a graceful crawl. No matter how often she watched, Kazuko was frightened to see Leonie's head growing smaller and smaller as she disappeared into the distance. Leonie once told Isamu that her Irish-born father went for a swim every New Year's Day even if snow was covering the ground. It was Celtic blood that made her so fond of swimming, she said. "When it became warm enough, my mother would swim far out, farther than I could see, and I was in constant dread that she might never come back," Isamu later recalled.[87] For the young boy, the sea was frightening—"a dangerous place of dark winds and typhoons."

When the Makino family returned to Tokyo the summer ended for Isamu and Ailes. Isamu returned to his daily routine, rising at dawn to catch the early train to Yokohama. "Every day, the same thing"—arriving at St. Joseph's with a downcast face. "One season, when I was about ten," he recalled, "my mother, who had her own ideas about education, decided

to keep me out of school and teach me herself."[88] At the time Leonie told Catherine a different story: "[Isamu] objects strenuously to going to school, begging me to teach him at home this winter. Of course, the train journey is strenuous upon him every day. On the other hand, the education at home with a mother busy as a teacher is apt to be desultory."[89]

Isamu told his mother that he wanted to become a landscape gardener or a horticulturist. "He is quite enthusiastic in choosing his specialty. But he does not see the use of arithmetic or spelling and all that—for the gardener. He thinks a man should begin life working young."[90] Leonie put him in charge of their little garden, and he soon could think of little else. He carefully tended several dozen rose bushes he had grown from clippings given him by one of Leonie's students who worked at a nearby agricultural experimental station. When "Auntie Catherine" sent purple pansy and yellow primrose seeds, the garden was soon filled with their blooms. Every Sunday he hiked three miles to the surrounding hills to look for mountain azaleas and other interesting plants. He even added a water feature. "The overflow from the pump I had formed into a brook," he recalled in his memoir. "To this was attached my earliest feeling of guilt, for I stole a rock from a neighbor's wood to place there."[91] To nurture her son's artistic talent Leonie encouraged his creativity in other directions, too. On her days off, she often took him for walks through temple gardens at Kamakura. Isamu later recognized that he was very much his mother's creation. " [S]he was a lover, you might say, of Japanese culture. . . . I think I have the same kind of background. I took it with my mother's milk. . . . In a way, . . . I think, I'm the product of my mother's imagination."[92]

When Isamu refused to return to St. Joseph's in the fall of 1915, Leonie decided to teach him at home. She arranged for him to attend a *kendō* fencing class—a photograph shows him in his gear—while she was at work but that did not hold his interest very long. With his mother away, he often pestered little Ailes to the point of tears. He was not fond of the little intruder who had come between him and his mother. She played outside all day, catching snakes and frogs she found in the garden, and she often trampled on the flowerbeds he had struggled so hard to make perfect. He could not stand the "very stubborn and wild baby" and teased her mercilessly.[93] Leonie found herself scolding him more and more. Sometimes he ran away from home, thinking that everyone would be sorry that he was gone, but his mother always fetched him back.

At her wit's end, Leonie apprenticed Isamu to a local carpenter. She bragged to Catherine that he had a skill with his hands unusual for a child, and she decided to test his talent for carpentry. Isamu later recalled that he was "semi-apprenticed" to a "shrine carpenter" (*miyadaiku*) but since there were none in Chigasaki at the time it seems likely that he worked with a cabinetmaker. "There I learned the basic uses of wood tools; to sharpen them, to plane, to saw, pulling in the Japanese way. Of the joining and interlocking, I learned the simpler kinds. I also carved wood panels for above the sliding doors (*fusuma*), some of which were antiqued by burning and rubbing with straw and wet sand. And I made carvings in cherry wood of such traditional themes as rabbits in waves and dragons in clouds. . . . It was real education for me."[94] "[T]hat was," he continued, "the only education I remember with pleasure. All the rest of it means nothing to me. It's the only thing that I remember that had some bearing on [my] future."[95] He surprised everyone by how quickly he learned to work almost as skillfully and elaborately as apprentices who had been training for several years.

His period of semi-apprenticeship as a carpenter lasted only one school term. Leonie thought that he needed a basic education even if he were to become an artist or craftsman so she arranged for him to live in a dormitory at St. Joseph's. When that proved too great a financial burden she moved her family to a "palatial foreign house" on the "Bluff" in Yokohama in December 1917. After eleven years in Japan, Leonie, who wanted her son to blend into Japanese society, finally settled in a foreigners' neighborhood where nearly everyone spoke English. Isamu could walk to school from the house, and Leonie could keep an eye on him, as she had not been able to in Chigasaki. Even so, she did not stop feeling concerned about him.

"I'm still worried about Isamu," she wrote Catherine. "Want to get him to America. There are charges of immorality among the boys at St. Joseph's. It is said that the majority of boys over fourteen are immoral so you can see why I'd like to get him away before he reaches that age."[96] In December she wrote again: "[T]he Catholic school which Isamu attends . . . is not good for developing character and originality. . . . I'm always anxious about him."[97] Her thirteen-year-old son, now a sixth grader "four feet, ten inches, broad-shouldered and husky," was reaching an important turning point in his life.

"When I was thirteen years old, my mother decided that I must go to America to continue my education," Isamu recalled. "I am sure that she must have been concerned about the unfortunate situation of children of

Isamu in kendō *fencing gear at about age ten*

mixed blood growing up in the Japan of those days—half in and half out. She decided that I had better become completely American, and took me to the American consul, who performed a ritual . . . which I believe was my renunciation of Japanese citizenship."[98] His mother had brought Isamu to Japan to "make a little Japanese boy" out of him but she had come to realize that her dream was impossible in a society where "blood" counted for everything.

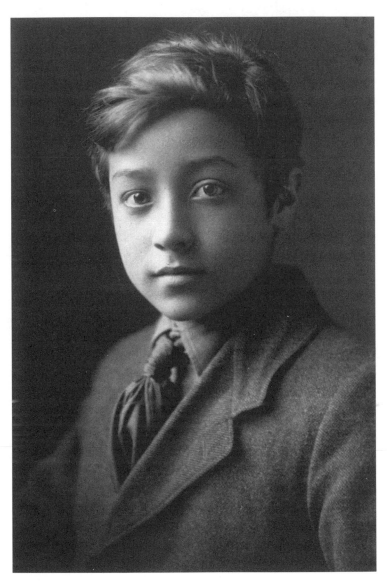

Isamu in passport photograph, 1918

All–American Boy

Interlaken School

"For my part, there wasn't much choice. I was to be an American, banished as my mother had decided."[1]

Isamu often claimed that his mother had sent him off to school in America against his will but it is clear from her correspondence at the time that he was quite eager to leave Japan. "He is begging me to let him go over to America, perhaps returning when he is old enough to enter an Art School here," Leonie wrote her friend Catherine. "He has three reasons for going. Curiosity to see the unknown. A desire to play baseball. Emulation of Christopher Columbus." Isamu began nagging his mother soon after he started commuting to St. Joseph's in Yokohama. He even wrote to the Tōyō Steamship Company inquiring about fares to the West Coast, and he made a list of things to take with him—his silver spoon, his teddy bear, several favorite books, his carpentry tools, and the chopsticks he had used since he was an infant.[2]

His plan was to move in with his godmother, Catherine, now living with her new husband in the Los Angeles suburbs, and attend school in her neighborhood. "He wishes me to inform you that he is an American not a Japanese," wrote Leonie. "In fact, so far as appearance, speech and habits are concerned, he would pass far more easily for an American than for a Jap. He has been going to foreign school since he was eight but he can neither read nor write Japanese, sorry to say. He could take my name in America if it seemed desirable."[3]

Leonie had no one to turn to for help in America but Catherine. Her sister Florence had not written for several years, and it was from Catherine

that she learned that her mother, Albiana, had died. "I feel like an orphan," she wrote.[4] Her migraine headaches were getting worse, and more than once she had fainted at school, awakening to find herself put to bed. The strain of working in Japan as an unmarried single mother with two small children was taking its toll. Perhaps because she seemed physically and mentally near the end of her tether, other foreign residents in Yokohama offered help. An English couple wanted to adopt Isamu, and a childless Russian living with his Japanese wife proposed to adopt Ailes.

It is clear that Leonie wanted to get Isamu away from his school. There were "charges of immorality" among the boys at the school, she told Catherine.[5] After the little family had settled into their new house in Yokohama, Isamu joined the Boy Scouts, and as he made new friends he finally stopped pestering his mother about going to America. That only made her all the more eager to send him back to America. Isamu later offered his own speculation about her motives. "I think I know why she wanted to send me off to America, or at least that's the rationale I give myself. I had become too friendly with an English family and a boy there named Jeffrey. I'd started spending time more and more there, even at night, and I don't think my mother approved of this. And then there were these girls—one of them in particular that I quite fancied. In fact that was during the time of my . . . awakening sexuality, you might say."[6]

Leonie also worried that her son might be conscripted into the Imperial Japanese Army. His status in Japan was that of a stateless person, and unless he demonstrated that he had lived in the United States he could not claim American citizenship. Leonie took him to the American consulate in Yokohama where he remembered "a ritual, mumbling over a Bible, which I believe was my renunciation of Japanese citizenship."[7] Since his name had never been entered in Yonejirō's household register he had no Japanese citizenship to renounce. The "ritual" was probably an oath to establish his American citizenship. Even so, Leonie remained uneasy. Shortly after arriving in Japan, she had gone to the local police station to enter Isamu as Yonejirō's son, "Noguchi Isamu," in the local residential register. "If he is here when he is 18 years old," she wrote Catherine, "the Japanese Government may seize him for military service, a brutalizing and demoralizing service I am told by Japanese who have been through it."[8]

What finally made up Leonie's mind was an article in *Scientific American*—"The Daniel Boone Idea in Education"—about the Interlaken School, an innovative private boarding school in LaPorte, Indiana.[9] Dr. Edward A. Rumely, the heir to a local tractor-manufacturing company, had founded the school under the motto "Knowledge through experience." Its goal was to instill students with the frontier spirit of self-reliance and self-sufficiency. Leonie was delighted to learn from the prospectus that the boys spent part of the day working with their hands in a shop or in the garden. They lived in log cabins they built themselves, and they ate meat and produce raised on the school farm. Leonie's dream of raising her son as a Japanese had failed. Now she put all her hopes in educating him in the United States as a "true American."

The only problem was money. Leonie had enrolled Ailes in a school for foreign girls, and she also sent money to her ailing seventy-two-year-old father in New York every month. Even after taking on more work as an English tutor, she made barely enough to get by. She asked the Interlaken headmaster if Isamu could earn a small part of his expenses, perhaps $50–$100 a year, working part-time during summer vacation and on weekends. "He has a very strong inclination for manual work," she wrote, "in fact rather a surplus of motor energy."[10] Happily the school's response was an offer to reduce the $600 tuition to $300 by taking on Isamu as a "special student" and promising to find him enough odd jobs to earn $70 during the summer holiday.

In early June 1918, as soon as the school's reply arrived, Leonie rushed to complete preparations for Isamu's departure. She wanted him to enter the ongoing summer session so he could get used to his new environment before the fall semester began. The United States had declared war on Germany the year before. Rumors spread that enemy U-boats might attack American ships in the Pacific Ocean so she arranged for Isamu to depart from Yokohama on the Tōyō Steamship Company's *Amerika-maru* on June 27.

To Isamu her sudden decision was upsetting. He had been in Japan since he was an infant. To be sure, his father had never accepted him as a legitimate son, and he had been shunned as a mixed-blood child, but Japan was the country where he had lived with the mother he adored so deeply. He had never been separated from her, and she had always done her best to protect him, but now, just as he was beginning to enjoy life in Yokohama, she had suddenly decided to pack him off to America. Even though he had

longed to go there it was a great shock, he later recalled. His mother was sending him to a "homeland" completely unknown to him. Leaving for America meant cutting his psychological umbilical cord, and the memory remained vivid in his later years. "I felt abandoned," he recalled, forgetting how doggedly he had begged Leonie to leave Japan.[11]

His American passport bore the name "Isamu Gilmour." Except for a ruptured left eardrum that left him slightly hard of hearing, he was a healthy young boy, just short of five feet tall and weighing 95 pounds. "He has a tendency to be very absorbed in the thing he is interested in for the moment to the exclusion of all else, to ignore other people and their claims, to be domineering and self-willed," Leonie wrote the school.[12] His strongest traits, she said on the application form, were "enthusiasm" and "capacity for taking pains," but she asked that the school give him special guidance in "truthfulness" and "politeness."[13]

The face in Isamu's passport photograph is very different from the one that Kazuko Makino remembered from summer days in Chigasaki. His round heavy-lidded eyes do not sparkle with anticipation at the adventure awaiting him. His gaze is somehow timid, as if looking for protection.

To add to his anxieties, just as he left for America, his father suddenly barged into his life again. For most of his childhood Yonejirō had been no more than a fragment in his memory. Indeed, Isamu had not seen his father since he had been stricken with measles five years before. But on the day of his departure for America Yonejirō arrived in Yokohama to stop him from leaving Japan. It was still too early for Isamu to return to the United States, he told Leonie, and he promised to enter the boy in his household register as an "adopted son" (*yōshi*) if he stayed in Japan.[14]

Yonejirō's eldest son with Matsuko had died two years before at the age of six. At the time of the child's death Yonejirō wrote a poem expressing regret that "now that I have become forty years old, for the first time I have come to understand my life more broadly and more deeply." Yonejirō had secured a respected position in Japanese society as a professor at Keiō University, one of the country's leading private universities, and to all appearances he was a responsible husband and father. The scene that unfolded on the day of Isamu's departure revealed his recognition, however belated, that he was a father to Isamu, as well.

Leonie and Yonejirō stood on the pier arguing heatedly. As Isamu started up the gangplank his mother urged him to hurry aboard. "You are

to stay in Japan!" Yonejirō shouted in English at the top of his lungs. It was the first time that Isamu had heard Yonejirō speak as a father to him. Uncertain what to do, he stood transfixed, unable to move, not knowing what to say. Suddenly his mother uttered a sharp single word: "No!" He turned to his father and repeated it: "No!" When his mother brought him to Japan at the age of two "to become a Japanese" his father had called him "Isamu," a name that meant "brave" or "courageous." With his simple brave "No," he demonstrated his courage. He had decided to cross the Pacific again, this time alone, on his way "to become an American."

"The boat trip I remember as fabulous, with two Fourth-of-Julys at the international date line. My first view of America was the pine-spired coastline of the Northwest and the passage past Victoria to Seattle."[15] A YMCA official who at Leonie's request met him in Seattle and put him on the train to Chicago gave him a stick of Juicy Fruit gum. "I thought this was the most delicious and wonderful thing," he later recalled. "What a wonderful country to have such a wonderful thing like that. So I felt very happy about America because of that Juicy Fruit Gum."[16]

The train was filled with soldiers headed for the war front in Europe. During the three-day trip they plied the "boy from Asia," his name and destination written on a cloth tag sewn to his shirt, with food and drink. At Chicago Isamu changed to a train for New York, then changed again two hours later to a local intercity line at LaPorte, Indiana. After a twenty-minute ride he arrived at Rolling Prairie, Indiana, early in the afternoon of July 17, exactly three weeks after he left Yokohama. He was the only passenger to get off the train.

Today only freight trains pass through Rolling Prairie, and none stop there. When Isamu alighted he saw no station building, only a space by the side of the tracks for passengers to get on and off. A dozen or so houses and buildings were scattered nearby. The humidity was high, and the summer heat intense. Suddenly Isamu found himself in the midst of the rolling open spaces of the American Midwest. With the sun beating down on his head, he trudged two miles down the road to the Interlaken School, lugging a big suitcase in one hand and a box of carpenter tools in the other. The narrow road was lined with overgrown weeds and brush. Not a single farmhouse was in sight, only cornfields. What most impressed Isamu on his "return home" was how different the landscape was in America. In

Japan the landscape had "the beauty of a miniature garden, a beauty that appreciated small things—the insects, the leaves, the flowers." But as he walked along the dusty road he was overwhelmed by the "vastness, [the] sweep, the panorama of that open Indiana countryside."[17]

Today a Catholic boys' school sits on the former site of the Interlaken School. Its main building is a three-story, red-brick structure built after the property was sold to the church. Behind it stretches broad green pastureland dotted with round haystacks. Off to one side are a big silo and a cluster of farm buildings, and beyond them lies a small lake still called Silver Lake. The Interlaken School buildings were scattered along the lakefront. The main building, an ordinary-looking wooden structure, held the school offices and fifteen classrooms. The rest—the gymnasium, the woodworking shop, the metalworking shop, the craft shop, the printing shop, and the student dormitories—were log structures the students had built themselves. During the summer, tents in the woods by the lake served as dormitories.

The director of the summer school, C. A. Lewis, reported on Isamu's arrival in the schoolyard to Dr. Edward A. Rumely, the school's founder: "I have a little Jap in camp—half Japanese, half English. He's a peach. He was muchly interested in wood-work, wanted to go to the wood-shop. I sent him, with flying colors. He came back to me almost in tears. 'I wanted to make something that I've planned for a long time, and Mr. Hedrain [the woodworking teacher] set me to planing a block of wood, just to plane it.'" The woodworking teacher, an "utterly inelastic" Swede, treated his students like items "to be put through a mill." Lewis wanted his "little Jap" to pursue his own "genial and refreshing" techniques. He immediately found a space for Isamu to work in the corner of a storage building and provided him a bench and shelves for his Japanese tools. "He can carve a Jap cod a heap better than Hedrain could in a year of Sundays, and he can make a spoon more quickly and artistically than Hedrain can in his. So I have him at it, and the boys are already wearing a path to his door."[18]

When Isamu graduated from St. Joseph's School he ranked fourteenth among his thirty-two classmates. His highest grades were in drawing (90), in reading (90), and penmanship (94); he received only a 70 in arithmetic, a 73 in geography, and a 53 in French. In her application to the Interlaken School, Leonie wrote that Isamu's grades were usually a little above the middle level but when he attended a Japanese kindergarten that emphasized artwork he was "at the head of his class." "His Japanese ances-

The Rumely family (Fanny Rumely, seated at left; her father, Emmet Scott, seated third from left; Edward A. Rumely, standing at right)

try and environment," she wrote, "would undoubtedly make him superior to the average American boy along these lines."[19]

Isamu's prized bag of carpentry tools was his passport into American society. Leonie had him take them along to lessen his feelings of inferiority as a mixed-blood child, and the Interlaken School staff had immediately understood his situation. Leonie had chosen the right school. "Isamu Gilmour," the new boy from Japan with a genius for woodworking, was made to feel at home right away. Everyone wanted to know how he used his tools, he later recalled, and suddenly he found himself spending "happy days" at the center of attention. It was as though he had been invited to a "big party."[20]

The school day at Interlaken began with a wake-up call at 5:30 in the morning. Everyone went for a swim in the clear waters of Silver Lake, and then returned for breakfast at 6:00 where they ate eggs and milk from the school diary. At 7:00 came clean-up time, and from 8:30 the students devoted themselves to farm work and other manual labor. At noon there

was another half-hour to swim. After lunch the boys spent the afternoon in the classroom studying science, history, geography, European literature, Latin, and other academic subjects. When classes ended at 4:00 the boys could pursue a sport of their choice—horseback riding, canoeing, or tennis—until dinnertime at 6:00. Then from 7:00 until bedtime at 9:00 they prepared their homework for the next day or read books.

Most of the boys came from affluent Midwestern families but there were a few foreign students, too. Isamu's roommate, Agapoan, an older Filipino boy headed for military officers' school, taught him how to ride a horse. After a few days in the midst of the dynamic Midwestern landscape, Isamu's life in Japan seemed part of a distant past. When one of the Japanese cooks at the school tried to strike up a conversation by asking if he were Japanese, the flustered Isamu reddened. He suddenly had trouble speaking Japanese.

Had Isamu's exciting new life continued through high school, as Leonie hoped, his personality—and his future—might have been different. It is even possible that he might not have become the sculptor Isamu Noguchi. But for better or for worse, his "big party" came to a sudden end just a month after his arrival in Indiana. In late August, the Interlaken School closed down at the end of the summer term. The American students went home, and Agapoan departed for military school, but Isamu had no place to go. He camped out in one of the faculty buildings with two caretakers.

The arrival of more than two thousand army recruits a few days later transformed Interlaken School into a training camp for a motor battalion. The young soldiers made a pet out of Isamu, treating him like a "kind of mascot," he later recalled.[21] Some recruits were already suffering from severe coughing fits, symptoms of the so-called Spanish flu that had begun to spread through American military camps early in the spring. The epidemic followed the American doughboys to Europe, and then spread through the rest of the world, taking more than twenty million lives during the next three years. Stricken soldiers died even at Interlaken. It was only a matter of time before Isamu, who ran errands for the recruits, came down with the flu himself. He was confined to his bed in the school dormitory with a high fever. Fortunately his case was not serious. He spent his days reading *Le Mort d'Arthur* and browsing through the Bible as he rested.[22]

By the time Isamu recovered the recruits had begun to vanish from the camp. On November 11, 1918, the war in Europe came to an end. Isamu passed his fourteenth birthday living in an empty school building surrounded

by withered cornfields whipped by a chill wind blowing off Lake Michigan. "I knew everyone had disappeared and I was alone," he later recalled. "I felt like Daniel Boone. I would get in a canoe and paddle across the lake there and look for food and this and that. And there was a dog that I liked." Every now and then he rode to Rolling Prairie in the early morning on his favorite horse to pick up milk, food, and mail, then came back to make breakfast.

When Isamu later spoke about this time in his life, he invariably described himself as a "waif." "I was left there [Interlaken] as a waif," he told a reporter in 1973, "and I've been fending for myself since I was 13."[23] The word was central to his personal legend, the heartbreaking childhood story of a boy abandoned even by his mother, a story he often told to the women in his life. But is it likely that Leonie would have done nothing when she learned the school had closed? Correspondence between Leonie and the school in the archives of the Lilly Library at Indiana University tells a different story, one that Isamu perhaps did not understand at the time.

Far from abandoning Isamu, when Leonie received an urgent international cable from the headmaster in early October saying "SCHOOL CLOSED SEND MONEY ADVICE," she immediately wrote back: "In the emergency I wish Isamu to go to public High School in LaPorte and will be obliged if you will consult with the secretary of the Y.M.C.A. about finding a home for him. If there is a Boy Scouts organization the scout master might be interested in helping to place him."[24] She also worried that Isamu might not have enough money. On his way to Indiana he had lost the $95 check for summer tuition. Leonie had sent another $100 draft through the Yokohama branch of the Hongkong and Shanghai Banking Corporation in late August, but bank correspondence, like regular correspondence, took more than a month to travel across the Pacific, and the money had still not arrived in October when the school closed. Even though it meant paying double, Leonie sent another $100 just in case, and she told the school authorities to get in touch with her friend Catherine in California if the school had not received her bank drafts.

Three weeks later Leonie received a bundle of three letters from Isamu and another letter from the school asking for tuition. "My first thought on hearing of the closing of the school," she wrote back, "was that I must take the first opportunity to go to America myself, and I am now trying to make an engagement over there. If you hear of an opening I

should be glad to know of it. I have been advised that I might get a secretaryship to one of the faculty of my college, Bryn Mawr, at a salary of $100 for half time, with the chance of putting in the rest of the time at tutoring or writing. But although this is fair pay I do not feel that I can undertake the expense of a long journey to settle in a high-priced place like Bryn Mawr. I rather look to the Pacific Coast or the Middle West."[25]

When Leonie first considered sending her son to the United States, she thought about going back, too. Saying nothing to Isamu she wrote her alma mater to see if she could find work there. The salary Bryn Mawr offered was not enough to support her and her two children so she decided to stay in Yokohama, where she could supplement her income as a schoolteacher by tutoring students in English. That was why she decided to send Isamu to America by himself. When the Interlaken School closed she had been deeply disturbed about the fate of her distant son. To ease her mind, she sent the school another check for $100 in early December.

It was not until January 18, 1919, that a letter from C. A. Lewis informed her that Isamu had been enrolled in a local school in LaPorte. The delay seems difficult to understand, given the sensitivity Lewis had shown toward Isamu when he first arrived at Interlaken, but Lewis, who was also Dr. Rumely's personal accountant, was dealing with other problems. When the Interlaken School began to run in the red Rumely made up the deficit with his own funds and put Lewis in charge of the school's finances. After Rumely bought the *New York Evening Mail* in the hope of establishing himself in the publishing world, Lewis took over the management of the newspaper's accounts. At the time the school closed down, he was in New York City under a court subpoena for concealing documents.

The *New York Evening Mail* had sent John Reed to cover the Bolshevik Revolution, an assignment that produced his famous book *Ten Days That Shook the World*. But in early July 1918, just before Isamu's arrival in Indiana, Rumely was arrested on charges of perjury for failing to report the true ownership of the newspaper to the Federal authorities. A German-American businessman, Herman Sielcken, had helped Rumely to finance its purchase while Germany was still at peace with the United States, and he had funneled his funds through the German Embassy in Washington, but when anti-German sentiment reached a fever pitch after the United States declared war on Germany, Rumely soon became the target of public suspicion and hostility.

It was charged that the real source of funds to purchase the paper was the German government itself, and that German ambassador von Bernstoff was behind the transaction. The accusation seemed plausible. Rumely, a third-generation German-American, had studied in Germany as a young man. Even before his indictment, rival papers in New York accused him of acting as a "German agent" and reported that Interlaken School was a training school for the kaiser's spies. Many Interlaken students did indeed come from German-American families, which was not surprising, since the Midwest had been a magnet for German immigrants.

After Rumely's arrest, Lewis was required to remain in New York City. When the school closed most of the school staff left to find work elsewhere. Only the school principal and a few teachers stayed on to take care of loose ends. When all of them came down with the flu—and one died—Isamu had no one to look after him. But that did not mean that he was completely forgotten or left to fend for himself. The school staff was reluctant to do anything definite without his mother's permission, and it took several months to find out what she wanted to do.

In December 1918 Lewis's wife, just out of the hospital, took Isamu home with her. The time he spent living like Daniel Boone in the wilderness had lasted no more than a month or so. His later memory of being "abandoned" or "sent away" referred to the brief few weeks after the Interlaken School had closed.[26] But the unexpected situation that confronted him after he recovered from the flu was deeply unsettling. Coming so soon after happy early days at the school, his sense of isolation was all the more intense. The only way he could later express how he felt was to remember himself an abandoned "waif." There is no doubt that the closing of the school was a traumatic experience that left a deep scar on his personality.

Proxy Father

"I was still out there on this abandoned school when the wife of the treasurer of this school came by and found me." Isamu recalled.[27] Mrs. Lewis arranged for him to live in Rolling Prairie, where he was to attend the local high school while working part-time in a garage. Distrust of outsiders ran deep in the placid rural community. One day on his way home from school Isamu found himself confronted by an unfriendly crowd of other students. It was a world quite different from the Interlaken School.

After years of being treated as a "freak" because he was not of pure Japanese blood Isamu had become deeply ambivalent toward Japan. This had worried Leonie. In her application letter to Interlaken School she wrote: "He inclines to admire all things American, and to slight his Japanese ancestry."[28] But once Isamu arrived in what he hoped was his homeland, he found himself identified with the country that had rejected him. He thought himself an American, only to discover that even in America he was still an outsider. He was an "Oriental." He was a "Jap."

Those who live in two cultural worlds feel the pain of being at home in neither. Recall his father's poem *Nijūkokusekisha* ("Dual Citizen"):[29]

> The sadness of becoming neither a Japanese nor an American. . . .
> The tragedy of being neither the one nor the other. . . .
> How stupid! By the time I have said it, already it is too late.
> Nothing to do but laugh, nothing to do but laugh!

With self-mocking humor the poem laments Yonejirō's rejection by the Japanese poetry circles, but even though Yonejirō played the role of the lonely international poet, he never had any doubt about his Japanese identity. Isamu, on the other hand, had no choice but to accept "the sadness of becoming neither a Japanese nor an American." From the day of his birth he bore the stigma of dual ancestry. It was an inescapable fact of his life. "The whole problem of being neither Japanese nor American—that has always been a trouble," he told an interviewer in 1968. "In many ways, I'm like a soldier in a campaign in the desert—far off, but always with the idea that there's some place I'm going back to someday. Where I won't be alone, chasing the enemy on a camel."[30]

In the summer of 1919, after he graduated from school in Rolling Prairie, Isamu was suddenly "rescued" by Dr. Rumely, who was free on a bail bond after his indictment for perjury.[31] Branded as a traitor by sensational newspaper headlines Rumely found his business ventures faltering. To deal with his financial difficulties, he decided to turn the Interlaken School—the "dream of his youth"—over to others. On a trip back to LaPorte to arrange the transfer he "discovered" Isamu, whom he plucked out of Rolling Prairie. He enrolled the boy in LaPorte High School and found a local family for him to stay with.

After returning to New York, Dr. Rumely bombarded Isamu with fatherly advice: "I wish you to open up immediately an account book. . . .

Start in with the $15 balance that I am giving you herewith. First, I wish to know how you are using your money and to guide you by suggestion. Second: You can practice economy better if you know what you are spending for. Third: The habit of careful accounting is an essential for many lines of work and you must learn it now. Let me know how your school work is getting on. Who are your teachers? I have spoken to Mr. Simon, the art teacher at the school, and I am sure that you will find him a very valuable instructor. I wish you to keep me informed by an occasional letter. I shall write your mother shortly."[32] Isamu had never received such a letter, or even such advice, from his own father.

Under Dr. Rumely's wing Isamu took his first steps toward becoming an "all-American boy." "[Dr. Rumely] took it upon himself to teach me everything that he could," he later recalled, "and he imbibed me with a knowledge of American history and of his values."[33] Rumely's grandfather, who emigrated from Germany in the mid-nineteenth century, had made his fortune manufacturing agricultural machinery. Like the children of the German immigrants who worked in his grandfather's factory, Dr. Rumely grew up with German as his second language. Always at the top of his class, he went to Oxford University after graduating from high school. Deciding to become a physician, Rumely left Oxford for Heidelberg, and then moved to the University of Freiburg, where he took his medical degree. It was during his years abroad that he first read Rousseau's *Emile*, a work that shaped his interest in a "natural" education for children. After returning from Europe, Dr. Rumely opened a medical practice in LaPorte and took over the management of the Rumely Manufacturing Company from his father. In 1910 he founded the Interlaken School to put into practice the educational ideals that inspired him as a university student.

Even after his indictment "Doc" Rumely, as he was fondly known in LaPorte, remained a pillar of the community, respected by the local townspeople. The family company was the biggest business in the town, and the Rumely Hotel on Michigan Avenue, the town's main street, was a gathering place for the town's elite. When "Doc" Rumely became a scapegoat for anti-German sentiment the townspeople sprang to his defense. By a stroke of good luck, Isamu had found a patron and protector who was the chief citizen of LaPorte.

A large and stocky man, the thirty-seven-year-old Edward A. Rumely had penetrating blue eyes and a constant smile. His wife, Fanny,

was the eldest daughter of Emmett Scott, for many years the mayor of LaPorte. She married Rumely after graduating from Smith College. Fanny was member of the local Swedenborgian church, and it was the pastor of the church, Charles S. Mack, who offered Isamu a place to stay.

The Mack home at 212 Maple Street was a gray, three-story wooden house with a sharply angled roof in a middle-class residential neighborhood. Isamu's room was in the attic on the third floor. Before becoming a Swedenborgian pastor, the sixty-two-year-old Mack, a grandfatherly figure with a bushy white beard, had been a professor of homeopathy at the University of Wisconsin. To the citizens of LaPorte he, too, was known as "Doc" or "Doctor." Four of his children—three sons and a daughter—had already left home, and only the two youngest sons remained. One of them, Julian, was a year older than Isamu, who took Julian as a model in everything. The intellectual atmosphere in the Mack home was lively. Mrs. Mack, a calm woman never flustered by anything, had been a schoolteacher before marriage, and all the children, including the only daughter, graduated from college and went on to professional careers as lawyers, scientists, and college professors. Julian became a well-known physicist who worked on the development of the first atomic bomb.

Isamu later remembered the Macks as a "wonderful family." He described Dr. Mack as "a lovely man, a really sincere man, and a good man."[34] At the dinner table parents and children talked about what had happened during the day, and for the first time in his life, the fifteen-year-old Isamu discovered the quietly affectionate atmosphere of an ordinary family. The Mack household was a small universe centering on a dutiful father. Even though Isamu was an outsider he was warmly accepted as a member of the family. Friends and colleagues later remarked on Isamu's elegant use of the English language and his good manners. Despite his unusually intense and passionate personality he was usually polite and never used profanity. The imprint of his mother's discipline was strong but so was the influence of his experience with the Mack family.

Although the Macks led a frugal life, their house was filled with books. It was on their bookshelves that Isamu rediscovered the poetry of his mother's beloved William Blake, and it was there, too, that he became acquainted with the poems of Goethe, an admirer of Swedenborgianism. Dr. Mack was careful not to force his religion on the boy but Isamu attended Sunday services out of deep respect for his erudition and sincerity.

Although a warm and generous man, Dr. Mack was old enough to be Isamu's grandfather. It was the lively and energetic Dr. Rumely who became Isamu's "proxy father." As a child Isamu always dreamed of heroes like King Arthur, George Washington, and Christopher Columbus. Because he was fatherless his mother worried that he tried to imitate those he admired. Dr. Rumely was the first "living hero" that Isamu had ever encountered, and he soon became the object of Isamu's long-repressed filial love and respect. Isamu did his best to live up to the standards Rumely set for him, and for the first time in his life he was able to carry on a dialogue with a father figure. Isamu reported to Dr. Rumely the small details of his life—how he was managing his savings account, the grades on his school report cards, the books he had read—and his other daily triumphs and tribulations.

"The bysycle [sic] frame busted," he wrote in one letter, "so I had to get another and the tire is about to [go] on the blink. Otherwise the byclycle [sic] is all right as I got another frame from the Great Western. All these tough lucks however are counteracted by the fact that I have acquired a dandy coat from Mrs. Voth on Maple Street, which she gave to me because her son has outgrown it. This coat is just about new being thick and kind of granite black. Mrs. Mack said it could not be got for $30."[35] Isamu had never had a chance to share such chatty news with his biological father.

To encourage Isamu Dr. Rumely often told him that he was given the "best advantage anybody has"—no advantage at all. What Rumely meant was that in America a man had to make his own way through life and earn a position in society by his own efforts. "[T]his was his greatest gift to me," Isamu later recalled. "And I think it's correct."[36] Indeed, he once remarked that he thought of his whole life as a "Horatio Alger story," ironically true, since most of Alger's heroes rose in the world with the help of an older mentor.

The Mack family provided Isamu with free room and board but he had to work for spending money. On weekdays he delivered newspapers, and on the weekends he worked at odd jobs for Mrs. Rumely's widower father, Emmet Scott, who lived on Rose Street in a two-story, yellow-brick mansion on a lot that covered a full city block. When Dr. Rumely bought the *New York Evening Mail*, he moved his family to New York City, returning to LaPorte only for the Christmas holidays and summer vacation. Mr. Scott, then in his seventies, lived by himself. Isamu cleaned the fireplaces, chopped wood, cut the grass, and ran other small errands for him.

"Thank you very much for the article about my father," Isamu wrote to Dr. Rumely in January 1920, "but Mr. Scott brought the same article in just before the mail."[37] The *New York Times Magazine* had run an interview with "Yone Noguchi," the pensive "poet of the Flowery Kingdom who writes mostly in English."[38] Yonejirō waxed nostalgic about his youthful days in America, but made no mention of the young American woman who had helped him write his first poems in English or of the mixed-blood child who had been born of their union.

In October 1919 Yonejirō had returned to the United States for the first time in fifteen years, just as Isamu was starting high school. He was on a three-month tour of the United States, giving lectures on Japanese poetry and the Noh drama. At the end of November Yonejirō spent three weeks in Chicago, a city only two hours from LaPorte by train. He did not lack money for a ticket, and indeed earned enough from his lecture tour for a down payment on a new house in Tokyo, but not once did he visit his son even though Leonie had asked him to get in touch with Isamu. "I lost interest in you and even in Isamu," he replied.[39] Yonejirō had tried to stop Isamu from leaving Japan just a year before. Now he completely ignored him. He never sent him a letter or even a bit of pocket money.

Isamu's feelings toward his father hardened. After experiencing the kindness of Dr. Rumely and the Mack family, he could not forgive a father who refused to recognize his existence. Indeed he was beginning to hate this phantom father. Even at the end of his life he remained intensely bitter: "I thought of [my mother] always, thinking . . . what a tough time she had. . . . I didn't expect her to try to send me money, for instance. I would have been greatly surprised if she sent me money. . . . How could she afford to send me money? I'm sure nobody ever helped her. I'm sure my father never helped her. . . . No, I felt badly about her, and I disliked my father intensely because of the way he treated her."[40]

"It is two weeks since I started working for the labratory [*sic*] so I asked Dr. Martin for my pay," Isamu wrote Dr. Rumely in the spring of 1920, telling of a part-time job at a doctor's office. "He asked 'How much do you want?' I replied '$5.' He said that the laboratory could not afford it and that as training was very valuable . . . I ought not to ask for any. I have enjoyed the work very much but I guess I will have to look for another job. He gave me

$7 for two weeks. . . . I shall wait for an answer before I accept another position. . . . I hope that your trial ends speedily."[41]

In the summer of 1920 Dr. Rumely was still waiting for his day in court. His wife, Fanny, and their children returned to LaPorte without him. The yellow brick house on Rose Street was once again filled with the clamor of happy children. The oldest daughter, Mary, was nine, the second daughter, Isabella, was seven, and the only son, Scott, was two. "The children will play in the big dining room and gym this rainy day," Fanny wrote to her husband. "Ejnie [Isabella] told that Isamu was going to teach her how to swim, that he was a wonderful swimmer, etc. etc. . . . Isamu is very nice indeed. When I see him lokin [sic] a little long faced I jolly him up and he immediately responds and is so lightning quick at every thing he does. He considers M[a]ry's every wish the law. He really spoils her and she enjoys queening it."[42]

During the muggy Indiana summer Isamu stayed with the Rumely family, sometimes sleeping on a hammock strung on the veranda of Mr. Scott's house. The Rumelys also owned property in Michigan City, a nearby resort area on the shore of Lake Michigan. Isamu taught the children how to swim there. In snapshots of family outings to the beach, the children all wear one-piece black swimsuits. Isamu played with them like an older brother, his face wreathed in a happy smile. One snapshot shows him helping Julian Mack hoist Isabella into the air; others show him reading a picture book to Isabella and Scott or playing with the family's pet parrot, Polly, who could pronounce the names of all of the family members, including Isamu.

When the Rumely children returned to LaPorte again for Christmas, Isamu greeted them with presents he had made himself. A wooden sleigh he built survives only in a photograph, but a large dollhouse he made for Isabella sat in the Rumely living room for many years—and still sits in her daughter's attic. The fine detail is so elaborate that it is difficult to believe it was the work of a high school student. Isabella remembers that Isamu also made her a Cinderella carriage.

Dr. Rumely's trial finally began at the end of November 1920. The war had ended two years earlier, and the trial was perfunctory. At the end of two weeks, Dr. Rumely was convicted as charged and sentenced to prison for a year and a day. He insisted on his innocence, but paid a $10,000 fine, then promptly filed an appeal of the verdict. The case was not resolved until several years later.

On the beach at Lake Michigan (Julian Mack at left; Isabel Rumely in middle; Isamu at right)

On June 7, 1922, Isamu Gilmour graduated from LaPorte High School. "Supper was topped off with a huge strawberry shortcake smothered with Fulton County whipped cream," he wrote Dr. Rumely. "Mrs. Rumely, Mary, Mrs. Helen Smith, Dr. Mack and Mrs. Bradley attended my commencement last night. I was rather surprised to see Mary keep awake. We arrived home about ten o'clock and ate some more of that wonderful shortcake."[43]

Isamu had worked hard to prove himself to the two men who had treated him with such kindness—Dr. Rumely who had "discovered" him, and Dr. Mack, who had taken care of him. His school record was outstanding. His grade average was 92, and he graduated at the top of his class. He also drew illustrations for his class yearbook and designed its cover—a pen drawing of two Grecian-looking male nudes and a triangular stone tablet incised with the class year "1922." In his yearbook photograph he sports a strange pompadour, a mound of hair piled on top of his head like a soufflé, with the sides close-cropped. It was not a faddish teenage style but a free haircut provided by a local barber school.

The yearbook listed each student's school activities—clubs, sports, theater groups, elocution, and the like—alongside their photographs. Among the thirty male and thirty-four female students, only two listed no activities at all—Isamu Gilmour and Harold Kelling. Kelling's parents were poor, and like Isamu he had to work after school delivering newspapers, so he had no time for school clubs or sports. Now in his nineties, he says that Isamu was known at school by the nickname "Sam" and that he was always a loner who kept to himself.

Isamu remembered feeling isolated during his years in LaPorte. "I did not have intimate friends, excepting for the Rumelys and the Macks. . . . Those people were my friends and they helped me."[44] Perhaps as an instinctive defense mechanism, he never tried to become one of the crowd at school. If he kept to himself, no one could hurt him. But under the protection of Dr. Rumely, Isamu no longer felt like a pitiful "waif." His classmates elected him the "Biggest Bull-Head" in the class. Mimicking Henry Clay, he inscribed beside his yearbook photograph the personal motto: "Sir, I would rather be right than be president."[45]

"Isamu Noguchi"

"When I finished high school, Dr. Rumely asked me what I would like to do. I said promptly, artist. It was an odd choice, considering that art had become altogether foreign to me since coming to America. I did not show any particular aptitude. On the contrary, I had acquired what is known as a healthy skepticism, and perhaps even a prejudice against art, since my father was an artist—that is, a poet. Yet now my first instinctual decision was to become an artist."[46]

His response to Dr. Rumely did not spring from an irrepressible urge to create. He was still uncertain about what to do with his life. He had graduated from high school with a 95 in art, but his grades in science were better—97 in chemistry, 96 in mathematics, 96 in biology, and 93 in physics. Indeed, his record was good enough to get him into medical school. Isamu's childhood had been unstable, and Dr. Rumely wanted him to find a profession that would spare him economic hardship as an adult. He thought Isamu's great manual dexterity would make him a fine surgeon. Perhaps he also hoped that Isamu would follow in his own—and Dr. Mack's—footsteps.

Leonie had long since planted in Isamu a wish to become an artist. When he was still an infant she had told Yone that she "would like to put [Baby into] an Art School somewheres [*sic*], where he will have his eye and hand trained to express his ideas."[47] Even after Leonie sent Isamu back to the United States, she wrote to Catherine that he might return to Japan to enter art school after two or three years.[48] Consciously or unconsciously, her hopes had taken deep root in Isamu's mind. It was she who pointed out the path that he was ultimately to follow.

Dr. Rumely raised no objections when Isamu said that he wanted to become an artist. Instead he suggested that Isamu test the possibility for himself. The summer after his high school graduation, Rumely arranged for him to work with an old friend, the sculptor Gutzon Borglum, who later carved the gigantic portraits of Washington, Jefferson, Lincoln, and Theodore Roosevelt on the face of Mount Rushmore. "I began to do sculpture," Noguchi later recalled, "because of my admiration for Rodin,"[49] and it was Rodin who had discovered Borglum's talents as a student. Borglum was working at his estate in the Connecticut woods on a Civil War memorial with more than forty figures, including horses, commissioned by the city of Newark, New Jersey. Isamu's job was to pose as a model for General Sherman—and to keep the horses in line. "There was a horse there which was very ornery and didn't like to pose," he recalled. "So we would have to force him to pose . . . with his mouth sort of open and one leg up in the air."[50] For his weekly pay of five dollars Isamu also chopped firewood and tutored Borglum's ten-year-old son. Not once did Borglum make the slightest effort to teach him anything about sculpture.

Despite Isamu's professed admiration for Rodin, he knew nothing at all about the sculptor's craft. He absorbed basic sculpting skills by osmosis, carefully watching the dozen or so Italian plasterers and metal casters who worked as Borglum's assistants. Imitating what he saw, he fashioned his first work, a bust of Abraham Lincoln. The original piece no longer exists so it is impossible to say how successful it was, but at the end of the summer, Borglum made it clear that he had little regard for Isamu's talent. "Borglum told me I would never be a sculptor," he later said.[51] He remembered Borglum as "an irascible fellow" with a rough and violent temperament who enjoyed making others uncomfortable. "I didn't get along with Borglum very well. . . . He didn't get along with anybody, for that matter."[52]

It was perhaps with some relief that Isamu left his brief apprentice-ship and returned to New York City, where he was reunited with the Rumely family at their apartment on Riverside Drive. For an adolescent who had come straight from a sleepy Midwestern town, New York City was full of exciting things to see and do. "I felt liberated coming from the countryside to a big city like New York," he recalled.[53] During the 1920s the American economy was growing faster than ever, and the city distilled the energy and prosperity that invigorated postwar America. The skyscrapers that defined the Manhattan skyline were rising ever higher, and the streets glittered with the technology of the new age, from automobiles to neon lights. New York had emerged as the center of a new American culture.

After settling in with the Rumelys Isamu decided to follow Dr. Rumely's advice. In February 1923 he enrolled in the premedical program at Columbia University. Dr. Rumely and Mr. Scott paid his tuition fees. Dur-ing his first summer vacation as a premedical student, he returned to LaPorte with the Rumely family to work as a chauffeur for Mr. Scott, who was now nearly eighty.

In early September the headlines reported that a huge earthquake had struck the Tokyo-Yokohama region. Nearly 100,000 died in the catas-trophe, and two-thirds of Tokyo was reduced to ashes by the fires that spread after the quake. Happily Isamu did not have to worry about the fate of his mother Leonie and his younger sister Ailes. Three years earlier, in 1920, they had returned to the United States and settled in San Francisco.

The homecoming had not been easy for Leonie. She could not find work as a teacher so she scraped together a living by selling woodblock prints, netsuke, and other Japanese trinkets. Even so she still had trouble paying her bills. She moved from lodging to lodging after being evicted for defaulting on the rent. After arriving in San Francisco she made no attempt to arrange a reunion with Isamu. With her limited means, she did not have enough extra money to travel east for a visit. More than anything else, how-ever, she thought it best to leave Isamu in Dr. Rumely's care so that he could complete high school in supportive family surroundings. For his part Isamu, even though living with strangers, did not want to interrupt his stable life in LaPorte. But when Leonie learned that Isamu had enrolled in the Colum-bia premedical program she decided to return to the East Coast.

In early September 1923 Isamu wrote Dr. Rumely from LaPorte that he had to go back to New York to take his "defficiency [sic] examinations"

at Columbia. "I want to be with my mother," he added.[54] But Isamu had been separated from his mother for five adolescent years, and he had grown apart from her. "If she had thought to break my independence in sending me away, my own reaction had been to feel deserted," he recalled. "My extreme attachment never returned, and now the more motherly she became, the more I resented her."[55]

By the time mother and son were reunited in New York, Leonie was forty-nine years old. Isamu was shocked to see how old and worn she looked. Ailes, who attended the Ethical Culture School on a scholarship, remembered their life in New York as more difficult than it had ever been. At first Leonie tried to peddle Japanese goods as she had in San Francisco, and for a time she also worked in a shop selling Oriental knick-knacks. It was painful for Isamu to see how insecure his mother's life had become. Even though he had delivered newspapers and worked at odd jobs to earn spending money, Dr. Rumely's financial support had dispelled his worries about money. Now that he understood what a normal family was like, Isamu was less forgiving of the way his mother lived. He began to question the choices she had made, choices that denied him a sense of security as a child.

The growing emotional breach between Isamu and his mother was exacerbated by his close relationship with Dr. Rumely, who treated him like a son. Leonie recognized her debt to the man who was "Isamu's best friend and adviser," but she could not forgive him for persuading Isamu to go into medicine. Indeed that was the reason she had decided to come back to New York. Shortly after her arrival she visited Dr. Rumely. Instead of thanking him for his kindness to her son, she raised an "awful row," hotly denouncing him for "turning a boy of artistic temperament toward a career for which he was entirely unsuited."[56] To her way of thinking economic stability ought not be a major consideration in choosing one's life's work, nor did she think uncertainty about the future was any reason to give up a life as an artist.

When Isamu left for America as a thirteen-year-old, his mother had been the only person in the world he could depend upon. Now he was a rebellious nineteen-year-old who wanted his independence. He lived with his mother and his sister Ailes for only three months. "I didn't want her to tell me what to do, you see," he recalled. "I was very independent-minded. . . . I lived with her a while, but I didn't like it."[57] He moved into a cheap apartment in Greenwich Village, attending classes at Columbia during the

day and washing dishes in a restaurant at night. But he was restless and unhappy. He hated his premedical training. The only teacher he could later remember was a Dante professor who gave him passing grades no matter what he did. "In my two years at Columbia [I was] totally isolated. . . . I don't have any recollection of any friends at Columbia. Attending class, that's all . . . and hating it. . . . I didn't associate with anybody. I don't know a single person who I would consider having had as a friend there."[58] But his world was gradually expanding beyond his mother and his sister, and even beyond the Rumely family, too.

Later in life Isamu projected an image of himself as someone who had struggled on his own since childhood. He always took pains to distance himself from his father, sometimes even insisting that he knew nothing about his father's literary work. But his hostility toward his father was mingled with admiration, and even a bit of pride at his father's accomplishments and his international reputation. He was not only familiar with his father's English poems, he also told his friends about them. He also made the acquaintance of Yonejirō's friends and colleagues, capitalizing on his relationship with them. In one way or another, many helped advance his career. But out of continuing resentment toward his father, in his later reminiscences he often downplayed the importance of these connections or this side of his relationship with this father.

Shortly after entering Columbia, Isamu was befriended by Hideyo Noguchi (no relation), the famous bacteriologist, whom his father Yonejirō met during his 1920 stay in New York. Hideyo Noguchi played *shōgi* (Japanese chess) at the Japanese Club, and the two men soon became friends. Hideyo Noguchi was one of the scientific celebrities of his day. Widely considered a candidate for the Nobel Prize, he was known for his discovery of the spirochete bacteria that caused syphilis and for his studies of yellow fever in South and Central America. He had an American wife but no children. Noguchi often took Isamu to dinner at one of New York's Japanese restaurants. He introduced the young premedical student to Dr. Simon Flexner, his mentor at the Rockefeller Institute, and offered him a job as an assistant after he completed premedical studies.[59]

One day Isamu casually asked Noguchi whether it would be more meaningful to spend his life as a doctor or as an artist. "An artist, of course," replied Noguchi. "Become an artist as your father is."[60] Isamu was

surprised to hear his first Japanese hero discourage him from going into medicine. It does not seem likely that Noguchi offered his unexpected advice because he recognized Isamu's potential as an artist. He may simply have been expressing doubt about his profession after being dragged into a bruising public debate after other bacteriologists had questioned his discovery of a yellow fever virus. But for Isamu, who still lacked confidence about becoming an artist, Noguchi's words were like a stone tossed in a pond, sending ripples of uncertainty across his mind.

The dancer Michio Itō, another of his father's acquaintances, also had a profound impact on Isamu as he pondered his future. Itō was the eldest of several brothers—including the stage designer Kisaku Itō and the director Koreya Senda—well known in the Japanese theater world. Itō had gone to Paris to study opera, but decided to become a dancer instead after seeing the spectacular performances of the brilliant Russian dancer Nijinsky and the free choreography of Isadora Duncan. During World War I Itō moved to London, where he frequented William Butler Yeats's salon, and he achieved celebrity when he performed in Yeats's "Hawk's Well," a one-act play written for him in the style of a Noh drama. Moving to New York at a time when classical European-style ballet was still the mainstream in American dance, Itō developed an avant-garde style that incorporated everything from the tango to sword dances. His innovations had enormous impact on a generation of young American performers who were to become the pioneers of modern dance in the United States.

When Isamu met him the thirty-one-year-old Itō was running his own dance studio on Madison Avenue and choreographing Broadway shows. A playboy since his teens, the dashing Japanese dancer cut a dynamic and dazzling figure. He had just married one of his American students, but he still liked to be surrounded by beautiful young women. Isamu later recalled how much he had learned from Itō and his younger brother Yūji, a stage-set and costume designer. As he vacillated between choosing a career in medicine or a life in art, Michio Itō's example probably influenced him more than Hideyo Noguchi's advice.

From his childhood Leonie had steered Isamu toward a world that transcended borders, a world cut free from the fetters of country, ethnicity, and birth. Michio Itō was the model of a man who lived in such a world. As he observed Itō's life, Isamu, branded as a "freak" from childhood, came to realize that though culture differed from country to country it was pos-

sible to express universal human emotions that transcended national borders. He also learned from Itō that to be different from others, to sprout from a different seed, made it easier to express one's individuality. The search for identity that began in his childhood, when he wondered where he belonged or where he might find a peaceful haven, was the psychological starting point of his decision to become an artist. Hideyo Noguchi's advice only confirmed what Isamu's own internal voice already told him.

"After all," he later remarked, "for one with a background like myself the question of identity is very uncertain. And I think it was only in art that it was ever possible for me to find any identity at all. . . . [I]t is only in art that a person who does not belong with any social contact . . . could find a viewpoint on life which is free of social contact. One can be an artist and alone, for example. An artist's life is really a lonely life. It is only when he is lonely that he can really produce. If he is not lonely, he may be a social, nice person but, you know, he might not be driven to it. After all, in a sense you're driven to art out of desperation."[61] Until the end of his life Isamu thought of himself as a pariah. "The artists were all pariahs to start with," he once said. "And I, being a pariah, was among pariahs and was no longer a pariah."[62] It was through his art that he could communicate with others, and it was through his art that he felt part of a community.

"I saw an art school on Avenue A," Leonie told Isamu one evening. "Why don't you go there?"[63] The Leonard da Vinci Art School, housed in the former St. Mark's Memorial Church on the Lower East Side, near Greenwich Village, had opened its doors six months before. Local Italian-American community leaders, worried that under Prohibition Italian-Americans were identified with rum-smuggling gangsters, had raised funds for a school to train their children in the arts and crafts of their homeland. Classes were held in the evening, and tuition was free. "I walked there and looked around, rather disdainfully," Isamu recalled. When the school director Onorio Ruotolo asked him, "Wouldn't you like to study here?" Isamu dismissively answered that he wasn't interested in sculpture. "I just came by because my mother told me to come and take a look," he said. Ruotolo was insistent. "Oh come on, try something." When Ruotolo saw a clay copy Isamu made of a plaster foot, he immediately admitted him into the school.[64]

The thirty-eight-year old Ruotolo, known as "the Rodin of Little Italy," was a large muscular man. Born in Italy, he had studied at the Royal

Academy of Fine Arts in Naples where he became a protégé of Vincenzo Gemito, one of Italy's most distinguished sculptors. Seized by an urge to go to America, he had moved to New York in 1908, supporting himself as a reporter for an Italian-American immigrant newspaper while establishing himself as a sculptor. Many of his commissions came from Italian-American organizations, and he was known for his intensely naturalistic portrait busts of Dante, Enrico Caruso, Helen Keller, Thomas Edison, and other famous persons.

His only son, an emeritus professor of English at Stanford, says that Ruotolo immediately recognized Isamu's exceptional talent. "He thought he was the second coming of Michelangelo."[65] Most aspiring young sculptors in New York entered the Art Students League school, but Isamu chose not to follow this conventional course. Infected by Onorio Ruotolo's enthusiasm, he took evening classes at the Leonardo da Vinci School while commuting to his premedical classes at Columbia during the day. Most of the other students came from Italian immigrant families. Perhaps, as he told a newspaper reporter a few months later, Isamu wanted "a place where he might work without too much confining of his individuality, such as he had experienced in his desultory studies before."[66] Isamu was clearly uncomfortable with too much authority and too much discipline.

Isamu began working with clay. Ruotolo was determined to make him into a sculptor. Since Isamu's double life took a heavy physical toll, Ruotolo offered to pay him the five dollars per week he earned as a dishwasher to clean up and help out at his studio. Although Ruotolo ran the school out of a sense of service to the Italian-American community, he made a living from sculpture commissions and woodcut book illustrations. As his assistant, Isamu learned basic sculpture techniques with a speed that amazed Ruotolo. After only three months, Isamu held his first show of twenty-one plaster and terra-cotta pieces in the school lobby. The unusual event was a token of Ruotolo's high regard for his natural gifts.

"19-Year-Old Japanese American Boy Shows Marked Ability as a Sculptor" ran a headline in the August 24, 1924, issue of *The World and Word*. A photograph of Isamu surrounded by pictures of four of his sculptures—*Fountain Study, Christ-Head, The Archer*, and *Salome*—stood at the top of the article. "He looks most like one of those meridional lads the romantic painters used to pick in Rome near the Fontana de Tartarughe, to place on canvas with guitar and cluster of lime blossoms behind one ear,"

gushed the reporter, who thought Isamu looked like a "Donatello faun." He was impressed that in just three months the young artist had produced works "of lasting value" and praised his "gift for endowing his busts with personality." The sculpture of Christ, he concluded, had "the mature feeling for a person that is more than human, a sorrow more than divine."[67]

On Ruotolo's recommendation Isamu was elected a member of the National Sculpture Society, and he exhibited work at the National Academy of Design and the Architectural League, both influential institutions in the New York art world. He also began to work at Ruotolo's atelier in an artists' district on Fourteenth Street several blocks north of Washington Square. Isamu soon had a falling out with his teacher. When he rudely turned several of Ruotolo's friends away from the studio one day because he did not want to interrupt his work, Ruotolo was furious, and he told Isamu to leave. But there were other, deeper reasons for the break. Isamu's attitude toward his mentor's art was changing almost as rapidly as his skills at sculpting.

In 1908 the American art world took its first step into the twentieth century with an exhibition by "The Eight," a group of realist painters whose work was rejected by the National Academy of Design. Rebelling against conservative academicism, the "Independents" exhibited paintings depicting lower-class urban life—the vibrant life of the streets, the music halls and saloons, and the working-class ghettoes. The exhibition appalled the art establishment. One critic even called "The Eight" a "revolutionary black gang." Five years later the 1913 Armory Show, the first big exhibition of modern art in the United States, sent another shock wave through the art world. Works like Henri Matisse's *Red Studio*, with its brilliantly intense primary colors, and Marcel Duchamp's *Nude Descending a Staircase, No. 2*, with its fractured abstraction of a female figure in motion, provoked hostile reviews and popular ridicule. The exhibition nevertheless had an enormous impact on young American artists like Georgia O'Keeffe, Joseph Stella, John Marin, and Arthur Dove, who were encouraged to experiment in new ways. Stuart Davis later called the Armory Show the greatest single influence on his work.

By the 1920s modern art had established a firm foothold in New York City. Onorio Ruotolo, who thought that Michelangelo represented the pinnacle of sculptural art, completely rejected avant-garde modernism but Isamu's young artist and sculptor friends ridiculed worship of naturalistic figurative sculpture. Isamu, a child of his times, was also seduced by the "modern." It was almost a rite of passage for him to reject his teacher's

academicism. Like any creative artist, after mastering basic techniques he wanted to establish a distinctive personal style by transforming and transcending accepted artistic conventions. Even during his early years as a sculptor he was never content to do the same thing over and over again. He explored one new creative path after another.

In his autobiography Isamu placed complete responsibility for his shift from the naturalistic to the abstract on his teacher Onorio Ruotolo. Indeed he disparaged his own early training in figurative sculpture. "Alas, all this was false feeding," he said. "Everything I learned I had to unlearn. This was the slick and quick way of doing academic sculpture."[68] Rejection of the figurative was a rejection of Onorio Ruotolo. To be sure, Isamu later expressed appreciation for what his first teacher had done for him. In a 1952 interview with a Japanese magazine, for example, he remembered Ruotolo as "an academic artist" who gave him unselfish and devoted guidance. "It was as though nurturing me had given his life a purpose," he said.[69] And in the final year of life he recognized that Ruotolo had given him confidence and led him to the most important turning point in his life.[70] Sadly, Ruotolo, deeply disappointed at Isamu's earlier criticism, did not live to hear these words of gratitude.

After being thrown out of Ruotolo's studio, Isamu found a new one at 127 University Place. It was here that he received his first commission as a sculptor: a portrait bust of Emmet Scott, Dr. Rumely's father-in-law, who had died a few months earlier. Even though he fashioned the bust from a photograph he managed to capture his subject's open and generous character. The Rumely family also commissioned him to make a bust of Dr. Rumely's mother and profile relief portraits of their four children, including their new daughter Niles, and Dr. Rumely introduced him to prospective clients among his well-to-do business friends.

The Supreme Court upheld the lower court's guilty verdict and sentence in Dr. Rumely's perjury case, but since he was well connected in the Republican Party he was freed by presidential pardon after only a month in jail. Even in the midst of his personal troubles Dr. Rumely continued to encourage Isamu. "You have the real stuff in you!" he wrote him. "I admire that quality which enables you to stick through the night to get out a job. It is that quality which will carry you far in life, and which is so valuable in combination with your sensitiveness and your artistic abilities."[71]

Isamu also made portrait busts of young women he met at the Leonardo da Vinci School—*Georgina*, *Magdalene*, and *Nuska*. The model

Isamu with a portrait bust of Emmet Scott, 1924

for his first large work, *Undine*, which took eight months to finish, was a
Russian ballerina named Nadja, who promised to pose free if she got 10
percent of the sale price. The statue, vibrant with lithe movement, was the
figure of young woman with a fresh girlish face, her body twisted in a
voluptuous pose with her hands clasped invitingly above her head. Isamu
produced works that became more and more technically accomplished but
he still had not established a style of his own. "By twenty-one I had run the
gamut," he later recalled, "and was disillusioned."[72]

Modern art exhibitions were still uncommon in New York galleries but
Isamu began frequenting shows at Alfred Stieglitz's Intimate Gallery (later
An American Place) and J. B. Neuman's New Art Circle, a gallery special-
izing in German avant-garde art. Exchanging even a few words with these
two pioneers, already recognized as legendary figures for their contribu-
tions to American modernism, was an exciting experience for him.

The first of his works to break away from a conventional academic
figurative style was a bronze of Michio Itō that looked more like a Japanese

Isamu at work on Undine, *1926*

Noh mask than a portrait bust. It marked the beginning of Isamu's transition from the realistic to the abstract. The simple but powerful molding of the clay accentuated Itō's strong brooding features and a rope-like strand of hair dropping dramatically down the left side of his head captured the muscular dancer's masculinity. As Itō sat for the portrait, he regaled Isamu with tales of his youthful days when he went to Paris at the age of nineteen, the same age that Isamu had decided to become a sculptor. As an artist who built a career in a foreign land by creating "an art that joined the

tranquility of the East with the activity of the West," Itō was an inspiration to Isamu. "Do the impossible!" Itō constantly urged him.[73]

In late 1926 Isamu applied for a Guggenheim Fellowship. The director of a bronze foundry where Isamu did his casting told him that Harry Guggenheim had seen a piece of his sculpture there and urged that he apply for a fellowship. The program, established just a year before with funds from the Guggenheim family's copper-mining fortune, offered young artists, authors, and scholars the opportunity to study abroad. Applicants were required to be between the ages of twenty-five and thirty-five. Even though he was only twenty-two, Isamu was nonetheless one of the three artists selected for the fellowship. His application had included a letter of recommendation from Alfred Stieglitz.

In his statement of purpose, Isamu set forth ideas that he carried through the rest of his life:[74]

> It is my desire to view nature through nature's eyes, and to ignore man as an object for special veneration. . . . An unlimited field for abstract sculptural expression would then be realized in which flowers and trees, rivers and mountains, as well as birds, beasts, and man, would be given their due place. Indeed, a fine balance of spirit with matter can concur only when the artist has so thoroughly submerged himself in the study of the unity of nature as to truly become once more part of nature—a part of the very earth, thus to view the inner surfaces and the life elements. The material he works with would mean more to him than mere plastic matter, but would act as a coordinant [sic] and asset to his theme. In such a way may be gained a true symphony in sculpture.

Isamu had learned how to work with clay but he still lacked skill in carving stone and wood. He proposed to spend the first year of his fellowship in Paris "studying stone and wood cutting and gaining a better understanding of the human figure." During the second year he planned to go to Asia, first visiting India, then traveling through China to Japan, where he hoped to hold an exhibition before returning to New York. "I have selected the Orient as the location for my productive activities for the reason that I feel a great attachment to it, having spent half my life there. My father, Yone Noguchi, is Japanese and has long been known as an interpreter of the East to the West, through poetry. I wish to do the same with sculpture." He concluded his application politely: "May I, therefore, request your assistance in enabling me to fulfill my heritage?"

Isamu entered the American art world tagged as a Japanese-American artist. The reviewer of his first exhibition identified him as "Japanese-American," and six months later an article in the February 1925 issue of *American Boy* magazine described him as a "Japanese-American boy . . . who critics say is one of the most promising young sculptors in the world."[75] Although Isamu disliked the label "Japanese-American" it stuck to him throughout his career.

It is worth noting that from the moment he embarked on his career as a sculptor he started calling himself "Isamu Noguchi" again. Until he was eight years old he had gone by that name, but he took his mother's surname when he attended St. Joseph's School in Yokohama and the Interlaken School in LaPorte. In his autobiography Isamu suggested that he had changed his name for no particular reason. "I had become completely Americanized," he wrote. "There was no hint of Japan about me. Yet when I finally became conscious that I was a sculptor, I decided almost involuntarily to change my name, adopting one that perhaps I had no right to. I could see my mother's consternation, but she did not object, helping me rather in my travail, away from her, toward Japan, and the way that I had chosen."[76] In fact, his decision to change his surname as he launched on his career as an artist suggests that it was indeed a voluntary and conscious act. In taking back his father's surname, Isamu was bidding psychological farewell to his mother, the parent who had single-mindedly hoped that he would become an artist, and it was precisely for that reason that he began to deny that he was his mother's child when he decided on an artistic career.

The Noguchi surname had a celebrity value, too. It was well known in America because of his father. What identified Isamu with Japan, wrote the reporter from *The World and the Word*, was not that he looked Japanese, but that he was "the son of Yone Noguchi, a Japanese writer who helped translate the spirit of Japan in his books and poetry and art criticism."[77] From his debut as a sculptor, Isamu was defined not simply as "Japanese-American" but as the son of a famous father. Although he later dismissed his father as someone who "simply planted his seed," he was also keenly aware of the value of his father's reputation. It was only because he was Yonejirō's son, for example, that Hideyo Noguchi and Michio Itō had taken notice of him while he was still just a student.

"As to why I felt it was inappropriate for a sculptor to have a name like Gilmour and appropriate to have a name like Noguchi," he said toward the

end of this life, "I can not tell you."[78] But Isamu knew that the surname Noguchi set him apart, and by reclaiming it as he began his career as an artist, he was flaunting the "exotic" blood that ran in his veins. It seemed a natural thing to do. As he later observed, "I associated in some way the life of art closer to Japan than America."[79] His visual sensibility had been formed as a child in Japan, and the imprint of that experience often prevailed over his conscious actions. Whenever he tried to express himself creatively, the Japanese sense of beauty deeply rooted in him sprang to the surface. Consciously or not, his creative urge gave form to the Japan within him, and by changing his surname Isamu linked his artistic reputation to Japan.

Yonejirō had made a name for himself as "an interpreter of the East to the West" through his poetry. When Isamu told the Guggenheim Fellowship committee that he wanted to fulfill his heritage, it was not merely a rhetorical flourish. His words expressed his ambivalent feelings as a son. The more he longed for the absent father who never recognized him as a son, the more he despised him—and the more he wanted to be like him.

When asked several months before his death about the forces at work creating a work of art, he replied, "There are many emotions that get you going. One of them is anger, one of them is the desire for creativity. It's out of despair and conflict. . . . Conflict is then the spark of creation."[80] As he launched his career he directed his creative anger toward his father. Love and hate for Yonejirō, bottled up for so long, lit the fires of his ambition. In taking his father's surname without his father's permission he was not only reclaiming his rights as a "Japanese," he was also transforming his smoldering anger into a vital creative drive. "I am a fusion of East and West," he later said, "but I want to transcend both worlds."[81] Ironically, his father's passionate dream of conquering two cultural worlds had taken firm root in his bastard son.

The face in the passport photograph of the twenty-two-year-old mixed-blood child is a fierce one. His wavy black hair stands on end; his broad brow is knit taut; his mouth is drawn in a tight and determined line; and his eyes stare defiantly at the camera. It is the belligerent expression of an Ashura, one of the fighting guardian deities found at the gate of a Buddhist temple. It is a face trembling with endless ambition and uncertainty about the future, but it is also a face aflame with youthful energy, ready for battle. It is the face of a youth who has begun a lifelong marathon but is racing as though he were running a 100-yard dash.

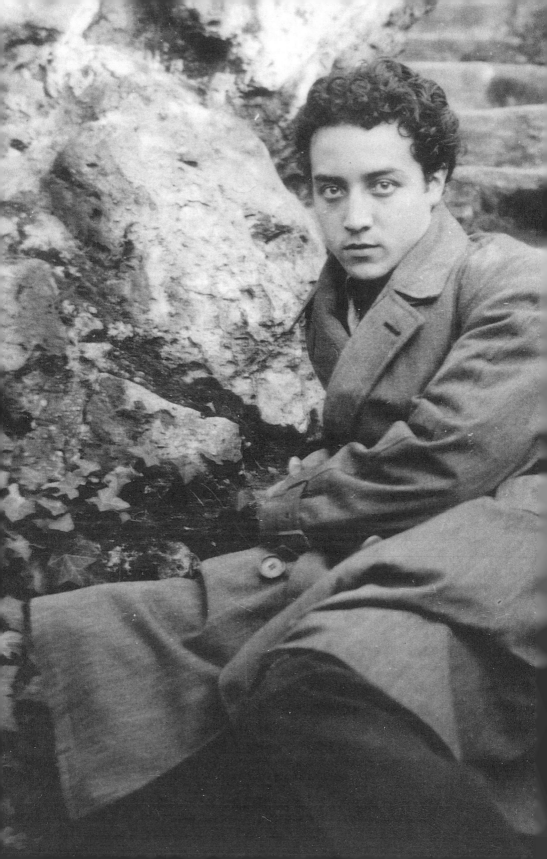

Journey of Self-Discovery

A Youth in Paris

On May 21, 1927, Charles Lindbergh landed at Le Bourget Airport on the outskirts of Paris in his single-engine plane, *The Spirit of St. Louis*. The people of Paris poured into the streets to welcome the All-American hero, the first man to succeed in flying solo across the Atlantic. Among them was Isamu Noguchi. Seven weeks earlier he had arrived in Paris, "the heart of all that mattered."[1] After World War I, new movements in art, in literature, in theater, in dance, and in other cultural spheres erupted across Europe in reaction to the experience of wartime death and horror. During the 1920s Paris was at the center of this pan-European cultural renascence, attracting artists, some real, some self-proclaimed, from all over the world. Aspiring American writers, journalists, painters, and sculptors flocked to the city, where every sort of avant-garde movement—Cubism, Dadaism, Surrealism—was flourishing.

The day after his arrival in the "miraculous April of 1927," Isamu sat sipping coffee at the famous Café de Flore on the Left Bank. Half the customers watching the native Parisians pass by seemed to be American tourists or aspiring American artists. Chatting excitedly about being in Paris, Isamu spoke of his great admiration for the work of Constantin Brancusi. Four months before leaving for France, he had gone to a Brancusi exhibition at the Brummer Gallery in Manhattan in November 1926. Brancusi's close friend Marcel Duchamp planned the show, and it was soon the talk of the New York art world.

Brancusi, raised on a farm in Romania, had come to Paris in 1904 to study at the Ecole des Beaux-Arts. He had been an admirer of Auguste

Rodin, and even worked for him after graduating from art school, but as Brancusi later commented, "Nothing grows under big trees." Fascinated by the African masks that inspired the Cubist movement, the Egyptian and Asian sculpture in the museums in Paris, and the symbolic decorations in the folk architecture of his native land, he gradually moved toward abstraction. At the 1913 Armory Show, his abstract sculptures caused a sensation. *The Kiss*, a sculpture of two lovers, their breasts and lips locked in embrace, carved from a single rectangular block of stone with moving simplicity, and *Sleeping Muse*, an egg-shaped bust of a woman with almost indistinct features, revealed that the art of sculpture had moved beyond an era defined by Rodin's figurative style.

Bird in Space, one of the works in the Brummer Gallery show, attracted much critical attention. The sculpture, a slender, yellow marble propeller-like form poised on a short, slightly tilted cone, captured the moment of a bird soaring into flight. It was a motif that Brancusi experimented with throughout his life. It pared line and form to a minimum, omitting any fine detail. Brancusi pushed simplicity to the limit in his abstract sculptures by discarding all but a suggestion of the figurative. When Isamu saw the show, he recalled, "[It] completely crystallized my uncertainties. I was transfixed by his vision."[2]

It was these feelings that Isamu shared with others as he sat at the Café de Flore. "Robert McAlmon, who overheard me, said he would be glad to introduce me," he wrote in his autobiography. "Great good fortune such as this has something of the divine and inevitable."[3] McAlmon, an American short-story writer, had lived in Paris for many years. Today he is known less for his writing than for the company he kept. He went with Ernest Hemingway on his first trip to see bullfights in Spain, and he typed the last half of the *Ulysses* manuscript for James Joyce. Those who knew McAlmon thought him outspoken but cold. It is difficult to believe that in a Paris overflowing with aspiring young American artists, he would take an unknown student met by chance in a café to meet Brancusi, who was well known for rarely meeting anyone. It seems likely that Isamu's introduction to Brancusi was not a stroke of "great good fortune" but a prearranged meeting.

On his way to Paris Isamu had stopped in London. On the evening of his arrival, he was taken to dinner at the Café Royale by Nina Hamnet,

a painter who had lived in Paris for many years. Michio Itō had given him a letter of introduction. Hamnet was a member of Brancusi's small circle of friends. When the sculptor Jacob Epstein fashioned a statue decorated with an erect penis for Oscar Wilde's grave in a Paris cemetery, she and Brancusi had accompanied him daily to remove a cloth the scandalized authorities had draped over the offending member. During a visit to London, Yonejirō had met not only Epstein, but also Henri Gaudier-Brzeska, a pioneering avant-garde sculptor who later died in World War I, and Nina Hamnet, who was Gaudier-Brzeska's lover at the time. In a 1975 interview with a Japanese art magazine, Isamu recalled that Hamnet was the first person he talked with about Gaudier-Brzeska.[4]

When Hamnet met Isamu, an aspiring young sculptor like her own former lover, he may have told her about the Brancusi exhibition that had transfixed him, and she may have mentioned that her good friend "Bob" McAlmon was acquainted with Brancusi. In short, it seems possible, perhaps even likely, that Hamnet provided Isamu with his "miraculous" opportunity to study with Brancusi. By later telling the story of his meeting with McAlmon as a matter of "great good fortune" he tried once again to conceal an important connection between his father's friends and his own success.

Brancusi's studio at 8 Impasse Ronsin, a dead-end alley abutting the grounds of the Necker Children's Hospital, was about a twenty-minute walk from the Café de Flore. From outside the building looked like a warehouse. One side was lined with glass windows, and inside a two-story-high stairwell reached its ceiling. "The first time I went to see the sculptor Brancusi in his studio," said the photographer Man Ray, "I was more impressed than in any cathedral. I was overwhelmed by its whiteness and lightness."[5] Isamu was overwhelmed by Brancusi's "all-white world," too. When they first met the fifty-one-year-old Brancusi was clad in a white smock. His hair and beard were already turning white, and even his two pet dogs were white. "I remember feeling strangely moved," Isamu recalled. "Brancusi himself, everything in the studio, the pieces of wood and marble and plaster, in fact the whole studio itself felt pure white. I felt the greatness of Brancusi's art the moment I stepped into his studio."[6] The works that had excited him at the Brummer Gallery show sat on pedestals, looking less like works in progress than works on exhibition.

"My memory of Brancusi is always of whiteness and of his bright and smiling face." Although Isamu had not gone to Paris intending to study with Brancusi, he asked to work with him. "Somehow the words came out," he recalled. Brancusi never took students or apprentices. It was his principle that the artist had to work alone, doing everything himself. "An artist should always do his own chores," he declared, "a sculptor's toil is slow and solitary." But when Isamu, with McAlmon interpreting, asked Brancusi if he needed a helper for stone cutting, and added that he was willing to work without pay, Brancusi accepted the offer. "It was understood," Isamu recalled, "that I would work in the mornings with him, starting the very next day."[7] Within a day of his arrival in Paris, Isamu had become an assistant to a pioneer of avant-garde sculpture. His success demonstrates his gift for making his own opportunities—and it also brings to mind his father's visit to Joaquin Miller with a plea to study poetry with him.

Isamu spoke little French, and Brancusi spoke no English. "Communication was through the eyes, through gesture and through the materials and tools to be used," he later wrote. His first task was to square and smooth a piece of limestone for a pedestal. Isamu was skilled at working with clay and plaster but he had no experience handling stone. He did not even know what tools to use. At first he was not much use as an assistant. "Brancusi would show me . . . precisely how a chisel should be held and how to true a plane of limestone," he recalled. "He would show me by doing it himself, indicating that I should do the same. . . . It had to be done just his way no matter how long it took me to master it."[8]

Large and small files, wood chisels, hammers, compasses, and stone chisels hung in several neat rows along one wall of the white studio like works of art on exhibition. Brancusi carefully selected each for the job at hand and honed it carefully. As fastidious with his tools as the Japanese carpenter Isamu worked with as a child, Brancusi had "the same kind of love for the material, the pristine, original, basic material" that Japanese craftsmen did. "It was the wood itself and its contact with the chisel that he liked—not something faked up, painted or ill-treated," he later recalled. "Brancusi, like the Japanese, would take the quintessence of nature and distill it. [He] showed me the truth of the materials and taught me never to decorate or paste unnatural materials onto my sculpture, to keep them undecorated like the Japanese house."[9]

In early July, Isamu arrived at the studio one day to discover that the floor had caved in to a cistern below under the weight of the sculptures. Duchamp arranged for Brancusi to move into two smaller studios across the street at 11 Impasse Ronsin, and Isamu worked day and night helping with the move. Every now and then he went to polish Brancusi's swanlike bronze *Leda*, then on exhibition there at the Salon des Tuileries, to keep its surface shining like a mirror.

Isamu spent seven months as Brancusi's assistant. During his apprenticeship his skills as a sculptor had not made much progress, but Brancusi's vision penetrated his whole being. Brancusi lived a modest bachelor's life, sleeping in a small room adjoining the studio and doing all his own shopping, cooking, and washing. Except for an occasional trip to see a movie on the Rue de la Gaieté, he was a man totally absorbed with his work. "The one thing he could not stand was lack of absolute concentration." He did not let Isamu's attention wander for even a minute. "Concentrate and stop looking out the window!" he would shout. "Whatever you do it is not for fun or study," he constantly told Isamu. "You must treat it as the best thing you will ever do."[10]

"One of the most important things I learned from him was the value of the moment," Isamu recalled. "I remember he used to say: 'Never make things as studies to be thrown away. Never think you are going to be further along than you *are*—because you are as good as you ever will be at the *moment*. That which you *do* is the thing.'"[11] Even in his later years Isamu felt that the greatest gift Brancusi had given him was the thought that he must treat every moment in life as though it were his most important possession.

Youth, too, is a moment that never comes twice. "There is no doubt that Paris has a very disintegrating effect upon certain natures," Isamu confessed in a letter to Dr. Rumely.[12] The Montparnasse district was a gathering place for artists of all sorts, French and foreign, from the famous avant-garde to the completely unknown, who congregated in local cafes at night, arguing about life and art until dawn, often in badly accented French. "Studios are very scarce around here," he told Dr. Rumely, "and were it not for the help of a friend I would not have been able to find one. As it is I will move into one next week—the address is 7 Rue Belloni."[13] Located about five minutes from Brancusi's studio, it had once been occupied by the American painter Max Weber. It was also less than a block

from the studio of Tsuguharu Fujita (also known as Tsuguji Fujita and Leonard Foujita), the Japanese painter who helped him find it.

Fujita was a darling of the Ecole de Paris, a circle of artists centering on Piet Mondrian, Marc Chagall, and Jules Pascin. After graduating from the Tokyo Academy of Art he had gone to Paris in 1913. His works were exhibited at the Salon d'Automne, the gateway to success in the world of modern art, and soon afterward he was chosen as a member of the salon's selection committee. His elegant style fused the delicate line of traditional Japanese painting with the solidity of Western realism, and his paintings, such as his reclining nude portrait of the famous model Kiki, were much sought after by collectors and dealers. "Fou-fou," as his friends had nick-named him, was a flamboyant character who wore his hair in short bangs and sported gold earrings. He lived at the heart of the "celebration and frenzy" of the Paris of the 1920s.

Michio Itō, who had met Fujita in London during the war, gave Isamu a letter of introduction. Fujita played the role of a Parisian *flaneur* with great gusto but at home he sat on the floor Japanese-style as he painted. Isamu visited Fujita's studio often, attracted as much by his lifestyle as by his style of painting. Separated from his first wife, a French woman who supported him when he was still unknown, Fujita was in the midst of a passionate love affair with a young French woman he called "Yuki." He lived with her in a studio different in every way from the monastic white world where Isamu spent his mornings with Brancusi. For Isamu it was a world no less fascinating.

Itō had also written Isamu a letter of introduction to Jules Pascin, a Bulgarian-born American painter who was a friend of the Swiss sculptor Alberto Giacometti and the Russian painter Chaim Soutine. Isamu had difficulty getting to know these artists since he could not speak French. "Far from my having to look for Americans," he wrote Dr. Rumely, "they are almost the only people with whom I come into active contact."[14] The other young Americans he met practically every day—Alexander Calder, Stuart Davis, Morris Kantor, Andrée Ruellan, and others—lived behind Montparnasse Station in an enclave on Rue Vercingetorix, exchanging news and gossip at neighborhood cafes in the evening. "Whereas previously I had very few friends, in France I suddenly came upon, you might say, people who either were like me, or that I could accept, or who would accept me."[15]

Isamu became a good friend of Calder, whose father and grandfather had both been sculptors. Indeed, Isamu had met Calder's father in New York, where he kept a studio in the same building as Onorio Ruotolo. Calder was building his famous miniature circus at the time, delicately fashioning tiny performers and animals from bent wire. He staged amusing shows for artist friends at first but as word spread about the acrobatics of his miniature trapeze artists, tightrope walkers, and trained animals he began giving performances for Paris society. Isamu introduced him to Fujita, who invited him to entertain at one of his parties, and Isamu often helped Calder by managing the lights and cranking the record player.

The two young men often met Calder at the studio of Andrée Ruellan, an American painter living near Stuart Davis's studio. In November 1927 Isamu wrote his mother: "As I have not yet received any letter in reply to my last, I take it that you are still perched on top of the mountains. Anyway, I am writing this in case you are in NY this winter—because—a young girl artist friend and her mother have recently left for the States and would be able to give you considered information concerning your son. . . . You know I have a prejudice about mixing female friends and mothers—however, I am giving this case a special dispensation. She is a nice girl, intelligent, etc—judge for yourself."[16] In his first letter from Paris, annoyed that Leonie had gotten in touch with one of his many girlfriends, Nadja, the young ballerina who modeled for his *Undine*, he had angrily complained that his mother was "poking around in my graveyard."[17]

Just before Isamu left New York, Dr. Rumely had thrown a farewell party at the Miyako, a Japanese restaurant. The Rumely family, Leonie, Onorio Ruotolo, some of Isamu's artist friends, and two young women attended. After a toast to Isamu's future success, Onorio Ruotolo gave a farewell speech. "I recognize that it is the prerogative of the great to speak their mind out freely," he began, "and to be so full of themselves that they will follow their own bent against every opposition and advice." Isamu's contrariness, he said, was the reason that he thought Isamu a genius, but he ended with an affectionate word of warning. After "profuse Italian bows and flatteries to the ladies present," he cautioned that even though women were undoubtedly the source of all inspiration in every art they were also "a source of danger." As he spoke Isamu winked at Nita, a model sitting at the end of the table, who blew back a kiss. Nita, who had modeled for Isamu's *Nuska*, was deaf and spoke with a slow and indistinct drawl. At the dinner

party she kept telling Leonie over and over again that Isamu was the "most wonderful, nice boy" she had ever met. When the guests gathered at the dock to see him board the ship, Nita wrapped her arm in Isamu's and "skipped about like a lamb." At their parting they kissed on the lips. "I suspect they're a romance there," Leonie wrote Catherine. "I wonder how long it will take to cure the ache of their parting and perhaps, probably find other lovers."[18]

Andrée Ruellan, whom Isamu wanted his mother to meet, was very different from his girlfriends in New York. Isamu described her to Dr. Rumely as "an extremely [t]alented young American artist" who had been working in Europe for the last four years and was returning to New York for an exhibition of her work.[19] Andrée, born in New York as the only child of French parents, was a year younger than Isamu. After graduating from the Art Students League, she had won a fellowship to study in Rome and Paris. Her father had died when she was fifteen but her widowed mother accompanied her abroad. The two women were very close, always cheerful, never quarreling. Other young American artists enjoyed visiting their one-room apartment-studio.

It was the fashion for young women, especially art students, to make themselves as striking as possible, with bobbed hair and short skirts. Andrée was an old-fashioned girl who put up her hair with bangs in front and a bun in the back and wore sweaters that her mother knitted. She listened to others attentively, her pretty, round face cocked to one side and her eager eyes glistening like a child hearing an adventure story. Two years after meeting Isamu she returned to live in the artists' colony in Woodstock, New York, her home ever since. Even in her nineties, she remained robust, sitting in front of her easel every day in the converted barn she used for a studio.

When Andrée reminisced about her days with Isamu during the "most wonderful time in Paris" her eyes sparkled, as they must have when she first met him.[20]

> Isamu spent only the morning in Brancusi's studio, and in the afternoon he studied sketching at the Académie Grande Chaumière and the Académie Collarosi. Since he had no formal training in art, he wanted to master basic design skills. I met him in the free drawing class at the Académie Chaumière. Every day after that we visited art galleries and museums together and went to cafes to talk about art. Isamu didn't know much about Paris so I took him on walks through the city. We didn't take the bus to go anywhere.

Mostly we just walked. He seemed to be attached to everything about Brancusi. He even wore Romanian wooden shoes like Brancusi did. And he talked over and over again about how Brancusi lived for nothing but work. I can't say that in our circle Isamu attracted special attention for his talent. But I thought that he had a wonderful sense of beauty.

Although Andrée never regarded Isamu as anything more than a good friend, he fell in love with her. Whenever he found another guest already at the apartment ahead of him he always made a sour face. "He made no effort to hide his jealousy or his hostility," said Andrée, "and he said cruel things to the other person. Or he carried on arguments about the most trivial things. My mother sympathized with how he had been brought up, and she was nice to him, but whenever he acted like that she told him, 'Isamu, if you don't change your attitude, you must go home.'"

"Sandy [Calder]," she recalled, "was good friends with Isamu, but they were so different—and not just physically." Calder, unlike Isamu, was a completely open person, who always arrived at the apartment on his bicycle wearing his favorite red socks. With a sly flourish he would pull a piece of cheese out of one jacket pocket, and a bottle of wine out of the other. The atmosphere was gay and lighthearted whenever he came around. "A lot of artists are extremely intense people. That's where their creative energy comes from. But I don't think that explains everything in Isamu's case. From his childhood something got twisted. He was part of our group of American artists but he never really showed his feelings to anyone. I think he was withdrawn from the very first."

Andrée accompanied Isamu to Fujita's studio several times. She thought it was good for Isamu to have ties with the Japanese community in Paris. "I felt that Isamu was different from the Japanese, too. Yasu [Yasuo Kuniyoshi] was a good friend of mine from Art Students League days, but he and Isamu were different, and not just in personality. Yasu was a Japanese but he chose America of his own free will. Isamu belonged to both countries from his birth but psychologically he didn't belong to either. Isamu was uncertain about his identity."

Although Isamu often told Andrée how bitter he felt toward his father, he was proud of Yonejirō's work, and even gave Andrée a collection of his English poems. "I remember talking with him about his father's poetry. When I looked at his father's picture in the front of the book, I thought how much his craggy face resembled Isamu's. When I went back to

New York for my first exhibition, I visited his mother as Isamu asked me to. She was living in a very poor apartment, and she had a very pale face. She was soft-spoken and seemed to be a very reserved person. That's also when I met Dr. Rumely, who was just like a father to Isamu. He was very German, the type of person that's hard for someone who is French like me."

On an excursion to Versailles, Andrée took a snapshot of Isamu.

> It shows the intensity of this young man. I knew he would have to go his own way alone. He was the handsomest boy I have ever met, too handsome for his own good. When he was feeling good his face was so handsome it almost had an aura, but when he didn't like something his face changed to a very dark expression like this. Especially with those big deep dark eyes . . . it reflected his strong ego. I did not want to be anything more than a friend to him. . . . Isamu paid no attention to what he wore or what he ate. The only thing that seemed to possess him was pursuing his dream to become a "great sculptor." It was not just ambition. It was much bigger than a dream. He wanted to prove to the world that he was somebody. Maybe that was the other side of his lack of confidence because of his birth. Anyway, Isamu didn't think about anyone but himself. He was not a person who was considerate to others. Our friends were upset by his woman trouble.

At the end of his life Isamu confessed that one reason he chose to become an artist rather than a physician was sex. "Sexuality is a strong factor in becoming an artist. It's liberal. . . . So you can imagine what it was like for me to go to Paris from New York."[21] When Isamu first arrived in Paris, Andrée says, he was intimate with a French art dealer old enough to be his mother. His private life became more complicated when a former lover pursued him from New York. "I forget whether or not she had been a model for Isamu, but Isamu pretended to us that he was married to her and they lived together for a while. When she got pregnant Isamu insisted that she get an abortion. It was an illegal abortion, and it didn't go well, and the girl was in critical condition when we learned about it."

Isamu later told a friend that in his youth he had asked a lover to have an abortion because Leonie opposed the idea of an artist having a family. No mention of the incident in Paris is made, however, in any of Leonie's surviving letters to Isamu. Instead she recalled her own student days in fin-de-siècle Paris. "Have you flowers on your balcony and a woman to come and tidy up," she wrote. "Those French women are so

clever. They will wax your floor or make an omelette or do your marketing without any fuss." In a motherly way she offered advice about everything he was doing: "Be careful not to breathe any marble dust as it injures the lungs." "Take care of your little charcoal stove. Remember that charcoal has to be used sparingly for your health." "The autumn in Paris has a penetrating chill. Those woolen shirts of gray and khaki are the thing."[22]

Unlike the happy-go-lucky Sandy Calder whose parents supported him, Isamu always had to worry about his mother, who still scrambled to make ends meet by selling Japanese prints and trinkets in rented shops at East Coast resorts. He husbanded his $2,500 fellowship carefully, and every few months he sent her money, but as the cost of sculpture materials piled up, he frequently turned to Dr. Rumely for loans, promising to repay him with works he had made in Paris. In 1928 the Guggenheim Foundation accepted an application for the renewal of his fellowship drafted with Dr. Rumely's help. To save money he moved from his Montparnasse studio to another one located in a district of small workshops and factories in the suburb of Gentilly. The rent was lower, and it was easier to hold down living expenses. When Andrée visited the studio she was surprised to see that it looked exactly like Brancusi's. Along a whitewashed wall Isamu hung the same kind of tools Brancusi used in a neat row just as his teacher did. "I had become Brancusi completely," he later recalled.[23]

During his first year in Paris, Isamu produced many sketches but only one piece of sculpture: *Sphere Section*, a marble sphere sixteen inches in diameter with a quarter section precisely cut out of it. It was the first stone sculpture he had attempted. It was little more than an exercise in copying Brancusi. "Brancusi used to say how lucky were the young people of the new generation such as myself, who could look forward to uninhibited and true abstractions, not like himself who always started out from some recognizable image in nature." His teacher remained his standard in everything. But Isamu wondered whether Brancusi had bequeathed him a blessing or a curse. "I was always being torn between Brancusi's admonition and my desire to make something meaningful to myself."[24] Eventually, he recalled, "My primary effort, you might say, was to get away from him."[25]

During his second year on the Guggenheim Fellowship, Isamu studied the fundamental skills of stoneworking with the Italian sculptor Mateo Hernandes, and he produced twenty-two pieces of sculpture; his application for a renewal of the Guggenheim Fellowship said, however, that his ultimate

destination was India. Consciously or not, his planned pilgrimage to the East may have been another way to escape Brancusi's influence. To prepare himself he spent a month in London reading everything about Oriental sculpture that he could find in the British Museum but when he applied for yet another extension of the fellowship, the Guggenheim committee turned him down. In February 1929 he decided to go back to the United States. He sublet his Gentilly studio to another artist, hoping to return to the "City of Light" as soon as he could.

Pilgrimage to the East

A month after Isamu's return to the United States the *New York Times* ran a review of works recently exhibited by American artists in Paris. It took only brief note of Alexander Calder's miniature circus: "Of its own volition wire jokes and teases. Deliberately tantalizing, with all but human imagination, it goes off into wild scrolls and tight tendrils." Its coverage of Isamu was twice as long. Most of it dealt with his background as the son of "the well known Japanese poet" Yone Noguchi—and quoted at length the young artist's earnest statement about his philosophy of art. The only comment on his sculpture was, "It does create a mood, vigorous and sturdy, to which one makes a physical rather than an emotional response."[26]

At a small one-man show at the Eugene Shoen Galley, Isamu exhibited several abstract works strongly influenced by Brancusi, including one entitled *Leda*. The *New York Times* review was positive but none of the sculptures sold. The return home was not easy for Isamu, either psychologically or financially. "I personally had this moment of liberation in Paris for two years with the Guggenheim Fellowship," he recalled. "It was like a trip to paradise and then coming back to the cold world. And one doesn't expect it to be transferable."[27] Although New York City was on the cutting edge of modernism in American art, Isamu decided to abandon abstract sculpture. "I was too poor and could not afford it," he recalled. "On the other hand, I was too poor inside myself to insist upon it. How presume to express something from within when it was empty there? . . . [A]ll my dreams were left in Paris, and all the tools that I had accumulated." For the next two years, he produced no abstractions at all. "I felt myself too young and inexperienced for abstraction," he said. "I would have to live first."[28]

He also needed to make money. His half-sister Ailes was a scholarship student at a Connecticut girls' school, and his mother was still peddling her wares at summer resorts. To help his mother out, and to support himself as well, he began making portrait busts again. Although he disdained the "superficial skills" Onorio Ruotolo had taught him, figurative sculpture was an easy way to make a living. "There was nothing to do but make heads," he said. "It was a matter of eating, and this was the only way I knew of making money."[29]

With Dr. Rumely's help he rented a studio at the top of the Carnegie Building. Dr. Rumely was in a new line of business—selling vitamins for personal health. His company, founded after he had surmounted his legal difficulties, was doing well, and once again he persuaded business friends to commission portrait busts. There were always four or five plaster works in progress covered with damp cloth in Isamu's studio. "It made money," he recalled.[30] In October 1929 the stock market crashed, plunging the financial world into an unprecedented panic, and the door closed on the glamour, hedonism, and exuberance of the 1920s, but the deepening Depression had little immediate impact on Isamu's livelihood. Commissions kept coming in from wealthy patrons.

In 1930 Isamu exhibited seventeen portrait busts at the Marie Sterner Gallery, including those of celebrities, like the composer George Gershwin, the photographer Berenice Abbott, the dancer Martha Graham, and the architect-engineer Buckminster Fuller. The critics praised his technical skill. "[The exhibition at the Eugene Schoen gallery] was a surpassingly good show," wrote the *New York Times* reviewer, "so that young Mr. Noguchi's introduction was auspicious. But it did not adumbrate the success with portrait heads that the present affair at Mrs. Sterner's gallery establishes beyond doubt. As a portraitist, while still true to the fundamental principles of abstraction, Noguchi can rank with the best. . . . Isamu Noguchi is decidedly a young man with a future."[31] The monthly *Art News* compared him favorably to the French sculptor Charles Despiau, a student of Rodin and a leading French figurative sculptor of the day. Isamu might well have achieved early fame as a portrait artist had he wanted to, and during the next decade or so, he produced about 115 portrait busts, but he rarely mentioned these works in his later years. On the contrary he dismissed them simply as a way to make money in his struggling youth.

Money was not his only motive, however. "The problems of portraiture interested me: the confluence of personality and sculpture where the concentration of characteristics and identity, of sensibility and type, of style, even, belonged more to the sitter or his race, than to the sculptor. Or if to the sculptor only as a medium of expression, limited in form, as is a sonnet."[32] Portraiture allowed him to experiment with his craft. It provided a learning space to explore his artistic freedom while working within a fixed form. He chose materials—metal, bronze, wood, and plaster—to bring out the inner personality and character of his subjects as well as their physical features. Since he had no difficulty producing portrait busts, he worked with a variety of materials to challenge himself creatively.

His creative experiments were reflected in the sculptures exhibited at the Sterner Gallery. The bronze busts of Martha Graham and Scott Rumely were conventional, reminiscent of Rodin's portrait sculptures, but the bust of Gershwin, cast in the same material, was polished to a high luster like a Brancusi sculpture to underscore the elegance of the popular composer. The work that attracted the most attention was a dazzling bust of Buckminster Fuller, whose close-cropped head was rendered in chrome-plated bronze. Fuller, a heavyset man shorter than Isamu, had a huge head that seemed to balance unsteadily on his shoulders as an incessant stream of ideas bubbled out of him. What more suitable material could there be for a bust of this unusual genius—an inventor, architect, engineer, designer, and philosopher considered a generation ahead of his times—than dazzling chrome.

Fuller was a regular customer at Romany Marie's, a bohemian Greenwich Village restaurant-cafe that reminded returnees from Paris of a French bistro. Its regular customers were radical intellectuals, including some who claimed to be Communists. Every evening Fuller ordered a bowl of soup, then held forth on his ideas and theories to anyone willing to listen. Some dismissed him as a loudmouth crackpot as he rattled on at the top of his voice, but Isamu, just back from Paris, listened raptly. Fuller was nine years older than Isamu, and for a long time after they met Isamu addressed him as "Mr. Fuller" rather than by his nickname "Bucky."

Fuller, who came from an old New England family, was descended from a long line of religious Nonconformists. His father had died early, and his mother had given him a strict upbringing. Perhaps for that reason he became rebellious as a youth. He was twice expelled from Harvard, once after spending a semester's tuition money on a night of partying with a

group of showgirls. When World War I broke out he joined the Navy, and when it ended he married the daughter of an architect who had invented a modular construction system using blocks of compressed fiber. Fuller started a construction company with his father-in-law but when the company ran into financial trouble Fuller was forced out in 1927.

By then Fuller had already developed his idea of the Dymaxion House, a factory-built residence complete with its own utilities, that would be assembled from lightweight materials like duralumin and plastic for easy delivery from the factory to the building site. The name Dymaxion was a compound of two words that Fuller used constantly: "dynamic" and "maximum." His path-breaking concept anticipated the prefabricated house but the construction industry did not take much notice of him, and since he was an autodidact with neither a formal academic degree nor a well-defined professional specialty, neither did the business and academic worlds.

After hearing one of Fuller's harangues at Romany Marie's, Isamu offered to make a bust of him. He had discovered that there was no better way of getting to know interesting people—or approaching attractive women—than offering to do their portraits. Isamu had just moved from his studio in the Carnegie Building to a new one near the intersection of Madison Avenue and Twenty-ninth Street. The new studio, formerly a laundry, had high windows that provided better light. Fuller suggested making it even brighter by painting it silver from floor to ceiling, and, with sunlight reflected from every direction, Isamu fashioned Fuller's chrome-plated bust as Fuller talked nonstop in the newly repainted studio. Fuller was living alone in the city as he struggled to make a business comeback while his wife and children stayed at her parents' home. He enjoyed Isamu's companionship and took him along everywhere.

After the Sterner Gallery show closed, Lincoln Kirstein, a Harvard student who had founded the Harvard Society of Contemporary Art with several classmates, invited Isamu to exhibit the same works there. Fuller thought the show a wonderful opportunity to publicize his Dymaxion House concept. He loaded a model of his Dymaxion House along with Isamu's exhibition pieces into his old station wagon, and the two men headed off for Cambridge. On the road Fuller, as usual, never stopped talking. He declaimed as if he were addressing a large audience rather than a single companion. "This was the beginning of my personal instruction by this great teacher (whom does he not teach who is ready to listen?)," Isamu later recalled.[33]

It was on this trip that Isamu heard for the first time Fuller's ideas about a vectoral system of geometry that made it possible to create maximum strength with minimum structure. The basic unit in Fuller's system was the tetrahedron (a pyramid with four sides including the base), which constituted the most economic way of filling space when combined with an octahedron (an eight-sided shape). These ideas were the basis for his best-known invention, the geodesic dome. Fuller opened up a new world of possibilities for Isamu, who absorbed everything that his "great teacher" had to say. The geometrical tendencies that began to appear in his own work clearly reflected Fuller's influence.

Isamu was still struggling to escape from Brancusi's influence at the time he met Fuller. "To find one's own identity you can not borrow from someone else," he later said. "Also one has to revolt against one's parents. . . . I had that very strongly in me in any case because I hated my father. . . . Not that I hated Brancusi. I didn't hate him, but I felt obliged to be free of him."[34] At every important turning point in his life, Isamu sought a mentor to point him in the right direction. He had an extraordinary instinct for finding someone who gave him the advice he needed, and since he had grown up without a father, he found it easy to bond with his mentors. At this moment in his career he could not have found a better mentor than Fuller, who remained a close friend for the rest of his life.

Isamu was attracted not simply by Fuller's fresh and original mind but by his firm sense of identity. In contrast to Isamu he never had any doubt about who he was. His family's roots went back to the pre-Revolution era, and for Isamu he personified America. "I first met Noguchi when I was thirty-two years old," Fuller remembered, "and I recall his stated envy of the natives of various lands who seemed to him to 'belong' to their respective lands. As with all human beings, he had the deep yearning for the security of 'belonging'—if possible to a strong culture or at least some identifiable social group. Despite this yearning it proved biologically and intellectually impossible for him to escape his fate of being a founding member of an omni-crossbred world society." It was Isamu's "remote and complex crossbreeding," Fuller thought, that defied his "conscious urge to settle down."[35]

In a sense, Isamu's long journey through life confirmed Fuller's observation. Ever since his first exhibition at the Leonardo da Vinci School, he had been labeled a "Japanese-American" artist, but just what did that mean?

Like it or not, he had become an American at the age of thirteen but buried in the shadowy recesses of his memory was another identity that he felt he had to explore. "I wanted to find myself," he recalled. "I wanted to find my future."[36] For the Schoen Gallery show Isamu had fashioned several works from bent or folded sheet metal. Calder's technique of twisting wire into interesting forms had inspired him to experiment with the material but part of his inspiration, he recalled, "may have been childhood memories of paper use in Japan."[37] As a child he had learned origami, the art of folding paper into figures of birds and animals or other ornamental shapes. It was a skill easily mastered by a child. As so often happened when Isamu expressed himself artistically, a bit of the Japan inside him, memories of folding origami, had surfaced in his sheet metal sculptures.

Isamu wanted to see Japan again through the eyes of a sculptor. To break away from Brancusi's influence and to establish his own abstract sculptural style he wanted to rediscover his Japanese roots. His talks with Fuller only confirmed his urge to make a "pilgrimage to the East." His plan was to return to Paris to retrieve his sculptor's tools, and then go on to Asia. He hoped to finance the trip with money earned from his portrait busts. His fees were steep. For example, while his bust of Gershwin, a work that won him publicity, was sold for only $209, he charged $600 for a portrait of Edla Frankau, the daughter of a wealthy family. Happily, commissions kept coming in. In less than a year his portrait busts earned him more than twice the $2,500 he had received from the Guggenheim Fellowship.

The exotic-looking young sculptor was popular in New York high-society circles. "I was attracted to a society that was international and honorable," he later recalled.[38] Relying on an artful tact learned as young man, he was able to ingratiate himself to the privileged but he disliked being the temporary companion of wealthy art collectors. His plan to launch on a journey of self-discovery abroad offered escape from this world of artistic dilettantes. He tried to explain his reasons for leaving New York in a letter to Dr. Rumely, who had helped him establish himself financially: "I am taking this course fully appreciative of all that you have advised to the contrary—and my only wish is that you may in time be convinced of its necessity."[39]

In a sense Isamu was instinctively fleeing from a success he had achieved all too easily as he tried to make money. "I have a deep sort of suspicion about [success]," he said later. "Now it's easy to be successful. . . . Success seems to fix a person or tends to fix a person. It may free him to a

certain extent but it also tends to make him continue in that success. He just doesn't want to have it one day and give it up the next. . . . He doesn't want to blur his image once it's been established so that he tends to be less experimental and creative, I think."[40] At the time, however, Isamu may not have realized so clearly that he suffered from a phobia toward success or that he had begun a pattern of sudden flight from success often repeated in his later life.

On April 16, 1930, Isamu left from New York on the first step on his long-planned "pilgrimage to the East." It was already summer in India, where the heat was unbearable. He decided not to go there directly. Instead, he spent two months in Paris waiting for a Soviet visa to travel to Asia on the Trans-Siberian Railway. At his studio in Gentilly he finished *Glad Day*, a small bronze of a spread-eagled male nude inspired by William Blake.

Just before Isamu left Paris his mother wrote that Yonejirō did not want him to come to Japan using the Noguchi surname.[41] Isamu was deeply upset. His trip to Asia was not simply to rediscover the bits of Japan that consciously or unconsciously kept erupting into his art; he also hoped for reconciliation with the father who had rejected and ignored him. "As I became an adult I gradually began to feel that I wanted to meet him."[42] Isamu was unexpectedly delighted, for example, to learn that his father had written a poem about Jacob Epstein and Henri Gaudier-Brzeska, two pioneers of abstract sculpture, after a London visit in 1914. It was the first time he had found common ground with his father.

His father had also written *Tsunawatari* ("The Tightrope Walker"), about the artist's life, while Isamu was studying at the Leonardo da Vinci School.[43]

He has no time to think about others.
The egoist's art is to be himself. . . .
What passion he brings to his work.
And when the passion peaks, he holds his tongue,
And when he is at a loss for words, he shapes his own personality.
He who never makes a false step, how sparingly he moves.
He has his secrets and his rules.
He does not gambol his way through life . . . he is reality itself.
As we watch him we put aside our own fancies and beauty,
And thus we feel the agony of modernity.
Like him, we too are artists on the stage of life and death.

The poem warned that an artist always lives on the edge of danger, just as the tightrope walker does. Perhaps Yonejirō intended it as a message to his son in America.

Leonie hoped that her child and his father, both of whom had chosen to become artists, might get to know one another when Isamu visited Japan but Yonejirō once again rejected his son. It was a shock for Isamu to receive the news just as he was about to depart but he forged ahead anyway. "How could I stop," he recalled. "I decided to go to Peking instead."[44]

"This finds your son stranded in Harbin waiting for his luggage which is a day late," Isamu wrote to his mother at the end of July 1930. "Ten days in a wagon lit over steps [sic], mountains and deserts. Two more days, then Peking. May stay there, may go to Kyoto, depending. Think it would be a splendid idea to return by way of India and model Gande's [sic] head if it can be arranged."[45] His long journey on the trans-Siberian railway ended at the city of Harbin in central Manchuria, and from there he went south to Peking, the "Paris of the Orient."

"Without doubt there is no greater city than Peking," he recalled. "If my father did not want me, Peking had heart and warmth to spare. There must be a habit of welcome to the stranger."[46] The city was filled with antique shops and painting galleries that Isamu could not pass by without going in. Compared to Paris and New York, everything in Peking was cheap. Even with his limited resources he rented an old Peking-style house inside the city walls at Hutung 18, Ta Yang Mao. It came with a French-speaking cook, a live-in rickshaw man, a houseboy, and their families. In the morning he studied Chinese, and in the afternoon he made the rounds of art and antique shops.

Isamu was entranced by the painted ceramic figurines of the T'ang period. Their influence can be seen in his *Chinese Girl*, the sculpture of a girl reclining on her elbow. He fashioned it from dental plaster, the only kind he could find in Peking. Sculpture materials not being easy to come by, he decided to try his hand at ink brush painting. He arranged to study with Ch'i Pai-shih, the leading Chinese painter of his day, whose bold, simple brush style bore the influence of the Ming eccentrics. "[S]hifting to materials more natural to the place, I made enormous drawings with fantastic brushes and expressionist flourishes upon their incredibly beautiful paper."[47]

"I'm very glad I stayed here in China. It's a great country and I love the people, especially the working class, shopkeepers and coolies," he wrote his mother. "They are delightful. . . . I have a very good Japanese friend here, Mr. Katsuizumi, with whom I take long walks, eat Japanese food, sukiyaki, etc. and take Japanese bath every week. O, it's great!!"[48] In fact, his life in Peking was so pleasant that Isamu stayed six months. Since his funds were rapidly dwindling he abandoned his plan to go to India. "I wanted to see something of Japan before my money ran out and I didn't see why I should have the hesitancy I did, or why my arrival should ever be known."[49]

Toward the end of January 1931 Isamu departed from Tianjin sailing for Kobe on the *Nanrei-maru*. A Japanese reporter on board was curious about the young American sculptor with a Japanese name, and by the time the ship reached Kobe, the *Mainichi shinbun* had published an article headlined "YEARNING FOR HIS FATHER THE POET." It reported Isamu's joy at the prospect of reunion with his father: "I remember my father's face very well. I never forgot him for a moment and I always talked about him with my mother. I never got out of my head the idea of going to Japan, where my father was, and now I am finally realizing my hopes."[50] Whether Isamu spoke these words or the reporter invented them is not clear. In any case, several other newspapers picked up the story of "the Poet Noguchi and his son Isamu." When Isamu arrived at Tokyo Station on the Fuji Special Express at 4:55 PM on January 28, a crowd of reporters was waiting for him.

When one reporter observed that his father was not there to meet him, Isamu took pains to avoid any misunderstanding. "I have not come to Japan to meet my father," he said. "I have come to Japan not as the son of the poet Yone Noguchi. I have come as the American Isamu Noguchi to see Japan for my own sculpture. . . . I want to see how Japanese culture has progressed, I want to look at the splendid sculpture of ancient Japan in Kyoto and Nara, and I want to work here under their inspiration. *Wakari-masu ka*? I have come to Japan only for work. I will not meet my father."[51]

Yonejirō, on the other hand, told reporters who visited his house in suburban Nakano,

> I really want to see my son. I want to do what I can for him. I did not know that he was coming to Japan. The first I knew about it was when I read the

newspaper yesterday. . . . I do not deny that he is my son. There is no connection between the big public fuss that happened twenty years ago and what is happening now. Now that he has come to Tokyo, to this land, I want to help him. I want to explain the misunderstandings, but he may not accept my feelings.[52]

A few days later father and son met at the Marunouchi Hotel. It was a "trying meeting," Isamu later recalled. "I felt pity and resentment." As he sat facing Isamu, Yonejirō did not look him straight in the eye. The person Isamu saw before him was not the father he had hated, and so longed for, but a weak-willed middle-aged man henpecked by his wife. "It was his wife, Matsuko, as she was about to have a child, who had been difficult, he said—my being the eldest."[53] Matsuko felt threatened by the return of her husband's long-lost son. She had borne Yonejirō eight children, three boys and five girls, three of whom died in infancy. Their oldest daughter, Hifumi, the wife of art historian Usajirō Toyama, had given birth to their first grandchild a year before, and the forty-one-year-old Matsuko herself was pregnant again. She did not want Isamu to come to Japan. She feared that her family would be tainted with scandal if her husband's mixed-blood bastard suddenly reappeared.

Yonejirō first began publishing poems in Japanese in 1921, a year after Leonie returned to the United States. Several collections appeared over the next few years. Most were translations of his English poems, but as he reworked them they read less and less as though they had been written first in a foreign language. Yonejirō had finally developed his own style in Japanese. In the late 1920s, as the public mood in Japan became more stridently nationalistic, his poetry collections, published with titles like *Shinpi no Nippon* (*Mysterious Japan*) and *Shin Nipponshugi* (*New Japanism*), took on a distinctly nativist tone. The fact he had sired a child with an American woman was a part of his past that he did not wish to have exposed.

In 1931 the political atmosphere in Japan was increasingly oppressive. In 1925 the Imperial Diet passed the Peace Preservation Law to crack down on the Communist Party and other radical political groups. The Home Ministry strengthened the Security Bureau of the national police system and established Special Higher Police offices in every prefecture. The political police kept close surveillance not only on the domestic Left but also on foreigners in Japan. During his stay in Japan, Isamu always felt as

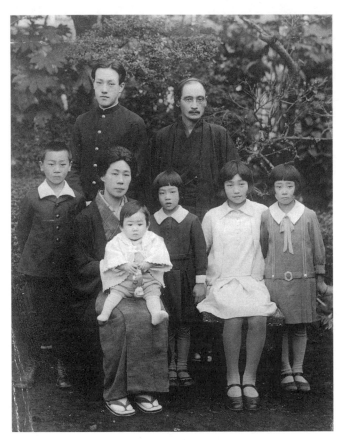

Yonejirō Noguchi and his family, 1932

though someone was watching him. "I remember my trip in '31 very well," he recalled. "It was right at that time when the military were becoming very dominant. I was being pursued by their *kempeitai* [military police], and . . . being bothered all the time. . . . It was still the old Japan and there was a kind of nationalistic or militaristic, reactionary thing which had set in, which continued to get worse and worse until the war. This misconception of the West, you know, this aggressive, commercial, military thing which gripped them."[54] It was not a pleasant experience. "In fact, I thought I disliked [Japan] when I was there in 1931. I didn't have a good time. Because of all the restrictions and so forth."[55]

The first person to offer him a warm welcome was his uncle, Tōtarō Takagi, who invited him to stay in his newly rebuilt house in the Nihon-

bashi district of downtown Tokyo. Takagi, who had inherited property from his late wife, lived a comfortable life in retirement. He usually stayed with his mistress at a second house in Kyōbashi, and his only daughter lived with her family in Yoyogi. Isamu had the main house to himself, except for a live-in maid and her mother who took care of the housekeeping. During his two months in Tokyo, Isamu finished two portrait busts—*Uncle Takagi* (*Portrait of My Uncle*) and *Tsuneko San* (*Head of a Japanese Girl*), a portrait of the maid. Both works are suffused with gentle warmth, perhaps a reflection of Isamu's gratitude for their kindness. His uncle provided Isamu with spending money during his stay in Japan, perhaps because Yonejirō had asked him to. In his portrait Uncle Takagi has the calm demeanor of a Zen monk. One would not suspect that he ran a side business as a moneylender.

When Mary Nitobe—the American wife of Inazō Nitobe, a prominent Japanese Christian educator, intellectual, and diplomat who served as undersecretary of the League of Nations—learned of Isamu's arrival from the newspapers, she invited him to their house in Tokyo. When Leonie had first arrived in Japan with Isamu, Yonejirō had taken them to pay their respects at the Nitobes. (Nitobe was then principal of the First Higher School, a preparatory school for Tokyo Imperial University.) The Nitobes' only child had died soon after birth, so they were quite fond of little Isamu. When Isamu visited their summer villa in Karuizawa in 1931, he was startled one day to find himself face to face with Charles Lindbergh in the midst of their garden. Lindbergh, who had succeeded in flying across the Pacific, was in Japan with his wife, and to avoid the press he came to visit the Nitobes through their back gate.

The well-connected Nitobes introduced Isamu to Japan's high society. In their parlor Isamu met several young women graduates of the Gakushūin, a school for children of the Japanese elite: Yukika Ozaki, the daughter of Yukio Ozaki, a prominent liberal politician, and his English wife; Akiko Arishima, daughter of the leader of the *Nikakai*, an influential art association; and the daughters of other prominent families. Marquis Iesato Tokugawa, a direct descendant of the shogun, and a good friend of Nitobe, took Isamu to visit a sumo wrestling stable, where he sketched the grand champion Tamanishiki, whose terra-cotta portrait he exhibited along with his brush painting *Chinese Girl* (*Girl Reclining on Elbow*) at the *Nikakai* exhibition. Both works were signed "Noguchi Isamu."

As the weeks passed Isamu grew weary of his life in Tokyo, coddled by his father's friends and sheltered from the economic hardship that hit Japan after the 1929 crash. He found that he could not work at all. "I didn't like being protected," he recalled. "I wanted to be on my own." He was chafing at his awkward meetings with his father, who felt obliged to visit him at the Nihonbashi house. "My father would come to call on me, and we would hold long silent conversations," he recalled. "Two months of this was enough."[56] Yonejirō also introduced Isamu to various Japanese artists, among them the poet and sculptor Kōtarō Takamura, a graduate of the Tokyo School of Fine Arts, who had attended classes at the Art Students League in New York and worked as an apprentice of Gutzon Borglum before traveling to England and France. Isamu was not interested in meeting an admirer of Rodin who clung to an outdated figurative style. He had other interests. He had been told in Peking that the best counterfeit T'ang period figurines were made in Japan, and he wanted to meet someone who knew how to make them.

Jirō Harada, head of the Tokyo Imperial Art Museum (now the Tokyo National Art Museum), recommended that Isamu get in touch with Jinmatsu Uno, a well-known potter in Kyoto. When he arrived in Kyoto, he discovered that Uno, far from being a counterfeiter of T'ang figurines, was in fact the leading Japanese maker of Chinese-style celadon ware. In his unusually capacious rising kiln (*noborigama*) in the Kumano district Uno produced huge pieces, including vases more than two meters tall. Isamu decided to stay in Kyoto to work there. He lodged in a small zinc-sheet-roofed cottage usually occupied by one of Uno's kiln workers and began to fashion terra-cotta figures that he fired at the kilns of Jinmatsu Uno and his son Kenji, a tile maker.

"Isamu made some weird things," Jinmatsu's daughter recalled, "He shocked everyone."[57] *Queen*, a four-foot-high cylindrical shape topped by a hatlike globe, looked like a cross between a chess piece and a *haniwa*, an ancient Japanese burial figure. Ironically enough, after abandoning abstraction for nearly two years, Isamu turned his hand to it again in the ancient capital of Japan. "I have since thought of my lonely self-incarceration then, and my close embrace of the earth, as a seeking after identity with some primal matter beyond personalities and possessions," he recalled. "I wanted something irreducible, an absence of the gimmicky and the clever."[58] The city of Kyoto comforted him psychologically as he worked. "I had a period of great intro-

spection and silence. It was a dusty city of unpaved streets of indescribable charm. I felt a refuge from the vicissitudes of my emotional life at the time and I feel very grateful for it." With its low-lying tile-roofed houses, the city retained the atmosphere of an older Japan, a Japan he had known as a child.

In the Kyoto Imperial Art Museum (now the Kyoto National Museum) Isamu discovered *haniwa*, the hollow, unglazed earthenware cylinders and figurines placed around the tombs of ancient Japanese rulers. The *haniwa* were much simpler, and much more primitive, than the T'ang-period figurines he had seen in Peking but Isamu found them astonishingly "modern" in style. "In searching for my own roots, I started with abstraction in Paris, then finally found it in the abstraction of prehistoric Japan."[59] His discovery of the *haniwa* gave him a new vision of sculpture. He came to realize that sculpture, unlike other works of art, had been an essential part of human life since ancient times. "I think that once sculpture became a type of artwork and moved into art museums," he later observed, "it became something separated from people."[60]

Isamu eagerly made the rounds of Zen temple gardens in Kyoto. His mother had introduced Isamu to the beauty of the Japanese garden as a child when they lived in Chigasaki. She had taken him to see the temples and gardens in nearby Kamakura. The Japanese garden still remained a metaphor for the "ineffable nostalgia for the Japan of my childhood," he later said.[61] During his visit to Kyoto, he began to look at the Japanese garden with the eye of a sculptor. It was a "small universe," a separate world of beauty, which revealed many different faces to the viewer. "Front and back disappear," he later wrote. "You can not tell which is front and which is back. . . . The same thing looks different even if you look at it again and again."[62] Unlike a painting, the face of a garden, like that of a sculpture, changes as the position of the observer, the time of day, and the angle of the sun change. The effect was not only spiritually moving, but it also possessed its own kind of plastic beauty. The Japanese garden, Isamu concluded, was a kind of sculpture. Buckminster Fuller later suggested to Isamu that the Japanese garden could also be understood through the concept of "space." The world was made of spaces with different meanings— the space surrounding human beings, the space occupied by sculpture, the space of gardens. The garden, he said, was "a sculpture of space."[63]

"I have always loved Kyoto, and I always hope to come back again. Being here, I can not help but think of all that I owe to Kyoto," Isamu told

a Japanese audience shortly before his death. "Indeed, I consider Kyoto to be my great teacher."[64] His four months in the city during his 1931 visit had an enormous impact on him as an artist. A Japanese sense of beauty was already an instinctive part of him, but he finally realized in Kyoto that the Japanese artistic heritage was his own, too. His "journey of self-discovery" in Kyoto helped him find a distinctive individual style.

When Japanese troops invaded Manchuria on September 18, 1931, Isamu was already on his way across the Pacific aboard the *Chichibu-maru* from Yokohama to Hawaii. He had not come to an understanding or reconciliation with his father, but his visit to Japan freed him from the resentment he had long harbored toward Yonejirō. The deep love for Japanese culture that he rediscovered in Kyoto had liberated him. "I wish to tell you that I have no regrets about my trip to Japan," he wrote his father in early November after his return to New York. "I believe it to have been all for the best. I feel grateful for whatever you were able to do for me there. I feel great attachment for Japan. I love it as much as I would some person for its faults as well as its virtues. [I] feel there a great humanity—the foundations of my earliest dreams." He signed the letter, "Affectionately, Isamu."[65]

Leonie's Death

"I was very scared of not eating. I was very hungry and I was very scared I was not going to have enough to eat. I used to gorge if I was invited someplace. I'm not kidding. I was always afraid of not having enough to eat."[66]

Isamu's pilgrimage to the East had left him penniless. To make matters worse, the American economy continued to slide deeper and deeper into hard times. "The depression is rampant," he wrote to Yonejirō. "The people seem so tired—having seen the futility of their mad scramble after wealth—they have nothing. The whole place seems an enormous mistake—mostly sham."[67] Police clashed with demonstrators protesting unemployment, and white-collar workers crowded into soup kitchens. The New York City relief bureau allotted an average of $2.39 of foodstuffs per week to families in need.

Isamu still charged a minimum of $200 for a portrait bust but commissions did not come in as they had before his trip around the world. In February 1932 he exhibited work at two shows, one at the John Becker Gallery and another at the Demotte Galleries. He wanted to advertise

what he had produced on his "pilgrimage to the East" and to sell the ceramic works he had made in Kyoto. The *New York Herald Tribune* reviewer praised the Becker Gallery show, where he exhibited *Chinese Girl, Uncle Takagi, Tamanishiki, Erai Yatcha Hoi, Kintarō,* and several urns. "A more interesting group of sculpture portraits has not been displayed in New York for some time. Without creating anything approaching a literal likeness, he catches the essentials of physiognomy and character."[68] The *New York Times* reviewer described his "often compellingly beautiful sculpture" as "finished work, with all the sculptural implication realized, rather than notations flung off 'on the wing,' like Rodin's."[69]

The ink brush paintings and drawings done under the tutelage of Ch'i Pai-shih—*Mother Nursing Her Child, Nude Woman, Nude Couple,* and others—were shown at the Demotte Galleries. His rickshaw man had found models on the streets of Peking. The paintings were large, some five or six feet wide, boldly composed and brushed with strong skillful strokes shading from thin gray wash to deep black. "There is in them a something universal and eternal," the *New York Times* reviewer noted. "Noguchi's line is as pure as Ingres's and as evocative as Picasso's."[70] *Art News* observed, "The drawings . . . reflect an artistic consciousness, susceptible equally to Oriental and Occidental persuasions."[71] The monthly *Creative Art* compared Isamu's work favorably to a recent exhibition of contemporary Japanese artists, including Tsuguharu Fujita. "The modern art of those Japanese who ape European models is invariably of low order. Noguchi has done something altogether unique—combined the virtues of his double artistic heritage." The reviewer also pointed out that no "vestige of Brancusi" was detectable in the new work. "Noguchi, whose life has been spent almost entirely in the Occident, reverts to the spirit of his ancestors with the ease and naturalness of a life-long student of Hokusai himself."[72]

Isamu later remembered these exhibitions as the "most successful of all my shows."[73] Combined into a single exhibition—"The Brush Painting and Sculpture of Isamu Noguchi"—fifteen brush paintings and twenty of his portrait busts went on tour, first to Chicago, then to a dozen museums on the West Coast, including ones in San Francisco, San Diego, Portland, and Honolulu. The critical reception was positive everywhere but hardly any works were sold. In early April 1932, while in Chicago for the opening of the show there, Isamu received bad news from Leonie. "I went up to your studio this morning. There was a notice fastened to the door. I believe

legal notice of eviction, rent and claim for $210. I left it on. But if you like I will tear it off. Then I gathered up the letters I saw around and sent them in a package. . . . also many letters from Tel. and Edison Co. The telephone company sent a letter from a lawyer."[74]

Isamu was in no hurry to return to New York to deal with his financial troubles. He was in the midst of a passionate love affair with Ruth Page, a dancer he had met at a concert in the Chicago Art Club. "I was crazy about Noguchi," Ruth Page later recalled. "But in a funny kind of way. I don't know what kind of way it was. . . . He was one of the most beautiful men you had ever seen. . . . He had a sort of lost, faraway look that was irresistible; very penetrating eyes that looked right into your soul."[75]

The twenty-eight-year-old Ruth was the only daughter of an Indianapolis brain surgeon and his pianist wife, and her brother Irvine was a leading medical researcher on hypertension. Well-bred, open, and easy to like, she was just a year older than Isamu. After seeing her perform at a dance recital in Indianapolis, the Russian dancer Anna Pavlova had urged her to become a ballerina. By the time she met Isamu, she was director and choreographer of a Chicago avant-garde dance group that introduced modern dance techniques into classic ballet. A striking beauty with deep black hair, pale skin, and sparkling brown eyes, she had the lithe and energetic body of a dancer.

Swept away at their first meeting, Isamu asked her to model for him. After his exhibition ended, he stayed in Chicago, sending Ruth love letters every day. She had been married for six years to a well-known lawyer, and their home in Chicago was a gathering place for musicians, dancers, and other artists. Ruth got along with her husband, but she was attracted to Isamu because he was so very different from her spouse. "Tom, my husband . . . had so much business to attend to, and he was so intellectual and businesslike," Ruth recalled. "I think Isamu was sort of quiet. . . . I think I needed an artist in my life at the time, you know."

Their relationship went deeper than physical attraction. Isamu had become interested in modern dance after meeting Michio Itō in New York. Although he had skimped on everything else in Paris, he often went to performances of Diaghilev's Ballet Russe. Isamu shared another interest with Ruth. During a tour of Japan four years before, she had become enchanted by Japanese culture. "I've always been crazy about Japanese art," she recalled, "even before I knew Isamu."

Their love affair lasted nearly a year. "I almost got a divorce and married him," she said. "He wanted me to but I don't know. . . . [H]e had so many women, you know. I would have been just one among many. Oh, at the time I was the one and only but you know those things. . . . Women are crazy about him. And I had the good sense to say goodbye, finally." Ruth had another reason for staying with her husband. Without his financial support she could not pursue her devotion to dance. In rejecting Isamu she chose her art, and until her death at ninety-two she was a leading figure in the American dance world. No dramatic or decisive event brought their affair to an end. During their year as lovers they were often apart, living in different cities—New York and Chicago—with Ruth often on tour. Even in her old age, Ruth spoke fondly of Isamu. "I don't know what he looks like so much now but he was perfectly beautiful. And a wonderful person. A marvelous person." She was the first woman Isamu seriously considered marrying.

The affair with Ruth established a pattern repeated over and over again in Isamu's relations with women. It was not simply beauty that he sought in his lovers. He was drawn to women passionately absorbed in their own work. Raised by a working mother perhaps he thought it natural for a woman to pursue an independent career. He also knew that women who lived in their own professional worlds were more likely to let him immerse himself in his own. After parting from his lovers, Isamu usually kept them as friends, as he did with Ruth.

Isamu's affair produced his first real masterpiece—*Miss Expanding Universe*—a large aluminum sculpture nearly four feet high and three feet wide. Ruth was the model, and Bucky Fuller decided on its name. The sculpture was not a likeness of Ruth; it barely suggested facial features. Rather it was a streamlined abstraction of a dancer, her arms and legs flung wide, her body expressing its intense internal energy in motion. The sculpture was exhibited at a show of Isamu's new work at the Reinhardt Gallery in December 1932, suspended from the gallery ceiling as though its model were exuberantly hurling herself through the air.

"So much modern stuff is so bitter, so hopeless," Isamu told a *Time* magazine reporter. "To me, at least, *Miss Expanding Universe* is full of hope."[76] Isamu had discovered the roots of his aesthetic consciousness during his trip to Japan. He learned that it was something stronger than nostalgic memory. It was rooted in his blood. But he also discovered that Japan was not a country to which he belonged. "Ultimately even in Japan," he

later said, "I was not able to find the homeland that I had been looking for so long."[77] Paradoxically his trip to Japan had also awakened him to the realization that he really was an American, and he returned home feeling a new "enthusiasm for America."[78] *Miss Expanding Universe* expressed not only his love for Ruth but his desire to lift the spirits of an America plunged into economic despair.

Miss Expanding Universe marked Isamu's emergence as an American abstract sculptor. The critical response was negative, however. The *New York Times* reviewer characterized the work "as resembling a sublimated scarecrow going through setting up exercises in conjunction with one of the early morning radio health programs. . . . This reviewer prefers Noguchi in a shinier and in perhaps a less expansive mood. He used to do handsomely curved abstractions that needed no titles."[79] The *Art News* reviewer did not "find much cause for celebration" in the sculpture, and the *Chicago Tribune* dismissed it as a "strange creation," the "most debatable" of Noguchi's abstractions.[80] *Time* magazine described it as "a great white plaster shape something like a starfish and something like a woman."[81]

About a month before the Reinhardt Gallery show, two major New York art museums—the Metropolitan Museum of Art and the Whitney Museum—bought two of Isamu's sculptures: *Portrait of a Young Woman (Angna Enters)* and *Ruth Parks*. Both were portrait busts. The museum's choice tells much about Isamu's reputation as an artist. The art world showed interest in works he had produced in the "Orient," and the critics praised them, but they responded coolly to his abstract sculpture. One reason was that he had been labeled a Japanese-American artist. But there were other reasons, too. The range of the works exhibited at his three New York shows—portrait busts, ink brush paintings, abstract sculptures—was deliberately diverse. His versatility bewildered professional art critics who found it difficult to categorize him. He could not easily be pigeonholed.

The only person to recognize Isamu's real strength as an artist was Julien Levy, the son of a highly successful Manhattan real estate dealer, who opened a gallery for avant-garde art on Madison Avenue in 1931. A month after Isamu's show at the Reinhardt Gallery opened Levy wrote a long essay on his work in *Creative Art*.[82]

He was born with many gifts—all but the proverbial silver spoon—endowed with precocious facility as a sculptor and draughtsman, with striking good

looks and an attractive personality. With one or another of these assets he could not but find it easy to "make things." Many artists and almost all very young men would have been content. But Noguchi, because of ambition, or modesty, or sensibility, has been lured into the wilderness of artistic and spiritual experiment, where success is more richly rewarded, the chances of error are infinitely multiplied and technical ability becomes a very secondary aid. That is why he is today less . . . an accomplished artisan—and so much more significant as an artist.

This was the first serious review to express a clear understanding of Isamu Noguchi's art. Levy found his work, including *Miss Expanding Universe*, to be "only half-realized, amorphous," but at the same time he recognized that Isamu was seeking a "balance between the abstract and the concrete, the relating of fact to meaning, while he specifically exercises a vigorous interpretation of oriental and western aims."

Brancusi had never stopped telling Isamu that his generation was fortunate because they could plunge directly into true abstraction without having to tie sculpture to natural reality—they could pursue pure abstraction in a way his generation could not. Isamu had not taken his teacher's advice to heart. "Pure abstractions, or at least those geometrically derived, left me cold, and I was always being torn between Brancusi's admonition and my desire to make something more meaningful to myself," he recalled. "This is not to say that I thought of deriving anything from the figure. But I craved a certain morphological quality."[83] It was perhaps this unwillingness to plunge headlong into pure abstraction that Levy found wanting in Isamu's work.

Although Brancusi's abstract works fascinated Isamu, he continued to make figurative works in the style of Rodin, working with all kinds of materials, from natural wood and stone to modish materials like aluminum and chrome. Throughout his career, as he experimented with sculpture, Isamu was drawn to contradictory extremes, and through a process of trial and error, he tried again and again to reconcile them. The unique versatility of Isamu Noguchi, as Julian Levy pointed out, lay in the bipolarity that sprang from his mixed birth. Indeed, Levy was the first critic to suggest that Isamu's instinctive impulse to demolish walls around the "in-between" was a positive trait.

Three months after the show at the Reinhardt Gallery, newly elected President Franklin D. Roosevelt launched the New Deal. Recovery was slow in

coming, however. Isamu felt the impact of the economic downturn more than ever before. Despite critical praise, few of his works sold. "Things had gone so badly," he recalled, "that I was evicted from my studio and my work was seized by the sheriff." Indeed, he had to seek temporary refuge in a vacant store on East 76th Street.[84] But he was still able to make a living with his portrait busts, and he soon moved into the Hotel des Artistes, a well-known gathering place for bohemians.

In early 1933 Isamu went on a Caribbean cruise with Dorothy Hale, a socialite actress better known for her unusual beauty than for her stage performances. Isamu was in love once again. The trip was more than a pleasure jaunt, however. On the ship he met many of Hale's wealthy New York friends who commissioned portraits. In June Isamu arrived in London, hoping to find commissions there, too. Hale came with him for the first few weeks, and before he settled down in England, they visited Paris where Isamu ordered white marble for the busts. Paris was no longer the "magic city" that it had been in the 1920s. The Depression had hit Europe as hard as it had hit the United States. The Nazi party had won a plurality in the German election and taken control of the German government in January 1933. Jewish refugees were already making their way from Germany to France.

Nothing was going as Isamu had expected. "London is not easy to get used to," he wrote Leonie in July. "It is expensive and inconvenient—yet undoubtedly there are a surplus of interesting people here once one can reach them. . . . I am always full of expectations."[85] Leonie was spending the summer on Cape Cod, where she had rented a seaside shop. "I like to be all alone as much as I can while I am here," she wrote Isamu in early August. "Have an attic room and get my food. Mostly living on berries and fish, like the Cape Cod Indians who formerly inhabited here."[86]

The summer before Leonie had written him from Bar Harbor, Maine: "Do come and see how your mother sleeps on a shelf, eats off her lap and hangs herself from the ceiling to save space."[87] The deepening Depression had hit her tiny business hard. Aside from a brush painting of Isamu's that she sold for $200—enough to cover her expenses for several months— Leonie peddled Japanese prints, inexpensive bead necklaces, and other trinkets. No matter how hard her life became her letters to her son remained strangely cheerful, written with a kind of wry detachment, as though she were describing someone else's life. She brushed aside the hard realities confronting her with a blithe sangfroid that often bordered on recklessness.

In her letter from Maine in the summer of 1932, however, Leonie's tone was different. It was the first time—and as it turned out, the last time—she asked her son for a favor. She wanted his help to rent a cottage in a resort town on the Connecticut seashore, where rent was cheap and where she could do business in the summer. The cottage had only two rooms. It was a "family place" that Isamu and Ailes could visit on weekends. Now fifty-eight years old, Leonie had tired of her transient life as a bird of passage with no fixed nest, but Isamu, absorbed in his passionate affair with Ruth Page at the time, never answered. Someone else rented the cottage, and Leonie's modest dream ended.

In early August 1933 Isamu wrote his mother that he had rented a studio in the tranquil London suburb of Chiswick Mall. "Have taken it for 2 months so I will not get back to America untill [*sic*] October."[88] Perched on the banks of the Thames overlooking tidal flats on the eastern side of London, Chiswick Mall had long attracted artists and literary figures like William Butler Yeats and William Morris. "Just now (7 PM) I have just stopped working—it is Sunday, a beautiful day, and the church bells are ringing—that it the only noise, otherwise utter quiet here by the river," he wrote Leonie in early September. "I have never had such relaxation in a long long time. All my thoughts and energies and attention are just now most taken up with the statue which I hope to have finished for delivery in New York next month. I feel out of touch with actuality here—sometimes. I feel so very lonesome for you, for Ailes and New York—indeed I begin to love N.Y. for what it is, what it contains. London is still a complete stranger to me."[89]

Isamu was concerned that he had not heard from his mother since her letter from Cape Cod a month earlier. She had always been a faithful correspondent whether he was in Paris, in Peking, or in Tokyo. It is clear from her letters that she was always with Isamu in spirit, enjoying his adventures abroad vicariously. In that sense she had been a truly fortunate mother. She had recognized her son's promise as an artist before anyone else had, and she was happy that he had fulfilled her dreams for him. She did not care whether he became famous or not, she simply hoped that he would lead a life passionately exploring the borders between East and West. She never expressed any self-pity in her letters to him nor did she ever complain, but like many mothers she found it hard to accept her child's independence.

Every year on his birthday Leonie sent Isamu a letter marked with the same number of *x*'s for kisses as his age. In November 1933 no letter marked with 29 *x*'s arrived at Isamu's London studio. "My birthday evening," he wrote Leonie on November 17, "and I am visiting Sir Michael Sadler for the night, a thing so appropriate. He has a remarkable collection and we spent the afternoon looking at his paintings and sculptures. . . . Do keep a lookout for a studio—although I may find it convenient to move to some other city on account of my many creditors in N.Y.—or else it might be best that I went into bankruptcy—but we will talk about that later." [90]

Isamu wrote his mother a letter at least once a week but he received no reply. He grew more and more uneasy as the days passed. (Her friend Catherine was worried about Leonie, too. "[Your letter] let us know you are alive, which is the same thing we have been wondering about," she wrote. "Are you managing to eat in these times? Has Ailes a job? Does Isamu find any buyers in England?") [91] On November 28 Isamu wrote asking whether Leonie had received his check. He expected to leave England, he said, on December 17 rather than on December 8. "In any case, I will absolutely be there for Xmas with you. . . . Am now working with wood and having a glorious time of it." [92] The next day he sent another note saying that he would leave on December 8 as planned. "Why have I not heard from you for so long—of course I can not expect any reply to my complaints before I leave so I will simply complain—and you will say the same of me." [93]

When Isamu arrived in New York on December 17 he learned that Leonie had been admitted to Bellevue Hospital with pneumonia five days before. His mother was old beyond her years. Long years of stress, often without enough to eat, had taken their toll. Her health had been failing but she could not afford to see a doctor. Had she not been destitute, she would not have gone to a charity hospital like Bellevue, where the flood of sick and injured poor overflowed the halls and waiting rooms and where there was never enough staff to treat them. Of the more than twenty thousand patients who died there every year, the bodies of about nine thousand were never claimed. The hospital was not far from the cheap apartment where Leonie had lived with Yonejirō after he gave her his declaration that she was his "lawfully wedded wife." At 6:30 PM on December 31, 1933, two weeks after being admitted, Leonie breathed her last. She was fifty-nine years old. According to her death certificate, she had died of coronary thrombosis with arteriosclerosis as a contributory factor. Her marriage status was listed as "separated."

Isamu made only one portrait of his mother, a terra-cotta bust he completed as he raced back and forth between New York and Chicago a year before her death. Perhaps he had a premonition, however slight, of her death. *Leonie Gilmour* is unique among his portrait sculptures. His mother's deeply wrinkled face is rendered with utter simplicity. A shy faint smile hovers on her lips almost as though filtered through a veil. It is the image of a concrete human being, a mother worn down by long years of fatigue. But a monochrome black and white photograph of the bust, with its strong contrast of dark and light, conveys a completely different impression. Another image of Leonie Gilmour emerges, the image of a proud woman who led life her own way, even if it meant defying convention. When her daughter Ailes once scolded her for living like a socialist, she replied, "Yes, I am an anarchist." [94]

When Ailes graduated from school in 1928, she wrote Isamu: "I still love you, Isamu. If only I were a boy or you a girl. . . . Sometimes I'm so hungry for love that I cry very much. . . . Do you know very much about your father? I dislike asking mother because I believe it hurts her, yet I have a right to know. Can you tell me about him?" [95] Isamu replied, "I love you. I just did not like the way you treated mother. You may take it for granted that I love you as much as it is proper for a brother to love a sister—so do be satisfied." [96]

Ailes, who had joined the Martha Graham dance troupe after graduation, had fallen deeply in love with another dancer. While Isamu was in London she was hospitalized after her lover jilted her. The last letter that Leonie ever wrote was to console her deeply wounded daughter. The letter is not dated, but since Leonie devoted the first two pages to thoughts about Ailes's performances with the Martha Graham troupe, it was probably written sometime after October. Even though her own health was too poor to write to Isamu and her friend Catherine, she felt that she had to encourage her only daughter. Perhaps knowing that she was facing the end of her life, Leonie wrote in a strong, clear voice: [97]

> One of the strangest phenomena of life is a sudden violent love affair—generally taking one absolutely unawares and "out of the blue." No one is to blame—they come and go—leaving their poor victim powerless to keep themselves. All through the ages this has occurred and no solution has been

found. If people are free to marry or do so, this violent passion subsides—usually in a year or so—& perhaps the lovers find they have absolutely nothing in common. . . .

If they can not marry and are separated—they idealize each other—& are terribly unhappy apart—& this may last several years. Though if either person is doing creative work—or has some interesting outlet for emotion—the [burden?] is much gentler—but the one certain thing is—that people never get over it. The real problem is to find the best mode of conduct when the need is greatest. . . .

Sometimes I think the Russian and French way is better—either partner to just go on a vacation & live with their beloved and get it out of their system. It is surprising how the gratification of sex—opens the eyes of lovers—even the Anglo-Saxon world would approve of this for men—& women do this more and more. I see why artists do not marry, as the ties of marriage do hamper any career—and I am convinced that the possessiveness of marriage is what is bringing about so many divorces today.

You do not realize how dependent you are upon physical comfort— . . . good food—comfortable and charming surroundings—you think you would not feel the loss of all these things—but you would. Cheap clothes—restaurant food—cheap ugly rooms—no place to keep your costumes—work hard to get badly paid. These things can wreck a life no matter how much love there is back of it all. And you are not physically strong—it really frightens me to death to think of my beautiful little girl brought bang up against all the ugly, sordid condition of life.

Then too—one idealizes the beloved beyond all semblance of fact—& when disappointment & disillusion come, life is too terrible—one hardly has the strength to go on. I know only too well. What an ecstasy of joy—being in love brings—but it is as unstable and evanescent as the froth of champagne. . . . I wish I could help you—but no one can—you have to work it out for yourself. Well, remember that whatever you do—or do not do—you will always have a devoted and loving friend in your Mother.

The only keepsakes Leonie left to her children were two Japanese woodblock prints by Eizan Kikugawa, a late Edo-period artist. To Isamu she gave *Yamanba Kintarō*, a print of a chubby and lively Kintarō (Golden Boy), the hero of a children's story, who carried a hatchet and wrestled with bears; and to Ailes she gave a print of *Imayō onna-ōgi*, a full-breasted young mother nursing her infant. A few days after New Year's Day, 1934, Isamu and Ailes went to the Japanese restaurant Miyako to eat New Year *mochi*

(rice cakes) in memory of their mother, who had fallen in love with Japan in her youth. It seemed more appropriate than a funeral.

Isamu and Ailes erected a small gravestone for Leonie on the family plot in the Cypress Hills Cemetery in Brooklyn, where her mother Albiana was also buried. Just as the ancient Japanese interred their dead surrounded by *haniwa* figures, Isamu placed in the grave an unglazed ceramic piece that he made in Kyoto to keep her from being lonely. The gravesite is recorded in the Cypress Hills Cemetery register, but it is no longer possible to find. It may lie beneath one of the weathered headstones scattered on the family plot, whose inscriptions have been worn away. Leonie disliked churches and she did not believe in an afterlife. Perhaps she was content to blend quietly with the earth.

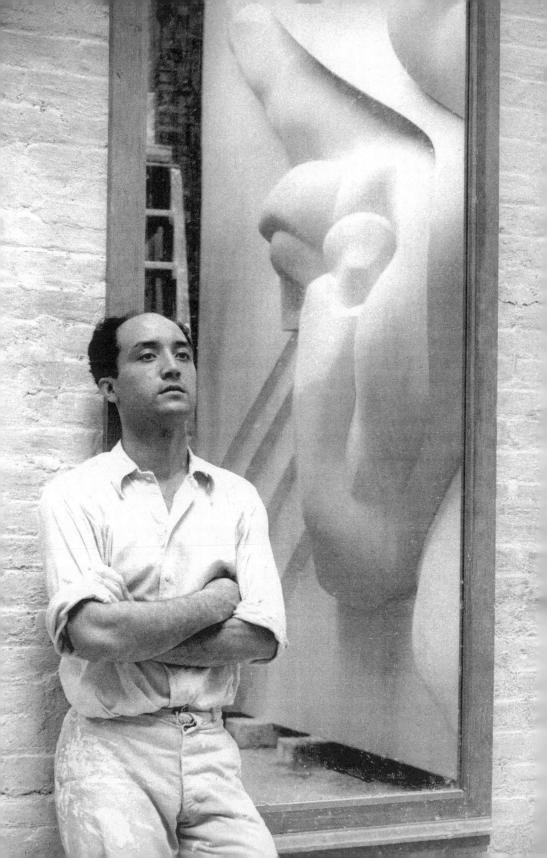

Becoming a Nisei

Frida, the Mexican Butterfly

"One day in the winter of 1933–1934 a vision appeared before me. It was a sculpture made from earth. I thought to myself maybe in the future earth will become sculpture."[1]

In February 1934 Isamu proposed a monument to Benjamin Franklin, an abstract rendering of the famous kite-flying experiment in stainless steel, to the Public Works of Art Project (PWAP), a new federal relief program for artists. He included a photograph showing a small part of the model and a full view of himself. When the agency asked for a picture of the whole monument without the artist, he sent them photographs and drawings for *Monument to the American Plow*, a huge triangular pyramid of soil, twelve thousand feet at the base, tilled in furrows radiating from one corner and topped by a stainless steel form representing the plow. It was his first attempt to produce a "sculpture made from earth."

Dr. Rumely had once told Isamu that the American plow had made possible the settlement of the Great Plains. The monument, "at once abstract and socially relevant," was intended to celebrate this great American symbol but the project also had personal significance for Isamu. "My model indicated my wish to belong to America, to its vast horizons of earth," he later recalled.[2] The Washington office, an official wryly noted, "turned their thumbs down . . . so hard that they almost broke their thumbnails."[3] Officials at the New York PWAP suggested that Isamu work on something of a more purely sculptural character. A few days later Isamu submitted drawings for *Play Mountain*, a playground for Central Park, the first of a series of playground designs, all variations on a pyramidal form

with steps, sloping surfaces and nested spaces rising to a narrow ridge or summit. Children could sled down its sloping sides in winter or splash in a shallow pool fed by a huge water chute in summer.

When asked about his interest in playgrounds, Isamu sometimes replied that Brancusi once told him when an artist stopped being a child, he would stop being an artist. His real goal was to link sculpture to daily life, to make sculpture that was functional as well as ornamental. "The sculptural elements [in the playgrounds]," he later said, "have the added significance of usage—in actual physical contact—much as is the experience of the sculptor in the making."[4] Bored with making portrait busts of fashionable New Yorkers, he wanted to explore new directions in sculpture. He rejected the idea that sculpture was simply decorative. "[I had] a kind of desire to get into another realm, another dimension," he recalled. "I suppose it's the same thing that makes us go to the moon—a desire to get away," he later said.[5] "[M]y head felt as though it was burning and all kinds of grand schemes came bubbling up."[6]

Not until the 1960s did terms like "public space," "environmental art," and "earth art" enter the vocabulary of American art, but three decades earlier Isamu was already groping toward the concept that the soil itself could be fashioned into sculptural forms. *Play Mountain* was a "sculptural landscape that people [could] inhabit." His vision of creating "sculpture made from earth" was ahead of the times, however, and he found few people who understood it. With an introduction from the *New Yorker* art critic Murdock Pemberton, Isamu showed a model of his visionary playground to Robert Moses, the powerful New York Parks Commissioner, who was also an important member of the New York PWAP regional committee. "Moses just laughed his head off and more or less threw us out," he recalled.[7]

To make matters worse, Isamu was dropped from the PWAP payroll in the spring of 1934. Once again he was forced to take on portrait commissions to support himself. Perhaps to rescue him, Marie Harriman, wife of the businessman (and later Secretary of Commerce) W. Averell Harriman, who had met Isamu at society parties, invited him to stage a solo exhibition at her gallery on East Fifty-seventh Street. With an advance of $1000, he rented a studio at the Woodstock artist colony in New York State for six months, and the show opened in late January 1935.

The *New York Times* critic called the Harriman Gallery show "an extraordinary exhibition." In using the word "extraordinary" he referred not

to the Benjamin Franklin monument, *Play Mountain*, or *Monument to the Plow*, all of which he found "bizarre" and "experimental," but to *Death*, a metal sculpture of a lynched African-American. The work was based on a photograph Isamu had seen in the left-wing *International Labor Defense*. The sculpture was a life-size stylized but not quite abstract human figure with a featureless face. It was suspended from a gallows with a rope around its neck, its torso and limbs contorted in the agony of death. Although rendered with simplicity, it conveyed the brutal cruelty of the lynching. "To a disastrous extent," the reviewer noted, "the portrayal is 'realistic.'"[8]

"[*Death*] no doubt stemmed from my sudden emergence into the field of social protest," Isamu later said.[9] During his career he created only a handful of works that might be called political but *Death* attracted the most attention. The *New York Times* reviewer, while recognizing it as a protest against lynching, concluded that it was "merely sensational and of extremely dubious value" as a work of art. Others were even less charitable.

Henry McBride, the reviewer for the *New York Sun*, not only was puzzled by the exhibition, he panned it viciously. He had already taken a jab at Isamu in a review of his brush drawings at the Demotte Galleries in 1932: "Isamu Noguchi, as his name indicates, stems from Japan, but he came to the West so early in life that he prefers now to have his art regarded as Occidental. It will be difficult to persuade the public to this opinion. Once an Oriental always an Oriental, it appears."[10] In his review of the Harriman Gallery exhibition, McBride conceded that Isamu had grand ideas but he could not help feeling that as an artist Isamu was "wily." Why, he asked, did this "semi-Oriental sculptor" propose design monuments to American icons like Benjamin Franklin and the steel plow? "[A]ll the time he has been over here," he concluded, "[he] has been studying our weaknesses with a view of becoming irresistible to us."[11]

Although McBride admired Isamu's drawings and portrait busts, he dismissed his "gruesome study of a lynching" as "just a little Japanese mistake." It would be wrong to see him simply as a racist, however. He was, after all, the critic who discovered and praised the work of Yasuo Kuniyoshi, an artist who painted scenes from American life with a delicate Japanese sensibility. McBride was suggesting that there was an element of hypocrisy in Isamu's work. Although he had established himself as a renegade sculptor, he cultivated patrons and clients in New York high society. Many artists did so, too, but Isamu, with his reputation for being a "society

playboy," stood out more than others, and was even criticized as an opportunist. In calling Isamu "wily," McBride simply meant that he seemed overly eager to please his audience.

Isamu, who returned from Japan fired by a new sense that he really was an American, was deeply offended by McBride's dismissive criticism. He never forgave him. McBride, along with Robert Moses, was one of his "lifelong enemies." Perhaps the critic had touched a sore spot. Early in his career Isamu had learned to manipulate the ambiguity of his identity. Even though he thought of himself as American, he continued to use his "semi-Oriental" status as a passport for survival, identifying himself with the East and with the West as circumstances demanded. For example, when the Harriman Gallery staged an exhibition of "Japanese artists" in 1935, it included works not only by Yasuo Kuniyoshi, Eitarō Ishigaki, and Hideo Noda, all resident aliens legally barred from American citizenship, but also by Isamu, who could make no claim to Japanese citizenship. By participating in the exhibition, Isamu was in effect declaring himself "Japanese."

The only expatriate Japanese artist in New York to become a close friend of Isamu was Eitarō Ishigaki, who had known his father Yonejirō. Ishigaki treated him like a younger brother, and like Hideo Noguchi he encouraged Isamu to take his father's surname when he decided to become a sculptor. A native of Wakayama prefecture, Ishigaki had been brought to America by his father, an immigrant worker. While supporting himself as a manual laborer, he studied art at night school. His long struggles as a common laborer, and his experience of anti-Japanese discrimination in California, converted him to socialism. His first wife, an American sculptor, was herself the ex-wife of a reporter who worked on the same San Francisco Japanese-language newspaper as Yonejirō. In the late 1920s Ishigaki separated from her to marry Ayako, a much younger Japanese woman who came to America to study.

When the Ishigakis first visited his studio, Isamu, ignoring Ayako after a glance, chatted only with Eitarō. He later told Ayako that he had thought to himself, "What an unattractive woman!" After Leonie's death Isamu often dropped by the Ishigakis' run-down apartment in Greenwich Village. He seemed to be in search of family company. Burying himself deep in the sofa, he chatted in broken Japanese that often sounded like direct translation from English. Ayako found him to be "an affectionate

person but lonely at the bottom of his heart." She was also aware that he thought "he had to astonish the world, whether it was through his art or his relations with women."[12]

Not long after the Harriman Gallery show closed, the WPA Federal Art Project opened an office in New York, announcing that it would pay weekly salaries of $23.50 to local artists. Isamu submitted a proposal for a "relief mural" but again he was turned down. He had once made a portrait bust of Audrey McMahon, the New York director of the WPA Federal Art Project. "[S]he was sort of ugly as a mud fence," he recalled, "and I guess I made her even more so."[13] Even if he had not offended her, he still did not qualify for the program since he could support himself by turning out portrait busts. Nevertheless he felt that he had been treated unfairly out of personal spite. Yasuo Kuniyoshi, who worked as a teacher at the Art Students League, got WPA support, and so did other employed artists. Swallowing his resentment, Isamu proposed yet another WPA project, *Relief Seen from the Sky*, an earth sculpture for the grounds of the New York City airport. "They laughed at me," he recalled. "In despair, I took off for Hollywood."[14]

In June 1935 Isamu arrived in Los Angeles, the birthplace he no longer remembered. He had driven across the continent in a Hudson automobile borrowed from Buckminster Fuller. With introductions from Michio Itō, then working as a choreographer in Hollywood, he landed several portrait commissions to earn money for an exploratory trip to Mexico. He had already received a short-term Guggenheim Foundation fellowship to study there before he left New York.

The sudden efflorescence of Mexican art drew many American artists south of the border in the 1930s. After a decade of revolution and civil war, the Mexican government had encouraged public art as an instrument of political education in the 1920s. The national literacy rate was low, and public murals were an ideal medium to promote popular understanding of the country's history and its new revolutionary ideals. Drawing inspiration from the monuments and wall paintings of the pre-Conquest period, artists like Diego Rivera, David Alfaro Siqueiros, and José Clemente Orozco launched the Mexican mural movement. Their work appeared in public spaces all over Mexico City—at the Presidential Palace, at the Ministry of Education, even in the subways.

The most famous Mexican artists, like Rivera and Orozco, were swamped with commissions in the United States, too. Isamu met Orozco

in New York City shortly after his return from Japan and asked him to pose for a portrait bust. He also served as an assistant on a mural project at Dartmouth College. It was this experience that gave him the idea of doing a "mural in sculpture." Although the WPA turned down his proposal for a relief mural, Marion Greenwood, an old friend from his Paris days, with whom he had had an affair shortly after his return from Europe, offered him a chance to create one in Mexico City.

A large woman full of energy, Marion was openhearted and sociable, and later became one of the few women artists to cover the World War II front. She and her sister Grace, also a painter, decided to study with Rivera in Mexico City after seeing his work in New York. In the summer of 1935 they began work under his supervision at the Abelardo Rodriguez market in downtown Mexico City, a five-minute walk from the Zocalo. Formerly a convent, it had been taken over by the government for conversion into a marketplace, theater, and child-care center. Today the lively pink-walled building is still crammed with shoppers and stores.

Eight artists were hired to decorate the market. The Greenwood sisters, who were painting a mural on the stairwell at the eastern corner of the market, asked Isamu to design a relief mural above the second floor landing. He chose as his theme the prerevolutionary oppression of the workers. After looking at a simple sketch entitled "History of Mexico," Rivera gave him permission to go ahead. For the next eight months Isamu grappled with his first public art project. The mural, entitled *War*, was fashioned from colored cement and carved brick. It covered a space about six feet high and seventy-two feet long wrapped across two walls. Isamu packed it with heavy-handed political symbolism: a skeleton killing a bloated capitalist, workers' bodies being crushed by a Nazi swastika, a huge fist raised in defiant protest, and even a Communist hammer and sickle. "It was what you [could] call my social protest against the WPA," Isamu later admitted.[15] He worked for the same wage as the Mexican artists, far less than what he could earn with a single portrait bust, and in the end he was paid only $88, half of what he had been promised. He had to sell Fuller's Hudson for his fare home.

Isamu had not come to Mexico City to make money; he had come to create socially useful art. In a 1936 article in *Art Front* magazine, "What's the Matter with Sculpture?" he wrote that contemporary sculpture "whether imaginative or realistic, has no relation to life of today." He called for a sculptural art that engaged contemporary society. "Let us make sculp-

ture that deals with today's problems. Draw on the form content so plentiful in science, micro- and macro-cosmic; life from dream-states to the aspirations, problems, sufferings and work of the people. . . . It is my opinion that sculptors, as well as painters, should not forever be concerned with pure art or meaningful art, but should inject their knowledge of form and matter into the everyday, usable designs of industry and commerce.[16]

"It was marvelous," he recalled of his experience in Mexico City. "They were open to art, open to artists' propaganda, . . . open to people coming from abroad and doing things." In Mexico he never felt like an outsider. "Here I suddenly no longer felt estranged as an artist; artists were useful people, part of the community."[17] In the evenings he and the Greenwood sisters went to gatherings at Rivera's house, and he soon became a regular at parties thrown by Miguel Covarrubias, the popular artist and illustrator who had just returned from New York, where he had drawn satirical covers for *Vanity Fair* and the *New Yorker*. His American wife, Rosa, a former Broadway dancer, had been a close friend of Ruth Page. During work breaks Isamu often stopped by the nearby Presidential Palace, where Diego Rivera was working on one of his masterpieces. The forty-eight-year-old Rivera loved to talk as he worked, and the more onlookers gathered to watch the more voluble he became.

Isamu first saw Rivera's wife, Frida Kahlo, while walking across the Zocalo with a friend. A dark complexioned woman in a taxicab cast a slightly mocking glance in their direction and shouted a greeting to his companion. Isamu was immediately enchanted. "She was a lovely person," he recalled. The most striking feature of Frida's face was the unbroken line of dark eyebrows above piercing eyes that cast a haughty but voluptuous look on everyone. Her intense gaze intimidated most men but Isamu found it attractive. He was not in the least concerned that Frida was the wife of the leading figure in the Mexican art world, the patron who had given him work. To his delight, Frida took a liking to him, too. "I used to have assignations with her here and there," he recalled. Their romance, according to Frida's biographer, sometimes smacked of a French bedroom farce.

Frida was twenty-one years younger than her husband. When Isamu met her, she was twenty-eight years old. Her father was a Hungarian Jew, and her mother was of Spanish-Indian descent. Although only one-quarter Indian, as if to emphasize her Mexican ancestry she wore her long black hair in traditional style and donned showy folk-festival dresses with long

petticoated skirts that rustled as she walked. As a child Frida had been stricken with polio, and as a teenager she had been in a bus accident that broke her spine, ribs, hip, and left leg. Her long skirts hid the fact that her left leg was not as long as her right one. "We went dancing all the time," Isamu recalled. "Frida loved to dance. That was her passion, you know, everything she couldn't do she loved to do. It made her absolutely furious to be unable to do things."[18]

Frida claimed that an iron handrail penetrated her lower abdomen and vagina during the bus accident, and it was rumored that she could not have sex, but according to Isamu she functioned perfectly normally as a woman. When an American reporter asked what she did while her husband was working on a mural for Rockefeller Center, she replied with a straight face, "I sleep with men." She liked to startle others with tall tales and off-color humor. To Isamu that was a mark of her quickness of mind and her refusal to bow to convention. Like her husband, Frida was a member of the Communist Party. Isamu, then going through a radical phase, sympathized with her radical critique of Mexican society, but he discovered that Frida was also fond of a good time and, like him, was comfortable consorting with the rich and famous in New York City.

Most people thought of Frida as an amateur artist, but Isamu was deeply impressed by her paintings. Indeed, he was one of the first to appreciate their value. He even thought them more interesting than her husband's. Her well-known self-portraits express the physical pain she suffered from repeated operations as well as the psychological pain she suffered from her husband's womanizing. They are devoid of self-pity, however. In spite of Rivera's peccadilloes he remained the center of her world. Her own sexual adventures were a response to his infidelities. "In those days we all sort of, more or less, horsed around, and Diego did and so did Frida," Isamu later recalled. Rivera never bothered to conceal his love affairs from his wife, and her own dalliances were a way of fighting back. "Since Diego was well known as a lady chaser," Noguchi recalled, "she can not be blamed if she saw some men. . . . It wasn't quite acceptable to him, however."[19] Rivera was the embodiment of machismo, and he played the role of a jealous husband to the hilt. Whenever Frida went out dancing with Isamu, he insisted that her sister Cristina go along as a chaperone.

Frida's flamboyant sexual behavior—she was rumored to be bisexual—is said to have begun when she discovered Rivera's affair with her sister. She

retaliated by having a fling with Isamu, and also with Leon Trotsky, then in exile in Mexico City. Whether Isamu was aware of Cristina's affair with Rivera is not clear, but it was at her house in Coyoacan that he arranged trysts with Frida. The only painting Frida completed during this time—*A Few Small Nips*—is among her best works. It was inspired by a newspaper story about a man who had brutally murdered his girlfriend by stabbing her repeatedly in a drunken fit. In court he protested his innocence: "But I only gave her a few nips." In the painting he stands nonchalantly, a slight smile on his face, with one hand in his pocket and the other holding a knife, as he gazes down at his lover's naked body covered with bloody gashes.

It was at Frida's house, where Isamu and Frida were in bed together, that Rivera brought an end to the affair. Owing to a split in the Mexican Communist Party between Stalinist and Trotskyite factions, Rivera carried a pistol for self-protection. When the houseboy warned the lovers of Diego's sudden arrival, Isamu jumped out of bed, pulled on his clothes, and clambered onto an orange tree outside the window to escape over the roof. Rivera came in hot pursuit, pistol in hand. When Isamu visited Frida at the hospital sometime later, the two men met again. "Next time I see you, I'm going to shoot you," said Rivera, flourishing his pistol. Back in New York, Isamu regaled the Ishigakis with the story of how he had cuckolded Mexico's greatest artist and was thrown out of his house at gunpoint. He was as excited as a little boy as he talked about his adventure, says Ayako, and from then on he became more and more interested in other men's wives. Such affairs involved less responsibility, she speculated, and were seasoned by a touch of danger.

In June 1946, Frida flew to New York for surgery to fuse four vertebrae. Isamu visited her at the hospital while she was recuperating. "She was there with Cristina," he recalled, "and we talked a long while about things. She was older. She was so full of life, her spirit was so admirable."[20] As a gift he brought her a collection of butterflies in a glass-covered box. Frida, who loved the delicate creatures, was absolutely delighted and hung the box over the door to her hospital room. It was the last time Isamu saw her. In April 1954 she died at the age of forty-seven. The house where she lived in the Coyoacan district of Mexico City has been preserved as the Frida Kahlo Museum. After she returned to Mexico, Isamu told her biographer, she installed the box of butterflies under the canopy of her four-poster bed. Today the bed stands in the second floor corridor between her studio and her bedroom, but there is no box of butterflies to be found. Instead there is

a mirror where Frida could see her own reflection. According to Cristina's daughter Isolda, whom the childless Frida had raised, her aunt had slept in Cristina's bed for several years before her death. It was there that the butter-fly collection, twenty-seven specimens, all Japanese, large and small, spread their wings behind a glass cover. The bright creatures that consoled Frida as she lay motionless, tormented by the intense pain in her spine, had very probably come to America with Isamu after his "pilgrimage to the East."

Fatherland and Motherland at War

In early December 1937, five months after the outbreak of undeclared war between Japan and China, Isamu told a reporter, "Virtually all Japanese art springs from Chinese roots. The essential Japanese attitude toward life—the love of contemplation, the affection for nature—comes from China, too. But Japan, overcome by a capitalist-military group, has developed a frantic spirit of nationalism, whereas China has never believed that progress lies along the path of power. Japan should love China for what China has given us. It is tragic that instead Japan has set about the methodical business of maiming and slaughtering her people."[21]

At a fund-raising tea sponsored by the Chinese Women's Relief Association to raise money for war-stricken China, Chinatown merchants contributed antiques, paintings, jade ornaments, and other objets d'art for an auction. The item of greatest interest was Isamu's brush painting of a Chinese mother nursing her child, a potent symbol of an enduring China that had survived countless foreign conquests. A Chinese merchant on Broadway bid $70 for the painting but offered to triple the amount if Isamu explained why he as a Japanese-American artist was helping China's cause. Somewhat embarrassed, Isamu answered, "I would give this drawing as my way of showing that not all Japanese are militaristic."[22] To remain silent about the war was tantamount to supporting Japanese aggression in China. His donation was an act of conscience as an American in whose veins ran Japanese blood.

The world crisis was deepening in Europe, too, where the Spanish civil war pitted the forces of political and social democracy against militarism and fascism. Like many artists and writers, Isamu supported the radical Loyalist cause against the right-wing Falangists. "I think that all artists, or most artists, had a strong sense of belonging to the Loyalist cause," he said. "I mean there were very few that took the opposite side. I think it all

came from all our experience in the Depression and ... that we associated ourselves with the more liberal element. You know, we had hopes of a better world. I suppose we also had a strong sense of guilt."[23]

After his return from Mexico Isamu turned two run-down carpenter's workshops behind a building at 211 East Forty-ninth Street into a pair of studios. He kept one for himself and sublet the other to Aaron Ben Schmuel, a sculptor who taught him the finer points of stone carving. To survive financially he made portrait busts of Lillian Gish and other celebrities, and to overcome his frustration at rejection by the WPA he entered every sculpture competition he could. His proposals were rejected over and over again until he was finally selected to do a sculpture for the Ford Motor Company pavilion at the 1939 New York World's Fair.

Eager to try his hand at a new material, magnesite, Isamu designed his first fountain. The result, an abstract assemblage of various automobile parts, was less than successful—even in his own view. As a sarcastic critic later described it: "The assemblage is balanced on the wheel, with the engine block high in the air, so one gets the impression of a Ford having crashed to earth tail first and landed on its left rear wheel, then having experienced a strange process of decay that eliminated most of its parts while bleaching and fossilizing [the rest.]"[24] The fountain's only virtue, Isamu later admitted, was that it taught him how to use magnesite.

Isamu's fortunes rose when he won a competition for a bas-relief sculpture over the entrance to the Associated Press Building in Rockefeller Center, a commission much sought after by other artists. Isamu submitted two proposals, one that he spent two months preparing, and another dashed off in three days. The second won the competition. The massive stainless steel bas-relief, entitled *News*, displayed several figures using the tools of modern journalism: the telephone, the typewriter, the camera, and the reporter's notepad. Weighing over nine tons, it was the largest stainless steel casting ever made. The enlarging, grinding, and welding of the piece took a year to complete. Isamu did much of the physical labor himself, often working sixteen hours a day.

When the bas-relief was unveiled on April 29, 1940, the *New York Times* praised it as "an artistic achievement" and a "technical triumph."[25] The event attracted notice even in Japan where the *Mainichi shinbun* reported: "Last month the construction of the building for the Associated

Press, one of the two big American wire services, was completed in Rockefeller Center in the center of New York City. A ceremony was held to unveil the decorated bas-relief at the front entrance. The design of the sculpture was the work of the Japanese Noguchi Isamu. The 35-year-old Noguchi, the son of the poet Noguchi Yonejirō, is a rising young sculptor, and he received $1000.00 as prize for first place in the nation-wide competition."[26]

The Japanese consulate in New York asked the "rising young sculptor" to voice support for the Japanese war effort. Several years earlier Yonejirō had gone to India on a lecture tour under the auspices of the Japanese Foreign Ministry to promote Japanese-Indian friendship. He had met with his longtime friend, the poet Rabindranath Tagore, and with Mahatma Gandhi, the leader of the Indian independence movement. In late 1938, however, Yonejirō broke with Tagore in an exchange of open letters accusing him of being blind to the fact that Japan was fighting a holy war to liberate Asia from Western imperialism. The dispute made the headlines even in the United States. The Japanese consulate wanted the son of "Japan's patriotic poet" to make a pro-Japanese statement, too. Isamu flatly refused.

Ironically, at almost the same time the American State Department asked Isamu to send an open letter to his father, the "militaristic propagandist." Troubled about how to respond, he sought advice from Hu Shih, the Chinese ambassador to the United States, whom he had gotten to know through the Chinese Relief Association. Hu, who had led anti-Japanese demonstrations as a professor at Peking University, gave him an unexpected reply, "Don't do anything," he said. "Don't attack your father. You'll regret it. Don't do anything."[27] In the end, Isamu followed his advice.

After completing the Associated Press Building project, Isamu had little reason to remain in New York. He had no more artistic projects, and no romantic ties to keep him there. Officials from the Parks Department had rejected his designs for modernistic playground equipment as too dangerous, and when he proposed a playground with no equipment at all they were slow in responding. Frustrated, and convinced that nothing would come of the project, Isamu loaded an old Ford station wagon with his tools and other belongings and set off for the West Coast with the painter Arshile Gorky and his fiancée in the summer of 1942. The trip to California was, as for so many others, "an attempt to find new roots in the West."[28]

Isamu had befriended Gorky in the early 1930s, and after his return from Mexico their friendship deepened as they made the rounds of art

museums and visited each other's studios. Gorky, well over six feet tall with dark skin, black hair, and an elaborately bushy mustache, cut an impressive figure. Isamu barely reached his shoulders. The two men made an odd couple, but they shared similar childhoods and similar views about art. They were the same age, too. "Gorky felt that he wasn't totally American," Noguchi told Gorky's biographer. "I think he emphasized his non-American-ness, in a sense. And there was a kind of bond between us, not being entirely American, you see. We were friends and we had a good deal in common because we were artists and we had a certain loneliness here, which we shared, and art was something we could talk about. It was something that kept us going."[29]

Gorky's childhood had been hostage to the tragic circumstances of his homeland, Armenia, a country swept up in the struggles between two powerful neighbors, Persia and Turkey. He was born in 1904, the year that Turkey invaded Armenia and brought it under control. His family was in constant flight from Turkish troops during his childhood. When Gorky was fifteen he and his sister fled Turkey to live in America with their father, who had immigrated earlier to escape conscription into the Turkish Army. He was obsessed with the memory of his mother, who starved herself to death so that her children could survive. One of his best-known paintings is *The Artist and His Mother*, a poignant self-portrait of himself as a child with his mother.

When they first met Gorky was painting WPA murals in a Cubist style heavily influenced by Picasso and Miró. Isamu thought that Gorky was falling into a rut as an artist, and he invited him on his trip to the West Coast. Jeanne Reynal, another artist friend, arranged a Gorky retrospective show at the San Francisco Museum of Modern Art. In early July 1941, the two men headed off across the country with Gorky's twenty-year-old fiancée, Agnes Magruder, as a third passenger. Isamu's half-sister Ailes and one of her girlfriends came along for a few days, too. Gorky talked constantly as they drove along Route 66. "He'd always be seeing some peasant woman up in the sky," Isamu recalled. "That is, in the clouds. And we had terrible arguments about it because I said, 'That's just a cloud.' And he'd say, 'O no, don't you see that peasant woman up there?' And then he'd go on about his Armenian childhood recollections which seemed to tinge everything he saw."[30] By the time they reached San Francisco in mid-July relations between Isamu and Gorky were tense. "In all my life I had never before made such an

error," Gorky wrote to his sister in Chicago. "It appears that my friends wanted me along for the purpose of reducing their traveling costs."[31]

The Gorky exhibition at the San Francisco Museum of Modern Art in early August was a critical success. At a cocktail party in celebration of the show Katherine Kuh, a Chicago gallery owner, met Isamu for the first time. Two years earlier she had exhibited several of his pieces at her gallery but she had never met him. When Isamu entered the party in a grand mansion overlooking the Golden Gate Bridge, he took her breath away. "He was as beautiful as the dawn because he was young then, had all his hair, and was really beautiful," she recalled.[32]

Kuh was intrigued by the relationship between Isamu and Gorky's fiancée, Agnes. "Gorky was crazy in love with her but Noguchi was flirting his head off with her," she recalled. "Now here was Noguchi, beautiful . . . and charming, every woman rushing after him, and Agnes was no fool. And here was Gorky at her side, looking angry and morose and depressed. He was really depressing to have around. And all of them had come in a little station wagon of Noguchi's, and he had driven them across the country."[33] Perhaps Isamu's interest in Agnes, and not Gorky's monologues about visions in the clouds, had been the reason for the tension between Isamu and Gorky, but Isamu soon left San Francisco for Hollywood, and by the time Gorky and Agnes boarded a bus to return home they were safely married.

On the morning of Sunday, December 7, 1941, Isamu was in his station wagon driving south from Los Angeles to pick up material at a stone supplier near San Diego. In Hollywood, where Michio Itō had looked after him, he had been making a portrait bust of the painter Fernand Léger, a refugee from the European war. Ginger Rogers, Fred Astaire's famous dancing partner, had commissioned a bust, too. As he sped along the nearly empty road he switched on the radio to dispel his boredom. From the speaker came the tense and somber voice of an announcer repeating over and over again, "The Japanese have attacked Pearl Harbor." At 7:49 a.m. Hawaiian time, the peaceful Pacific stretching off in the distance had been sundered by the outbreak of war between his father's land and his mother's.

In the days after the Pearl Harbor attack rumors spread that the Japanese navy was preparing to strike the American mainland. Reports of brutal atrocities by the Japanese army in China had been in the news since 1937. A wave of panic and fear rippled along the West Coast, and anger toward Japan

aroused by the "sneak attack" on Pearl Harbor soon turned against the 110,000 Japanese-Americans living on the West Coast. Like all foreign-born Asians, the first-generation Japanese-Americans, the Issei, were barred by law from naturalizing as citizens, and when the war broke out they automatically became "enemy aliens." For security reasons the Federal authorities quickly rounded up key Japanese-American community leaders—Japanese language school teachers, Buddhist and Shinto priests, editors and reporters of Japanese-language newspapers, leaders of prefectural homeland associations—and shipped them off to a relocation center in Montana. Among them was Michio Itō, who was arrested by FBI agents the day after the Pearl Harbor attack as a suspected saboteur. Unlike their parents, the Nisei—second-generation Japanese-Americans born in the United States—were full-fledged American citizens but in the face of growing public fear there was an outcry to remove all Japanese-Americans, Issei and Nisei alike, from the West Coast. It was difficult to tell one "yellow face" from another.

"Pearl Harbor was an unmitigated shock, forcing into the background all artistic activities," Noguchi recalled. "With a flash I realized that I was no longer the sculptor alone. I was not just American but Nisei. A Japanese American. . . . I felt I must do something. But first I had to get to know my fellow Nisei; I had previously no reason to seek them out as a group."[34]

In fact, the Nisei had already sought him out. In 1940 the newly organized Japanese-American Citizen League (JACL), a Nisei group, had presented him with the "Yamamoto Award for Nisei Achievement" after the completion of the Associated Press Building project. On a visit to Honolulu that spring to discuss a project for the Dole Pineapple Company, Isamu asked Franklin Chino, a JACL leader in Chicago, for contacts with local Japanese-American groups who might provide support. Chino offered instead to put him in touch with several Japanese-American newspaper editors in California. "They are among the leaders of the West Coast Nisei," Chino wrote, "and naturally enough would be quite interested in meeting you since I can say, without any flattery, that you are the only Nisei who has accomplished anything in art."[35] Perhaps hope of developing ties with the California Nisei community had prompted his decision to leave for the West Coast in the summer of 1941.

"O my God, I'm a Japanese—or I'm a Nisei at least," he thought to himself when he heard the news of the Pearl Harbor attack.[36] He was keenly aware of his ambiguous identity. Time and again he was identified as

"Japanese-American," but now he realized that the Nisei, like himself, were caught between two homelands. Even though they were citizens, other Americans doubted their loyalty to the United States because of their Japanese heritage, and even though Japanese blood flowed in their veins, because they lived in America the Japanese no longer thought of them as fellow countrymen. The Nisei, like Isamu himself, belonged nowhere.

In February 1942 Jeanne Reynal, with whom Isamu was living in San Francisco, wrote to Agnes Gorky, "Isamu is very busy with the Japanese minority problem and is showing great capacities for political organization. The problem is a vast and knotty one, and I am afraid the time element is playing against them and that now even American citizens will be shunted around."[37] Isamu's first step toward "acting as a Nisei" was to organize "Nisei Writers and Artists for Democracy" at Jeanne's studio on Montgomery Street in San Francisco. The small group included Larry Tajiri, a JACL leader, Shūji Fujii, editor of a Japanese-American newspaper in Los Angeles, and several others.

In an unpublished 1942 essay Isamu wrote, "To be hybrid anticipates the future. This is America, the nation of all nationalities. The racial and cultural intermix is the antithesis of all the tenet [sic] of the Axis Powers. For us to fall into the Fascist line of race bigotry is to defeat our unique personality and strength. . . . [B]ecause of my peculiar background I felt this war very keenly and wished to serve the cause of democracy [in] the best way that seemed open to me. . . . I felt sympathy for the plight of the American-born Japanese, the Nisei. . . . [A] haunting sense of unreality, of not quite belonging, which has always bothered me made me seek for an answer among the Nisei."[38]

Although the JACL had not yet established itself in the Japanese-American community, a Nisei organization involving Isamu Noguchi was bound to attract public attention. Not only was Isamu well known for a Japanese-American, he was also well connected with the elite in the white majority. It was inevitable that he was chosen as the group's representative, but he found the West Coast Nisei very different from the Japanese-Americans in Hawaii. Growing up with constant discrimination had made them "very timid," "always on the right side," and reluctant "to have anything to do with liberals."[39]

The Nisei Writers and Artists for Democracy sought to prevent the compulsory relocation of Japanese-Americans from the West Coast by

explaining to the public that the Nisei were loyal citizens. At the suggestion of a former client, Clare Booth Luce, the wife of Henry Luce, the publisher of *Time, Life,* and *Fortune* magazines, Isamu sent Archibald MacLeish, head of the Library of Congress, a proposal that loyal Japanese-Americans proficient in the Japanese language be recruited into the government's wartime propaganda effort. Not only would that counter Japan's racial propaganda, he said, it would counterbalance disloyal elements within the Japanese-American community. Interestingly, he concluded his letter to MacLeish, a poet, by noting that his father was Yone Noguchi, "one of Japan's leading advocates."[40]

Compulsory relocation of Japanese-Americans, Isamu hoped, could be halted once the hysteria surrounding the Pearl Harbor attack died down. He placed high hopes in President Franklin D. Roosevelt, a leader who consistently opposed racial discrimination. But as Jeanne Reynal reported to Agnes Gorky, plans to intern Japanese-Americans were already in the works. Under pressure from the press and from Congress, on February 19, 1942, the president issued Executive Order 9066 authorizing the evacuation of all Japanese aliens and all American-born of Japanese descent from the West Coast. Two days later a congressional committee headed by Representative John Tolan opened hearings in San Francisco to investigate the advisability of evacuating "enemy aliens" from the West Coast.

In early March, Isamu and two other Nisei leaders sent the Tolan Committee a statement. "In testing for loyalty," they wrote, "we wish to point out that loyalty is not entirely a matter of citizenship or educational background, nor a matter of religious or political affiliation."[41] Carey McWilliams, chief of California's State Immigration and Housing Division, suggested to him that the best way to get fair treatment for the Nisei was to cooperate with the Tolan Committee and explain the Nisei viewpoint.[42] Isamu, hoping for an opportunity to testify, attended the hearings every day as the representative of the Nisei Artists and Writers for Democracy but the committee gave the Japanese-Americans little chance to defend their position. In Los Angeles, German refugees like Thomas Mann and Bruno Walter urged the government not to lock up German refugees who fled the Nazi regime as "enemy aliens," and in San Francisco Joe Dimaggio's mother spoke on behalf Italian-Americans. "[T]hat really helped [them]," Isamu recalled, ". . . that was a clincher! I mean that clearly fixed the Italians up. Who could they get to testify for the Japanese?

For the Nisei? I remember saying a few words, but I was . . . not in my league."[43] In the end the hearings of the Tolan Committee simply served as a forum for anti-Japanese groups urging evacuation.

General John DeWitt, commander of the Western Defense Command, entrusted with the authority to carry out the evacuation of Japanese-Americans, believed that the Nisei, even though American-born citizens, were potential enemies. As he famously said, "A Jap is a Jap." On March 2, 1942, while the Tolan Committee hearings were continuing, he announced that for reasons of "national security" and "military necessity" all those of Japanese heritage, whether citizens or aliens, were to be removed from the Western Defense Command, an area that included California, Oregon, Washington, and the southern half of Arizona. Japanese-American families were suddenly forced to leave their homes for temporary assembly centers such as the Santa Anita Race Track, where they lived in stables reeking of horse manure until relocation camps were built to accommodate them.

In late March, Isamu and his colleagues in the Nisei Artists and Writers for Democracy committee asked Milton Eisenhower, the newly appointed director of the War Relocation Authority, to support a privately financed documentary film about the evacuation. To facilitate filming, they asked for a relaxation on the travel restrictions and curfews placed on Japanese-Americans, who could not travel more than five miles from home or go out between the hours of 8:00 PM and 6:00 AM. The purpose of the documentary was "to counter any false propaganda put out by the Japanese government by showing the democratic and humane treatment accorded the evacuees," to prevent "undue hysteria" among white Americans by demonstrating Japanese-American cooperation in the war effort, and to bolster "the morale of the Japanese evacuees" by showing what conditions at the camps were really like.[44]

About one thousand feet of film was shot at the Manzanar reception center and other sites with money raised in part from Isamu's Hollywood connections. By the time the first unedited, uncut version of the documentary was shown to a small audience in Los Angeles Isamu had already left California. The Federal authorities had decided that anyone "with even one drop of Japanese blood" was to be evacuated from the West Coast, a standard that surely placed Isamu among the "Japs," but as a temporary visitor from New York he was permitted to return home. Since the JACL had no foothold on the East Coast, he took on the job of drawing public attention to the relocation policy in New York and in Washington.

Poston Relocation Camp

Isamu was disappointed at the attitude of his radical leftist friends in New York who had supported the Popular Front during the Spanish civil war. He had expected that they would back a protest against the government's policy but "not a single communist" spoke up against the relocation of the Japanese-Americans, he recalled. They thought—probably correctly—that what the American government was doing to the Japanese-Americans was no different from what the Soviet Union had done when it shipped German nationals off to Siberia. "[They] thought Roosevelt was doing just the right thing in locking up all the Nisei," he said.[45]

The novelist Pearl Buck, the author of *The Good Earth*, a best-selling novel about peasant China, offered him help. Buck was chairman of the East-West Society, an organization devoted to promoting mutual understanding among different racial and ethnic groups. Among its members were Clare Booth Luce, her husband Henry Luce, the anthropologist Margaret Mead, and other luminaries. Buck promised to help the Nisei group spread word about the plight of the Japanese-Americans. "She suggested that our temporary committee busy itself in interesting well known authors to write for Nisei publications," Isamu wrote to Larry Tajiri, by then incarcerated at the Santa Anita Race Track. "The purpose is twofold—to supply the Nisei with good articles, but in her estimate, more important, in doing so, to interest the writers themselves." Rather than ask support for the Japanese-Americans, she said, it would be better to approach writers as "Americans to promote Americanism." "[We] will gain friends because they will have an interest in seeing that there be justice."[46]

Isamu headed for Washington, where he hoped to find a way to contribute to the war effort. At the State Department he was told, "No, go away; there's nothing you can do; you're the last person we want to see; you're a half-breed; what do we want with you." At the Office of Strategic Services, he was rebuffed again. "They said to me: what do you want to do? Get involved in killing your brother?"[47] The idea was not so far-fetched. Unbeknownst to Isamu, his oldest half-brother, Masao, had been called up for military service in China; shortly afterward Tomiji, another half-brother, had been sent to north China; and in 1943 Isamu's half-cousin (the son of his Uncle Takagi) was called up in the general mobilization of university students. The harsh reality was that the war between Japan and the

United States made enemies not only of his Japanese father but of his Japanese half-siblings too.

Still hoping "to do something as an American" for the war effort, Isamu met with John Collier, the head of the Office of Indian Affairs, a man with a long-standing reputation as a defender of Native-American interests. The meeting had probably been arranged with the help of Dr. Rumely, whose ideas on education had interested Collier. Indeed, the two men had become regular correspondents after Collier visited the Interlaken School. One of the ten relocation camps was situated on an Indian reservation at Poston, Arizona, and the Office of Indian Affairs cooperated in its management. Collier, who had spent much energy trying to revive Native-American arts and crafts, invited Isamu to help create "an ideal cooperative community" there by promoting an arts and crafts movement. He hoped the camp would provide the internees with useful work, educational opportunities, and other services to ease their postwar rehabilitation. Fired by Collier's idealism and enthusiasm, Isamu accepted the invitation.

Eight Japanese artists living in New York City, all "enemy aliens," including Yasuo Kuniyoshi and Eitarō Ishigaki, had issued a statement supporting "American democracy" after the attack on Pearl Harbor but when Isamu urged them to work in the relocation camps not one volunteered. Some were willing to serve as visiting artists, teachers, or lecturers but no one saw any point in self-incarceration. Only Isamu was willing. It was an idea that Ayako Ishigaki thought was "crazy."[48] In early May 1942, less than a month after his return to New York, Isamu flew to Los Angeles, a city now off limits to Japanese-Americans, where he retrieved his Ford station wagon, and set off for Arizona after securing a travel permit from the military authorities.

As the Colorado River flows across the border between Arizona and California its waters turn as red as the parched soil. The river marked one boundary of the Colorado Indian Reservation where the Poston relocation camp was being built in the midst of a desolate desert. The soil was baking in the midsummer sun when Isamu arrived there on May 12, 1942. Rough wooden barracks were under construction, and although no roads or drainage ditches had been laid out within the camp, a barbed-wire fence surrounded the camp periphery. Watch towers manned with machine guns pointing inward were built every five hundred meters, and at night search-

lights roamed the camp interior. The fence was not intended to protect the Japanese-Americans; it was intended to enclose them.

Two weeks after his arrival in Poston, Isamu wrote the Surrealist photographer Man Ray, a friend since his Paris days, then living in Hollywood. He was shocked at life in the camp. "This is the weirdest, most unreal situation—like in a dream—I wish I were out. Outside, it seems from the inside, history is taking flight and passes forever. Here time has stoped [sic] and nothing is of any consequence, nothing of value, neither our time nor our skill. Our sphere of effective activity is cut to a minimum. Our preoccupations are the intense dry heat, the afternoon dust storms, the food. But maybe this is sence [sic]—the world is nuts. . . . Maybe it's the weather that makes everything so unreal."[49]

The tarpaper-covered walls of the hastily built wooden barracks did little to shield the inhabitants of the camp from the merciless desert sun or the dust storms that swept through it. Isamu had never lived under such harsh natural conditions. The eight hundred barracks were divided into blocks, with a communal mess hall, showers, toilets, and washrooms for every fourteen barracks. Isamu's address was Room A, Barracks 7, Block 5. When he arrived, the only inhabitants of the camp were a small group of JACL members cooperating with War Relocation Authority officials to prepare for the arrival of the internees. Ten days later internees began pouring in from West Coast assembly centers, carrying only the hand baggage they were permitted to take when evacuated from their homes. By early 1942 the population of Poston had grown to 17,000, and plans were under way for construction of a second unit.

Every aspect of the internees' daily lives was controlled by their serial numbers, not by their names. There is no serial number for "Isamu Noguchi" to be found in War Relocation Authority records. The Office of Indian Affairs indicated to the WRA that Isamu "had volunteered his services to the Bureau of Indian Affairs . . . to aid in the development of a handicraft project among Japanese evacuees."[50] He was the only such volunteer to enter the camp, and that is probably why he had no serial number. In other respects his life was no different from the rest of the internees. His day began with the sound of a siren at 7:00 AM, and it ended with lights out at 9:00 PM. Three meals at the mess hall, showers in the communal bath, standing in line for everything—these were the same for Isamu as for everyone else. Indeed, all former internees repeat the same mantra: "We waited for everything."

"Your very beautiful and moving letter reached me several weeks ago," his half-sister Ailes wrote from New York, "but the news therein was very sad to me. . . . I can only urge you to leave as soon as possible. In that intense heat and with no fruit or vegetables or milk you will lose your health." Ailes, who gave up her career in modern dance after injuring a leg, was working at Macy's. She had kept her mother's surname Gilmour, and since she did not look very Japanese the outbreak of war had not affected her life much. "You had a very delicate stomach anyway and how can it stand such a diet. It seems a pity that you must all live like that. . . . Can you really do so much staying there with them or are you punishing yourself?"[51]

To provide the internees escape from the frustrations of their closed and isolated life the War Relocation Authority set up adult-education programs. Isamu opened up a woodcarving and carpentry shop but the only tools available were those he brought with him, and for material he had to scavenge leftover lumber from camp building contractors or comb the nearby desert for mesquite. He was also put in charge of producing bricks for recreation facilities. After he drove to the nearby town of Parker to pick up two tons of clay, he wrote John Collier, "It was my first trip outside the camp since coming in and was sure a thrill."[52]

During his early days at Poston, Isamu was bursting with his usual energy. He turned out plans for parks, baseball fields, swimming pools, a cemetery, and even an irrigation system. He was eager to build the "ideal community" that he and John Collier had talked about. It was an opportunity to carry out projects he had earlier proposed to the WPA. But building an "ideal community" in the desert was not what the WRA officials had in mind. They had no intention of creating anything permanent to testify to the existence of the camps once the war ended. Isamu, with all his plans and all his demands, became a nuisance to the WRA officials. Even if he had not been, his status remained ambiguous. He began to feel his usefulness "terribly restricted."

On July 28 Isamu asked the WRA to give him more responsibility or release him from the camp: "My reason for coming [to Poston] appart [sic] from my sympathy and interest, was the recommendation of Mr. John Collier that I might contribute toward a rebirth of handicraft and the arts which the Niseis have so largely lost in the process of Americanization. . . . I have suggested that there should be coordination and a distribution of talents available in the various camps, so that the urban centers may enrich

the more rural developments such as this. I have wanted to get some sort of job which will enable me to visit the other centers to arrouse [sic] interest and to find talent. . . . I hope that you may find it possible to help me secure such a position. Otherwise I must be asking for my release back to New York, much to my regret."[53]

In a letter to John Collier Isamu revealed another reason for wanting to leave Poston. "I am extremely despondent for lack of companionship. The Niseis here are not of my own age and of an entirely different background and interest."[54] He also told Carey McWilliams how little in common he had with the Japanese-Americans. "The people here are for the most part farmers, completely un-intelectual [sic], and with little apparent interest in the policies or politics of democracy other than resentment with their common lot. Actually conditions are not bad—rather it's the racial basis that makes them despair."[55]

Isamu had been elated by his discovery that he could identify himself as a Nisei. It overcame the anxiety that had dogged him from childhood—the feeling that he belonged nowhere. His new sense of identity was the reason he had volunteered to go to Poston. Once there he found himself an outsider in two senses. To the WRA camp administrators he was a troublesome interloper from the Bureau of Indian Affairs, and to the internees he was a "half-breed" agent of the camp administration. Many internees mistrusted him, and his privileged position in the camp only deepened their suspicions that he was "a spy." "I haven't got the same history," he later recalled. "I haven't got the same background and so forth. There was a lot of resentment."[56]

Henry Kanegae, Block 5 representative on the Camp Council, saw Isamu every day. The twenty-five-year-old Kanegae had attended college for two years but since it was difficult for Nisei college graduates to find jobs suited to their education he returned to work on the family farm in Orange County. He and his family occupied a single room in the barracks next to the bachelors' quarters where Isamu lived. "Noguchi was a famous person, and he found it difficult to get close to a bunch of farmers like us," Kanegae recalled. "Everything about him was different."[57] He went to the communal mess hall in geta clogs that he had made himself, and on his forays into the desert to collect mesquite wood he wore high-heeled cowboy boots and a pith helmet.

In the bachelor quarters several occupants were usually crammed together in a single room but Isamu had a big room all to himself with a

big sculpture like an African mask at the front door. "Every day," Kanegae recalled, "Noguchi-san worked by himself sawing wood that he had picked up. I remember once seeing him make a long table. Even when I saw him at the mess hall, he always ate quickly by himself, then went right back to his room. I never saw him talking to any of the other internees." Isamu had never been comfortable as a member of a group, and he suffered considerable stress when suddenly thrust into the tightly regulated communal camp life. When Kanegae took his infant daughter outside to lull her to sleep one fiercely hot midsummer evening, he saw Isamu looking over some wood he had gathered during the day. Mustering his courage, he asked, "What's someone like you doing in a place like this?" Whenever they met afterward, they always greeted each other with a "Hello."

On a bus trip to the dedication of a memorial monument at Poston in 1995, other former residents of Unit 1 talked of Isamu's involvement with women internees. The handsome, "blue-eyed" Noguchi was a celebrity, an artist who had won success in New York City, a metropolis that few Japanese-Americans dreamed of ever visiting. Not surprisingly young women often gathered in front of his room to get a look at him, and a few even made advances. Some former internees remembered a big fight in front of a camp warehouse one evening just before sunset. Two young women, screaming at the top of their voices, tussled on the ground tearing at each other's hair as they battled over the "famous Noguchi," heedless of a gathering crowd who egged the combatants on. Both were married women. Rumor had it that the husband of one had asked the camp authorities to throw the "troublemaker Noguchi" out of the camp and that the husband of the other had threatened to kill Noguchi for breaking up his family.

Clearly Isamu wanted to leave Poston for reasons more complex than his correspondence with the WRA suggested. He had found nothing in common with the Nisei, who regarded him as a strange "outsider." He was not only older than the Nisei, whose average age was eighteen, he had grown up not in the United States but in Japan. Psychologically and culturally he was much closer to their parents' generation. He was also uncommonly attractive to women. Once again he faced a wall of racial prejudice, this time because he was "half-Caucasian" not because he was "semi-Oriental." Despite his hopes of bonding with the Nisei he found no place among them. His brief dream of belonging ended abruptly.

"I was completely alone," he recalled. The unbearable sense of deso-

lation and isolation he felt at Poston changed him. "That experience in camp, you know, knocked any feeling of responsibility that I had. I no longer felt guilty. . . . It knocked out my sense of social responsibility. I was always worried that I wasn't doing the proper thing for people or for a cause."[58] But he confessed his sense of guilt and frustration at quitting a job half-finished in a letter to John Collier. "As you know I sought some place where I might fit into the fight for freedom. This might have been the place were I stronger or more adaptable. As it is I become embittered." He ended with a postscript: "I might add it's the heat that drives me frantic."[59]

Getting into the camp had been easy but getting out was an altogether different matter. Collier asked Dillon Myer, the head of the War Relocation Authority, to secure his release, and Myer told the Poston camp director, Wade Head, to file a report with the Fourth Army and the Western Defense Command. The military authorities, charged with the defense of the West Coast, stood by the rule that anyone "with even a drop of Japanese blood" was to be interned. On August 24, about a month after requesting release, an irate Isamu appeared at Wade Head's office. A notice on the camp bulletin board indicated that "people of mixed blood or mixed marriage" had been notified of their release. Fears of a Japanese invasion of the West Coast receded after the American naval victory at Midway in early June 1942, and criticism of the internment policy was growing within the government. The Fourth Army relaxed its criteria for internment. Isamu should have qualified for release as a "mixed blood" under the new regulations but his name did not appear on the list. "He was greatly upset," Head reported.[60]

"I felt was like being in prison," Isamu later recalled. "Of course, it was a prison made in my own head, but now that I think of it 'war' itself was a kind of prison."[61] In early September 1942 small groups of Poston internees were sent as temporary workers to harvest sugar beets in Utah and celery in Idaho, and others were allowed short-term leaves to visit elderly parents in other camps. The Fourth Army still did not consent to Isamu's release. Shortly after the war began the military authorities had received a secret file that tagged him as a "suspicious person." The Fourth Army Intelligence Section regarded his shuttling back and forth between San Francisco and Los Angeles while organizing the Nisei artists and writers group as "suspicious behavior." When he stopped over at the house of Wright Luddington, a well-known collector of modern art in Santa Barbara, intelligence officers suspected that he might have been gathering

information on a nearby local airport; and when he made a detour to visit a fellow sculptor in the artists colony at Carmel, he excited suspicion simply because the town was close to an important naval facility.

The army authorities finally approved Isamu's release on November 2. Indefinite leaves had to be approved in Washington but the camp director could issue short-term furloughs of up to 30 days and extend them for up to 60 days. On November 12 Isamu was given a short-term furlough, freeing him from his "prison" 184 days after he entered it voluntarily—and 108 days after he first requested release. At 9:00 in the evening, when the whole camp was plunged into darkness, Isamu drove into the night at the wheel of his Ford station wagon heading north through the barren landscape. It seems that the camp authorities wanted this "celebrity" to leave the camp as stealthily as possible.

Langdon Warner, curator of Asian art at the Fogg Museum at Harvard, whom Isamu had met in Kyoto during his "journey to the East," had written a letter of support while Isamu was in Poston. So had Frank Lloyd Wright. He invited Isamu to stay at Taliesin West, his workplace in Arizona, bringing with him any talented Nisei he could recruit from Poston. On his way back to New York, Isamu visited Wright's home and studio in Wisconsin to thank him. "I will be out in my old haunts certainly by the end of the month," Isamu wrote Ailes. . . . Please let my various friends know that I am on my way. I feel like Rip Van Winkle."[62]

The November 13 issue of the *Poston Bulletin*, the camp newsletter, announced that Isamu Noguchi had left for New York on a month-long furlough. "I have every expectation of coming back here in a month," he told the paper, "unless some unforeseen development keeps me out. Until then I wish to say 'Sayonara for a while' to all my friends in Poston."[63] He spoke about future projects of the Poston Art Society, including a plan to market dishes made by the pottery group but he gave no hint that he would not return. The impression that he had slipped away secretly still dogs his reputation in the Japanese-American community, which has never formally acknowledged his wartime efforts on their behalf.

Shortly before Isamu left Poston, a Nisei working with camp authorities was severely beaten by another internee who thought he was an informer. When a suspect was arrested, a crowd of Issei stormed the camp administration office demanding his release. Pent-up frustration at a life of

forced isolation and incarceration erupted not only at Poston but at other relocation camps, where tensions between "pro-American" and "pro-Japanese" factions mounted. In response to a similar incident at Manzanar, troops summoned by the camp authorities fired on a protesting crowd, killing two Japanese-Americans. Perhaps Isamu's "short-term furlough" was prompted not simply by John Collier's repeated requests but also by WRA officials' concerns over rising anger among internees who associated the "half-breed" Isamu with the camp authorities.

In early 1943 Isamu wrote an article about the relocation camps for the *New Republic*.

> I had been at Poston until a short time before the disturbance [there], and I am afraid I must report that the newspaper interpretation of it—the rioters were merely pro-Axis elements—was oversimplified. Pro-Japanese sentiment, and a plain hoodlum element in the center, played a part in the trouble. But the situation of which the troublemakers took advantage was produced by other causes, chiefly two: the great sense of frustration, which all members of the camps feel; and the great cleavage between the first generation and the second generation which has the American-born, who cooperate with the authorities, the subject of attack. . . . It must be remembered that these 110,000 people are presumably in the camps because they were unable to find places to go, voluntarily, before the mass-evacuation order was issued. They should not be confused with the 1,974 suspected enemy aliens in internment camps.[64]

Whatever Isamu felt about his experience at Poston, he spoke as one who knew what life was like in the camps, and his sympathies lay with those who remained there. "The solution of the problem," he concluded his article, "is, in short, to return the evacuees to their normal civilian status both by getting them out of the centers and by making the centers themselves as much like other places in America as possible." Just a year after the outbreak of the war few others had publicly denounced the relocation of the Japanese-Americans so openly and so clearly. But when Isamu returned to New York he said nothing about his difficulties living behind barbed wire fencing to the Ishigakis. "He talked only about the good things," Ayako recalled. "He was stubborn about it."[65]

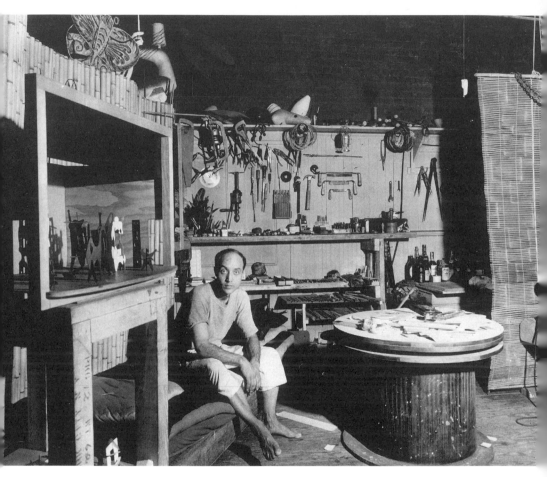

Isamu in his MacDougal Alley studio, 1946

The Song of a Snail

MacDougal Alley

"Noguchi's studio [is] in MacDougal Alley, one of the loveliest places in New York," wrote Anaïs Nin in her diary during a brief affair with Isamu. "The houses are small, the streets of cobblestones, there are gas lanterns. It is an echo of English or French streets. At the closed end is a wall with trees behind. The houses and streets are each different in shape and decoration. It is intimate and mysterious."[1]

MacDougal Alley ran behind the handsome early nineteenth-century townhouses lining the north side of Washington Square in Greenwich Village. It remained the only street in New York still lit by gaslight. Before the advent of the automobile it was lined with the stables and carriage houses of Washington Square families. The carriage houses had high ceilings, and by the 1930s many were converted into artists' studios. Today MacDougal Alley dead-ends into a high-rise apartment building. Isamu's studio at No. 33 was torn down to make way for its construction.

Isamu brought Anaïs Nin to his studio after they met at a Surrealist artists' party. In front was a small garden where pale purple flowers bloomed on a trellis in early summer. A welder machine for cutting and joining metal pieces stood in the middle of the high-ceilinged main room. Above a sofa that also served as Isamu's bed hung *Miss Expanding Universe*, floating with her arms and legs eternally flung outward. The floor of the studio was cluttered with unsold works Isamu had completed since coming back from Paris.

"It was really Noguchi who opened my eyes to form," Anaïs Nin recalled.[2] What impressed her most about his work were not the finished pieces but the tiny maquettes for future projects, each just two or three

inches high. When she asked him about them he told her, "I feel great tenderness for them. They belong to me. They are human and possessable; they are near; they lie in the hollow of my hand. The major work is so large. It is cut off from me. It goes to big buildings, but it is not mine any longer. I love this universe of small statues."[3]

Peggy Guggenheim, an avid collector of modern art, opened her Art of This Century Gallery about a month after Isamu's return to New York. Almost immediately it became a gathering place for modern artists in New York. Guggenheim's own collection included works by Marcel Duchamp, Salvador Dali, Giorgio de Chirico, Max Ernst, Jean Arp, Yves Tanguy, and others, all members of the European avant-garde who had fled to New York from Nazi-occupied Europe. These refugee artists, especially the French Surrealists, had an enormous impact on young American modernists who felt provincial and isolated from European developments. "The Surrealist émigrés had brought the center with them," writes Robert Hughes. "Their sense of mission, their belief that art and life were inseparable, heartened American artists who wished, above all, to believe in the value of an avant-garde."[4]

The new currents enlivening the New York art scene energized Isamu, too. Marcel Duchamp was a close friend of Brancusi, and Isamu had met André Breton when he was a student in Paris. He acquainted himself with the group around them. "I had had about enough of all causes and everything else," he recalled. "I just chucked the whole works, I mean I wasn't going to have anything to do with it."[5] Like the Surrealists Isamu was a refugee, too, but in his own country. As he later put it, he was like "a snail who draws back into his shell." In evening he crawled out to Surrealist artists' gatherings but during the day he quietly pursued his own work in the "shell that I called a studio." "I decided simply to be an artist," he said.[6]

The first work he completed in the MacDougal Alley studio—his "oasis," as he sometimes called it—was the abstract sculpture *Leda*. As a student in Paris he had made another *Leda* by folding brass sheets like origami. The new one was carved in alabaster. "For me," he wrote, "the direct carving of the stone was a return to basic principles."[7] Working on stone with his chisel was "a ceremony of exorcism to wipe away the distress that had built in my soul." Covered with white marble dust as he worked he must have recalled what Brancusi had repeated over and over again: "Don't look out the window. Concentrate on what you are doing."

Although Isamu wanted to return to the basics of sculpture, he experimented with Surrealism in his own way. "Everything was sculpture. Any material, any idea without hindrance born in space, I consider sculpture. I worked with driftwood, bones, paper, strings, wire, wood, and plastic and magnesite which I had learned to use at the World's Fair."[8] He fashioned works in a variety of free and impromptu forms, giving them titles—*Monument to Heroes*, *I Am a Foxhole*, and *This Tortured Earth*—that reflected the struggle going on within him.

A novel and uniquely American style was emerging dramatically in the New York art world. In September 1943, the Museum of Modern Art held an exhibition of Alexander Calder's sculptures. His "mobiles," as Marcel Duchamp called his moving sculptures, were a hit with the public, and the exhibition was extended into the following year. An exhibition of Jackson Pollock's work at Peggy Guggenheim's gallery also attracted much attention, and so did shows by upcoming young abstract painters like Robert Motherwell, William Baziotes, and Mark Rothko; all this passed Isamu by. New works crowded the floor of his studio, but no dealer showed any interest in them nor did any museum offer to exhibit them.

To support himself Isamu turned more and more to design work, including "industrial art" intended for mass consumption. A few years earlier he had designed a three-legged coffee table for the furniture designer Robsjohn Gibbings. He heard nothing more until he saw at Poston an advertisement for a table made on a variation of his design. Gibbings had marketed it without his knowledge. Irritated when Gibbings told him that anyone could make a three-legged table he designed another coffee table for the Herman Miller Furniture Company. It sold very well, producing a steady source of income for Isamu.

Isamu also designed stage sets for Martha Graham. He had met her in the 1920s through the introduction of Michio Itō, who had choreographed her in a Broadway show. After Isamu's return from Paris in 1928, she had commissioned a portrait bust, and their friendship grew into a family affair. His half-sister, Ailes, joined Graham's troupe for four years, and his mother, Leonie, earned money sewing costumes. In 1935, after the WPA rejected his design for a public playground Graham asked Isamu to design a stage set for her early dance masterpiece *Frontier*. He took the job, he later said, to earn money.

The set was the point of departure for all Isamu's later theater work. What interested him was the problem of how to treat the theater as a

sculpture created by the interaction between space and the audience. The design was simple. At the back of the completely darkened stage two horizontal poles suggested a log fence. A white rope hung in a dramatic V-shape from the two top corners of the proscenium to rear center. The stage seemed to extend to the audience's seats, creating a limitless space that infused Graham's dance with intense spirituality. "I used a rope, nothing else," he said. "It's not the rope that is the sculpture, but it is the space which it creates that is the sculpture. It is an illusion of space."[9]

In 1944 Graham asked Isamu to design a set for *Appalachian Spring*, a dance to be performed at the Library of Congress in December. With choreography by Graham, music by Aaron Copeland, and a set by Isamu Noguchi, *Appalachian Spring* became one of the masterpieces of modern American dance. For Isamu, shut away in his "snail shell" on MacDougal Alley, the production was a heaven-sent opportunity to escape isolation. *Appalachian Spring* was an ode to the hope and courage of a young couple starting their new life together on the American frontier. Isamu's set created a spare, surrealistic space with wooden poles suggesting a house and a farm, and a rocking chair casually placed to one side of the stage. The set, he said, was "like Shaker furniture," trimmed to the bare essentials, summoning up a vision of life simplified in the extreme, a life reflecting the stark pioneer spirit at the heart of the dance.

"My own background," he once said, "has a strong admixture of Japanese, which had that quality too in its craft work; it's a kind of a cleanliness and less-is-more attitude, which is not unlike the American puritan ethic. . . . It is very lean."[10] The Japanese sense of beauty shares with the Puritan ethic a spartan aesthetic simplicity but it is based on a different psychology. In Japanese art rejection of the excessive and the unnecessary springs not from spiritual parsimony but from an urge to seize the essence of beauty itself. The principles behind his stage sets clearly sprang from this sensibility. In the midst of war with Japan, Martha Graham gave him the opportunity to express himself in an aesthetic mode rooted in Japanese culture—and to rediscover the Japan deep in the recesses of his heart. Ironically the rediscovery liberated him from both his radical sympathies and his need to exaggerate his American identity.

Isamu designed twenty-two more stage sets for Martha Graham. Katherine Kuh says he completely changed the concept of the stage set. He and Graham were bound by an absolute trust in each other's talents and by an

absolute respect for each other's work. It was a true collaboration, and a long-lasting one, but there was nothing between them beyond a shared goal of producing the best possible work. Graham lived by her passions, and she often drew a thin boundary between her work and her private life, but according to her autobiography she never had a romantic relationship with Isamu.

Three months before the performance of *Appalachian Spring*, Jeanne Reynal wrote Agnes Gorky: "I believe [Isamu] is in love again, or so he writes, and from the general description I have a quaint feeling that it is the 'Parroqueeta.'"[11] "Paquarito" was the nickname of Ann Matta, wife of the Chilean-born Surrealist painter Roberto Matta (Roberto Sebastian Antonio Matta Echaurren), whom André Breton thought the hope of the next Surrealist generation. Matta's work was deeply influenced by Breton's concept of "biomorphism." Since his wife was an American he was more fluent than other refugee artists, and he attracted a following of young American artists who listened eagerly as he held forth passionately in his peculiar English on his views about Surrealism.

"[Matta] was an *enfant perpetuel*, always in a tantrum or a triumph of self-admiration," wrote the gallery owner Julien Levy, a close friend of Matta. "I never saw him in the depression that should have balanced such hyperactivity, but I never saw him at peace either."[12] By contrast, his wife, Ann, who had grown up the daughter of the mayor of Lincoln, Illinois, was "gentle, shy and unobtrusive." After graduating from the Art Institute of Chicago she had studied costume design in Paris and created innovative designs for the Ballets Russes and other dance troupes. Among the intensely flamboyant Surrealist women, Ann's fragile and delicate beauty stood out. Her openness captivated André Breton, who gave her the nickname "Paquarito," which means "little bird" in Spanish.

In her eighties Ann Matta seemed to have changed little from the young woman described by her friends. When she spoke in her quiet voice a gentle smile hovered on her lips. In 1943 Ann gave birth to identical twins. Roberto intensely disliked taking responsibility for anything but his work, and rather than helping her with the newborn infants he flew into a rage whenever he heard them crying. Soon after their birth he abandoned his family and moved into another studio. Others in the Surrealist circle were attracted to Ann, the only calm presence in the midst of their artistic storms, but no one wanted to care for her two infants. The only person who did not

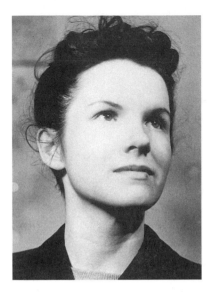

Ann Matta

mind was Isamu. Although he joined their evening gatherings, Ann says, Isamu was never really a part of the Surrealist group. He lacked any strong sense of companionship, even with longtime friends like Arshile Gorky, but there was something about Isamu's sense of isolation and his lack of close friends that appealed to Ann, and he, quite naturally, was drawn to her.

Roberto Matta, who started living with other women almost immediately after leaving Ann, was always late with money for her living expenses. Since apartment rent was in arrears, and the babies were always crying, her landlord finally evicted her. Isamu offered help. He arranged for the little family to stay temporarily at a friend's place on Long Island. In late December 1944 Jeanne Reynal wrote Agnes Gorky that "Isamu writes AGAIN that he wants to come west, get Ann divorced, spend some time in the mountains, make some tables and remarry or rather marry Ann. He adds by way of final inducement that you and Arshile approuve [*sic*] of this. I also approve highly."[13] It was during this time that Isamu produced *Mother and Child*, a touching onyx abstraction suffused with the affection he felt for Ann.

What remained freshest in Ann's memory of the MacDougal Alley studio was a series of light sculptures fashioned from rough hemp cloth reinforced with thin magnesite and lit within by the soft glow of an electric light bulb. "While I was living my dark prison-like life at the relocation

camp at Poston," Isamu later recalled, "I had a never-ending yearning for a brighter world. It was from then that I thought about making a sculpture that had a controllable light. I thought that I wanted to free the dark world with *akari* [light]."[14] "I thought of a luminous object as a source of delight in itself—like fire it attracts and protects us from the beasts of the night."[15] His first light sculpture, entitled *Lunar Infant*, evoked the peace and safety of the mother's womb. Although his dismal experience at Poston may have inspired him to turn light into art, his *Lunar* series also testified to his deep affection for Ann and her children.

Ann expressed no bitterness or resentment at the self-centered husband who abandoned her with two infants. She must have reminded Isamu of his mother, who had possessed enough inner strength to confront her troubles with quiet patience. Ann was grateful when Isamu asked her to marry him, but she did not think that he understood what raising her sons might mean for his life. He was "a sincere and honest person, who revealed everything in his heart," she said, but he was also an artist who felt his work more important than anything else.[16] Ann feared that she might take advantage of Isamu's love simply out of physical and psychological exhaustion. She decided instead to visit Matta's wealthy parents in Chile, who wanted to see their new grandchildren.

Isamu wrote several times asking her to return, and he promised to go to Santiago to bring her back. In the end that was not possible. Isamu could not be sure whether he would be allowed return to the United States once he left the country, for shortly after his return from Poston, Isamu found himself facing a new problem—the possibility of deportation.

In February 1943 the American government, responding to requests from young Nisei to exercise their "right to fight as Americans," decided to organize an all-Nisei military unit. At the same time all Japanese-American internees over the age of seventeen, men and women alike, were required to register their "loyalty" to the United States. The demand for loyalty pledges sparked new confrontations between the "pro-Japanese" and "pro-American" factions in the camps. At issue were two questions on the loyalty questionnaire. Question no. 27 asked, "Are you willing to serve in the armed forces of the United States on combat duty wherever ordered?" and Question no. 28 asked, "Will you swear unqualified allegiance to the United States of America and faithfully defend the United States from any or all attack by foreign

or domestic forces, and forswear any allegiance or obedience to the Japanese emperor, to any other foreign government, power or organization?"

It was easy for Nisei born in the United States to answer yes to both questions but for the Issei, who could not become American citizens, denying allegiance to the Japanese emperor was tantamount to declaring themselves stateless. Most Issei, trusting their children's country, answered yes to both questions but those who replied no were moved to camps reserved for "pro-Japanese" elements, and some who had lost faith in America chose to be repatriated to Japan in the middle of the war.

Isamu was required to fill out a similar loyalty questionnaire when he applied for a leave from Poston. The wording of Question no. 28 read differently: "Have you forsworn any and all allegiances which you may knowingly or unknowingly have held to the Emperor of Japan? If not, do you repudiate such allegiances?" Isamu left the answer to the question blank. Although he provided "Caucasian references" such as John Collier, Attorney General Francis Biddle, and Henry Allen Moe, the secretary of the Guggenheim Foundation, his failure to answer yes or no was construed as a request for repatriation.

When his thirty-day extension of his short-term furlough from Poston expired on January 9, 1943, Isamu received a permit for leave without limit signed by the head of the War Relocation Authority. Three months later, however, the FBI sent him a deportation order. The New York office of the FBI had tagged the "half-breed" Japanese-American sculptor as someone who needed watching after his article on the relocation camps appeared in the February 1943 issue of the *New Republic*. The mailman who delivered to MacDougal Alley told them that Isamu received only one or two letters a week, all of them domestic, but the FBI remained suspicious. He was, after all, the son of a "Japanese nationalist," and his visit to Hawaii in 1940, a year before the Pearl Harbor attack, excited their interest—even though he had been the guest of the Dole Pineapple Company.

The FBI also took notice of Isamu's continuing involvement with the cause of the Japanese-Americans. In December 1943 he organized the Arts Council of Japanese Americans for Democracy, a group of "anti-Fascist" Japanese-American artists, authors, and musicians living in New York City. Like the Nisei Artists and Writers for Democracy its goal was to promote better public understanding of the Japanese-Americans' situation and to prevent them from becoming embittered by their evacuation. Yasuo Kuniyoshi

served as chairman, and Isamu and the architect Minoru Yamazaki, who later designed the World Trade Center in New York, served as vice-chairmen.

The FBI had other evidence suggesting that Isamu might be a Japanese spy. At Poston he had become acquainted with a visiting soil conservationist from the Bureau of Indian Affairs. The conservationist's wife, who had an interest in art, was friendly with Isamu, too. After the couple returned to Washington, the wife, who had been in and out of mental institutions, was once again admitted to a sanitarium, where she insisted to the staff that Isamu was her husband and that she be called "Mrs. Noguchi." According to FBI investigators her correspondence with Isamu reflected a "close friendship" and dealt with "intimate matters." In one letter she wrote that "there are things that I want to talk to you about that I cannot write in letters due to the publicity"; and in another she vaguely referred to "playing ball."[17]

The FBI launched a full-scale investigation of the couple's relationship with Isamu. Agents suspected that Isamu had become close to the official's wife with the "ulterior purpose" of extracting intelligence information from her. According to one informant he had put her "in a position where she must furnish confidential information to him which in turn she picks up from her husband."[18] Clandestinely reading her correspondence with Isamu, the FBI compiled a hefty file on the woman, who was clearly psychologically troubled.

The American Civil Liberties Union eventually intervened in Isamu's deportation case. In response to their inquiries the WRA affirmed in February 1945 that contrary to the FBI's insistence there was no record that Isamu had ever requested repatriation to Japan. The ACLU staff lawyer concluded that he could "only assume that such a statement may have been orally made, probably to someone who is Noguchi's enemy."[19] Isamu never talked about his deportation ordeal, even with Ann. The episode was one more proof that the authorities doubted that he had wanted "to do something as an American" for the war effort or that he had volunteered to go to Poston out of a sincere sense of duty as an American citizen. His reluctance to talk about it even after the war indicates how deeply this wounded his sense of being a patriotic American.

Nayantara, the Star of the Eyes

After *Appalachian Spring* Martha Graham turned to Greek myths as inspiration for her dance performances. On May 10, 1946, *Cave of the Heart*, based on

the legend of Medea, a woman so maddened by jealousy that she took revenge on her husband by killing her own children, was performed at Columbia University. In Isamu's set design stepping-stones spread across the stage represented the Greek archipelago. At center stage was a huge biomorphic object sprouting twenty gold-painted copper wires that looked like porcupine quills. At the climax of the dance, Martha Graham slid into the object, transforming it into a "chariot of golden flames" that carries Medea into the nimbus of the setting sun. The *New York Times* review pronounced the production "triumphant dance and triumphant theater," and it praised Isamu for "finely creative settings" that "poignantly heightened" the dance.[20] When the curtain fell on the first performance, Isamu rose to his feet shouting "Bravo."

"Just before the performance began," recalled his friend, the Japanese-American artist Mine Okubo, "when most of the audience was already seated, Isamu showed up with a group of Indian women in bright-colored saris. So even before the performance Isamu would have stood out that evening."[21] During the war Isamu began to attend meetings of the India League of America. He had given up most political activities but he had not put aside his dream of going to India. That lingering yearning drew him to the league. He was less interested in promoting Indian independence than in making Indian friends. League members welcomed him as the son of Yone Noguchi, whom they knew not as a "Japanese fascist" but as a friend of the poet Rabindranath Tagore.

In 1943 Isamu was invited to a dinner party arranged by J. J. Singh, the chairman of the league, to welcome two nieces of the Indian nationalist leader Jawaharlal Nehru, who had become a hero to Isamu after he heard him speaking on the radio. The party for the Pandit sisters was a small affair with perhaps ten or so guests. From the moment Isamu met the younger sister, Nayantara, whose name meant "the star of the eyes," he was captivated. Tara, as her friends called her, was then just sixteen years old. Though still girlishly innocent, she was already a young beauty, with a graceful and elegant sari-wrapped figure and powerful dark eyes that sparkled with unusual brilliance and directness.

The Pandit sisters grew up at the center of the Indian struggle for independence. Their mother, Vijaya Lakshmi Pandit, was Nehru's younger sister, and their father, Ranjit Sitaram Pandit, like Nehru, came from a well-known Kashmiri Brahman family. Nehru had studied at Cambridge University, and Tara's father, a lawyer, was trained at Oxford. Both men,

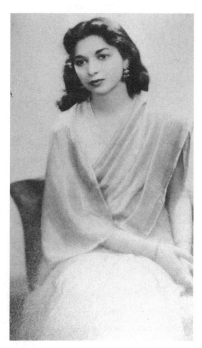

Nayantara Pandit

won over by Gandhi's principles of nonviolence and passive resistance, had plunged into the Indian independence movement early on. Mahatma Gandhi, an old friend of Ranjit Pandit's father, served as go-between for Ranjit's marriage to Nehru's sister. To Tara and her sisters Gandhi was "Bapu" ("Father"), and Nehru was "Mamu" ("Uncle").

Tara spent her childhood in a household constantly under the surveillance of the British colonial authorities. The police often arrived at the Pandit house on unannounced searches. They harassed not only Nehru and her father but her mother, who was jailed three times, and her grandmother, as well. After the outbreak of war in 1939, the leaders of the Indian independence movement refused to cooperate with the war effort as long as the British refused to promise national independence. The British retaliated with even harsher suppression. After Tara's older sister, Lekha, a university student, was arrested for her political activities, their parents decided to send the two girls to study in the United States.

Unexpectedly Tara and her sister soon found themselves playing a role publicizing the nonviolent independence struggle against the British.

Newspaper reports about "the dark-eyed Nehru nieces" offered no criticism of British rule in India—Great Britain was a wartime ally, after all—but they mentioned that their father had been illegally detained for his political activities and jailed without benefit of a trial. Mail came pouring in from college students, American servicemen overseas, African-Americans, and organizations supporting Indian independence. The sisters were showered with the attention of unknown friends eager to meet two young women who had grown up in Nehru's shadow. The cheerful Lekha was a lively and witty conversationalist, but Tara had a melancholy strain. The jailing of her parents had upset her more deeply than it had her sister. Sadly pensive for her age, she often withdrew into her own thoughts but her dreaminess only made her unusual beauty more luminous.

Isamu could not keep his eyes off Tara at the Singh's dinner party. Tara noticed the air of loneliness that seemed to envelop this older Japanese-American artist, but by the time she left New York for Wellesley College she had forgotten him. Isamu, of course, was not about to fall in love with one of Nehru's nieces, no matter how attractive. He was still involved with Ann Matta, whom he yet hoped to marry even though she had left for Chile without accepting his proposal.

During the winter semester of her freshman year Tara received news that her beloved father had died in prison. "He was more handsome than anyone, kind and gentle, a person of understanding. He was the human being closest to my heart, the person whose opinions I most respected."[22] American friends did what they could to console her and her sister. Pearl Buck, whose husband had published Nehru's autobiography, invited them for summer vacation at her house in Pennsylvania, and during school holidays they stayed at the elegant Manhattan home of Dorothy Norman, an important member of the India League. To acquaint the sisters with the New York cultural world, Norman threw parties for artists and literary figures, and it was at one of these affairs that Tara met Isamu again.

Whenever she came to New York afterward, Isamu invited her to art museums and galleries and took her to parties where she met artists like Salvador Dali and Marcel Duchamp. Once they went to a splendid affair where Ingrid Bergman, then at the peak of her early career, was one of the guests. Even at these parties, Isamu seemed shrouded by a peculiar sense of isolation, as though he were not fully present. Tara much preferred the quiet moments they spent together; they never ran out of things to talk about.

What surprised Tara about Isamu was how much knew about traditional Indian art and culture. He did not think of India as the "exotic East." He seemed to have a deep understanding of the country. Although he never told Tara about his family background, she sensed that somehow he belonged to both East and West. That, more than anything else, made her feel close to him. It was customary for the sons of upper-class Indian families like the Pandits and the Nehrus to send their sons to England for schooling and to hire English tutors for their daughters. Tara and her sisters went to an American Methodist missionary school and were tutored at home by a Danish woman. It was only through her friendship with Isamu that Tara realized that she had been privileged to move in two cultural worlds and that her life had been richer as a result. Unlike Isamu, however, she did not feel suspended between East and West. She knew that she belonged equally to both.

Isamu, Tara thought, had the soul of an Indian. He understood that there was more than one way to live one's life and more than one way to look at the world. In appearance he could be mistaken for an Indian, and that attracted her, too. College boys who visited other Wellesley girls on the weekends were interested in dating Tara, but she preferred her meetings with Isamu in New York. He was old enough to be her father, and he had already begun to lose his hair, but the twenty-three-year difference in their ages did not bother her. The more she got to know him, the more she was attracted by his mature charm and thoughtfulness. "He swept me off my feet," she recalled.[23]

Tara, still in her teens, saw only the positive side of Isamu's personality. Though troubled by his own inner turmoil, Isamu was almost painfully gentle and considerate of others' feelings, she recalled. He bared his sense of isolation to her, almost as though reflecting her own, and showed her his softer side. She found him sensitively discerning and immensely patient. She never sensed any insecurity or lack of confidence in him either. Like her father, he was a fountain of knowledge that never stopped flowing. He seemed to know about everything. He answered her every question. He was a voracious reader, and often he gave her a favorite book—Kafka's *Metamorphosis* or Lady Murasaki's *Tale of Genji*—to read. When they made the rounds of art galleries and art museums Isamu never offered opinions in an overbearing way. He simply stopped in front of a work that interested him and exclaimed admiringly, "Isn't that splendid?" Without exchanging words, Tara felt that she had shared his feelings.

Their affair blossomed in the summer of 1945, shortly after Isamu introduced her to Ann Matta, who had just returned from Chile. Peace had returned to Asia, and Tara had turned eighteen years old. When she opened the gate to Isamu's garden on MacDougal Alley, she felt as though she were entering an enchanted "magician's house," with *Miss Expanding Universe* floating over the sofa and a model theater stage no larger than a dollhouse sitting nearby. On the miniature stage sat a cardboard mock-up of his design for *Cave of the Heart*. Every time Tara visited the studio she discovered new work. The studio was like a small factory, with a heavy chain pulley hanging from the ceiling to lift the larger sculptural pieces, and a stone-cutting machine standing in one corner. Even the shower room was a workspace. During the winter Isamu donned a fireman's rubber coat, cap, and high boots to cut marble under running cold water from the shower, and when the weather turned hot he worked in the studio naked to the waist. He had the sinewy physique of a much younger man.

"I found marble to be a stable and beautiful medium," Isamu noted in his autobiography, "too beautiful perhaps. The nature of its stability is crystalline, like its beauty. It must be approached in terms of absolutes; it can be broken, but not otherwise changed." [24] Marble had been too expensive for Isamu when he was a struggling young artist but by the time he moved to MacDougal Alley marble slabs used for building decoration were being sold cheap by East Side marble yards condemned for urban development projects.

Isamu began experimenting with a new sculptural style, cutting and polishing thin marble slabs, then fitting them together into three-dimensional shapes with interlocking slots. Balancing individual slabs was complicated but the sculptures looked as though they had been put together spontaneously. Isamu explained that "ancient Oriental calligraphy" inspired his innovative new style, and many of these marble works did indeed look like Chinese ideographs translated into three dimensions, but what is most striking about them is the influence of Surrealism, especially biomorphic shapes like those in the paintings by Matta and Gorky, that suggest a mythical world buried deep in the human psyche.

"A purely cold abstraction doesn't interest me too much," Isamu once told art critic Katherine Kuh. "Art has to have some kind of humanly touching and memorable quality. It has to recall something which moves a person—a recollection, a recognition of his loneliness, or tragedy, whatever is at

the root of his recollection."[25] In the winter of 1945–46 Isamu was at work on *Kouros*, the best known of his assembled marble-slab sculptures. On the wall of his studio he pinned a picture postcard from the Louvre of an ancient statue of Apollo, the god of light, poetry, music, and prophecy, whose face was lit by an archaic smile. Another name for the statue is *Kouros*, a Greek word meaning "young man." Early Greek sculptors produced many similar monumental statues of beautifully muscled naked youths.

Wrapped in Tara's affection, Isamu exuberantly invested his whole being into this sculpture, dedicated to his young lover, of an ideal youth. It was a spectacular work, more than nine feet tall, assembled from eight pieces of thin pink marble rippled with gray. In September 1946 *Kouros* was exhibited at a Museum of Modern Art show—*Fourteen Americans*—the first important postwar exhibition of new trends in American art. The work of eleven painters, including Arshile Gorky, Mark Tobey, and Robert Motherwell, was on display, and the three sculptors represented were Theodore Roszak, David Hare, and Isamu Noguchi. *Kouros* was the talk of the show. Most reviews of the exhibition featured a photograph of the work, and critics had only praise for the work. The *Art Digest* review observed that even though "the superbly balanced *Kouros*" might have been "just a little bit less cold" Isamu had succeeded best among the sculptors in achieving "the intangible and super-reality through the abstract."[26]

Isamu's sculptural work had not attracted much public attention since the unveiling of his bas-relief for the Associated Press Building. His last one-man show had been in 1935. The critics had lauded his stage sets for Martha Graham but his voice as a sculptor remained unheard during the war years. With *Kouros* Isamu ended his long silence. He returned to the front rank of the American art world. An eight-page feature article in *Art News* called him "one of America's most distinguished yet least-known artists."[27]

Many critics count *Kouros*, a work that opened a new frontier for Isamu, as one of his masterpieces. Some regard it as a work that expresses his "essence" as an American. The sculpture does succeed in internalizing that "essence" but blends it with inspiration drawn from the Japanese cultural roots deep within him. The figure of an ideal youth was an aesthetic distillation that transcended both East and West. The Metropolitan Museum of Art bought *Kouros* for its twentieth-century collection. This contemporary American Apollo, with its noble but mysterious sense of being, transcends the passage of time.

A week before the *Fourteen Americans* exhibition opened, Jawaharlal Nehru, as head of the Congress Party, formed a "neutral government" in India. The war's end had brought the country to the verge of independence, but on the eve of its realization clashes between Muslims demanding a separate state in Pakistan and Hindus opposing them erupted all over the country. In her letters from Wellesley, Tara wrote little about the political struggles afflicting her native land, and not until the middle of July 1946, while on a visit to California, did she express her passionate feelings toward Isamu.

In May 1947 Martha Graham staged her first performance of *Night Journey*, a dance based on the Greek tragedy *Oedipus Rex*. The central character was Queen Jocasta, who unknowingly sleeps with her own son, then kills herself after discovering that she has. Graham told Isamu that she wanted a set with a bed at center stage for the scene where Jocasta shares her bed with fate. He designed two sawhorse-like supports on which two horizontal forms—a bonelike phallic cylinder (representing the male) and an oval with a hole in the center (representing the female)—rested side by side. The bed was raised at a high angle so the audience could see both.

"Work is something like having a conversation with oneself," Isamu told Katherine Kuh, "a personal soliloquy in which through argument and trial you try to nail something down—express the inexplicable. You can't quite tell what's going to happen when you start, but then *after* the work is done recognition comes: certain things affect you; and then you recognize the work is really yourself."[28] Around the time he designed the "bed" for Martha Graham he also carved on a small flat piece of African ebony an abstract image of a man and a woman lying side by side. The man's figure is suggested by a long wedgelike shape, and the woman's figure by full breasts and belly. He gave this simple but charming piece the title *Bed*. Indeed, his sculptures were a kind of diary.

After graduating from Wellesley in June 1947 Tara visited Mexico. Mexican culture had come to fascinate her as she listened to Isamu talk about his experiences there. His friend, Miguel Covarrubias, invited her to stay with his family, and Isamu wrote a letter introducing her to Frida. "I am beginning to understand about Frida," Tara wrote Isamu in early July.[29] From the moment they met, Frida took a liking to the exotic "present" Isamu had sent her and threw a welcoming party for her. She gave Tara a photograph of herself inscribed: "To Tara darling who loves 'September

Song' as much as I do . . . for different reasons."[30] The song was the hit number of a musical about the May–September love between a young woman and an older man. It was Frida's way of encouraging her affair with Isamu, who, like her own husband, was a much older man.

Tara spent her days in Mexico City preoccupied with thoughts of Isamu. She wrote him every day. Others warned her about his earlier love affairs but it had no effect. When flowers bloomed in the Covarrubbias' garden, she could think only about Isamu's garden at MacDougal Alley: "The roses in the garden are incredible, so enormous and lovely. Have you given away all your gardenias?" she wrote. "Enclosed is a sprig of something-or-other that grows all over the terrace—sorry to crush it. It is such a beautiful little flower—but I can't reach you any other way."[31] She wanted Isamu to come to Mexico City to show her all the places and monuments that had so excited him, but Isamu was reluctant to travel—and that was the end of it.

"Isamu was more serious than he had ever been before," says Ayako Ishigaki.[32] He was very protective of Tara's reputation. Indeed, in later life he never mentioned his affair to anyone, a fact that bespoke Tara's importance to him. Before she left for Mexico City he asked her to marry him, and when she returned to New York he asked her again. Tara adored Isamu, the most attractive man she had met in her still young life. She had never known anyone with such a complicated character, she says, but she recognized the many layers of his personality echoed her own complexity.

Sitting in her home in the Himalayan foothills, half a century later, she reminisced about their affair in a deep soft voice. "I never once thought about marrying him," she said quietly. "If he had just met the right partner Isamu would have been a good husband and a good father. I think that at the bottom of his heart he always really wanted to have a family. He was off here and there doing his work and he very much hoped for a place to set down an anchor. I never once doubted that."[33] But Tara was still young, and she wanted to find herself before she got married.

Isamu kept pressing her about his proposal. A woman could blossom into a beautiful flower under the radiant sunrays of a man's love, he wrote; he did not want to pluck her from the vine but wanted to help her to bloom, to discover herself, to develop her talents. Tara never doubted the sincerity of his entreaties but she never considered marrying him either. "The age difference was too great for me to spend the rest of my life with him. And I was not suited for the bohemian lifestyle of an artist like Isamu."[34]

What concerned Tara more than anything was that Isamu did not belong to her country, and for that reason alone her entire family would never consent to marriage. No matter how much she loved him she did not have the strength to defy their opposition. Her uncle Jawaharlal Nehru once told her, "Wherever in this wide world goes an Indian, there goes a piece of India with him, and he may not forget this fact or ignore it."[35] Even after she arrived in America, Tara had never forgotten his words. Neither could she forget that her whole family had fought for Indian independence, and that her beloved father had given his life for the cause.

What ultimately tore Tara from Isamu was her unwavering identification with her country. "I had no doubt that I would return to India," she said. "That was clear to my heart from the beginning."[36] On August 15, 1947, her father's dream was finally realized. Nehru, the uncle she so respected and admired, a surrogate parent after her father's death, became the first prime minister of independent India, and her mother, Vijaya Lakshmi Pandit, the first Indian woman ever to hold a cabinet post, was appointed to head the Indian delegation to the United Nations. Perhaps hoping to make himself better known to Madame Pandit, Isamu offered to make a portrait bust of her, and he visited her office in the United Nations building for sittings. Her mother understood her relationship with Isamu, Tara says, but she pretended not to and never made an issue of it.

After returning from her summer in Mexico City, Tara arranged to leave for India in October 1947. During the month and a half before her departure Tara visited Isamu's studio for portrait sittings, too. Her eyes constantly welled with tears. "I was confronting the realization that I had reached an important turning point in my life," she recalled.[37] Even though India had undergone great changes since she had left four years before, she looked forward to returning to her homeland, but she was uneasy about whether she could adjust to life there after having taken her first steps toward adulthood in the United States. Remorse at abandoning Isamu, who loved her unconditionally, compounded the anguish of their approaching separation, and the burden of confronting it broke her young heart. As he molded her likeness in clay Isamu managed to capture her sadness and distress. Instead of presenting her with the portrait bust, however, he gave her a small nude plaster statue entitled *Primavera*, Italian for "spring"—and also, not incidentally, the title of a famous Botticelli painting—that he had made while Tara was in Mexico. When asked whether

tears seemed to flow quietly from her half-closed lids in the portrait bust, Tara replied, "It wasn't only the model who was in pain. Perhaps you can also see the heartbreak of the person who made it."[38]

Passage to India

On October 14, 1947, Tara left for India. As a parting gift, she gave Isamu a sweater that she knitted for him. Enclosed with the gift was her photograph and a short note: "The thought of you is the only sane, wholesome thing that I have to hold on to in all this confusion."[39]

"You are surrounded by too many heroes—your father, Gandhi, Nehru," Isamu once told her. "I can't do battle with them no matter how hard I try."[40] He knew that India was a formidable obstacle that blocked their future together, and he tried to reconcile himself to their separation. As Tara expected, he behaved like a "real adult," accepting the reality that he was losing her. After she returned home she had to confront her own unresolved feelings. It is clear from her letters from India, all addressed to "darlingest" Isamu, that she was still in emotional turmoil. It was as though she was trying to escape from the reality of her homeland by writing to him.

British colonial rule had come to an end but independence was achieved at the cost of "separate independence" for Pakistan, a state demanded by Islamic nationalists. Prime Minister Nehru faced the sad and difficult ordeal of presiding over an India sundered from within. Since Tara's mother had gone to Moscow as the first Indian ambassador, Tara thought that the most useful thing to do after her return was to provide support to her uncle. She moved into the prime minister's residence to deal with his constant parade of visitors and to help her cousin Indira take care of her two small children.

As she watched her uncle's daily struggles Tara was soon caught up in the complicated politics of her country. It was a dramatic change from life in America, and it drained her psychologically. Often she woke up in the middle of the night, wondering whether she was awake or still asleep, as her mind wandered back to quiet days at MacDougal Alley when she listened to soft music on the radio as Isamu worked. Even during the day, as she entertained visitors she suddenly felt Isamu's invisible presence looking over her shoulder, watching her, somehow knowing what she was doing.

"I think of you a great deal in one connection or another and realize more and more what an important part of my life and particularly my

growing up process you have been," she wrote him. "Whatever the future holds your value to me will never grow less. I can't appreciate art, or poetry or fairy tales without thinking of you. . . . All my notions of happiness have been altered by you—and you have shown me that a human being can be considerate, courteous and civilized in closer contact. I appreciate you for this and much more—our talks and silences and love. . . . [P]lease don't ever forget all this. You can only mean more and more to me."[41]

Isamu was not simply a page in Tara's adolescent memories. He was someone who had played an essential role in her growth as a human being. She thought that she had been destined to meet Isamu. Indeed, she thought of herself as his "creation." In a sense, he was as much a surrogate father as a lover. No one else had understood her so well, and no one else had treated her so thoughtfully. Their love affair had been wonderfully complete, almost as unreal as a "perfect dream." Though they would never be able to live together, she told him that he would always be the love of her life.

Her words kindled new hope in Isamu. Still brokenhearted at having to give her up, he assaulted her wavering emotions with passionate letters, but in early 1948 the tone of her replies changed as she finally came to terms with her emotions. The tragic death of her beloved Bapu at the hands of a Hindu fanatic on January 30, 1948, made her realize just who she was and where she belonged. Gandhi was cremated on the banks of the Yamuna River the day after his death, mourned by a crowd of more than a million. Tara, her uncle, and her cousin Indira later scattered the gentle Bapu's ashes on the waters of the Ganges River.

"Dearest, how wonderful of you to send a cable," Tara wrote Isamu two days after the funeral.[42]

Life is very hard here—as if all the lights had gone out since Bapu's death. We find it impossible to believe he is not here to guide us—he was so much more than a great man—he was our friend and confidante, the father of a nation in so many ways, the person above all to whom we could turn to for advice and guidance, no matter what our troubles were. There is no way of describing to you the void that this death has created, how unbearably empty life is. He has changed the history of so many millions of families in India, ours was only one among them. He has meant something special to every one of us, his love was a wonderful inspiring thing—almost like the love of God—so nurturing and selfless . . .

I cannot think of anything else at the moment. I saw his body first a few minutes after he was shot—so frail, covered with blood. What madness led anyone to raise a hand against this little man, so humble and gentle, full of love for all the world.

This fool wretched country is certainly a ghastly mess. . . . It is a heartbreaking thing. More and more I feel my own inadequacy as a human being to take part in this struggle. . . .

I am overawed at my great good fortune, and grateful for the privilege of living in the India of Gandhi and Nehru, and being so closely associated with them. Something must come of it. I feel I will not be happy unless I serve India as fully and uncompromisingly as I am capable of doing.

Three months later Tara wrote Isamu from Moscow, where she had gone to confer with her mother about an important decision.[43] "Going home to India made certain things very clear to me," she wrote.

You know I had believed very strongly in my background and in India as a necessary part of me. . . . I have a sense of belonging to my country for better or worse—and it may often be for the worse—I don't know. At any rate, I feel after I got home I must give myself fullest to be an Indian, live like one, think like one. . . . I have decided to get married, and I want you to know why. Perhaps I shouldn't get married. There's you—and your outlook and opinions which I value above all others as far as my personal life is concerned, but you are always drawing me away from my sense of duty, and my feeling of believing to fulfill myself as all Indian. You can not help that, and I feel close to you as you do. That's why I have always felt that our relationship had nothing to do with time, age or country, or conventions. That's why it meant so much. But life isn't like that—not as I've seen it after I got home—it demands a great deal that one has no right to refuse.

In India a single unmarried woman had no recognized social role; a married woman did. Her intended husband came from a rich business family that had fled from the Punjab after the partition. He was willing to give Tara independence after they married, and the two families were happy to bring the marriage discussions to a quick conclusion.

When Isamu received Tara's letter, he was hard at work on a stage set for Martha Graham's production of *Orpheus* with music by Igor Stravinsky and choreography by George Balanchine. The production promised to attract considerable public attention but Isamu's only thought was to go to India to

see Tara again. To raise money he took on several new design commissions—ceilings for the Time-Life headquarters and the American Stove Building, light sculptures for a passenger ship, and other commercial projects.

As he worked frantically in mid-summer 1948 to finish them, Isamu received another shock: his friend Arshile Gorky committed suicide. Gorky's reputation had surged after André Breton anointed him as a new standard-bearer for Surrealism, and the Julien Levy Gallery began to hold annual shows of his work. In the midst of his success, an operation for colon cancer had plunged him into deep depression. To make matters worse, he fractured his neck in an automobile accident, and his right hand—the hand that held a paintbrush—was paralyzed too. His psychological instability eroded his once happy home, and his wife, Agnes, returned to her parents with their two children. A deepening sense of isolation triggered his final act.

Every day for three days before his suicide Gorky knocked on Isamu's door at MacDougal Alley. The last time was in the early morning before dawn. He stood in the doorway, his neck still in traction, clutching two rag dolls his daughters had left behind. "This is all I have left. This is all I have left," he kept repeating as tears poured down his cheeks.[44] Everyone had betrayed and abandoned him, he told Isamu. People had been interested in him when he was successful but no one took care of him when he fell ill. Isamu rushed him to the doctor who had been treating him, and together with his artist friend Wifredo Lam, whose father was Chinese and whose mother was Cuban, he drove Gorky back to his country place in Connecticut, where they looked at some of his unfinished canvasses and strolled through his apple trees. That night Gorky hanged himself. "I thought he had come to me as a fellow immigrant out of his past," Isamu recalled in his autobiography.[45] His death shook Isamu to the core. It was all the more distressing now that Tara had chosen to live her life without him.

Two and a half months after Gorky's suicide, Tara wrote Isamu again from Paris, where she was traveling with her mother. "Of course, you should go to India for the sake of your work and your soul," she wrote. "Some little time at least." On the surface Isamu had concealed his disappointment but he still wanted very much to see her again. Tara knew that their parting had been a great blow to him but she told him that was precisely the reason they could not meet. "I am glad that it all seems to be working out, but I don't think I will have the strength to see you there," she wrote. "The

strength, perhaps, not the heart. For myself, I would not like you to come—but that is [a] ridiculous selfish attitude. Of course, you should come. And I hope it will be all that you want and expect. Even if we don't meet there, you will think of me, because surely I am in some small way associated with your interest with India."[46]

Isamu applied to the Bollingen Foundation for a traveling fellowship to India to do research for a book about "leisure." "In the creation and existence of a piece of sculpture," he wrote in his proposal, "individual possession has less significance than public enjoyment. Without this purpose, the very meaning of sculpture is in question." Sculpture, he said, had a public function: it "should illumine the environment of our expectations."[47] The world was facing a moral crisis in the aftermath of two world wars and in this new environment the arts had to be reintegrated into some larger social purpose. By looking at the remains of ancient cultural monuments and sculpture, Isamu hoped to understand how artists had established relationships with society in earlier times. As he later admitted, "leisure" was not quite the appropriate word for what he wanted to study, but the Bollingen Foundation nevertheless provided him a fellowship to travel around the world.

In April 1949, a month before Noguchi left on his passage to India, a one-man exhibition, arranged with the help of Willem de Kooning, opened at the Charles Egan Gallery. It had been fourteen years since his show at Marie Harriman's gallery. Isamu hoped to earn enough money for a long stay in India. His newest works, sculptures assembled from interlocking marble slabs, especially *Cronos* (named for the Greek god who devoured his own children), were generally well received. "A long step farther toward the nonobjective we come to in the sculpture of Isamu Noguchi, at the Charles Egan Gallery," wrote the *New York Times* reviewer. "Noguchi's originality is not to be questioned—he is rather bafflingly original. . . . Bone-like objects, sex symbolism and pointed objects are repeated in this echoing primitivism." But the critic was puzzled by the message. "Whatever they may mean to the sculptor, it is far from clear that they encompass anything like universal communication."[48]

Ironically Isamu decided to leave New York just as he was coming into his own as one of America's leading sculptors. "It has often been pointed out to me that when I have achieved a certain success of style, then I abandon it," he later admitted.

There is no doubt a distrust on my part for style and for the success that accrues from it. There is another factor: after a period of introspection—this time six years—there comes an urge to break out. After the elation and effort that go with preparing an exhibition, comes a depression. Following my show fourteen years previously, I had gone to Mexico. This time I was determined to get away from everything. The reasons I gave myself were varied. On the one hand, over the years I had developed a horror of the politics of art, the narrow outlook of critics and dealers with their pet discoveries and pat judgements (like the rites attending fashion, advertising and the Stock Exchange.) I felt myself no part of this, and wanted no part of it.[49]

Isamu's departure for India was neither as clearly thought out nor as carefully planned as he later claimed. After completing his series of marble slab works, Isamu had reached a dead end artistically. He was searching for new directions. Shaken by the suicide of his old friend Gorky, who had been embittered by "superficial and cruel recognition," he was also uneasy about his own growing reputation. But his main reason for going to India was to come to grips with his disappointment over his failed affair with Tara. His later claim that he was fleeing the petty, backbiting art world of New York was simply a way of explaining his trip without revealing his failed love affair.

The Bollingen fellowship, supplemented by earnings from commercial design projects and sculpture sales, gave Isamu the chance to reflect on the meaning of sculpture once again. He was forty-four years old, and as he thought about what he wanted to do in the future he felt a need to return to first principles. Ultimately he never finished his book on "leisure" but his journey to ancient monumental sites around the world gave him new ideas, especially a new conception of environmental art. Indeed, without understanding the impact of his trip to India, it is difficult to understand the work of his later years. His search for the origins of "leisure" was one of the most important turning points in his long artistic career.

In May 1949 Isamu left New York for Paris, where he visited his mentor Brancusi. From there he traveled to see the dolmens and menhirs of Brittany, and the prehistoric caves at Lascaux and Altamira, voraciously taking pictures with his Leica. In Italy he photographed not only ancient Roman ruins but also the urban gardens and the piazzas at the center of every city. From Italy he went to Greece and Crete, then to Egypt, where

in the enervating summer heat, he saw ancient monuments of extraordinary power and beauty at Luxor along the banks of the Nile and visited the great mosques in Cairo. Everywhere he sought out scholars and other travelers for suggestions about what to see in order to understand the links between sculpture and society. "The evidence of the past," he later wrote, "attests to the place of sculpture in life and in the ritual of communion with spirit, with tranquility."[50]

In September he flew from Cairo to Bombay, arriving at last in Tara's homeland. Marriage had not brought her happiness. Her husband, perhaps on account of love for his beautiful new bride, displayed an unusually deep streak of jealousy. Almost immediately after the wedding, he began bringing up Tara's past. She had to throw away not only Isamu's letters and the ring and necklace he had made for her, but also all the books he had given with his affectionate signature—"From Isamu." So distressing were those nightmarish days that her brief reunion with Isamu later slipped completely from her memory. "I did not meet Isamu when he came to India" she said, but her older sister Lekha is certain that she did.[51] Lekha, who married an Indian diplomat, was living with her husband's family in Bombay at the time, and her father-in-law invited Tara for tea to meet Isamu, who had pleaded to see her just once. By then she was already pregnant.

The Sarabhai family, a wealthy and powerful merchant clan who dominated the cotton market in Ahmadabad, a major center of the cotton textile trade, treated Isamu almost as one of their own during his stay in India. The country was fraught with daily annoyances and difficulties for foreign visitors, and the Sarabhai family provided him a safe refuge. Isamu had made the acquaintance of Gautam Sarabhai, the family's eldest son and heir, at a meeting of the India League. After graduating from Cambridge University, Gautam had come to expand the family business in New York. He and Isamu became friends right away. When Gautam's sisters came to the United States to study, Isamu had acted as a kind of older brother. He arranged for the youngest sister, Gira, to take an apprenticeship at Frank Lloyd Wright's architectural office, and he introduced the third sister, Geeta, who performed on Indian percussion instruments, to his friend the avant-garde composer John Cage.

In Bombay Isamu stayed with Geeta, now married, who took him on sightseeing trips. He constantly grumbled about how dirty India was, she recalled, and acted as though he feared being struck down by some virulent

microbe. Geeta thought that he really did not like India. But whenever they visited a cave or a temple, Isamu was like a man possessed. No matter how oppressively hot it was, he kept Geeta waiting as he took photograph after photograph. He was fascinated by *lingam*, stone phallic images related to the god Shiva, as sculptural objects. His interest seemed inexhaustible. Geeta was repelled by the thought of touching one, turned shiny black as they were by the hands of countless worshippers praying for the prosperity of their descendants, but despite all his complaints about sanitary conditions Isamu had no qualms about doing so. To him *lingam* were not a part of "dirty India."

"The Retreat," the huge Sarabhai family compound in Ahmadabad, was his home base in India. Probably no place better revealed the extremes of Indian society. Gaudily colored peacocks, parrots, and birds of paradise roamed its extensive grounds—and still do today. Imposing stone walls, twice a man's height, surrounded it. Outside the gate, guarded by an armed sentry, lay another world, where poor beggars slept by the side of the road. Indian society remained very much as it had for centuries. Most occupations were hereditary, determined by birth and caste, and deep-reaching economic inequality persisted even after independence. The India that Isamu visited was a country where grinding poverty and great wealth existed side by side, as distant from one another as heaven and hell.

From September 1949 into the spring of 1950 Isamu spent seven months traveling around the country. Riding on slow moving Indian trains and stopping at native-style hostels, he visited every corner of India in search of stone monuments and cultural sites. Wherever he went, whether the caves at Ajanta or Ellora, or the astronomical observatories at New Delhi and Jaipur, what he saw had an "extraordinary impact" on him. What impressed him most were the observatories (*Jantar Mantra*) built in the eighteenth century. The huge stone sundials, the hemispherical pits dug into the earth, the celestial spheres, the observational instruments, and the winding truncated stairwells that ended abruptly as they climbed toward the sky all looked like geometrical forms in a Surrealist landscape painting.

In 1956 Isamu recalled the enormous importance of his visit to India, where sculpture had been infused with religious meaning since prehistoric times, to his development as a sculptor. "India is a place that taught me something about various fundamental problems of sculpture. . . . You can still see the raison d'etre of sculpture there. The relationship generated

between sculpture and human beings is ceremonial, but our aesthetic appreciation of this sculpture is quite different from our appreciation of the sculptures we see on pedestals in our art museums. . . . [Indian sculptures] imitate nature, they are not artificial. They bring the materials at hand to life more effectively. And they are shocking. In that respect they resemble modern art. . . . When we rethink the future of sculpture I think that we can learn a great deal from India."[52]

Sculpture was not the only thing that attracted Isamu to Indian culture. Music, drama, dance, folk craft, even the sari, he thought, were unchanged, all still alive, as they had been for millennia. To Isamu, these folk arts "achieved the maximum effect with the minimum means." He discovered an enchanting and unfathomably deep beauty in Tara's homeland, and even though he only caught a glimpse of it he was completely captivated. "Isamu was possessed by the intense raw energy of the country from the moment he set foot in India," says Gautam's nephew Anand Sarabhai, who had known Isamu from childhood.[53]

India was endlessly fascinating to Isamu as an artist. Even the stacks of the flat round patties of dried cow dung used for fuel had a kind of modern geometry, and the women peddlers balancing the patties on their heads wore colorful sari of brilliant beauty. Just as he had been stunned by Tara's beauty at their first meeting Isamu had lost his heart to her India, and just as he had fallen in love with Tara, he burned with a passion for her country too. The longer he stayed, the more he was captured by its intense vitality, its contradictions, it overflowing energy, and its rich diversity. And it was during his days in India that he accepted that it was his fate never to be Tara's companion in life. The country she loved so much slowly helped to heal the psychological wounds he had suffered in losing her.

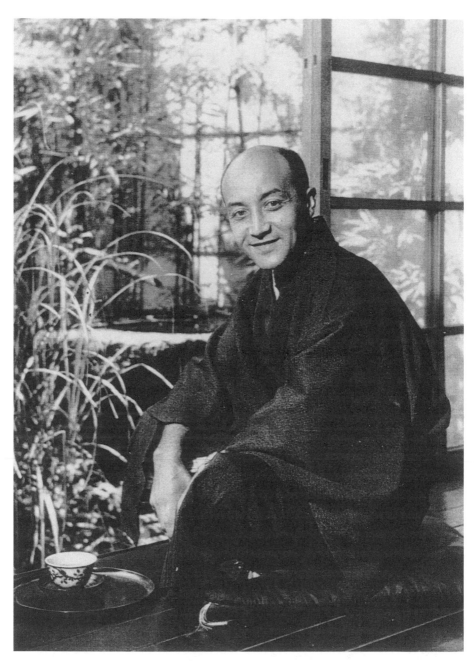

Isamu at the Noguchi family house, 1950

Honeymoon with Japan

A Country in Ashes

"Here I am in the wonderful island of Bali, where I have been 2 weeks now, enjoying the experience of living among people undisturbed by the uncertainties and problems that beset the rest of the world," Isamu wrote his half-brother Tomiji Noguchi in early February 1950. After leaving India he had gone to Jakarta, where he made a portrait bust of President Sukarno, and from there he flew to Bali. "You can understand how I hate to leave this place, and so considering that it will still be cold in Japan in early March [I] have decided to alter my date of arrival to the end of March instead."[1] Isamu had been corresponding with Tomiji for three years.

On March 27, 1947, the lead story in the *Nippon Times* magazine, an English newspaper in Tokyo, was a United Press reporter's interview with Isamu at his MacDougal Alley studio. "FAMED SCULPTOR SEES NATION'S SALVATION IN INDIVIDUAL CREATIVE EFFORTS, DEVELOPMENT OF HANDCRAFT," ran the headline. Isamu's message to the "new Japanese," then taking their first steps toward democracy amid the ruins of their war-devastated country, was to warn against absorbing everything American, good or bad, as a true expression of American democracy. "The Japanese," he said, "should utilize that inner sense of beauty that has always existed; they should apply themselves to art and handicraft. Only in that manner will they build for themselves a place of prominence in the world, and achieve a national identity. They could be the leaders in the Orient, just as the French are leaders in Europe, not through arms, but through culture."[2]

Isamu asked the UP reporter to find out whether Yonejirō was still alive. He had been deeply concerned about his father's fate during the

American bombing raids that reduced Tokyo to rubble in 1945. No news of Yonejirō arrived when the war ended. "It was more than I could bear," he later said. "I was beside myself."[3] In fact, Yonejirō was safe and sound. In April 1945, his house in the Tokyo suburb of Higashi Nakano had burned to the ground in an incendiary raid. He and his family evacuated to a country village in nearby Ibaragi Prefecture, where they lived for the next two years. It was there that Yonejirō received word that his son Isamu was trying to find him.

In early May 1947 Yonejirō wrote Isamu that he had met with a Mr. Hobright at the UP office in Tokyo.

> [He] handed me a delightful sketch about yourself [that] appeared in the Nippon Times. . . . I know you are doing a very distinguished work of which I feel so applaud. Oh if your mother is living today and sees you of today! . . . I lost almost everything from books and moments [sic] to things of daily necessity. . . . But I say this not for your sympathy. War is terrible particularly when we lost it. Inflation, inflation—we do not know how it goes up. Though we have no decent clothes to wear, we can not buy them because we have to pay an impossibly fabulous prise [sic] for them. . . . Takagi, my elder brother, when you lived while in Japan, passed away under the noise of fire. But the other people when you know are all safe, if you come to Japan again you will see her certainly in a different aspact [sic]. I am getting old and feel sad and awful with what happened in Japan. But I have no complaining about it. Wright [sic] to me when you get this letter; yours, father.[4]

"How wonderful it is to have finally located you," Isamu replied a week later. "I had made other inquiries through what I thought were more important chanels [sic] without success, and even heard from somebody . . . that you had died some years ago. So imagine my delight to hear that you are well. . . . I was told that you liked the interview which appeared in the Nippon Times. I hope that you agree that individual creativity should be fostered in these totalitarian times." Yonejirō's admission that he felt "sad and awful" about the war signified to Isamu that his father, an ardent supporter of extreme wartime nationalism, realized that he had been wrong. "I should so much like to help in bringing back the dignity of individual labor in the Orient," he assured Yonejirō. "If there is anything that you think I could do please let me know. I should of course like to come to visit you in the not too distant future, and perhaps that might be accomplished through some more impersonal mission."[5]

Yonejirō was bed-ridden when he received Isamu's reply. The abdominal pains he had suffered for several months had been diagnosed as stomach cancer. The disease had spread to his liver but his family did not tell him that his condition was inoperable—or even that he had cancer. His two sons, both safely home from the China war front, and his son-in-law, a physician, took care of him. "Your letter dated May 15 reached me safely," he wrote Isamu, "and it made me cry from joy and I could not speak for some moment. . . . I am suffering from serious illness with my liver troubles. My doctor says my illness is very serious and now for months I could not leave bed, my activities being forbidden. I feel very weak. But I believe that I will come over my present difficulties spiritual and physical. . . .Your [sic] very kind to send me a living necessaries which I need very badly. I can not say what I want because whatever you sent me is all welcome. Of course, food is first thing, but people are without clothes and shoes."[6]

In early July, Yonejirō thanked his son for the packages he had sent. A week and half later, on July 13, he died at the age of seventy-one, surrounded by his family. At the end he simply closed his eyes as though sleeping. UP immediately informed Isamu of his death. "Oh! How he cried from joy hearing your famous name in art, and he hoped to see you again!" Tomiji wrote. "Leaving the world he said [to] me your unknown brother is in U.S.A. and [if] he comes here we must welcome him heartily."[7]

One of the sculptures that attracted attention at Isamu's one-man show at the Charles Egan Gallery in 1947 was the aforementioned *Cronos*. According to Greek legend, when Cronos, the king of the Titans, learned that one of his children would seize the throne, he devoured his newborns one after another. His last son, Zeus, survived thanks to the ingenuity of a mother who hid him in a cave, and when he grew to manhood he overthrew his father to become the ruler of the gods. A gruesome Goya painting in the Prado—*Saturn Devouring One of his Sons*—portrays Cronos as a monstrous naked giant with bulging eyes about to stuff an infant down his gaping maw. Modern interpretations explain the Cronos legend as symbolizing the annual cycle in nature as each new year overturns the old. Perhaps in creating his sculpture *Cronos*, Isamu was exorcizing resentment of a father whose irresponsible behavior had distorted not only his mother's life but his own.

On his way back from India, Isamu planned to visit his father's grave with his half-brothers and half-sisters. As the day of departure approached

he grew increasingly uneasy. Until he was thirteen he had lived in a Japan where traditional values remained deeply rooted, and when he returned a second time in 1931, the country had become a militarist state. On the eve of his third visit Isamu was worried about what he would find there. "My previous experience of [Japan] in 1931 had not been entirely happy and I hardly expected the war to have improved matters."[8] No country could have been more of a contrast to the culturally and ethnically diverse India than his "father's country," where everyone, as he knew from experience, belonged to the same race and marched to the same beat, and anyone different was excluded.

At 3:30 on the afternoon of May 2, 1950, Isamu landed at Haneda Airport to find Tomiji and his two other half-brothers, Masao and Michio, waiting to welcome him. Their mother Matsuko had come, too. In 1931 Matsuko, then pregnant with Michio, had objected hysterically to a reunion between her husband and his illegitimate mixed-blood child, but now she was a gray-haired woman of sixty-one. At their first meeting she welcomed Isamu with eyes full of gratitude. His gift packages had washed away the painful complications of the past. Isamu's strong family resemblance immediately broke the ice. Tomiji, a white-collar bank worker, had a very different temperament from his artistic half-brother but resembled Isamu in height, figure, and carriage. A few years earlier Isamu's name had been taboo in the Noguchi household. Now they welcomed him as one of their own.

The day after Isamu's arrival all the major Tokyo newspapers carried a photograph of the "avant-garde Japanese-American artist" alighting from his plane. A swarm of reporters waiting at Haneda asked why he had come to Japan. He told them that he wanted to learn about the Japanese art world. "I want to meet young Japanese artists and architects," he said. "There is a new world emerging in Asia, and I think it is extremely important to learn what the new generation here is doing and also trying to do."[9] Many young Japanese artists and architects were also eager to learn from him about the American art world. New York City had supplanted Paris as a center of modern art, and hardly anyone in Japan knew what was going on there.

The postwar revival of the Japanese art world came relatively early. Just six months after the war's end the Ministry of Education sponsored

the first postwar All-Japan Art Exhibition. Private groups like the *Nikakai* and the *Shinseisaku kyōkai*, organized before the war in reaction to officially sponsored academicism, became active again, too. What breathed new life into postwar modern art was the initiative of the *Yomiuri shinbun*, a major newspaper company. In 1948 the paper sponsored an exhibition of modern art organized by the Japan Avant-Garde Artists Club, a federation of abstract and Surrealist artists groups, and the following year, it also sponsored the first Japan Independent Exhibition (known as the Yomiuri Independent), a show that offered young artists outside the art establishment an opportunity to display their work.

The *Mainichi shinbun*, which had helped UP find Yonejirō, poured its energies into promoting Isamu's visit, touting him as "a Japanese American artist . . . who can tell us about the lively state of American art."[10] Isamu arrived in Japan unaware that a warm welcome awaited him. A week after his arrival, the *Mainichi shinbun* sponsored a public lecture in the annex of its main office. Three hours before it began, a line formed at the entrance, and late arrivals squeezed into the back of the hall. Not only sculptors and painters came to hear Isamu, but also architects, furniture designers, and others seeking guidance about the postwar future of Japanese art. The audience was abuzz with anticipation.

Isamu began his lecture on "Art and Community" by talking about his yearlong journey around the world to look at "ancient sculptures inspired by religion, which, when all is said and done, expresses the feelings of society." His goal, he said, had been to meditate on "sculpture's relationship to 'leisure.'" He called on his audience to think about art in new ways. "Architecture and gardens, gardens and sculpture, sculpture and human beings, human beings and social groups—each must be tightly linked to the other. Isn't this where we can find a new ethic for the artist?"[11] But his main message, as in his 1947 interview in the *Nippon Times*, was to encourage Japanese artists to draw on their own traditions.

"I have been in Japan only eight days," he said, "but I have discovered how much today's Japan is under American influence and how poor the country is. Poverty is nothing to be concerned about. But to lose one's own individuality is a terrible thing." In reaction against their wartime experience, when everything had to be done in the name of the state, the Japanese were now blindly pursuing the West in everything. "I agree that things should change," he said. "And I think we should always make things anew.

But one cannot claim that foreign countries are at the forefront of the new in everything. To be authentic and original is to be modern. Therefore if something in Japan is authentic and original it is even more modern than anything imported from abroad. [For example,] the Japanese themselves ought to understand how authentically rational Japanese architecture is, but strangely enough, it is the Americans who are most influenced by its beauty."[12]

The day after his lecture newspapers carried headlines like "AMERICA ENVIES JAPAN'S BEAUTY" and "DON'T LOSE INDIVIDUALITY." Clearly the message Isamu brought to Japan was not that of a foreigner enchanted by its exotic culture. He embodied in his person the friendship newly constructed between Japan and the United States. Even though he had "blue eyes," Japanese blood ran in his veins. Everything about him, including his name, made it easy for the Japanese to accept what he had to say. Even Shūzō Takiguchi, the leading postwar art critic, reconsidered his position that "art is an international language" after hearing Isamu's lecture. He described Isamu's impact on the Japanese art world as "a shock."[13]

For his part Isamu himself was jarred by his visit to the "New Japan." It was not the material poverty of the country that surprised him. The extremes of human misery he had encountered during his six months in India softened his shock at seeing the country's battered landscape. What most surprised him was how much Japanese attitudes had changed. There was an "extraordinary sort of springtime feeling" in Japan in 1950, he later recalled, as though something was about to burst into bloom. "I was absolutely astonished to find how extraordinarily . . . open the Japanese were at that time," he later recalled. "It was the best time in Japan then."[14]

"It takes fortitude to see good in poverty when oneself [sic] is poor," he wrote on his return home. "Few are lacking in envy, but I think I saw less ill will in Japan than elsewhere. I found a kind of envy without bitterness; envy, for example, of our American energy and imagination, our efficiency and drive. . . . I suggested that to be modern did not mean to copy us but to be themselves, looking to their own roots for strength and inspiration. They wanted me to show them how to function again after long years of totalitarian misdirection of all energies, and I found a duty to do what I could to help prime the pump of their renaissance."[15]

Isamu was overwhelmed by his reception. "As an American I expected to be treated like a foreigner. This was certainly true to a degree. How could it be otherwise, with my Japanese forgotten since my last visit twenty years before. Yet there was an eager approach to brotherhood, which other Americans, too, can attest to. I was immediately swamped by all the artists, and their various groups seeking my participation. I felt like the pigeon harbinger after the Deluge."[16]

During his first two weeks Isamu happily pursued the busy schedule his Japanese hosts had laid out for him. Forty members of the Avant-Garde Artists Club greeted him at a welcome dinner at the Mon Ami Restaurant in Higashi Nakano, where he arrived dapperly dressed in a gray suit with a black shirt and a black handkerchief tucked in his suit pocket. In contrast to his formal lecture, he spent a relaxed two hours with Japan's abstract-art community, answering questions and shaking hands with everyone in friendly American fashion. He struck up a lively conversation with Tarō Okamoto, an abstract painter and sculptor soon to become an icon of the postwar Japanese modern art world, who spoke with him in French, their only common language. Okamoto had spent more than a decade in Paris before the war, and, like Isamu, he looked at Japan with the eye of an outsider, immune to mindless Japanese curiosity about the West.

The painter Saburō Hasegawa, who made a welcoming speech at the Avant-Garde Artists Club dinner, visited the rebuilt Noguchi house in Higashi Nakano with Shūzō Takiguchi to interview Isamu for *Bijutsu techō*, a leading Japanese art magazine. Isamu, greeting them in a subdued man's kimono, led them to a six-mat Japanese-style room facing the sun-filled garden and sat with his legs folded in formal Japanese style. Only when Hasegawa offered him a Gold Bat cigarette did the formality dissolve. Isamu seemed at ease as a new member of his father's family. A photograph taken by the *Bijutsu techō* cameraman shows him sitting on the veranda in his kimono. His smiling face had never looked more cheerful; it was a face free of anxiety and suspicion.

Isamu chatted volubly with the two men, answering their questions and reminiscing about New York. In clear and understandable English, occasionally mixed with French technical terms and "a charming, half-forgotten broken Japanese," he told them stories about playing chess with

Marcel Duchamp in his one-room apartment, and he mused on the resemblance between the aesthetics of Mondrian's geometric paintings and the Japanese *shōji*. What most delighted Hasegawa was his comment that "no outstanding new work was as harmonious with Japanese people, the Japanese living environment, or the Japanese architecture as the work of Paul Klee." Klee had been a strong influence on Hasegawa's own work.

"From my first meeting with Noguchi I felt that in an almost uncanny way he was a man who held his opinions as strongly as I held my own," Hasegawa said. "In fact, what surprised me instead was we really had so many ideas in common."[17] Hasegawa, who was two years younger than Isamu, had graduated from the art history department in the literature faculty at Tokyo Imperial University, then studied painting in Paris. In his pioneering critical writings he promoted abstract art in Japan. His life, he later confessed, was a "history of anguish at being caught between East and West." He was entranced by the abstractions of Kandinsky, Klee, and other Western painters, but he was also deeply interested in traditional Japanese artists like the monochrome ink painter Sesshū and in the philosophies of Taoism and Zen Buddhism. Sensing in Hasegawa a kindred spirit, Isamu asked him to join him on a two-week trip to Kyoto.

On June 1, 1950, the two men arrived by overnight train in Kyoto. The city had escaped significant war damage. It looked very much as it had when Isamu visited nineteen years before. Isamu was eager to absorb and learn everything that he could about Japanese culture. Hasegawa, who had an insatiable appetite for explaining everything, was a perfect guide. Nothing could have suited Isamu better as he set off on his "rediscovery of Japan" with a Leica camera slung around his neck and a calico *furoshiki* packed with camera lenses, Japanese paper and brush, and an ink stick and stone. The two men stopped first at the Katsura Detached Palace, an elegantly designed seventeenth-country villa admired by Japanese and Westerners alike as a masterpiece of traditional Japanese architecture. Isamu was "like a hunting dog with a camera," Hasegawa recalled. As they walked along the veranda, he suddenly jumped down into the garden. "It's because I want to make photos of my first impressions," he muttered.[18] Silently he shot four rolls of film, as though he wanted to print everything on his mind's eye.

Isamu spent every day visiting temples and gardens through the city, constantly changing film and clicking his camera shutter. "Since I had

promised the Bollingen Foundation that I would write up my research I took notes and gathered material with my camera wherever I went."[19] He was interested not only in gardens and rocks but in painting and calligraphy, as well. In everything he found the spare beauty of abstract form. The words he kept repeating over and over again to Hasegawa were "leisure," "poverty," and "nothing." "Asleep or awake," Hasegawa said, "he was in constant pursuit of the beauty of simplicity."[20]

"Never for even a day did I stop thinking about 'space' and 'leisure,'" Isamu later recalled. It was on this trip to Kyoto that he began to think of the Japanese garden, "the sculptured space" he first discovered in 1931, in terms of the relationship between "leisure" and "space." He became more and more firmly convinced that the Japanese garden was "just the kind of space that I had been searching for"—a space that "made one feel an unlimited breadth even in a limited space." It was a space "where the human spirit lived rather [than] where human beings lived."[21]

When Hasegawa told Isamu that some Japanese thought his appreciation and respect for traditional Japanese art was "simply a taste for the exotic," he replied with a smile, "Many Japanese today are themselves addicted to an exotic taste for American and European things so I guess that they think I too must be addicted in the opposite direction." Indeed, he was quite critical of modern art in Japan. "Picasso may be modern art," he said. "But imitating Picasso is not modern art." There were too many Picassos in Japan, he feared, and too many young Japanese "ignorant of Japan."[22]

"You just don't meet anyone as pure as that fellow Noguchi," Hasegawa told his wife after returning home.[23] A few days later Isamu visited their house to look at Hasegawa's copy of Sesshū's *Four Seasons Scroll* (*Shiki sansui zukan*), the subject of his graduation thesis at Tokyo Imperial University. When Hasegawa brought out another treasure, a set of 150 picture postcards of prehistoric clay objects, Isamu's eyes slowly savored each. "These are more interesting than *haniwa*," he said. "They have a lot in common with Mexican and American Indian things." By the end of the day, said Hasegawa, "he was dead tired, but he wanted to see the Sesshū scroll again. He stared at it as though punching holes in it with his gaze. He seemed to get tired. 'Let's go to bed,' he said, but he kept on looking at it. Then, almost with sighs of admiration, he began to praise everything about it—the composition, the use of the brush, the brush strokes, the humanity expressed in the work."[24]

Hasegawa's daughter Sumire, then fifteen years old, remembers meeting "Isamu-san" for the first time as he was gazing at the Sesshū scroll. He suddenly glanced up at her with a vacant stare when she opened the sliding door to the room. An exotically beautiful young woman with pale white skin, Sumire was Hasegawa's daughter with his first wife, a French woman who left him when Sumire was still an infant. Sumire thought "Isamu-san" sensed the pain she experienced during the war because of her un-Japanese looks and manner.

Sumire accompanied Isamu one day on a walk along the beach toward Chigasaki, where he visited the little house he had lived in as a child. It was still standing but in very bad repair, looking to Sumire like an old board shack.[25] An old woman suddenly called out to Isamu from a neighboring house. It was the maid who had taken care of his half-sister, Ailes. She still recognized him after so many years. Isamu often invited Japanese friends to visit the house his mother had built, and the elderly maid always rushed out in her apron to offer the visitors freshly roasted sweet potatoes as a snack. Was it simply sentimental memories of his mother and her hardships in Japan that kept drawing him back? Or did he want to assure himself that he could make a new start in his "father's country" with all the pain of the past forgotten?

"I'm Rip Van Winkle," Isamu told Yoshirō Taniguchi, a professor at Tokyo Institute of Technology, on a visit to the house in Chigasaki.[26] The two met when Isamu visited Keiō University, where his father Yonejirō had taught for forty years. Taniguchi, who was supervising reconstruction of the campus, took a liking to Isamu. He asked him to design a faculty reception room for a research building on a hill overlooking Tokyo Bay. Immediately Isamu agreed with a simple handshake. "I became preoccupied with this [project] as my own act of reconciliation to my father and to the people," Isamu said of his quick decision.[27] His father had refused to give him his family name, and his "father's people" had discriminated against him as a mixed-blood bastard child, but Japan's defeat had softened Isamu's feelings toward his father and brought closure to the resentment he had felt toward the Japanese since childhood.

His design for the reception room took inspiration from the Shisendō, a seventeenth-century poet's retreat in the foothills of Kyoto that his father had been fond of. He wanted to create an interior suitable as "a room for a

poet." The area of the reception room, the *Shinbanraisha* ("New Welcoming Hall"), was about eighty square yards. At its center stood two round pillars reminiscent of the central posts (*daikokubashira*) found in traditional Japanese farmhouses and town houses. One pillar served as a chimney for a round stone fireplace standing between it and the other pillar. The most striking aspect of the room was its division into three different sections, each with floors at slightly different elevations. One section was paved with stone flooring for walking, another was covered with *tatami* mats for sitting, and a third had a wooden floor for walking or sitting. The room could function in either Japanese style or Western style.

In modern Japanese culture, it is sometimes said, there is an irreconcilable tension between those who sit on the floor and those who stand. In a poem entitled "Sitting Person" (*Suwatte iru ningen*) Yonejirō wrote, "As a human who sits on the floor / now I gaze with delight at the face of the garden." The years Yonejirō spent in the West changed his daily lifestyle but not his sense of values. After returning to Japan he adapted himself to the spirit of the times by becoming an extreme Japanophile. His son was different. He had lived in two cultures, but unlike his father, he believed that "those who sit on the floor" and "those who stand" could indeed coexist. In a sense, his interior design for the *Shinbanraisha* was a prayer of hope for the "New Japan."

When the Korean War broke out on June 25, 1950, many Japanese feared that the conflict might lead to another world war. Isamu seemed unconcerned even though Japan was separated from the battlefront by only a narrow stretch of sea. Too busy to worry about the war, he was finishing a sculpture for the Keiō University project and making feverish preparations for a one-man exhibition. Just after his return from Kyoto the *Nihon bijutsuka renmei* (Federation of Japanese Artists) asked him to exhibit the photographs he had taken on his trip around the world. Isamu did not want to devote his first show in his "father's country" to photographs. He wanted to display his talent as a sculptor instead.

After a week in the pottery town of Seto, where he fashioned thirteen terra-cotta works, Isamu began a daily commute to the Japan Craft Center (*Kōgeishidōsho*), a design facility operated by the Ministry of Trade and Industry on the outskirts of Tokyo. Originally established by the prewar Ministry of Commerce to develop designs for export goods, the

postwar center pioneered in the new field of interior design under the direction of Isamu Kenmochi, who had met Isamu at the Tokyo University office of the architect Kenzō Tange. Several weeks later the painter Gen'ichirō Inokuma invited Isamu to stay at his house in Denenchōfu, a well-to-do Tokyo suburb, while he worked at the craft center.

Wearing blue jeans and a T-shirt, Isamu arrived every day with a leather bag of tools in one hand and a sketchbook in the other. His first project was to make chairs and stools using bamboo-weaving techniques to demonstrate how to make products for foreign markets with traditional methods and materials. Kenmochi was astonished at the extraordinary blend of form and function in this experimental bamboo furniture. At work Isamu seemed entirely different from the quiet person he had met in Tange's office. "He suddenly changed into another human being. A worker ant? An artistic demon? I can't even find words to describe him." Isamu went at everything with meticulous intensity, and when Kenmochi asked if he wanted help, he simply replied, "I don't need an assistant." [28]

Isamu made an exception when he fashioned a sculpture for the *Shinbanraisha*. He took as an assistant Tsutomu Hiroi, an instructor in the Department of Sculpture at the Tokyo School of Fine Art Education, who had waited several hours to hear his lecture at Mainichi Hall, and who had visited the next day to show him one of his terra-cotta sculptures. After making several clay models, Isamu stared at them for two days, trying to decide which to use and which to discard. Finally pointing to one of them, he told Hiroi, "Enlarge this to two meters." [29] Hiroi made a pattern on graph paper. Isamu transferred it to a sheet of plywood, then cut it and assembled the pieces into a frame for the sculpture. Working quickly, he applied layer after layer of plaster to the frame. Hiroi had to mix twenty-three sacks of plaster for him in one day. Isamu splattered plaster everywhere as he worked—on the floor, on the walls, on the ceiling. His face, balding scalp, and arms were covered with plaster but he kept layering it on, oblivious to everything, even the humid August weather. He stripped off his T-shirt and worked naked to the waist, as though lost in a trance.

The sculpture that gradually emerged was a circular form mounted on a slim pedestal, altogether about two meters high. To Hiroi it looked like an ancient hand mirror but Isamu described the shape as "the circle

made by the thumb and index finger." The ends of the circle were slightly twisted so that its "finger tips" crossed over one another. From the front the circle appeared to be broken at the top but from the side it appeared complete. "I inadvertently called [it] *Mu*, meaning nothingness, a Zen term well-known in Japan," he said, "but provoking innumerable wisecracks and cartoons."[30]

The center staff worried that the door to Isamu's workroom would have to be widened to transport the huge plaster sculpture to the exhibition site. When they raised the question, Isamu acted as though the problem had nothing to do with him. He continued working as if possessed by a demonic urge. The staff concluded that he was "an extreme egoist," but as one of them explained, "When someone is working on something it is all right to be extremely engrossed. There's no reason not to sacrifice everything for the sake of the work. . . . That is egoism in the good sense of the word—in the artistic sense."[31] The plaster sculpture was eventually cast in concrete for the *Shinbanraisha* garden and positioned so that the panorama of Tokyo Bay could be viewed through the circle made by the two "fingers." In the late afternoon the sinking sun gleamed through the circle like a candle in a Japanese garden lantern.

From the opening day of Isamu's one-man show at the Nihonbashi branch of the Mitsukoshi Department Store, large crowds gathered to see what the "standard bearer of American abstract sculpture" had learned in Japan and how he expressed himself with Japanese materials. *Mu*, the largest work, was one of twenty-one pieces. The exhibition included *Bell Tower for Hiroshima*, five ceramic *dōtaku*-like bells of different shapes fired in bisque and suspended on a white wooden frame like that used in Shinto ceremonies, and *Lovers*, two terra-cotta cylinders clinging to one another like the couple in Brancusi's *The Kiss*. The exhibition also displayed a model of the *Shinbanraisha* reception room as well as the tables and chairs Isamu designed to match its interior.

The exhibition, noted the *Mainichi shinbun* review, had "such enormous vigor and talent and perspective that it is hard to believe that one artist could have produced it in a month's time."[32] The review in the art magazine *Atorie* summed up the general view: "In an era when even exhibitions of Japanese paintings [*nihonga*] imitate the West, this exhibition

conveys the feeling of something Japanese-like [*nihonteki*], even though the sensibility is not Japanese."[33] The range of materials used—not simply the marble, plaster, and wood traditionally associated with sculpture—surprised many, too. The *Kōgei News* predicted the exhibition would have "an extraordinary influence on the creative world."[34]

"Everything happened all at once," Isamu later recalled. "It seems ridiculous that all this could have happened within four months. [But money] was running out, and I decided that I had better return to the U.S.A. to find the means to resume living in Japan."[35] On the night before his departure his new Japanese friends—Gen'ichirō Inokuma, Saburō Hasegawa, Yoshirō Taniguchi, and others—threw a relaxed and festive farewell party for him at an Okinawa-style restaurant on the Ginza. A reporter asked Isamu, "What is the most important thing you have gotten out of coming to Japan?" Stopping a moment to lick some grated yam off his fingers, Isamu replied, "Making good friends."[36]

The friends Isamu made during his trip were to remain close for the rest of his life. It was the first time that he had encountered sympathetic Japanese who valued him for who he was. "It was the first time after the war when everybody was more or less peerless and everybody was sort of equal and there was this tremendous feeling of friendship and possibility, not just toward me but toward each other. I think most Japanese would agree that this [was] the best time."[37] Isamu ended his journey to "rediscover Japan" bathed in the warm glow of good feelings.

His visit also stimulated and encouraged the generation of young Japanese artists who dominated the postwar art world. He was the first famous foreign artist to visit Japan, and he arrived at a time when these artists, liberated by a new atmosphere of openness and freedom, were searching for the possibility of a new art. After defeat they had lost confidence and faith in their own culture, and many thought that blind pursuit of Western models was their new way of life. Isamu, a messenger with the right message at the right moment, told them to value their own traditions. It is easy to see how important his visit was simply by counting the number of articles about him in the daily press and in leading magazines, from the art journal *Bijutsu techō* through the the general culture magazine *Bungei shunjū* to the women's magazine *Fujin gahō*.

As Isamu Kenmochi noted later, his impact was like that of two other prominent foreigners who visited the craft center before the war—

Bruno Taut, the German architect who drew parallels between traditional Japanese architecture and modern Western architecture, and Charlotte Perriand, a French furniture designer who had collaborated with the Swiss architect Le Corbusier. Isamu's visit, however, influenced not just the center staff but the whole Japanese modern art world.

On the morning of September 5, just six days after his one-man show closed, Isamu boarded a Pan American flight for Los Angeles at Haneda Airport. His half-siblings and newfound friends waved from the terminal. His tread was light as he climbed aboard. He was on his way home to America, intent on returning to Japan as soon as he could.

Yoshiko-san

"Before he went to India, Isamu consciously insisted that he was an American, even to old friends like us." The dancer Jean Erdman and her husband, Joseph Campbell, a well-known writer on religion, had first met Isamu in the 1930s. "Before the war," she said, "he was always extremely critical in what he had to say about Japan. But all that changed when he came back from Japan. He wanted to be Japanese after that. He had fallen blindly in love with Japan."[38]

Isamu bubbled with enthusiasm about the "New Japan" when he visited Eitarō and Ayako Ishigaki the day after his return to New York City. "Tokyo is even more lively and energetic than New York," he told them. "The Japanese may not have enough food and clothing but they're full of hope and they want to learn about everything."[39] Even the Communists were having "no problems," he added. Things had changed in Japan because the country had "abolished armaments and lets America worry about war."[40] Ayako was skeptical.

The political mood in the United States had changed during Isamu's absence, too. Just before he arrived in Japan, Senator Joseph McCarthy of Wisconsin announced that Communist agents had infiltrated the American State Department. The Chinese Communist Party had won the civil war in China in 1949, and Republican politicians attacked the Truman administration for "losing China" and "being soft on Communism." By the time Isamu returned to New York, a hysterical anti-Communist "hunt for Reds" was spreading through American society, targeting State Department officials, scientists, academics, and even Hollywood personalities.

The FBI had interrogated the Ishigakis, who had been members of the Communist Party before the war, and tapped their telephone, too. Eitarō was surprised to hear Isamu say that Communists were having no problems in Japan. In fact, when the Korean War broke out, the Japanese government, backed by the American Occupation forces, began a "Red purge" to weed out Communists in the unions, in schools, in journalism, and in other areas of Japanese society. Enjoying his honeymoon with the Japanese art world, Isamu had not taken much notice of Japanese politics, and he did not quite understand what the Ishigakis told him about the "Red hunt" in America.

The New York art scene had changed, too. The abstract expressionists of the New York School had become the mainstream in American art, and their work dominated the New York art market. Jackson Pollock, Willem de Kooning, and the late Arshile Gorky, who had discovered their own distinctive new styles under the influence of the wartime Surrealist refugees, were chosen to represent the United States at the 1950 Venice Biennale. After an absence of a year and a half, Isamu once again found himself a Rip Van Winkle.

"New York was totally unreal," he later recalled. "I lived only with thoughts of how to get back again to Japan."[41] He spent his days looking for material to send to the Japan Craft Center in Tokyo and arranging exhibitions for his new Japanese artist friends. He even managed to have paintings by seven-year-old Gen Nishida, whose work Gen'ichirō Inokuma admired, placed in an exhibition of children's art at the Museum of Modern Art. It was at this moment of transition in his life, as he pondered about ways of returning to Japan, that he met the movie actress Yoshiko Yamaguchi.

Isamu's half-sister, Ailes, had married Herbert Joseph Spinden, a man thirty-three years her senior. He was curator of American Indian and primitive art at the Brooklyn Museum. In November 1950, the museum sponsored an exhibition for Chiyo Tanaka, a well-known kimono designer, who had sought Isamu's advice on how to preserve Japanese-style clothing. He offered her some ideas that she worked into a design for a simplified kimono intended to look natural in a Western setting, and with the help of his brother-in-law he had arranged for her to stage a kimono show at the Brooklyn Museum. It was the first postwar Japanese fashion show in the United States. To assure its success the Japanese community in New York

turned out in full force. The guest who attracted the most attention—even more than the kimono models—was Yoshiko Yamaguchi, who arrived wearing a gorgeous kimono with long sleeves that nearly swept the floor. Three days later, on November 16, Ayako Ishigaki invited her to dinner. She also invited Isamu.

"That evening," she wrote, "Isamu arrived at our studio apartment early, looking as though he was expecting something interesting to happen." He had a stack of several Japanese art magazines with articles and photographs about his work. "They just came today so I brought them as a gift," he said. While the Ishigakis were looking at them, Yoshiko arrived wearing a long black Chinese-style dress decorated with embroidered flowers. "After I introduced them," says Ayako, "sparks as bright as fireworks seemed to fly from the moment they looked at each other—Yoshiko with her big black eyes and Isamu with his severe gaze."[42]

It was not the first time that they had met. Yoshiko recalls exchanging a few words with Isamu at the kimono show. Still recovering from dysentery he had picked up in India, Isamu was very thin. "He had a puny build," Yoshiko said, recalling her first impression. "On top of that he was bald and much older than I was. I was not at all attracted to him as a man."[43] But she was touched when he said to her, "It must have been tough for you during the war. It was trouble for me, too." Out of spite or curiosity people often bombarded her with questions about her past but Isamu spoke with a strangely natural directness. He immediately understood that she, too, had been caught between two cultures.

The best-selling Japanese record in 1950 was Yoshiko Yamaguchi's "Ye lai xiang" ["Evening Fragrance"]. Isamu probably heard the sentimental love song playing on the radio every day when he was in Tokyo. Yoshiko had first sung it before the war, when she was known as Ri Ko Ran (Li Shiang-lan, in Chinese), one of the most popular movie actresses in occupied China. She had been born in a suburb of Mukden (Fengtien) in Manchuria in 1920, the eldest of six children, and had grown up in Fushun (Shengyang), a coal-mining town dominated by the quasi-governmental South Manchuria Railway Company. Her father taught Mandarin Chinese to the company's employees. Yoshiko studied the language from early childhood, and by sixth grade she had passed the national proficiency test. Her father hoped that she would pursue his dream of Sino-Japanese friendship.

When Yoshiko was thirteen her father gave her as an "adopted daughter" to General Li Chi-ch'un (Li Jichun), a pro-Japanese military leader who had been appointed president of the Bank of Mukden as reward for his services to the Kwantung Army, the Japanese military force that took over Manchuria in 1931. The custom of "adoption" was a Chinese way of marking friendship between two men, and it was General Li who gave Yoshiko the name Li Shiang-lan (Ri Ko Ran). In 1934 Yoshiko went to Peking to live with another old friend of her father, P'an Yu-kui (Pan Yugui), a key political figure in North China soon to become mayor of Mukden. Under the name P'an Shu-hua (Pan Shuhua), Yoshiko attended a missionary girls' school as his adopted daughter.

After graduation the pretty and charming Yoshiko made her movie debut as the "Manchurian" actress Ri Ko Ran in a film produced by the Manchukuo Motion Picture Company (Man'ei). Yasunao Yoshioka, a Kwantung Army staff officer who pulled the strings of puppet emperor Henry Pu-yi, agreed to serve as president of her fan club. Although Japanese by birth, Yoshiko had been raised as a Chinese. Taking a Chinese name did not bother her. In a sense she was Chinese emotionally. The new puppet state of Manchukuo was touted as a multiethnic society, and the Japanese army adopted the slogan "harmony among the five races" to promote cooperation among the Japanese, Chinese, Koreans, Mongols, and Manchus living there. Assuming a Chinese identity seemed a natural thing to do.

The Manchukuo Motion Picture Company, although backed by the Japanese government, hired Chinese actors and produced Chinese-language movies. Its president, Masahiko Amakasu, a former military police officer who had helped to plot the Japanese takeover of Manchuria, marketed Ri Ko Ran, a Japanese girl with a perfect Mandarin Chinese accent, as the company's trademark actress to promote "Japan-Manchukuo friendship." Yoshiko kept her nationality a secret. She always appeared in Chinese dresses with high closed collars, a high breast line, and slit skirts that flattered her tiny but voluptuous figure. Her large passionate eyes, full sensuous lips, and exotic "un-Japanese" looks made her seem all the more Chinese, and she sang with a bell-like soprano voice associated with Chinese beauties. Within a year of her debut, her popularity skyrocketed. She became the company's top star, and by the end of the war the name of Ri Ko Ran was inextricably associated with the Great East Asia Co-Prosperity Sphere.

At the war's end Amakasu committed suicide by swallowing cyanide; Ri Ko Ran's adoptive father, General Li, was executed by the Chinese government as a traitor; and Yoshiko Kawashima, a member of the Manchurian royal family working for Japanese intelligence who had befriended Ri Ko Ran as a "younger sister," was sentenced to die before a firing squad. Yoshiko, in Shanghai at the time of the Japanese surrender, was placed under house arrest by the Chinese authorities. Newspapers carried rumors that she too was to be tried and executed as a traitor. Just before the execution was carried out, the local military court cleared her of charges, in April 1946, when she proved her Japanese nationality by producing the Yamaguchi family register. With only a knapsack on her back, she returned to Japan on a repatriation ship under her real name. After disembarking at the Kyushu port of Hakata she announced her retirement from the film world.

At first Yoshiko tried to make a living as a singer and stage actress but it was not easy to change careers. In 1948 she made a movie comeback in *Waga shōgai no kagayakeru hi* (*The Shining Day of Our Life*), and in 1950 she co-starred with the popular actor Ryō Ikebe in her first big hit, *Akatsuki no dasso* (*Escape at Dawn*), a film about a love affair between a Japanese army private who had killed his superior officer and a "comfort woman" in a Japanese military brothel. With the simultaneous success of her best-selling record, Yoshiko had returned to stardom. In April 1950, after completing the filming of *Scandal*, a movie directed by Akira Kurosawa and co-starring Toshirō Mifune, Yoshiko arrived in the United States, just eleven days before Isamu arrived in the "New Japan." "I want to study movies in Hollywood and musicals in New York," she told Japanese reporters before she left, "and I really want to met Mrs. Pearl Buck and Bing Crosby. Is that too much to hope for? I'm taking along two or three kimonos for the stage but I am usually going to wear Chinese dresses."[44]

The American Occupation authorities had begun allowing Japanese nationals to travel abroad a year or so earlier. Most entertainers who went to the United States were popular singers eager to earn dollars performing for Japanese-American audiences. During her scheduled three-month stay Yoshiko hoped to make $4,000, an enormous sum at a time when the starting monthly salary for a Japanese university graduate was about $11. During the war the U.S. army had used Ri Ko Ran's movies in its training program for Japanese language interpreters, and many Japanese-American veterans had become her fans. She appeared at recitals in Honolulu, Los

Angeles, and San Francisco, but she made headlines all over the United States when she told a Hollywood press conference, "I have come to America to study how to kiss!"

After her singing tour ended, Yoshiko wanted to study stage diction and elocution at the Actors Studio in New York. There she met Yul Brynner, then starring in the musical *The King and I*, and she began negotiations to play the role of the Chinese emperor's daughter in a new musical about Marco Polo. The talks went without a hitch, and she was chosen for the part, but soon afterward Chinese Communist "volunteers" crossed the Yalu River to fight American troops in Korea. The producers suddenly had second thoughts about staging a musical set in a fantasized China.

Yoshiko met Ayako Ishigaki at a fashion show to raise money for Welcome House, an orphanage founded by the novelist Pearl Buck for the Eurasian children fathered by American soldiers, but Ayako did not think about introducing her to Isamu until the Brooklyn Museum kimono show. Eitarō, worried that Isamu was still single even though he was over forty, thought it was a great idea. "Isamu likes glamour girls," he said, "and there is a lot that Yoshiko could learn from Isamu. Let's invite them to dinner."[45]

Isamu and Yoshiko met at a moment when each was infatuated with the other's country. Isamu was still intoxicated by his memories of the "New Japan," and Yoshiko, still hoping to play the female lead in a major Broadway production, felt at home in the United States. "To someone like me who was brought up on the Asian continent, the relaxed atmosphere and businesslike way of doing things in America suits me fine," she told a Japanese reporter.[46]

Clearly awed by Yoshiko's beauty, at dinner Isamu sat gazing at her from every angle, and he soon had her laughing at his broken Japanese. When the conversation shifted to English, he asked with a gentle directness: "So when you became a Chinese actress, did the Japanese army use you for propaganda?" Unperturbed, Yoshiko replied simply, "Yes, I regret it very much." She had some leading questions of her own for Isamu: "How old are you, Isamu-san? Are you famous?" Isamu spread out the Japanese art magazines he had brought to show the Ishigakis. Yoshiko was impressed to see how enthusiastically leading Japanese sculptors and critics praised his work.

When the clock struck midnight, Isamu offered to drive Yoshiko back to her hotel. Their affair began that night. Isamu was forty-six years old, and Yoshiko was thirty. Although separated in age by nearly a decade

and a half, Yoshiko felt they had something in common. "Both of us had lived between two countries under similar circumstances."[47] Like Isamu she had crossed the borders between two different cultures, and she never overcame the feeling that she remained a foreigner in her own country. Isamu could understand her feelings without needing an explanation. Neither probed the other's past, Yoshiko says, and neither felt the need to reveal his or her own past to the other. She knew little about his background, and the only time she talked with him about her wartime experience was when they first met.

The next day, and every night afterward, Isamu arrived at Yoshiko's small residential hotel on Riverside Drive to take her to gatherings of his artist friends or parties with Broadway and movie people. But what captivated her about him, she says, was the "uncompromising purity" of his work. When he picked up his chisel to shape a piece of marble in his studio, he completely forgot that she was there. As he worked intently he became "as young and masculine and savage as a twenty-year old." Part of Isamu may have been Japanese, she thought, but his outlook on life was completely American. He never hid his feelings, he always spoke directly, and he had the courage to act when he wanted to. Yoshiko liked all of that very much.

On December 7, 1950, Isamu invited the Ishigakis to dinner at a Szechuan Chinese restaurant. Together they drove to Yoshiko's hotel. "When Yoshiko opened the door," said Ayako, "she greeted Isamu breathlessly. Her cheeks were as flushed as a school girl in love for the first time."[48] Isamu had transformed her hotel apartment by decorating it with masks and fans he had brought back from Southeast Asia. When the Ishigakis had dinner with Yoshiko a month or so later she could talk of nothing but Isamu. She told them for her an ideal husband was a man that she could respect from the bottom of her heart, who would make her life richer and lead her to a higher goal. Isamu fitted that ideal perfectly. "What would you think if Isamu and I got married?" she suddenly asked. Ayako broke open a fortune cookie. After glancing at the paper fortune slip inside, she silently handed it to Yoshiko. "Marrying your present lover will bring the greatest good fortune," it said. Delighted as a child, Yoshiko stuffed the slip into her handbag to show to Isamu.

Isamu had proposed to Yoshiko on their third date, just a few days after their meeting at the Ishigakis. In the past two years he had gradually

overcome his despair and disappointment at losing Tara, first by his encounter with Indian culture, then by his unexpected and enthusiastic welcome in Japan. His love affair with Yoshiko raised his hopes that he might find a place to belong in her country. He told her that he thought of her as an artist like himself, and he promised to share his creative passions with her, but he added, "As an artist, I want to be always as free as a little bird." It was a feeling that she shared. "Even if I got married I did not want to be tied down," she says. "My own work would always come first." [49]

Although her plans for a Broadway debut collapsed, Yoshiko had landed a role in a Twentieth Century Fox movie *Japanese War Bride*. Production was to begin in June 1951, and she had to return to Japan. Isamu and Ayako saw her off at the New York airport in early March. "When it was time to board the plane," Ayako wrote in her diary, "the two lovers, thinking about others watching them, could not kiss. They parted with embarrassed expressions on their faces. Not being able to kiss, of course, is very Japanese." [50] There was nothing sad about their parting. A few days later Isamu followed her.

In January 1951 the Museum of Modern Art in New York opened *Abstract Painting and Sculpture in America*, an exhibition of the latest trends in the New York School. Isamu's marble slab assemblages were exhibited along with works by Jackson Pollock, Willem de Kooning, Mark Rothko, Robert Motherwell, and Franz Kline. Isamu could still not help feeling at a loss because he had been away from New York for so long. "When I come here [to New York]," he later told an interviewer, "I'm sort of troubled by things that are extraneous to my development or belief in art here. . . . It's a little bit removed. I don't like it." [51] He had never completely submerged himself in the New York art scene. He always stood a bit apart, grappling with his own original work and style. His sense that he really did not belong to the New York School made him all the more anxious to return to Japan.

Notes and photographs for his book on "leisure" still sat in unopened cardboard boxes. When he applied to the Bollingen Foundation for an extension of his grant he was turned down. By a stroke of good luck, however, he received a letter from the architect Antonin Raymond asking for help on a project in Tokyo. Raymond had been Frank Lloyd Wright's design assistant on the Imperial Hotel Project in Tokyo, and during the 1930s he stayed on in Japan, where he completed several modernistic build-

ings. After the war he had returned to Tokyo to set up an office again. The Reader's Digest had asked him to design a headquarters building on a site directly across from the Imperial Palace. Its Japanese-language edition found a large audience among Japanese eager to learn about the United States, and its sales boomed. Raymond in turn asked Isamu to design a garden for the project. With the promise of a free ticket to Japan and a fee of $1,500 Isamu accepted without a second thought. He hoped the project would give him a chance to learn about garden making in Japan.

In mid-March 1951 a Kyōdō News Agency dispatch from Honolulu carried the first press report of the romance between Yoshiko and Isamu: "On her way home Yamaguchi Yoshiko is presently staying in Hawaii, but it is widely rumored that during her stay in the United States she has become good friends with Isamu Noguchi. Her partner Isamu Noguchi left New York just a little after she did, and news that she will be riding to Japan on the same airplane from Hawaii adds further fuel to the rumor."[52] Yoshiko arranged to meet Isamu in Honolulu after signing her movie contract in Hollywood. They stayed for twelve days at the Royal Hawaiian Hotel on Waikiki Beach. When pressed by reporters, Yoshiko told them, "Mr. Noguchi is a splendid artist and a fine gentlemen and this is the only reason that we have gotten to know each other." She made no public statement about their intended marriage, but Isamu's friends in Honolulu held an engagement party for the couple.

To pay off a loan from the Hawaiian promoter who sponsored her visit to America, Yoshiko agreed to perform in a Honolulu hotel show. Since Isamu had to start work on the Reader's Digest garden at the end of March he left for Tokyo without her. With Tsutomu Hiroi as his assistant once again he set to work on a garden design that incorporated both Japanese and Western elements: a broad greensward on one side of the garden was linked by a large pond to a Japanese-style miniature mountain landscape on the other; and in the middle of the pond stood an abstract sculptural tower with nine tiers of iron rings inspired by the pagoda. The project was a significant experiment for Isamu. "Here was the opportunity to learn from the world's most skilled gardeners," he later wrote. "Through working with them in the mud, I learned the rudiments of stone placing—using the stones we could find on the site."[53] (Unfortunately the garden no longer exists. When Tokyo land prices rose, the Reader's Digest building was torn down to make way for a new high-rise office building.)

On April 21, Yoshiko, slated for the lead role in a Hollywood production, made her "triumphal return" to Haneda Airport. A large crowd crammed into the terminal to greet her. What excited interest, the Kyōdō News Agency reported, was that the sculptor Isamu Noguchi, "with whom she is said to have a romance in the United States," and Ryō Ikebe, "her boy friend before she left for the United States," were both on hand to meet her.[54] Yoshiko left the airport directly for a welcoming party at the Gajōen Kankō Hotel in Meguro, and when she returned to her Asagaya house in the middle of the night another crowd of onlookers was waiting to get a glimpse of the famous "international actress."

The next day Yoshiko embarked on a packed schedule, starting with an appearance at the Nichigeki Theater. After busily negotiating Japanese movie appearances and record contracts, she was off again to Hollywood to begin work on *Japanese War Bride*. When she boarded the plane, the Kyōdō News Agency reported, she wore "a light dress apparently combining Western and Japanese styles that was designed by her close friend Isamu Noguchi instead of her usual Chinese dress."[55]

Marriage

On the afternoon of June 26, 1951, Isamu arrived by special express at Hiroshima station at 4:13 PM. A year before he had hesitated to go to Japan in part because of his bitter memories at suffering discrimination as a mixed-blood child. But there was another reason, as well. Like many Americans, he felt a sense of guilt at the atomic bombing of Hiroshima. "I wished somehow to add my own gesture of expiation."[56] At his 1950 one-man exhibition at the Mitsukoshi Department Store he displayed an abstract sculpture with *dōtaku*-like bells hung on a white wood frame. "My big interest," he told a newspaper reporter, "is to design a bell tower to put somewhere in Hiroshima to commemorate the people who died in the war."[57]

In 1949 the architect Kenzō Tange's design for a peace memorial had won first place in a competition held by the city of Hiroshima. The Hiroshima Peace Memorial project—consisting of a Hiroshima Peace Park, a Peace Memorial Museum, a Memorial for the Atomic Bomb Victims, a public hall, and other facilities—was the biggest new architectural project since the end of the war. Construction work was already under way when Isamu first met Tange in the spring of 1950. He often told Tange that

as a person with both American and Japanese blood in his veins he wanted to create a work in Hiroshima to contribute to "the dream of peace and coexistence."

"If it is simply a peace movement, I am afraid that I might be used by certain elements for their own purposes," Isamu told the press on his 1950 trip. "But if it is Tange-san's 'Peace Center Project' I can work on it with a completely open feeling."[58] Tange welcomed Isamu's participation. "Since it is a peace center for the whole world, I would rather include a work by Isamu Noguchi than a huge Buddhist temple or something like that." When Shinzō Hamai, the mayor of Hiroshima, visited Tokyo shortly before Isamu's return to the United States in 1950, Tange took him to see the Mitsukoshi show and introduced him to Isamu. A year later discussions about Isamu's involvement in the Peace Center project became more concrete.

Amid a blaze of flashbulbs, Isamu descended onto the Hiroshima station platform after a sleepless night on the overnight express. The city government provided a bus to take him with an entourage of reporters and city officials to Ground Zero, over which the first atomic bomb had exploded. It had rained the night before, and the air was hot and heavy with humidity. Shedding his khaki-colored jacket, Isamu got off the bus with his Leica camera. "It's like Bombay," he murmured to himself with a tight expression as he looked at the devastated cityscape.[59] All that remained on the site was the shell of the Hiroshima Chamber of Commerce Building. Girders that once supported the building's domed roof sat forlornly in a rubble pile of concrete and brick. As Isamu made his way through the ruins snapping pictures, he murmured to no one in particular, "This is terrible." The words seemed to erupt from him unconsciously.

Tange's plan proposed to leave the "A-bomb dome" at the north end of the site as a symbol of Hiroshima. Directly south, at the opposite end of the site, a Peace Memorial Museum was to exhibit materials and mementos from the atomic blast, and a large tree-filled park was to lie in between. Rising steel girders outlined the future shape of the Peace Memorial Museum, whose construction had begun three months before, but the future park was still a burned-out area covered with low wooden barracks thrown up to house displaced atomic bomb survivors. Just before reaching the Peace Memorial Museum construction site, Isamu stopped with a puzzled look on his face. Fallen gravestones and burial urns were scattered helter-skelter everywhere. "This is the remains of a cemetery," a city official

explained." "A cemetery?" said Isamu. He turned and pointed his Leica at a group of children who had followed them from the barracks. "The living, the dead. I guess I prefer the living," he said softly to himself.

The city of Hiroshima is located in an alluvial plain where several rivers flow through the city on their way to the Inland Sea. The Peace Museum was situated between two rivers, the Motoyasugawa to the east and the Ōtagawa to the west. Concrete bridges were being constructed across both rivers. Mayor Hamai's first city reconstruction project was a Peace Boulevard, 130 feet wide, running on an east-west axis through the city center across the two bridges. The bridge across the Motoyasugawa was to be called the Peace Bridge (*Heiwa ōhashi*), and the bridge across the Ōtagawa was to be called the Western Peace Bridge (*Nishi heiwa ōhashi*). The city hoped to open them to traffic by time of the Sixth National Physical Education Tournament in late October 1951, and construction was moving ahead with the help of American foreign aid funds.

Although the bridges provided the entry point to the Peace Memorial Park, the Ministry of Construction, not the city government, was in charge of constructing them. Ministry officials asked Tange to design the bridges to harmonize with the architecture of the Peace Museum and the rest of the Peace Park. "I agreed to the request," Tange later said, "all the while thinking that I would ask Noguchi-san for help."[60] Isamu had hoped to serve "the dream of peace" by designing a bell tower for Hiroshima, but when Tange asked him to design the bridge railings instead he readily agreed. He used the make-up table in Yoshiko's dressing room on the Twentieth Century Fox lot as a desk to work on the project, and he sent his designs to Tange's architectural office with Yoshiko's translation of his letter explaining the details.

"The horrible aura of what happened six years ago lies quietly on the land," he told a Japanese reporter, "but the faces of the people living on that land are now strong and full of hope. Those are the two faces of Hiroshima."[61] His abstract designs for the railings reflected his idea that the two bridges should symbolize the themes of life and death. The ends of the thick sturdy railings on the Peace Bridge curved up toward the sky, tipped with hemispherical forms symbolizing the rising sun. At first Isamu wanted to call these railings *Ikiru* (*To Live*) but the film director Akira Kurosawa had made a film with the same title about a man facing death from cancer,

and to avoid misunderstanding Isamu chose instead to name the bridge *Tsukuru* (*To Build*), a word he thought connoted life. The railings on the Western Peace Bridge were narrower and more delicate, and their end pieces were curved like the prow of a Japanese boat. "In ancient Egypt and in Greece it was said that when human beings died and went to be with the gods, their souls traveled by boat," he explained to a Japanese magazine. The meaning of [the bridge end pieces] is that the people who died in the atomic bomb attack have gone to be with the gods."[62] He named these railings *Yuku* (*To Depart*), a word that could also mean "to die"—the fate not only of the atomic bomb victims but of all human beings.

Japanese War Bride, directed by King Vidor and starring Yoshiko under the name "Shirley Yamaguchi," was released a month after Isamu arrived in Los Angeles. The plot centered on a Japanese nurse who falls in love with an American soldier wounded in the Korean War. After she marries him and returns to the farm town where his parents live, she encounters anti-Asian hatred and prejudice, but in the end, with the help of understanding friends, the young couple's love triumphs over national differences. The Kyōdō News Agency reported that most audiences found the hackneyed plot boring, but even though the reviews were unenthusiastic, the American press liked "Shirley Yamaguchi." The *New York Times* review reported that she "was as beautiful as a doll and spoke excellent English, much to the surprise of the audience, who were expecting a peculiar Japanese accent."[63]

Yoshiko had picked "Shirley" as her American stage name since it sounded like her Chinese name, "Shang-lan." On a publicity tour of New York for the opening of the picture she checked into room 1918 at the St. Moritz, a luxury hotel overlooking Central Park. Three days earlier Isamu had checked into room 1033, giving his address as "Nakano, Tokyo, Japan." He moved out of his MacDougal Alley studio and no longer had a place to call home in New York. On August 28 they both moved to the Great Northern Hotel, staying in separate rooms until Yoshiko formally announced their engagement on October 16. The couple left the same day for London on their way to Paris for a one-month tour of Europe before returning to Tokyo by way of India. "We will probably get married in Paris or Milan," Yoshiko told reporters with a big smile.[64]

When they arrived in Paris, Isamu wanted Yoshiko to meet "his teacher" Brancusi right away. Brancusi did not answer his phone so they

decided to drop by his studio. "Is that you, Isamu?" Brancusi greeted Isamu with a happy voice. The two men had not met since Brancusi had visited New York for an exhibition eleven years before. Many artists had fled Paris before the Nazis occupied the city but Brancusi remained in his studio. When the war ended, he continued to live like a hermit, as he always had, shutting himself in his studio to work on his sculpture. The studio was just as Isamu remembered it. Every nook and cranny of the studio was white. Brancusi, covered with marble dust, had been in the midst of work.

The seventy-five-year-old Brancusi looked to Yoshiko like a little old man with a long white beard. When Isamu introduced them, Brancusi squinted at her through narrowed eyes, then silently led her to a table by the window covered with a dirty cloth. He pulled the cover aside to reveal a polished bronze *Leda* beneath. It slowly began to turn in the rays of the setting sun. Unaware that the sculpture sat on a motor-driven turntable, Yoshiko watched it rotate as if by magic, making no sound as it gleamed in the light. "It was the most beautiful thing I had ever seen in my life," she recalled in a soft voice.[65] As tears streamed down her cheeks Brancusi silently hugged her shoulders. The sight of his masterpiece made her suddenly feel that she was "glad to be alive."

Yoshiko had never encountered anyone who lived as spartanly as Brancusi. He was a man who could think only of his sculpture, she thought to herself, and it was for his sculpture that he lived and breathed. His studio was devoid of anything mundane or commonplace. Yoshiko thought she saw there the kind of life to which Isamu aspired, and she remembers feeling a moment of hesitation about the future on which she was about to embark with him.

After a week in Paris, Isamu rented a car to drive through the south of France to Italy. When their tour ended he and Yoshiko were still engaged but not married. At the end of November the couple arrived in a sweltering New Delhi. With kimono-clad Yoshiko at his side, Isamu visited Prime Minister Nehru's official residence, where he showed Nehru plans for a park and memorial at Gandhi's grave. On his trip to India two years before, he had offered to design a memorial to Nehru himself, but the prime minister had no interest in a monument. Isamu offered to make his portrait bust instead, and during the sittings he proposed a memorial to Gandhi. Nehru said that he would consider a park around Gandhi's grave,

but since then India had suffered floods, then droughts, and people were dying of starvation in many regions. The Indian government's priority was to improve popular living standards not to build monuments, and the prospects for a Gandhi memorial park collapsed. But Nehru still greeted Isamu like an old friend and took the couple to lunch. Yoshiko did not know why Isamu conversed on such familiar terms with the world-renowned Indian prime minister but she was proud that he could.

The horrors of life in India stunned Yoshiko. She had seen poverty in wartime China and postwar Japan but she had never seen anything like the hunger in India. On the streets and in trains, beggars with a nose or an ear eaten away by leprosy crowded around, thrusting hands in front of her face. Her most shocking experience came on a trip from Calcutta to Puri to see the Rath Yatra festival. After it ended, Isamu wanted to visit the Water Palace in the middle of a "lake of the gods" on the outskirts of town. A guide with legs swollen by elephantiasis led them there. As they approached the lake, Yoshiko noticed a strange, nauseating smell—like the smell of the dead—growing stronger and stronger. The source was the lake itself, which was covered with a layer of emerald green slime. Devout worshippers pushed their way in, bathing themselves and even drinking the water. "The water here heals wounds," the guide explained.

Isamu showed no surprise at anything they saw in India, no matter how absurd or horrible it seemed to Yoshiko. On the contrary, India seemed to make him more energetic than ever. He snapped pictures relentlessly with his Leica wherever they went. Yoshiko thought that he was dragging her to places that he wanted to see himself. But Isamu may have had another motive. Although Yoshiko always appeared frank and open in her films, smiling a broad smile, and although she was known for her toughness, she bore the scars of a deeply disturbing past. She could never escape from her reputation as the infamous Ri Ko Ran, branded as a "traitor," and she often confronted her past in unexpected places.

She and Isamu never talked to each other about their past lives, says Yoshiko, and they never felt the need to do so. It was not that Isamu took no interest in her past. It would be more accurate to say that he understood why Yoshiko herself did not want to look back. He wanted to salve her inner wounds, and that is probably why he took her to India, a country whose strange energy had cured his own heartbreak two years earlier. The trip may have been a token of affection for his future wife, but Yoshiko did

not understand that at the time. Instead she felt like a hunted animal, and she responded to India as though she were staring at the face of Hell. Nevertheless, several months after returning home, she told a Japanese art journal with great sincerity, "India is such a wonderful country. I'd like to go there again. When anyone asks me where I want to go next I tell them I want to go to India."[66] As she looked back, she had come to appreciate the enduring spirit of the Indian people, who transcended material misery and personal pettiness.

At 1:40 on the morning of November 16 Isamu arrived at Haneda Airport on a flight from Manila to find the terminal packed with a waiting crowd. Yoshiko's family and the Noguchi family, including Masako and her sons, were waiting, surrounded by the press. So were Gen'ichirō Inokuma, his wife, and other Japanese artist friends, as well as representatives from Columbia Records and the Tōhō Movie Studios. There was even an entourage of chorus girls from the Nichigeki Theater carrying bouquets of flowers. Isamu seemed dazed by the welcome as he descended from the plane. A buzz of disappointment ran through the crowd when Yoshiko failed to appear behind him.

"Did you get married to Yamaguchi Yoshiko?" Reporters peppered him with questions. "How far did she come with you?" Isamu had planned to marry Yoshiko in a Hindu ceremony in India but since neither was a believer they were unable to. Still unmarried they left India for Manila, where Yoshiko departed for Hong Kong to discuss an appearance in a Chinese film. Isamu was astonished to see what it meant to be the fiancé of a popular movie star. There had been rumors about his relationship with Yoshiko during his visit in the spring but the press had focused all their attention on her. Although he had tried to distance himself from the publicity, news of their imminent marriage changed everything. Like it or not, Isamu found himself caught up in the whirl of a publicity-hungry entertainment world that left little room for his privacy.

Sixteen hours later the crowd returned to Haneda to greet Yoshiko on her arrival from Hong Kong. The newspapers reported that she was wearing a purple kimono with a pattern of "small crests" that Isamu had designed for her. To be accurate, the kimono was navy blue, and the "small crests" were *X*'s and *O*'s that meant "love and kisses" in America if not in

Japan. One newspaper described her return as that "of a triumphant general" whose prize was not only her lead role in a Hollywood movie but "her groom-to-be, the first rank internationally known avant-garde sculptor, Isamu Noguchi."

On December 15 Isamu and Yoshiko were married at a morning ceremony at the Meiji Shrine with no one else in attendance. "Since just the two of us are getting married, we wanted to do it quietly just by ourselves," Yoshiko explained to reporters. "We did not want to be bound up in formalities."[67] After the ceremony the couple exchanged wedding cups of sake at the home of their formal go-between, the well-known painter Ryūzaburō Umehara, who had used Yoshiko as a model for a series of paintings of "A Chinese Lass" in wartime Peking.

A wedding reception for forty guests was scheduled for 6:00 in the evening at the Hannyaen, a well-known Japanese-style restaurant in an upscale neighborhood of Tokyo. Yoshiko's parents were still alive, but they were no longer on good terms with her. Nagamasa Kawakita, president of Tōwa Film Company, a company that imported foreign movies, acted in loco parentis. Kawakita had been in wartime Shanghai making patriotic films under Japanese army supervision, and when the war ended, he had used his connections with Chinese officials to rescue Yoshiko from punishment as a war criminal. The Inokumas were to take the role of Isamu's parents, but they learned their role only on the day of the reception.

The newly married couple was late arriving at the reception, and a worried Kawakita kept pacing the floor. Suddenly Inokuma heard the sound of flash bulbs popping as cameramen outside snapped their picture. Inside the couple sat Japanese-style in front of a gilt-covered folding screen in the reception hall. Isamu was forty-seven years old, and his bride was thirty-one, but both looked much younger in their photographs. Isamu had "the face of a happy child," said Inokuma, and Yoshiko was "as pretty as a flower."[68] Yoshiko, who seemed to be glowing from within, looked very much the modern bride. Her wedding dress, a long-sleeved white kimono with a checkerboard pattern and a gold *obi* (sash), was tailored like a Western-style dress and fastened with hooks instead of cords. It was based on the simplified kimono Isamu designed for her daily wear. Isamu wore what appeared to be a full formal kimono with a *haori* (tunic) but it lacked a family crest and the cut of the formal pantaloons was simplified. The couple's

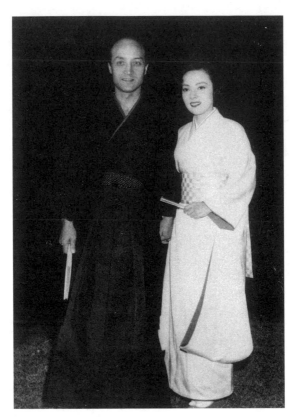

Isamu and Yoshiko Yamaguchi at their wedding, 1951

wedding clothes blended the elegance of traditional Japanese dress with the convenience of Western clothing—another meeting of East and West.

The reception opened with a recital by a *gagaku* musician from the Imperial Household Ministry. After salutations by the formal go-between, and greetings by the two couples acting in loco parentis, the wedding banquet began. Isamu had invited only the Noguchi family, Saburō Hasegawa, Yoshirō Taniguchi, and a few other acquaintances. Most of the guests were Yoshiko's, among them Akira Kurosawa, who had just won Grand Prize at the Venice Film Festival for his film *Rashomon*, and Toshirō Mifune, the star of the film. "The groom went here and there to greet everyone dragging his long kimono sleeves as if he wasn't used to them," said Inokuma, "and the bride was smiling cheerfully like a girl of 17 or 18 as she made the rounds to everyone's seat."[69]

The Japanese press reported on the wedding under headlines such as "UNCONVENTIONAL NOGUCHI WEDDING AS ABSTRACT AS HIS SCULPTURE,"[70] or "NOVELTY OF NOGUCHI'S ABSTRACT SCULPTURE SHOWS UP ELSEWHERE."[71] American newspapers carried stories, too. The American Occupation had come to an end just three months before, and Japan had regained its "independence," turning a new page in its relations with the United States. The enormous media interest in the wedding was a reflection of the times. To many the newlyweds symbolized the beginning of a new relationship between the two countries.

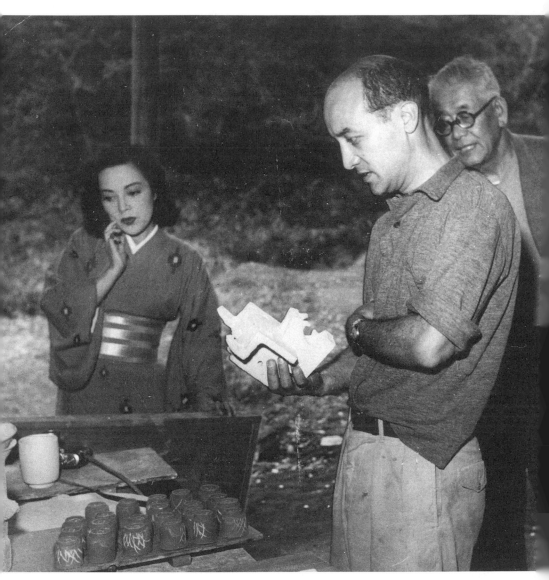

Isamu and Yoshiko with Rosanjin Kitaōji (right) before a kiln firing at the "world of dreams"

The World of Dreams

Rosanjin

Isamu and Yoshiko began their married life on the outskirts of Kamakura, an old city about an hour south of Tokyo by train. "Looking for a place to live, I remembered the lovely small valley of rice fields between hills and a cluster of old thatched-roof houses near Kita Kamakura where Rosanjin Kitaōji lived, the greatest living potter of Japan. I had been there on a previous trip, when I looked him up following the trail of his pottery as I came across it in famous restaurants. Rosanjin was surprisingly gentle (he was famous for his caustic tongue) and offered me a farmhouse 200 years old which he had had transported to the hill facing his, as a view and as a retreat. 'Live in it as long as you like,' he said."[1]

A few days before the wedding Isamu bought a big brick-colored Plymouth sedan from a former American Occupation officer and drove to Kita Kamakura with his half-brother Michio, Yoshiko's younger sister, Tsutomu Hiroi, Nagamasa Kawakita, and Kawakita's wife. The Kita Kamakura railway station stood in front of Engakuji Temple, where Yonejirō had retreated to write poetry. A narrow country road curved through the wooded terrain to Rosanjin's estate. Today the trip there takes about fifteen minutes by car but at the time it took much longer. The road followed one of the many narrow paths cut through the Kamakura hills in medieval times. It had been widened for automobile traffic but steep banks on either side made it feel like a tunnel. The sunlight was dim, and the road wandered capriciously in one direction, then another. It was a kind of natural checkpoint on the way into Rosanjin's world. As the automobile emerged from the narrow cut, the passengers suddenly found themselves in

the midst of a secluded paradise, with rice paddies stretching off to a fringe of green forest beyond.

The estate covered six acres of fields and hilly copses. Rosanjin had built his kiln there in 1927, then moved in several reconstructed old thatch-roofed buildings. He worked and slept in what once had been the main house of a wealthy landlord. Surrounding it were a guest house from an old local samurai government headquarters; a teahouse built in the *sukiya* style; two low one-story buildings joined together to house his huge ceramic collection; and several smaller houses for his workmen. From the road the estate looked like an elegant village.

The thatch-roofed guest gate bore a plaque inscribed in elegant calligraphy with the characters *Mukyo* ("World of Dreams"), the name of the estate. Crossing a sprawling garden that used the neighboring fields and a lotus pond as "borrowed landscape," Isamu's party made their way to the main house, where the sixty-eight-year-old Rosanjin was waiting at the entrance. A large man of sturdy build, often described as a "giant," he wore thick round glasses, and kept his bristly white hair cut short. He was so tall that Isamu and Hiroi literally had to look up at him. In a surprisingly powerful deep bass voice, he welcomed the visitors before they had a chance to greet him. "Come in, come in," he said, leading them to a large Japanese-style room with a *tatami* floor and a high ceiling, where he had beer and food brought in.

Rosanjin's bold but sensitive taste was visible everywhere in the house—in the huge stepping stone at the entrance, in the artificial hill in the Japanese-style garden visible outside, in the carefully cut flowers placed in the *tokonoma* alcove. Isamu's half-brother Michio excused himself to go to the toilet but returned a few minutes later with a puzzled look on his face. "I couldn't find it," he whispered to Hiroi. The urinal was an Oribe-style ceramic urn filled with Japanese cedar leaves to kill any odor, and Michio had mistaken it for a formal flower arrangement.[2]

Rosanjin's eyes often glimmered with irony, often with severity, but he gave Isamu a gentle look when he said that he was looking for a place to live after he and Yoshiko were married. Rosanjin pointed toward a restored farm house beyond the garden. "Why not come to live here?" he said casually. Everyone but Isamu was surprised by the invitation from a man legendary for the sharpness of his tongue.

Rosanjin Kitaōji had been born Fusajirō, the second son of a hereditary priest at the Kamogamo Shrine in Kyoto. His father had killed himself

before he was born, and his mother showed her infant no affection at all. There were rumors that his father's identity was uncertain and that Rosanjin was illegitimate. His mother placed him in the care of a poor farm family nearby, who treated him like an indentured apprentice. His formal education ended in fourth grade, but early on he showed a rare talent for calligraphy. At the age of thirteen he went to work carving wooden shop signs, and by his early twenties he had established himself as a professional calligrapher and seal engraver with a distinctive style. Moving from place to place in the employ of well-to-do merchants in Kyoto, Omi-Nagahama, Kyoto, and Kanazawa, he gradually developed a connoisseur's eye for objets d'art and a gourmet's taste for first-class restaurants.

At the age of thirty-six, Rosanjin and a boyhood friend from Kyoto opened an art and antique shop in Kyōbashi, a thriving commercial district in downtown Tokyo. In 1921 they organized a Gourmet Club on the second floor of the shop, where they served their clients light meals. After the earthquake of 1923 destroyed the shop Rosanjin opened the Hoshigaoka Teahouse, a gathering place for well-known figures from the worlds of business, art, and literature. As a chef Rosanjin was known not only for his culinary skill, but also for the exquisite dishes and plates that set off his cuisine. He crafted them with his own hand at the Hoshigaoka kiln in Kita Kamakura. As his fame grew, personality quirks rooted in his unfortunate and irregular upbringing became more pronounced. He was known as a megalomaniac who lashed out at anyone who did not pay him proper respect and as a tyrannical boss who bullied his employees about the most trivial matters. After a falling out with his partner, Rosanjin was forced to leave the Hoshigaoka Teahouse, and he decided to devote himself solely to making pottery. After the war he opened a store on the Ginza to sell his works directly to Americans serving with the Occupation forces.

"In the life of human beings there is a time separate from our work time that we call 'leisure,'" Isamu wrote in 1960. "It is a free time when we are liberated from our efforts to make a living. We can use it to play, we can use it to pursue our avocations and interests. We can even call it 'a time to be with the gods.' . . . And is it not in leisure especially that human beings live in the midst of a 'human space'? And is it not from this that art is born?"[3]

To Isamu the world that Rosanjin had created for himself in Kita Kamakura was a Shangri-la. On his first visit he may have revealed his

feelings about art and life to Rosanjin—and perhaps he even told him it would be ideal to live and work in a setting like the one Rosanjin created for himself. The older man must have been pleased to hear compliments from an "international artist" whose name was in all the magazines and newspapers. Perhaps that is why he showed so little hesitation in inviting Isamu to stay in his "world of dreams."

Newspaper reporters who visited Isamu and Yoshiko did not know quite what to make of their "farm house" on Rosanjin's estate. "They call it their 'love nest' but it is a very odd place," wrote one. "Some people think it looks like a haunted house."[4] The long, narrow, one-story building was shaped like one of the well-known "eel's bed" townhouses in Kyoto. It had been reconstructed on a narrow strip of land along the road between rice paddies and a steep dirt cliff. Inside, three rooms were laid out in a straight line: an eight-mat living room, a six-mat bedroom, and a one-mat room where Yoshiko kept her make-up table (one "mat" refers to a space roughly three feet by six feet). To one side of the house was another structure with a maid's room, a kitchen, and a three-mat room with a dirt floor, and on the edge of the garden stood an old-style outdoor privy. Clearly Isamu thought that if he lived in Japan he should have a traditional Japanese-style house. His only concession to modernity was a new kitchen oven.

In a *New York Times Magazine* article an American visitor described the house as follows: "Barefoot we passed from the polished wooden floor onto the soft resilient floor matted with the inevitable thick woven straw *tatami*. Here even slippers are taboo. We were in an empty room, empty at least to Western eyes. In the alcove which is known as the *tokonoma* was the traditional flower arrangement, a hanging scroll, and a bronze Buddha head from old Japan. There was no another object in the room, and the muted patter of bare feet on the soft padded floor in the hushed atmosphere gave the room a dreamlike quality that almost imposed contemplation."[5]

Isamu had Japanese carpenters build him a bathtub of fragrant *hinoki* wood, and he made a studio for himself by hollowing out a space in the side of the cliff with a pickaxe. When a photograph appeared in a Japanese magazine, Isamu had to explain that the studio was not a prehistoric cave dwelling. "Should anyone be asked . . . what is characteristic of my development now," he wrote at the time, "I think it is rediscovery of this intimate nature which I had almost forgotten since childhood."[6] The only people who admired his secluded life in the country—more than two

miles from the nearest store—were American journalists enchanted by the beauty of Japan. Japanese journalists usually asked him, "Isn't it inconvenient to live here?" Isamu always replied with a smile, "There are three or four abandoned puppies at the back of the hill, and there are ducks and geese, so it looks like I have become a peasant farmer. But fortunately, there is a kiln nearby so I am free to work on my pottery."[7]

Rosanjin's "world of dreams" may not have been inconvenient for Isamu, who wanted to live where he worked, but it was for Yoshiko. The day after the wedding, production began on *Muteki* (*Foghorn*), her first movie since returning home, and soon she was busily working on one film after another. A Packard limousine came every day to take her to the Tōhō Studios at Kinuta but no matter how many shortcuts the driver tried the one-way trip still took an hour and twenty minutes. Yoshiko had never lived in a Japanese-style house before. In Manchuria and Peking, and after the war in Tokyo, she had always lived in Western-style houses and she had never used an outdoor privy. Nor did she have to worry about a prickly landlord like Rosanjin. In the "world of dreams," on the other hand, she always had to hang her laundry in a spot where Rosanjin could not see it from his perch across the rice paddies. Nevertheless, as she looked backed on her life there she vehemently insisted, "As Isamu said, our life at Rosanjin's place was like being in Shangri-la."[8]

Yoshiko was so busy with her movie work that she hardly had any time off. On her few holidays she enjoyed helping Isamu clean the garden and do other household chores, but she had few chances to cook for her husband or sit alone with him at the dinner table. Even on the rare evenings when she was home in time for dinner, a hollow knock on the wooden clapper-bell in front of the main house sounded across the rice paddies. It was Rosanjin's signal for a dinner invitation. Yoshiko and Isamu would hurry across the narrow path through the rice paddies in anticipation of a gourmet meal prepared with the best and freshest ingredients. The meticulous Rosanjin kept two barrels in his kitchen, one filled with fresh water and the other with seawater. He would pluck a fish from one to serve at dinner, garnished with shredded *daikon* radish grown in the vegetable garden behind the main house.

During their days as newlyweds, Yoshiko says, "Isamu's head was always full of his work." He worked not only in his studio every day but went to Rosanjin's kiln at the base of a hill near the main house. A separate world, it was reached through a narrow natural dirt tunnel. Rosanjin

employed ten or so workmen to help with his pottery. He had never apprenticed or trained formally as a potter but instead lured the best craftsmen from kilns all over the country with offers of high salaries to prepare the clay, turn the potter's wheels, and apply the glaze to his pottery. It might be argued that someone who does not sit at a potter's wheel is not a true potter, but with a squeeze of his finger tips Rosanjin could transform what his craftsmen fashioned, even a teacup or a rice bowl, into a work of his own. With a decisive touch or a subtle curve of his hand he put his own stamp on it, and he painted patterns on his ceramics with a lively freedom absent from his craftsmen's work.

"Making pottery, it's all just copies," Rosanjin once said. "I don't think there's anything that is not a copy. The important thing is what you're aiming at when you imitate."[9] Rosanjin himself had learned much from his private collection of more than three thousand pieces of antique Chinese and Korean pottery. He reinterpreted these works in his own style, creating objects with a new and original sensibility. He kept the door to his private museum locked and rarely let his craftsmen inside, but he made an exception for Isamu, who was allowed to visit the collection whenever he liked. Rosanjin extended other generosities to Isamu, too. He had a reputation for not spending money on anyone but himself, but he gladly provided Isamu everything needed for his work. In effect he became Isamu's patron.

"I used his clay, his kiln, all his tools and material, and I had his workmen help me fire my ceramics," Isamu later recalled. "He even gave me glazes."[10] Freed from worrying about expense, Isamu plunged enthusiastically into pottery making. He had not worked with clay since his brief stay at Jinmatsu Uno's kiln in Kyoto twenty years before, and he found it much superior to stone and wood. While crafting abstract ceramic works in Rosanjin's kiln, he came to realize that "pottery is sculpture."

"Pottery loses its human smell after being put in the kiln and being baptized with fire," he told a Japanese art magazine. "It acquires the 'time' of bronze through the magic of 'fire.' Pottery deeply interests me as an art that is baptized by fire."[11] It took three days and three nights to fire works in Rosanjin's sloping kilns. Workmen stayed up all night feeding kindling wood into the flames, their attention never wavering for a minute. Isamu and Rosanjin watched, too, carefully checking the color and strength of the flames, waiting for the right moment to open the kiln and discover what the baptism of fire had wrought. The kiln opening, when Rosanjin put

newly fired pieces on display for sale, was a chance for Yoshiko to "repay" Rosanjin for his generosity to Isamu, and even though his works were expensive she bought as many as she could.

At kiln openings Rosanjin greeted old friends from the business and political worlds with a genial smile. His normal mood was intense irritability. If a maid did not hand him a cold beer immediately after he stepped out of the bath, he would scream and curse at the top of his lungs. Most maids lasted no more than a week. But Rosanjin was always hospitable toward Yoshiko and Isamu. Isamu saw him face to face every day, except when Isamu practiced Zen meditation at the Engakuji Temple with his friend Saburō Hasegawa. "Isamu and Rosanjin-san really were good friends," says Yoshiko. "Isamu was not a very patient person. Whenever he met actors I was working with, he looked as though they were boring him. Sometimes it was so bad that I would have to jump in. But he never seemed to run out of things to talk about with Rosanjin even though they saw each other every day."[12]

Sydney B. Cardozo, the Tokyo branch manager of *Stars and Stripes*, who visited the estate for an interview with Rosanjin, was surprised to discover that his interpreter was the famous American sculptor Isamu Noguchi. "What are you doing here?" he asked. Isamu turned toward Rosanjin and replied, "I'm here because of this fellow."[13] His dutiful glance, thought Cardozo, revealed a heartfelt and affectionate respect. Being American, Cardozo says, must have helped Isamu to accept Rosanjin as he was. The old man might speak his mind bluntly but not bluntly enough to upset someone from a country where no one hesitated to express himself.

In 1954 Isamu contributed a small essay about Rosanjin to *Vogue* magazine. "'To make good pottery for the table,' says Kitaōji Rosanjin, the seventy-year-old master classic potter of Japan, 'you must know good food, and to know good food you must know how to cook.' In his Japanese country house—an old temple—my neighbor Rosanjin often cooks in front of his guests. A man of wit, who often dispenses insults or laughter as casually as he pours a beer, Rosanjin explains what he's doing as he prepares a meal. . . . Recognized as a rebel, frequently charming, but sometimes impossible even to his friends, he has been called by his disparagers . . . a retired restaurateur fooling with a kiln." The old potter reminded Isamu of the photographer Alfred Stieglitz, whom he had met as a young sculptor. "There can be no question that Rosanjin is also a great master of his profession in whom shines the same kind of unusual individuality. . . . [He] is

a person with a special kind of intellect. [He] is a dilettante, and moreover an exceptionally high-class dilettante. Rosanjin's success is founded entirely on his dreams of an older, better Japan."[14]

The admiration was mutual. Rosanjin once told a gathering of old friends, "Isamu was with me for only a year but you know, I have never met anyone that 'innocent' (*ubu*) or that direct. There aren't any artists like him in Japan. He is a natural, he never overdoes himself."[15] In the world of Japanese connoisseurship the adjective *ubu* described an artifact taken from the storehouse and revealed to the world for the first time, thus "innocent." It was used to praise an object that one admired. To call Isamu *ubu* was a heartfelt compliment, a recognition that he had an excellent pedigree.

"In Japan everyone says that they don't understand what the things Isamu designs are," Rosanjin observed in an essay about his "revolutionary artist" friend.

> That seems reasonable—people like me don't even understand things they see in front of them every day. Some dodge the issue by saying they don't understand American taste, but his work is something you can not dismiss as a matter of American taste. An art object may not be to one's taste but one can appreciate its value if its lines are effortlessly and flawlessly executed. . . . No matter what form [an art object] takes, it can be accepted as a thing of artistic value because of the beauty of its composition. We talk about Picasso and Matisse not because they make objects difficult to understand or because the way they express themselves surprises ordinary people. . . . [It is because] they are revolutionaries who continually struggle to devise new ways of expressing themselves. Isamu seems to me the same. But I feel that his work is more beautiful than Picasso's. . . . He is a fortunate soul. From the start he ignored tradition, studied the primitive, was charmed by children's art and believed in natural beauty. I hope and pray that he will become more and more revolutionary.[16]

Isamu brought an unexpected breath of fresh air into Rosanjin's "world of dreams." The older man gained as much from their days together as Isamu did. He had ambitions to play on an international stage, and Isamu introduced him to new postwar trends in world art. He also understood Rosanjin's approach to art as no one else had. Rosanjin began his career as a calligrapher and woodcarver, then discovered pottery and lacquer. In all these arts he created an enormous body of work. For virtuosity he was a match for Isamu, who had turned his hand from sculpture to stage

sets to furniture design. Neither man confined himself to one kind of creativity, and both relentlessly challenged fixed expectations about themselves. In this sense Isamu was a perfect reflection of Rosanjin.

Although Rosanjin had a reputation for getting into fights with everyone, and in his later years often disparaged old friends and acquaintances, he never clashed with Isamu. His former household assistants say that neither did he speak ill of Isamu, for whom he had only praise. Nor could Yoshiko remember Isamu ever complaining about Rosanjin. "Whether it was his work or his taste," she says, "Isamu respected Rosanjin-san from his heart. Isamu was a pure person, and he was honest about what interested him. Even though he was famous, he always tried to learn things he didn't know about. Rosanjin-san liked Isamu for that, and even spoiled him with kindness. . . . They were just like father and son."[17]

Rosanjin had been married five times and kept many mistresses but he had few family ties. His fifth wife, a Shinbashi geisha, had left him during the war. His two sons by his first wife were both dead; and he forbade his only daughter, born to his third wife, to visit him after she and her husband pilfered antiques from his collection. When he offered to let Isamu stay on his estate, he was living alone except for his servants and workmen. Perhaps their brief time together helped both men heal wounds suffered during their unfortunate childhoods. Isamu was a surrogate child for Rosanjin, and Rosanjin a surrogate father for Isamu.

For Yoshiko the five or six huge cherry trees that stood by the side of the entrance gate summed up her memories of life as a newlywed on Rosanjin's estate. "I will never forget how beautiful they were in full bloom," she says. "From our place it looked as though they were gently wrapped around Rosanjin-san's house. Rosanjin chopped off a branch about four inches thick and stuck it in a huge ceramic vase in the *tokonoma*. That kind of elegance, that kind of energy, was Rosanjin-san's real gift to us. He was a person with a tremendously big-hearted disposition, you know."[18]

Perhaps cherry blossoms symbolized Isamu's memories of that time, too. "After the mountain cherry blossom season ended and the Yoshino cherry blossoms fell," Rosanjin wrote in an essay at the time, "I arranged some peony cherry blossom cut from my garden in an antique vase on my table to enjoy them for a few days. Isamu Noguchi, who is living across the way from my house, dropped by. 'Those cherry blossoms are pretty, aren't

they,' he said. 'Why aren't there more splendid cherry trees like that planted in Japan? It seems strange that they aren't planted everywhere.' I instinctively blurted out, 'It's because they are too beautiful.' Noguchi-sensei, who grasps everything so quickly, accepted my answer with a smile."[19]

Isamu had no memory of living with his own father but at every important turning point in his life he had been fortunate to meet older men that he deeply respected: "Doc" Rumely, Brancusi, Buckminster Fuller, and then Rosanjin. Each of these mentors, in his own way, was a person of extraordinary talent and intellect. In his encounters with them Isamu was always as dutiful as a child—and sometimes as importunate as an infant. Rosanjin was to be his last mentor—a Japanese mentor, whom he met at a moment in his life when he had come to live in Japan with his Japanese wife. This Japanese "surrogate father" had a profound influence not only on his art but on everything else in his later life.

The End of a Dream

Five months after arriving on Rosanjin's estate, Isamu accompanied his mentor on a trip to the pottery village of Imbe in Okayama Prefecture to work at the kiln of Tōyō Kaneshige, a well-known maker of Bizen ware. Every day Isamu sat by the window of the workshop molding clay. "What impressed me about [Isamu] was his attitude toward work," Kaneshige later wrote. "My own attitude toward work hardly comes close to his. He throws himself into it like seriousness personified. It's incredible!"[20] Once he began to work Isamu seldom spoke, and except for a break of twenty or thirty minutes for lunch, he kept going until sundown. When someone suggested a tea break, he would take a cup but sit staring hard at the piece he was working on. Kaneshige had never seen anyone with such powers of concentration.

> First he makes a detailed design drawing with the measurements written in, then he turns the design into an object. He makes nothing spontaneously. His technique is to make a rough model, then shape the clay around it. He uses a "mold" but of course he works over what comes out of the mold, shaping the clay with a spatula or cutting it away with a sharp knife to finish it. When he trims a flat piece of clay into a shape like a tray, he cuts so decisively with his knife that it makes your heart skip a beat as you watch. He is extraordinarily skilled with his hands. . . . He doesn't turn the potter's wheel himself but shows his design to a workman and supervises him as he turns the piece.

If there is some little thing he doesn't like, he makes the workman do it over and over again, and even works directly on it with his own hands too. But if he still doesn't like it he doesn't hesitate to break the whole thing up.

Rosanjin worked more spontaneously than Isamu. During their six days at Imbe he and his three assistants turned out more than eight hundred pieces while Isamu finished only fifty-seven. Except for six plates, all Isamu's pieces were different shapes, most so unusual that Kaneshige had trouble understanding what they were. In mid-August, Isamu returned for the kiln opening. The plates disappointed him but he was very pleased by his abstract objects: a jar with breasts, hair, and two small protruding lines to symbolize a woman; a jar representing a male figure; a flower vase in the shape of a bird; a flower vase in the shape of a hand; and so forth. Kaneshige thought the pieces were all rather strange-looking as he watched Isamu fashioning them, but when they came out of the kiln his impression was entirely different. "Ideas that no one had thought of before had taken shape in Bizen clay," he wrote. "This breathes new life into Bizen ware."[21] The Kaneshige kiln had been in continuous operation since the sixteenth century. During the Occupation the Americans in Japan seemed to prefer brilliantly colored Kutani porcelains, and Kaneshige feared that the subtler earth-colored Bizen ware might disappear for lack of customers, but Isamu's example inspired him to define a new Bizen style. According to his oldest son, Michiaki, it is impossible to overestimate the impact that Isamu's work had on his father.

"The attraction of ceramics lies in its internal contradictions," Isamu wrote in the Japanese art magazine *Geijutsu shinchō* in June 1952. "In ceramic art there are elements beyond our control. One can say that it is both easy and difficult. It is also both fragile and enduring. Like ink painting, it does not permit change or hesitation. The best ceramic work is not carefully designed. It lets nature speak through it. But in America people do not think that way." Isamu worked on ceramics only in Japan. He never did so in America because he never felt the need to. "Japanese clay and Japanese emotions are suited to pottery," he said. Indeed, he seemed to be exploring what Japan meant to him through the craft of pottery.

The results of Isamu's "search for Japan" were exhibited at a month-long show at the Museum of Modern Art in Kamakura that began on September 23, 1952. "It seems that [Isamu Noguchi] is known in Japan only

because he is famous in America," the exhibition catalogue explained. "We think that the reason he is not recognized in Japan is that people are not familiar enough with the kind of works [presented in this exhibition]."[22] But the catalogue added a caveat: "Please put aside theories or preconceived ideas; evaluate these forms as they are with an open mind."

Among the 119 new works exhibited were two that can be counted among his masterpieces: *Centipede*, a tall wooden post like a totem pole, reaching from the floor to the ceiling, on which eleven oval objects were tied with rough yarn at irregular intervals; and *War*, a bell-shaped terra-cotta piece crisscrossed with geometrical patterns reminiscent of a Mondrian painting. Most of the other pieces were simple abstract terra-cotta works resembling *haniwa* figures. "[I]t's not just work," he wrote to his friend Jeanne Reynal, "but work as a reflection of living."[23] Some pieces captured his affection for his bride: *Yoshiko-san*, a piece with two huge eyes; *Marriage*, two smiling faces emerging from a surface long and flat like a futon; *L'Amour*, *Pretty Girl*, *The Beautiful*, *Il Lai Chian*; and *Home*. Others pieces, such as *The Bully Boy*, *Daruma*, *Cat*, *Tiger*, *Frog*; and *Mosquito*, embodied his "rediscovery" of nature. As Kaneshige observed, Isamu did nothing spontaneously, working only with precise designs, but when his work emerged from the kiln it seemed to have been fashioned with complete freedom, almost impulsively. Even though created by one of America's leading sculptors, these works with innocent-sounding titles looked the work of a gifted child.

"Noguchi pretends to be a potter," wrote the art critic Shūzō Taniguchi, "and it is almost correct to say that this is a ceramics exhibition. But Noguchi fired his ceramics as sculpture. Or at the very least, one can say, they were fired in a way that would not be interesting were he not a sculptor." Since Isamu's ceramic work did not conform to conventional Japanese notions about pottery, viewers might find themselves bewildered by its freedom, he continued, "but previously we Japanese created things freely at the boundary between sculpture and ceramics. We did not try, as we do today, to draw a strict distinction between them. We must have known then how to breathe form into our daily life more freely."[24]

Tarō Okamoto, whose grandfather had taught calligraphy to Rosanjin, stopped by the exhibition on his way to visit to the old man. He, too, was impressed. As he wrote in *Bijutsu techō*, "Isamu Noguchi is a pure-hearted beast, who seizes all kinds of shapes and devours the beauty of each with relish. . . . He chews up and swallows traditional Japanese shapes like haniwa,

pots, paper lanterns, and the like, and he shapes a new kind of beauty out of them. The so-called beauty of Japanese form, indeed everything else, meshes nimbly. His refined and sophisticated modernist sense is important to Japan, where we are inundated with country bumpkins who think they are modern."[25] The exhibition challenged Japanese artists to reconsider the meaning of "plastic arts," and it had a great impact on artists like Kazuo Yagi, leader of the Sōdeisha, a group of avant-garde ceramic artists, who had begun to produce nonfunctional ceramics in an abstract mode.

Just as Isamu's exhibition at the Mitsukoshi Department Store two years before had puzzled spectators expecting to see "normal" sculpture, the ceramics at this exhibition puzzled them even more. The lighting instruments Isamu called "Akari" puzzled even the sponsors of the exhibition. In his review Tarō Okamoto referred to them as "paper lanterns," but other newspaper and magazine reviewers ignored them.

"The name *akari* which I coined, means in Japanese 'light as illumination,'" Isamu wrote in his autobiography. "It also suggests lightness as opposed to weight. The ideograph combines that of the sun and the moon. The quality is poetic, ephemeral, and tentative."[26] He began designing the lamps after a visit to see cormorant fishing on the Nagara River in Gifu City, where the mayor asked him for advice on how to interest interior decorators abroad in using traditional paper lanterns. His answer was: make them look modern.

The lanterns may have reminded Isamu of a dimly remembered time when he and his mother lived briefly with Yonejirō in Tokyo. On dark nights when little Isamu could not see the reflection of "Mr. Moon" on the *shōji*, his father would bring a lantern covered with translucent white paper from his study, and when Isamu saw its light he quietly drifted off to sleep. His first attempt to turn these shreds of memory into artworks was the series of *Luna* light sculptures he made in his MacDougal Alley studio during the war. He also designed for his house in Kamakura several lamps using soft Japanese paper and bamboo.

Isamu thought of the Akari lamp as a "light sculpture" with a practical purpose. "They perch light as a feather, some pinned to the wall, others clipped to a cord, and all may be moved with the thought," he wrote. Easy to fold and light to carry, the lamps were modern and functional in design but crafted from traditional Japanese materials by traditional methods. For Isamu they represented "a true development of an old tradition."[27] But Japanese reporters who saw the lamps at his house thought of them as

"deformed Gifu lanterns." Their odd shapes did not to conform to the Japanese notion of what a lantern should look like, and many assumed that Isamu had designed them purely for commercial purposes.

While Isamu remained at work in his studio until the show opened, Yoshiko had taken charge of practical matters: negotiating with the museum staff, planning publicity, arranging the display of the works, and even selecting envelopes for the exhibition brochures. It was not unusual for people in Japan to refer to Isamu as "Mr. Yamaguchi" or "Yamaguchi Yoshiko's husband." His name often appeared in the gossip columns of movie magazines and entertainment newspapers, but his encounter with celebrity was beginning to affect his reputation. "He has been enjoying himself a little too much since he has fallen so deeply in love," commented one Japanese magazine. "We would like him to do something out of a much bigger love for Japan."[28] At the unveiling of his sculpture *Mu* for the *Shinbanraisha* garden at Keiō University a month or so before the wedding, a Keiō professor remarked that the sculpture looked like "an over-sized doughnut perched on top of a very tall crème caramel."[29] That provoked a response from Isamu's friends Yoshirō Taniguchi and Saburō Hasegawa, who carried on a spirited debate in the press for several days. It was another sign that Isamu's reputation in Japan as an artist had begun to dim.

A few days after the wedding the prominent social critic Sōichi Ōya remarked to Ayako Ishigaki, "A big and sudden change will come when Japan ratifies the Peace Treaty. Isamu Noguchi and Yoshiko Yamaguchi will be branded as traitors."[30] The public mood was shifting. Three days after the Peace Treaty went into effect on April 28, 1952, Japanese riot police fired on crowds demonstrating at the Imperial Palace Plaza, killing two and injuring over two thousand. Demonstrators burned thirteen American military vehicles parked by the Imperial Palace moat, and an American GI who happened to be walking by was thrown into the moat. The continued presence of American troops in Japan aroused resentment that the United States was turning the country into a Cold War base. Many Japanese had rejected traditional Japanese culture and embraced anything American during the early postwar years but times were changing. A wave of reaction against American influence was about to inundate Isamu, drawing him into a public dispute that distressed him until the end of his life.

The Hiroshima Peace Memorial City Construction Committee specified that the peace memorial should include a cenotaph for a tablet listing the names of the 110,000 victims who died in the atomic blast. The memorial was to be a site that appealed to the conscience of all humankind, a site where annual peace ceremonies would be held. "It is desirable," planning documents said, "that the memorial, without being associated with any existing religious groups or sect, take a form of expression that will never lose its future universality, transcending national boundaries and enduring throughout the ages."

In late November 1951 Isamu visited Hiroshima with Kenzō Tange to inspect the construction of the bridges on the Peace Boulevard. Tange brought him along because he wanted Isamu to design the cenotaph and thought it best to get Mayor Hamai's agreement. Tange originally proposed two designs for a memorial to the dead: the first resembled Eero Saarinen's Jefferson Memorial Arch in St. Louis too closely; and the second, as Isamu described it to John Collier, was like a "smaller crossing of two Torii."[31] "I was trying to fashion something like a *haniwa*," Tange later wrote, "but then I thought to myself that if [the memorial] was to be something sculptural like that it would be better to ask Noguchi-san to do it."[32]

Isamu eagerly accepted Tange's invitation to design this symbol of a "prayer for eternal peace." "It was a participation agreed upon by the three of us [Isamu, Tange, and Mayor Hamai] over tea in Hiroshima," he wrote John Collier. "I was asked, and I agreed to contribute my share for nothing—a matter of simple altruism, I thought, on my part in which were mixed thoughts of wanting (as a citizen of the outside world) to participate in symbolic expiation of our mutual guilt."[33] He told the *Asahi shinbun* that there could be "no greater honor for me as an artist."[34]

The design took shape in Tange's studio at Tokyo University, where Isamu silently concentrated on a clay model "like a person possessed." The memorial was a "challenging subject," he wrote in his autobiography. "I thought of sculpture as a concentration of energies. My symbolism derived from the prehistoric roofs of 'Haniwa' like the protective abode of infancy, or even equating this with birth and death, the arch of peace with the dome of destruction."[35] The *Arch of Peace*, as he first called it, was a "mass of black granite, glowing at the base with a light beyond and below."[36] It was intended to convey the themes of birth and death. The memorial looked

less like a conventional arch than an ancient semicircular burial mound. Only the top third was visible above ground, framing the A-bomb dome at a distance. The rest was underground, the round legs of the arch, twice as thick below the surface, enclosing a chamber, almost like a cave, where a granite box cantilevered on the wall was to hold the tablet with the names of the atomic bomb victims.

The design, Isamu told a Japanese art magazine, was inspired by the Japanese tea ceremony room (*chashitsu*). "A tea ceremony room resembles a cave. When you sit in the dim light surrounded by walls, your mind seems to become perfectly clear and to open up. The deep soul of the person who created the closed space awakens us, and the expanding of that person's soul leads us to the unknown horizons of our own soul."[37] The arch above ground was "a place of solace for the bereaved," he continued, and the underground chamber was a space suggesting "the womb of generations unborn who would replace the dead in time."

Isamu, constantly consulting with Tange, tried to harmonize the memorial with the total design for the Peace Center project. In that sense, he later wrote John Collier, the design was a "true collaboration."[38] Tange was struck by the brilliance of the final conception. "It was a small model but it overflowed with generosity of spirit," he said. "It had the placidity of an ancient jewel. I could sense that it was something wonderful."[39] His assistants made drawings from the model and technical structural calculations for its construction. "All was going well in the most amicable of collaborations," Isamu told Collier, "past every obstacle, it seemed, till the very last concluding judgment."[40]

In early March 1952 all that remained before seeking construction bids was formal approval of the design. Suddenly, and unexpectedly, Mayor Hamai sent Isamu a letter saying that his design had not been accepted. "What struck me then I can never tell," he wrote John Collier. "Tange was as bewildered as I. All he could tell me in the beginning was that it was perhaps because I was an American." It was, Isamu said, "my one most disagreeable experience in Japan."

The two Peace Bridges had been built under the jurisdiction of the Construction Ministry but final decisions over the Peace Center project were in the hands of the Hiroshima Peace Memorial City Construction Committee. The mayor had told Isamu his design had been rejected but the decision had not been his own. He admired Isamu as an artist, and he

was upset, too. Isamu offered to change the design if it was deemed inappropriate. "Both the Mayor and I rushed about trying to restore most of it," Tange later recalled. "Together with Isamu the three of us got the Minister of Construction to act. But we were unable to find any way of resolving the problem. The press enjoyed making a big issue out of it."[41]

Although the City Construction Committee immediately approved a design that Tange had made in just four days, Isamu was still unable to accept rejection of his own. "I made the design out of pure altruism, with no compensation," Isamu told the *Mainichi shinbun*, "but it was rejected as too difficult to understand. But even if I accept that, I do not understand what is wrong with my being a foreigner. Citizens of Hiroshima who became victims at the end of the war gave their lives for world peace. Hiroshima exists not just for Japan, it exists for the world."[42] Isamu decided to go to Hiroshima to discuss the matter with city officials directly, and he brought along Yoshiko for support.

The arrival of a famous movie star suddenly turned the affair into headline news. The Hiroshima City Assembly had not known about the memorial until then, but three days after Isamu arrived in the city his visit was debated on the assembly floor. One member of the assembly asked Mayor Hamai why Isamu's design had not been accepted. If it was rejected simply because Noguchi was a foreigner, he said, it might become an international problem, and he asked the mayor to clarify who made the decision. Other assemblymen wanted to learn more about the Hiroshima Peace Memorial City Construction Committee, which had made the decision about the memorial.

The debate soon spilled over into public criticism of Isamu's work on "the two strange bridges." Some now jokingly called them the "Isamu Bridge" and the "Yoshiko Bridge." One irate citizen wrote to Mayor Hamai complaining that the railings "looked like caterpillars" and were so dangerously low that children might fall over them into the river. Another composed a comic poem about them. "There is something about Noguchi's art," the *Chūgoku shinbun* said, "that is impossible to understand."[43]

Mayor Hamai told the city assembly that the Hiroshima Peace Memorial City Construction Committee based its decision on public responses to the Peace Bridge railings. The committee had concluded that the memorial design was "too difficult" for ordinary citizens to understand, and in any case, he added, the committee decided that since Tange had

won the competition for the Peace Center project he should take responsibility for the whole design. The mayor was also careful to emphasize that the committee "did not take into consideration anything like the fact that the designer was a foreigner."

Tange thought the committee's decision reflected a widening but unspoken sentiment that a memorial for the atomic bomb victims ought to be designed by a Japanese. "One of the committee members was one of my old teachers," he later wrote. "He was a person who usually let me have my own way, but this was the only time he stubbornly refused to budge. He told me, 'You must choose what you are going to hold onto and what you are going to throw away—your friendship with Noguchi or our feelings.' I spent many sleepless nights."[44] The ten-member Hiroshima Peace Memorial City Construction Committee included representatives from Hiroshima and leading architects from Tokyo. Its most influential member was Tange's mentor, Hideto Kishida, a professor of architecture at Tokyo University, the revered "emperor" of the Japanese architectural world, who had trained not only Tange, but also Kunio Maekawa and many other top architects. He was known to be a dealmaker who parceled out important architectural projects all over the country.

"The frankest reason for my expulsion was given me by Mr. Hideto Kishida in person, who I understand is the most influential person of the Hiroshima Committee," Isamu wrote John Collier. "He said Mr. Tange had been awarded [the] Peace Park, and had no need to seek outside assistance. . . . The reason for the rejection of my work had nothing to do with art. It had its origins in something else. . . . If Mr. Kishida and the other architects had been opposed based on their opinion as artists, then I was prepared to fight back as a sculptor." But since the reason for rejection "was no reason at all, I didn't even have the chance to become truly angry."[45]

The mayor's secretary, Chimata Fujimoto, says that Tange had a reputation in the Hiroshima City Hall as a "Tokyo University professor who thought only about what was going on in Tokyo."[46] He was not as arrogant or patronizing as the university's faculty often were, but in dealing with City Hall staff he did not always go through the proper channels or check with the appropriate office. Whenever he had a problem he went directly to the Mayor's Office. City Hall staff members speculated that the "biggest reason" behind the trouble over Isamu's proposal was that "he didn't go through Kishida, the big boss."

In a 1956 magazine interview, Isamu made a comment that suggested he understood why his design had been rejected. "What I find regrettable," he said, "is that in Japan there is an especially deep-rooted problem of political—or maybe boss—favoritism. I am surprised to find that in many organizations a particular group centering on some influential person rather than the opinions of the whole committee controls the leadership on public issues. The architect [Antonin] Raymond once told me that in Japan it is not possible for an artist without political influence to get work. And someone who does have political influence is given projects whether he is talented or not. That is not just a personal problem for me. I think it is something that the Japanese people should think about seriously."[47]

A newspaper report that Isamu had claimed Tange's design was a copy of his own stirred more controversy. "I never heard Noguchi say that I copied his plan or anything like that," Tange assured the local press. "The design is, of course, my own."[48] In fact, it was quite different from Isamu's. It had no underground chamber. The only resemblance was that it was also an arch, a simple form with soft lines. The design was more attuned than Isamu's to the emotions of ordinary Japanese, who would feel comfortable praying in front of it with folded hands. The inscription on the stone sarcophagus in front of the arch read, "Let all souls here rest in peace / For we shall not repeat the mistake."

The model for Isamu's memorial is on exhibit today in the Isamu Noguchi Garden Museum in New York City. The dynamic mass of the aboveground section radiates an energy that touches the soul but the boldly conceived underground chamber, rooted deep in the earth, expresses even more clearly what Isamu intended to convey—"healing" of mankind's error and "hope" for the future. Martin Friedman, former director of the Walker Art Center in Minneapolis, thinks the Hiroshima memorial "would have become one of the representative monuments of the twentieth century."[49] It is a view that many share. As someone with roots in both Japan and the United States, Isamu had invested his deepest feelings in the design, and until the end of his life he searched for another site for his "phantom masterpiece." But what made the work a masterpiece was that it was intended for Hiroshima—and not someplace else.

Since his first postwar visit Isamu had been troubled by uncertainty about how the Japanese really felt about Americans. Although elated at his unexpected welcome, he was disturbed by the country's mood. Everyone

seemed to think that anything American was good but he could not help having doubts. "I couldn't understand why the Japanese liked Americans so much," he told a Japanese magazine in 1952. "Perhaps what I was seeing was false, perhaps they concealed their real feelings."[50] The dispute over the Hiroshima memorial resolved his uncertainty. As an American army doctor who had spent several years in Hiroshima investigating the medical effects of the atomic bomb told him, "The Japanese think it is shameful to show how they dislike America and they hide it. They seem to have a very deep psychological hatred."[51] The physical wounds resulting from the atomic attack would close in time, he added, but the deepest wounds were psychological and they might not be healed until death.

Isamu's distress at losing the opportunity to build a Hiroshima memorial eroded his dreams about the "New Japan." The hope he had invested in the country had proven illusory. "Whenever I meet with interference or with opposition, it immediately upsets me, and I go back into my shell," he said at the time. "That was true of the trouble over the Hiroshima memorial. All kinds of ridiculous problems arose. I got sick of it, so I kept quiet and withdrew. I am always like a snail."[52]

His friend Saburō Hasegawa understood his frustration. "Isamu's eyes were opened anew to 'Japan,' the land of the father that was so hard to forget," Hasegawa said in 1952, and on his first postwar visit he had encountered "a carnivalesque welcome that he did not understand at all. . . . Under Rosanjin's guidance he sought to explore the 'essence of Japan.' Concentrating on that effort he absorbed what he could learn from Japan with astonishing speed. But gradually he realized that the hopes that he had placed on postwar Japan were an illusion." On their trip to Kyoto, Isamu often told Hasegawa, "The only people in the world today who don't learn from Japan are the Japanese." Hasegawa had heard the same words from other visiting foreign artists who used what they learned in Japan to create a new kind of art after returning home. For Isamu the words meant something different. "Noguchi tried to do it here in Japan." He did his best to chart new directions for modern Japanese art but the Japanese did not accept him. It was a "curious tragedy," Hasegawa said.[53]

A few months after Isamu moved to Rosanjin's "Shangri-la," a newspaper reporter asked him if he planned to live in Japan permanently. "No, I don't feel that I will," he replied. "I go wherever I can do my work, whether in Japan or someplace else. I have no idea how long I will be in Japan or

when I will go someplace else."[54] Yoshiko says that she and Isamu thought it would be ideal to live half the time in Japan and half the time in the United States so that both could pursue their own careers. In early November 1952, Isamu wrote his friend Jeanne Reynal about their future plans: "Just now we are sitting in our little garden, where we have spread mats and cusions [sic] to enjoy the autumn sun. Yoshiko-san is pealing [sic] a persimmon which grow plentifully in the garden. Before us the rice has now been cut and stacked high on poles. We wish you were both here as it is the kind of place where lovers belong."[55] His exhibition at Kamakura had closed two weeks before, and he was packing the works for a show at the Egan Gallery in New York. "Yoshiko-san is planning to make a Chinese movie in Hongkong [sic] during January, and I myself plan to get back [to New York] the early part of February. We expect to be there perhaps a year. . . . We still don't know where or how we will live in New York. She prefers the country, and I hope this may fit in with my doing work earning money." Their future did not turn out to be so simple.

"East Is East, West Is West"

"Please forgive me for the long delay in writing to you," Isamu wrote Rosanjin in mid-March 1953.

> First and mainly I want to express my deep and boundless gratitude for your kindness in giving us a haven while in Japan. It is your generosity which is at the root of all the happy days we spent there together. Through living there we were able to glimpse those eternal values of beauty that may be found in the Japanese countryside. Through living near to you we learned to discriminate and savor the quality of real epicurianism. Working next to you was a priviledge [sic] which I will always cherish. Coming back to New York after a year in Yamazaki is a terrible shock. There seems no sense to the mad rush—I am unable to adjust myself to the tempo or the people, and as for the food it is awful. Is it because Yoshiko-san is not here that I feel so homesick for Japan?[56]

On January 18, 1953, Isamu returned to the United States alone. Yoshiko had planned to accompany him but her visa had not yet arrived. When applying at the American Embassy in Tokyo three weeks earlier, they had not brought along their marriage certificate. Neither realized that

a permanent-resident visa for a Japanese spouse took six months to process. An embassy staff member suggested that if they were in a hurry Yoshiko could apply for a regular three-month tourist visa instead. Since Yoshiko had to return to Japan in a few months to work in two movies, she decided to do so. For some reason approval took longer than usual.

New projects were waiting for Isamu in New York. Besides preparing an exhibition of recent works, he had agreed to design a ground-floor garden for the Lever Brothers Building, one of the new glass-walled skyscrapers rising on Park Avenue. He had taken on the project more than a year before and worked on a model in his studio at Rosanjin's estate. Construction costs ran over budget, and much to Isamu's disappointment plans for the garden were cancelled several months later. The project was then suddenly revived, and Isamu received a telegram asking him to come back to New York right away.

After a year in the rustic "world of dreams," Isamu was overwhelmed by the fast pace of life in the city. It was lonely to be living by himself. He was especially disappointed that Yoshiko could not be in New York for the show in which he planned to exhibit work he had done when they lived together in Japan. "Because she is not here," he wrote Rosanjin, "I have postponed giving an exhibition till next fall. I have therefore not even opened the cases (not having the space), and so have not been able to show your beautiful ceramics to people. . . . I am hoping to get Yoshiko's visa soon, but in the meantime I shall be very grateful if you will please look after her and help her." [57]

In Tokyo, Yoshiko was filming a movie about a romance between a gangster pursued by his former comrades, played by Toshirō Mifune, and a nightclub singer, played by Yoshiko. When the shoot ended in the mid-February, her visa still had not been approved. Isamu got in touch with Mike Masaoka, a Japanese-American Citizens League leader he had met during the war. A politically savvy lobbyist who worked on Japanese-American issues in Washington, Masaoka suggested that the best way to expedite the visa was to persuade a congressman to vouch for the couple's good faith. Isamu once more turned for help to Dr. Rumely, who contacted Congressman Ralph Gwinn, a friend for many years. In mid-February, Gwinn told Rumely that the "visa was apparently being held up for security purposes." Isamu immediately hired a lawyer and went to Washington to talk directly with immigration service officials. "The trouble at the visa

office," he wrote Dr. Rumely, "does not seem to involve [accusations that Yoshiko was a Communist], but rather that my wife had known such people in the past, and that until the circumstances of her acquaintance can be satisfactorily explained her visa is held in abeyance."[58]

The "Red hunt" that had begun three years earlier was in full swing. Anti-Communist politicians, making no distinction between liberals and Communists, hounded former government officials, university professors, journalists, artists, actors, and writers. The charge of being a Communist or "fellow traveler," even if backed by no evidence at all, could destroy an individual's career. Isamu had spent very little time in the United States after he left for India in 1949. Indeed, he lived there a little less than six months after his return from Japan in the fall of 1950, then four months during the summer and early fall of 1951, and not a single day during all of 1952. Isolated on Rosanjin's estate, he had not grasped the impact of the anti-Communist hysteria sweeping through American society.

"[I] have never been a Communist and am not a Communist," he wrote Dr. Rumely, "and I am sure neither is my wife. . . . We all meet so many people, and artists especially, I suppose, are sought out by all kinds of people who presume to impose their kindness for all kinds of dubious causes. That Yoshiko did meet such characters on her first trip to this country is not only possible but almost inescapable."[59] Nearly everyone working in Hollywood, from actors to grips, belonged to a labor union. It would not have been unusual for Yoshiko to encounter a radical activist on the set of *Japanese War Bride*.

The only other suspicious contact that might have raised "security problems" for Yoshiko was her acquaintance with Eitarō and Ayako Ishigaki. Three months after the attack on Pearl Harbor the Ishigakis had been put under FBI surveillance as espionage suspects, and after the war they were under FBI suspicion because of Eitarō's prewar political activities, Ayako's involvement in pro-China support movements, and Ayako's friendship with the journalist Agnes Smedley, a sympathizer of the Chinese Communist movement. In June 1951 the Ishigakis were issued deportation orders, and just before their departure from Los Angeles for Japan they called on Yoshiko. Eitarō had not been to Japan for fifty years, and Ayako for twenty-five. Yoshiko offered some advice: "When you get back to Japan it would be better if you didn't talk about what you really think for a while. Otherwise you'll get tripped up right away."[60]

To the end of his life Isamu never learned why Yoshiko was denied a visa. Declassified government documents reveal that her intuition had been correct. The FBI file on "Yoshiko Yamaguchi" reported that she and Isamu had frequented the home of "Ayako ISHIGAKI, [who] from her youth, belonged to what later became the 'international school' (*kokusaiha*) of the Japanese Communist Party."[61]

The FBI had kept separate files on both Isamu and Yoshiko for several years even before they met. Isamu had attracted the attention of the Federal authorities before the war because of his public criticism of Japanese aggression in China and his support of China relief efforts. Shortly before his departure to California in 1941 he also had a brief affair with Martha Dodd Stern, author of several popular books about Nazi Germany, who was later accused with her husband of spying for the Soviet Union. The Sterns fled to Mexico City in 1953, then to Prague in 1957 after being indicted on espionage charges.

Isamu's wartime activities also excited suspicion. He had helped to organize a Nisei group that protested the forced relocation of the Japanese-Americans on the West Coast, and he had stayed in San Francisco with Jeanne Reynal, then under FBI suspicion because of her involvement in the labor movement. In December 1942 a confidential informant told the FBI that Isamu was "an artist, a Communist, and anti-Japanese."[62] When he volunteered to enter the relocation camp at Poston, the authorities were puzzled about his motives, and after he left the camp he was suspected of being a "spy for Japan." He was tainted even by his participation in the India League, which the FBI regarded as a dangerous left-wing group because it supported Indian independence. Although Isamu might not have thought so, it was easy for the FBI to view him as a Communist.

The FBI file on Yoshiko was much thicker than Isamu's and twice as thick as that of the Ishigakis. It listed her many "aliases" (Yoshiko Yamaguchi, Ri Ko Ran, Pan Shuhua, and Shirley Yamaguchi), and it reviewed her wartime past as a movie star. Much of the file was based on postwar reports by the Army Counter-Intelligence Corps. After her postwar return to Japan, Yoshiko attracted CIC attention because of "her rumored background as a possible Japanese espionage agent in Manchuria."[63] Her father and sister, who lived so long in China, were also suspected of being Communist Party sympathizers, and in 1947 an anonymous informant reported that Yoshiko had sung at the Russian embassy and later attended a Christmas

party at the home of Effim F. Voevodin, a known Soviet agent. Several CIC officers investigating the attractive "Chinese actress" developed a personal interest in her. Major Jack Canon, head of the CIC Special Operations Section, feared by the Japanese as the "Canon organization," was one of them; another was his executive officer. The two men reportedly made a bet about who would seduce Yoshiko first. The executive officer won but his success led to a falling out with Canon, and several years later when he was under consideration for promotion to colonel the army investigated the "scandal."[64]

To woo the famous "Ri Ko Ran," the American officers often visited her Asagaya home bearing gifts from the PX. According to a CIC informant judged as "usually reliable," neighbors complained that Yoshiko and her sisters threw "nightly parties . . . of singing, dancing and drinking to the accompaniment of jazz music" until the early hours of the morning. The Yamaguchi sisters were accused of having "loose morals," and there were even allegations that the house had been bought with money the sisters earned as prostitutes. "All the members of the family lacked the Japanese spirit," the report noted, "and were more westernized. Money appeared to be their only concern." The FBI, however, coded the report: "Truth cannot be judged."[65]

Yoshiko arrived on her first visit to the United States just three months after Senator McCarthy's subcommittee began its hearings. A January 1951 army intelligence report noted, "SUBJECT allegedly has had long training in espionage work during the Japanese occupation of China, and appeared in many Japanese propaganda films. She is said to be fluent in Chinese, Japanese, Russian and English. She is alleged to have recently associated with various Chinese, Japanese and Korean Communists."[66] During the shooting of *Japanese War Bride*, the FBI kept Yoshiko under surveillance, and after Isamu's arrival in Los Angeles in early July 1951 the FBI followed him for several days, too. The FBI files are filled with detailed reports about where the couple went together and whom they met. The surveillance continued in New York. The FBI traced all Yoshiko's phone calls, including one to a Japanese-born dentist, and it checked the backgrounds of everyone she spoke to.[67]

What further aroused FBI suspicions was that Yoshiko and Isamu had not presented any marriage certificate when she applied for her permanent visa. Since Ayako Ishigaki, a "known Communist," had introduced the couple, FBI officials surmised that the marriage was intended to

provide cover for Yoshiko's espionage activities in the United States. Yoshiko was considered such an important "suspicious alien" that her file was sent directly to J. Edgar Hoover, the director of the FBI. Under those circumstances, her visa had little chance of approval.

Isamu and Yoshiko had no way of knowing that they were under FBI surveillance or what was in their FBI files. Even when they learned that Yoshiko's visa had been refused for "security purposes," neither could imagine what she had done to arouse suspicion. The only plausible explanation was that her connections with the Ishigakis, and possibly with left-wingers in Hollywood, had entangled them in the Red hunt. In his autobiography Isamu recalled how upset he was. "Gradually I became frantic. Finally, I got a lawyer and went to Washington. I was told that there were certain questions about her past associations. . . . From then on, I had to fight this unjust thing while still trying to work. I made countless trips to Washington, seeking whoever might be of influence, and trying to discover what were the specific accusations."[68]

Thrust into an ominously opaque bureaucratic world, Isamu sought help not only from Dr. Rumely's friend in Congress, but also from other influential political figures whose portrait busts he had made. He even tried a direct appeal to the newly elected President Dwight Eisenhower through his secretary. In the meantime Yoshiko presented the American Embassy in Tokyo with statements of personal guarantee from mentors like the painter Ryūzaburō Umehara, the businessman Nagamasa Kawakita, and the movie director Akira Kurosawa, as well as from acquaintances like Ken Inukai, a former Minister of Justice. Hollywood associates like King Vidor, the director of *Japanese War Bride*, sent similar statements to the State Department in Washington.

For a time it seemed that their desperate appeals on both sides of the Pacific might succeed. In response to Isamu's inquiries, the State Department notified them on May 21, 1953, that there was "no security objection to the issuance of an appropriate visa" for Yoshiko as the wife of a United States citizen. The message added that final confirmation was needed from the Tokyo Embassy, which was responsible for issuing the visa. On June 4, however, the Tokyo Embassy sent the State Department "a long additional report full of derogatory information."[69] Just what was in the report is not clear but these new secret documents renewed suspicions about Yoshiko, and once again the FBI firmly opposed granting her a visa.

Still hoping the visa would soon come through, Yoshiko departed for the International Film Festival in Berlin, where one of her movies had been entered in the competition. When the festival ended she went on to Paris. By then the Japanese newspapers carried headlines: "YAMAGUCHI YOSHIKO BARRED FROM U.S."[70] and "YAMAGUCHI YOSHIKO REFUSED U.S. VISA."[71] Even the *New York Times* covered the story: "An unofficial report from Washington late in February said that Miss Yamaguchi was suspected of pro-Communist sympathies." Yoshiko complained to Japanese reporters who crowded into her Paris hotel, "I have no idea what they are talking about. I really don't feel like working after being kept waiting for so many months. Isamu keeps asking me whether I have the visa yet, and I just don't know what I should do."[72]

Isamu was in New York when he heard the visa had been turned down again. He had just finished the final model for the Lever Brothers Building garden, and the next day he flew to Paris to be reunited with Yoshiko for the first time in six months. He told newspaper reporters, "We'd like to have a 'second honeymoon' traveling around Spain and other places for about a month. . . . I think that the visa problem will be solved by then."[73] The minister at the American Embassy in Paris, who responded to Isamu's queries cordially, was optimistic that the visa would be cleared within two or three months. The Korean War had intensified the anti-Communist hysteria but it seemed likely that a truce between the opposing sides would be signed soon. Perhaps that would help, he said.

The couple drove through Europe on a second honeymoon, first to Barcelona, then to the marble quarries at Carrara in Italy, to Greece, and back to France. In Rome, Isamu visited the American ambassador, Clare Booth Luce. "It was her opinion," he wrote Dr. Rumely, "that I have a right as an American citizen to at least know what specifically and mainly is the charge they have against Shirley, and that I should call on the Consul in Japan and demand this information as well as the sourse [*sic*] of the charges."[74] Mrs. Luce speculated that the Kuomintang government might be the cause of the trouble, and she promised to make inquiries of her own directly to the State Department.

When the trip ended, Isamu returned to New York and Yoshiko to her hotel in Paris, where she spent her days inquiring at the American Embassy. On November 8, the American minister summoned her to inform her that once again her application had been denied. He could not

hide his embarrassment. The State Department gave no reason for the denial. When Yoshiko phoned Isamu with the bad news, he returned to Paris immediately. At the airport, he issued a statement to waiting Japanese reporters. "More than anything else I want to live together with my wife," he said, "so I am thinking about giving up my work as a sculptor. If the United States does not like us, then we intend to live in Japan."[75]

Once again their life together was plunged into limbo. Yoshiko was scheduled to appear in a Hong Kong movie production, and Isamu flew with her back to Asia. After Yoshiko had finished her shoot in mid-March 1954, the reunited couple returned to their house on Rosanjin's estate. Isamu had arranged for the Japan Society in New York to sponsor an exhibition of Rosanjin's pottery at the Museum of Modern Art but instead of greeting Rosanjin when he arrived in New York, Isamu and Yoshiko had to see him off at Haneda Airport. Talking to reporters about reports that Yoshiko was a "Red," Isamu said, "This business with the visas is not Yoshiko's fault. It's completely mine. The darkest country in the world today is my homeland America. The only thing that I keep thinking about in the back of my mind in the midst of this horrid McCarthyism is whether I can be truly hopeful or happy if I am separated from Yoshiko-san."[76]

The problem was finally resolved a month later. On May 28, ten months after Isamu flew to Paris to console Yoshiko, the Associated Press reported that Yoshiko's visa had finally been approved. "From all I had seen and heard, opposition to [issuing the visa] was the work of the American consul in Japan. I went to meet him personally. When I asked what was going on, he seemed unexpectedly surprised. 'I thought your wife had already gone to be with you a long time ago.'"[77] Dr. Rumely had used his influential connections again, and this time he had gotten results, but the resolution of the visa problem was as entangled in politics as its beginning had been.

On April 22, 1954, Senator McCarthy escalated his search for Communists by opening subcommittee hearings to investigate subversive influences in the U.S. Army. Unlike his previous targets, the Army directly confronted his charges as false and unfounded, and the hearings soon made clear that he had no evidence to back them up. The confrontation was played out on television screens across the country, baring the true nature of McCarthy and his methods to the whole country. The anti-Communist "witch hunt" he had carried on for four years was exposed as a fraud. When

the hearings ended, Joe McCarthy's influence as the most feared politician in America slipped away as quickly as the audience that left the hearing room while he droned into the microphone, unheard and ignored.

In early June, Yoshiko told guests she had invited to a cocktail party at the Imperial Hotel, "I will go wherever my husband goes. Many people in Japan had all kind of suspicions about me—for example, that I was a spy—since they did not understand the true facts. But now that it has all been cleared up, I could not be happier."[78] Soon afterward she left for New York to rejoin Isamu, who had decided on a November opening for the postponed show of his ceramic work. Busy with preparations, he had not yet found an apartment. The show opened at the Stable Gallery on November 23, 1954. In a sense, the works on display were a diary of his life with Yoshiko in the "world of dreams." Isamu happily introduced "Mrs. Noguchi," smiling radiantly in a gorgeous kimono, to his friends in the New York art world.

Two weeks later, Yoshiko closed a deal to star in another Hollywood production, *House of Bamboo*. "If I don't do work that is much, much better than *Japanese War Bride*, I am worried that I might not be able to return to Japan," Yoshiko told a reporter before coming to New York.[79] The film was a B-movie about American gangsters in Tokyo, but it still was unusual for a Japanese actress to star in a Hollywood production. At the age of thirty-four Yoshiko had reached a turning point in her career as a popular actress in Japan, and she seized on the movie as an opportunity to become an international film star.

In December 1954 Yoshiko and Isamu were separated once again. While he remained in New York, she left for Hollywood, then a month later went to Japan with her co-star Robert Stack to shoot on location in Tokyo. When the movie was shown in Japan under the title *Tokyo Ankoku-gai* (*Tokyo Underworld*), reviews savaged it as a national disgrace completely ignorant of Japanese culture and customs.

Things were not going well for Isamu either. The reviews of his show at the Stable Gallery noted a "growing Japanese influence on his work" but the pieces exhibited, fashioned as a salute to his affection for Yoshiko, did not make much of a splash.[80] The Lever Brothers Building project Isamu worked on for more than three years had also been canceled while he was in Paris with Yoshiko. "The Lever Brothers job fell through with a thud," he later recalled. "I had done my best—but it was refused. Did the anguish,

under which I had worked, show through, or had they really run out of cash?"[81] The visa problem had been costly. With reports circulating that his wife was a Communist pawn, Isamu was convinced that clients thought twice about offering him commissions. "Yet the harm is in all this time of life and work lost—we will never get it back," he wrote Dr. Rumely.[82] He was forty-nine years old, and he wanted to concentrate on work at his new studio in Manhattan.

After returning to Hollywood from location in Japan, Yoshiko often talked with J. B. Blunk, a former American GI she and Isamu had met in a Tokyo folk craft store. The casual meeting turned into friendship, and Blunk visited the couple at Rosanjin's estate whenever he got a leave from Korea. After he mustered out, Isamu introduced him to Tōyō Kaneshige, who took him on as an apprentice-student. Yoshiko seemed a different person to Blunk from the cheerful one he had known in Japan. She was quite depressed, she said, and she was having problems with Isamu. Although she wanted Isamu to fly to Hollywood right after she came back from Japan, he said nothing about coming out to California. Blunk soon found himself listening to Isamu, too, who called from New York to ask what Yoshiko had in mind. Just when they were about to live together once again as husband and wife after resolving the visa problem, he complained, Yoshiko had gone off again to work in a B-movie like *House of Bamboo*. Why should he have to put aside his own work to go to Hollywood, he wondered.[83]

When Isamu told Andrée Ruellan, his old friend from Paris student days, that he had married "a ball of fire," she replied, "Isamu, you met your match."[84] Isamu seemed offended, as though he did not realize how intense his own personality was. In a 1953 interview Yoshiko confessed that she and Isamu were always fighting. "Our points of view often clash," she said. "It may be philosophy, customs, culture, art, or politics. . . . We're both so eccentric, temperamental, egotistic. Perhaps it's an expression of the art in us. . . . My job, after all, is to work for the public, whereas Isamu-san's job is to work in private to please himself."[85]

As Isamu later admitted, his marriage to Yoshiko had been difficult because their patterns of life were completely different. "Yoshiko meets many people at work," he said. "But she doesn't meet anyone outside of work. When I work I shut myself up alone. But when my work is over I meet a lot of people. We were both just the opposite."[86] They often argued about that in front of others, and once they started neither would back down. Perhaps

Isamu unconsciously revealed his attitude toward the relations between the sexes in a comment about his set design for Martha Graham's *Night Journey*, a ballet based on the Oedipus legend. "We are all in a very peculiar dilemma," he said. "Can we be individuals and also a duo? It's a very difficult problem. . . . I think once both men and women begin to release their resistance our relationships will become much more constructive."[87]

The marriage continued to crumble. After finishing *House of Bamboo*, Yoshiko went home to Japan, and at the end of the year, when she returned to New York on a publicity tour for the movie, she met Isamu to talk about a divorce. It was she who proposed that they separate. "I thought he would say something to stop me," she said. "But Isamu never offered to start all over again."[88] When they met again a few days later Yoshiko wanted to talk about giving the marriage another try, but as they walked along the street Isamu suddenly stopped in front of a hot dog stand and pulled out a piece of paper. "Please sign it," he said. It was a divorce agreement. Yoshiko was taken aback. "Why the hurry?" she asked herself. She wondered whether Isamu was trying to make sure that alimony negotiations would not involve his artistic works.

If only there had been children, she said, things would have been different. "I love children," she told a weekly journal shortly after their wedding. "It's difficult because of my work, but I'd like about three."[89] There were still no children by the time Isamu and Yoshiko talked about divorce. Twice during their year on Rosanjin's estate Yoshiko miscarried. Her busy work schedule, and her long daily trips to the movie studio over bumpy roads, took a toll on her pregnancies but for financial reasons she could not stop working. She had to take care of her siblings as she always had in the past, and since Isamu did make enough to support them, she shouldered the financial burden of their life together. Isamu put all his income back into new artistic projects, but Yoshiko says that she never resented it. She respected her husband, who was always afire with some new creative urge.

"YAMAGUCHI YOSHIKO, INTERNATIONAL MARRIAGE DISSOLVED, ENDED BY DIFFERENCES IN LIFE STYLES." So ran the newspaper headlines on February 2, 1956. That evening Yoshiko held a press conference at the Sankei Hall. "I pray for Isamu-san's good fortune as an artist until the end," she said responding to a reporter.[90] Then she suddenly broke into tears.

Looking back on her divorce forty years later Yoshiko recalled the episode of the pink vinyl sandals.[91] On her way home from the movie stu-

dio one day Yoshiko stopped at a gift shop to buy a pair of vinyl sandals to replace the straw sandals she wore everyday at home. The straw chafed her feet so badly that they bled. The moment that Isamu saw the pink sandals in the entryway, his expression darkened, and without giving Yoshiko a chance to explain, he grabbed them and threw them in the rice paddies outside. Not once did he try to comfort his wife about her hurting feet.

Rosanjin often criticized Yoshiko behind her back for her "vulgar" taste, and Isamu later told friends that no matter how hard he tried to educate Yoshiko her aesthetic sense never improved. His frustration suddenly exploded at the sight of the pink vinyl sandals. Intoxicated as he was with traditional Japanese aesthetics, nothing could have seemed uglier to him. His emotional explosion took Yoshiko aback. It mimicked the pigheadedness she saw in Rosanjin every day. The two men shared the same view of women, she says. "Both Isamu and Rosanjin thought women were necessary only when they needed them, and ultimately they thought that women were a hindrance to their work."[92] She deeply respected Isamu as a "pure artistic genius," and she did her best to understand his aesthetic feelings, but she realized that she simply could not be his partner for the rest of her life. The fight over the pink vinyl sandals made that clear to her for the first time.

As a Japanese brought up in China, Yoshiko often had trouble understanding her movie scripts. "It was really difficult for me to work in scenes where there was a strange traditional custom or something like that." Her selling point as an actress was that she was exotically "un-Japanese." After marrying Isamu she realized how very Japanese she really was. Every day she experienced cultural shock. Isamu may have sought his Japanese roots through his sense of beauty but Yoshiko thought that he lacked "Oriental common sense." He never tried to understand the customs that lubricated social life in Japan—the family visits at the Bon summer festival and at the New Year, the monetary offerings at weddings and funerals, the gifts to friends departing on trips, and the like.

When Yoshiko told friends that a gift came from both of them, Isamu would always correct her immediately: "That's just Yoshiko's present." In that sense, she says, Isamu was a "stubborn American." "He believed that he was different from ordinary Americans and that he could understand Oriental feelings. But in the end he was an American. He always yearned for Japan, where he found half his roots. But I think it was a Japan connected to his childhood experience, a time when his roots were

not accepted. It was a Japan that was dead and gone. He was looking for a Japan that was no longer a reality. He was obsessed with things, and he yearned for things, that Japanese people did really not care about. Then he tried to approach Japan by logical reasoning. I thought he did that because he was an American."[93]

On March 4, 1956, Yoshiko's manager announced that Isamu and Yoshiko had reached an amicable divorce agreement. Their last talk took place the day before at the Fukudaya Inn in Tokyo where Isamu was staying. The atmosphere was tense. A mutual friend, the movie producer Kiichi Ichikawa, recalls watching for an hour as they discussed how to divide up dozens of Rosanjin ceramic works spread before them. Yoshiko, who had bought most of them with her own money, refused to make any concessions to Isamu. Thinking it would be easier for them if he left, he slipped off for a half hour, but when he returned, they were still facing one another, both refusing to give in.

Although their marriage had lasted four years and two months, Isamu and Yoshiko had lived together only half that time. After the divorce Yoshiko returned to New York to star in a Broadway musical, *Shangri-La.* The reviews were dreadful, and the show closed after a month. Two years later she married Hiroshi Ōtaka, a young diplomat eight years her junior. When she announced her second marriage, Yoshiko made public her decision to retire from a twenty-year show business career that began with her debut as Ri Ko Ran at the age of eighteen. "When I divorced Isamu," she said at the time, "it was because I had work. I overcame the demands and difficulties of my work by my youthfulness, but now I am tired. It seems foolish to spend the rest of my life as a woman trying to maintain my position as a movie star. I want to get married and have children."[94] Yoshiko was never blessed with children, and she returned to the entertainment world as the hostess of a television show. At the age of fifty-four she was elected to the House of Councilors as a representative of the Liberal Democratic Party and eventually became Political Vice-Minister of the Environmental Agency. Isamu always delighted in telling friends about "my former wife's" successes.

Isamu with workmen (left) at the UNESCO garden construction site in Paris, 1957

The Universe in a Garden

The UNESCO Garden

"Six leading artists have just accepted commissions for the headquarters building of the United Nations Educational, Scientific and Cultural Organization now under construction in Paris," the *New York Times* reported on June 13, 1956. An international team of architects—Marcel Breuer, Pier Nervi, and Bernard Zehrfuss—had designed a UNESCO headquarters building in the center of Paris on land donated by the French government, and there had been much speculation about who would be chosen to decorate UNESCO's "new Parthenon." The finalists were Pablo Picasso and Joan Miró, Spanish-born members of the Paris painting school, the sculptors Henry Moore of Britain and Jean Arp of France, and Alexander Calder and Isamu Noguchi from the United States.

The planners had wanted to include an Asian artist but instead they chose Isamu, whose garden for the Reader's Digest Building had demonstrated his skill as a designer of public spaces. Marcel Breuer had sounded him out about the project eight months earlier, just before he and Yoshiko decided to divorce. "I was apparently selected by an international committee of the arts partly with this in mind, a compromise, as someone whose work they knew and could work with, the results of whose efforts would be both modern and Japanese in feeling, which is what they wanted."[1] His assignment was to design the Patio des Délégues, a plaza on the southwest side of the seven-story building housing the UNESCO Secretariat. It had already been paved with marble, leaving no space to plant even a single tree or shrub. The architects, he speculated, thought that he "could do something interesting with the space as a sculptor."[2]

The UNESCO project offered Isamu an opportunity to distill all he had learned from mentors like Rosanjin and Saburō Hasegawa into a garden for the city where he had started as an abstract sculptor. "Nothing could have been more opportune or rewarding," he later wrote, "in showing the way I must go, toward a deeper knowledge through experience of what makes a garden, above all the relation between sculpture and space which I conceived as a possible solution to the dilemma of sculpture, as it suggested a fresh approach to sculpture as an organic component of our environment. Ultimately, of course, only the doing can teach. A job is a lesson, not to be learned otherwise, a great job [is] a great lesson."[3]

The UNESCO garden was also a project with global visibility, and for the next three and a half years it became the center of Isamu's life. Now that his marriage was at an end he no longer had to worry about adjusting to Yoshiko's schedule. On the way back from surveying the UNESCO site he met her for the last time in Tokyo, where he began to work on a design at Kenzō Tange's studio at Tokyo University. Initially his idea was to install a dry rock garden on the marble-paved plaza, but after visiting the site he realized there was no surrounding greenery to set off the beauty of the stone. Instead he decided to incorporate into the design a large sunken space between the building for the UNESCO Secretariat and an office annex. The overall concept was to fill the plaza with Western-style stone sculptures and benches and to create a Zen-style rock garden as a "space for philosophical conversation." The sunken space would be covered with trees to unify the plaza visually with the main UNESCO Secretariat building.

As the design evolved, his vision grew steadily grander. "I gradually became more and more involved, ever more ambitious for it to be something exceptional," he later wrote, ". . . as I elaborated on the model it became apparent to me that it would be ideal if the area below could be transformed into a major sculptural effort through the introduction of rocks and so forth."[4] The final plan included a path "like the Hanamichi or flower path of the Japanese theater" connecting the plaza to the sunken area, where an artificial hillock covered with plants stood in a pond dotted with Japanese natural rocks and fed by a cascade of water from above.

Isamu had no intention of designing a "Japanese garden" for UNESCO. Although he thought of the garden as a sculpture, he could just as easily have called it an "earth work." Calling it a garden simply made it easier for people to understand. "The garden is the first step, the first grop-

ing, toward another level of the experience of sculpture and its utility," he wrote at the time, "and it is an experience of a sculptural space as a whole transcending individual sculptural elements in it."[5] What he hoped to create was "a garden that was born from admiration and respect for the Japanese garden."

The UNESCO artistic committee was pleased with Isamu's concept for a garden in the sunken area, but the UNESCO Secretariat had only enough money for the marble-covered Patio des Délégués. Isamu suggested to Bernard Zehrfuss that UNESCO seek financial support from the Japanese government "both as a gesture of Asian participation and credit assistance."[6] UNESCO officials agreed but did not want to approach the Japanese government directly since they might be seen as putting pressure on Japan. Isamu took on the task of fund-raising himself. The other five artists invited to decorate the UNESCO headquarters had simply transported their work to the site. Even Picasso's mural for the building was completed in his own studio. But Isamu constantly visited the site as his plans took shape. Even before construction began, he had to raise money, select rocks and other material in Japan, and arrange to ship them to France. Whenever problems arose, he had to take care of them by himself.

In his fund-raising efforts Isamu had the help of two young Japanese women, one the daughter of a powerful politician and the other the daughter of an influential businessman. Yoshiko Ishii, whose father was a leader of the Liberal Democratic Party, was in Paris studying to become a chansonnier. She had often been a fellow guest when Sōfū Teshigahara, head of the Sōgetsu school of flower arrangement, invited him to dinner. She shared an apartment near the Bois de Boulogne with Tomiko Asabuki, the beautiful daughter of a powerful prewar Mitsui executive. Isamu found her quite attractive. Her family had suffered a reversal of fortune when the American Occupation broke up the Mitsui conglomerate, and when her marriage fell apart she came to Paris to attend a fashion school. She later achieved recognition as the translator of Simone de Beauvoir's works into Japanese. Both Tomiko and Yoshiko testified that Isamu worked hard to bring the UNESCO project to realization, but neither took credit for helping him behind the scenes.

In July 1956, through an introduction from Yoshiko Ishii, Isamu met Shōjirō Ishibashi, the founder of the Bridgestone Tire Company who was in

Paris on business. Yoshiko's father, Mitsujirō Ishii, had entered the political world with Ishibashi's financial backing. Four years earlier Ishibashi had donated his private art collection to the newly established Bridgestone Art Museum in Tokyo. When Isamu told him that Japan, as a defeated country, should make a contribution of cultural significance to international society, Ishibashi said that he wanted to help but advised Isamu to approach Japanese diplomats first. Isamu spoke to the Japanese cultural attaché in Paris, and in New York he met with Toshikazu Kase, the Japanese ambassador to the United Nations, who told him that the Japanese embassy in Switzerland had jurisdiction over UNESCO-related matters in Europe.

Tomiko put Isamu in touch with Tōru Hagiwara, the Japanese ambassador in Bern. "As I told Miss Asabuki," Hagiwara wrote Isamu in January 1957, "I am strongly recommending my Government to take up part of your plan as its donation to UNESCO."[7] Since the government's foreign exchange budget was quite limited, he suggested that Isamu take his case directly to officials in Japan. The UNESCO Secretariat, which had budgeted $15,000 for the garden, had informally expressed hope that the Japanese government would contribute ¥8,800,000 for construction costs and materials. The Ministry of Foreign Affairs, recognizing that financial support for the garden would help to introduce Japanese culture to the outside world, decided to back a joint government-private fund-raising effort by putting up ¥1,800,000, with the remaining ¥7,000,000 to be raised from private sources.

A distant relative of Tomiko's mother, Aiichirō Fujiyama, head of both the Tokyo Chamber of Commerce and Japan Chamber of Commerce, agreed to chair the newly formed Committee to Support the Construction of the UNESCO Garden to raise the rest of the money needed; when he became foreign minister he was succeeded by Kan'ichi Moroi, president of Chichibu Cement Company, and a founder of Keidanren, the premier business organization in Japan. Not surprisingly, with support from these influential business moguls, private contributions were raised in less than a year.[8]

In April 1957 Isamu went to Kyoto to select stones for the skeleton—and the center—of the UNESCO garden. "Many people have asked me, 'Why are you using Japanese stone? There are lots of stones in Europe, aren't there?'" he told a Japanese art journal. "But I tell them it is because I will learn much more by looking for stones here [in Japan]. The Japanese really know about stone. If you ask where to find good stones, everyone seems to

be astonishingly knowledgeable about where to go. There is no other country like Japan."[9]

Junzō Sakakura, a prewar student of Le Corbusier who had just designed a Japanese garden in Germany, introduced Isamu to Mirei Shigemori, the top Japanese garden architect of his generation. The sixty-two-year-old Shigemori had designed many famous gardens, including the dry sand and rock garden at the Tōfukuji Temple in Kyoto, and he was the author of the twenty-six-volume *Illustrated History of Japanese Gardens* (*Nihon teienshi zukan*), a foundational study of the traditional Japanese garden. Isamu had already learned much about the basics of Japanese garden architecture from his visit to Kyoto with Saburō Hasegawa in 1950. He had been excited by the gardens designed by the fourteenth-century Rinzai Zen priest Musō Soseki, especially the garden at the Tenryūji Temple, and Hasegawa used Musō's work to explain the principles of Japanese garden design to him. What Isamu sought from Shigemori was help in finding the right stones for the UNESCO garden.

Shigemori, who had taken his professional name "Mirei" from the nineteenth-century French landscape painter Jean François Millet, was known for his bold modernistic style of matching garden stones. He had a deep appreciation for traditional Japanese culture but his adventurous and innovative spirit led him, like Sōfū Teshigahara, to advocate avant-garde styles in traditional arts such as flower arranging. He was delighted at the chance to help a modern sculptor like Isamu to design a garden. "Shigemori took me all over the place," Isamu later recalled. "He was very kind."[10] The two men spent a day wading through a mountain stream at Tokushima on the island of Shikoku with a local stonemason as torrents of rain poured down. In the argot of Japanese stonemasons, they were "fishing for stones" (*ishi o tsuru*).

"It was not a very large mountain stream, but there were marvelous stones strewn everywhere," recalled Isamu. "I let out a cheer. I walked around in the rain with my paper umbrella, checking the ones that I liked." He was searching for "blue stones" like those Junzō Sakakura had used for his garden in Germany. "They were very bright blue, almost too beautiful, and not at all subdued like those used in a tea ceremony garden. But I didn't need anything subdued in my Paris garden so they would be just fine, I thought. I like things that are *sabi* [understated] and *wabi* [subdued], but I did not think that they were especially necessary in this garden. . . . The stones that Sakakura used were very beautiful but to my way of thinking they felt too

heavy. . . . They were too round in shape. The ones I picked looked flat and light, so that perhaps you get the feeling that they [are] jumping about or happily enjoying themselves or dancing. I thought to myself 'Why not?' I thought that they would match the building better."[11]

During the week and a half it took to retrieve his "catch" of eighty stones Isamu stayed in Kyoto as the guest of Jinbei Kawashima, head of the Nishijin Weaving Company, who had commissioned him to design a stage curtain for the Tōyoko Theater in Tokyo. In early May he returned to Tokushima to watch Shigemori and his workmen wrestle the stones into position according to his design. The layout took four days. For Isamu it was a grueling introduction to the art. "There could be no waste, such as might be afforded in Japan," he wrote in his autobiography, "no hauling of stones that were not to be specifically useful, and for a particular shape and purpose."[12]

Shigemori took special pains to follow Isamu's every wish but at the end of the second day he wrote in his diary, "Worked from the morning all day to lay out the garden, and got about half done. Very tired. Since I respect Noguchi-san's feelings above everything else, I can not arrange the stones the way I think they should be, and that is very hard for me."[13] Even at the point of exhaustion he kept going until Isamu was satisfied. "It was remarkable how smoothly the whole operation went," Isamu later recalled.[14] In the end he decided to use only fifty of the eighty stones he had selected, altogether weighing eighty-eight tons. After seeing the first load of stones off from Kobe at the end of July, he left for New York.

Isamu planned to visit Paris in September when the second load of stones was scheduled to arrive at Marseilles, but work in France did not go as smoothly as it had in Japan. "For a while it looked quite hopeless, with every bureaucratic reason why nothing could be done," Isamu later complained.[15] Troubles surfaced when UNESCO officials told him that he need not to come to Paris until spring since basic construction on the "Jardin Japonais," as they called the project, was proceeding smoothly. But Isamu kept revising his design. He did not want to make any final decisions about the layout of the stones until he saw how they fit together on the site.

Ignoring his entreaties, UNESCO officials cabled him not to come in September. The garden project was an unexpected headache for them. The other artists chosen to decorate the UNESCO headquarters received travel expenses to attend the installation and an honorarium of $5,000—

though it was rumored that Picasso and Miro had gotten $10,000. The financial arrangements for Isamu's project were different. The funds raised in Japan paid for the stones but UNESCO was responsible for everything else once they arrived in Marseilles. Costs mounted steadily, exceeding all expectations. Isamu had tried to hold down his expenses by flying tourist class instead of first class on his trip to Japan to hunt for stones, and while there he charged his living expenses to another project, a garden he was designing for the Connecticut General Insurance Company near Hartford. But the Jardin Japonais had become a monster that threatened to eat up the limited art budget for the UNESCO headquarters.

Frustrated by his dealings with UNESCO officials, Isamu threatened to abandon the whole project. Relenting, they agreed to let him come to Paris in late September. There he discovered new problems. The pace of work was slow. It had taken Japanese workmen only ten days to bring eighty stones down from the mountains to Tokushima City, but it took the Algerian and Spanish workers hired by UNESCO three weeks to move just one stone from one end of the site to the other. Not only did they lack experience with moving stone, they rested every forty-five minutes and took two hours off for lunch.

Claude Bernard, a gallery owner who organized Isamu's first Paris exhibition at his gallery, says that Isamu was the least known of the six "world-renowned" artists chosen to work on the UNESCO project.[16] Indeed, he was nearly unknown in Europe. Only a few people interested in Asian art took notice of him. The attitude of the UNESCO officials seemed to reflect his limited reputation in Europe.

Isamu was delighted when he learned that Tomiko Asabuki's older brother Sankichi had been appointed assistant director of the UNESCO Cultural Affairs Bureau. He had no direct responsibility for Isamu's project but his wife, Kyō (Yoshiko Ishii's older sister), offered to drive Isamu to the Bois de Boulogne and Fontainebleau to order pebbles, sand, moss, and other garden materials. As usual Isamu lost track of time as he worked, and when lunch was delayed Kyō's hungry six-year-old son Ryōji burst into tears. Much to Kyō's irritation Isamu complained, "Children are a real nuisance, aren't they?" He was also upset at hearing Ryōji call his favorite doll "Miyo-chan," the nickname of a popular singer. "I don't like to hear that name," he said. "It's the name of the woman I love."[17]

A few months earlier, Isamu had begun an affair with Miyoko Urushibara, a young woman he met at a summer fireworks display in New York that he had gone to see with Gen'ichirō and Fumiko Inokuma. The Inokumas had moved to Manhattan two years earlier, and their uptown apartment was always home to Isamu when he was in New York—just as that of the Ishigakis had been before and during the war. When the fireworks ended, a young woman sitting behind them spoke to Isamu in Japanese. "I'm a student at the Pratt Institute," she said. "It is a great honor for me to have the chance to meet such a famous artist."[18] Turning to see who had spoken, Isamu met the gaze of a beautiful young woman with a perfect oval face, almost like Brancusi's "Sleeping Muse." Her full cheeks and cool clear eyes must have reminded him of Tara. The resemblance was more than physical.

Her slightly melancholy but innocent expression, her elegant carriage, her soft voice, her well-bred diction, and her soft enigmatic smile were all reminiscent of his former lover but her demeanor was that of a gracious and gentle Japanese woman.

Several years after his divorce a Japanese reporter asked Isamu whether he would choose a Japanese bride if he remarried. "There are nice women in America but they do not understand half of my heritage," he replied. "Next time I would like to marry a nice Japanese woman well suited to my ideals and my reality."[19] Gentleness, he added, was one of the qualities he sought. On the night of the fireworks display, Isamu thought he saw before him the ideal Japanese woman.

The twenty-two-year-old Miyoko Urushibara was the daughter of an old established family in Takamatsu City in Shikoku. Her father had died on New Guinea during the war. After graduating from high school, she won a fellowship to the Pratt Institute, where she studied interior design, a profession just beginning to develop in Japan. Like her fellow students she knew Isamu Noguchi more as the designer of a distinctive coffee table and the Akari lamps than as a sculptor. Her excitement at meeting the artist whose work embodied "the good side of the Japanese-American relationship" prompted her to speak to him.

The next day Isamu invited Miyoko to see the elevator lobby he had designed for an office building at 666 Fifth Avenue. White aluminum and stainless steel louvers set together on the ceiling suggested drifting clouds, and contoured louvers on one wall evoked a waterfall. The lobby's novel

but elegantly modern look had impressed interior design students at Pratt. Soon he began taking Miyoko to art galleries and evening parties. Although he was older than Miyoko's father would have been had he lived, she felt no age difference. She was overpowered by his "charming personality." He was a man brimming with confidence, leading a glamorous life as he consorted with prominent New Yorkers from every walk of life. Miyoko never sensed the darkness that shadowed his birth and childhood.

"I'm walking on air having read your letters," Isamu wrote her from Paris in September.[20] "How wonderful it is to seem to be almost talking with you instead of into thin air as it has seemed when having no reply." Like a lovesick youth, he wrote her passionate love letters every day. "I am so glad to know that you also want to be together. I thought I was indulging too much in wishful thinking—but love is so strange & wonderful a thing. One does not know what to do, it seems something beyond belief. . . . That two people should both love each other at the same time is of course a miracle!" He showered her with letters, and sent her bouquets, as though he had completely forgotten all his casual affairs in Paris.

On his way to an international architects' conference in Italy, Kenzō Tange stopped in New York, where Miyoko acted as his guide. A few days later in Paris, Isamu told him that he wanted to talk about something he could not discuss with anyone else: whether or not he should marry Miyoko. Aware that competing careers had led to the failure of his marriage to Yoshiko, Isamu was worried about how deeply Miyoko was committed to her work. Tange, acting as a go-between, reported to her: "Isamu's frame of mind seems to be that now that everything has settled down he wants to do work that will really be his own from now on. Please think calmly about it yourself. If there is something that is difficult for you to say directly to Isamu, please tell me."[21]

Soon afterward Miyoko told Isamu that she would accept his marriage proposal. "How wonderful it was to get your letter yesterday about getting Tange-san's letter," Isamu replied in mid-October.[22] "I have been walking on air since then, about 5 ft. off the ground! I suddenly lost at least 10 years—which goes to show how everything with me is a matter of the imagination. I had been feeling blue & sort of sick, but the moment I read your letter everything changed—I was all over the place at once and working like mad; but inside I was calm. Now I am happy. This is what you can do for me, give me courage and confidence—I want to be able to do the

same for you. . . . I was feeling so gloomy and sorry for myself, thinking about my being too old. But now I feel fine and will live forever protected by your love—we will protect each other! You are the only music in my heart."

At the end of November the layout of stones in the plaza section of the UNESCO garden was completed. It was too cold to plant trees and shrubs in the sunken area, so Isamu postponed further work until the spring. He returned to New York to finish a design for an upcoming Martha Graham production of *Clytemnestra*, and during the Christmas holidays he and Miyoko, together again, talked about their future, but when Isamu returned to Paris two months later, he was alone. His engagement to Miyoko had lasted only six months. Her teachers at the Pratt Institute, and the family she was staying with in New York, too, advised her to postpone marriage until she graduated. Even the Inokumas strongly opposed the marriage.

What influenced Miyoko more than anything else was her mother's reaction. When her only daughter, who had never given her a moment of trouble, suddenly announced she was going to marry a man thirty years her senior, she told Miyoko that no matter how famous her fiancé was the marriage would wreck her life. Although Miyoko later became a well-known interior designer, at the time she had no overwhelming desire to pursue a profession. Neither did she allow herself to be influenced by others. But when everyone around her opposed the engagement she wavered. In retrospect, she says, she ultimately decided it was simply too early for her to think of marriage with anyone. When spring came to Isamu's beloved Paris, Miyoko was no longer at his side.

Nursing the wounds of yet another disappointing love affair, Isamu focused on completing the sunken portion of the UNESCO garden. Problems beset him once again. "There has been a fantastic amount of trouble over here, delay following delay, all stemming from the question of money and the uncertainty of what anything will cost," he wrote Shigemori in March 1958.[23] "Nobody seemed to want to take too much responsibility about decisions, and the only initiative to get things moving came from me, and I had no control over the spending of money. How lucky you are to be working in Japan where people know and appreciate the quality of a garden and give their cooperation with such generosity."

His design called for an upright oblong stone a little over six feet tall to be placed at the beginning of the *hanamichi*, a long walkway linking the

plaza with the sunken garden. Water flowing from the top of the stone was to tumble into a stream that fed the large pond in the sunken garden. Local workers were simply unable to position the stone as Isamu wanted. In response to a plea for help Shigemori dispatched several of his apprentices to Paris. The Japanese workmen, however, had been trained rigidly to follow the traditional rules of garden architecture, established over many centuries, and they thought what Isamu told them to do was all wrong.

In Isamu's mind the sunken garden was not a Japanese garden but a garden "to pay homage to the Japanese garden"—and it was also intended to fit with the UNESCO building. Kenzō Tange, who had watched Isamu develop his design, later noted, "My feeling was that inside him the laws of nature were struggling with his goals as a sculptor. It was a conflict between his Japanese orientation and his Western intentions. Gradually the design sloughed off its Japanese elements, but since it had to be called a 'Japanese garden' it did not completely break away from its Japanese-ness."[24]

Isamu recognized the problem himself. "It is a challenge to learn from tradition, and even more so to master it," he wrote. "My effort is to find a way of linking a style that has been passed down by the Japanese from the dawn of history to our own era with the needs of the new era. . . . The spirit of the garden is Japan itself, but the actual composition of the stones, apart from the large stones that follow the 'Hōrai' tradition and the placement of the artificial hill, is all my own."[25] He thought of the UNESCO project as a kind of sculpture but as his use of the term *hanamichi* suggests, he also saw it as a stage where he could apply the concept of space that he had grappled with while designing Martha Graham's stage sets.

Isamu could not explain to Shigemori's apprentices that his artistic goal was to experiment with "a space called a garden." After quarreling with him day after day, they returned to Japan a month earlier than planned, and completion of the project was delayed once again. In October 1958 Shigemori sent Isamu another assistant, thirty-year-old Kiichi Sano, scion of a gardener family that had worked in Kyoto for sixteen generations, who reluctantly left for Paris at the bidding of his father. Isamu had promised to meet him at the airport but when he arrived, carrying cherry tree saplings and bamboo shoots along with his luggage and workman's tools, Isamu was nowhere to be found. In desperation, Sano, knowing not a word of French, hired a taxi into the city. When he arrived at Isamu's place on the Seine overlooking Notre Dame, Isamu was taking an afternoon nap.

Given that introduction it is not surprising that the two men, who had to live together for several months in a two-room apartment, did not get along very well. To make matters worse, Sano found it difficult to survive without Japanese food. He had never prepared a meal in his life, and Isamu never made anything but breakfast eggs and toast. If Isamu's Japanese friends had not invited him to dinner occasionally, Sano says, he might have fled back to Japan right away, but he decided to stay in Paris to make sure that somehow or other the garden conformed at least minimally to the rules of Japanese landscaping. Isamu did not sit by quietly when he tried to do so.

"The Japanese garden is made from a collaboration with nature," Isamu said later. "Man's hands are hidden by time and by the many effects of nature, moss and so forth, so you are hidden. I don't want to be hidden. I want to show. Therefore I am modern."[26] When Sano tried to rearrange the artificial mountain and the layout of the stones, Isamu forbade him to lay a hand on them. He thought of them as modern sculptural elements, not as features of a Japanese garden.

Every day Sano, in his *happi* (working coat), workman's leggings, and *hachimaki* (headband), got into shouting matches with Isamu in his beret and khaki trousers. Sometimes Isamu became so impatient and so frustrated that he shoved Sano aside to do the work himself. The Algerian workmen, who understood not a word of Japanese, simply stopped working and watched. After berating Sano, Isamu would disappear from the worksite, only to return like clockwork two hours later. He had a habit of chewing on the frames of his reading glasses as he thought about something, and after several weeks Sano finally understood that when Isamu glared at him silently while chewing his glasses he was really paying attention to what Sano suggested. In the end, Sano says, Isamu usually accepted any idea that truly improved the work.

When the UNESCO garden finally opened at the end of May 1959 not everyone was pleased with the result. Half of the trees in the sunken garden were young saplings only a few inches in diameter, and the garden's strong Western design elements, rather than its Japanese touches, stood out most clearly. To the Japanese Embassy staff and Japanese artists living in Paris, the "Jardin Japonais" seemed a shabby imitation of the real thing. Reviewers in French art magazines generally agreed. The UNESCO garden might be called a Japanese garden, observed one, but it was basically the work of an American artist.

"If one is going to make something Japanese that is really good, then one must make something that really looks Japanese," Isamu told a Japanese art journal. "But the so-called Jardin Japonais does not do that."[27] A true appreciation of the UNESCO garden, he said, would have to wait twenty-five years until the trees and other plants matured. Despite all the construction problems, and despite the lukewarm critical reception, Isamu still felt that he had learned a great deal during the three and a half years he worked on the project. He had benefited immeasurably from everything he had done—developing the design, raising money, negotiating about the construction, and "fishing" for stones—and he felt that the Japanese gardeners he worked with had taught him much, too.

"I have always treated each new work as a lesson, a curiosity, which leads me—thinking to eliminate one mistake after another till finally—when?—to create greatly," he wrote in his autobiography.[28] His experiments in designing the UNESCO garden became part of his flesh and bone as an artist. They provided the foundation for his later pioneering work on "environmental figurative spaces," as he pursued his dream of producing "man-made spatial oases for the twentieth century" all over the world, and on many stages.

A Great Beginning

"Returning [to New York] I was always struck by the contrasts of America, Japan, and the rest of the world; the difference in materiality, or should one say, the concepts of reality, which is not just a question of place but of the modern world versus the old world—the permanent reality of the past and the fluid reality of the present. I found myself a stranger."[29] After nearly a decade of flying back and forth between Paris, Japan, and New York, Isamu experienced a sense of alienation whenever he returned to the United States. New trends in the New York art world tumbled over one another in rapid succession, and it was difficult to keep "one jump ahead of obsolescence in the modern." But New York, he concluded, was his reality, and he felt a need to associate himself with "the new reality, being born without me."

The "new reality" that Isamu confronted in New York in the late 1950s and early 1960s was the rise of neo-Dadaism and Pop art. Reacting to abstraction's absolute rejection of any concrete images or motifs, the mainstream in American art was shifting to a "reinstatement of reality" that presented the everyday form of things just as they were. Even in the world of

abstract sculpture David Smith, who once worked as a welder in a machine shop, had anticipated the new trends by welding iron scrap, farm tools, and other implements into seemingly free and spontaneous sculptures.

"This is how it was that returning to New York in 1958 I was seized by a great fear that I had lost touch with reality," Isamu later wrote, "and why I was driven to resume once more where I had left off ten years earlier."[30] After the UNESCO garden, his work took a new turn. Collaborating with architects, stonemasons, and international bureaucrats in Paris had drained him psychologically. He was used to working by himself, and now he wanted to return to sculpture. "Sculpture has always been my solace," he later remarked.[31]

"It seemed absurd to me to be working with rocks and stones in New York, where walls of glass and steel are our horizon, and our landscape is that of boxes piled high in the air." In Paris, Isamu had struggled with Japanese stones and Japanese ideas about how to use them. He wanted to disentangle himself from all that by experimenting with sheet aluminum, a new material he thought better suited to the metropolis than stone or clay. Using the workshop of his friend Edison Price, a manufacturer of stage lighting equipment, he wrestled with large sheets of aluminum, cutting and bending them into abstract forms for a show at the Stable Gallery. He worked after hours, often until midnight, and in the morning the shop foreman was impressed that the metal had been crafted into such intricate and complicated shapes without resort to welds or bolts.

When the gallery told Isamu that the aluminum pieces looked too facile and might hurt his reputation, he hurriedly finished some roughly carved Greek marble pieces he had put aside earlier. "I worked with fury in a cloud of dust and chips, in complete immersion, oblivious to everything but my own confrontation with marble." In two months he produced fourteen marble sculptures: "my love and understanding of what was basic to sculpture . . . led me to do what I did."[32] The May 1959 show at the Stable Gallery was intended as an "homage to Brancusi," who had died at the age of eighty-one shortly after Isamu was chosen for the UNESCO project, but the critical response was negative. The consensus was that the new works displayed no new ideas.

Working with sculpture again helped Isamu recover from his three years of trial-and-error experimentations in Paris. With his spirits restored, he

found himself sought after to design exciting new garden projects. "For me the 1960s was a 'great beginning,'" he later recalled.[33]

The person who played an indispensable role in Isamu's "great beginning" was Priscilla Morgan, who was awakened in her Rome hotel room by a jangling telephone early one morning in July 1959. She had gone to bed at dawn after a night on the town with musician and artist friends she had been working with as the American representative at the Spoleto summer music festival. When she lifted the receiver to her heavy head the voice on the other end of the line identified himself as "Isamu Noguchi." She had met Isamu about a month before at an artists' party in New York. His intense gaze, olive skin, and irresistible eroticism immediately attracted her. She knew that he was rumored to be "charismatic" with women, but she was surprised to hear him calling from her hotel lobby. "There is something that I want to discuss with you," he said. As she listened, Priscilla says, she had a premonition that she was to have a "fateful" connection with Isamu but, suffering from a hangover, she decided not to show her face that morning. She promised instead to meet him in Paris in a week or so.[34]

Isamu arrived at Priscilla's hotel on the Place Vendôme as the midsummer sun was setting on the eve of Bastille Day. After dinner at a Latin Quarter restaurant famed for its duck roasted with olives, he invited her to a luxurious apartment overlooking the Seine that a friend had lent him. Priscilla accepted his offer of a brandy. At the first sip she began to choke. "Oh no, that's too bad," said Isamu. "I forgot that I was using the bottle for soy sauce." That after-dinner drink, she recalled, was the "baptism" of her relationship with Isamu. The city was swept up in a carnival mood the following day. In the evening the abstract painter Hisao Dōmoto, his wife, Mami, and several other Japanese friends came by for champagne, and after watching fireworks from the terrace they all went dancing in the streets until dawn. "I was entranced by Isamu's magic," she says, "and it lasted the rest of my life."

Priscilla, now in her eighties, still wears her blonde hair in a casual straight cut. Her inexhaustible energy and bright smile belie her age. Isamu always looked for three things in a woman: that she be under thirty, possess exceptional beauty, and have a career of her own. Priscilla qualified only on the last count. Nearly forty when she met Isamu, she was not a beauty in the conventional sense, but she had established herself as a successful career woman. Her father was an inventor who had worked with Thomas Edison, and she had grown up a member of the East Coast establishment.

Priscilla Morgan

While at Vassar she had fallen in love with a young painter and married
him. To support herself and her husband, who had not yet made a name
for himself, she went to work for an advertising agency. In her early thirties
she was hired by the William Morris Agency, the leading talent agency in
New York City, to take charge of television and film rights.

Isamu knew that Priscilla was a talented and savvy veteran of the
public relations world. At the urging of John Becker, the gallery owner
who sponsored one of his early exhibitions, he was trying to write an auto-
biography. The New York art world was in the midst of a "Japan boom"
sparked by Akira Kurosawa's film *Rashomon* and other cultural events.
"With exhibitions by Japanese painters, woodblock print makers, and
sculptors at first-rate galleries one after the other," the Kyōdō News Service
reported in early 1959, "Japanese art is in bloom."[35] Isamu worried that the
Japanese elements in his own work would be swept up in this temporary
fad, and he wanted his autobiography to explain his unique position as an
artist straddling two cultures. When he called Priscilla in Rome, he wanted
to find out whether she thought the manuscript Becker had reworked from
his oral childhood reminiscences was worth publishing. As he feared,
Priscilla said it was riddled with hackneyed clichés. She urged Isamu to

write about his life in his own words, and she promised to do whatever she could to help him.

After divorcing her first husband, Priscilla had married a composer, then had left him to live with a painter. She used her considerable energy to promote the careers of both. Although Priscilla was attracted to artists, she had never met one as "pure" as Isamu in devotion to his work. He was, she thought, someone worth investing her life in. For nearly twenty years Isamu had entrusted his legal work to Charles Lieb and his financial affairs to Bernard Bergstein. During the UNESCO project he realized that he needed a collaborator to handle business and personal relations, too. Priscilla was only too happy to take on that role. She wanted Isamu to establish the position he deserved in the mainstream of American art, and she thought an autobiography the best first step to help the public understand his unique experience as an artist who transcended national borders from the day of his birth.

Isamu visited Priscilla's apartment on the Upper East Side every day after returning to New York, and they spent the weekends together at Priscilla's big country house in Bucks County, Pennsylvania. Work on the all-important autobiography made little progress. Isamu's powers of concentration were limited in front of a typewriter. "I wasn't born to write things," he told Priscilla with some irritation. "I was born to do sculpture."[36] It was not in his nature to sit quietly at a desk. There were too many other things that he ought to be doing, and the most important was to find a studio.

After giving up his MacDougal Alley studio, Isamu sublet one from an absent friend whenever he was in New York. If the city was to be his main base, he needed a studio of his own. He finally found a possibility across the East River in Long Island City, a dreary looking low-rent commercial district dotted with factories, warehouses, power stations, and small workshops. A small factory building on Vernon Boulevard, a street lined with small iron foundries where Isamu could cast his metal sculptures, was for sale at a good price. Isamu, who had never owned any property, at first hesitated. Buying the building, then converting it into a studio, would cost more than $90,000. That meant taking out a mortgage for the first time in his life.

At Priscilla's urging he finally decided to take the plunge. The concrete block building was about forty feet wide in front and a little more than eighty feet deep. It looked very much like the other small factories and warehouses in the neighborhood. Opaque glass windows under the

roofline offered good natural lighting. Isamu divided the interior into three sections: one for his workplace; one for his living space; and one for storage. To renovate the living space, which also served as an office, Isamu hired Yukio Madokoro, a furniture designer he had met at the Japan Craft Center in 1950, who was now living in New York.

Since the ceiling was high enough to accommodate a crane for moving heavy sculpture, Isamu decided to divide the living space into two floors. In the downstairs section, which Isamu used as working space, Madokoro built bookcases, drawers for drawings and plans, and a cabinet for stereo equipment under the staircase. Upstairs, he installed an American pine floor without using a single nail, and built a raised bed about a foot and a half high. Along one wall, he fashioned a *tokonoma* alcove and installed sliding *shōji* screens with white pine frames over the windows. The upstairs room was very much Isamu's "private space." In the *tokonoma*, he displayed several ceramic works he had made at Rosanjin's estate, some musical instruments he had bought in India and Bali, and an Akari lamp.

Madokoro worked on Isamu's studio for six months, commuting to Long Island City by subway six days a week. He did not find it an easy job. Isamu was always impatient. His hasty instructions to the lumber company were always approximate, and when the ordered material arrived it was invariably the wrong size. The best way to avoid mistakes, Madokoro discovered, was to order lumber in his own broken English. When a splendid cypress bathtub Isamu ordered from Japan turned out to be too big to fit through the front door, Madokoro had to cut it in half, then fit it back together in the bathroom.

A beautiful flat beige-gray stone that Madokoro wanted to use as a stepping-stone for the stairs to the second floor provoked his biggest fight with Isamu. "Are you going to trample one of my works?" Isamu shouted angrily.[37] The "stone" that Madokoro had found in the studio was *The Footstep*, a sculpture Isamu had carved after seeing a stone inscribed with the Buddha's footprint in India. Madokoro stood his ground. If slightly embedded in the floor it would be a perfect place for taking off one's shoes, he insisted. Isamu gave in, and the stepping-stone provided just the right touch for an artist's quarters. "Although the living area is definitely Japanese in feeling," a *New York Times* article noted, "all of the materials used are Western. . . . Their plain and honest good looks contribute greatly to the understated style that is so typical of Japanese interiors."[38]

During the day, Madokoro says, Isamu worked simultaneously on garden-design models and bronze sculptures. At the end of his workday he sat in front of the telephone with a thick address book in hand. His daily routine was to call women friends—dancers in the Martha Graham troupe, actresses in Broadway musicals, museum curators, and gallery assistants—until he finally found one willing to accept an invitation to dinner. Madokoro was impressed by Isamu's persistence, but he thought that the middle-aged bachelor, already in his mid-fifties, must be a lonely person. When Madokoro occasionally advised against getting involved with one of the Japanese women he called, Isamu always replied, "It's just for fun. Don't bother me about my girlfriends." But when Madokoro told him that his "girlfriend Morgan-san" was on the phone, Isamu was visibly irritated. "She's not my special girl-friend," he insisted. Madokoro guessed that despite Isamu's protest "Morgan-san" played a very important role in his public and private life.

The unenthusiastic reception of Isamu's Stable Gallery show was not due entirely to Isamu's choice of materials or his lack of new ideas. Many thought that he had become a garden designer rather than a sculptor. He was criticized for straying from his role as a "true artist." The sculptor David Smith often told him, "You're foolish to work with architects." [39] Isamu later observed that most sculptors, including David Smith and Henry Moore, did not like architects because they thought that a sculptor had to compromise if he worked with one. Isamu, on the other hand, felt that a sculptor in effect abandoned his work if he paid no attention to how or where it was displayed. "The question is not whether or not the sculptural work is made with the goal of being put to use," he said, "the question is whether or not the work lives and whether it gives life to the space around it." [40]

A design project for the First National City Bank in Fort Worth launched Isamu's "great beginning." Like his unrealized garden for the Lever Brothers Building on Park Avenue or his work on the Connecticut General Insurance Company in Hartford, it was a collaborative project with Gordon Bunshaft, the chief architect of Skidmore, Owings and Merrill. "It is due to [Bunshaft's] interests that projects were initiated, his persistence that saw them realized, his determination that squeezed out whatever was in me," Isamu later wrote. "Indeed, I am beholden to him for every collaborative architectural commission I have been able to execute in the United States." [41]

From the late 1950s the firm of Skidmore, Owings and Merrill designed thirty-eight high-rise office buildings that symbolized the postwar boom of corporate America. As an architect, Bunshaft, a devotee of modern sculpture who later bequeathed his collection of twentieth-century sculpture to the Museum of Modern Art, was ahead of his time. He saw sculpture not simply as decoration but as a functional part of the whole structure of a building. From the early design stages he worked with Isamu to create artistic spaces and sites of repose in his austere glass and steel high-rise office buildings

"Noguchi is one of the two or three greatest sculptors in the United States," Bunshaft said in 1968. "I know a lot of people think he's commercial. People are used to thinking of an artist as an artist, ivory tower and all that. In the Orient, it's different. There's no separation to the arts. A pot can be as important as a painting. The thing about Noguchi, he's one of the few artists in the world who understands architectural space. Very few design to scale, to a space enclosed by building."[42]

Bunshaft understood that Isamu's dual identity deepened his artistic sensibility. He worked with Isamu not only on the First National Bank in Fort Worth, but also on the headquarters for Chase Manhattan Bank on Wall Street, the Beinecke Rare Book and Manuscript Library at Yale University, and the IBM Headquarters in Armonk, New York. The two men were equally intense, but Isamu found Bunshaft "most easy to collaborate with" as a working partner. Their collaboration allowed Isamu to work on a series of epoch-making projects that profoundly transformed the meaning of the "garden" in contemporary life.

Priscilla Morgan oiled the gears of Isamu's relationship with Bunshaft, acting not only as Isamu's agent but also as his spokesman, his messenger, his protector, his comforter, his secretary, and even his errand girl. She was the only person to whom he revealed his real feelings or to whom he could turn for help in a crisis. "What a delight it is to get your letters," Isamu wrote her from Tokyo in May 1960 as he began work on the Fort Worth project.[43]

> I wish you could sound out Gordon as to how serious he is about my coming back there for July. I ask this since I have just heard from Skidmores [sic] Chicago firm that Gordon had been out there and had induced them to scrap the fountain design I had made for them. . . . I had done all of this for free, and for them to so easily dismiss and tell me to start all over again still with no pay is unfair. I feel that any time spent away from sculpture proper

should be at least well paid or I should not touch it—Gordon knows this, and he should not urge me to spend my time fruitlessly. On second thought maybe better not to speak to Gordon about this since it will make him mad. I must say I see no way of cooperating with architects who don't know their own mind [*sic*]. . . . [Y]ou are like a fountain of enthusiasm—I would soon become so dependant [*sic*] that I would dry up without its constant flow.

Isamu had gone to Japan to "fish" for stone for the First National City Bank project. He stayed with Kiichi Ichikawa, a well-known movie producer with a wide circle of professional connections, who investigated what material was available and where it could be found. The country was in the midst of a political crisis over the ratification of a renewed Mutual Security Treaty with the United States, and the streets of Tokyo were filled with demonstrations and tear gas. Isamu was oblivious to it all as he wandered the countryside. He knew that Bunshaft was testing him, and he wanted to find just the right stone for the project.

Clients often complained about how expensive it was to bring stone from Japan to the United States. "Why not use American stone?" they asked Isamu. "Why take the trouble to ship stone from Japan?" He always answered that he used only Japanese stone out of artistic necessity. But he explained himself differently when a Japanese reporter asked him the same question in 1960. "It's because I like Japan, you know. From time to time I arrange the convenience of my work so that I can come to Japan. . . . It is too expensive for me to come to Japan just for pleasure," he replied. "So you add your travel and living expenses to the price of the stone, I guess," asked the reporter. "Yes, that's right," he answered with a laugh. "So my work is not cheap."[44]

With Ichikawa as his guide Isamu found a twenty-ton rough-textured piece at Mount Tsukuba north of Tokyo. He fashioned it into three abstract sculptures that evoked the shape of the cylindrical cacti that dot the southwestern Texas landscape. The ensemble was arranged to unify an awkward narrow triangular space in front of the twenty-story glass-walled bank building. When Bunshaft saw how adroitly Isamu attuned this modern stone garden to its Texan setting, he asked him to design gardens for the Chase Manhattan Bank and the Beinecke Library.

From 1960 onward Isamu spent several months every year "fishing" for stone in Japan while Priscilla Morgan took care of his affairs in New York. "[A]ll your careful attention to detail leaves me full of admiration

and gratitude," he wrote her in August 1960. "I wish I had even a small portion of your precision—I'm so sloppy, about most things, that is."[45] Priscilla displayed a rare ability to plan and manage all aspects of Isamu's life down to the smallest detail. In her effort to secure him recognition as a "great American artist," she sometimes pushed too hard. To cultivate connections important to his career, she often threw intimate dinner parties at her New York apartment or her house in Bucks County. She always sat at one end of the table while Isamu sat at the other—like husband and wife. The arrangement irritated Isamu. If the guests were important he kept himself under control, but if they were close friends he usually exploded angrily in the middle of dinner, finding some trivial fault with Priscilla. She knew that he was thinking to himself, "Why should someone neither young nor beautiful be sitting there like my spouse?" His eyes could shine beautifully "like a wild African beast," she says, but when he was angry they "flashed as though he were hunting prey."[46] Once a quarrel began Isamu could not stop, and Priscilla would retreat into the kitchen, leaving the guests behind, until the storm passed.

Although Isamu was rude toward Priscilla in front of others, like a child testing his parent's patience, he phoned her several times a day to consult with her about everything. When he greeted her "Priscil-LA," with the stress on the last syllable of her name, she knew he was in a good mood. His childhood experience made him feel insecure with others, she says, and she knew that security was what he wanted from her. "Isamu's personality was endlessly complicated," she says, "but at the same time he was as pure and simple as a child. Just when you thought no one could be gentler, at the next moment he could suddenly explode like a tornado or a hot-water heater. He had a terribly uncontrollable temper. Even so, he was exceptional in his great pride as an artist and in his honesty toward people. I was always surprised by his fresh way of looking at everything. After some unforgivably selfish behavior of his, my heart would melt at some casual remark he made with his peculiar dry humor—and at the wonderful smile he made when we were together by ourselves."[47]

Priscilla became more deeply involved in Isamu's life than he had anticipated. She was indispensable to him, and he knew it. Since he had brought the situation on himself, it is not surprising that he vented his frustration at being so dependent on her. He knew that he was taking advantage of Priscilla's affection. That may have made him accept her "vol-

untary help" all the more grudgingly. But the more he depended on her well-honed skill at dealing with his business affairs, the less he became interested in her as a woman. Once he asked in a strangely puzzled way, "Why are you so devoted to me?"[48]

Early in their relationship Priscilla realized that neither she nor any other woman would ever monopolize Isamu's affections. Even so, whenever Isamu left for Japan, she was often seized by an uncontrollable anxiety. His other country was too far away. It was a land beyond the reach of her control.

From September 1960 Isamu spent two months wandering along the Uji River on the outskirts of Kyoto to hunt for stones for the Chase Manhattan Bank Headquarters, a towering high-rise huge even by Wall Street standards. Bunshaft's architectural team defied conventional wisdom by putting the lobby on an underground floor reached from the entrance by escalator. A circular well walled with clear glass windows in the middle of the lobby let in light from the outside. Isamu designed a "sunken garden" that pedestrians could view from above as they walked across the plaza in front of the building. The floor of the well was covered with small paving stones contoured in spirals like carefully raked sand in a Zen garden, and seven rocks from the Uji River were arranged in an symmetrical pattern to evoke "the sea with waves crashing on the rocks." During the summer the well filled with water, and during the fall and winter it was dry like a Japanese rock garden. "It is my Ryuanji, as it were," Isamu said of this masterpiece, alluding to the famous pebble and stone Zen garden at the Ryōanji temple in Kyoto. As with the UNESCO project he did not intend to create a Japanese garden but wanted to convey a sense of nature to soothe and comfort workers in this looming citadel of world finance. In that sense, he later wrote, the UNESCO garden served as "a study, and a tribute" for the Chase Manhattan Bank garden.[49]

Two Little Giants

Priscilla's happiest memories of her relationship with Isamu are tied to Spoleto, the medieval Italian town where she co-produced an annual summer music festival for sixteen years. Using Priscilla's apartment there as his roost, Isamu spent at least a month in Italy every year after 1961. Through his work with Martha Graham he had gotten to know many of the musicians and dancers at the festival, like the avant-garde composer John Cage

and the choreographer Merce Cunningham. He enjoyed reacquainting himself with them in relaxed surroundings far different from the hectic life in New York. He also met and deepened his friendship with the poet Ezra Pound, whom his father Yonejirō had met many years before in London.

Italy was a stimulating place for Isamu to work. He spent the summer of 1962 crafting bronze sculptures in a studio at the American Academy in Rome. Living in the city offered an opportunity to study urban public spaces. "In every Italian city there is a space called a piazza from which the streets radiate out. These do not have the 'spirituality' of the Japanese garden, but the relationship between the townspeople and the piazza was thought out with extreme care. I began my work on gardens, thinking that I wanted to complete a 'space for leisure' by adding 'spirituality' to such a space."[50]

After his summer in Rome, Isamu began visiting the famous marble quarry at Carrara. The sculptor Henry Moore, whom Isamu had met while working on the UNESCO garden, introduced him to Erminio Cidonio, the president of the Henraux Quarries, and the owner of Mount Altissimo, where Michelangelo had procured marble. Cidonio wanted to restore the Carrara district's lively past as a center for artists. He had offered well-known sculptors like Henry Moore, Marino Marini, and Jean Arp studios whenever they liked—and he provided the best stonecutters to help them. The massive marble chunks cut from the quarries fascinated Isamu, and the nearby town of Pietra Santa, where Michelangelo once lived and worked, enchanted him. Artists from all over the world, some famous and some not, congregated there. Isamu began to work at Pietra Santa every year, carving marble pieces in one of Cidonio's studios and casting bronze works at a foundry Cidonio recommended.

In September 1962, just after Isamu had returned from Italy, Gene Owens, a thirty-one-year-old sculptor, arrived at his Long Island City studio. A brawny Texan with the look and physique of a cowboy, Owens had received a master's degree in sculpture at Texas Wesleyan College in Fort Worth, then taught stonecutting and metal casting at his alma mater. When he saw Isamu's assemblage of stone "cacti" at the First National Bank, he decided to devote himself full-time to sculpture—and he hoped to work with the artist who had made them. In May he wrote Isamu offering to "accept any type of work available" if he could serve as Isamu's assistant.[51]

As a rule Isamu, like Brancusi, did not hire assistants. When he absolutely needed help for his large-scale projects with Gordon Bunshaft,

Isamu at the Spoleto Festival with Ezra Pound (left) and Buckminster Fuller (middle), 1967

he hired young Japanese would-be sculptors studying in New York. "Never have I had an assistant so experience [*sic*] as you," Isamu replied to Owens, "but the few I have had have all been beginners. Just now I have none. Having none constitutes a kind of freedom, a freedom to think at least if not so good for work."[52] But he needed someone to help with his next big project, a "marble garden" for the Beinecke Rare Book Library at Yale University, and he offered Owens a job as an assistant. Leaving his wife, a schoolteacher, and his eleven-year-old son in Fort Worth, Owens settled into a cheap Greenwich Village hotel and commuted every day to Isamu's studio to help work on the Beinecke Library project.

Like the Chase Manhattan Bank garden, the Beinecke Library garden was a sunken garden that could be viewed from ground level as well as from an underground reading room for scholars using the library's collection. The Chase Manhattan garden, nestled under the towering bank building, was circular and used natural Japanese rocks and stones. By contrast, the Yale garden was rectangular and paved with white Vermont marble incised with abstract geometric patterns. In the middle stood three

symbolic sculptures fashioned from the same white marble—a spherical *White Sun*, a low pyramid, and a cube mounted on one tip—all dazzlingly brilliant in the direct sunlight. The design was inspired by what Isamu had seen on his travels abroad. "The idea started from the sand mounds often found in Japanese temples," he wrote. "But soon the image of the astronomical gardens of India intruded, as did the more formal paving patterns of Italy. It became a dramatic landscape, purely imaginary; it is nowhere, yet somehow familiar."[53]

While working on the Beinecke garden, Isamu was simultaneously designing another garden for the IBM Headquarters in Armonk, New York. The IBM garden, visible from all the building's interior offices, was divided into two courtyards separated by a three-story glass-walled bridge. One courtyard was to "provide rest for the soul" for the employees of the high-tech company, and the other to provide "stimulus for the brain." The first, representing "mankind's past," was composed of trees and rocks arranged around a pool fed by water trickling down one of the rocks; the second, representing "mankind's future," was filled with scientific-looking abstract forms—a pyramid, a concave red fountain, a black dome inscribed with scientific diagrams such as constellations and atomic symbols, and a bronze sculpture with two interlocking helixes.

To Owens, who had grown up easygoing on the Texas plains, Isamu was a "complicated personality," but always kind. Whenever they were driving, or having a meal together, or going to art galleries on weekends, Isamu was always ready to answer any question that popped into Owens's head. "People all have their own 'Gardens of Eden,'" Isamu said, explaining his philosophy of garden design on a drive to New Haven one day. "I don't try to make a perfect garden. In all my gardens there is something a little off balance somewhere. But isn't that like life? There is no such thing as a perfect life."[54] While creating his "Garden of Eden" at Yale, Owens recalled, Isamu kept changing his original plan. He did not like to be constrained by his first design, and as the work proceeded, he constantly tried to improve it. Like the IBM garden, the Beinecke Library garden differed from the initial model in many details.

Although Isamu used the latest Western technology in his gardens, his work reflected his Japanese sensibility, too, according to Owens, and whenever he returned from a trip to Japan that sensibility became more pronounced. Isamu never talked much about Japan, about which his feel-

ings seemed quite complicated. His favorite topic was what he had seen and done in India and Italy. Knowing little about the world outside of Texas, Owens was never tired of hearing tales about Isamu's travels around the world and about his many friends abroad. To his surprise, wherever they went, Isamu often met someone Owens never imagined that he might know. Once on a visit to a Long Island City foundry, for example, Isamu introduced him to a distinguished-looking gentleman who greeted him as they came in. "This is Professor Robert Oppenheimer," he said. Oppenheimer, an amateur sculptor, was working on a bronze piece. He asked what Isamu thought of it. Isamu replied, "If you promise to make no more sculptures like that one, I will give up the idea of trying to make an atomic bomb."[55] Isamu was, above all, an "honest man," says Owens.

When Isamu met Gordon Bunshaft for lunch or dinner, Owens often went along. The two men never talked about anything but business. Although they pulled no punches as they exchanged opinions, says Owens, they never fought. Isamu kept himself under control because he knew that Bunshaft respected his talent and was doing all he could to give it full play. He had a high regard for the architect's business acumen—and he appreciated it.

During his "great beginning" the only big garden project that Isamu undertook without Bunshaft's collaboration was a commission for the showman and businessman Billy Rose. It was also the only project on which Priscilla did not serve as a buffer between him and his client. Owens sensed that Isamu's relationship with Rose was a difficult one. Whenever Isamu was on the phone with Rose, he says, his expression was grim, and he made no effort to hide his emotions. Indeed, he often angrily shouted into the phone.

"A showplace for modern art in Jerusalem, including its garden setting and sculptural contents, has been donated to the National Museum of Israel by Billy Rose," the *New York Times* reported on January 23, 1960. "With his gift to the museum, Mr. Rose is donating the services of Isamu Noguchi, the Japanese-American sculptor and landscape designer, whom he has commissioned to plot the garden setting."

Born into a poor, Jewish, immigrant family in the New York slums, Billy Rose had raised himself from poverty, making a name for himself first as a Broadway songwriter, producer, and theater owner, then as a daring and skilled speculator on Wall Street. He began his career during World War I as a stenographer for Bernard Baruch, the Wall Street wizard

heading the War Industries Board, who later advised Rose on his investments. As his fortune grew Rose assembled an art collection that included works by leading late-nineteenth- and early-twentieth-century sculptors like Rodin, Maillol, Epstein, Lipchitz, Daumier, and Zadkine.

It is said that when Rose lost money in the stock market he recaptured twice the amount the next day. He had built his art collection the same way, buying what he wanted without asking the price. It soon grew into one of the finest privately owned sculpture collections in the world. When Rose announced his decision to donate the collection to the new National Museum of Israel in 1960, the new Jewish homeland was barely a decade old. Although the National Museum was conceived on a grand scale, including not only a national art gallery but also a Shrine of the Book to house the Dead Sea Scrolls, its collection boasted few works of modern art. Rose's donation of a modern sculpture garden was a heaven-sent gift.

Isamu took on the project just as he was starting work on the Chase Manhattan Bank garden. He later recalled his delight at receiving the commission: "How many chances does one have to do such cosmological work, let alone earthworks?" At first, however, he had turned the unusual opportunity down flat. "Why should a sculptor concern himself with the display of any sculpture other than his own?" he thought to himself.[56] He did not entirely trust Billy Rose either. When Isamu spurned his offer Rose persisted. He was obsessed with creating a "world-class sculpture garden" as his legacy to the promised homeland of the Jewish people, and he was convinced that no one could design it better than Isamu Noguchi, who had been chosen to decorate the UNESCO headquarters. Rose invited Isamu to visit the museum site in Israel before he said a final no. He told him that someone who had "voluntarily incarcerated himself in a War Relocation Camp could not refuse such a challenge." "I must say that his saying this intrigued me into accepting," Isamu recalled. "Those who object to segregation often feel that Israel itself is a protest and a haven against it."[57]

The National Museum was to be located on a hilltop in a newly developed section of Jerusalem. Construction on the building housing the Knesset and the Hebrew University campus had already begun nearby. The site, Neva Shaanan, was mentioned in the Old Testament. The name, Rose explained, meant "place of tranquility." A five-acre plot covered with sand and strewn with rock had been set aside for the Billy Rose Sculpture Gar-

den. As he stood looking down the gentle slope of the hillside, Isamu thought to himself that the barren space was "a challenge indeed." Just as the scorched earth left by the atomic blast in Hiroshima had moved him, the rugged hilltop offered him an opportunity worth the risk. He decided to take on the job "out of respect for the place and people of Israel."

"I hoped to create an undulating and walkable landscape, something memorable born out of the adversity of the terrain." To take advantage of the undulations in the natural slope of the hillside, Isamu planned to divide the site into five sections on different levels like a terraced field of rice-paddies. Each section was to be set apart by curved retaining walls built from rough stones excavated from the site, using traditional Japanese techniques for castle-wall and moat construction. Each section was a "platform" to display sculptural works. "Sculptures are to be seen in three or more dimensions as we walk up and down as well as around, near or at great distances. . . . This sculpture garden is a setting or a stage where the disposition of sculpture will help define its purpose—to enhance its drama, that is—as a living experience."[58]

On the plane back to New York, Isamu formulated his grand concept for the garden. Three weeks later, on February 1, 1960, he signed a contract. He insisted on full aesthetic control, and he asked for round-trip first-class passage between New York and Israel as well as living expenses while staying in Israel, a working fee of $3,000 a week during the design phase, and $2,000 a week during the supervision of construction. Isamu set these conditions, including the high fees, to test Rose, who accepted them all without complaint. That did not mean a victory for Isamu, however. His struggles with Rose were just beginning.

Billy Rose donated money to the Israeli government through the America-Israel Cultural Foundation, a Jewish-American organization. Elaine Rosenfeld, then thirty-one years old, was hired to manage the project. Her unruffled calm kept it going despite the constant discord that plagued it from the start. Even before construction began Frederick Kiesler, who designed the Shrine of the Book, complained about the stone retaining walls Isamu intended to build next to his flamboyant onion-domed structure, and as work on the main museum galleries progressed, the elevation of the museum's front plaza, next to the entry to the sculpture garden, kept changing. Every time it shifted, Rosenfeld had to soothe both Isamu and the architect.

Her main job was to mediate between Isamu and Billy Rose when they got into one of their frequent fights. Since Isamu insisted on complete artistic control, he thought that Billy Rose would not involve himself in the project, but Rose expressed his opinion about everything as the work progressed. After leveling of the site began in 1961, Isamu visited Jerusalem three or four times a year. Rose always came along with him. The relationship was strained. Rose delayed payments to contractors if he was not satisfied with what Isamu was doing. His disagreements with Isamu, Rosenfeld says, were not always unreasonable. Whenever Isamu visited the site, he changed his plans. In the original design, for example, stone for the retaining walls was to be excavated from the site, but Isamu suddenly decided that he wanted to use brown granite from the Timna valley in southern Israel instead. Rose exploded when he heard about the change. The rocks would be too expensive to transport, he complained to Rosenfeld, and he wasn't "crazy enough" to give his approval.

As construction neared its final stages, Rosenfeld sent Yohanan Beham, the museum director, a desperate message: "Isamu is hoping to leave for Japan around September first. . . . Before leaving New York, Isamu would like a clarification as to whom he will be working for: Billy or the Museum. He feels it will be easier for him to make his recommendations to the Museum. . . . He also indicated that if he works for the Museum, and if Billy is out of the project altogether, he will charge one half of his usual cost; but if Billy reimburses the Museum he must charge the regular rate."[59]

The most serious fight between the two men erupted over how to exhibit figurative sculptures, especially those by Rodin. The Orthodox Jewish community objected to displaying human figures openly in the garden. Rose proposed to solve the problem by building separate "rooms without ceilings" next to the main museum building to prevent the sculptures from being exposed to everyone's view. Isamu objected at first but ultimately he was forced to agree. He was not happy about doing so. Constantly grumbling about Rose's interference, he devised geometrically shaped concrete walls that provided each figure sculpture its own enclosed space. "I am afraid that I have compromised in making changes which I should not have," he wrote when the project was completed.[60] In the end, however, the Billy Rose Sculpture Garden was hailed as "a new kind of open air architecture" and "a unique setting for sculpture."[61]

Despite his frequent disputes with Rose, Isamu's enthusiasm never flagged. Rosenfeld felt that Isamu thought he was doing the most important work of his life in Israel. Even during the fight over how to display human figures, she never heard him threaten to quit. For his part Billy Rose never wavered in his belief that Isamu was the best to realize his dream of building a "world-class sculpture garden" bearing his name. But Rose did not want other people to waste his money, and he wanted the last word on expenditures. Isamu's travel bills always irked him. He spent most of his day studying stock market returns on a ticker tape machine in the study of his mansion on 93rd Street. Whenever Rosenfeld got a call from Rose it was always at 4:00 PM after the New York Stock Exchange closed. "Elaine, come over right away!" he would shout. When she arrived, he would be poring over Isamu's expense account, complaining about the airfare to Israel. Isamu always downgraded his first-class ticket to economy class and used the money saved for a fare to Japan. Rose could not bear the thought that Isamu charged full airfare to the Israel project while working for someone else in Japan.

Two months before the opening of the museum, Rose confronted Isamu directly. Knowing that Rose was preoccupied with his Broadway affairs at the end of the year, Isamu visited the construction site alone. "You went from Japan to Israel without my knowledge, without my authorization and with the work virtually at a standstill for reasons which you well knew," Rose wrote angrily. "I do not believe that it is right for you to bill me for the greater part of going to Japan on personal business and returning to New York. The rest of the bill, of course, is okay and if you agree with me about the matter of transportation, I shall be glad to forward my check immediately."[62]

"Billy is shorter than me even in his elevator shoes," Isamu told Rosenfeld, "but he thinks he's a bigger man than I am." "The two little giants fought so hard . . . [each] hated the other's ego," Rosenfeld says, "but they were a good match for each other."[63] Teddy Kollek, chairman of the Committee to Establish an Israel National Museum, also mediated clashes between them. Kollek, who served as mayor of Jerusalem for twenty-eight years, was a politician legendary for his diplomatic skill at negotiating disputes between the Jewish and Palestinian populations. Even he was appalled at how Isamu and Rose behaved toward each other. "Dealing with

these two little dictators was awful," he says. According to Kollek, at the end of every day Isamu would shout, "I'm quitting! I'm going back to New York!" and then retreat to his room in the King David Hotel, but the next morning he was always back on the site charging ahead.[64]

The sculpture garden finally opened on May 11, 1965. The most expensive, and most visible, section was the stone wall at the entrance. It was built, as Isamu had wished, with granite from the Timna valley, and on top he had placed one of his own works, *Tsukubai* (*Water Basin*), a sculpture about eight feet long and three feet thick fashioned from the same granite. The sculpture's rough stone surface radiated the energy of the Israeli landscape. Like the wellspring of hope the Israelis gambled their fate upon, a stream of water flowed from the top of the stone through deep furrows boldly chiseled on its sides, then disappeared slowly into the earth as it trickled toward the bottom of the wall. By making the sculpture a "gift" to the museum Isamu cleverly secured the highest and most prominent site in the garden for his own work without upsetting Billy Rose or provoking his complaints about cost.

"Jerusalem," Isamu said, "is an emotion shared by all of us. It gains new meanings, and it is my hope that the garden, and the museum of which it is a part, will come to be a very integral part of this new image—acropolis of our times."[65] At the opening ceremony Rosenfeld, who had patiently stood between the "two little giants" with their gigantic egos, thought to herself that thanks to Billy's complaints, Isamu had created a "splendid masterpiece on [the] Biblical hilltop."[66] The garden, she says, reflected the "best side" of both men. Isamu's initial plan, for example, called for planting many varieties of trees and shrubs. Rose objected that it was too expensive, but as a Broadway producer, he also knew how a stage should look—and he thought Isamu's plan too cluttered. His complaints grated on Isamu's nerves but prompted him to step back and look at the project from another perspective. Confronting Rose's objections even on small things spurred him to improve the design.

Rosenfeld saw another side to their relationship, too. When architects for the main museum building demanded changes in the garden design, Billy Rose always backed Isamu. The tug-of-war between the two men was a struggle to achieve a legacy for both of them—"a sculpture garden beyond comparison in the world." The result was a simpler and bolder

creation, synthesizing elements from Japanese culture on the soil of Israel in a completely natural manner. Billy Rose poured his last energies into the sculpture garden. Less than a year after the opening ceremony he died of pneumonia at the age of sixty-six. Isamu undertook the role of the garden's guardian after his death. When bombing during the third Arab-Israel War in 1967 damaged part of it, he flew to Jerusalem as soon as the cease-fire was concluded, and he visited the garden every few years until his death to oversee the placement of new acquisitions added to the core collection.

Today the Billy Rose Sculpture Garden has become one of the world's largest collections of modern sculpture. Teddy Kollek, still active as the chairman of the museum's founding committee, speaks warmly of Isamu as a friend of Israel. "Isamu took splendid advantage of the chance of a lifetime," he says. "Like Kiesler's Shrine of the Dead Sea Scrolls, he gave something of eternal value to an Israel that was still culturally undeveloped."[67] Of all his large projects during his "great beginning," the Billy Rose Sculpture Garden was the most time-consuming, but once he signed the contract, Isamu always gave it first priority.

In 1965 Isamu received a gold medal from the New York Architects' League for the Beinecke Rare Book Library garden and the Chase Manhattan Bank garden. Three years later, once again in collaboration with Gordon Bunshaft, he designed *Red Cube*, a monumental vermilion steel sculpture, for the plaza in front of the Marine Midland Bank, about a block or so from the Chase Manhattan Bank. It resembled the white marble cube in the Beinecke garden. "The cube signifies chance, like the rolling of dice," he explained. "If the 'sun' [in the Yale garden] is primordial energy, the cube is that man-made pile of carbon blocks by which he had learned to stimulate nature's processes. The cube on its point may be said to contain both earthly square and solar radiance."[68] Among the many public sculptures that brought life to the sunless, skyscraper-lined streets of lower Manhattan, *Red Cube*, delicately balanced on one end, always seems to delight passersby.

During the 1960s Isamu worked on many large-scale projects. His successes were mixed with failures. One of the latter was a plan for a playground on Riverside Drive in upper Manhattan that he co-designed with the architect Louis Kahn. Mrs. Thomas Hess approached Isamu

with the idea of donating a playground to the city of New York. Several years before, she had offered to finance a park on the United Nations Plaza but the plan had died in the New York City Parks Department. To avoid repeating this unfortunate experience, Isamu wanted to involve a well-known architect to keep the Parks Department at bay. He chose as his partner Louis Kahn, thought by many to be the most talented American architect since Frank Lloyd Wright. Kahn "could not have been a more devoted and interested collaborator," Isamu later recalled, but he was very different from Gordon Bunshaft, who usually let him do what he wanted. By the time they had worked out a design that satisfied them both, the city government changed and the new administration cancelled all the projects its predecessor had launched. Once again Isamu's dream of building a playground in New York, which began with his 1932 *Play Mountain*, ended in failure. Nevertheless he profited from working with Kahn. "I came to feel that each meeting [with him] was an enrichment and education for me."[69]

Isamu was less philosophical about another of his unrealized projects, a design for the tomb of President John F. Kennedy in Arlington National Cemetery. This failure was a source of endless disappointment to him. The architect John C. Warnecke, a longtime friend of John F. Kennedy, was chosen to design the tomb, and a committee that included Jacqueline Kennedy and John F. Kennedy's sisters had final approval over the plans. Eunice Shriver thought that the tomb should express "the concept of Resurrection and an uplifting feeling" that Brancusi's *Bird in Space* represented. The committee turned for advice to Brancusi's student Isamu, whom they thought "one of the few contemporary sculptors who has a great ability to handle stone, granite and marble in a contemporary medium."[70] His judgment as a landscape designer was also important to the overall design of the grave. Isamu later said that he "was honored to be asked, and appreciative of the opportunity to contribute my best in acceptance and recognition as an American."[71]

Though busy with the final stages of the Billy Rose Sculpture Garden and the Beinecke Library garden, Isamu immediately produced several designs, including one that attempted to capture the spirit of Michelangelo's *Pietà* in an abstract idiom. He consulted with Warnecke on several visits to Washington, but the two disagreed over the inclusion of an "eternal flame" in the overall design. The flame was such a powerful symbolic

element that Isamu felt that it would overwhelm the sculptural features of the tomb.

Final plans for the Kennedy Memorial were announced in November 1964, a year after the president's death, but just a month earlier Isamu had dropped out of the project that he had "wanted to do as an American." He told the *New York Times* that he had disagreed with Warnecke over the issue of "artistic integrity." He worried that the architect would use his ideas but distort them. "He wants to be the genius," he added, "he doesn't want to do the work, but he gets the credit. . . . You can not treat an artist like an office boy."[72] The Kennedy project, unlike his continual disputes with Billy Rose, not only consumed his energy but left him with yet another deep psychological scar. "I could not help feeling that I had been rejected by America as I had been by Japan with the Hiroshima *Memorial to the Dead.*"[73]

Isamu's autobiography, *A Sculptor's World*, was published in 1968. Most of its 259 pages were devoted to photographs of his work. The autobiographical section was only thirty pages long. He had finished the manuscript several years before at Priscilla's urging, but publication was delayed for nine years because of a dispute with John Becker, who had ghostwritten his first attempt at autobiography. Isamu was ready to give the whole project up and burn the manuscript, but Priscilla eventually succeeded in resolving the dispute amicably. Astutely she asked Buckminster Fuller, by now a well-known name in the world of design, whose geodesic dome was adopted by the Montreal World's Fair in 1967, to contribute a foreword to the book.

"Isamu and the airplane were both born in the United States in the first decade of the twentieth century," Fuller wrote. "At two years of age, Isamu 'took off' or was taken off by his Japan-bound mother in what has since proved to be a half century of continuous world peregrinations. . . . As the unselfconscious prototype of the new cosmos, Isamu has always been inherently at home—everywhere. . . . In my estimation the evoluting array and extraordinary breadth of his conceptioning realizations document a comprehensive artist without peer in our time."[74]

As if to substantiate Fuller's claim, a retrospective show of Isamu's four decades as an artist opened at the Whitney Museum of American Art just as the autobiography was reaching bookstores in the spring of 1968. The show included sixty-eight pieces of sculpture, beginning with early pieces

heavily indebted to Brancusi, and including a range of works in aluminum, bronze, Carrara marble, and Japanese granite that demonstrated the diversity in his choice of form and materials. Eight models of his stage sets were also on display, and the walls were hung with large photographs of his major garden projects—the UNESCO garden, the Billy Rose Sculpture Garden, the Chase Manhattan Bank garden, and the Beinecke Rare Book Library garden. But Isamu complained to a reporter, "How can it be a retrospective? There will be no drawings, none of my lanterns or furniture, none of my terra cottas. It's simply a cross section from various periods."[75]

The Whitney Museum's decision about what to exhibit, and what not to, reflected the art world's evaluation of "Isamu Noguchi." In a six-page *New York Times Magazine* article on the exhibition, art critic Harold Schonberg observed that at a time when avant-garde sculptors were brandishing welding torches, hammering wooden boxes, putting pieces of scrap metal together, or molding humans for plaster casts, Isamu Noguchi remained a "throwback." "He is, basically, a carver as Michelangelo or Donatello were carvers."[76] Pop art, Op art, and Minimalist art were the hot new trends in the visual arts during the 1960s, and the concept of "environmental art" was beginning to take hold, but even in the midst of these new directions in the art world Isamu remained, as he always had been, an artist hard to categorize. Critics still saw him as an exotic creature, immersed in both American and Japanese culture. He was pigeonholed in a racial category—"Once an Oriental, always an Oriental"—as he had been since his debut as an artist forty years before.

Isamu's autobiography, especially his account of an upbringing that seemed unique even to readers in a country of immigrants, did little to change this view. He did not succeed in deepening public understanding of his artistic diversity by recounting the story of his life as someone destined from birth to "cross borders." On the contrary, the autobiography may have encouraged even more misunderstanding. Schonberg, for example, described Isamu as an "unhappy" man, rejected first by his father in Japan, then by a mother who sent him away to America, and then by his own country during World War II.

"Deep down, Noguchi gives the feeling that he is a bitter and even frustrated person," Schonberg observed. "He probably has more work around New York than any other contemporary sculptor; he makes a great deal of money through his alliances with architects; . . . His work is repre-

sented in all the museums that count; he is highly regarded in artistic circles, and even the critics have found [it] in their hearts to praise him. But he has removed himself from many of the contacts most other artists enjoy, and he does a certain amount of brooding. He has never taken failure lightly and was particularly disturbed at the rejection of his designs for a memorial to the dead in Hiroshima and for President Kennedy's tomb."[77] By the 1960s the body of Isamu's work entitled him to be regarded as a "giant" in American art, but he left critics with the impression that he remained a "tortured artist" suspended between two different cultural worlds.

Isamu in the "circle" at Mure, 1969

Encounter with a Stonecutter

Mure

"I've been at it, the big stone, which takes shape on some earth fill in the bay of the village of Aji on the island of Shikoku in the inland seas," Isamu wrote Gene Owens in May 1968. "Indescribably beautiful at this time of year—or any time still, for it is not spoiled. The houses are as they always have been."[1]

The village of Aji, and its neighbor Mure, lie on the outskirts of Takamatsu City, not far from Yashima, the site of a famous battle described in the medieval warrior epic, the *Tale of Heike*. East of the villages is Gokenzan, one of Japan's three great stone-producing regions, where about seventy quarries operate today. The local granite (*ajiishi*) is the finest in Japan. The stone is extremely hard, it weathers well, and its surface can be polished to a high gloss. The stonecutters who work the granite live in the two villages. The view along the old Aji highway as it runs north through Mure toward the quarries is an eerie one. The gravestones and stone lanterns lining the road in front of the stonecutters' shops remind Japanese visitors of a cemetery.

Isamu first visited the area in 1957 on his way to Tokushima to "fish" stones for the UNESCO garden with Mirei Shigemori. Masanori Kaneko, the governor of Kagawa Prefecture, invited him to stay at his official residence in Takamatsu City and took him to look for stone on the island of Shōdoshima and at the Gokenzan stone quarries. Gen'ichirō Inokuma, a student a few years ahead of Kaneko at middle school, had introduced them. Kaneko had always been interested in architecture. As governor he decided to build local industry and increase the tax base by making Kagawa into a prefecture known for its architecture. He commissioned several

well-known postwar Japanese architects to design local projects: Kenzō Tange for the Prefectural government offices and the Prefectural Gymnasium; Hiroshi Ōe for the Prefectural Cultural Hall; Yoshinobu Ashiwara for the Prefectural Library; and Junzō Yoshimura for the restoration of an old mansion in Ritsurin Park in Takamatsu City. Kaneko soon became known as the "Architecture Governor."

The governor invited Isamu to Takamatsu hoping that he might breathe new life into the stonecutting business in Mure. The high quality of Aji granite was well known, but Kaneko knew that gravestones and lanterns were not enough to sustain the industry's future growth. Isamu did not respond to Kaneko's overtures, or even contact him until several years later, so Kaneko turned instead to Masayuki Nagare, a contemporary avant-garde Japanese stone sculptor, who set up a studio in the largest stonecutting workshop at Mure and organized a "Stonecutter's Academy" to train a new generation of local stonecutters. The stone wall relief his students produced for the Japanese Pavilion at the 1964 World's Fair in New York was well received, and so was a huge stone work installed at the World Trade Center in 1975.

While working on Gordon Bunshaft's projects, Isamu tried to spend as much time as he could on his sculpture. During the early years of his "great beginning," he produced several bronze castings at his Long Island City studio—*Stone of Spiritual Understanding*, *Lessons of Musokokushi*, and *The Earth, This Passage*—that attempted to capture the tactility of stone in metal. In the late 1960s, beginning with *Variations on a Millstone, Mirage*, and *The Life of a Cube*, he produced more and more works carved from stone itself. "I should like stone to be treated like a newly discovered medium," he wrote. "Any medium, after all, is new (and old) in time. . . . [T]o fight gravity is a tour de force. The nature of stone is weight. In a sense I am led against my better judgment in attempting out of contradictions to draw a new emphasis. The deepest values are to be found in the nature of each medium. [The question is:] How to transform not destroy this."[2]

When his new stone sculptures were exhibited at the Cordier-Eckstrom Gallery in 1967, *Art News* commented: "The pieces are unified not only by the medium, but by his passion for economy of effect. In Noguchi's case passion implies fondness as well as fanaticism."[3] Whether working on Italian marble or Japanese stone, Isamu carved the material directly himself. "The execution of all these [pieces]," he said, "were an intimate

involvement between myself, the selection of the stone, the definition of what to do, and the employment of tools and willing collaborators, wherever I might be. My manner of work is extremely varied. The best is to find a stone and work on it directly. . . . At other times I make a small model (one to four inches) which is then blocked out on a larger scale, prior to my working on it."[4]

As the scale of his works grew larger, Isamu had to rely on the skills of professional stonecutters. In Italy he used the studio and assistants that Erminio Cidonio provided, but he had not found a satisfactory place to work in Japan. After finishing the UNESCO project he relied on stonecutters in the Shirakawa district of Kyoto, his "favorite place in the world." He wanted to establish a workshop in Kyoto, but the Shirakawa stonecutters he hired to turn his tiny maquettes into large-scale sculptures never really adapted themselves to his needs. It was to find a better place to work on his sculpture in Japan, and especially to find able stonecutters to help him, that Isamu paid a second visit to Governor Kaneko.

Kaneko was delighted. "If another world-famous artist rivaling Nagare came to Kagawa, it would stimulate local stone production and get everyone excited," he later recalled. "It was a Heaven-sent opportunity."[5] He introduced Isamu to Tadashi Yamamoto, section chief of the prefectural architectural office, and asked Yamamoto to find a stonecutter to serve as Isamu's right-hand man. He immediately thought of someone he believed would be perfect to work with Isamu.

The Izumiya Stone Company was the largest of the 191 firms in the Sanuki stonecutters cooperative. The company produced stone lanterns, stone monuments, and gravestones, and it also ran a small factory that manufactured stone architectural material. The Izumi family had been stonecutters for several generations. Masatoshi Izumi, the third-oldest son, went to work as a stonecutter immediately after graduating from middle school, while his older brother, heir to the family firm, managed the family business. (The eldest son died in the war.) Masatoshi was a member of the generation that came of age during Japan's remarkable postwar economic recovery. In 1964, the year that the Tokyo Olympics announced the country's reemergence as a respectable member of the international community, the twenty-five-year-old Masatoshi opened a "Stone Studio" (*Ishi no atorie*) to produce stone walls, rock gardens, and stone carvings. It was to his studio that Tadashi Yamamoto brought Isamu shortly after its opening.

Isamu was not looking for a stonecutter wedded to the traditional craft. He wanted one with the skill and sensibility to carve the forms he envisioned in his head. When Governor Kaneko asked Yamamoto to look for someone who would not only be stimulated by working with a world-famous sculptor but would also make a local impact, he spoke immediately of Masatoshi Izumi. Although Isamu was known in Japan as Yoshiko Yamaguchi's former spouse, Izumi had never heard of him. When first introduced he saw before him a bald man with a foreign-looking face who stared at him with the sharpest eyes he had ever seen and a body that radiated energy. It was hard for Izumi to believe that he was nearly sixty years old. Izumi's young wife, Harumi, pregnant with their first son, was also surprised at his fierce look. Neither she nor her husband had any premonition of the impact he was to have on their lives.

Staring at Izumi as though doubting his skill, Isamu took three small plaster models less than two inches high from his right-hand trouser pocket. "By the time I come back again," he said, "please enlarge these."[6] The models were round shapes, very much like *White Sun* in the Beinecke Rare Book Library garden. It was the first time anyone had asked Izumi to enlarge such abstract shapes in stone. "This will be an interesting experience," he thought to himself. He set to work using both Aji granite and Sanukite, a local stone of lighter weight. When Isamu returned to Mure a year later he was pleased with Izumi's meticulously carved samples.

The Seattle Art Museum had commissioned from Isamu a sculpture for the museum's main entrance. He designed a circular sculpture in black stone twice the size of *White Sun*, and in July 1967 he sent a plaster model to Tadashi Yamamoto. "Let me report on what we are doing here," Yamamoto immediately wrote back. "As I discussed about the execution of the work with Governor Kaneko in Takamatsu I think that on several grounds the best thing would be to have Mr. Izumi do the work and we asked him to do it. He is throwing himself into the project." The prefectural government was offering Isamu its total cooperation. "As I reported on the telephone we made inquiries both about Swedish stone and Brazilian stone as materials, but it will take at least two months to get either. We have ordered both. The plan is to use one to make the sculpture, and the unused one will be applied to some other purpose. Governor Kaneko is very happy about this."[7]

Isamu chose the Brazilian black granite for *Black Sun*. On January 13, 1968, a huge, thirty-five ton chunk of the stone, about ten feet square and

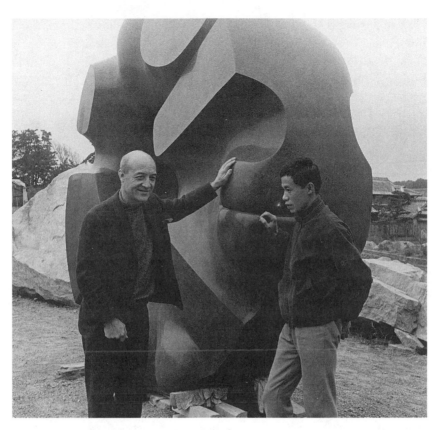

Isamu with Masatoshi Izumi (right) at Mure, standing front of Black Sun, *1968*

three feet thick, arrived in Aji harbor. It was too big for any workshop in Mure to handle so Izumi built a small, temporary straw work hut on some unused landfill in the harbor. Together with another stonecutter he had taken on as a partner, he began the first rough cut as chill winter winds swept in off the sea. From the beginning of his career Isamu refused to use machinery to fashion stone sculptures. Instead he relied on the old-fashioned stonecutting methods. He made small holes in the stone with a round-top chisel, and then cracked it open by inserting a thick iron bar in the holes. Isamu insisted that Izumi make a rough cut in exactly the same way.

It took Izumi eight months to trim the Brazilian granite down to twenty tons, then to chisel *Black Sun* into rough shape. Isamu visited every three or four months to supervise, giving him detailed instructions. "Noguchi-sensei" was a genius at stonecutting, Izumi thought to himself.

He found strength and beauty in stone by looking at it in ways that Izumi himself had never imagined. The rough-cut stone was eventually moved by crane from the seaside hut to Izumi's Stone Studio for polishing. Even at this stage Isamu refused to use machinery. He knew that hand-polished stone was gentler to the eye. At first glance machine-polished stone might look as flat, its edges as sharp, as hand-polished but it lacked the same subtle smoothness. Isamu also vetoed the use of sandpaper. He insisted that the polishing begin with coarse whetstone, then progress to ever-finer whetstone, until the desired effect was achieved.

Polishing a rough stone surface to a subtle sheen requires great patience. In Mure women traditionally did the job. Harumi and five other women worked four months on *Black Sun*, slowly transforming the rough gray surface into a lustrous black. Isamu was delighted with the result. He wrote the Seattle Art Museum in March 1969 that the finished sculpture was "very beautiful, with a superb finish."[8] At a party to celebrate its completion, attended by Governor Kaneko, Tadashi Yamamoto, Izumi, and all the other workers, including the women who polished it, Isamu had nothing but praise for Izumi.

"Whatever you say, Japanese stoneworkers have excellent skill and excellent sensibility," he told a Japanese magazine. "[Izumi and his partner] understood what I wanted very well, and they brought out the lines [of the sculpture] just as I planned."[9] Izumi had superb instincts as a stonecutter. He quickly realized that if he simply enlarged Isamu's plaster model the sculpture would not take the shape Isamu wished. The maquette gave no more than a hint of what Isamu had in mind, and Izumi knew that he had to wait for more precise instructions. "I think that the unexpected is the most important," Isamu once said about his principles as an artist. "It's a happening that occurs unpredictably in the process of creation. If it lacks the unexpected, to me it is not art. Art is a change prompted by something outside oneself, and the artist is no more than an instrument that gives form to that change."[10]

The circular form Isamu worked and reworked in his art after creating *White Sun* has often been described as a "doughnut" or a "bagel." When Isamu told the workmen in Mure that his circular sculpture was like "a grindstone standing on end," they were puzzled. Some took him literally and concluded that he was simply copying a traditional Japanese household utensil, but the models Isamu sent, no matter how odd or abstract, never puzzled

Izumi. Nothing was more interesting, he says, than carving strange shapes he had never seen before. He was careful in everything he did, working quietly and precisely, always checking himself as he went along, but at this turning point in his life he acted boldly. He had no hesitation, he says, about putting aside "everything that I had learned that had been handed down to me by my father and grandfather."[11] He knew that if he did not abandon all his preconceptions about stonecutting, he would spend the rest of his life carving lanterns and gravestones. By making himself the "shadow" of a sculptor who used stone creatively, Izumi began his own rediscovery of stone.

During their long collaboration Izumi remained deferential toward Isamu, who marched through life asserting his own ego. The temperamental Isamu might roil up emotional storms but Izumi coasted calmly over the waves by accepting Isamu for what he was. As a craftsman Izumi was infinitely patient. He did not find it easy to express himself, and he always listened quietly to others. When he dealt with "Noguchi-sensei," he never insisted on having the last word.

"Stone is directly linked to the core of matter," Isamu said in a 1968 interview. "It is a molecular conglomeration, so to speak. If you strike a stone it echoes back with the spirit of existence within us. It is an echo of the whole universe."[12] For Isamu stone was a material that "had a life before the existence of human beings." "Stone is always old and new, and like a living being it exists with links to the past, the present, and the future." Stones were the "bones of the earth."

When workmen at the Aji quarries sliced into the mountainside to extract these "bones," a single mistake could cost a life. Quarry work was tense and dangerous. The atmosphere, so intense that the air trembled, excited Isamu more than anyone else Izumi had ever met. He seemed to draw energy from the stone. Ordinary craftsmen instinctively turned their heads to avoid flying chips as they chiseled, but Isamu always bent close over the stone, his eyes steadily fixed on it. According to Izumi, even when a sliver sharp as glass struck his eye, his gaze never wavered. It was as though he became one with his chisel. "Noguchi-sensei," says Izumi, "loved stone so much that he staked his life on it." He was bound to Isamu by their common passion for stone, and he soon devoted himself so completely to his "teacher" that his own family had to take second place whenever Isamu came to work in Mure.

Many American critics regard the distinctive stone sculptures of his last twenty years as Isamu's best work. These remarkable sculptures infused nature into stone. All were fashioned at his workshop in Mure. Isamu did not like being labeled a "Japanese-American sculptor" but his fortuitous encounter with Masatoshi Izumi allowed him to immerse himself completely in "Japanese stone" in the final stage of his career—and ultimately to transcend ethnic and cultural borders.

With Izumi at his side Isamu was able to "fish for stone" to his heart's content, occasionally skirting danger on their excursions. Izumi vividly remembers a trip to the small island of Okinoshima on the southwest tip of Shikoku. By the time they arrived, the sun had already set. There being no inns on the island, they stayed at a private house, sharing for dinner a single roast fish, the only food left in the kitchen. Early the next morning, Izumi chartered two small fishing boats—one large enough for seven passengers, and the other large enough only for two—to scout stone along the island's coast.

Only one site interested Isamu—a pile of rocks deposited on the shore by a landslide. The water was rough and the waves still high in the wake of a typhoon. Isamu and Izumi shifted to the smaller boat, but about twenty yards from the rocky shoreline the boatman told them, "It's dangerous to get any closer than this. You'll have to swim from here." When the waves subsided a bit, they plunged into the water, swimming hard toward land. It was impossible to get a handhold on the rocks, which were covered with slimy moss. As they swam back to the boat, heavy waves kept sweeping them toward the rock outcropping. Izumi had trouble making any headway at all but by the time he reached the boat after swimming with all his strength, Isamu was already there. Even in his late sixties, Isamu, his body hard as stone, was a much stronger swimmer than thirty-four-year-old Izumi.

Isamu abandoned his search on Okinoshima but such a "poor harvest" was rare. Izumi usually made a reconnaissance to a site to set aside stones he thought Isamu might like. Isamu's favorites were stone from Shōdoshima and Kitagishima, two small islands visible from Aji harbor, *mannari* stone from Okayama Prefecture, and "muddy stone" from Miyazaki Prefecture. The price of stone rose every year, Izumi says, "but Sensei was timid about buying anything expensive."[13] He often hesitated before buying. When Isamu found stones he liked, he excitedly ordered several but he was always stricken by second thoughts, worrying about the

expense. If he ordered ten stones, he had Izumi cancel half of them as soon as they got home, then sank into a funk at giving them up.

Finding the right stone for a particular purpose is a once-in-a-lifetime opportunity. Stones are random products of nature, each different in color and shape. Izumi knew that finding a stone exactly like another was nearly impossible. He often ignored Isamu's cancellations without telling him. Takashi Ukita, whose father sold Isamu stone for the UNESCO garden, first met Isamu as a middle school student. He was always surprised at Isamu's nervous uncertainty, he says, but after Izumi started coming with him on buying trips, Isamu no longer canceled orders the same day they were made. It was not unusual for Izumi to add to Isamu's order whatever other similar stone they had in stock. "There's no telling when more of the ones Isamu-sensei likes will be on sale again," he would say.

The Izumi Stone Company in Mure paid for all the stone. Izumi never said anything to Isamu about it but in fact the company acted as Isamu's sponsor. Nor did Isamu ever guess what a large role the Izumi family played in establishing his credit in the stonecutting world. Whenever Izumi's older brother paid his own bill, he would always ask, "What about my brother's?" Isamu rarely met either Izumi's older brother or his father. Both men, however, shielded Izumi from local criticism for pursuing an untraditional path as a stonecutter, and they also quietly took care of the American sculptor he admired so much.

From 1969 onward Isamu spent two or three months a year working in Mure during the fall and the spring. Thanks to Izumi's attentiveness, he was freed from the bother of ordering stone and other miscellaneous business. After he returned to New York, Izumi made sure that work on Isamu's sculpture progressed, and when it was finished he supervised the crating, packing, and shipping.

During his early visits to Mure, since there was no suitable inn in the village, Isamu usually stayed in Takamatsu City. Izumi had to pick him up and take him home every day. Governor Kaneko asked Tadashi Yamamoto to find a place for Isamu closer to the Izumi workshop. Masayuki Nagare, who had settled in the neighboring village of Aji, had built for himself a red brick house and studio on a bluff that overlooked the Inland Sea, like a Mediterranean fort. In 1970 Yamamoto found a very different dwelling for Isamu, a decrepit old "samurai house" with thick white plaster walls, tile

Isamu at a quarry in Okayama, 1964

roof, and *shōji* windows. The building, which belonged to one of Governor Kaneko's middle school schoolmates, was to be torn down to widen a road. The walls were blackened by two centuries of smoke and soot, and at first Isamu refused to consider it. "I don't want to live in an old haunted house," he said.[14]

Without insisting, Izumi and Yamamoto arranged to have the house moved to the grounds of the Izumi workshop. They asked Shinkichi Idei, a traditional master carpenter who specialized in building temples and shrines, to fix it up. As Isamu watched the slow renovation he began to take a fancy to the house. The two-story structure, Idei says, had been built "with the eye of a sculptor."[15] Although it was said to be a "samurai house," Idei thought it had probably belonged to an eighteenth-century merchant family. A steep narrow staircase lined with vertical wooden railings like prison bars led from the earthen floor entryway to the second floor. At the top was a peep window that allowed an observer to see anyone coming up

the stairs. The staircase was probably designed for the merchant's self-protection, Idei thought, but Isamu found it so interesting that he had it completely restored to its original form.

The lower floor of the house was divided into four six-mat rooms. The front room, opening through sliding *shōji* onto the entryway, embodied the rational efficiency and simplicity that Isamu liked. Its floor, paved with local gray stone gentle on the feet, was the same level as the entryway. During the winter hot water pipes beneath the floor heated it. Next to the front room, a level higher, and separated by a sliding *shōji*, was a sitting room with a *tatami*-mat floor. Isamu wanted his living space to have clean lines, uncluttered by the paraphernalia of daily life. Idei converted inbuilt drawers in the wall into closets with sliding doors, and he concealed a small television set and a stereo record player behind panels in one wall.

The kitchen, the Japanese-style bath, and the toilet were in a separate section on the other side of the stairway. Isamu used one of the second-floor rooms, where he could see who was coming up the stairs, as his study and workroom. He retired there in the evening to read, mold clay models, or make drawings. His bedroom was a six-mat room under exposed roof rafters in the rear of the second floor, and in another small room he stored his work files, his photographs, Rosanjin's pottery, and other belongings in tea chests.

In the middle of the front room Isamu placed *Wave in Space*, an oblong sculpture carved from African black granite. A little over four feet wide and three feet long, it stood at knee height. The flat top was squared at the ends, and the sculpture looked almost as if it had been designed as a table, but a rounded form swelled up in the middle like a cresting wave. Although the sculpture was so heavy it took several men to install, *Wave in Space* seemed to pulse at the touch. By contrast, the garden visible through the window was suffused with soothing tranquility. A grove of tall bamboo punctuated by a single persimmon tree that blossomed in the fall stood in front of a rough-hewn rock wall. Six long, narrow pieces of Aji stone, looking as though they had sunk into the soil, were arranged in a gently sinuous row across the grass lawn. This was *Ground Wind*, another of Isamu's works.

Directly opposite the house was the "circle," an open-air work yard of about fourteen thousand square feet where Isamu created many of his late masterpieces. It was built a year before the "samurai house" was moved to the neighboring site. A stone wall about three feet high, built like the retaining wall on a river dike, surrounded the yard. It was in the "circle"

that Isamu "conversed with stone." He followed a daily work routine with monastic strictness. At 7:00 in the morning, he arrived in the "circle" sporting a baseball cap and clad in white shirt, khaki pants, and sneakers. Izumi and four or five assistants were already waiting. Under Isamu's watchful direction the workmen split large stones into smaller pieces, then made rough first cuts for sculptural pieces. Isamu marked a stone with white chalk lines, then drew the line with red ink to indicate where it should be cut. Only then he did say, "Cut it here." His was the only voice heard in the "circle" during the day. Izumi, acting as yard boss, watched Isamu's every move. He signaled his assistants with his hands and eyes as they worked in silence. After a tea break at 10:00 AM Isamu continued work until lunch.

Visitors to the "circle" during the workday could feel edginess in the air. The world of the stoneworkers, then as now, was governed by a master-disciple relationship. Izumi, then in his early thirties, recruited recent middle school or high school graduates as assistants, most of them not yet twenty years old. Masami Sasao, who worked with Isamu for twenty years, began at the age of twenty-two. He still remembers how stiff his shoulders were at the end of the day whenever Isamu was in Mure. The work atmosphere was tense. A slight mistake could lead to an accident that might cost a hand or a foot, and there was never a chance for the workmen to relax. To make matters worse, Izumi was always extremely nervous when he worked with "Noguchi-sensei."

"We don't work for Noguchi-sensei to make money," Izumi told his assistants. "The time that we spend with him is time spent learning from a genius."[16] Their job was to serve as Isamu's hands and feet, he said. The workmen trained themselves to follow "Noguchi-sensei's" directions down to the smallest twist in the peculiar crooked lines he drew. "It was very difficult," recalls Masanori Watanabe. "Noguchi-sensei was always changing the shapes on the spot." He worked on several pieces at once, chewing on his reading glasses as he paced the "circle" giving directions. When a sculpture neared completion Isamu took up a chisel to work on it himself. If a piece did not develop as he wished, he simply left it alone. He rarely discarded anything, even if he did not touch it for several years. Once a sculpture was begun he usually finished it, no matter how long it took. "Isamu-sensei was astonishing," says Izumi. When a work was ready for his final touches, he worked intensely at one stretch, completing it at breathtaking speed.

Isamu drawing a preliminary cutting line on a stone at Mure, 1984

Izumi's whole demeanor changed whenever Isamu was in Mure. His face even seemed to become thinner. The only thing that concerned him was to make sure that his assistants did not waste Isamu's time or energy. Isamu was normally very polite when he spoke to Izumi, his wife, or any of the workers. He always politely added the honorific "san" to their names, but if work in the "circle" did not go as expected, he would suddenly shout angrily, like a bomb exploding.

Isamu always worried about trivial things, Izumi says. When something bothered him, he would overreact excessively, almost neurotically, as if he could not control his feelings. He usually fretted about minor chores, like making sure a large sculpture was shipped safely, even though Izumi could take care of the matter with a few telephone calls. He often went to bed in the evening upset and woke up in the morning still agitated. The older he grew, the more frequently he was upset.

Isamu realized that he was a pathological worrier. "As you know," he wrote Priscilla from Japan in September 1971, "I am always the pessimist and you the optimist. . . . I myself am in one of my periods of deep depressions."[17] During the last twenty years of his life Priscilla and Izumi were

the two people closest to him. His relationship with each was different, and each offered him a different kind of protection and security. Izumi learned, as Priscilla had before him, that his most important task as Isamu's collaborator was to free him of his anxieties.

During his stay in Rosanjin's "world of dreams" in the early 1950s, Isamu had seen his mentor ensconced in a house arranged to his tastes and working with first-class craftsmen who did his bidding. Isamu tried to create his own "world of dreams" in Mure. Unlike Rosanjin, who built his little world by himself, Isamu relied on Izumi's devotion to build his. Izumi was more than a disciple; he was the pillar supporting Isamu's own "world of dreams." When Isamu stayed in Mure, Izumi abandoned his private life, responding without complaint to Isamu's every demand, no matter how unreasonable.

But Isamu was not content with his life in Mure as an honored "Sensei." Mihoko Okamoto, a Japanese-American woman who had known Isamu since her youth and later worked as Daisetsu Suzuki's secretary, often visited him there. More than once he told her, "No matter how comfortable I am, I simply can not stay in one place for a long time."[18] At Mure he did not have to worry about anything but his creative work, but he feared that if he basked too long in the reverent warmth that enveloped him at Mure, if he was constantly venerated as a great artist, he might start feeling too comfortable and complacent. Perhaps unconsciously, he feared losing his creative edge as he aged.

"Isamu, I miss you and love you so very much," Priscilla wrote in early 1971. "Please don't settle just for Japan; you belong to the world and are so valuable and important at this most extraordinary time. Come back soon."[19] Isamu rarely prolonged his stays in Mure beyond a few weeks. Always restless, he returned to immerse himself in the energy of New York.

A Season of Plenty

"I am grateful for the opportunity to do significant public works, and look upon them as challenges to sculpture rather than as jobs. Indeed it is far better financially to stick to individual sculptures. A free sculpture has a market value which as a monument it has not. Seldom reviewed as art the considerable time it takes removes the artist from the current of art and ris-

ing reputations. In neither the dedication of the Beinecke Rare Book Library nor of the Chase Manhattan Bank was my name mentioned, although the goldfish in the latter were."[20]

"Public art" usually refers to art for public spaces like parks, plazas, and playgrounds but it can also refer to an "environmental sculpture" like *Red Cube* that gives meaning to the space around it. During the 1970s, Isamu pushed toward new frontiers in public art by what he called "the creation of oases for contemporary society." In late January 1970 he completed plans for a set of fountains at Expo '70, an international exhibition in Osaka hosting 171 national and corporate pavilions to celebrate Japan's emergence as the second-largest industrial power in the free world. Kenzō Tange, who devised the master plan for Expo '70, asked Isamu to design the fountains to draw attention to an artificial lake next to the Festival Plaza at the center of the exhibition grounds. The Apollo 11 mission had successfully landed on the moon the year before so Isamu created a group of nine fountains to symbolize "the future of mankind" in outer space.

Each fountain recalled forms and shapes that Isamu remembered from his childhood in Japan. *Dice Cube* (*Saikoro*), a huge cube mounted on a shaft more than one hundred feet high, sprayed a shower of water onto the lake below; *Toy Drum* (*Denden taikō*), made of two intersecting circular disks, swirled water in all directions as it turned on an axis; and *Bald Priest* (*Tako nyūdō*) bobbed up and down on the surface of the lake, now visible, now submerged. When Japanese fountain manufacturers told Isamu that the designs were too complicated to build, he urged them to experiment with new technology, including jet engines. His persistence paid off, and in the end, he had his way. When the exposition opened in March 1970 the fountains sprayed, jetted, misted, and rotated in ways that no one had ever thought of or seen before.

After attending the Expo '70 opening ceremony Isamu returned immediately to the United States. In late April he went to Pietra Santa for a month to work on a marble sculpture, went back to his Long Island City studio at the end of May, and then returned to Mure in June. In the late summer he went to Italy as usual, arranged an exhibition for the Cordier-Eckstrom Gallery in November, left again for Mure by way of Europe and India, and was back home in New York by Christmas. This restless pattern of hectic global travel among his workplaces in New York, Mure, and Pietra Santa continued to the end of his life.

"My soul constantly wanders to the ends of the earth," Isamu told a Japanese interviewer.[21] His wanderlust was undiminished even as he approached his seventieth birthday. He was fond of the Italians for their bright and open emotionalism, he said, but Italy always remained a "foreign country." It was in Japan and the United States, the lands of his ancestors, where he felt most at home. "Both America and Japan live inside of me as a single human being, but whenever I am in one, I always feel lonely without the other." He had strong nostalgic attachments to Japan but he if he stayed there too long, he said, he started to be uncomfortable. "Whenever I get back to the United States, I feel that I have returned to reality. . . . [But then] when I begin to become uncomfortable in New York, I simply work to provide a financial base for my next trip to Japan." Isamu created ideal workplaces for himself in the two countries where his roots were deepest, but precisely for that reason his ambivalence about where he really belonged became all the more intense.

This ambivalence infused a series of works taking the circle as a motif. Isamu had deployed various geometrical shapes in his sculpture after meeting Buckminster Fuller in the late 1920s, but he attached special importance to round or circular forms that evoked the earth revolving on its axis or the sun sustaining life in the world. These circular forms are a persistent metaphor in his later work. It is not clear whether Isamu understood that in Zen art the circle is linked to satori, the moment of spiritual enlightenment, but he gave his first work using a circle motif, the sculpture for the *Shinbanraisha* garden at Keiō University, the Zen-inspired title *Mu* [*Nothingness*]. It was not until the 1960s, however, that he began experimenting with the circle in earnest. As he wrote in his autobiography, "The circle is zero, the decimal zero, or the zero of nothingness from which we come, to which we return. The hole is the abyss, the mirror, or the question mark."[22]

The sculptures *Black Sun* (1960–63), *The Sun at Noon* (1969), and *Magic Ring* (1970) were all variations on the circle. He also used the circle as a spatial concept in public art pieces fashioned from stainless steel industrial pipe like *Sky Gate* (1976–77) in front of Honolulu City Hall and *Portal* (1976) in front of the Cleveland Municipal Courthouse. He also made a series of granite sculptures entitled *Energy Void* (1971, 1976) that twisted the circle into an oblong shape or trapezoidal shape. "I have carried the concept of the void like a weight on my shoulders. I could not seem to avoid its humanoid grip. It is like some inevitable question I cannot answer."[23]

His largest project exploring the circle as a motif was a 1972 commission for the Horace E. Dodge Fountain at the Philip A. Hart Plaza (also called Renaissance Plaza), an eight-acre riverside park in downtown Detroit. The plaza was part of a large urban-development project to revive the city's downtown district. The Detroit automobile industry was being buffeted by Japanese competition, but the city had other troubles, too. The civil rights movement had stirred African-American political militancy, and civil rights protestors confronted the city authorities with growing frequency. During the hot and humid summer of 1968, the city was swept by violent rioting. The Hart Plaza project was intended to bring the community back together by providing a public gathering place for open-air theatrical performances, ice-skating, concerts, and other cultural events and activities.

During the late 1960s American public art developed in several directions. The fountain that Isamu designed for the Hart Plaza was one of its milestones. Even today it is a spectacular sight. Fashioned from stainless steel industrial piping, the fountain stands twenty-four feet high. Water pumped through hundreds of tiny holes in a horizontal circular top ring drizzles into a round granite basin below, then gushes upward into the air. Using computer technology developed for the Expo '70 project, the fountain goes through a thirty-minute cycle that spouts water in thirty-five different patterns with the Detroit River as backdrop. The cycle begins quietly like a satellite about to launch into space. The flow of water gradually gathers force, shooting upward like a fireworks display on a summer night, then spreads as a mistlike spray before slowly vanishing into the air. To maintain visual harmony between the fountains and the rest of the plaza, Isamu also designed an open-air theater and other facilities, and at its entrance he created a 120-foot pylon, twisted with a slight torque.

The Noguchi Fountain and Plaza Company, which presented Isamu's plans to the Detroit city design committee, shared an address with Buckminster Fuller's office in Cambridge, Massachusetts. As his partner for the project Isamu had chosen forty-six-year-old Shōji Sadao, a Japanese-American disciple of Fuller. After graduating from high school at an Arizona relocation camp in 1945, Sadao had left for college but a year later he was drafted into the army. He served in Germany, preparing aerial maps of Europe, then returned to the United States to study architecture at Cornell University on the GI Bill. It was there that he met Fuller, who visited the university during his senior year and who hired him after graduation.

Sadao had first met Isamu in the early 1950s when Fuller introduced them at an air show in Philadelphia. At dinner a few weeks later Isamu told him, "I think we can work together in the future. Keep in touch."[24] When Sadao was in Japan on a Fulbright grant he accompanied Isamu on a "stone-fishing" trip with Mirei Shigemori, and in 1958 he worked as his assistant shaping the aluminum-sheet sculptures that Isamu exhibited at the Stable Gallery. It was not until 1971 that he became one of his close associates. A designer without an architect's license cannot get a building permit unless he has an architect as a partner. For that reason Sadao had served as Fuller's collaborator on the geodesic-domed American pavilion at the 1967 Montreal World's Fair. Isamu hired him for the Detroit project because he also had engineering and technical skills needed to turn Isamu's models into working blueprints with carefully calculated structural specifications. Their partnership lasted to the end of Isamu's life.

Sadao was ten years older than Izumi but still young enough to be Isamu's son. Like Izumi he recognized Isamu's artistic genius and he saw his role as doing what he could to help him fulfill that genius. But unlike Izumi, who was devoted to Isamu as a disciple and subordinated all his own feelings and needs to his master's, Sadao's relationship with Isamu was fundamentally different. It was not simply that he had been raised in the United States or that he was businesslike in his work. He already had a respected master and teacher in the warm and outgoing Buckminster Fuller, whose far-fetched ideas had fascinated him.

Sadao found Isamu a "difficult personality" who "reacted to everything in a delicate way," but he also understood that Isamu had been scarred by his experience as a person caught between two cultures.[25] Even though he was an American citizen, when Sadao left the relocation camp for college he had felt frightened, as though he were traveling through enemy territory. He could understand why Isamu behaved as he did, but he never let Isamu into his own private world nor did he let himself be buffeted by Isamu's emotional storms. A calm and gentle man, he never lost composure in dealing with his mercurial boss.

Construction began on the Detroit project in 1975. Many of Isamu's public art projects—*Play Mountain*, the Hiroshima Memorial for the Dead, and the Riverside Drive playground—had never gotten off the drawing board. He was delighted at the great success of the Hart Plaza project. "The Detroit thing," he later said, "is the nearest thing to some of the ideas

Isamu at his Long Island City studio with Shōji Sadao, 1963

I've had being built. . . . That came about simply because . . . Mrs. Dodge left two million dollars for a fountain. And they could never decide what to do with it . . . until finally there was about two weeks till the deadline when they would have to give up the money. So at the last minute in desperation . . . they said, 'Hurry up and do something.' So I did. But I said, 'I have to do the whole place too.'"[26]

The opening of the Hart Plaza in Detroit, finally completed in June 1979, was celebrated by a week of daily music and dance performances. "What is generally agreed upon," commented the *Detroit News*, "is that Noguchi is at his peak and, as he approaches the three-quarter-century mark, shows no signs of slowing. . . . The eight-acre site at the edge of the Detroit River is considered his most ambitious, most socially significant venture to date."[27]

A special exhibition, *Isamu Noguchi's Imaginary Landscapes*, also opened at the Detroit Institute of Arts. It was very different from the Whitney Museum exhibition eleven years before. Isamu thought it a truly "retrospective" show. Martin Friedman, the director of the Walker Art

Center in Minneapolis, who planned the exhibition, focused directly on Isamu's public art. The exhibition had opened in Minneapolis, then moved to the Denver Art Museum and the Cleveland Museum of Art before coming to Detroit. It continued traveling the country, stopping at the San Francisco Museum of Modern Art and the Philadelphia Museum of Art until it closed in January 1980.

In the late 1970s Isamu finished another project that must be counted as one of his masterpieces. To commemorate the fiftieth anniversary of the Sōgetsu School of Flower Arrangement, Sōfu Teshigahara commissioned Kenzō Tange to design a new headquarters building in downtown Tokyo. Tange's plans envisioned an eleven-story building faced with opaque glass walls to reflect a rare surrounding zone of urban greenery, and he asked Isamu to create a sculpture for the space in front of the building. Teshigahara called a square granite pillar he designed the "alcove post [*tokobashira*] of the Sōgetsu school." Like the stainless steel pylon in Detroit, the monumental eighteen-ton pillar was thirty feet tall. A simple-looking form at first glance, the pillar was ingeniously fashioned from nine pieces of black Swedish granite piled on one another with a slight torque.

Even more striking was Isamu's design for the Sōgetsu Plaza, a stone garden in the building lobby, assembled with Izumi's indispensable skill as a stonecutter. The lobby space was two stories high. Teshigahara intended it as a showplace for the avant-garde flower arrangements pioneered by his school but he was not satisfied with Tange's original design. His good friend Yūsaku Kamekura, one of the top graphic designers in Japan, agreed. "Let's have Isamu take a look at it," he suggested. The moment Isamu saw Tange's model he softly said to himself, "The step area is too narrow." With a few scissor cuts he changed the space completely. Accompanied by Kamekura, Teshigahara visited Tange's Harajuku office the same day. Smiling sweetly but not bothering with a detailed explanation, he told Tange, "I want to ask Isamu-san to do the lobby." With his usual poker face Tange simply replied, "Is that so? I understand."[28]

Even though plans for Sōgetsu Hall had already been drawn, and the Kajima Construction Company had begun construction, Tange did not object to changing the lobby interior, the position of the steps or the skylight. (Indeed, when Tange later won a commission for a new high-rise city center in the Fiere district of Bologna, he asked Isamu to make a sculpture

for its central plaza.) Like Gordon Bunshaft, he had recognized Isamu's artistic breadth early on. "Isamu Noguchi's domain is much wider [than sculpture]," Tange told a journalist in 1960. "It manifests itself when he tackles the challenge of architectural space or urban space. He always sees sculpture as bringing human space and natural space together. . . . He was the one who devised the shape of the two bridges in front of the Hiroshima Peace Museum. At the time these bridges upset people, but they harmonized with the surroundings and scale, and they brought the space to life. There is probably no other sculptor in the world as knowledgeable about space as he." Tange also understood Isamu's inner compass as an artist. "[He] can visualize the true essence of Japan better than someone born in Japan. . . ," he said. "But what he visualizes belongs to the world rather than to Japan."[29]

The only thing Teshigahara asked of Isamu was to provide spaces to display flower arrangements, and Tange requested that the lobby be whitish in tone and color. Isamu responded with an interior stone garden unlike any other in the world. Sometimes he called it *Tengoku* [*Heaven*] and sometimes *Flowers and Stones and Water*. The garden was a multilevel stone stage, with four stone terraces connected by steps and indented with niches for flower arrangements. The top level, lit by the sun streaming down through a window, was as wide as a Noh drama stage. Each terrace was like a *hanamichi* providing space for visitors to walk while they admired the displays of flower arrangements. Water bubbling quietly from a basin on the top level flowed down in a small stream through each level to the bottom. The floor was paved with smoothly polished white Inada stone from Miyagi Prefecture with a beige-gray tinge, seemingly arranged in a simple pattern. The individual stones, carefully selected for uniformity of color, were cut precisely and fit together with great care. The overall effect was quiet, cool, and elegantly modern.

When the lobby was completed in December 1977 a delighted Teshigahara kept saying over and over that it could not have been more perfect. His son, the movie director Hiroshi Teshigahara, who succeeded him as head of the school, had nothing but praise for the lobby, too. "The arrangement of the natural stones and those cut into geometric form is not only exquisite when viewed from every angle," he wrote, "but also blends the stone gently with the water streaming down from the top level. [Isamu Noguchi] has created a wonderfully peaceful space."[30]

Not long after finishing the Sōgetsu Hall project Isamu installed *Momotarō*, a magnificent assemblage of huge stone sculptures, at the Storm King Art Center, an open-air sculpture museum near Poughkeepsie, New York. The sculpture's central piece was made from a massive three-ton oval stone that he had found on the island of Shōdoshima in the Inland Sea. Since it was too large to ship to Mure in one piece, Isamu had it cut in two. In its center was a cavity that reminded him of the story of Momotarō, or Peach Boy, the hero of an old Japanese tale remembered from his childhood, who had been discovered by a childless elderly couple as a baby inside a huge peach floating down a stream. To set the sculpture off Isamu built an artificial hillock for it near the main building of the Storm King Art Center.

Throughout the 1980s, the reserves of energy that had brought Isamu to his peak never flagged. In February 1980 he signed a contract with the city of Miami to design what the Miami Downtown Development Authority called "the largest single work of municipal art in the country."[31] It, too, began as an urban renewal project. As high-rise office buildings sprouted in the downtown section, but the shopping district had lost customers and luxury stores to suburban shopping malls, and the nearby city park facing Biscayne Bay had become a gathering place for homeless derelicts.

When city officials approached Isamu in 1978 about redesigning the park as a "front door" to the city he agreed to take on the job only if seventy-seven acres of unused city land north of the park were also included. The Miami Bayfront Park Project was ten times the size of the Hart Plaza, and the first stage of the project alone covered twenty-eight acres. Isamu's plan called for a monumental fountain 170 feet in diameter, a plaza 300 feet wide, an amphitheater seating 20,000, a 90-foot light tower to illuminate the sky, and a rock garden. "The idea was that it would be a park for people," Isamu explained to the *Miami Herald*, "not an escape from the city, but a place to go, a place to congregate."[32]

The project was the most ambitious Isamu had ever attempted but it soon became embroiled in local politics. Opposing Isamu's proposal to tear down a thirty-year-old library in the middle of the park, some city commissioners wanted to preserve it as a municipal office building. It was the first of many disagreements that were to plague the project over the next few years, making it a psychological burden that weighed heavily on Isamu to the end of his life. By the time of his death eight years after the project

began, only three quarters of the first stage had been completed. The victim of constant political bickering, the park remains unfinished today.

A month after signing the Miami contract, Isamu took on a project in California that went more smoothly. Henry Segerstrom, a land developer in Costa Mesa in Orange County, rang the doorbell of his Long Island City studio early one chilly morning in mid-December 1979. Segerstrom had made an appointment through an artist's agent in Los Angeles but Sadao told him over the intercom that Isamu was at home sick with a cold. Segerstrom had just arrived from California that morning, and he had to return for business that evening, so Isamu grudgingly agreed to meet him at his Manhattan apartment.

Segerstrom was born and raised on the farm in Costa Mesa that was said to produce the largest harvest of lima beans in the United States. He inherited the land from his father, and when the city of Costa Mesa, responding to rapid population growth, decided to rezone farmland within the city limits as commercial property, Segerstrom, rather than let outsiders in, organized his own company to develop his land. He wanted to promote hometown growth with local backing. The lima bean fields were transformed into South Coast Plaza, at that time the largest shopping mall in California, boasting five department stores and more than two hundred smaller shops, as well as a hotel, a theater, and several banks. To beautify the site, Segerstrom, whose hobby was collecting sculpture, installed outdoor sculptures by Alexander Calder, Henry Moore, Joan Miró, and others.

Segerstrom had been perplexed about what to do with a 1.6-acre plot sandwiched between two fifteen-story bank buildings and a huge parking structure in one corner of the mall. A year before he had seen an issue of *Smithsonian* magazine that devoted a ten-page spread to the Noguchi retrospective exhibition traveling around the country. The cover photograph, showing the Hart Plaza fountain spewing a torrent of water, made an indelible impression, and he wondered if he could persuade Isamu to accept a commission for the vacant site.

When Segerstrom arrived at Isamu's one-bedroom apartment on the top floor of a building on East Sixty-ninth Street he found him in a bad mood—perhaps because of his cold. The apartment was simply furnished with a tatami mat for a sofa and an Akari lamp for lighting. As Segerstrom spread out blueprints of the shopping center Isamu muttered, "People in

California drive too much. They ought to walk more."[33] The vacant plot was one-hundredth the size of the Miami project, and it was tucked away next to a garage for 1,200 automobiles. Isamu turned down Segerstrom's request right away. "Why don't you donate one of my sculptures to Stanford University instead?" he said. (Segerstrom's alma mater had assembled a large collection of twentieth-century sculptures on its sprawling campus.)

Segerstrom returned home feeling that Isamu regretted not having any works in the state where he had been born. He wrote Isamu urging him to leave a legacy to California, and three months later Isamu, in Los Angeles on his way back from Japan, visited him in Costa Mesa. The first thing he asked was, "How big a budget were you thinking about?" After pausing a moment Segerstrom proposed a figure that was half what he had in mind. "I want twice that much," replied Isamu. Segerstrom, without complaint, agreed on the spot.

When negotiating with Miami city officials Isamu told them that an artist had to be a "dictator." He could not agree to discuss his designs with the people of the city, he said. Segerstrom offered Isamu a chance to be the dictator of the Costa Mesa project. His only request was that Isamu design a place where people could sit and relax. The high-rise buildings surrounding the site were steel skeletons still under construction, only five stories high. When Isamu visited Costa Mesa again at the end of summer, he pulled a small model, about sixteen by twenty-three inches, from a battered old travel bag and arranged several small geometrical maquettes on it. "This is *California Scenario*," he told Segerstrom.

The model was not so much a plaza as a miniature landscape divided into six main sections, each symbolizing one aspect of California's diverse natural environment: desert, forest, mountain, agricultural, urban, and riverine. *California Scenario* was a three-dimensional ode to those who had come to California, as his mother had, drawn by the promise of America's last frontier. It laid out a symbolic panorama of the state, from the Sierra Nevada whose melting snows nourished the state with water, through its evergreen forests and farmlands to its dry desert. A small stream flowed from the top of a triangular hillock representing the mountain terrain (*Water Source*) through a plaza paved with irregularly shaped sandstone slabs (*River*), where it disappeared under a narrow pyramid resting on one side. Except for stainless steel in a fountain symbolizing the energy of industrialization, Isamu used only natural materials.

"I made a plan for the garden as a sort of menu," Isamu told the *Los Angeles Times*. "I wanted to do it all, but didn't expect [Segerstrom] to buy it all. One does not expect that much support."[34] Segerstrom, just as he had promised, gave Isamu 100 percent control from beginning to end. He chartered an airplane for Isamu to hunt sandstone in New Mexico, and he let him drive through the southern California desert selecting other stone that he wanted. Isamu used materials extravagantly, laying down paving stones two feet thick, even though only the top surface was visible. Even when the project went over budget Segerstrom let Isamu have his way. He trusted Isamu as an artist completely.

Segerstrom also understood Isamu's personality. "Sometimes he used Zen-like expressions," Segerstrom says, "but he thought about things in a rational American way."[35] Isamu was impatient but he never acted like a dictator. If you knew how to approach Isamu, Segerstrom says, he grasped things quickly. When Isamu first showed him the model for *California Scenario*, Segerstrom was disappointed that the design included no stone sculptures. Instead of complaining he casually offered a second commission for a sculptural work. Isamu got the point. In one corner of the garden he arranged a whimsical group of fifteen uncut *mannari* stones, each weighing about twenty tons. He wanted to call the work *The Beginning of Life* in memory of his father Yonejirō, who planted the "seed" that gave birth to him in California, but when Segerstrom turned the conversation to the story of his Swedish grandfather, the first farmer to succeed in growing lima beans in California, Isamu renamed the work *The Spirit of the Lima Bean*. In retrospect, it is difficult to think of a more suitable title. The stones, adding a warm humorous touch to *California Scenario*, look like nothing so much as a pile of giant lima beans.

The miniature landscape, designed with precision and without excess, opened in May 1982 after two years under construction. Thomas Messer, former director of the Guggenheim Museum, regards it as "the best of Isamu Noguchi's gardens," and so do many others.[36] Most specialists familiar with Isamu's work point to it as one of his masterpieces. *California Scenario* was the culmination of the many "Isamu Noguchi gardens" he had designed since the UNESCO garden twenty-five years before. It embodied the lessons learned from the gardens he had studied in Japan and from the geometrical forms he had seen at the ancient astronomical observatories in India. *California Scenario* transcended Oriental exoticism,

however. It celebrated Isamu's "Oriental" sensibility but completely assimilated it. In *California Scenario* the inspiration he drew from Asian models came to life effortlessly as part of the American landscape.

"My 'pilgrimage' has continued for a long time," he said in 1960. "But it has not yet ended. I think that I would like to pursue the path of my 'pilgrimage' more deeply, just as Musō Kokushi [Soseki] did. And I hope that I can produce works, of which I can say 'Yes, this is it,' just as enlightened pilgrims do when they reach the sacred site after the ordeals of their long journey."[37] In *California Scenario* Isamu had created such a work. He could truly say, "Yes, this is it!" But it was his client, Henry Segerstrom, who had drawn this masterpiece out of Isamu by providing him an unencumbered creative environment to produce a monument celebrating the state where both men had been born.

The Warmth of Eros

With Priscilla Morgan in charge of his personal and public relations, and Shōji Sadao supervising his creative projects during his absence from New York, Isamu had time to enjoy life at Mure. There was a subtle change in the way he compared his life in Japan to his life in New York. "In New York I can never take my eyes off work," he told a Japanese reporter in 1984. "When I come here, there is a little space between me and my work. I like feeling relaxed. Besides, Japan is a country very rich in its cultural tradition, so there is really much to learn in Japan. I studied many things in America, Europe, and China in my youth. The drawers in my head are bursting with material, but the drawer related to Japan is the most full."[38]

Thanks to Izumi's skill as a stonecutter, Isamu managed to juggle work on more than a hundred stone sculptures in different stages of completion in the "circle." Life at Mure approached his ideal "world of dreams." His only complaint was food. Isamu wanted to savor the same exquisite cuisine that he enjoyed on Rosanjin's estate but none of the local women Izumi hired as cooks met his requirements. He grumbled at every meal, and no cook lasted very long.

While working on the Reader's Digest Building garden, Isamu had made the acquaintance of Seijirō Ōi, an iron foundry master, whose family had been in business in the back streets of the Ginza district for several generations. Ōi fashioned an iron fountain for the Reader's Digest Build-

ing garden, and when Isamu began designing Akari lamps, he asked Ōi to make stands for them. Isamu was fond of visiting the foundry, which was in a neighborhood where the atmosphere of traditional Tokyo plebeian culture still survived. He would dine with Ōi at an old-fashioned noodle shop or eel restaurant nearby whenever he was in Tokyo.

When Isamu asked him to find someone to cook for him in Mure, Ōi immediately thought of Sakuko Shimokawa, a member of his mountaineering club and a companion on a trek through the Himalayas. Shimokawa was the youngest daughter of a family who had operated a freight business in the Nihonbashi district, and when her first marriage ended in divorce she returned home to live with her parents. Tall for a Japanese woman, she climbed mountain trails as energetically as any male member of the mountaineering club, and at the end of the day she whipped up meals from wild vegetables and plants gathered on the slopes. Indeed, so accomplished was she as a cook that she was certified as a *kaiseki* (traditional banquet cuisine) chef.

Although Ōi realized that even a good cook would not last long working for Isamu, he thought that Shimokawa might pass muster. She was an independent soul, disinclined to bow and scrape, but in her easygoing way she accepted people as they were. She seemed just right for the job. "Could you help out an old man who has a problem?" he asked her. She would work in Mure only twice a year for about five or six weeks in the spring and fall, he told her, and it would be a nice change of scene for her. She was reluctant to accept the offer, and it took nearly six months for Ōi to persuade her.

In 1974 Shimokawa took charge of Isamu's kitchen during his visits. He did not have to explain to her, as he had to countless local women, the culinary philosophy he had learned from Rosanjin: "Food should please not only the tongue but the eye and the nose, as well." After every meal he always told her, "That was delicious." And when she asked him what he wanted for dinner he always replied, "If I know what you're making ahead of time, it would be no fun."[39] Isamu followed as regular a routine in his meals as in his work. In the morning he had a light breakfast of toast and coffee, and for lunch he liked noodles or a rice bowl mixed with vegetables or meat. For his mid-afternoon break in the "circle" Shimokawa made him a rice confection flavored with freshly picked wild herbs, and for his dinner she prepared simple family-style dishes. Grilled fresh fish,

caught at Aji harbor, was his favorite food. Governor Kaneko and Tadashi Yamamoto often dropped by for dinner, and Izumi was always there, too, eating silently at a corner of the table, returning home only when the meal was over.

Shimokawa was sitting one day on the sunlit veranda with her helper Yōko Ōta, a young local girl, when she suddenly reached out and struck Isamu on the forehead. Isamu, who was finishing his lunch, stared at her with astonishment. "Look," she said excitedly as she opened her palm, "it's a striped mosquito." "Shimokawa-san," Isamu replied admiringly, "you're the only person ever to hit me since I've become an adult." Izumi often asked her if she was afraid of "Noguchi-sensei." "Why?" she replied. Isamu may have been "Noguchi-sensei" to the people of Mure, but to her he was simply an elderly gentleman not much different in age from her father.

Admiring art school students often visited the house in Mure. Isamu rarely offered to meet male students, Shimokawa says, but he greeted young women students with a smile and a chat. "Girlfriends" often spent the night at the house, too. All of them, she thought, looked like heavily made-up bargirls, who snuggled up to Isamu and called him "Senseiiiii" in cloying sexy voices. It was clear to her that "Sensei" had a weakness for women who fussed over him. "Why don't you fall in love with a woman that other women think is nice?" she asked one day. Isamu, amused by the question, simply smiled in reply.

The only decent woman to visit, Shimokawa says, was the "Okinawa Mama" who always thanked her politely for taking good care of Isamu. Akiko Miyagi, then about fifty years old, was a well-known Okinawan dancer. Since the early 1950s Isamu had frequented an Okinawan restaurant that her family owned in Tokyo. A warm person, well liked by all who knew her, Akiko was less a wide-eyed "Okinawan beauty" than a refined "Kyoto beauty" with fine features. Her relationship with Isamu had continued for many years. Indeed, when Saburō Hasegawa's wife first learned that Isamu intended to get married, her first thought was that "it must be the Okinawa woman."[40]

"I've always associated [Isamu Noguchi] with beautiful women, who enjoyed having them around," recalled the art critic Katherine Kuh, "but he never wanted to invest too much of his life in them or anyone else."[41] Allen Wardwell, a former director of the Isamu Noguchi Garden Museum, observes that Isamu was a "seducer" all his life.[42] The older he grew the more

he wanted to conquer younger women, and he remained sexually attractive to them even in his later years. A steady international parade of young women artists—American, Japanese, Korean, Brazilian, and others—visited his East Side apartment. Isamu made no secret of his liaisons with other women to Priscilla. Indeed, he always introduced them to her, as though seeking her approval. It was his way of testing her devotion to him. But Priscilla also offered protection. By introducing her, he let his young friends know that he was not interested in a deep or lasting relationship.

In the 1950s Isamu became a good friend of Chimako Yoshimura, the well-known mistress of the Minoya teahouse in the Gion entertainment district of Kyoto. He was the only customer who ever called her by her personal name instead of addressing her as "Madam." Whenever he dropped by her establishment she summoned several young geisha to meet him. Three or four would be waiting in her living quarters when she and Isamu returned from dinner in the neighborhood, and while everyone chatted pleasantly, Isamu would whisper to Chimako which one he wanted to spend the night with. He was very popular in the Gion district.[43]

Since his Paris days Isamu had a reputation for falling in love easily—and for tiring of his lovers equally easily. An old friend says of his later years, "He thought beautiful young women were an essential source of his vitality." Even Priscilla, who knew that she could never monopolize his affections, consoled herself by saying, "He needed beautiful young women to recharge his batteries."[44] When Tōemon (formerly Kiichi) Sano, who worked with him on the UNESCO garden, once asked where the eroticism in his work came from, Isamu, pointing to a young female companion, replied with a serious face, "From her."[45] All his dalliances, Sano concluded, were linked to his creativity.

Eros was a central element in Isamu's art. His sexual encounters with women added a "luster" in his works. As the *New York Times* art critic Harold Schonberg pointed out in 1968, "A good deal of his sculpture, while abstract, is really not far from the human figure and even contains a pronounced erotic element. Phallic symbols are all over the place."[46]

Isamu produced more and more phallic sculptures, such as *The Stone Within*, *Shiva Pentagonal*, and *To Bring to Life*, in his later years. Phallic stones and statues are common in Japan, but the sexual element in Isamu's works probably reflects the influence of Indian art, which celebrates sexual

union as the source of life's energy. Two months before his death Isamu told a Japanese interviewer that he, like the Indians, believed sex to be the source of life. "Sex is very important to give you a feeling of being alive," he said. "There are frequent changes in the history of the human race but one thing that never changes is sex. There is nothing special about sex. It is an ordinary but important thing that has lasted a long time. If there is a feeling of love in my works I am grateful."[47]

When visitors to Mure asked the significance of *Wave in Space*, the abstract black granite sculpture in his entryway with a plump, round lump protruding at the top, he replied without hesitation, "It's a man's testicles." "My works are about men and women," he told Akiko Kanda, a Japanese dancer in Martha Graham's troupe during the early 1960s, who had studied dance with Michio Itō in Japan after the war and was expected to take over the troupe. He explained the meaning of his sets for Graham's dances about love and hate between the sexes to her very simply: "This one is the man, and this one is the woman."[48]

Many of his works from the 1960s onward are full of sexual symbolism. *Origin*, *Woman*, *Double Red Mountain*, *Incubus*, and *Feminine* symbolize the woman's body or sex organ; and others, like *Endless Coupling*, *To Love*, *Two Is One*, *White Composition*, *Little She*, and *Eros* celebrate the sex act itself. But even sculptures that most explicitly evoke the erect phallus or the vagina do not suggest naked lust. They are sensual but never lascivious or prurient. Nothing could be further from the lewd and the bawdy than their vivid yet subtle softness. Perhaps no work better conveys Isamu's sense of the erotic than *Mitosis* (1962). Cast in black bronze, it is about twenty inches long and thirty inches wide. Two round objects, each shaped like a woman's breast, one slightly larger than the other, lie side by side with nipple-like protrusions just touching one another. The delicacy of the contact infuses this small work with an erotic yet elegant beauty.

Alfred Stieglitz once said of Georgia O'Keeffe's paintings of flower petals and blossoms that she "put on paper the male and the female principles." Isamu Noguchi achieved the same effect in three dimensions. His works were generous celebrations of life, confronting the reality, transcending all nationalities and even humanity itself, that human beings are sexual beings above all else. For Isamu, Eros was the most reliable expression of human warmth.

About a year after Isamu finished work on *California Scenario*, Kyōko Kawamura was often seen at his side. Her husband, Junichi, was a young architect from Kenzō Tange's office who had been assigned to work with him on the Sōgetsu Hall project. According to Junichi, he learned more from the job than he had as an architecture graduate student. Isamu had a better grasp of architecture, he says, than specialists who studied it all their lives, and his treatment of even the smallest details reflected his prodigious natural talent and supple intelligence. Isamu was the "artist he most respected in the world."[49]

In January 1978 Junichi visited Mure to introduce his wife, Kyōko, to Isamu, who was then spending his New Year's holiday in Mure. Isamu was delighted by their visit. After showing them *Energy Void*, a huge work just completed in the "circle," he invited them to lunch. They stayed for dinner, too, talking until late in the evening, not about sculpture or architecture but about music. Tange encouraged his young associates, and their wives as well, to acquire some kind of "Western skill" like piano playing or English conversation to make them feel more at ease when dealing with foreign clients. Kyōko, who studied Japanese music at Tokyo National University of Fine Arts and Music, was never comfortable with the other wives in the firm but she was impressed when Isamu put on a record after he learned that she played the *koto* (Japanese zither). By chance, it was a recital by her teacher Kinichi Nakanoshima. Then he began playing cassette tapes of Indian and African folk music from the gift shop at the UNESCO headquarters. "I bought them out," he said proudly. He began to dance, swinging naturally to the beat of the music. Swept up by his gaiety Kyōko and Junichi, who had never danced before, soon joined him. Charmed by the warmth of his hospitality, they told each other on the way home that Isamu was "an ideal human being."[50]

Although Kyōko was past thirty, perhaps because she had had no children she retained the fresh clean-cut look of a student. She thought to herself that Isamu was interested in her but he made no advances. What kept his feelings in check may have been hurtful memories of an another affair involving a young Japanese couple in New York, both graduates of Tokyo National University of Fine Arts and Music. The husband worked as Isamu's assistant, and the wife had an affair with him. The couple's

marriage had been troubled by other problems, the husband says, but eventually his wife left both him and Isamu to return to Japan, where she committed suicide. Her death was a great shock to Isamu, more than many friends suspected, and for the next few years he avoided any lasting relationship with a woman. Isamu's affair with Kyōko did not begin until five years after they first met. It was she who took the initiative. At an Osaka art exhibition in November 1982, Kyōko presented Isamu with a huge bouquet of cosmos flowers. A week later Isamu invited her to an Arshile Gorky show at the Seibu Department Store in Tokyo, then took her to dinner with Buckminster Fuller, who was in Japan for a lecture.

In the summer of 1983 Isamu completed work on *Constellation for Louis Kahn*, an arrangement of four basalt sculptures in a sunken courtyard at the Kimbell Art Museum in Fort Worth to commemorate his old friend, who had designed the museum building. Instead of going to Italy as he usually did, he returned to Mure, where Kyōko stayed with him for five days in August. Yōko Ōta, who had taken over as cook from Sakuko Shimokawa, prepared Isamu's meals and did other household chores. After Isamu left for the "circle" in the morning, Kyōko stayed at the house nearby practicing her *koto*. "It's nice to hear singing," Isamu said. "Yoshiko and Frida were both good at singing." Whenever she stopped playing, Isamu cast a worried look in the direction of the house. "What's wrong?" he asked.

As the sound of *koto* music began to drift into the "circle," Izumi saw a change in "Noguchi-sensei." The workplace had always been taut with excitement and tension from early morning until dusk. Isamu's intense concentration electrified everyone. For Izumi and his workmen the "circle" was a sacred place "where men and stone confronted one another." But in the summer of 1983 Isamu listened to the *koto* music with a gentle, distant expression as he worked, and whenever Kyōko came into the "circle" to see what he was doing, he simply greeted her with a smile. On those days, when work was done, Izumi told his disciples to scatter salt around the workplace—a form of ritual purification.

A month after her first visit to Mure, Kyōko accompanied Isamu to Sakata City for the opening of a museum dedicated to Ken Domon, a photographer who brilliantly captured the confusion of postwar Japan with his camera. The architect Yoshio Taniguchi, the son of Domon's old friend

Yoshirō Taniguchi, designed the museum building, a simple but elegant white-walled structure set against the background of the mountains surrounding the city. Next to a small artificial lake in front of the museum Isamu created an inner garden court with a gradually sloping gray granite surface, broken into several steps, over which water ran to the lake below. A phallic-looking stone sculpture symbolizing Domon stood in the midst of the gently cascading water as though meditating.

Kyōko was an attentive companion, never contradicting Isamu, and taking care of him with the delicate thoughtfulness of a Japanese woman. Since Junichi went on frequent trips abroad with Tange, it was easy for her to adjust to Isamu's schedule. Whenever he came to Japan, she was always at his side.

In Tokyo, Isamu stayed at the Fukudaya, an elegant and expensive Japanese inn to which Rosanjin had introduced him. It was his only extravagance, he often said. Once he settled in his usual room at the back of the inn, he phoned friends to let them know he was in town. During the last years of his life he often met with the architect Arata Isozaki, a student of Tange who had become a leading postmodern architect. He had met Isamu on his 1950 visit, and Isamu was always eager to probe him for new ideas. His wife, the sculptor Aiko Miyawaki, who usually joined them at dinner, recalls that Isamu displayed a pugnacious, almost arrogant attitude during the years he worked on commissions for large American corporations. His lips were tight and his brow furrowed. Once Kyōko became his constant companion, however, his expression grew warmer and softer, a change for the better, she thought.

The Isozakis were among the few friends who saw Kyōko as a positive influence on Isamu. Few doubted that she was devoted to him but most were cool toward her. Friends his own age were less generous toward her than they had been toward his other lovers. They understood he wanted to have someone close to him as he grew old, but they found it hard to accept a woman young enough to be his granddaughter in that role. Moreover, she was married. It was clear that she had an understanding with her husband but that made the relationship even more difficult to fathom. Many feared the affair might create a media scandal that would damage Isamu's reputation in his final years.

On July 13, 1984, Kyōko had sent her husband a postcard from the Forte dei Marmi, a seaside resort town near Pietra Santa, where she was staying with Isamu. A photograph she took shows Isamu sunbathing on the beach clad in swimming trunks, his body still tight and muscular, so youthful that it is difficult to imagine he was facing his eightieth birthday. Though on vacation, Isamu worked during the morning at Pietra Santa, where Giorgio Angeli, a stone craftsman with the Henraux Company for many years, had set up an independent workshop after his master died. Angeli respected Isamu as much as Izumi did, and he gave Isamu's young lover a warm and open Italian welcome, inviting them to dinner every evening on the terrace of his house. From Forte dei Marmi, Isamu drove a rented car to Florence, Bologna, and Venice with Kyōko. Then he returned to New York from Zurich, while Kyōko left for Tokyo. Less than a month later he was back in Mure to meet Kyōko again. His flights across the Pacific became more and more frequent.

On November 17, 1984, an Isamu Noguchi exhibition opened in the stone garden of the Sōgetsu Hall to celebrate his eightieth birthday. On display were stone sculptures with their rough natural surfaces left nearly intact. "These works are accidents that nature has forgiven me for," he told Hiroshi Teshigahara.[51] He had spent his career as a sculptor attacking his materials with full force. Now he was willing to let nature speak for itself. The critical response was favorable. "As a whole," reported the Kyōdō News Agency, "the stones convey a quiet sense of rhythmical movement, bringing to life the characteristics of the hard material, clearly expressing the presence of magnificently voluminous forms, and capturing with chisel carved lines the contrasts between relatively smooth surfaces and rough grainy surfaces."[52] The *Asahi shinbun* observed that the works revealed "the natural form of the stone itself as well as the sheer will power of the still-youthful Noguchi."[53]

The organizers of Isamu's eightieth birthday party included many old friends, all of them celebrities in Japan: Tomiko Asabuki, Ayako Ishigaki, Yūsaku Kamekura, Sōshitsu Sen, Tōru Takemitsu, Yoshio Taniguchi, Kenzō Tange, Hiroshi Teshigahara, clothing designer Issei Miyake, and others. Among the hundred or so guests were his half-brother Michio Noguchi, who had helped him with miscellaneous affairs after he first arrived in postwar Japan; Tsutomu Hiroi, who married Yoshiko's younger

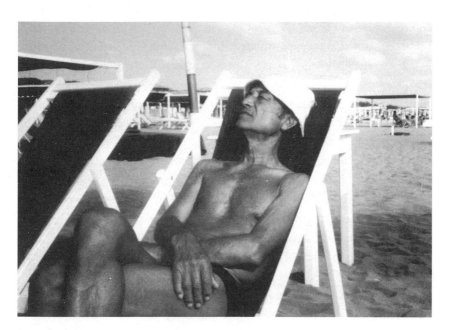

Isamu on the beach at Forte di Marmi, Italy, 1984

sister; Seijirō Ōi, the Ginza iron foundry owner; Hidetarō Ozeki, who manufactured Akari lamps at his Gifu factory; Takeshi Ukita, who supplied him with *mannari* stone from Okayama; Masanori Kaneko and Tadashi Yamamoto, who had made it possible for Isamu to work at Mure; and, of course, Masatoshi Izumi. Priscilla Morgan, and Shōji Sadao and his wife had flown in from New York, and Kan Yasuda had come from Pietra Santa. Junichi and Kyōko were there, too.

Delighted at being surrounded by so many friends, old and new, Isamu looked far younger than his eighty years. At a post-party celebration Isamu shed the dark brown raw silk jacket Issei Miyake had given him and took to the dance floor. All eyes turned toward him when he took Kyōko, another man's young wife, as a partner. It was the first time many of his friends saw them together in public.

In February 1985 Isamu took Kyōko along on a trip to India. Prime Minister Indira Gandhi wanted his advice on how to promote the export of traditional Indian folk art, and Isamu wanted to show his young lover the

country that had provided him so much creative inspiration. Although a Sikh religious fanatic assassinated Indira Gandhi before their arrival, Isamu was still welcomed at the airport as a guest of the government. During a tour of Bombay the next day, perhaps because of the intense midday heat, or perhaps because of the overly chilled hotel room, he suddenly felt ill. Fatigue from his heavy schedule of flying back and forth across the Pacific had taken its toll. He canceled a trip to southern India but his condition still did not improve. By the time he was admitted to a hospital in New Delhi he had come down with pneumonia. As his condition grew more serious, he lost his appetite. The hospital meals all smelled or tasted of curry. When he finally recovered after ten days in the hospital, he immediately flew back to Japan.

The sudden illness cost Isamu not only his consulting job with the Indian government but also a chance to pursue a huge project for the city of Ahmedabad. Although his dream of designing memorials for Gandhi and Nehru had not been realized, he had not given up his hope of completing a significant project in India. In 1957 he had collaborated with several young Japanese architects (including Tsutomu Hiroi, Yozō Shibata, Katsumi Omuro, and Jirō Kodera) in a competition to design a park commemorating the 2,500th anniversary of the Buddha's birth, but their plan came in second place. In the 1970s he worked on a commission for a water park in a Bombay suburb but it had been canceled because of budget difficulties.

Isamu often told Anand Sarabhai, the nephew of his late friend Gautam Sarabhai, that he wanted to leave an artistic legacy in the country he had loved so much and had visited for so many decades. What could be better, Sarabhai suggested, than a park combining stone, water, and light. The state of Gujarat was dotted with "step wells," distinctive public wells dating from medieval times. Built on a monumental scale with long stone staircases leading down to the water source, the step wells often reached three or four stories below ground level. Their walls, exuding a palatial splendor, were inscribed with elaborate carvings in Sanskrit lettering. Still in use after centuries, the step wells offered gathering places for common people to meet and rest in the shade as they came to draw water.

Sarabhai proposed that Isamu design a huge modern public facility replicating the wells and reviving the medieval technique of using naturally cooled underground air to provide relief from the sultry heat. The Sarabhai

family was prepared to provide land for the project and to finance all construction costs. Isamu's sudden illness cost him the opportunity to move forward with the project. The "Isamu Noguchi Step Well" would surely have attracted global attention for its ingenious use of the natural environment. Unfortunately the wellsprings of his own life ran dry before he could return to India.

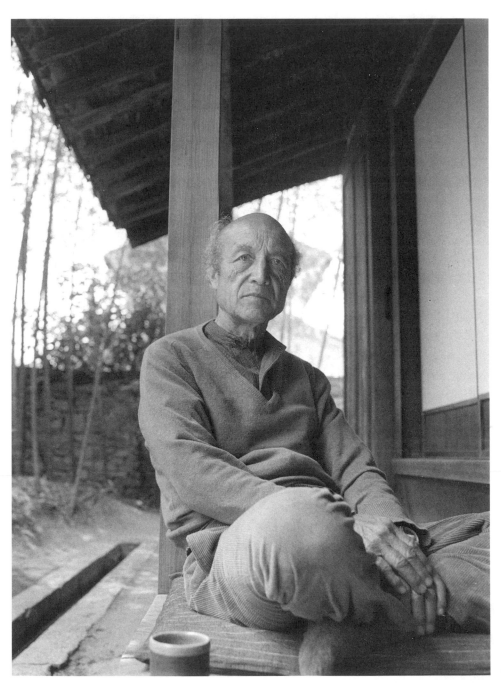

Isamu on the veranda of his house at Mure, 1984

Farewell to a Dreamer

The Isamu Noguchi Garden Museum

In explaining why he had established a museum for his own work Isamu wrote, "I define the reason for the Isamu Noguchi Museum as a desire to show the totality of my work as an evolving relationship significant to our time. This spans the development of sculpture in America, of which I have been part, from the first quick appreciation here of Brancusi with the arrival of modern art, to the present. . . . This is called a garden museum as a metaphor for the world, and how an artist attempted to influence its becoming."[1]

In 1970 Isamu bought a corner lot across the street from his studio to expand his working and storage space, and in 1981 he acquired an adjacent two-story photoengraving factory with a junk-filled backyard. The Isamu Noguchi Garden Museum was built on the enlarged site. The neighborhood had been a drab and decaying factory district when Isamu first moved there, but once he established a foothold younger sculptors followed his example, setting up their own studios. Mark di Suvero, a young star in the American sculpture world, was impressed by Isamu's bold break with convention. The idea that an artist would establish a museum for his own work, he says, was still a novel one. Indeed it was even shocking to some, who criticized Isamu for his "egotism."[2]

What also surprised many was that the museum contained some of his very best works. Isamu held on to them not because he planned to build a museum, says his lawyer Charles Lieb, but because he was so deeply attached to them even as a young man. He rarely sold anything unless he needed money. It was almost as though his creations were a part of him.

"The only works that Isamu let go," says Arne Glimcher, owner of Pace Gallery, "were the ones that he didn't think much of himself."[3] When Isamu turned seventy, Lieb says, he began to worry about what would happen to his personal collection. The Whitney Museum, the Museum of Modern Art, and several other museums expressed interest in acquiring it, but it was unlikely that all the works would be put on permanent display. Isamu also feared that his stage sets, his furniture, and his Akari lamps would be exhibited separately or that they might be put in storage, never to see the light of day. He wanted to keep his innovative creations before the public eye without surrendering them to the arbitrary decisions of museum curators.

As he reminisced with Ayako Ishigaki several days before his eightieth birthday party, he told her that he had been sterilized. "As I look back on it, it's too bad that I had no children."[4] It was not that he regretted not having a family heir, Ishigaki thought, but rather that he had no offspring to look after his artistic legacy. He chose instead to preserve that legacy by establishing his own museum. "A museum, I suppose, is a repository against time," he said. "Fragile objects need protection, but even without this there is a semblance of eternity, a sense of permanence that is implied by a museum and a removal from time's passage."[5]

Allen Wardwell, an art historian he consulted when planning the museum, says that Isamu came to his decision only after a long debate with himself. Although he wanted to devote all his assets to preserving his oeuvre, when he learned that he would have to take out an enormous loan to set up an endowment, he had second thoughts. Priscilla, as usual, came to the rescue. Recruiting important figures in the New York art world as trustees, she set up an Isamu Noguchi Foundation and found land for the expanded museum site.

The museum's first director, Miles Kubo, a third-generation Japanese-American, had been art director at the Japanese-American Cultural and Community Center in the Little Tokyo district of Los Angeles, where Isamu had designed a rock garden. When Kubo began his new job he was astonished to discover that Isamu had not only held on to so many creative works but that he had also accumulated an archive of newspaper and magazine reviews, correspondence, receipts for works sold, and other documents from his youth onward. Despite his peripatetic life, as he moved restlessly around the globe Isamu threw away hardly a single letter. As Kubo sorted through the massive trove, he sensed that even as a young sculptor Isamu

had been determined to establish himself as a great artist someday. He had kept everything as evidence for future generations to ponder. "Some day I will leave this world," he once said. "My last will and testament will show the direction I intended to go. In doing so I may be liberated from time. My museum may even become a prophecy of the truth."

The Isamu Noguchi Garden Museum, a two-story concrete-block structure with a windowless first floor, seems at home among the small factories, workshops, and warehouses surrounding it. Indeed, it almost seems built to repel visitors. The only hint that an art museum lies within its walls is a small sign on a heavy steel door at one corner of the building. In a sense the museum itself is one of his works. It took ten years under his watchful eye to design the building interior and arrange the work in its exhibition rooms. It bears the strong imprint of his way of seeing and doing things. When the museum was completed in 1983, access was limited to a few visitors but it was opened to the public in May 1985, just three months after Isamu fell ill in India. A *New York Times* article called it his "dream museum."[6]

The museum entrance, and the reception room immediately inside, are tight and narrow spaces. Beyond them the visitor enters an ample, high-ceilinged exhibition room, a quiet space whose concrete-block walls seem to absorb sound. A pair of stone sculptures immediately introduces the world of Isamu Noguchi. To one side is *Woman*, a stone sculpture on a heavy stone pedestal, whose lower section opens up gently like a decorative screen; facing it on the other side is *The Stone Within*, a phallic form bursting with energy. Both pieces are carved from basalt, the soft surface left natural in some places, polished to a luminous dark sheen in others. Of the three hundred works on display, these two, as well as twenty-one others that represent the intense efforts of his later years, arrived from Mure just a month before the opening. The reason they were displayed on the first floor and in the garden was not simply that they were too heavy to put elsewhere. By placing them where they made the most impact, Isamu was proclaiming these stone sculptures as his most original works.

The interior of the museum is unexpectedly spacious. On the second floor the visitor can trace Isamu's experiments in shaping clay, aluminum, steel, and stone into geometrical or biomorphic shapes. Other works on display attest to his breadth and depth as an artist: the portrait sculptures that demonstrate his exceptional skill as a traditional figurative sculptor;

the many stage sets he made for Martha Graham; the models for the many gardens, parks, and playgrounds he designed (including those never realized); and the bamboo and paper Akari lamps. The rear garden is cleverly fitted into a triangular space that looks deeper than it really is. Large and small stone sculptures are interspersed with pine and maple trees. Most of the exhibition rooms face the garden, with windows that let in natural sunlight all day. The museum offers a succinct summary of Isamu's unique career as an artist who walked a tightrope between Eastern and Western culture, between the concrete and the abstract, between the traditional and the new, between the natural and the man-made, between pure art and commercial art. It was a career difficult to summarize in words.

With the publication of *A Sculptor's World* and the retrospective show at the Whitney Museum in 1968, Isamu finally achieved recognition as one of the leading American sculptors of the twentieth century. Even though he was recognized as a master of his art, his place in the American art world was still hard to define. As the *New Yorker* art critic Calvin Tompkins noted in a 1980 review of *Isamu Noguchi: The Sculpture of Space*, an exhibition of his stage sets and gardens at the Whitney Museum, "In spite of this freshet of recognition, . . . Noguchi's place in contemporary art remains strangely elusive and uncertain. He is a master whose credentials are still in doubt."[7] The problem, Tompkins pointed out, was that Isamu was not really associated with a distinctive style. He had not produced a trademark that immediately identified a work as clearly one of his own

Isamu, of course, had an answer to such criticism. He told the art critic John Gruen in 1968, "I don't think I have any style. I'm suspicious of the whole business of style because—again it's a form of inhibition—the more I change, the more I'm me, the new me of that new time. To change is to invent, to create anew. That is why I applaud change. There is an unconscious line in my work—it's unavoidable. Still, this line has not always been recognized, and I wish I were more recognized for what I have really tried to do. You see, I'm not really interested in doing sculptures, as such. I do them, of course. But it's the world I look for, there where everything is sculpture."[8]

Isamu refused to limit himself to a repertory of fixed forms and materials that might have defined a characteristic artistic style in the usual sense. He constantly experimented with his art. As Tompkins observed, his

talent fed on contradiction. "His career has been a dialectic between tradition and invention, craft and technique, geometric form and organic form, weight (stone) and weightlessness (paper), the rough and the finished."[9] But experimentation did not mean that Isamu lacked a "style" in the sense of a distinctive inflection or quality that one can immediately recognize. That quality, which emerges in all his work, including his public art projects, and even in his rough-hewn pieces, is an unmistakable elegance. It was this distinctive touch of a refined elegance that constituted his style.

"I don't think that perfection is all that important," Isamu once said. "But I want to get things done just right. That may be a bad habit of mine."[10] The first person to comment on that habit was the Japanese sculptor Tarō Okamoto. Isamu, he wrote in 1952, was a "sophisticated abstract sculptor, unsullied by lack of refinement, with a tendency to become overly delicate and very pretty in his finished work." Okamoto, who had lived in Europe for many years, was familiar with both Eastern and Western culture. He admitted that the metal and marble works Isamu made in New York, as well as the unglazed terra-cotta pieces he crafted at Rosanjin's estate, were "cosmopolitan and aristocratic" in their sensibility, but he also found them lacking. "It is rare indeed to find works as detached from the earthy and unrefined as Noguchi's are. . . . There is an agreeable pleasantness about them but also a kind of weakness. To be sure, being cosmopolitan is an indispensable condition of today's art, and Noguchi possesses that quality in abundance. But if he were to bolster his brilliant sense of beauty by struggling with earthiness of reality . . . then his work would have an even more powerful impact."[11]

The elegance that a Japanese modernist like Okamoto criticized in Isamu's work was taken by American critics to be an inherent ascetic spirituality. Even the distinctive warmth, eroticism, and humor that undeniably suffused his work were much too elegant for American taste. In the vocabulary of American art criticism, "elegant" was an emasculating or neutering adjective. It implied "decorativeness," a quality that consigned much European art to the dead past. Thomas Messer, the retired director of the Guggenheim Museum, argues that the ambivalent critical response to Isamu's work was "a bias against his style."[12] But critical bias was not rooted simply in an assessment of his creative works. It was rooted in the perception of his personality, and the ambiguous self-identity that he had constructed, as well.

Of all the first-rank artists represented by the influential Pace Gallery, says Renate Danese, who handled Isamu's work at the gallery, Isamu was the hardest to please. According to Danese, he was always distrustful of people who made a "business" of art—those connected with art galleries and art museums, and without exception he dismissed art critics with a growl. Since his youth, when Henry McBride had dubbed him "half Oriental," he felt that critics were his enemies.

The only critic Isamu tolerated at all was Katherine Kuh, who wrote for the *Saturday Review* in the 1960s and 1970s. The author of many books on contemporary American art, Kuh first met Isamu on his 1941 trip to San Francisco with Arshile Gorky, and they had been close friends ever since. She knew him as a person, and she knew his work. Not only did she faithfully attend all his gallery shows and museum exhibitions, she traveled to see his works abroad, from Jerusalem to Mure. In recollections recorded for the oral-history project of the Smithsonian Institution's Archives of American Art, Kuh offered an appraisal of his work.

"I'll be dead before this is ever used," she began. "I think Noguchi is a most able and creative artist but not at his best as a highly inventive artist. It seems to me that he carried on two great traditions, his own tradition of Japan, which he modified, adapted and Westernized, and I think used beautifully. And second, the influence of the man of his early years, Brancusi, whom he adored. He has told us over and over how much Brancusi meant to him. Now, I think he goes far beyond what I've just said. It's far too pat to label him so easily. I think that he is really a highly creative man who used all these influences quite consciously but I don't think that he's broken any boundaries."[13]

Kuh was one of the few American art critics who spoke positively about the diversity of Isamu's work, the result of his attempt to expand the frontiers of sculpture. He "came nearer to being totally extraordinary" as a designer of theater sets than as a sculptor, she said, and she admired the portrait busts he produced in his youth as "deeply sensitive" with "more than just the meaning of what you touched or saw." His Akari lamps, dismissed by other critics as merely commercial, she thought "marvelous," indeed among his best work, and the more than two thousand sculptures that constituted the core of his work "well balanced" and "elegant."

Kuh was less enthusiastic about the garden projects in which Isamu had invested so much energy during the 1960s. The only one she thought

successful was the Billy Rose Sculpture Garden in Jerusalem. "I've never felt that his gardens have been a total success. After seeing the real thing in Japan—I don't mean his but the ancient ones—I just felt that he didn't quite do the job." Isamu, of course, always insisted that he was interested in making "gardens of the future" not in conforming to Japanese conventions of garden design, and no doubt Kuh heard him say that many times, but in the end she concluded that his gardens were imitations of "the real thing."

A critic with a sensitive eye and discerning judgment, Kuh clearly understood Isamu's work, but ultimately she could only see him from the same perspective as his other contemporaries did. She did not think much of his public art projects, including masterpieces like the Hart Plaza fountain in Detroit. She recognized that Isamu was a pioneer in the field, and that no other artist had as exceptional a sense of space as he did, but she thought that the fountains he designed using "steel and other new materials" were all failures. "I think he has no feeling for that," she said. "I feel that at his best he worked in smaller dimensions, human dimensions, which comes out of Japan." Probably for that reason she judged his largest sculptures, like *Sky Gate*, a twenty-four-foot-high steel piece in front of the Honolulu municipal building, unsuccessful, too.

What Isamu excelled at, Kuh said, was working with natural materials like stone, wood, and flint. His aesthetic debt to Japan was clear. His most outstanding and original works, she thought, were the sculptures that breathed life into natural stone. The half-completed works she saw in the "circle" at Mure moved her tremendously. "I was deeply impressed by the stonecarving he was making," she said. "They were rugged, more rugged than anything I had seen by Noguchi. Marvellous because they come out of the spirit of that country. They had nothing to do, really, except in overall shape, with Brancusi." And the most successful of all, she thought, were those works fashioned on a human scale.

In sum, Katherine Kuh believed that Isamu's importance as a sculptor lay in synthesizing and internalizing the artistic traditions not only of America and Japan, but also of Europe. But she was candid about her assessment of his standing in twentieth-century American art. "I am a great admirer of Noguchi, a very great admirer. . . . I also think that he is more an adapter and a follower than a great innovator. If I were to compare him with David Smith, I would put David way beyond him. . . . [Fundamentally] I don't think he changed our way of thinking. I don't think that's

important either. But if you asked me the two American sculptors of this century—of course, [in] the last century there were none who changed our way of thinking—who made history and in making history really changed our vision, I'd say Calder and David Smith. I would put Noguchi right after them." Both Calder and Smith were heavily influenced by trends in European art—Smith by Julio González and Calder by Miró and Fernand Léger—but both had blended those influences into their own distinctive styles. Smith "integrated his European influences so totally into his own vision that they actually became American, a part of industrial America." Calder, on the other hand, "remarkable as he was, visually remained very close to Miró and Léger." Despite their inspiration by European models, however, both men had changed the American conception of sculpture.

As Calvin Tompkins pointed out in his *New Yorker* review, Isamu's position in contemporary American art was "strangely elusive and uncertain." To some extent he thought that was the "result of prevailing critical winds" that defined the path of modernism in sculpture as the one taken by Picasso with his welded metal constructions of the 1930s. "But critical doctrine does not make or break reputations in the visual arts," he added. "The real trouble seems to be that Noguchi, for reasons that bear directly on his development as an artist, has never settled long enough in one place, geographically or aesthetically, to make it his own."[14]

In her recollections Katherine Kuh spoke of Isamu as a friend. "He's just a lovely person as a friend," she said. "I can't imagine him ever being vulgar or unkind." Even though she had handled and sold his work as a gallery owner, "We've never in our lives had an unpleasant experience." She mentioned Isamu's fondness for beautiful women but she pointed out his loneliness, too. "Noguchi was always a loner, very much a loner. . . . He doesn't often tell you about his personal feelings. . . . He had a kind of inner graciousness. He's very closed away. Anyone who pried too much and wanted too much from him would be rebuffed. When he's a friend he remains a friend. He picks the person with his or her quirks and accepts you if you don't demand anything. He doesn't want anything demanded of him. . . . He has certain quiet loyalties. . . . When I see him he doesn't confide a lot the way some artists do."

Not surprisingly, Kuh found Isamu very different in personality from both Calder and Smith. Calder, the son of a prominent sculptor, was a fam-

ily man, happily married to a grandniece of Henry James and the father of two daughters. He was outgoing, graceful, and popular with others. Smith, on the other hand, was a man of large and lusty habits. Kuh spoke of him as an "American artist" with a personality as powerful as his work. He was a "very tender man and a wonderful friend," she said. "He was such a big, overpowering, violent, angry man. . . . I don't think he had the slightest doubt of who he was and how important he was. And how angry he'd get when people didn't realize it." Smith, like Jackson Pollock, died in an automobile accident at the height of his career, and like Pollock he became a legend, the kind of romantic hero that Americans find irresistible. He avidly pursued his own ambitions, like a pioneer or a frontiersman, doing as he pleased with his life, but he was delicate and tender when he wanted to be.

Isamu's personality, by contrast, was withdrawn. "He's shy," Kuh said. "He has never done things to excess. He's never been a drinker, he's never overeaten." In everything he did, including his life style, "He's always been keenly aware of being torn in two directions. . . . There's no doubt he's torn more toward Japan than toward us." Kuh's assessment of Isamu's personality rather than her evaluation of his artistic accomplishments suggests why so many American critics found it so difficult to grasp just who Isamu Noguchi was. The problem was that he did not conform to the image of what a "100 percent American artist" should be. With his slight physique, and a disposition that everyone described as complicated, there was little chance that Isamu would ever be seen as an "American hero." What he confronted throughout his life was not simply a critical bias against his style, which seemed Oriental or European in its "elegance," but also his image as someone who did not quite fit in in America. As Allen Wardwell observed, "Depending on the circumstances, Isamu was sometimes an American and sometimes a Japanese. Exoticism was his passport to everything."[15]

There was another reason that Isamu, even in his last years, remained "a master whose credentials were still in doubt." "He was always running from something, running, running. If he stood still, he might be tied to a routine," says Bonnie Rychlak, his studio assistant during his final decade.[16] Whenever a problem arose at the museum office, Isamu usually overreacted, then left for Japan or some other distant place without resolving it. Rychlak thinks that Isamu never stayed anywhere more than a few months because he was always avoiding something.

"[T]he more you travel, the less contact you have outside because you're thrown upon yourself," Isamu told a Japanese reporter in 1960. "You come to a new place and people get along very well without you. They don't need you. So normally speaking you're all alone. There's no more lonely thing than being a traveler, right? . . . I pass as a person of whatever country I am in. I have a very convenient face."[17] Ironically, the one country where he could not pass as a native was Japan, the "homeland of his heart." He remained a foreigner (*gaijin*), even in physical appearance, and although he could speak enough Japanese to get along in his everyday life at Mure, when he tried to express his feelings or ideas his language was stilted and childish. Even after he returned to Japan after the war, he still expressed himself best in English.

In the United States, on the other hand, Isamu was fully assimilated linguistically and culturally, but until the very end of his life he gave the impression of having no fixed identity. It would be wrong to attribute this impression to the covert prejudices of the American art establishment. In fact, Isamu had a reputation for leading a peripatetic life and a bad habit of disappearing from the United States just before his shows opened. His continual absence from the United States confirmed the impression that he did not feel comfortable there. Unlike most artists, who early on in their careers establish an ongoing relationship with a single art gallery, from his early days as an artist Isamu also kept changing dealers. Renate Danese thought this habit was rooted in his "fear of belonging."[18] Whatever the cause, it only added to his reputation as a difficult person to deal with.

Isamu may have been part of the American art world but he never worked at belonging to it. "I'm not very community-minded," he said. "[M]y main problem from my earlier childhood is the lack of communication, a lack of real intimacy between myself and my surroundings."[19] It was not that he deliberately rebelled against "belonging"; rather it was that he could not escape the cultural duality that he had shouldered since his birth. Throughout his life Isamu hungered to belong but at the same time he was afraid of making a choice about where to belong. He instinctively avoided the act of belonging—whether to an art gallery or anything else.

"I am not a Japanese artist by any means but neither am I a local New York artist either," he once said. "I mean, although I am based in New York—I consider New York to be my home in a way—and yet it isn't my home for some reason—I'd be constrained if I had only to stay in New

York or do what is possible in New York. . . . To be completely Japanese you can not have a world viewpoint. I had to be universal or nothing at all. I couldn't be just localized. And I was all over the place. I feel equally at home wherever I am. People seem to welcome me as a native and that's my pleasure and that's my sadness—that I really haven't got a home."[20]

Isamu's greatest strength, Calvin Tompkins observed, "is that he does not belong."[21] From the beginning of his career as an artist, Isamu turned the ambiguity of his identity into an asset. "I have always desired to belong somewhere," he once told a Japanese newspaper reporter. "My longing for affiliation has been the source of my creativity."[22] This sentiment, which he repeated over and over again during his long career, summarized the way he lived. He spent his life searching for a place to belong but he realized that his strongest asset was his "longing for affiliation" rather than affiliation itself. Insofar as that longing was a source of inspiration and creativity, Isamu knew that he could never attach himself to any country or any group. Realizing that he could never be completely American or completely Japanese, he pursued his search for artistic self-discovery with the freedom of a nomad, but the inevitable consequence of having few close ties to others was a constant feeling of extreme isolation. This loneliness gnawed away at him psychologically, especially during his final years. As he told Tompkins, "Being half-Japanese and half-American, I am always nowhere."[23]

At the time he made this remark, disturbing memories of his father had surfaced once again. When his half-sister Ailes, responding to an inquiry from a scholar interested in Yonejirō, opened an old trunk that Leonie had left her, Isamu, already in his seventies, read for the first time the correspondence between his parents before and after his birth. He was confronted by indisputable evidence of how badly his father had betrayed his mother and how he himself had come to be branded as a "bastard." His feelings toward his father had softened after the war. Being on the winning side in the war made that easier. But when he discovered the circumstances of his birth, long buried emotions suddenly surged up out of the recesses of his mind. The more he recalled his mother's misery, which ended in extreme poverty, the more it deepened his hatred toward the father who abandoned him. Friends recall that he suffered violent swings in mood around this time, suddenly bursting out angrily about his father or reacting uncontrollably when some trivial matter triggered him.

A few months before his death Isamu characterized himself as a "pariah."

> You might say, in some way, that I'm an expatriate wherever I am, either in America or in [Japan]; that I'm after all, half-breed there or half-breed here. It makes no difference. And therefore I'm [not] trusted, in either side. Either I'm being too American or not American enough, or I'm too Japanese or not Japanese enough. . . . I'm very curious to know, for instance, what do the Japanese people really think about me—as a fake Japanese or as a fake American? Which? Am I trying to be Japanese or am I trying to be American? I suspect they think I'm trying to be Japanese—and that's even worse from a Japanese point of view than to be an American, because they will say he's a real phony, he's an exotic.[24]

"I distrust people," Isamu once confessed. He knew that his suspicion of others was his greatest fault. As a child he had grown up in a fatherless home, then at the age of thirteen he was suddenly thrust into a life among strangers, never sure about who was a friend and who was not. The experience deepened his mistrust of others, and until the end of his life whenever he faced a crisis he withdrew into his own shell. That shell was his creative work, the only sanctuary where he felt secure.

The prevailing evaluation of Isamu Noguchi is not very different from that of Katherine Kuh. Even though he is acknowledged as a master of the art of sculpture, he does not have a secure place in the mainstream of twentieth-century American art. He died without ever hearing what Kuh had said about him, but that does not mean that he was not aware of how she and the rest of the art establishment perceived him.

Was he to be understood as a "pioneer who broke every boundary that he encountered in the art world"?[25] Was he an artist "who opened a multi-cultural future in the field of sculpture"?[26] Was he an artist "who took on the challenge of all kinds of materials but never pursued the essence of any single one to the fullest"?[27] Or was he "the victim of his own intense curiosity about everything"?[28] His decision to establish the Isamu Noguchi Garden Museum was his answer to these questions. It was a site where visitors could come to their own conclusions after seeing his creative works.

Miles Kubo resigned as director of the museum after only a year because he felt that Priscilla spent too much time shepherding Isamu

around New York society circles without trying to understand the responsibilities of a nonprofit organization. But Isamu stood by Priscilla, soliciting financial support from the National Endowment for the Arts, the New York City government, and various private foundations. He charmed rich and influential patrons of the arts like Jacqueline Kennedy into giving money, too.

At the opening reception for the museum he told a Japanese journalist how happy he was but he also confessed, "I am always thinking about money."[29] The museum required a staff of five or six people, and there were other operating expenses, as well. Isamu constantly fretted about the museum's finances. When he first purchased the Long Island City studio, he told Priscilla that he felt as though he were drowning. Once something bothered him, especially a money problem, he could not get it out of his mind. Priscilla thinks he worried about money so much because he had arrived in America so poor and alone.[30] To build his museum he borrowed heavily, and he often felt depressed about the debt. He complained to Kyōko constantly about the "millions of dollars" he had to raise. As usual, to escape his worries he plunged himself into work, producing hot-dipped galvanized steel sculptures folded like origami that he hoped would sell easily.

"I think you'll be interested in the museum," he told an interviewer, "as an example of one artist who couldn't make it into the social world of art—a lone wolf."[31] Already past eighty, Isamu had taken on a financial responsibility larger than any he had faced before. He gamely mingled with society people and cultivated politicians he loathed if that was what he had to do to assure the survival of his artistic legacy. He wanted to do more than provide an overview of his artistic career. He wanted the American public to consider whether his lifelong struggle to bridge two cultures had been worth it. He wanted his museum to pose the question: "What mark have I left on the world?"

The Venice Biennale

Just before the museum opened, Alanna Heiss, executive director of P. S. 1 in Long Island City, paid a visit to Isamu at his second-floor office. Accompanying her was Henry Geldzahler, an independent curator who had been the first curator of twentieth-century art at the Metropolitan Museum of Art. Heiss had come to invite Isamu to participate in the 42nd

Venice Biennale. Begun in 1895 and held every two years, the Biennale attracted art experts, curators, dealers, and connoisseurs from all over the world who gathered to reconnoiter the latest trends and movements. It was an international "artistic Olympics" where artists took to the field to display their prowess. As with the Olympics, nation-states, not individual artists, were the official participants. Twenty-seven countries had permanent pavilions at the exhibition site in the Giardini di Castello, and a committee of representatives from each participating country ran the Biennale. In 1956 Katherine Kuh had served as the American commissioner, and in 1986 Henry Geldzahler was the American representative.

At each Biennale the American government chose a different museum to take charge of the American pavilion. In 1986 P. S. 1, an innovative contemporary art museum that Alanna Heiss had founded in 1971 in an abandoned public school building in Long Island City, took on the task. P. S. 1 was a unique presence on the New York art scene, different from both commercial art galleries and conventional art museums in that it offered young avant-garde artists studios as well as exhibition space. The American committee had decided to choose the works of only one artist to represent the country in 1986, and Alanna Heiss had a very clear idea of what she wanted to do with the American pavilion.

"I wanted to choose an artist," she said, "who would symbolize the fact that the contemporary artistic culture was a mosaic woven of many different ethnic groups."[32] Conventional wisdom might have suggested someone like Willem de Kooning, an artist with a European background, but Heiss's choice of the artist most appropriate to represent America's diversity was the "Japanese-American" Isamu Noguchi. No one better symbolized America as a multiethnic immigrant country, she thought, than Isamu, who spanned the cultures of "East" and "West," and who had lived a life transgressing borders, refusing to evade the disadvantage of being Japanese-American in an America where the "West" was mainstream— and indeed constantly exploring the ambiguity of his identity. His was a life appropriate to symbolize the emergence of a borderless world.

Alanna Heiss, a maverick in the American art world, was known for her efforts to encourage a new generation of artists. As she expected, her selection of an aging master rather than a less well-known younger artist caused a stir. Henry Geldzahler, who was concerned about America's aggressive image abroad, supported her completely. In the early 1980s the

Reagan administration, dedicated to building a "strong" America, had increased armaments spending and dubbed the Soviet Union the "evil empire." Geldzahler hoped that Isamu's "cool and peaceful work" might correct the idea that the United States had become "the land of Reagan and Rambo."[33] Together he and Heiss pushed their choice through the American selection committee.

Heiss took Geldzahler, an old acquaintance of Isamu, along on her visit to his office to assure that her first meting with him went smoothly. When she asked Isamu to represent the United States at the Biennale, Isamu caught his breath for a moment, then, as if to shake it all off, he blurted out a forceful "No!" His eyes were brimming with hostility. Speechless at this unexpected reaction, Heiss could only listen as he sputtered angrily, "Represent America? I absolutely refuse. Just what has America done for me until now? You don't mean to tell me that you don't know the American government put Japanese-Americans in relocation camps because it thought they were enemies. I'm one of the Japanese-Americans that were not recognized as being Americans. Please tell me the reason why I should now represent America."

Several months before his death, Isamu told a different story about his reaction to the invitation. When he heard that he was to represent the United States at the Biennale, he said, he was quite pleased. "I've never been able to be considered an American. The reason I took this Venice thing so much to heart was because it was the first time that I was named an American representing something. I thought it was sort of cute, you know. . . . I never expected to represent America. People like Sandy Calder or someone like that, they can be Mr. America."[34] It seems likely that this later recollection reflected his true feelings.

In 1972 Isamu had participated in *Four Projects for Venice*, a special exhibition at the Venice Biennale. Along with three world-famous architects—Louis Kahn, Frank Lloyd Wright, and Le Corbusier—he had been invited to offer a plan to modernize Venice but he had never been asked to exhibit his sculptures at the Biennale. What Heiss offered was a chance not simply to represent American sculpture but to represent all of the American art world. It is puzzling that Isamu did not show his excitement openly and accept the invitation right away, rather than raising the issue of the Japanese-American internment camps and giving vent to his bitterness toward the American government.

The "depth of Isamu's resentments" often surprised Allen Wardwell, who succeeded Miles Kubo as director of the Isamu Noguchi Garden Museum. Even as Isamu neared the end of his life, he remained unreasonably adamant, remembering every critic who had ever given him a bad review. "He never forgot," says Wardwell, "and he never forgave."[35] He constantly complained about all the disappointments in his career, from the WPA's rejection of *Play Mountain* to his dismissal from the John F. Kennedy Memorial project. The American government had even rejected him at Expo '70 in Osaka, he said, where he hoped to establish his position as an artist with unique links to both Japan and the United States by designing the American pavilion. His proposal failed to win the competition, and instead he had to design a group of fountains for Kenzō Tange's master plan. Selection as American representative at the Biennale was a happy surprise that should have swept all these past humiliations away, but instead of showing how touched he was by the honor, Isamu angrily blurted out his bitterness toward the United States.

Isamu often expressed his resentments, says Wardwell, as jealousy of fellow artists like Alexander Calder and David Smith. In an interview with Paul Cummings, he candidly admitted his reaction to Calder's easy success in establishing his reputation after he returned from Paris. "Frankly I resented him very much because I had done a similar kind of thing and had given up because I was very poor, I had to make a living. Sandy somehow, whether he was rich or wasn't rich, was able to get away with it."[36] Since both had started their careers at the same time, Isamu was especially envious of Calder. During the war, when Isamu was sharing the plight of the Japanese-American internees, Calder was able to concentrate on his own work. In 1952 Calder won the Grand Prize for sculpture at the Biennale, and six years later, David Smith consolidated his reputation as a leading American sculptor by exhibiting at the Biennale. Isamu never concealed his ambition to surpass both these rivals by securing public recognition as the greatest American sculptor of the twentieth century, Wardwell recalls.

Alexandra Snyder, Buckminster Fuller's granddaughter, and a former assistant director of the Noguchi Garden Museum, understands why Isamu did not accept Heiss's request immediately or graciously. The businesslike Heiss, who thought she was making an offer Isamu could not refuse, wasted few words but Isamu, Alexandra says, liked to test other people.[37] Almost "like a child" he tried to push their patience to the limit. Alexandra had known Isamu since her childhood, when she spent sum-

mers at her grandfather's house in Maine, where Isamu was often a visitor. His personality was "complicated," she says, but he was not difficult to get along with if you accepted the fact that you were being tested. The only thing that interested him was himself. He was hungry for praise. In that respect he resembled her grandfather, who, perhaps because he achieved recognition only late in life, never stopped showing off.

When Isamu turned down Heiss's invitation so emphatically, Snyder thinks that he was really saying that the honor came too late. He had no need to prove himself to the world yet again, and it was almost humiliating to be chosen as American representative after the age of eighty. Though surprised, Snyder found his refusal refreshing. Isamu had faced the prejudices of the American art world not only as a Japanese-American but as a sculptor whose experiments had changed the art. He made an excellent point by saying "No," she says, and once he made the statement he should have stuck to his principles. She had hoped that he would say that the opportunity should be given to someone younger.

Although Heiss was taken aback, she was not upset by Isamu's initial response. It was just "the beginning of the dance," she concluded. She was determined to escort Isamu to the place of honor at the Biennale. She did not like ingratiating herself but she was persistent and willing to take time. That made her an excellent dance partner. Since his studio was close by, she continued courting him, and Isamu's "No" eventually became a "Yes." That did not mean that things went smoothly afterward.

Martin Friedman, director of the Walker Art Center in Minneapolis, who celebrated Isamu's pioneering work in environmental art by organizing *Isamu Noguchi's Imaginary Landscapes*, recalls that it was the most difficult exhibition of his entire career. More than once planning came to a halt when Isamu, with his "monumental . . . ego," tried to take control of everything.[38] Because of his reputation for prickliness, many major American museums were reluctant to mount exhibitions of his work.

From the moment Isamu accepted the invitation to the Biennale, Heiss says, she and her staff were "jerked around" by his demands. He immediately flew to Venice to inspect the exhibition space, then told Heiss that he intended to display a huge new work sculpted from white Carrara marble and wanted her to know that the material alone involved considerable cost. He also insisted that a lavishly produced catalogue of all his work

be published in conjunction with the exhibition. Finally, in addition to a huge fee, he demanded that his contract provide first-class airfare and hotel for himself and expenses for his assistants.

The United States Information Agency and the National Endowment for the Arts, the two government agencies responsible for the American pavilion, had limited budgets. The committee for the American pavilion had to look for corporate help. Union Carbide offered to sponsor the exhibition but withdrew when an explosion at one of its chemical plants in India killed several hundred people. Heiss and her staff had to scramble for funds until the last minute. The federal government put up $150,000, the Philip Morris Company gave another $75,000, and the committee for the American pavilion raised an additional $90,000. "It's not my job to worry about the budget," Isamu told Heiss when she complained about the unprecedented cost.[39] "I am not a businessman, I am an artist," he said, and with a dramatic flourish left the room. According to Alexandra Snyder, Isamu had an astute business sense, and to get what he wanted he often played the role of "artist" with exquisite timing.

His most outrageous request was that the Japanese architect Arata Isozaki be invited to design the exhibition. Isozaki's staging of *The Space of Akari and Stone*, a 1985 exhibition at the Art Forum in downtown Tokyo, had delighted Isamu. "You have shown me new directions," he told Isozaki.[40] Since Isozaki had recently designed the Los Angeles Museum of Contemporary Art, news that he would plan the American pavilion exhibition was met with considerable anticipation, and Heiss strongly recommended that the American committee accept Isamu's unusual request. No one seemed concerned that Isozaki was Japanese.

Not surprisingly Heiss was completely taken aback again when Isamu suddenly told her not to proceed with Isozaki's appointment. He had decided to design the exhibition himself with the help of Shōji Sadao. The American pavilion, a neoclassical structure built of dreary gray stone, was divided into three narrow wings arranged around a central courtyard. Heiss thought Isamu's initial proposal to invite Isozaki to work on the display was the decision of a "real pro." Given the awkward configuration of the pavilion, Isozaki's design for the display space would set Isamu's work off to best advantage. His change of heart, she says, was "a big mistake." She found it hard to believe that he feared Isozaki's design might steal attention from his own works.

But Henry Geldzahler wanted to avoid a direct confrontation with Isamu. "For Isamu it's his first—and his last—chance to appear on the highest stage in the world. Let's let him do what he wants," he told Heiss. "That's exactly why we ought to make it the best for Isamu," she replied. "Who is to say what is best for Isamu in the last stage of his life?" said Geldzahler. Heiss was at a loss to answer. As she later looked back on the matter she admitted, "Henry and I just couldn't handle Isamu."[41]

The 42nd Venice Biennale opened on June 29, 1986. Artists from forty-one countries were on display. After a hiatus of eighteen years, prizes were to be awarded again, and there was excitement about who would win the Grand Prize.

"The show I am trying to cook up for Venice is a stretching of (credulity?) I mean credibility of what sculpture can encompass," Isamu wrote Gene Owens in late April.[42] The theme of his exhibit was: "What Is Sculpture?" Its centerpiece was *Slide Mantra*, a new work in white Carrara marble, more than ten feet high and weighing seven tons, just finished at Giorgio Angelo's workshop. The word *mantra*, derived from a Hindu word for "truth," came to mean "incantation" in the Buddhist tradition. The sculpture itself, however, is reminiscent of Yantra Mantra, an astronomical observation platform Isamu had seen on his many "pilgrimages" to India. He had used the concept of spiral geometrical form before, when he designed a similar spiral slide during his collaboration with Louis Kahn on the Riverside Drive playground project. *Slide Mantra* was an enlarged version of that design.

The heavy but elegant white marble sculpture stood directly in front of the pavilion, as though rooted in the ground. Its scale had been meticulously calculated to fit the space and the background. The spiral form and cubic steps matched the neoclassical exterior of the pavilion, but the sculpture remained abstract in feeling. "The work is architecture, playground, earthy and cosmic image at the same time," wrote the *New York Times* reviewer.[43] It was a pioneering work attuned to the Biennale's goal of pointing to new directions in world art. Though fashioned by the traditional Western sculptural techniques, *Slide Mantra*'s spare lines were reminiscent of an Eastern ascetic spirituality. Sitting in front of the American pavilion, at once an homage to Indian culture and a love song to Italy, it stubbornly transcended national boundaries.

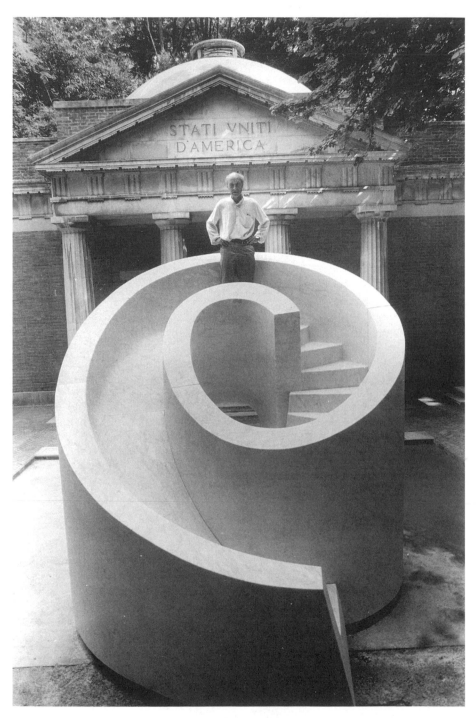

Isamu standing in Slide Mantra *at the Venice Biennale, 1986*

The huge sculpture evoked the carnival spirit of the event. "In the atmosphere of the Biennale, half art exhibition and half carnival," *Artforum* noted, "*Slide Mantra* was a surefire hit, simultaneously grandiose and innocent, profound and playful."[44] It was popular with visitors, too. "The public is invited to enter, climb the circular stairs inside the stone, rest at the top of what resembles a telescope or a shell, then descend along a precipitous slide," reported the *New York Times*.[45]

The problem with Isamu's exhibit lay in the five interior display rooms of the American pavilion. As Heiss had feared, the rooms were crammed and cramped. At her own exhibitions she usually arranged the display space to maximize the impact of each work, sometimes installing only a single work in a room, no matter how large, and sometimes installing nothing at all. When Heiss first approached Isozaki, he had agreed that the display should concentrate on Isamu's recent stone sculptures. Isamu insisted on doing things differently.

In the first display room to the left of the entrance, Isamu placed *Beginnings*, five small, dark, roughly finished gray stones arranged like the rocks in a Japanese garden. In the next long and narrow room, he hung several Akari lamps, including one five feet in diameter. In the third room, at the rear of the building, he displayed *Tetrahelix*, a huge steel geometrical sculpture constructed of interlocking triangular forms that symbolized DNA. In the fourth and largest room he displayed more than a dozen Akari lamps of various sizes and shapes. And in the last room, near the exit, he placed *Ends*, a boxlike hollow cube fashioned from six slabs of jet-black Swedish granite, hinting perhaps at his own death.

Heiss thought that the most effective way to use the interior space was to focus on *Beginnings* and *Ends*, leaving the other exhibition rooms empty. Isamu turned a deaf ear to her suggestion. He even crammed nine bronze models of unrealized parks and playgrounds, including *Play Mountain* and the Riverside Drive playground, into the final room alongside *Ends*. Although the exhibit was supposed to challenge conventional conceptions by exploring the question "What Is Sculpture?" Isamu had instead mounted a retrospective show of his work. He was inviting a reassessment of his whole oeuvre. An exhibition that looked to the past, however, was bound to make a weak impression at the Biennale, where the emphasis was on the future cutting edge in art.

Like Heiss, many artist friends doubted the wisdom of including the

Akari lamps in the exhibit. Mark di Suvero, who struck up a neighborly friendship with Isamu after establishing a studio in Long Island City, knew how difficult he could be when challenged but he still warned Isamu not to exhibit the lamps. Di Suvero very much wanted the Grand Prize to go to Isamu, a pioneer who had demonstrated new possibilities in sculpture to his own generation. If the exhibition focused on a masterwork like *Slide Mantra*, di Suvero thought, few artists could compete with him, but if he displayed the Akari lamps he would forfeit his chance to win; di Suvero's parents had come from Venice, and he knew that the European art world drew a sharp line between fine art and applied art. He warned Isamu that the judges would see the lamps as applied art, or even commercial art, but Isamu ignored him.

Indeed, Isamu stubbornly ignored everyone's advice. He did not give up his plan to exhibit his "light sculptures born of paper and bamboo." He had designed three hundred Akari models since his first postwar trip to Japan, and he was proud that New York department stores like Bloomingdale's sold them at prices even young white-collar workers could afford. "The Akari lamps are not status symbols," he said. "They are evidence of taste that does not depend on whether one is rich or poor. They add to the quality of life, and they fill any world with light."[46]

Whenever someone treated the Akari lamps simply as lighting fixtures, says Priscilla Morgan, who organized Akari Associates, a company to market them, Isamu became quite annoyed. It was as though his offspring were being treated as stepchildren. "It's the one thing I've done out of pure love," he said late in his life. "Nothing to do with commerce or anything. . . . However, each time I did it I was trying to prove something—that it could be better. So I was always working on it."[47] He never tired of experimenting with new shapes and forms. In his dogged determination to have the Akari lamps recognized as legitimate art, he seemed to take pity on them, as if they too had been branded as "bastards" or "half-breeds." These "nomads, restless wanderers between the realms of art and design," were always rejected as pure art. The Biennale was a once-in-a-lifetime opportunity to present them to the gaze of the international art world, a last chance to overcome critical scorn. Perhaps by committing himself so fully to the Akari lamps, Isamu, consciously or unconsciously, was trying to legitimize his own career as an "in-between" person.

The Japanese commissioner to the Biennale, Tadayasu Sakai, director of the Museum of Modern Art in Kamakura, thinks that it was an excel-

lent time for Isamu to raise the artistic meaning of "in between." During the 1980s the Japanese art world debated the question of artistic identity in art by asking "What does it mean for an artist to be Japanese?"[48] On the other hand, Arne Glimcher of Pace Gallery, who was certain that Isamu would win the Grand Prize when he saw *Slide Mantra* at the entrance to the American pavilion, changed his mind after he stepped inside. Like most others from the New York art world, he thought that Isamu, at the peak of his fifty-year career as an artist, had made a tactical mistake. Thomas Messer, a former member of the Biennale prize jury, points out that exhibited works were judged on their "artistic quality." Sure enough, after seeing the display of the Akari lamps, some Italians unfamiliar with Isamu's work asked if his main activity was industrial design.

"Given that the Japanese pavilion was being installed with metal sculpture suggestive of Richard Serra," observes a history of the Biennale, "there were those who mistook the U.S. pavilion for the Japanese and vice versa."[49] That impression, says Heiss, was not simply created by the two rooms full of Akari lamps. On the list of Isamu's collaborators were Shōji Sadao, an American, albeit a Japanese-American; Kan Yasuda, who helped to install *Slide Mantra*; and Masatoshi Izumi, who arranged the stone sculptures *Beginnings* and *Ends*. Shigeo Anzai was the only photographer allowed to take pictures in the American pavilion, and of the forty-six people surrounding Isamu Noguchi in a memorial photograph of those involved with the American pavilion, eleven were Japanese.

Before the opening of the Biennale the American consul general in Venice, the Pace Gallery, and the Peggy Guggenheim Museum cohosted an evening party for Isamu. As the Israeli environmental artist Dani Karavan made his way down the narrow street toward the museum, worried that he was a bit late, he suddenly encountered Isamu coming from the other direction. Karavan had just seen *Slide Mantra* earlier in the day. "Is that you, Isamu?" he said. "How are you? That was a marvelous piece of work." "Oh, Dani," said Isamu, casting him a gloomy look. "Thanks. Sorry, but I'm in a hurry." With that terse greeting, he fled quickly in the direction of his hotel with Kyōko. As Karavan watched the couple fade into the dark, it seemed to him that Isamu was trying to escape from the party in his honor as fast as he could.[50] The Grand Prize selection was to be announced the next day, and everyone knew that Isamu had not won it.

On opening day of the Biennale, Isamu left Venice early in the

morning, accompanied only by his Japanese friends—Kyōko and Junichi, Izumi and his wife, and Kan Yasuda and his wife. Afterward Isamu never talked about how the Grand Prize slipped from his hands, nor did he ever say a word of thanks to Alanna Heiss and her staff or to Henry Geldzahler. And since the exhibit budget had been used up, the magnificent catalogue that he demanded was never published.

On November 11, 1986, four months after the opening of the Venice Biennale, Isamu returned to Kyoto, the city he loved "more than any in the world," to accept the Kyoto Prize. He received news of the award while working on *Slide Mantra* at Giorgio's workshop in Pietra Santa. Kan Yasuda took the phone call from Japan. Isamu asked him in Japanese, "Kyoto Prize? What's that?" When Yasuda explained, he said, "What do I have to do to get it? Are they going to take my picture with someone?"[51] He did not seem very excited by the invitation.

The Inamori Foundation had established the Kyoto Prize the previous year. Its purpose was to recognize "individuals or groups who have made outstanding contributions" in three fields: advanced technology, science, and culture. The size of the prize award—¥45,000,000 (about $300,000 at 1986 exchange rates)—immediately attracted international attention. Isamu had won in the category of "spiritual science and expressive art." Tadayasu Sakai, a member of the prize committee, says the award was made to Isamu for helping modern and contemporary Japanese artists broaden their horizons and speak an "international language."

Isamu offered his own theory about why the Japanese had accorded him recognition. "I was thinking why in the world did this group in Kyoto . . . decide they want to give me some money. I could not figure it out. I came to my own logical reason as to why they decided to give me . . . a prize. And that was because I was in the Venice Biennale. I was now a bona fide American, recognized as such. Because I'd been selected to represent America, right? Therefore, from the Japanese point of view, I was . . . the kind of status which is acceptable."[52] In other words, he thought that poised as he was between America and Japan his reputation rose immediately in Japan when he was selected as the top artist in the United States.

The award ceremony in the Kyoto International Kaikan was attended by Prince and Princess Mikasa. Isamu smiled contently in his tuxedo from beginning to end. His tepid reaction to news that he had received the Kyoto

Prize was very different from his emotional explosion when he heard that he had been chosen to represent America at the Biennale. Although he was not able to contain his conflicting feelings at finally being recognized by the United States, he had never craved recognition by Japan. He wanted only recognition by the American art world as an indisputable "giant" in modern art. To him that meant recognition as one of the first-rank artists in the world. By comparison, the Kyoto Prize was almost like a footnote.

The Kyoto Prize, however, came with substantial prize money, and it was the occasion for an unexpected celebration. On November 13, 1986, two days after the award ceremony, a symposium on the theme "Beauty in the East, Beauty in the West" was held to mark the event. Arata Isozaki, Hiroshi Teshigahara, and Shūji Takashina, a Tokyo University professor, were panelists. Fifty of Isamu's friends gathered that evening for a banquet at Kitchō, one of the best restaurants in Kyoto. The guest list included many who attended his eightieth birthday party. This time Isamu was the host. He invited his friends to show thanks for their help and kindness over many years. It was the first time he had ever done so. When the wife of a friend called Chimako Yoshimura, the mistress of the Minoya teahouse, to make reservations on Isamu's behalf, Chimako asked in an anxious voice, "Is Isamu-san paying?" She had never seen him pick up the tab when he brought friends to her restaurant. At an after-dinner party on the second floor of the Minoya, Isamu, bathed in the warm company of his Japanese friends, seemed unusually relaxed.

The Final Work

The rocks of Kukaniloko on the island of Oahu are sacred to the Hawaiian people. It was the site where the consorts of the Hawaiian kings gave birth to royal heirs. A dozen or so volcanic rocks still remain scattered on the reddish-brown volcanic soil in the middle of a pineapple field. During the 1970s Isamu was asked to devise a plan for preserving the sacred site. Delighted to take the job, he immediately produced a model but the project eventually collapsed for lack of funding.

On his many trips across the Pacific, Isamu often visited Hawaii, a racial melting pot where the children of Japanese immigrant laborers intermarried with those of other ethnic groups who worked on the sugar cane plantations. Perhaps on these islands in the middle of the Pacific he felt

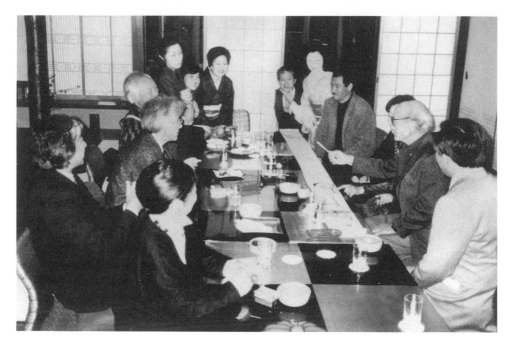

Party hosted by Isamu after the Kyoto Prize ceremony, 1986. (In left row, Yoshio Taniguchi, second from front; Hisao Domoto, third from front; Hiroshi Teshigahara, fourth from front. In right row, Isamu, second from front; Issei Miyake, fourth from front; Arata Isozaki, sixth from front.)

liberated from the stress of living a life betwixt and between Japan and America. By the 1980s most of the friends who had thrown a wedding party for him and Yoshiko in Honolulu thirty years before were gone. Whenever he stopped there he stayed with Sumie Yoshioka, a Japanese-American interior designer, whose shop carried his Akari lamps. Sean Browne, a young sculptor who admired Isamu so much that he named his own son after him, was dispatched to meet him at the airport. Isamu took a liking to Sean, a product of the Hawaiian melting pot, whose forebears were Hawaiian, Chinese, English, and Irish. He even arranged for Sean to work at Giorgio Angelo's workshop in Pietra Santa and at Izumi's studio in Mure.

Isamu usually visited Hawaii on the spur of the moment. It was not unusual for him to stop overnight, swimming in the bright blue waters of the Pacific before continuing his journey. If his schedule allowed he toured the other islands with Sean as his guide. He always seemed very relaxed. When Isamu arrived in Honolulu in mid-April 1987, however, he was suf-

fering such severe pain that he could hardly relax at all. His back began to trouble him in his seventies after decades of hard physical labor grappling with stone. Two operations for a herniated disk had not been entirely successful. To avoid being bound to a wheelchair, Isamu took up a rigorous regime of daily abdominal-muscle exercises to strengthen his back. After cataract operations on both eyes, his doctor had advised complete rest, however, and he had not been able to continue his exercises. On the plane to Honolulu he had suddenly been seized with almost unendurable pain.

"These days I feel I am getting weaker," he told Kyōko after they returned from the Biennale. Day by day Isamu was coming to realize how much he was aging physically. For several years he had been suffering from an enlarged prostate. He also spent many hours in the dentist's chair. Just before the Biennale, he had broken his two upper front teeth without eating anything hard, and then another lower front tooth broke as he was brushing his teeth.

Scan Browne took him to Queen's Hospital in Honolulu for an examination. The violent back pain persisted. Only after repeated injections of pain killer and ten days of rest was he able to walk normally again. After release from the hospital, he immediately left for Japan to supervise several unfinished projects at Mure, and while there he commuted regularly to an acupuncturist in Ōtsu. The pain seemed to subside but he decided to return to New York before the hot and humid Japanese summer set in. At the end of July the pain returned. It was so severe that he was unable to move. Only with the help of a Japanese acupressurist in New York was he able to control it. He began a new routine of exercises to correct distortion in his spine, and by late September he felt well enough to return to Mure.

Once again Isamu was in the "circle," never taking a day off, prowling among his unfinished pieces, watching over Izumi and his apprentices as they worked. A year earlier Kyōko had written in her diary that Isamu seemed "driven as though he had to hurry because he had no time left."[53] Even when several specks of stone caught in his eye, he was reluctant to see a doctor, although Izumi finally persuaded him to do so. Realizing that he was overexerting himself, Isamu cut down his time in the "circle," working instead in his study on notes for the Isamu Noguchi Garden Museum catalogue.

On December 21 Isamu left Narita Airport for Santa Fe, New Mexico, to spend the Christmas holiday with his half-sister Ailes, who had moved there several years before. On the way he stopped in Los Angeles,

where he wanted to show Kyōko *California Scenario*. "I'd like to take you to see all my work while I'm still healthy," he told her. He lingered for a long time gazing at the garden he had designed, as though bidding it farewell. On Christmas Eve, when the residents of Santa Fe put luminaria—brown paper sacks lit with candles—on the adobe walls around their houses, Isamu and Ailes walked through the streets in the early evening, enjoying the warm glow that simple decorative lights cast on the snow-dusted ground.

The Christmas holiday was Isamu's only moment of family time during the whole year. Ailes had always respected her half-brother as a substitute father, but she was a bit intimidated by him. Her much older husband had died twenty years before, and she often had to ask Isamu's financial help for her son Jody's education and other expenses. His visit was the most important holiday of the year for her. In the evening she sat with Isamu in front of a blazing fireplace reminiscing about their mother.

On December 27 Isamu returned to New York with Kyōko. Her husband, Junichi, arrived from Japan the same day. On New Year's Eve Isamu took the couple to a small party at the home of the Chinese-American architect I. M. Pei. Buoyed by Pei's warm personality and his wife's excellent Chinese cuisine, everyone was in a relaxed mood. At midnight the sky was suddenly bathed with the glow of fireworks celebrating the new year. Everyone including Isamu stepped out into the freezing air to watch the display across the East River. It was an elegant way to ring in 1988, a year of which Isamu would not see the end.

Even though Isamu's back was bent, his pain was under control. He seemed to have returned to good health, both physically and psychologically, working as hard as he had ten years earlier. Izumi thought Noguchi-sensei would live to be one hundred. As if to endorse that prediction, Isamu launched on a schedule even more frenetic than usual. He traveled from New York to Japan and to Europe, and back again. When he decided it was time to move on he left immediately, within the day, as though unwilling to waste a moment. His restlessness was most obvious in New York, perhaps because every day he had to confront the problem of how to keep his museum going. He seemed to be chasing himself as he impatiently awaited the approach of his eighty-fourth birthday.

Junichi had left Kenzō Tange's architecture office to set up a new firm, Architect Five, with several colleagues. Their first big project was design-

ing an office building for a high-tech firm in Sapporo on the northern island of Hokkaido. A few days after the New Year's party Junichi brought the company's president, Hiroyuki Hattori, a young entrepreneur still in his twenties, to visit the Isamu Noguchi Garden Museum. Isamu greeted him wearing a beige ski jacket and a navy blue ski cap. Snow had fallen in the morning, and the weather was fiercely cold, but the central heating had been turned off because the museum was closed that day.

Isamu paused for a long time in front of his bronze models of *Play Mountain*, *Monument to the Plow*, and the Hiroshima *Memorial to the Dead*. "My best things have never been built," he said, as he often did. He was obsessed with finding a way to realize his environmental sculptures. Against everyone's advice he had exhibited his bronze models for these projects at the Venice Biennale, perhaps thinking it his last chance to find backers. As he once told an interviewer from *Art in America*, "I'm stubborn."[54] Two years earlier, when he learned that Philadelphia was planning a monument to Benjamin Franklin, he offered city officials a model of the *Monument to Ben Franklin* he had designed in 1934, and he kept pressing them until finally they agreed to build it. The one-hundred-foot stainless steel monument, an abstract rendering of Franklin's kite experiment, now towers over the middle of a traffic circle at the foot of the Benjamin Franklin Bridge across the Delaware River.

The two projects that most obsessed Isamu were *Play Mountain* and the Hiroshima *Memorial to the Dead*. Time and again he sought a way to carry them out. Over the years he proposed building the Hiroshima monument—renamed the *World Peace Monument*—in Washington, D.C., at the United Nations Headquarters in New York City, in Central Park, and even in Long Island City. He also offered it to Los Alamos, the site of the first atomic bomb test, where a Robert J. Oppenheimer monument was to be built, and he approached the mayor of Hilo, Hawaii, about building it in Mauna Kea Volcano Park. When he heard that Tange's memorial arch at Hiroshima needed to be rebuilt because the concrete had corroded, he even phoned Tange with a blunt offer to replace it with his original design. A much-irritated Tange broke off relations with him for a while.

The only chance he had of seeing his *Play Mountain* design realized was his collaboration with Louis Kahn on the Riverside Drive playground. *Play Mountain* was extremely important to Isamu. The concept had come to him one day in 1933 with the sudden flash of insight that the "earth itself

is sculpture." *Play Mountain* was, he said, "the kernel out of which have grown all my ideas relating sculpture to the earth. It is also the progenitor of playgrounds as sculptural landscapes."

Since Isamu had no children of his own, and never seemed much interested in his friends' children either, many wondered why he was so fixated on building playgrounds. "You see, for me playgrounds are a way of creating the world," he once explained. "It's not a job. It's a way of creating an ideal world—on a smaller scale. It's nothing specific. It's a topology I'm interested in—a land in which one can run around, three feet high. I've been more attentive to that than, say, creating a park in which grown-ups might run around. The very restrictions make room for the more intense experience of childhood—where the world is newer, fresher, and where you have a kind of geometric confrontation with the world. I want the child to discover something I create for him. And I want him to confront the earth as perhaps early man confronted it."[55] He also observed, "I like to think of playgrounds as a primer of shapes and functions; simple, mysterious, and evocative: thus educational. The child's world would be a beginning world, fresh and clear."[56]

Isamu's obsession with the playground as "an ideal world" was rooted in his memories of the time when he himself was only "three feet high." "You can reduce yourself to that size and wander around and make [a world] on a scale suitable for children," he said. "And maybe because I didn't have all the things that children do have—never did have—and maybe it's because I was never educated or went to proper schools and had my brain washed that I can still think of things like that."[57] The picture of a wave that he had drawn at Morimura Gakuen as a five-year-old remained fresh in his memory into his old age. It reminded him of a time, all too short in his life, when he had felt a sense of security and fulfillment, when he had lived in an "ideal world" that he had been torn away from so abruptly and so completely. What compelled him to build a "paradise for children" as an adult was a desire to heal psychological wounds suffered in his childhood.

In 1964, shortly after finishing the Billy Rose Sculpture Garden, Isamu designed a playground for Kodomo no kuni (Children's Land), a children's park on the outskirts of Yokohama built to celebrate the tenth anniversary of the Crown Prince's wedding. Sachio Ōtani, one of Tange's students who had been commissioned to design the children's pavilion, asked Isamu to work on the attached playground. Isamu furnished it with play equipment he had

designed for Ala Moana Park in Honolulu before the war—a spiral slide, a semispherical jungle gym, a turtle-shaped sand box, a triangular sandbox, and several other pieces. In 1974 the High Museum of Art in Atlanta commissioned him to design *Playscapes*, a playground for a local park. Budgets for both these projects were limited, however, and Isamu was able to realize only a small part of his vision of "an ideal world" for children. The concepts for *Play Mountain* were not incorporated into either playground.

Hiroyuki Hattori, whose thriving new company boosted optimism in Sapporo, had come to New York at Junichi's urging to explore the possibility of building *Play Mountain* in the economically depressed city. The elderly sculptor's passion impressed Hattori tremendously. When he returned home he immediately sought a way to bring "Isamu-sensei's eternal vision" into being. In early February he reported that the prospects looked good, but Isamu, who had cracked a bone in his left arm after stumbling in his studio, could not visit Hokkaido until the end of March. It is difficult to say whether he really believed that the project would ever see the light of day, but Junichi's and Hattori's youthful zeal appealed to him.

Snow still covered the ground when he arrived in Sapporo. "It's a new place," he said, "it's not Japan, more or less. It's more or less like Canada or someplace other than that."[58] Isamu often said that he was "looking for frontiers." He had spent his whole life exploring the frontiers of sculpture, and an ambivalent sense of identity propelled him along the cultural frontier between Japan and America. It is not surprising that he found the landscape of Japan's northern frontier fascinating. The island of Hokkaido, like America, was a land of immigrants. It had been settled by pioneers from the main islands only a century before. On the drive from the airport the passing scenery reminded him of his view from the train window as he crossed America from Seattle to Indiana at the age of thirteen. Sapporo had been laid out on a grid by American advisors in the late nineteenth century, and when he arrived in the city he felt that he was back in the United States again. Everything he saw reminded him of the "primal landscape" of his heart.

The mayor told Isamu he wanted to build a park that he could "boast to the world about," a site where the city's inhabitants could enjoy themselves as well as a "new landmark" for the city's tourist industry. The Japanese economy was enjoying an unprecedented boom in the late 1980s, and the mayor said that the city budget would cover the cost of a large-scale artistic

and cultural project. The city proposed three possible sites: the Sapporo Art Park, an open-air art museum; a land parcel set aside for the construction of a new university of the arts; and a dumping ground at Moerenuma.

According to Jin Yamamoto, chief of the Green Belt Section of the City Park Department, Moerenuma was added to make the list longer but it was the only site that excited Isamu. Located about six miles northeast of the city center, it had been set aside ten years earlier as a dump site for non-combustible garbage and incinerated garbage ash. The 455-acre site, about half the size of Central Park, had nearly reached its 2,700,000-ton capacity, and officials had decided to turn it into a public park as part of the city's "greening" policy. The moment Isamu set foot on Moerenuma his eyes brightened. "Now this is something interesting," he said, his curiosity aroused. Moerenuma originally was a semicircular swamp created by a bend in the meandering Toyohira River. What sparked Isamu's interest was that water surrounded the site like a moat on three sides. He walked around restlessly in rubber boots, tramping on plastic bottles and vinyl bags that poked up through the snow. By the end of his brief tour, he had a sense of the whole site and talked eagerly about building a park "like a garden in outer space seen in its entirety as sculpture."[59]

When Yamamoto delivered aerial photographs and other materials to him in Tokyo a week and a half later, Isamu said he would only accept the commission on one "absolute condition"—the removal of a tall steel tower that supported a high-tension power transmission line running across the dumpsite. The line belonged not to the city but to the Hokkaido Electric Power Company. Moving the line posed a potentially serious bureaucratic obstacle. A few weeks later the Japanese government awarded Isamu the Third Order of the Sacred Treasure in recognition of his "distinguished service" to Japan. The Reagan administration had awarded him a National Medal of the Arts the year before, and the Japanese government followed suit by honoring him now that he was officially recognized as a member of the American art establishment. News of the award helped city officials to persuade the power company to move the line.

When Isamu visited Sapporo again on May 20, city officials asked him to install *Slide Mantra* at Ōdori Park in the center of the city. The white marble slide so highly praised at the Biennale had already been moved to the Bay Front Park in Miami. Isamu proposed to create *Black Slide Mantra*, a larger version of the sculpture, for the children of Sapporo.

It was to be carved in black granite to stand out against the winter snow. The site Isamu chose for installation of the sculpture required closing off a street across Ōdori Park but the city officials were so anxious to acquire the work that they readily agreed to do so.

In late June the city officially announced the Moerenuma Park project. It was expected to cost ¥15 billion (about $120 million at 1988 exchange rates)—and in the end cost nearly ¥24 billion. A 1/2,000 model of Isamu's master plan for the project, produced by Architect Five, was on display. The basic concept was to provide recreational space for all seasons, including the long Hokkaido winter. The plan also took into consideration the need to restore the natural environment and to keep the recreation areas in harmony with the surrounding landscape.

Isamu was attentive to the child's perspective, but his concept for the park was a grand one, intended to reshape the topography dramatically and create a new symbolic space on Japan's frontier. At the center of the park was *Play Mountain*, an artificial hill one hundred feet high surrounded by several specialized sites: *Tetra Mound*, a forty-three-foot triangular pyramid fashioned from stainless steel pipe; *Cherry Forest*, seven play areas with geometrically shaped play equipment; an open-air stage; *Moere Mountain*, a ski slope for the winter season; a *Symbolic Zone*, with a glass pyramid, central fountain, and other monuments; a *Sports Zone*, with a baseball field, tennis courts, a track and field facility, a closed gymnasium, and swimming pool; a *Water Amusement Zone*, with a water slide, a fishing pier, and a boat pier; a *Water Zone*, with a wild bird shelter for bird watching and a nature preserve; and a *Forest Green Zone*, with groves of cherry trees, larches, and white birches.

The design was a summation of Isamu's ideas about environmental sculpture. Its scheduled completion was the year 1997, when Isamu would turn ninety-three, but Sapporo city officials were unconcerned. Isamu seemed ageless. He glowed with his dream of completing the largest project of his career on Sapporo's mountain of garbage. Daily exercises and visits to the acupuncturist reduced his back pain, and he seemed as eager as ever to scout for new ideas. He now found more stimulus from the work of architects than from sculpture, and while in Sapporo he visited another Hokkaido project designed by Tadao Andō, a rising architectural star. He seemed to everyone to be bursting with physical and psychological energy that belied his age.

In late July Isamu left for Pietra Santa, meeting Kyōko in Paris on the way. During their stay in the city, Isamu hardly relaxed at all. He eagerly looked everywhere for ideas to incorporate into the Moerenuma project. In the sweltering summer heat, he drove to see Monet's water garden at Giverny in the suburbs of Paris, and he toured the construction site of I. M. Pei's glass pyramid for the new entrance to the Louvre. The only break from business was a visit to the Musée d'Orsay, across the river from the Louvre, where he wanted to show Kyōko his "most favorite painting." Without looking at anything else, he marched her directly to the second floor, where he stopped in front of a huge painting that covered almost the entire wall. It was Henri Rousseau's *The Snake Charmer*, a painting of a dark, naked, silhouetted woman with long flowing hair who stood in a night-darkened jungle playing a flute to a black snake curled in a tree. The moment Kyōko saw it she felt an indescribable anxiety, but Isamu stood praising the painting's distinctive mingling of the realistic with the fantastic. "He was a customs officer and an ordinary family man," he told Kyōko. "People made fun of his work as childish, but he painted a splendid picture like this without any formal training." [60]

After five days in Paris, Isamu left for Pietra Santa to work on an unfinished marble piece for a week. Then braving the hordes of summer tourists they went to Rome, where he took Kyōko to a restaurant he had frequented since the 1960s. Only on the Greek island of Paros, known for its marble, did Isamu finally take time for a few lazy days of swimming, dining, and napping under a sun-drenched azure sky. At the end of August he was back in New York, pursuing a relentless pace that Kyōko could hardly keep up with. When he finally settled in Mure once more on September 3, his head was brimming with ideas about what to do in Moerenuma.

On September 28 Isamu departed for Paris to attend the thirtieth anniversary of the UNESCO garden. Tōemon Sano had pruned the vegetation for the first time since the garden was built, and as Isamu stood in front of the newly restored garden, he contentedly told Tamaki Tachibana, a Japanese reporter, "I knew from the beginning that it would take thirty years for the garden to mature. Humans can do only so much. All humans can do is plant a tree thinking it will grow in a certain way. It wasn't humans who finished the garden. Nature did that all by itself." [61] As he spoke in his halting Japanese, Isamu reminded Tachibana of a dignified "old samurai." With an old-fashioned kind of grit, he talked about how

important time was—a message he wanted the Japanese to hear. "Nowadays everything in the world has become too 'instant.' People are interested only in the newest things in culture, and they chase one thing after another. That is very dangerous. Humans are not like that. Humans spent many years giving shape to culture. I think we have come to a period when we must take another close look at that. Not just Japan, the whole world."

When Isamu turned to look at the garden again he said admiringly, "It's beautiful, isn't it? It's really beautiful. That's something I did, isn't it?" Tōemon Sano was standing beside him. Isamu had never once uttered the word "*Arigatō*" (thank you) when Sano worked as his assistant, but now he turned and thanked him. Something was glistening in the eyes of this man "who never stopped running," says Sano.[62]

After a brief stay in New York, Isamu returned to Tokyo on October 16. Two days later he went with Junichi to visit the park site in Sapporo. As usual Isamu made changes in his master plan for Moerenuma as he watched the work progress. He drew up a detailed list of suggestions, then returned to Mure, where he made additions to the master plan and finished a model for *Black Slide Mantra*.

On November 17, Isamu celebrated his birthday—his eighty-fourth—in Mure as he had for several years. In a snapshot with Issei Miyake and other close friends, his face and neck seemed to have shrunk a size, but those at the party remember him as being the same old lively Isamu with the same big appetite for grilled fish. When Miyake showed a video of his Paris fall collection, Isamu sat with his eyes glued on the screen, commenting on Miyake's new pleated designs. Two days later Isamu left with Kyōko to stay at his usual small inn in Kyoto. He went to nearby Ōtsu for acupuncture treatments, then dropped by to say hello to Chimako Yoshimura at the Minoya. It was the third time in a month he had visited the city. He had come twice before to see old friends: Tōemon Sano; the abbot of the Daitokuji Temple; and the Shirakawa stonemasons with whom he had once worked.

The night before his departure for New York, he and Kyōko went to a *bunraku* (puppet theater) performance at the Osaka National Theater. What Isamu most liked about *bunraku* performances was neither the puppets themselves nor the stage sets but the sound of the shamisen music and the chanting of the *gidayū* (narrator). He did not understand the narration

very well but he could follow the gist of the play from the *gidayū*'s voice and expression. The play was *Tsubosaka reigenki,* a love story about a husband and wife ready to sacrifice their lives for one another. What moved Isamu so deeply about this conventional domestic drama was that it reminded him of the death of Buckminster Fuller and his wife. In 1983 Fuller had been stricken with a heart attack as he was taking care of his bedridden wife, unconscious in a coma. He died grasping the hand of the woman who had been at his side for fifty years, letting him lead his life as he wished, defying conventional wisdom and breaking new frontiers. Fuller was eighty-seven years old. Two days later, as though following him, his wife passed away. It was the ideal way to die, Isamu told his friends.

The *gidayū* narrator was Koshijidayu Takemoto IV, who chanted this tale of sublime marital love as though wresting every emotion of the characters from his own body. A month earlier he had announced his intention to retire. Perhaps Isamu was especially moved by the performance of an artist who intended to retire at the peak of his ability. After the curtain fell, he visited the *gidayū*'s dressing room, something he had never done before. For a few moments, without uttering a word, he quietly grasped the hands of a man he was meeting for the first and last time.

The next day Isamu left from Osaka by himself. He had arranged to meet Kyōko in New York in late December and promised that after a visit to Ailes in Santa Fe for Christmas he would take her to see the relief mural he had done in Mexico City fifty years before. "I'll be waiting to see you," he said. Then with a lively step he disappeared through the gate.

After Thanksgiving dinner at Priscilla's apartment with Shōji Sadao and his wife, Isamu suddenly decided to leave for Pietra Santa to work on an unfinished marble sculpture. Every evening after wielding a chisel all day, he had dinner at Giorgio's house with Kan Yasuda and Sean Browne. Looking intently out the window at a sculpture that he had made thirty years before, he said, "How wonderful it is to see an old friend. The mistakes still give it a certain freshness."[63] He offered Sean a piece of advice. The older one gets, he warned, the fewer doubts one has, and there is a tendency to make a work too perfect. Then he told Sean, whose ancestry was Hawaiian, to take over the project at the sacred rocks of Kukaniloko.

The weather was chilly in Pietra Santa; sleet and rain fell every day, as it always did at this time of the year. The evening before his departure to

Isamu at his eighty-fourth and last birthday, 1988

New York, Isamu went to bed early, complaining about a headache. A meeting of the board of directors of the Isamu Noguchi Foundation had been scheduled for December 13, the day after his return from Italy. That morning he phoned Priscilla from his Manhattan apartment. "I don't feel good," he said. Priscilla told him to skip the meeting and to stay in bed. Winter had set in, and the temperature had dropped. Priscilla stopped by Isamu's apartment after the meeting to report on what happened and to see how he was feeling.

"Isamu was flat in bed," she recalled. "I took his temperature, and he had a fever. I squeezed some oranges to make some fresh juice for him. Then I asked the Puerto Rican woman who took care of the housekeeping to make him a light evening meal. But he just didn't have any appetite."[64] The next morning she phoned Isamu's doctor, who thought that he had simply caught a cold but suggested taking his temperature since he was getting on in years. Priscilla decided to spend the night at Isamu's apartment to take care of him.

Throughout his life Isamu had moved from one woman to another, often at dizzying speed, but his relationship with Priscilla had lasted longer than any other. She was the only person in whom he really confided. Although he often acted uncomfortable about their relationship in public, when he ran into trouble, public or private, he turned to her rather than anyone else. Like a child seeking protection from a parent, he called Priscilla whenever he fell ill, and even if she was busy with her own work, she put everything aside to take care of him. Whether he was down with a slight cold or facing major surgery Priscilla was always there, managing his life with her usual efficiency.

Their relationship had lasted nearly thirty years. No matter how pompous or disdainful Isamu might act in front of others, when they were alone together, Priscilla says, he treated her with a reassuring tenderness. He could be as egoistic as a spoiled child, sparing no one from his blunt and harsh honesty, not even himself, but behind his often cold, cruel behavior lay an enveloping gentleness. Most people saw only the difficult side of Isamu's complex personality, but Priscilla saw him whole. She accepted his virtues and his vices, his good points and his bad.

Colleagues like Allen Wardwell and Alexandra Snyder say that Priscilla was at her best whenever Isamu ran into deep difficulty. She worked for Isamu as no one else could or would. To those who knew both of them over the years, Priscilla was like an old and familiar spouse to Isamu. Some point out that she was his "other half" in another sense, too. Isamu often seemed genuinely hostile toward Priscilla, they say, because she reflected his own "philistine desire" to win fame, a side of his personality that contradicted his self-image as someone "who lived for his art." There are others who point out that his selfish, one-sided relationship with Priscilla was very much like the fetters that bound his own parents. No matter how their relationship might be described, it is clear that Priscilla was

the only person who spared no pains to take care of him. When she tried to help, her aggressive and sometimes officious style often irritated him, but he admired her strong-minded willingness to wait patiently in the face of rejection and her ability to remain optimistic whatever the circumstances.

Since Isamu's high fever did not abate, his doctor made a house call on December 16, four days after he had taken sick. He diagnosed the illness as pneumonia, and he arranged for an ambulance to take Isamu to New York University Hospital. "Once I go into the hospital I don't think I am ever coming out again," he whispered to Priscilla as she sat beside him in the ambulance. "It's different from your mother's day," she answered, trying to cheer him up. "There are lots of wonder drugs these days."[65]

It was on a cold day in the middle of December 1933 that Leonie had been taken to Bellevue Hospital. Less than two weeks later, on New Year's Eve, she had died from complications of pneumonia. Bellevue stands next door to New York University Hospital, and it shares a staff of physicians. It still occupied the building where Leonie died, and most of its patients still could not afford to pay for their own medical care. The New York University Hospital, a modern building with a glass-walled lobby, polished floors, and the latest medical equipment, was one of the best general hospitals in New York.

Isamu muttered gloomily in the ambulance. When a hefty African-American nurse greeted him at the hospital entrance with a wheelchair, his wry humor returned. "I always wondered what kind of angel would be waiting to greet me in Heaven," he said to Priscilla. No single rooms were available so Isamu was put in a room with another patient. He did not seem irritated or upset. When Priscilla insisted that he be moved to an individual room as soon as possible, he fretted that the hospital bill would be much higher. The only thing that really upset him was changing into hospital pajamas. He insisted on wearing the *yukata* (summer-weight kimono) that he always slept in at home.

The penicillin and several other antibiotics the doctor prescribed over the next several days seemed to have no effect. The doctors were unsure what kind of pneumonia afflicted him. His condition weakened visibly every day, his voice growing weaker and his coughing more severe. Then suddenly he took a turn for the worse. After Ailes, waiting to spend Christmas with him in Santa Fe, called on December 22, she decided to leave for New York with Jody right away, but when she arrived Priscilla did

not let her talk with her brother. Priscilla worried that if Isamu saw his sister so upset he might think he was close to death.

Whenever he had been hospitalized before, Isamu had Priscilla read to him every day. After his back operation, for example, Priscilla had faithfully made her way through a nine-hundred-page book on the Russian Revolution, and she had also read him the daily newspaper to satisfy his curiosity about what was going on in the world. But after his second day in New York University Hospital Isamu lost interest in hearing about international news.

The only person Priscilla allowed into Isamu's sick room was Arne Glimcher, the head of Pace Gallery, who sat at his bedside talking about his next exhibition and chatting about the latest news in the art world. Soon even that kind of encouraging outside contact became impossible. Isamu suffered a heart attack at 3:00 on the morning of December 24. The hospital called Priscilla in the middle of the night to ask permission to move him into the intensive care unit. With an oxygen mask attached to his face, Isamu could not talk with anyone any more. He communicated with Priscilla in brief notes scribbled in shaky handwriting. "Am I finished with pneumonia? What date?" His mind was still alert. He managed to jot down Kyōko's thirteen-numeral telephone number, including the country and area code, mistaking only the last digit.

As the days went by not only did his pneumonia grow worse and his lungs need more oxygen, his medication began to have side effects. He slipped out of consciousness more and more often. Whenever his eyes fluttered open, he could express only the simplest of wishes. Priscilla swabbed his lips with a dampened cotton ball when he wrote that he was thirsty. She had remained in love with Isamu for thirty years even though she knew that he would never belong to her or any other woman. Sitting now at his bedside, she finally had Isamu all to herself. When the doctor told her that Isamu would not last much longer, Priscilla reacted fiercely, as though Isamu were still a youth with a future ahead of him whose life was coming to an unreasonably early end. The doctor agreed to do whatever was needed to prolong his life even a day.

On the third day after being put on oxygen, Isamu struggled to remove the mask that allowed him to breathe and the intravenous tubes stuck in his arms. His doctors could not tell whether or not he was consciously trying to sever the cords that kept him alive, so they had his hands

and feet tied to the bed. In that immobilized condition Isamu breathed his last at 1:32 on the morning of December 30, 1988. When the night nurse came to check, he was already dead. The immediate cause, according to the death certificate, was heart failure. He was eighty-four years and forty-three days old.

Isamu had lived his life like a long-distance runner trying to run a hundred-yard dash. The *New York Times* had once called the life of this Japanese-American artist "highly improbable," but he had remained active as one of America's leading artists until his death. His life ended just one day before the anniversary of his mother's death more than a half-century before.

About four hundred people attended the memorial service for Isamu at the Isamu Noguchi Garden Museum in Long Island City at 3:30 PM on February 7, 1989. Two months later, on April 7, as the cherry blossoms were bursting into full bloom, a larger number gathered inside the walls of the "circle" at Mure for another service.

Although Isamu did not seem to realize it, his assets had grown considerably in his later years. At a Pace Gallery exhibition in May 1988 his stone sculptures sold at prices ranging from $10,000 to $300,000. To the end, however, Isamu lived a parsimonious life, never wasting money on luxuries or on display. His only real extravagance was the money he spent on first-class airfares and hotels when he traveled abroad. Isamu left all his fixed assets, including unsold works, to the Isamu Noguchi Garden Museum. His savings were divided among seven people: his half-sister, Ailes, and her son, Jody Spinden; his half-brother Michio Noguchi; three close friends—Priscilla Morgan, Shōji Sadao, and Kyōko Kawamura—who made up a kind of surrogate family; and finally Ann Matta, who was now old and alone.

In his will Isamu left nothing to Masatoshi Izumi but he expressed his wish that the compound at Mure be left "unchanged" as a "branch" of the Isamu Noguchi Garden Museum in Long Island City. "[Izumi will] have an identity and a place that no one else will have," he said a few months before his death. "He will become the caretaker. And this is fine with me. . . . I have no children, you know. So this is my way of doing it."[1] The compound at Mure included not only his house and the "circle," but an old sake warehouse used for exhibition space and an old rice storehouse

that was turned into a studio where Isamu exhibited his Akari lamps and made plans and models for his public art projects.

Izumi tried to abide by Isamu's intentions but his patience was tested by a long dispute with the Isamu Noguchi Foundation in New York. The "circle," Isamu's house, indeed all the buildings connected to Isamu's life and work in Mure, stood on Izumi family property. Negotiations over the disposal of the buildings as well as property rights to the finished and unfinished stone pieces in the "circle" were long and difficult, compounded by repeated misunderstandings and deep differences of opinion on both sides of the Pacific. On May 14, 1999, the Mure compound was opened as the Isamu Noguchi Garden Museum in Japan.

Izumi remembers seeing Isamu standing in the "circle" on the morning before he left Mure for the last time. He walked through the workplace as he always did, gripping in his right hand a piece of white chalk he had taken from his pocket. With a smooth stroke, as if brushing an ink painting, he drew a white line on an unfinished piece to indicate where to split and cut it. Izumi preserved the unfinished piece, and everything else in the compound, just as it had been when Isamu was still alive.

The abstract stone sculptures, large and small, scattered across the "circle" are full of life. Ninety-six are unfinished but even these works bear the unique and unmistakable stamp of Isamu's imagination. Just as Isamu showed different sides of himself to those he met on his journey through life, each of his stone sculptures has its own distinct expression. Some stand, some sit, and some crawl. All of them, the finished and the unfinished, greet the visitor with individual faces.

"I have come to feel less and less disappointed if a stone does not crack the way I want it to. When that happens the power of the stone is fighting back. It happens because I follow myself instead of listening to the stone. When I make a mistake the gods are knocking my door. They are telling me to listen." As Isamu aged he left more and more of a stone's natural surface untouched. He often cut away only one section, then polished it or pitted it with a chisel, making it look as though it had been pecked by a huge bird beak. "Stones lived before humans existed. They are the earth itself."[2] Isamu broke holes in the earth's belly, opening up space within a stone to make its natural form and character emerge more vividly, sometimes inscribing its surface with bold lines that twisted and turned around the stone, and sometimes with delicate lines that danced lightly across its

face. The peculiar elegance of his style arose from his technique of embracing a stone with chiseled lines while leaving the rest of its surface naturally rough.

His late stone sculptures evoke the sensual warmth of human skin. Each has its own distinctive texture. It is easy to see that some are smooth and some are rough or grainy, but they feel different to the touch as well. The more a stone's surface is polished, the more it absorbs sunlight and radiates heat, but if the surface is left natural it remains cool to the touch even in the hot midsummer sun. "Isamu-sensei's stones are most beautiful during the last few minutes before the sun sets," Izumi says.[3] In the summer especially, when the sculptures escape the strong sunlight at the end of the day, their colors come alive, and as the contrast between light and shadow grows weaker, their surfaces are infused with fresh fullness. Each of the sculptures, echoing with the beat of a living heart, insists on its own individuality. A part of Isamu's life remains lodged in the stones in the "circle."

While Isamu was designing *California Scenario* he began building a garden for himself on terraced fields belonging to the Izumi family. The two gardens were entirely different in concept, but the one for the "hill behind the house" in Mure was in no way inferior to the one in California. The house stood on a shallow plot of land. A steep slope of terraced fields immediately behind made it difficult to open up the space. Izumi's mother had raised vegetables on the slope, but it remained uncultivated several years after her death. When Izumi suggested Isamu use it as a place to take a nap, he was no more enthusiastic about the idea than he had been about restoring the "samurai house" as a place to live. With his customary persistence, Izumi quietly kept bringing the idea up again until Isamu, won over by his enthusiasm, began work on the garden in the fall of 1981.

Thinking like a sculptor, Isamu began by cutting away the terraced slope. Taking command of Izumi and his workers, he carved out the garden's foundation and leveled it. "I cut into the hill . . . to reveal this object, this piece of earth, which is no other than the hill itself," he recalled several years later.[4] Unfortunately a typhoon soon turned the site into a mass of mud. Isamu worked frantically to stop a torrent of rain water that crumbled the soil but whenever a typhoon struck again, the water found a way through the soil and shot out some unexpected spot, demolishing the site. Isamu struggled with the problem for three years, then decided to abandon

the project altogether. When the site was left alone, however, the rainwater finally found its own natural course.

"In many works all over the world, I have made good use of the old Japanese wisdom that you learn about stones from the stones themselves," Isamu told a Japanese reporter in 1984. "But this time I learned something new—that what you learn from typhoons is important, too. I learned from the typhoon that you should not resist nature but wait until it decides to do whatever it wants by itself."[5]

A few months before his death, he showed slides of the Mure garden to an audience at the Japan Society in New York. "You might say this garden is a song of praise to nature. I enjoy it very much. The waters come, the typhoons come but it is completely immune. The grass and everything flows and nothing washes away. . . . The grasses have come to that mound which you saw nude. There is such a composition that nature completes in a way that nobody can imitate. I have come to understand that things which are removed from the havoc of nature miss a lot. . . . When you see how nature, trees and stones come together, this is the appreciation of life. To have sculpture that partakes of this, is to me a great joy."[6]

All gardens, Isamu once told his assistant Gene Owens, were a metaphor for the Garden of Eden. He best expressed that idea in the garden at Mure. "My enthusiasm for making gardens," he said late in life, "may spring from my upbringing, in other words, from my longing for someplace where I belonged. I was born bearing the burden of two countries, and I have never ceased searching to answer where is my native place, where can I find a peaceful life, where is there a place where I can be of use."[7] At the top of the garden is a small, rounded hillock or mound. Isamu leveled the ground around the base, and then planted flat grass that spread over it like a prairie. A firm stone retaining wall kept the soil from eroding. To block a view of the house roof directly below he planted trees, mainly pines, along the boundary of the garden. The design created the illusion that the "hill behind the house" was a separate world, all by itself, cut off from its surroundings, and in that separate world he planted peach trees, Japanese bellflowers, and other favorite flowers, as well as eucalyptus trees from his birthplace, California.

The garden Isamu made for himself paid homage to his mother, Leonie, the person who had been the "strongest influence" on his life, who had fallen in love with his Japanese father, given birth to him, then crossed

the Pacific to raise him as a "Japanese boy" in Japan. Enchanted by the country's beauty, she had wanted Isamu, in whose veins ran the blood of two countries, to become an artist who could give expression to his Japanese heritage. It was his mother's "love for the Japanese garden" that Isamu inherited most completely. In explaining why he lived and worked in Mure, and why he had put down roots in Japan, he told an interviewer, "It was not because of my memory of my Japanese father. It was rather because of my American mother."[8] Although she had never been accepted by Japanese society, she had fallen in love with Japanese culture. It was because of her, and not because of his father, that Isamu could feel closer to Japan than to the United States.

"For artists there is no such thing as progress," he said in 1984. "It's only a deepening. Art is of the moment, and we try to deepen our awareness going inwards and going backwards because the future is anybody's guess, and it is so thin and problematical."[9] By immersing himself in Japan's cultural heritage, Isamu had moved backward and inward on a journey of retrospection as he built his garden in Mure. His whole life is laid out for view there.

The hill garden begins with a steep-pitched and narrow set of thirty steps. A twenty-five-ton stone buried alongside the steps to brace them evokes the atmosphere of a traditional Japanese rock garden. At the top of the steps an uncarved stone stands like a human figure to greet the visitor. Like other stones used for the garden, it was left over from an earlier project, the Chase Manhattan Bank garden. On the broad, flat space spreading out to the right lies a huge skull-like stone about ten feet long that Isamu bought for the *Momotarō* sculpture at the Storm King Art Center. In front of it is a "stone stage" made up of ten rows of foundation stones left over from reconstruction of Isamu's "samurai house" and the old sake warehouse. A steep path of stepping stones leads like a gently murmuring stream up the side of the small mound at the top of the garden. The rainwater that had vexed Isamu for so many years had cut the path. At the top of the mound there opens up a view as far as the eye can see. Directly to the north lies an inlet of the Inland Sea, to the west the ancient battlefield of Yashima where the armies of the Taira and Minamoto clashed, and to the east the Gokenzan stone quarries.

A quiet harmony absent from Isamu's other gardens inhabits the garden at Mure. The natural stone, the trees, the grass, and the mound sit side

by side in gentle concord. The space is neither "Western" nor "Eastern." It is at once "American" and "Japanese"—and perhaps it is "Italian" and "Indian," as well. It was "a garden filled with memories," he told Izumi.[10] After the garden was finished, Isamu often went there alone, climbing the mound during a work break and spreading out for a nap. From the top he could see the islands of the Inland Sea that he once said were the original inspiration of the Japanese garden. Perhaps in this space devoted to his mother's memory he had found a place where he came to terms with himself. At the top of the mound, which looks much like an ancient Japanese burial mound, stands Isamu's gravestone.

On his Christmas visit in 1987 Isamu asked Ailes, as though something had just suddenly occurred to him, "If you die before I do, what do you want me to do with your remains?" Ailes, who did not know who her father was, replied without hesitation. "Mother was buried in the family grave in Brooklyn, but please have me cremated. I'd like my ashes scattered in a field or somewhere. I want to return to the earth and be blown by the wind." Isamu quietly said, "I'd like that, too. But cremation sounds so hot. The best thing would be to be dropped all at once from an airplane. . . . Anyway I don't want to be buried in one place."[11]

On January 1, 1989, a day after his death, Isamu was cremated. A few days later half of the ashes were buried in a corner of the garden at the Isamu Noguchi Garden Museum, and the rest were given to Ailes, who hoped to scatter half of them in the ocean off the island of Maui, a place Isamu had been fond of. Indeed, he once told Sean Browne on a visit to see the grave of Charles Lindbergh in Maui that someday he would like to retire on a spot overlooking its rock-lined seacoast. Ailes gave the other half of her share of Isamu's ashes to Izumi to return to the soil of Japan.

Three years before his death Isamu had found an egg-shaped *mannari* stone about six feet long in Okayama. As he watched the huge stone being excavated from the ground, he turned to Izumi and said with his usual wryness, "How would it be if I were put in there?" When the egg-shaped stone was delivered to the "circle," he drew a red line around its girth about a third of the way from the bottom. The stone sat there, its red line gradually fading, until Isamu's death. Before the memorial service at Mure, Izumi took a chisel to the red line and cut the egg-shaped stone into two pieces. In the center he carved a hole for the urn containing Isamu's ashes, then reassembled the two halves in a perfect fit. Neither the name of

Isamu Noguchi nor the date of his death is carved on the stone. The only decoration is the band of twenty-seven chisel marks where the stone was cut. The surface is rough, as complicated and gritty as the person interred within, but in the light of the setting sun its brownish surface turns the soft pink of a baby's skin.

"Stones are the skeleton of the earth," Isamu once said. The artist who so loved stone, and who had shown its beauty to the world, sleeps eternally at one with mother earth, embraced by stone. From his grave, he still looks down on the "circle," where he lived and worked. He looks down on "the world of Isamu Noguchi," a place unlike anywhere else in the world, where one can begin to understand how this artist, who was destined to live in two cultures and who moved freely in both, struggled to uncover the ultimate truth—and how he turned his struggle into art.

Prologue

1. Isamu Noguchi, *A Sculptor's World* (New York: Harper and Row, 1968), 11.
2. Isamu Noguchi, interview by Kazue Kobata, spring 1988, transcript, Isamu Noguchi Foundation (hereafter "Noguchi tape transcript").
3. Noguchi, *A Sculptor's World*, 7.
4. Thomas Messer, interview by author, Sept. 19, 1995.
5. Andrée Ruellan, interview by author, Sept. 15, 1995.
6. Richard Lanier, interview by author, Sept. 20, 1995.
7. Noguchi tape transcript.
8. Ibid.
9. Ibid.

Chapter One: Yone and Leonie

1. Noguchi tape transcript.
2. Ibid.
3. Yone Noguchi, *The Story of Yone Noguchi* (London: Chatto and Windus, 1914), 1.
4. Yonejirō Noguchi, "Hōrō no omoide," *Bunshō kurabu*, Apr. 1918.
5. Noguchi, *The Story of Yone Noguchi*, 29–30.
6. Ibid.
7. Ibid., 16.
8. Kōsen Takahashi to Blanche Partington, Mar. 29, 1900, Bancroft Library, University of California, Berkeley (hereafter BL).
9. Noguchi, *The Story of Yone Noguchi*, 17.
10. Noguchi, "Hōrō no omoide."
11. Yonejirō Noguchi to Blanche Partington, Aug. 17, 1900, BL.
12. Yonejirō Noguchi, *Seen and Unseen: or Monologues of a Homeless Snail* (San Francisco: G. Burgess and P. Garnett, 1897), 1.
13. Noguchi, *The Story of Yone Noguchi*, 17–19.
14. Yonejirō Noguchi to Blanche Partington, Oct. 11, 1898, BL.
15. Yonejirō Noguchi to Charles Stoddard, July 3, 1900, BL.
16. Diary, Charles Stoddard, Sept. 27, 1900, BL.
17. Yonejirō Noguchi to Charles Stoddard, Sept. 27, 1900, BL.
18. Yonejirō Noguchi to Leonie Gilmour, Feb. 4, 1901, Archives of the Isamu Noguchi Garden Museum (hereafter NA).
19. Yonejirō Noguchi to Leonie Gilmour, n.d., 1901, NA.

20. Yonejirō Noguchi to Leonie Gilmour, n.d., 1901, NA.

21. Noguchi tape transcript.

22. Leonie Gilmour to Catherine Bunnell, Nov. 20, 1900, NA.

23. Noguchi tape transcript.

24. Stoddard diary, Jan. 31, 1903, BL.

25. Noguchi tape transcript.

26. Yonejirō Noguchi to Leonie Gilmour, Apr. 5, 1901, NA.

27. Ibid.

28. Yone Noguchi, *The American Diary of a Japanese Girl* (New York: F. A. Stokes, 1902), 7, 11, 160.

29. Yonejirō Noguchi to Charles Stoddard, Nov. 9, 1902, NA.

30. Ibid.

31. Yonejirō Noguchi to Leonie Gilmour, Dec. 9, 1902, NA.

32. William Michael Rossetti to Yonejirō Noguchi, Jan. 7, 1903.

33. Yonejirō Noguchi, *From the Eastern Sea* (London: 1903).

34. Yonejirō Noguchi, *Tōkai yori no rekishi* (Tokyo: 1903), 53.

35. Charles Stoddard to Yonejirō Noguchi, Nov. 7, 1902, BL.

36. Yonejirō Noguchi to Charles Stoddard, Dec. 1900, BL.

37. Charles Stoddard to Yonejirō Noguchi, Jan. 31, 1903, BL.

38. Yonejirō Noguchi, *Eibei no jūsannen* (Tokyo: Daiichi shobō, 1905).

39. Leonie Gilmour to Catherine Bunnell, Sept. 19, 1902, NA.

40. Yonejirō Noguchi, "Hiniku no ittō," in *Jinsei shishū* (Tokyo: Daiichi shobō, 1929).

41. Yonejirō Noguchi to Leonie Gilmour, Sept. 1, 1903, NA.

Chapter Two: His Mother's Child

1. Leonie Gilmour to Catherine Bunnell, Oct. 30, 1904, NA.

2. *Los Angeles Herald*, Nov. 14, 1904.

3. Leonie Gilmour to Catherine Bunnell, Jan. 1, 1905, NA.

4. Leonie Gilmour to Catherine Bunnell, Oct. 30, 1904, NA.

5. Leonie Gilmour to Catherine Bunnell, Nov. 4, 1905, NA.

6. Yonejirō Noguchi to Leonie Gilmour, Oct. 4, 1905, NA.

7. Sakutarō Hagiwara, "Noguchi Yonejirō ron," in *Shijin Yone Noguchi kenkyū*, ed. Usaburō Tōyama, vol. 1 (Tokyo: Zōkei bijutsu kyōkai shuppankyoku, 1965), 15–16.

8. Yonejirō Noguchi, "Nijūkokusekisha," in *Nijūkokusekisha no shi* (Tokyo: Daiichi shobō, 1921), 12–13.

9. Yonejirō Noguchi to Charles Stoddard, Jan. 25, 1905, BL.

10. Yonejirō Noguchi to Charles Stoddard, Apr. 25, 1905, BL.

11. Ethel Armes to Charles Stoddard, n.d./1905, BL.

12. Ibid.

13. Yonejirō Noguchi, "Aikyōshin," in *Jinsei shishū* (Tokyo: Daiichi shobō, 1929), 332–33.

14. Yonejirō Noguchi to Leonie Gilmour, Apr. 5, 1905, NA.

15. Yonejirō Noguchi to Leonie Gilmour, Jan. 28, 1906, NA.

16. Yonejirō Noguchi to Charles Stoddard, Oct. 20, 1905, NA.

17. Yonejirō Noguchi to Leonie Gilmour, Jan. 28, 1906, NA.

18. Yonejirō Noguchi to Leonie Gilmour, Feb. 10, 1906, NA.

19. Leonie Gilmour to Yonejirō Noguchi, Feb. 24, 1906, NA.

20. Leonie Gilmour to Frank Putnam, Mar. 14, 1906, NA.

21. Yonejirō Noguchi to Leonie Gilmour, Apr. 2, 1906, NA.

22. Yonejirō Noguchi to Leonie Gilmour, May 5, 1906, NA.

23. Ibid.

24. Yonejirō Noguchi to Leonie Gilmour, June 22, 1906, NA.

25. Leonie Gilmour to Frank Putnam, Aug. 8, 1906, NA.

26. Leonie Gilmour to Catherine Bunnell, Jan. 20, 1907, NA.

27. Leonie Gilmour to Charles Stoddard, Dec. 6, 1906, BL.

28. Leonie Gilmour to Catherine Bunnell, Jan. 20, 1907, NA.

29. Leonie Gilmour to Frank Putnam, Jan. 23, 1907, NA.

30. Noguchi tape transcript.

31. Yonejirō Noguchi, "Isamu and Others," *The Sunset* 25 (Nov. 1920): 534–35.

32. Noguchi tape transcript.

33. Leonie Gilmour to Frank Putnam, May 1907, NA.

34. Yonejirō Noguchi to Charles Stoddard, May 19, 1907, BL.

35. Leonie Gilmour to Charles Stoddard, Dec. 6, 1906, BL.

36. Yonejirō Noguchi to Charles Stoddard, May 19, 1907, BL.

37. Leonie Gilmour to Catherine Bunnell, July 1907, NA.

38. Leonie Gilmour to Frank Putnam, Feb. 26, 1908, NA.

39. Leonie Gilmour to Catherine Bunnell, Apr. 4, 1908, NA.

40. Leonie Gilmour to Charles Stoddard, Dec. 6, 1906, BL.

41. Yonejirō Noguchi, "Ningen no zentaikei," in *Jinsei shishū*, 17–18.

42. Noguchi tape transcript.

43. Yonejirō Noguchi to Charles Stoddard, July 26, 1908, BL.

44. Noguchi tape transcript.

45. *Mainichi shinbun*, Dec. 23, 1951.

46. Leonie Gilmour to Catherine Bunnell, July 15, 1910, NA.

47. Leonie Gilmour to Catherine Bunnell, June 13, 1909, NA.

48. *Hanatachibana*, 1910, 11.

49. Leonie Gilmour to Catherine Bunnell, Nov. 3, 1910, NA.

50. Noguchi tape transcript.

51. Leonie Gilmour to Catherine Bunnell, Nov. 3, 1910, NA.

52. Noguchi tape transcript.

53. Leonie Gilmour to Catherine Bunnell, Nov. 3, 1911, NA.

54. Isamu Noguchi, *A Sculptor's World* (New York: Harper and Row, 1968), 11.

55. Katherine Kuh, *The Artist's Voice: Talks with Seventeen Artists* (New York: Harper and Row, 1962), 171.

56. Isamu Noguchi, "Isamu Noguchi no naka ni aru higashi to nishi," *Fujin gahō* 672 (July 1960): 220–25.

57. Noguchi tape transcript.

58. Ibid.

59. Ibid.

60. Isamu Noguchi, interview by Paul Cummings, Nov. 7, 1973, Archives of American Art, Smithsonian Institution.

61. Noguchi tape transcript.

62. Shishi Bunroku, "Isamu-kun," *Bungei shunjū* 30 (Jan. 1952): 168–76.

63. Isamu Noguchi and Ailes Gilmour Spinden, conversation videotaped by Jody Spinden.

64. Shishi Bunroku, "Isamu-kun."

65. Noguchi, *A Sculptor's World*, 12.

66. Noguchi tape transcript.

67. Leonie Gilmour to Catherine Bunnell, July 2, 1912, NA.

68. Noguchi tape transcript.

69. Leonie Gilmour to Catherine Bunnell, Mar. 7, 1913, NA.

70. Isamu Noguchi and Ailes Gilmour Spinden, conversation videotaped by Jody Spinden.

71. Noguchi tape transcript.

72. Leonie Gilmour to Catherine Bunnell, Sept. 23, 1913, NA.

73. Noguchi tape transcript.

74. Ibid.

75. Ibid.

76. Ibid.

77. Leonie Gilmour to Catherine Bunnell, Nov. 19, 1913, NA.

78. Ibid.

79. Noguchi tape transcript.

80. Leonie Gilmour to Catherine Bunnell, Jan. 8, 1914, NA.

81. Noguchi tape transcript.

82. Yonejirō Noguchi to Leonie Gilmour, Jan. 17, 1914, NA.

83. Leonie Gilmour to Catherine Bunnell, Aug. 23, 1914, NA.

84. Kazuko Kunieda, interview by author, Jan. 15, 1996.

85. Noguchi, *A Sculptor's World*, 12.

86. Isamu Noguchi and Ailes Gilmour Spinden, conversation videotaped by Jody Spinden.

87. Noguchi, *A Sculptor's World*, 12.

88. Ibid.

89. Leonie Gilmour to Catherine Bunnell, Aug. 29, 1915, NA.

90. Ibid.

91. Noguchi, *A Sculptor's World*, 12.

92. *Honolulu Advertiser*, Apr. 6, 1973.

93. Leonie Gilmour to Catherine Bunnell, Nov. 5, 1914, NA.

94. Noguchi, *A Sculptor's World*, 12.

95. Noguchi tape transcript.

96. Leonie Gilmour to Catherine Bunnell, July 13, 1917, NA.

97. Leonie Gilmour to Catherine Bunnell, Dec. 7, 1917, NA.

98. Noguchi, *A Sculptor's World*, 13.

Chapter Three: All-American Boy

1. Isamu Noguchi, *A Sculptor's World* (New York: Harper and Row, 1968), 13.

2. Leonie Gilmour to Catherine Bunnell, Feb. 24, 1916, NA.

3. Leonie Gilmour to Catherine Bunnell, Feb. 20, 1917, NA.

4. Leonie Gilmour to Catherine Bunnell, Mar. 26, 1915, NA.

5. Leonie Gilmour to Catherine Bunnell, July 31, 1917, NA.

6. Noguchi tape transcript.

7. Noguchi, *A Sculptor's World*, 13.

8. Leonie Gilmour to Catherine Bunnell, Feb. 20, 1917, NA.

9. "The Daniel Boone Idea in Education," *Scientific American: The Weekly Journal of Practical Information* 109, no. 19 (Nov. 3, 1916): 361–62.

10. Leonie Gilmour to Superintendent of Interlaken School, Apr. 5, 1918, Edward A. Rumely Papers, Lilly Library, Indiana University (hereafter LL).

11. Noguchi tape transcript.

12. Leonie Gilmour to Superintendent of Interlaken School, Apr. 5, 1918, LL.

13. Application for Admission, Interlaken School, Apr. 7, 1918, LL.

14. Leonie Gilmour to Catherine Bunnell, Feb. 20, 1918, NA.

15. Noguchi, *A Sculptor's World*, 14.

16. Noguchi tape transcript.

17. Katherine Kuh, *The Artist's Voice: Talks with Seventeen Artists* (New York: Harper and Row, 1962), 171.

18. C. A. Lewis to Edward A. Rumely, July 25, 1918, LL.

19. Application for Admission, Interlaken School, Apr. 7, 1918, LL.

20. Noguchi tape transcript.

21. Noguchi, *A Sculptor's World*, 14.

22. Noguchi tape transcript.

23. *Honolulu Advertiser*, June 4, 1973.

24. Leonie Gilmour to Superintendent, Interlaken School, Oct. 5, 1918, LL.

25. Leonie Gilmour to Superintendent, Interlaken School, Oct. 14, 1918, LL.

26. Noguchi tape transcript.

27. Ibid.

28. Application for Admission, Interlaken School, Apr. 15, 1918, LL.

29. Yonejirō Noguchi, "Nijūkokusekisha," in *Nijūkokusekisha no shi* (Tokyo: Daiichi shobō, 1921), 12–13.

30. John Gruen, "The Artist Speaks: Isamu Noguchi," *Art in America* 56 (Mar.–Apr. 1968): 31.

31. Noguchi, *A Sculptor's World*, 14.

32. Edward A. Rumely to Isamu Noguchi, Sept. 15, 1919, LL.

33. Yoshinobu Hakutani, *Selected English Writings of Yone Noguchi*, vol. 1 (Rutherford, N.J.: Fairleigh Dickinson University Press, 1990), 39.

34. Isamu Noguchi, interview by Paul Cummings, Dec. 18, 1973.

35. Isamu Noguchi to Edward A. Rumely, n.d., 1919, LL.

36. Noguchi tape transcript.

37. Isamu Noguchi to Edward A. Rumely, Jan. 1920, LL.

38. *New York Times Magazine*, Jan. 18, 1920.

39. Yonejirō Noguchi to Leonie Gilmour, Sept. 9, 1919, LL.

40. Noguchi tape transcript.

41. Isamu Noguchi to Edward A. Rumely, n.d., 1920, LL.

42. Fanny Rumely to Edward A. Rumely, n.d., 1920, LL.

43. Isamu Noguchi to Edward A. Rumely, June 8, 1922, LL.

44. Noguchi tape transcript.

45. *La Porte High School Yearbook, 1922.*

46. Noguchi, *A Sculptor's World*, 14.

47. Leonie Gilmour to Yonejirō Noguchi, Feb. 24, 1906, NA.

48. Leonie Gilmour to Catherine Bunnell, Feb. 24, 1916, NA.

49. Isamu Noguchi, "Shōjijoden," *Geijutsu shinchō* 3 (Nov. 1952): 137–44.

50. Noguchi tape transcript.

51. Noguchi, *A Sculptor's World*, 15.

52. Noguchi tape transcript.

53. Ibid.

54. Isamu Noguchi to Edward A. Rumely, Sept. 6, 1923, LL.

55. Noguchi, *A Sculptor's World*, 15.

56. Leonie Gilmour to Catherine Bunnell, Mar. 27, 1927, NA.

57. Noguchi tape transcript.

58. Ibid.

59. Noguchi, *A Sculptor's World*, 15.

60. Isamu Noguchi, "Isamu Noguchi no naka ni aru higashi to nishi," *Fujin gahō* 672 (July 1960): 220–25.

61. Isamu Noguchi, interview by Paul Cummings, Dec. 18, 1973, NA.

62. Ibid.

63. Noguchi, *A Sculptor's World*, 15.

64. Noguchi tape transcript.

65. Lucio Ruotolo, interview by author, Sept. 26, 1996.

66. *The World and Word*, Aug. 24, 1924.

67. Ibid.

68. Noguchi, *A Sculptor's World*, 15.

69. Noguchi, "Shōjijoden," 137–44.

70. Noguchi tape transcript.

71. Edward A. Rumely to Isamu Noguchi, June 2, 1924, NA.

72. Noguchi, *A Sculptor's World*, 16.

73. Noguchi tape transcript.

74. Application letter, Guggenheim Foundation, NA.

75. *The American Boy*, Feb. 1925.

76. Noguchi, *A Sculptor's World*, 15.

77. *The World and Word*, Aug. 24, 1924.

78. Noguchi tape transcript.

79. Hakutani, *Selected English Writings*, 46.

80. Isamu Noguchi, "Conversation with Isamu Noguchi," *Kyoto Journal* 10, Spring 1989.

81. David Shirley, "Noguchi," *Newsweek*, Apr. 29, 1968, 94.

Chapter Four: Journey of Self-Discovery

1. Isamu Noguchi, *A Sculptor's World* (New York: Harper and Row, 1968), 17.

2. Ibid., 16.

3. Ibid., 17.

4. Isamu Noguchi, "Paundo no haka to Godeie Jaresuka," *Geijutsu shinchō* 26 (Nov. 1975): 157–59.

5. Man Ray, *Self Portrait* (Boston: Little, Brown, 1963), 164.

6. Isamu Noguchi, "Shōjijoden," *Geijutsu shinchō* 11 (Nov. 1952): 45–47.

7. Noguchi, *A Sculptor's World*, 17.

8. Ibid., 17.

9. Sam Hunter, *Isamu Noguchi* (New York: Abbeville Press, 1978), 35.

10. Isamu Noguchi, "Noguchi on Brancusi," *Craft Horizons* 36 (Aug. 1976): 26–29.

11. Katherine Kuh, *The Artist's Voice: Talks with Seventeen Artists* (New York: Harper and Row, 1962), 173.

12. Isamu Noguchi to Edward A. Rumely, Jan. 12, 1928, LL.

13. Isamu Noguchi to Edward A. Rumely, Apr. 16, 1928, LL.

14. Isamu Noguchi to Edward A. Rumely, May 1927, RA.

15. Isamu Noguchi, interview by Paul Cummings, Dec. 18, 1973, NA.

16. Isamu Noguchi to Leonie Gilmour, Nov. 8, 1927, NA.

17. Isamu Noguchi to Leonie Gilmour, May 1, 1927, NA.

18. Leonie Gilmour to Catherine Bunnell, Mar. 17, 1927, NA.

19. Isamu Noguchi to Edward A. Rumely, Nov. 8, 1927, NA.

20. Andrée Ruellan, interview by author, Sept. 15, 1995.

21. Noguchi tape transcript.

22. Leonie Gilmour to Isamu Noguchi, May 4, 1927, Aug. 3, 1927, and Oct. 30, 1927, NA.

23. Isamu Noguchi, "Jisaku ni yoru jijoden," *Apurōchi* 109 (spring 1990): 8–17.

24. Noguchi, *A Sculptor's World*, 18.

25. "Speech to the Japan Society," Apr. 26, 1988. Unpublished manuscript, NA.

26. *New York Times*, Mar. 31, 1929.

27. Isamu Noguchi, interview by Paul Cummings.

28. Noguchi, *A Sculptor's World*, 19.

29. Ibid.

30. Noguchi tape transcript.

31. *New York Times*, Feb. 9, 1930.

32. Noguchi, *A Sculptor's World*, 19.

33. Ibid.

34. Isamu Noguchi, interview by Paul Cummings.

35. Noguchi, *A Sculptor's World*, 7–8.

36. Noguchi, "Jisaku ni yoru jijoden," 8–17.

37. Noguchi, *A Sculptor's World*, 18.

38. Noguchi tape transcript.

39. Isamu to Edward A. Rumely, Mar. 8, 1930, NA.

40. Isamu Noguchi, interview by Paul Cummings.

41. Noguchi, *A Sculptor's World*, 19–20.

42. Isamu Noguchi, "Isamu Noguchi no naka ni aru higashi to nishi," *Fujin gahō* 672 (July 1960): 220–25.

43. Yonejirō Noguchi, "Tsunawatari," in *Hyōshōjojōshi* (Tokyo: Daiichi shobō, 1925).

44. Noguchi, *A Sculptor's World*, 20.

45. Isamu Noguchi to Leonie Gilmour, July 30, 1930, NA.

46. Noguchi, *A Sculptor's World*, 20.

47. Ibid.

48. Isamu Noguchi to Leonie Gilmour, Dec. 28, 1930, NA.

49. Noguchi, *A Sculptor's World*, 20.

50. *Mainichi shinbun*, Jan. 26, 1931.

51. *Mainichi shinbun*, Jan. 29, 1931.

52. Ibid.

53. Noguchi tape transcript.

54. Ibid.

55. Isamu Noguchi, interview by Paul Cummings.

56. *A Sculptor's World*, 20.

57. Asa Tetsuo, interview by author, Apr. 6, 1995.

58. Noguchi, *A Sculptor's World*, 21.

59. Isamu Noguchi, "Conversation with Isamu Noguchi," *Kyoto Journal* 10, Spring 1989.

60. Kyoto Prize Speech, 1988, unpublished manuscript, NA.

61. Isamu Noguchi, "Sekai ni niwa o tsukuru," *Geijutsu shinchō* 11 (Nov. 1960): 72–80.

62. Isamu Noguchi, "Sōzō genba kara—Isamu Noguchi + Yonekura Mamoru," *Mizue* 949 (winter 1988): 35–42.

63. Paul Cummings, *Artists in Their Own Words* (New York: St. Martin's Press, 1979), 111–12.

64. Noguchi, "Conversation with Isamu Noguchi."

65. Isamu Noguchi to Yonejirō Noguchi, Nov. 1, 1931, NA.

66. Noguchi tape transcript.

67. Isamu Noguchi to Yonejirō Noguchi, Nov. 1, 1931, NA.

68. *New York Herald Tribune*, Feb. 2, 1932.

69. *New York Times*, Mar. 8, 1932.

70. Ibid.

71. *Art News* 20 (Feb. 1932): 10.

72. *Creative Art* 10 (Mar. 1932): 228–29, 232.

73. Noguchi, "Jisaku ni yoru jijoden," 8–17.

74. Leonie Gilmour to Isamu Noguchi, Apr. 7, 1932, NA.

75. Ruth Page, interview transcript, New York Library of the Performing Arts, Lincoln Center.

76. *Time*, Dec. 18, 1932.

77. Noguchi, "Sekai ni niwa o tsukuru," 72–80.

78. Noguchi, *A Sculptor's World*, 21.

79. *New York Times*, Dec. 17, 1932.

80. *Art News* 30 (Dec. 17, 1932).

81. *Time*, Dec. 18, 1932.

82. Julien Levy, "Isamu Noguchi," *Creative Art* 12 (Jan. 1933): 29–35.

83. Noguchi, *A Sculptor's World*, 18.

84. Ibid., 21.

85. Isamu Noguchi to Leonie Gilmour, July 9, 1933, NA.

86. Leonie Gilmour to Isamu Noguchi, Aug. 8, 1933, NA.

87. Leonie Gilmour to Isamu Noguchi, July 9, 1932, NA.

88. Isamu Noguchi to Leonie Gilmour, Aug. 9, 1933, NA.

89. Isamu Noguchi to Leonie Gilmour, Sept. 3, 1933, NA.

90. Isamu Noguchi to Leonie Gilmour, Nov. 17, 1933, NA.

91. Catherine Bunnell to Leonie Gilmour, Nov. 27, 1933, NA.

92. Isamu Noguchi to Leonie Gilmour, Nov. 28, 1933, NA.

93. Isamu Noguchi to Leonie Gilmour, Nov. 29, 1933, NA.

94. Isamu Noguchi and Ailes Gilmour Spinden, conversation videotaped by Jody Spinden.

95. Ailes Gilmour to Isamu Noguchi, May 22, 1928, NA.

96. Isamu Noguchi to Ailes Gilmour, June 14, 1928, NA.

97. Leonie Gilmour to Ailes Gilmour, n.d., 1933, NA.

Chapter Five: Becoming a Nisei

1. Isamu Noguchi, "Jisaku ni yoru jijoden," *Apurōchi* 109 (spring 1990): 8–17.

2. Isamu Noguchi, *A Sculptor's World* (New York: Harper and Row, 1968), 22.

3. PWAP New York Office, Report on Isamu Noguchi, Feb. 28, 1934.

4. Noguchi, *A Sculptor's World*, 161.

5. Katherine Kuh, *Artists in Their Own Words: Talks with Seventeen Artists* (New York: Harper and Row, 1962), 104.

6. Isamu Noguchi, "Isamu Noguchi ōi-ni kataru," *Geijutsu shinchō* 36 (Jan. 1985): 76–79.

7. Noguchi tape transcript.

8. *New York Times*, Jan. 30, 1935.

9. Noguchi, *A Sculptor's World*, 22.

10. *Star-Telegram* (Fort Worth), Feb. 28, 1932.

11. Noguchi, *A Sculptor's World*, 23.

12. Ayako Ishigaki, interview by author, May 12, 1992.

13. Isamu Noguchi, interview by Paul Cummings, Dec. 18, 1973.

14. Noguchi, *A Sculptor's World*, 23.

15. Isamu Noguchi, interview by Paul Cummings.

16. Isamu Noguchi, "What's the Matter with Sculpture?" *Art Front* 16 (Sept.–Oct. 1936): 13–14.

17. Isamu Noguchi, interview by Paul Cummings, Dec. 18, 1973, NA.

18. Hayden Herrera, *Frida Kahlo* (New York: Harper and Row, 1983), 200–201.

19. Ibid.

20. Ibid.

21. *New York Telegram*, Dec. 3, 1937.

22. *New York Times*, Dec. 12, 1937.

23. Isamu Noguchi, interview by Paul Cummings.

24. David Gelertner, *1939: The Lost World of the Fair* (New York: Free Press, 1995), 165.

25. *New York Times*, May 5, 1940.

26. *Mainichi shinbun*, June 4, 1940.

27. Noguchi tape transcript.

28. Noguchi, *A Sculptor's World*, 25.

29. Karlen Mooradian, *The Many Worlds of Arshile Gorky* (Chicago: Gilgamesh Press, 1980), 183.

30. Ibid., 181.

31. Ibid., 227.

32. Katherine Kuh, interview by Avis Berman, Archives of American Art, Smithsonian Institution, 1982–83.

33. Ibid.

34. Noguchi, *A Sculptor's World*, 25.

35. Franklin Chino to Isamu Noguchi, May 17, 1940, National Archives, Washington, D.C. (hereafter NADC).

36. Isamu Noguchi, interview by Paul Cummings.

37. Jeanne Reynal to Agnes Magruder, Feb. 27, 1942, NA.

38. Isamu Noguchi, "I Become a Nisei," 1942. Unpublished manuscript, NA.

39. Noguchi tape transcript.

40. Isamu Noguchi to Archibald McLeish, Jan. 21, 1942, NADC.

41. Shūji Fujii, Isamu Noguchi, and George Watanabe to John H. Tolan, Mar. 7, 1942, NADC.

42. Isamu Noguchi to Mike Masaoka, Feb. 21, 1942, NADC.

43. Noguchi tape transcript.

44. Shūji Fujii to Milton Eisenhower, Mar. 31, 1942, NADC.

45. Noguchi tape transcript.

46. Isamu Noguchi to Larry Tajiri, Apr. 3, 1942, NADC.

47. Isamu Noguchi, interview by Paul Cummings.

48. Ayako Ishigaki, interview by author, May 12, 1992.

49. Isamu Noguchi to Man Ray, May 30, 1942, NA.

50. John A. Bird to Whom It May Concern, Apr. 27, 1942, NADC.

51. Ailes Gilmour to Isamu Noguchi, July 10, 1942, NA.

52. Isamu Noguchi to John Collier, May 3, 1942, NADC.

53. Isamu Noguchi to E. R. Fryer, July 28, 1942, NADC.

54. Isamu Noguchi to John Collier, July 27, 1942, NADC.

55. Isamu to Carey McWilliams, June 11, 1942, NADC.

56. Noguchi tape transcript.

57. Henry Kanegae, interview by author, Nov. 4, 1995.

58. Noguchi tape transcript.

59. Isamu Noguchi to John Collier, July 27, 1942.

60. Wade Head to E. R. Fryer, Aug. 28, 1942.

61. Isamu Noguchi, "Akari," *Geijutsu shinchō* 5 (Aug. 1954): 194.

62. Isamu Noguchi to Ailes Gilmour, Nov. 9, 1942, NADC.

63. *Poston Bulletin*, Nov. 13, 1942.

64. Isamu Noguchi, "Trouble Among the Japanese Americans," *New Republic* 108 (Feb. 1, 1943): 142.

65. Ayako Ishigaki, interview by author, May 12, 1992.

Chapter Six: The Song of a Snail

1. Anaïs Nin, *The Diary of Anaïs Nin (1944–1947)*, vol. 4. (New York: Harcourt, Brace, and Jovanovich, 1966), 99–100.

2. *Anaïs Nin*, videocassette, produced by John Snyder.

3. Nin, *Diary of Anaïs Nin*, 100.

4. Robert Hughes, *American Visions: The Epic History of Art in America* (New York: Alfred A. Knopf, 1997), 468.

5. Isamu Noguchi, interview by Paul Cummings, Dec., 18 1973, NA.

6. Isamu Noguchi, "Shōjijoden," *Geijutsu shinchō* 3 (Nov. 1952): 45–48.

7. Isamu Noguchi, *A Sculptor's World* (New York: Harper and Row, 1968), 26.

8. Ibid.

9. Isamu Noguchi, "Collaborating with Martha Graham," *Ballet Review* 13, no. 4 (winter 1986): 9–17.

10. Isamu Noguchi, interview by Tobi Tobias, transcript, Oral History Archives, Dance Collection, New York Public Library.

11. Jeanne Reynal to Agnes Gorky, Aug. 17, 1944.

12. Julien Levy, *Memoir of an Art Gallery* (New York: Putnam, 1977), 248.

13. Jeanne Reynal to Agnes Gorky, Dec. 12, 1944.

14. Isamu Noguchi, "Akari," *Geijutsu shinchō* 5 (Aug. 1954): 194.

15. Noguchi, *A Sculptor's World*, 27.

16. Ann Alpert (former Ann Matta), interview by author, Sept. 19, 1995.

17. RH File No. 65-1514, July 14, 1943, Federal Bureau of Investigation.

18. Ibid.

19. Clifford Forster to Edwin E. Ferguson, Feb. 26, 1945, FBI.

20. *New York Times*, Feb. 27, 1947.

21. Mine Okubo, interview by author, Nov. 14, 1995.

22. Nayantara Saghal, *Prison and Chocolate Cake* (New York: Alfred A. Knopf, 1954), 208.

23. Nayantara Saghal, interview by author, Jan. 31, 1996.

24. Noguchi, *A Sculptor's World*, 27–28.

25. Katherine Kuh, *The Artist's Voice: Talks with Seventeen Artists* (New York: Harper and Row, 1962), 175.

26. *Art Digest*, Sept. 15, 1946.

27. Thomas B. Hess, "Isamu Noguchi '46," *Art News* 45 (Sept. 1946): 34–38, 47, 50–51.

28. Katherine Kuh, *The Artist's Voice*, 186.

29. Nayantara Pandit to Isamu Noguchi, July 5, 1947, NA.

30. Frida Kahlo to Nayantara Pandit, n.d., 1947.

31. Nayantara Pandit to Isamu Noguchi, July 5, 1947, NA.

32. Ayako Ishigaki, interview by author, May 12, 1992.

33. Nayantara Saghal, interview by author, Jan. 31, 1996.

34. Ibid.

35. Saghal, *Prison and Chocolate Cake*, 126.

36. Nayantara Saghal, interview by author, Jan. 31, 1996.

37. Ibid.

38. Ibid.

39. Nayantara Pandit to Isamu Noguchi, Oct. 14, 1947, NA.

40. Nayantara Saghal, interview by author, Jan. 31, 1996.

41. Nayantara Pandit to Isamu Noguchi, Nov. 11, 1947, NA.

42. Nayantara Pandit to Isamu Noguchi, Feb. 2, 1948, NA.

43. Nayantara Pandit to Isamu Noguchi, Apr. 26, 1948, NA.

44. Karlen Mooradian, *The Many Worlds of Arshile Gorky* (Chicago: Gilgamesh Press, 1980), 185.

45. Noguchi, *A Sculptor's World*, 30.

46. Nayantara Saghal to Isamu Noguchi, Sept. 30, 1948, NA.

47. Isamu Noguchi, *Isamu Noguchi: Essays and Conversations*, ed. Diane Apostolos-Cappadonna and Bruce Altshuler (New York: Harry N. Abrams, 1994), 26–31.

48. *New York Times*, Mar. 6, 1949.

49. Noguchi, *A Sculptor's World*, 29–30.

50. Ibid., 31.

51. Nayantara Saghal and Lehka Pandit, interviews by author, Jan. 31, 1996.

52. Isamu Noguchi, "Shinde iru tera, ikite iru tera," *Geijutsu shinchō* 7 (May 1956): 197–99.

53. Anand Sarabhai, interview by author, Feb. 9, 1996.

Chapter Seven: Honeymoon with Japan

1. Isamu Noguchi to Tomiji Noguchi, Feb. 8, 1950.

2. *Nippon Times*, Mar. 27, 1947.

3. Isamu Noguchi, "Isamu Noguchi no naka ni aru higashi to nishi," *Fujin gahō* 672 (July 1960): 220–25.

4. Yonejirō Noguchi to Isamu Noguchi, May 6, 1947, NA.

5. Isamu Noguchi to Yonejirō Noguchi, May 15, 1947, NA.

6. Yonejirō Noguchi to Isamu Noguchi, June 24, 1947, NA.

7. Tomiji Noguchi to Isamu Noguchi, July 18, 1947, NA.

8. Isamu Noguchi, *A Sculptor's World* (New York: Harper and Row, 1968), 31.

9. *Kyōdō News*, May 3, 1950.

10. *Mainichi shinbun*, May 27, 1950.

11. Isamu Noguchi, "Geijutsu to shudan shakai—Art and Community," *Bijutsu techō* 31 (July 1950): 3–5.

12. Ibid.

13. Shūzō Taniguchi, "Fushigi na geijutsu no ryokō—Isamu Noguchi shōron," *Mizue* 568 (Dec. 1952): 20–31.

14. Isamu Noguchi, interview by Paul Cummings, Dec. 18, 1973.

15. Isamu Noguchi, "Notes by the Artist on His Recent Work in Japan," *Arts and Architecture* 67 (Nov. 1950): 24–27.

16. Noguchi, *A Sculptor's World*, 31.

17. Saburō Hasegawa, "Isamu Noguchi ten," *Bokubi* 19 (Dec. 1952): 29–31.

18. Isamu Noguchi, "Watakushi no mita Nihon," *Geijutsu shinchō* 2 (Oct. 1951): 100–106.

19. Isamu Noguchi, "Sekai ni niwa o tsukuru," *Geijutsu shinchō* 11 (July 1960): 72–80.

20. Saburō Hasegawa, "Noguchi no Nihon," *Bijutsu techō* 33 (Aug. 1950): 58–60.

21. Ibid.

22. Saburō Hasegawa, "Isamu Noguchi no hibi," *Sansai* 45 (Aug. 1950): 7–9.

23. Kiyoko Hasegawa, interview by author, Oct. 20, 1996.

24. Hasegawa, "Isamu Noguchi no hibi."

25. Sumire Hasegawa, interview by author, Oct. 20, 1996.

26. Minami Gallery, *Isamu Noguchi chōkoku ten*, exh. cat. (Tokyo: Minami Gallery, 1973).

27. Noguchi, *A Sculptor's World*, 31.

28. Kenmochi Isamu no sekai henshū iinkai, *Isamu Kenmochi no sekai* (Tokyo: Kawade shobōsha, 1975), 182–85.

29. Tsutomu Hiroi, interview by author, Jan. 18, 1995.

30. Noguchi, *A Sculptor's World*, 31–32.

31. Isamu Kenmochi, "Sonogo no Isamu Noguchi," *Kōgei nyūsu* 18 (Nov. 1950): 27.

32. *Mainichi shinbun*, Sept. 12, 1950.

33. Sadao Wada, "Isamu Noguchi no koto," *Atorie* 28 (Nov. 1950): 46–51.

34. Kenmochi, "Sonogo no Isamu Noguchi," *Kōgei nyūsu* 18 (Oct. 1950): 25–26.

35. Noguchi, *A Sculptor's World*, 31–32.

36. *Mainichi shinbun*, Sept. 6, 1950.

37. Isamu Noguchi, interview by Paul Cummings.

38. Jean Erdman, interview by author, Oct. 3, 1996.

39. Ayako Ishigaki, interview by author, May 12, 1992.

40. Ayako Ishigaki, *Ishigaki Ayako nikki* (Tokyo: Iwanami shoten, 1996), entry for Sept. 14, 1950.

41. Noguchi, *A Sculptor's World*, 32.

42. Ayako Ishigaki, "Yamaguchi Yoshiko no kyūpiddo," *Bungei shunjū* 30 (Jan. 1952): 163–64.

43. Yoshiko Yamaguchi, interview by author, Dec. 27, 1994.

44. *Asahi shinbun*, Apr. 22, 1950.

45. Ishigaki, "Yamaguchi Yoshiko," 162–63.

46. *Mainichi shinbun*, July 27, 1950.

47. Yoshiko Yamaguchi, interview by author, Dec. 27, 1994.

48. Ishigaki, "Yamaguchi Yoshiko," 165.

49. Yoshiko Yamaguchi, interview by author, Dec. 27, 1994.

50. Ishigaki, *Nikki*, entry for Mar. 7, 1951.

51. Isamu Noguchi, interview by Paul Cummings.

52. *Kyōdō News*, Mar. 15, 1951.

53. Noguchi, *A Sculptor's World*, 32.

54. *Kyōdō News*, May 28, 1951.

55. Ibid.

56. Noguchi, *A Sculptor's World*, 32.

57. *Chūgoku shinbun*, June 12, 1951.

58. Ibid., July 22, 1950.

59. Funato Kōkichi, "Musshū Noguchi," *Geijutsu shinchō* 2 (Oct. 1951): 123–26.

60. Tange Kenzō, "Gomannin no hiroba—Hiroshima pīsu sentā kansei made," *Geijutsu shinchō* 7 (Jan. 1956): 76–80.

61. *Chūgoku shinbun*, Jan. 30, 1952.

62. Isamu Noguchi and Hidezō Kondo, "Isamu Noguchi, Kondo Hidezō taidan," *Shūkan yomiuri* 19 (June 19, 1960): 58–62.

63. *New York Times*, Dec. 30, 1951.

64. *Kyōdō News*, Oct. 17, 1951.

65. Yoshiko Yamaguchi, interview by author, Dec. 27, 1994.

66. Isamu Noguchi and Yoshiko Yamaguchi, "Nihon ni ikiru," *Geijutsu shinchō* 3 (June 1952): 154–64.

67. *Kyōdō News*, Dec. 16, 1951.

68. *Shūkan Asahi*, Dec. 30, 1951.

69. Ibid.

70. *Kyōdō News*, Dec. 16, 1951.

71. *Ōru yomimono*, Feb. 1952.

Chapter Eight: The World of Dreams

1. Isamu Noguchi, *A Sculptor's World* (New York: Harper and Row, 1968), 32.

2. Tsutomu Hiroi, interview by author, Jan. 18, 1995.

3. Isamu Noguchi, "Sekai ni niwa o tsukuru," *Geijutsu shinchō* 11 (July 1960): 58–62.

4. *Sun shashin shinbun*, Mar. 19, 1952.

5. Betty Pepis, "Artist at Home," *New York Times Magazine*, Aug. 31, 1952, 26–27.

6. *Isamu Noguchi* (Kamakura: Museum of Modern Art, 1952.) Exh. cat.

7. *Tōkyō shinbun*, Mar. 15, 1952.

8. Yoshiko Yamaguchi, interview by author, Dec. 27, 1994.

9. Rosanjin Kitaoji, *Rosanjin tōsetsu* (Tokyo: Chūō kōronsha, 1992), 281.

10. Kyoto Prize speech, 1986. Unpublished manuscript, NA.

11. Isamu Noguchi, "Shōjijoden," *Geijutsu shinchō* 3 (Nov. 1952): 45–48.

12. Yoshiko Yamaguchi, interview by author, Dec. 27, 1994.

13. Sydney Cardozo, interview by author, May 13, 1995.

14. Isamu Noguchi, "Rosanjin, Potter and Cook," *Vogue* 123 (May 1954): 170.

15. Rosanjin Kitaoji, *Rosanjin chōsakushū* (Tokyo: Satsuki shobō, 1980), vol. 2, 442–45.

16. Ibid.

17. Yoshiko Yamaguchi, interview by author, Dec. 27, 1994.

18. Ibid.

19. Kitaoji, *Rosanjin chōsakushū*, vol. 3, 442–43.

20. Tōyō Kaneshige, "Noguchi-shi no shigoto ga oshieru mono," *Nihon bijutsu kōgei* 168 (Oct. 1952): 35–37.

21. Ibid.

22. *Isamu Noguchi*, Exh. cat.

23. Isamu Noguchi to Jeanne Reynal, Nov. 2, 1952, NA.

24. Shūzō Taniguchi, "Fushigi na geijutsu no ryokō," *Mizue* 568 (Dec. 1952): 20–31.

25. Tarō Okamoto, "Isamu Noguchi no shigoto," *Bijutsu techō* 63 (Dec. 1952): 43–44.

26. Noguchi, *A Sculptor's World*, 33.

27. Ibid.

28. Saburō Hasegawa, "Isamu Noguchi ten," *Bokubi* 19 (Dec. 1952): 29–31.

29. *Mainichi shinbun*, Nov. 20, 1951.

30. Ayako Ishigaki, *Ishigaki Ayako nikki* (Tokyo: Iwanami shoten, 1996), entry for Dec. 19, 1951.

31. Isamu Noguchi to John Collier, Feb. 4, 1953, NA.

32. Kenzō Tange, "Gommanin no hiroba—Hiroshima pīsu sentā kansei made," *Geijutsu shinchō 7* (July 1956): 76–80.

33. Isamu Noguchi to John Collier, Feb. 3, 1953, NA.

34. *Asahi shinbun*, Apr. 8, 1952.

35. Noguchi, *A Sculptor's World*, 164.

36. Ibid.

37. Isamu Noguchi, "Modan to iu koto—Hiroshima mondai ni furete," *Atorie* 30 (Aug. 1952): 39–41.

38. Isamu Noguchi to John Collier, Feb. 4, 1953, NA.

39. Kenzō Tange, "Gomannin no hiroba," 76–80.

40. Isamu Noguchi to John Collier, Feb. 4, 1953, NA.

41. Kenzō Tange, "Gomannin no hiroba," 76–80.

42. *Mainichi shinbun*, Apr. 8, 1953.

43. *Chūgoku shinbun*, Jan. 30, 1952.

44. Kenzō Tange, "Gomannin no hiroba," 76–80.

45. Isamu Noguchi to John Collier, Feb. 4, 1953, NA.

46. Chimata Fujimoto, interview by author, Apr. 19, 1995.

47. Isamu Noguchi, "Modan to iu koto," 39–41.

48. *Chūgoku shinbun*, May 8, 1952.

49. Martin Friedman, interview by author, Sept. 20, 1995.

50. Isamu Noguchi and Yoshiko Yamaguchi, "Nihon ni ikiru," *Geijutsu shinchō* 3 (June 1952): 154–64.

51. Ibid.

52. Ibid.

53. *Mainichi shinbun*, July 20, 1952.

54. *Shin Ōsaka shinbun*, Mar. 6, 1952.

55. Isamu Noguchi to Jeanne Reynal, Nov. 2, 1952.

56. Isamu Noguchi to Rosanjin Kitaōji, Mar. 18, 1953.

57. Ibid.

58. Ralph Gwinn to Edward A. Rumely, Feb. 20, 1953.

59. Isamu Noguchi to Edward A. Rumely, Feb. 25, 1953, NA.

60. Ishigaki, *Nikki*, entry for June 2, 1951.

61. Operations Memorandum, American Embassy, Paris, to Department of State, Oct. 23, 1953.

62. Agent Report, FBI, Apr. 1, 1942.

63. Agent Report, "Chinese Communist Espionage Agent," n.d., FBI.

64. Agent Report, 044-07-4596, HQ, 115th MI Group, FBI, Dec. 28, 1967.

65. Summary of Information, Hq. Sixth Army, OAC of S, G-2, Jan. 22, 1951.

66. Ibid.

67. Agent Report, File # 65-15644, Oct. 11, 1951.

68. Noguchi, *A Sculptor's World*, 33–34.

69. Operations Memorandum, American Embassy, Paris, to Department of State, June 4, 1953.

70. *Kyōdō News*, June 12, 1953.

71. *Mainichi shinbun*, June 12, 1953.

72. *Kyōdō News*, June 12, 1953.

73. Ibid., July 5, 1953.

74. Isamu Noguchi to Edward A. Rumely, Nov. 17, 1953.

75. *Kyōdō News*, Nov. 10, 1953.

76. Ibid., Apr. 30, 1954.

77. Isamu Noguchi to Edward A. Rumely, Apr. 30, 1954.

78. *Kyōdō News*, June 5, 1954.

79. *Mainichi shinbun*, Apr. 4, 1954.

80. Isamu Noguchi, "A Project, Hiroshima Memorial to the Dead," *Art and Architecture* 72 (Feb. 1955): 4.

81. Noguchi, *A Sculptor's World*, 34.

82. Isamu Noguchi to Edward A. Rumely, Jan. 26, 1954.

83. J. B. Blunk, interview by author, Mar. 10, 1996.

84. Andrée Ruellan, interview by author, Sept. 15, 1995.

85. *Hawaii Magazine*, March 1953: 29.

86. Isamu Noguchi, "Isamu Noguchi no naka ni aru higashi to nishi," *Fujin gahō* 672 (Aug. 1960): 220–25.

87. Isamu Noguchi, "Collaborating with Graham," *Ballet Review* 13 (Apr. 1986): 9–17.

88. Yoshiko Yamaguchi, interview by author, Dec. 27, 1994.

89. *Shūkan Asahi*, Jan. 13, 1952.

90. *Mainichi shinbun*, Feb. 4, 1956.

91. Yoshiko Yamaguchi, interview by author, Dec. 27, 1994.

92. Ibid.

93. Ibid.

94. *Kyōdō News*, Dec. 13, 1957.

Chapter Nine: The Universe in a Garden

1. Isamu Noguchi to Toshikazu Kase, Sept. 24, 1956, NA.

2. Isamu Noguchi, "Sekai ni niwa o tsukuru," *Geijutsu shinchō* 11 (July 1960): 72–80.

3. Isamu Noguchi, *A Sculptor's World* (New York: Harper and Row, 1968), 166.

4. Isamu Noguchi, "Ishi: Pari no 'Nihon no niwa' o tsukuru," *Geijutsu shinchō* 8 (July 1957): 153–57.

5. Ibid.

6. Isamu Noguchi to Bernard Zehrfuss, Sept. 26, 1956, NA.

7. Tōru Hagiwara to Isamu Noguchi, Jan. 15, 1957, NA.

8. The Ishibashi Foundation contributed ¥1, 000,000; the Chichibu Cement Company ¥500,000; the Ajinomoto Company ¥550,000; the Kajima Construction Company ¥50,000; the Hankyu Department Store ¥30,000; Aiichirō Fujiyama and Masaichi Nagata, president of the Daiei Film Company, ¥1,000,000 each; Kan'ichi Moroi ¥500,000; and Nagamasa Kawakita ¥50,000.

9. Isamu Noguchi, "Ishi," 153–57.

10. Isamu Noguchi, interview by Mamoru Yonekura, Sept. 26, 1988.

11. Isamu Noguchi, "Ishi," 153–57.

12. Noguchi, *A Sculptor's World*, 166.

13. Diary of Mirei Shigemori, entry for May 9, 1957.

14. Noguchi, *A Sculptor's World*, 166.

15. Ibid.

16. Claude Bernard, interview by author, Nov. 22, 1994.

17. Kyō Asabuki, interview by author, Apr. 14, 1995.

18. Miyoko Urushibara, interview by author, May 19, 1995.

19. Isamu Noguchi, "Isamu Noguchi no naka ni aru higashi to nishi," *Fujin gahō* 672 (July 1960): 220–25.

20. Isamu Noguchi to Miyoko Urushibara, Sept. 25, 1957.

21. Kenzō Tange to Miyoko Urushibara, Oct. 4, 1957.

22. Isamu Noguchi to Miyoko Urushibara, Oct. 15, 1957.

23. Isamu Noguchi to Mirei Shigemori, Mar. 4, 1958, NA.

24. Kenzō Tange, "Chōkokuka Isamu Noguchi: higashi to nishi ni ikiru," *Asahi jānaru* 3, no. 29 (Oct. 1961): 27.

25. Noguchi, *A Sculptor's World*, 167.

26. Isamu Noguchi, "Conversation with Isamu Noguchi," *Kyoto Journal* 10, Spring 1989, 35.

27. Isamu Noguchi, "Ishi," 153–57.

28. Noguchi, *A Sculptor's World*, 160.

29. Ibid., 35.

30. Isamu Noguchi, *The Isamu Noguchi Garden Museum* (New York: Harry N. Abrams, 1987), 11.

31. Noguchi, *A Sculptor's World*, 35.

32. Ibid., 36.

33. John Gordon, *Isamu Noguchi* (New York: Whitney Museum of American Art, 1968). Exh. cat.

34. Priscilla Morgan, interview by author, Nov. 14, 1994.

35. *Kyōdō News*, May 7, 1959.

36. Priscilla Morgan, interview by author, Nov. 14, 1994.

37. Yukio Madokoro, interview by author, May 4, 1995.

38. *New York Times*, Apr. 8, 1962.

39. Isamu Noguchi, "Sekai ni niwa o tsukuru," 72–80.

40. Isamu Noguchi, "The Sculptor and the Architect," *Studio* 176 (July–Aug. 1968): 18–20.

41. Noguchi, *A Sculptor's World*, 172.

42. Harold Schonberg, "Isamu Noguchi: A Kind of Throwback," *New York Times Magazine*, Apr. 14, 1968, 29.

43. Isamu Noguchi to Priscilla Morgan, May 1960.

44. Isamu Noguchi and Hidezō Kondo, "Isamu Noguchi, Hidezō Kondo," *Shūkan yomiuri*, June 19, 1960, 58–62.

45. Isamu Noguchi to Priscilla Morgan, Aug. 28, 1960.

46. Priscilla Morgan, interview by author, Nov. 14, 1994.

47. Ibid.

48. Ibid.

49. Noguchi, *A Sculptor's World*, 171.

50. Ibid., 160.

51. Gene Owens to Isamu Noguchi, May 14, 1962.

52. Isamu Noguchi to Gene Owens, May 28, 1962.

53. Noguchi, *A Sculptor's World*, 170.

54. Gene Owens, interview by author, Oct. 14, 1996.

55. Ibid.

56. Ibid.

57. Isamu Noguchi, unpublished memorandum, Apr. 19, 1965, NA.

58. Noguchi, *A Sculptor's World*, 173.

59. Elaine Rosenfeld to Yohanan Beham, Aug. 13, 1964.

60. Isamu Noguchi, unpublished memorandum, Apr. 19, 1965, NA.

61. Katherine Kuh, *The Open Eye* (New York: Harper and Brothers, 1971), 122–23.

62. Billy Rose to Isamu Noguchi, Mar. 8, 1965.

63. Elaine Weitzen (formerly Elaine Rosenfeld), interview by author, Sept. 26, 1995.

64. Teddy Kolleck, interview by author, Nov. 30, 1994.

65. Isamu Noguchi, "An Art Garden in Jerusalem." Unpublished manuscript, fall 1964, NA.

66. Elaine Weitzen, interview by author, Sept. 26, 1995.

67. Teddy Kolleck, interview by author, Nov. 30, 1994.

68. Noguchi, *A Sculptor's World*, 170–71.

69. Ibid., 178.

70. Design Review, unpublished memorandum, June 18, 1964.

71. Noguchi, *A Sculptor's World*, 174.

72. *New York Times*, Oct. 7, 1964.

73. Noguchi, *A Sculptor's World*, 175.

74. Ibid., 7–8.

75. *New York Times*, May 5, 1968.

76. Schonberg, "Noguchi, A Kind of Throwback," 24.

77. Ibid., 34.

Chapter Ten: Encounter with a Stonecutter

1. Isamu Noguchi to Gene Owens, May 30, 1968, NA.

2. Isamu Noguchi, *A Sculptor's World* (New York: Harper and Row, 1968), 39.

3. *Art News* 64 (May 1965): 13.

4. Noguchi, *A Sculptor's World*, 39.

5. Masanori Kaneko, interview by author, Apr. 22, 1995.

6. Masatoshi Izumi, interview by author, May 21, 1992.

7. Tadashi Yamamoto to Isamu Noguchi, Aug. 21, 1967, NA.

8. Isamu Noguchi to Ibsen Nelsen, Mar. 3, 1969, NA.

9. Isamu Noguchi, "Isamu Noguchi 'Kuroi taiyō' ni idomu," *Shūkan shinchō* 641, no. 15 (June 1968): frontispiece.

10. *Newsweek*, Dec. 18, 1986.

11. Masatoshi Izumi, interview by author, May 21, 1992.

12. Ruth Wolfe, "Noguchi: Past, Present and Future," *Art in America* 56 (Apr. 3, 1968): 32–45.

13. Masatoshi Izumi, interview by author, May 21, 1992.

14. Ibid.

15. Shinkichi Idei, interview by author, Nov. 17, 1995.

16. Masatoshi Izumi, interview by author, May 21, 1992.

17. Isamu Noguchi to Priscilla Morgan, Sept. 19, 1971, NA.

18. Toshiko Okamoto, interview by author, June 16, 1995.

19. Priscilla Morgan to Isamu Noguchi, Jan. 17, 1971, NA.

20. Noguchi, *A Sculptor's World*, 175.

21. Isamu Noguchi, "Isamu Noguchi no naka ni aru higashi to nishi," *Fujin gahō* 672 (July 1960): 220–25.

22. Noguchi, *A Sculptor's World*, 170.

23. Isamu Noguchi, *The Isamu Noguchi Garden Museum* (New York: Harry N. Abrams, 1987), 64.

24. Shōji Sadao, interview by author, Jan. 28, 1995.

25. Ibid.

26. Isamu Noguchi, interview by Paul Cummings, Dec. 18, 1973.

27. *Detroit News Magazine*, June 25, 1979.

28. Yūsaku Kamekura, interview by author, Aug. 2, 1995.

29. Kenzō Tange, "Chōkokuka Isamu Noguchi: higashi to nishi ni ikiru," *Asahi jānaru* 3, no. 29 (Oct. 1961): 27.

30. *Asahi shinbun*, Feb. 19, 1993.

31. *Miami Herald*, May 23, 1980.

32. Ibid.

33. Henry Segerstrom, interview by author, May 15, 1998.

34. *Los Angeles Times*, May 17, 1982.

35. Henry Segerstrom, interview by author, May 15, 1998.

36. Thomas Messer, interview by author, Sept. 19, 1995.

37. Isamu Noguchi, "Sekai ni niwa o tsukuru," *Geijutsu shinchō* 11 (July 1960): 72–80.

38. *Asahi shinbun*, Oct. 22, 1984.

39. Sakuko Shimokawa, interview by author, Mar. 1, 1995.

40. Kiyoko Hasegawa, interview by author, Oct. 9, 1995.

41. Katherine Kuh, interview by Avis Berman, Archives of American Art, Smithsonian Institution, 1982–83.

42. Allen Wardwell, interview by author, Sept. 18, 1995.

43. Chimako Yoshimura, interview by author, Apr. 3, 1995.

44. Priscilla Morgan, interview by author, Nov. 14, 1994.

45. Tōemon Sano, interview by author, Oct. 22, 1994.

46. Harold Schonberg, "Isamu Noguchi: A Kind of Throwback," *New York Times Magazine*, Apr. 14, 1968: 30.

47. Isamu Noguchi, interview by Tamaki Tachibana, 1988.

48. Akiko Kanda, interview by author, Mar. 30, 1995.

49. Junichi Kawamura, interview by author, June 28, 1995.

50. Kyōko Kawamura, interview by author, Oct. 7, 1994.

51. Hiroshi Teshigahara, interview by author, Apr. 27, 1995.

52. *Kyōdo News*, Nov. 17, 1984.

53. *Asahi shinbun*, Nov. 21, 1984.

Chapter Eleven: Farewell to a Dreamer

1. Pamphlet for opening of the Isamu Noguchi Garden Museum, n.p., n.d.

2. Mark di Suvero, interview by author, Sept. 20, 1996.

3. Arne Glimcher, interview by author, Sept. 20, 1996.

4. Ayako Ishigaki, interview by author, May 12, 1992.

5. Isamu Noguchi, *The Isamu Noguchi Garden Museum* (New York: Harry N. Abrams, 1987), 55.

6. *New York Times*, May 10, 1985.

7. Calvin Tomkins, "Rocks," *New Yorker* 56 (Mar. 24, 1980): 76.

8. John Gruen, "The Artist Speaks: Isamu Noguchi," *Art in America* 56 (Mar.–Apr. 1968): 28–31.

9. Calvin Tomkins, "Rocks," 82.

10. Isamu Noguchi and Hidezō Kondo, "Isamu Noguchi, Kondo Hidezō taidan," *Shūkan yomiuri* 19 (June 19, 1960): 58–62.

11. Tarō Okamoto, "Isamu Noguchi no shigoto," *Bijutsu techō* 63 (Dec. 1952): 43–45.

12. Thomas Messer, interview by author, Sept. 19, 1995.

13. Katherine Kuh, interview by Avis Berman, Archives of American Art, Smithsonian Institution, 1982–83.

14. Calvin Tomkins, "Rocks," 76.

15. Allen Wardwell, interview by author, Sept. 18, 1995.

16. Bonnie Rychlak, interview by author, Nov. 15, 1994.

17. Isamu Noguchi and Hidezō Kondo, "Taidan," *Shūkan yomiuri*, 58–62.

18. Renate Danese, interview by author, Sept. 22, 1995.

19. Noguchi tape transcript.

20. *Portrait of an Artist: Isamu Noguchi*, videocassette, directed by Bruce W. Bassett (Whitegate, 1980).

21. Calvin Tomkins, "Rocks," 76.

22. *Ōsaka mainichi*, Nov. 20, 1984.

23. Ibid.

24. Noguchi tape transcript.

25. Thomas Messer, interview by author, Sept. 19, 1995.

26. Renate Danese, interview by author, Sept. 22, 1995.

27. Mark di Suvero, interview by author, Sept. 20, 1996.

28. Martin Friedman, interview by author, Sept. 20, 1995.

29. *Asahi shinbun*, Nov. 13, 1986.

30. Priscilla Morgan, interview by author, Nov. 14, 1994.

31. Noguchi tape transcript.

32. Alanna Heiss, interview by author, Sept. 29, 1996.

33. *Newsweek*, Dec. 18, 1986.

34. Noguchi tape transcript.

35. Allen Wardwell, interview by author, Sept. 18, 1995.

36. Noguchi tape transcript.

37. Alexandra Snyder May, interview by author, Sept. 5, 1996.

38. Martin Friedman, interview by author, Sept. 20, 1995.

39. Alanna Heiss, interview by author, Sept. 29, 1996.

40. Arata Isozaki, interview by author, Feb. 12, 1995.

41. Alanna Heiss, interview by author, Sept. 29, 1996.

42. Isamu Noguchi to Gene Owens, Apr. 22, 1986, NA.

43. *New York Times*, July 1, 1986.

44. *Art Forum*, Oct. 1986

45. *New York Times*, July 1, 1986.

46. *Isamu Noguchi: Light Sculptures*, 1982. Exh. cat.

47. Noguchi tape transcript.

48. Tadayasu Sakai, interview by author, May 31, 1995.

49. Philip Rylands and Enzo di Martini, *Flying the Flag for Art: The United States and the Venice Biennale* (n.p.: Wyldbore and Wolferstam, 1993), 199–201.

50. Dani Karavan, interview by author, Sept. 10, 1995.

51. Kan Yasuda, interview by author, Sept. 5, 1995.

52. Noguchi tape transcript.

53. Kyōko Kawamura, diary, entry for Aug. 18, 1986.

54. John Gruen, "The Artist Speaks," 28–31.

55. Ibid.

56. Noguchi, *The Isamu Noguchi Garden Museum*, 172.

57. *Sculptors at Storm King*, videocassette (Storm King Art Center, 1992).

58. Noguchi tape transcript.

59. Ibid.

60. Kyōko Kawamura, interview by author, Oct. 7, 1994.

61. Isamu Noguchi, interview by Tamaki Tachibana.

62. Tōemon Sano, interview by author, Oct. 22, 1994.

63. Sean Brown, interview by author, Apr. 13, 1996.

64. Priscilla Morgan, interview by author, Nov. 14, 1994.

65. Ibid.

Epilogue

1. Noguchi tape transcript.

2. Isamu Noguchi, "Ishi no sonzai o kizamu," *Chūō kōron* 101 (Dec. 1986).

3. Masatoshi Izumi, interview by author, May 20, 1992.

4. Isamu Noguchi, "Speech to Japan Society, Apr. 26, 1988." Unpublished manuscript, NA.

5. *Asahi shinbun*, Oct. 22, 1984.

6. Noguchi, "Speech to Japan Society."

7. *Isamu Noguchi: The Sculpture of Spaces*. Directed by Kenji Hayashi and Charlotte Zwerin (Sapporo Television Broadcasting, 1995).

8. Yoshinobu Hakutani, *Selected English Writings of Yone Noguchi*, vol. 1 (Rutherford, N.J.: Fairleigh Dickinson University Press), 48.

9. Isamu Noguchi, "Isamu Noguchi and Japan," *IHJ Newsletter*, International House of Japan, 1982.

10. Masatoshi Izumi, interview by author, May 20, 1992.

11. Isamu Noguchi and Ailes Gilmour Spinden, conversation videotaped by Jody Spinden.

Archives

Archives of American Art, Smithsonian Institution, New York
Bancroft Library, University of California, Berkeley
Isamu Noguchi Foundation, Long Island City, New York
Israel National Museum, Jerusalem
Keiō University Library, Tokyo
LaPorte City Library, LaPorte, Indiana
Lilly Library, Indiana University, Bloomington
Museum of Modern Art, New York
National Archives, Washington, D.C.
New York Public Library for the Performing Arts, New York
UNESCO Headquarters Archives, Paris
United States Department of Justice, Washington, D.C.

Published Works

Note: This list includes only the main sources cited in the original Japanese biography in 2000.

Altshuler, Bruce. *Isamu Noguchi*. New York: Abbeville Press, 1994.

Armstrong, John. *Isamu Noguchi: The Sculpture of Spaces.* New York: Whitney Museum of American Art, 1980.

Ashton, Dore. *Noguchi: East and West*. New York: Alfred A. Knopf, 1992.

Austen, Roger. *Genteel Pagan: The Double Life of Charles Stoddard*. Amherst: University of Massachusetts Press, 1991.

Bach, F. T., M. Rowell, and A. Temkin. *Constantin Brancusi*. Philadelphia: Philadelphia Art Museum, 1995.

Cole, Roger. *Gaudier-Brzeska: Artist and Myth*. Bristol, U.K.: Sansom and Company, 1995.

Chaves, Anna C. *Constantin Brancusi*. New Haven, Conn., and London: Yale University Press, 1993.

Cummings, Paul. *Artists in Their Own Words*. New York: St. Martin's Press, 1979.

Friedman, Martin. *Noguchi's Imaginary Landscapes*. Minneapolis: Walker Art Center, 1978.

Fuller, Buckminster. "Foreword." In Isamu Noguchi, *A Sculptor's World*, 7–8, New York: Harper and Row, 1968.

Funato, Kōkichi. "Musshū Noguchi." *Geijutsu shinchō* 2, no. 10 (Oct. 1951): 123–26.

Gelertner, David. *1939: The Lost World of the Fair*. New York: Free Press, 1995.

Grove, Nancy, and Diane Botnick. *Isamu Noguchi: A Study of the Sculpture, 1924–1979: A Catalogue.* New York: Garland, 1980.

Gruen, John. "The Artist Speaks Out: Isamu Noguchi." *Art in America* 56, no. 2 (Mar.–Apr. 1968): 28–31.

Hagiwara, Sakutarō. "Noguchi Yonejirō ron." In *Shijin Yone Noguchi kenkyū*, ed. Usaburō Toyama. Tokyo: Zōkei bijutsu kyōkai shuppankyoku, 1965.

Hakutani, Yoshinobu. *Selected English Writings of Yone Noguchi.* Vol. 1. Rutherford, N.J.: Fairleigh Dickinson University Press, 1990.

Hasegawa, Saburō. "Isamu Noguchi no hibi." *Sansai* 45 (Aug. 1950): 7–9.

———. "Noguchi no Nihon." *Bijutsu techō* 33 (Aug. 1950): 58–59.

———. "Isamu Noguchi ten." *Bokubi* 19 (Dec. 1952): 29–31.

———. *Ga Ron.* 2 vols. Tokyo: Sansaisha, 1977.

Herrera, Hayden. *Frida Kahlo.* New York: Harper and Row, 1983.

Hess, Thomas B. "Isamu Noguchi '46." *Art News* 45 (Sept. 1946): 34–38, 50.

Hirano, Masaji, ed. *Rosanjin chōsakushū.* Tokyo: Gogatsu shobō, 1980.

Hughes, Robert. *American Visions: The Epic History of Art in America.* New York: Alfred A. Knopf, 1997.

Hunter, Sam. *Isamu Noguchi.* New York: Abbeville Press, 1978.

Inokuma, Gen'ichirō. "Isamu Noguchi—Nihon wa kare o matte ita." *Nihon hyōron* 25, no. 9 (Sept. 1950): 36–37.

Ishigaki, Ayako. "Isamu Noguchi no geijutsu." *Bijutsu techō* 8 (Aug. 1948.): 17–20.

———. "Yamaguchi Yoshiko no kyūpiddo," *Bungei shunjū* 30 (Jan. 1952), 162–67.

———. *Ishigaki Ayako nikki.* Tokyo: Iwanami shoten, 1996.

Kamekura, Yūsaku. "Kyōshō jidai no saigo no hito." *Apurōchi* 109 (spring 1990): 4–5.

Kanashige, Tōyō. "Noguchi-shi no shigoto ga oshieru mono." *Nihon bijutsu kōgei* 168 (Oct. 1952.): 35–37.

Kenmochi, Isamu. "Sonogo no Isamu Noguchi." *Kōgei nyūsu* 18, no. 11 (Nov. 1950): 27.

Kenmochi Isamu no sekai henshū iinkai. *Kenmochi Isamu no sekai.* Tokyo: Kawade shobōsha, 1975.

Kitaoji, Rosanjin. "*Rosanjin chōsakushū.* Ed. Masaaki Hirano. 3 vols. Tokyo: Satsuki shobō, 1980.

———. "Kakumei geijutsuka: Isamu Noguchi no sakuhin." In *Rosanjin tōsetsu.* Ed. Masaaki Hirano. Tokyo: Chūō kōronsha, 1992.

Koizumi, Setsuko and Koizumi Kazuo. *Koizumi Yagumo—Omoide no ki. Chichi "Yagumo" omou.* Tokyo: Tanbunsha, 1986.

Kondō, Hidezō. "Chōkokuka Isamu Noguchi." *Shūkan yomiuri*, June 19, 1960, 58–62.

Kuh, Katherine. "An Interview with Isamu Noguchi." *Horizon* 11 (Mar. 1960): 105–12.

———. *The Artist's Voice: Talks with Seventeen Artists.* New York: Harper and Row, 1962.

Lader, Melvin P. *Arshile Gorky.* New York: Abbeville Press, 1985.

La Porte High School Yearbook, 1922. La Porte, Ind.: 1922.

Levy, Julien. *Memoir of an Art Gallery.* New York: Putnam, 1977.

Makino, Yoshio. *Kiri no Rondon*. Tokyo: Saimaru shuppansha, 1991.

Marberry, M. M. *Splendid Poseur: Joaquin Miller, American Poet*. New York: Thomas Y. Crowell Co., 1953.

Mooradian, Karlen. *The Many Worlds of Arshile Gorky*. Chicago: Gilgamesh Press, 1980.

Moriya, Shiryū. "Isamu Noguchi sakuhinten o miru." *Sho no bi* (Oct. 1950): 15.

Nin, Anaïs. *The Diary of Anaïs Nin (1944–1947)*. Vol. 4. New York: Harcourt, Brace, and Jovanovich, 1966.

Noguchi, Isamu. "What's the Matter with Sculpture?" *Art Front* 16 (Sept.–Oct. 1936.): 13–14.

———. "I Became a Nisei." Unpublished manuscript, 1942.

———. "Trouble Among the Japanese Americans." *New Republic* 108 (Feb. 1, 1943): 142

———. "Meanings in Modern Sculpture." *Art News* 48 (March 1948): 12–15, 55–56.

———. "A Proposal to the Bollingen Foundation: A Proposed Study to the Environment of Leisure." The Isamu Noguchi Garden Museum web site. 1949.

———. "Towards a Reintegration of the Arts." *College Art Journal* 9, no. 1 (autumn 1949): 59–60.

———. "Geijutsu to shūdan shakai—Art and Community." *Bijutsu techō* 31 (July 1950): 3–5.

———. "Gendai chōkoku no shomondai." *Atorie* 283 (Aug. 1950): 20–31.

———. "Zen no geijutsu." *Geijutsu shinchō* 1, no. 9 (Sept. 1950): 68–72.

———. "Gekiteki na butai." *Kokusai kenchiku* 17, no. 5 (Nov. 1950.): 31.

———. "Notes by the Artist on His Recent Work in Japan." *Arts and Architecture* 67 (Nov. 1950): 24–27.

———. "Watakushi no mita Nihon." *Geijutsu shinchō* 2, no. 10 (Nov. 1951): 100–106.

———. "Modan to iu koto—Hiroshima mondai ni furete." *Atorie* 30, no. 9 (Aug. 1952): 39–41.

———. "Shōjijoden." *Geijutsu shinchō* 3, no. 11 (Nov. 1952): 45–48.

———. "A Project, Hiroshima Memorial to the Dead." *Arts and Architecture* 69, no. 4 (Apr. 1953): 24–26.

———. "Rosanjin, Potter and Cook." *Vogue* 123 (May 1954): 170.

———. "Akari." *Geijutsu shinchō* 5, no. 8 (Aug. 1954): 194.

———. "Indo kenchiku ni manabu—minka to kindai kenchiku o megutte." *Mizue* 610 (May 1956): 2–13.

———. "Shinde iru tera, ikite iru tera," *Geijutsu shinchō* 7, no. 5 (May 1956): 197–99.

———. "Niwa no zōkei." *Geijutsu shinchō* 7, no. 6 (June 1956): 163–84.

———. "The 'Arts' Called 'Primitive.'" *Art News* 56 (Mar. 1957): 24–27, 64–65.

———. "Ishi: Pari no 'Nihon no niwa' o tsukuru." *Geijutsu shinchō* 8, no. 7 (July 1957: 153–57.

———. "UNESCO Gardens in Paris." *Arts and Architecture* 76, no. 1 (Jan. 1959): 12–13.

———. "Isamu Noguchi no naka ni aru higashi to nishi." *Fujin gahō* 672 (July 1960): 220–25.

———. "Sekai ni niwa o tsukuru." *Geijutsu shinchō* 11, no 7 (July 1960): 72–80.

———. "Sculpture Garden of the New National Museum in Israel." *Arts and Architecture* 77 (Oct. 1960): 20–21.

———. "New Stone Gardens." *Art in America* 52, no. 2 (Mar.–Apr. 1964): 28–31.

———. *A Sculptor's World.* New York: Harper and Row, 1968.

———. "The Sculptor and the Architect." *Studio International* 176, no. 902 (July–Aug. 1968): 18, 20.

———. "Paundo no haka to Gōdeie Jaresuka." *Geijutsu shinchō* 26, no. 11 (Nov. 1975): 157–59.

———. "Noguchi on Brancusi." *Craft Horizons* 36 (Aug. 1976): 26–29.

———. "Isamu Noguchi ōi-ni kataru." *Geijutsu shinchō* 36, no. 2 (Jan. 1985): 76–79.

———. *The Isamu Noguchi Garden Museum.* New York: Harry N. Abrams, 1987.

———. "Collaborating with Graham." *Ballet Review* 13 (Apr. 1986): 9–17.

———. "Conversation with Isamu Noguchi." *Kyoto Journal* (spring 1989): 32–37.

———. "Jisaku ni yoru jiden." *Apurōchi* 109 (spring 1990): 8–17.

———. *Essays and Conversations.* Ed. Diane Apostolos-Cappadona and Bruce Altshuler. New York: Harry N. Abrams, 1994.

Noguchi, Isamu, and Hidezō Kondo. "Isamu Noguchi, Kondo Hidezō taidan." *Shūkan yomiuri* 19, no. 25 (June 1960): 58–62.

Noguchi, Isamu, and Yamaguchi Yoshiko. "Nihon ni ikiru." *Geijutsu shinchō* 3, no. 6 (June 1952): 154–64.

Noguchi, Yonejirō. 1897. *Seen and Unseen: or Monologues of a Homeless Snail.* San Francisco: G. Burgess and P. Garnett, 1987.

———. *The Voice of the Valley.* San Francisco: W. Doxey, 1897.

———. *The American Diary of a Japanese Girl.* New York: F. A. Stokes, 1902.

———. *From the Eastern Sea.* London, 1903.

———. *Ei-Bei no jūsannen.* Tokyo: Daiichi shobō, 1905.

———. "Isamu and Others." *The Sunset* (Nov. 1910): 534–39.

———. *The Story of Yone Noguchi: Told by Himself.* London: Chatto and Windus, 1914.

———. "Hōrō no omoide." *Bunshō kurabu.* Apr. 1918.

———. *Nijūkokusekisha no shi.* Tokyo: Genbunsha, 1921.

———. *Hyōshōjojōshi.* Tokyo: Daiichi shobō, 1925.

———. *Jinsei shishū.* Tokyo: Daiichi shobō, 1929.

Okada, Takahiko. *Isamu Noguchi: Space of Akari and Stone.* San Francisco: Chronicle Books, 1986.

Okamoto, Tarō. "Isamu Noguchi no shigoto." *Bijutsu techō* 63 (Dec. 1952): 43–45.

Pepis, Betty. "Artist at Home." *New York Times Magazine* (Aug. 31, 1952): 26–27.

Ray, Man. *Self-Portrait.* Boston: Little, Brown and Company, 1988.

Rylands, Philip, and Enzo di Martino. *Flying the Flag for Art: The United States and the Venice Biennale.* N.p.: Wyldbore and Wolferstam, 1993.

Sakai, Tadayasu. *Chōkoku no niwa.* Tokyo: Ozawa shoten, 1954.

Saghal, Nayantara. *Prison and Chocolate Cake.* New York: Alfred A. Knopf, 1954.

Schonberg, Harold. "Isamu Noguchi: A Kind of Throwback." *New York Times Magazine* (Apr. 14, 1968): 24, 27, 29–30, 32, 34.

Shirley, David L. "Noguchi." *Newsweek* (Apr. 29, 1968): 94.

Shishi, Bunroku. "Isamu-kun." *Bungei shunjū* 30, no. 1 (Jan. 1952): 168–76.

Spender, Matthew. *From a High Place: A Life of Arshile Gorky.* New York: Alfred A. Knopf, 1999.

Takiguchi, Shūzō. "Fushigi na geijutsu no ryokō—Isamu Noguchi shōron." *Mizue* 568 (Dec. 1952): 20–31.

———. *Takiguchi Shūzō korekushon.* Tokyo: Misuzu shobō, 1991.

Tange, Kenzō. "Gomannin no hiroba—Hiroshima pīsu sentā kansei made." *Geijutsu shinchō* 7, no. 1 (Jan. 1956): 76–80.

———. "Chōkokuka Isamu Noguchi—Higashi to nishi in ikiru." *Asahi jānaru* 3, no. 44 (Oct.): 27.

Taniguchi, Yoshiro. "Isamu Noguchi ten no tenji." *Bijutsu techō* 35 (Oct. 1950): 20–22.

Toyama, Usaburō. *Shijin Yone Noguchi kenkyū.* 3 vols. Tokyo: Zōkei bijitsu kyōkai shuppankyoku, 1965.

Wada, Sadao. "Isamu Noguchi no koto." *Atorie* 28 (Nov. 1950): 46–51.

Winwar, Frances. *Ruotolo: Man and Artist.* New York: Liveright Publishing, 1949.

Work Projects Administration. *The WPA Guide to New York City.* New York: Random House, 1938.

Yamaguchi, Yoshiko, and Fujiwara Sakuya. *Ri Kō Ran: Watakushi no hansei.* Tokyo: Shinchōsha, 1987.

Interviews (Japan)

Dates indicate initial interviews only.

Shigeo Anzai, May 3, 1995

Haruo Aoki, Mar. 26, 1995

Shigeo Arai, Apr. 28, 1995

Kyō Asabuki, Apr. 14, 1995

Tomiko Asabuki, Mar. 31, 1995

Sydney Cardozo, Apr. 13, 1995

Hisao Dōmoto, Oct. 4, 1994

Mami Dōmoto, Mar. 23, 1995

Yumi Dōmoto, Mar. 24, 1995

Chimata Fujimoto, Apr. 19, 1995

Akira Fukuda, Oct. 28, 1994

Emiko Gō, June 7, 1996

Fumiko Hamai, Apr. 19, 1995

Hiroyuki Hattori, June 4, 1995

Shōji Hashimoto, May 22, 1995

Shōichi Higuchi, May 29, 1995

Masaaki Hirano, Feb. 19, 1995

Tsutomu Hiroi, Jan. 18, 1995

Fumiko Hori, Feb. 19, 1995

Kiichi Ichikawa, Mar. 7, 1995

Shinkichi Idei, Dec. 31, 1994

Masuo Ikeda, June 19, 1995

Toshimitsu Imai, Mar. 14, 1995

Ayako Ishigaki, May 12, 1992

Kinuko Ishihara, Jan. 13, 1995
Yoshiko Ishii, Apr. 28, 1995
Arata Isozaki, Feb. 12, 1995
Jerry Itō, Mar. 16, 1995
Masatoshi Izumi, May 20, 1992
Yūsaku Kamekura, Feb. 8, 1995
Akiko Kanda, Mar. 30, 1995
Masanori Kaneko, May 22, 1992
Kōsuke Kaneshige, Apr. 24, 1995
Michiaki Kaneshige, Apr. 24, 1995
Ryūnosuke Kasahara, Jan. 14, 1995
Junichi Kawamura, June 23, 1995
Kyōko Kawamura, Oct. 7, 1994
Junkichi Kawashima, Jan. 11, 1995
Ryūkō Kawazoe, Mar. 26, 1995
Shinsuke Kenmochi, Feb. 5, 1995
Yasuo Kihara, Apr. 18, 1995
Takeshi Kinoshita, Apr. 4, 1995
Kazue Kobata, Mar. 26, 1997
Bon Koizumi, May 1, 1995
Toki Koizumi, May 1, 1995
Keisuke Koretsune, June 28, 1995
Sumiko Kumagai, Jan. 13, 1995
Kazuko Kunieda, Jan. 15, 1996
Masaki Kunieda, Jan. 15, 1996
Yukio Madokoro, May 4, 1995
Mihoko Masuda, Apr. 21, 1995
Yatako Masuyama, Mar. 15, 1995
Jūichirō Matsumoto, May 25, 1995
Setsuko Miyagi, June 18, 1995
Issei Miyake, June 14, 1995
Masao Miyamoto, Apr. 18, 1995
Aiko Miyawaki, Mar. 11, 1995
Setsuko Murao, Sept. 19, 1994
Hirozō Murata, Apr. 3, 1995
Shinichi Nagami, Apr. 23, 1995
Masayuki Nagare, Apr. 20, 1995
Kinzō Nishimura, Apr. 4, 1995
Akira Nitoguri, Apr. 15, 1995
Hajime Noguchi, Jan. 15, 1995
Michio Noguchi, Nov. 4, 1994
Tomiji Noguchi, Mar. 15, 1995

Shigeo Ogawa, May 25, 1995
Tadao Ogura, Apr. 9, 1995
Shinji Ōi, Feb. 17, 1995
Mihoko Okamura-Bekku, Apr. 6, 1995
Yōko Ōta, May 21, 1992
Sachio Ōtani, May 26, 1995
Toshiko Okamoto, June 16, 1995
Hidetarō Ozeki, Oct. 22, 1994
Tsuneko Sadao, Apr. 12, 1995
Nobue Saitō, Oct. 3, 1994
Tadayasu Sakai, May 31, 1995
Tōemon Sano, Oct. 22, 1994
Takashi Sasaki, Apr. 28, 1995
Masami Sasao, Apr. 20, 1995
Shinichi Segi, June 6, 1995
Chieko Seki, Mar. 7, 1995
Masao Senda, Mar. 2, 1995
Jyakuchō Setouchi, Jan. 15, 1995
Yōzō Shibata, Apr. 14, 1995
Geite Shigemori, June 7, 1995
Hiroko Shigemori, Apr. 4, 1995
Sakuko Shimokawa, Mar. 1, 1995
Edward Suzuki, Mar. 13, 1995
Yasuyuki Suzuki, Apr. 2, 1995
Daiki Tachibana, Jan. 12, 1995
Tamaki Tachibana, May 24, 1995
Tatsuo Takagi, Jan. 29, 1995
Kōji Takahashi, June 15, 1995
Minoru Takekoshi, Oct. 22, 1995
Asaka Takemitsu, Jan. 14, 1996
Koshijidayu Takemoto IV, May 23,
 1999
Yoshio Taniguchi, Feb. 15, 1995
Akira Tatehata, June 23, 1995
Hiroshi Teshigahara, Apr. 27, 1995
Asa Tetsuo, Apr. 6, 1995
Mitsuo Toyama, June 24, 1995
Giichi Tsuji, May 21, 1995
Takashi Ukita, Apr. 19, 1995
Miyoko Urushibara, May 19, 1995
Aijirō Wakita, June 5, 1995
Masanori Watanabe, Apr. 20, 1995

Sei Watanabe, Oct. 20, 1994
Akira Yagi, Oct. 1, 1995
Hikaru Yamada, Apr. 5, 1995
Yoshiko Yamaguchi (Yoshiko Ōtaka),
 Dec. 27, 1994

Jin Yamamoto, June 3, 1995
Tadashi Yamamoto, May 22, 1995
Susumu Yanagatsubo, Apr. 17, 1995
Chimako Yoshimura, Apr. 3, 1995
Kaoru Yoshimura, Apr. 3, 1995

Interviews (United States, Italy, Israel, India, France, Mexico)
Dates indicate initial interviews only.

Tetsurō Akanegakubo, Aug. 30, 1995
Ann Alpert (formerly Ann Matta),
 Sept. 19, 1995
Bruce Altshuler, Sept. 3, 1994
Giorgio Angeli, Sept. 6, 1995
Dore Ashton, Sept. 18, 1995
Bernard Bergstein, Sept. 22, 1995
Claude Bernard, Nov. 22, 1994
J. B. Blunk, Mar. 10, 1996
Nigette Brennan, Sept. 13, 1996
Sean Browne, Apr. 13, 1996
Diane Apostolos-Cappadona, Sept.
 12, 1996
Renate Danese, Sept. 22, 1995
Mark di Suvero, Sept. 20, 1996
Betty Ecke (Tsing Yuho), Apr. 15, 1996
Sono Osato Elmaleh, Sept. 18, 1995
Jean Erdman, Oct. 3, 1996
Martin Friedman, Sept. 20, 1995
Arne Glimcher, Sept. 20, 1996
Peter Grilli, Sept. 26, 1995
Stanley Grinstein, Nov. 5, 1995
Nancy Grove, Sept. 14, 1995
Kiyoko Hasegawa, Oct. 9, 1995
Sumire Hasegawa, Oct. 20, 1995
Alanna Heiss, Sept. 20, 1996
Hayden Herrera, Jan. 7, 1996
Harry Honda, Nov. 6, 1995
Ryōzō Iwashiro, Sept. 21. 1995
Isolda Kahlo, Mar. 24, 1996
Henry Kanegae, Nov. 4, 1995
Dani Karavan, Sept. 10, 1995
Harold Kelling, July 8, 1996

Shigeno Kenmochi, Nov. 20, 1994
Michiko Kobi, Nov. 16, 1994
Machiko Kodera, Aug. 30, 1995
Teddy Kolleck, Nov. 30, 1994
Miles Kubo, Apr. 13, 1996
Richard Lanier, Sept. 20, 1995
Charles Lieb, Sept. 11, 1996
Martin Margulies, Sept. 24, 1996
Alexandra Snyder May, Sept. 5, 1996
Thomas Messer, Sept. 19, 1995
Priscilla Morgan, Nov. 11, 1994
Luchita Mullican, Nov. 5, 1995
Yukuto Murata, Nov. 23, 1994
Akira Niitsu, Sept. 24, 1995
Sadaichirō Okajima, Nov. 23, 1994
Mine Okubo, Nov. 14, 1995
Gene Owens, Oct. 14, 1996
Lester Pancoast, Sept. 30, 1996
Alice Kagawa Parrot, Dec. 30, 1996
Michel Passet, Nov. 23, 1994
Charlotte Perriand, Dec. 3, 1994
Noriko Prince, Sept. 21, 1995
Kitty Roedel, Sept. 29, 1996
Andrée Ruellan, Sept. 15, 1995
Elizabeth Rumely, July 9, 1996
Lucio Ruotolo, Sept. 26, 1996
Bonnie Rychlak, Nov. 15, 1994
Shōji Sadao, Jan. 28, 1995
Nayantara Sahgal (formerly Pandit),
 Jan. 31, 1996
Mitsuo Sakaba, Nov. 23, 1994
Anand Sarabhai, Feb. 8, 1996
Gira Sarabhai, Feb. 9, 1996

Gita Sarabhai, Feb. 8, 1996
Henry Segerstrom, May 15, 1998
Claire Shulman, Sept. 14, 1995
Cassandra Bowyer Simpson, July 8, 1996
Jody Spinden, Dec. 29, 1996
Peter Stern, Sept. 15, 1995
Toshiko Takaezu, Sept. 16, 1995
Hideki Takami, Sept. 19, 1995

Ansei Uchima, Sept. 17, 1996
Toshiko Uchima, Sept. 17, 1996
Allen Wardwell, Sept. 18, 1995
Paul Weidlinger, Sept. 18, 1996
Elaine Weitzen (formerly Rosenfeld), Sept. 26, 1995
Kan Yasuda, Sept. 5, 1995
Takeshi Yasuda, Sept. 5, 1995
Marta Zamora, Mar. 25, 1996

ACKNOWLEDGMENTS

Having written several books about the Japanese-Americans and U.S.-Japan relations, several years ago I decided to work on the biography of an individual whose life would illustrate the complicated and often troubled relationship between Japan and the United States during the twentieth century. I wanted to look at the history of that relationship from both sides of the Pacific. In the end, rather than focus on a prominent political or intellectual figure, I decided to write about an artist, Isamu Noguchi, whose works I deeply admired. From the beginning, indeed from his birth, his life was entwined with both cultures in a way that few lives are. He was an ideal subject.

At first the task seemed a daunting one but when I mentioned it to Tadayuki Tashiro, then chief of the nonfiction department of Kodansha Publishing Company, he was enthusiastically supportive. With his help I met the architect Arata Isozaki, a friend and colleague of Isamu Noguchi, who was then still alive. He agreed to introduce me to Noguchi, and since the artist was deeply suspicious of people he did not know, he also offered to join me at the first meeting. Unfortunately, Mr. Isozaki's schedule was quite busy, and my time in Japan was limited, so we were unable to arrange anything. Several months later I heard the news of Isamu Noguchi's death.

When I discovered that during the last year of his life Isamu Noguchi taped oral reminiscences in preparation for an autobiography, I decided to move ahead on the project. Research for the book took six years. I was fortunate to have the help of Shōji Sadao, Bruce Altshuler, as well as Bonny Rychlak and Amy Hau at the Isamu Noguchi Foundation in Long Island City, where Isamu Noguchi's personal letters and papers are preserved. Amy Han was especially generous in guiding me through the col-

lection and providing me space to transcribe rare letters and other materials that could not be photocopied.

I am also grateful to the staff at the Bancroft Library, University of California, Berkeley, where I found material related to Yonejirō Noguchi, the artist's father; to the staff at the Lilly Library at Indiana University, where the papers of Edward A. Rumely are stored; and to the staff at the Keiō University Library in Tokyo, the Israel Museum, and the UNESCO archives. Through the Freedom of Information Act, I was also able to obtain documents from the FBI covering Isamu Noguchi's wartime and postwar experiences, and I found similar material in the National Archives.

The many individuals in the United States, Japan, India, and the rest of the world who agreed to meet with me to talk about their memories of Isamu Noguchi are too numerous to mention. A complete list of the interviewees can be found in the bibliography.

While doing research for the book, Tsuneo Muramatsu, my editor at Kodansha, helped me to arrange interviews in Japan and find needed materials there. Hisae Sawachi, who spent three months as a visiting scholar at Stanford University, made helpful suggestions about how to shape the overall outline of the book. As the original Japanese manuscript moved toward publication, Shunkichi Yabuki took over as my editor. He had worked with me in 1991 when I wrote an article on Isamu Noguchi's atelier at Mure for the monthly magazine *Gendai*. His suggestions for changes and additions in the final draft were invaluable. And Mr. Tashiro continued to remain enthusiastic even though it took three years after I promised, "I'll have it done by next year."

I am also grateful to Nancy Grubb for her efficiency in guiding the manuscript through the review process and for helpful answers to my questions; to Devra K. Nelson and Linny Schenck for overseeing the production process; and to Jonathan Munk for his careful and thoughtful copyediting.

My husband, Peter Duus, who read through early drafts of the Japanese manuscript, has translated the Japanese version into English. Without his help in this and many other ways, the book would not have appeared in English as smoothly as it did.

Contrary to the usual convention, all Japanese names in the book are written with the personal name first, and the surname second. Macrons are used to indicate long vowels in Japanese names and other terms.

Tokyo National University of Fine Arts and Music, 340
Tokyo School of Fine Arts, 133
Tolan, John, 165
Tolan Committee, 165–66
Tompkins, Calvin, 352, 356, 359
Toyama, Usaburō, 54, 131
Tsuda, Umeko, 52–53
Tsukubai, 304
Twain, Mark, 15

Ukita, Takashi, 319, 345
Umehara, Ryūzaburō, 264
UNESCO garden, 273–85, 307, 382–83
Uno, Jinmatsu, 133–34, 244
Uno, Kenji, 133
Urushibara, Miyoko, 280–82

Venice Biennale, 361–71

Walker Art Center, 257, 329, 365
Walter, Bruno, 165
War, 154
War Relocation Authority (WRA), 166, 169–74
Wardwell, Allen, 350, 357, 364, 386
Warnecke, John C., 305–06
Warner, Langdon, 174
Watanabe, Masanori, 322

Wave in Space, 321, 340
Weber, Max, 115
White Sun, 298, 314, 316
Whitney Museum of American Art, 8, 307–8, 350, 352
Works Projects Administration (WPA), 153–54
"World of Dream," 239–48
WPA. *See* Works Projects Administration
WRA. *See* War Relocation Authority
Wright, Frank Lloyd, 174, 363

Yamaguchi, Shirley. *See* Yamaguchi, Yoshiko
Yamaguchi, Yoshiko, 220, 274; childhood, 220–21; marriage, 230–36, 259–71; movie career, 221–23, 225–27, 230, 243, 260–61; in postwar Japan, 223, 262–63
Yamamoto, Jin, 380
Yamamoto, Tadashi, 313–14, 316, 319, 337, 345
Yasuda, Kan, 345, 371–72
Yeats, William Butler, 51, 100, 143
Yoshimura, Chimako, 339, 373, 383
Yoshioka, Sumie, 374

Zehrfuss, Bernard, 273, 275

Illustrations are reproduced courtesy of the owners or sources listed here: Ann Alpert (pp. 75, 182); photo by and reproduced by permission of Shigeo Anzai (pp. 348, 368); Morimura Gakuen (p. 59); Eliot Elisofon/Time Life Pictures/Getty Images (p. 176); Masaaki Hirano (p. 238); Isamu Noguchi Foundation, Inc. (frontispiece and pp. 10, 24 [right], 65, 272, 297); photo by Michio Noguchi, courtesy of Masatoshi Izumi (p. 315); Junichi Kawamura (pp. 374, 385); Kyōko Kawamura (pp. 323, 345); Toki Koizumi (p. 32); Lilly Library, Indiana University (pp. 76, 83, 94, 105, 106); Yukio Madokoro (p. 329); Priscilla Morgan (p. 288); Hajime Noguchi (p. 132); Tomiji Noguchi (p. 204); Mihoko Okamura-Bekku (p. 310); Yoshiko Ōtaka (p. 236); Andrée Ruellan (p. 110); Nayantara Sahgal (p. 187); Nobue Saitō (p. 49); photo by Charles W. Hearn, Miscellaneous Photographs Collection, Archives of American Art, Smithsonian Institution (p. 24 [left]); Takashi Ukita (p. 320); Underwood Photo Archives, Inc. (p. 148)